THE PROVINCIAL
INSURANCE COMPANY
1903–38

SIR JAMES WILLIAM SCOTT, BART. (1844–1913)
Chairman of the Provincial Insurance Company, 1903–13
(after F. O. Salisbury)

THE
PROVINCIAL
INSURANCE
COMPANY

1903–38

*Family, markets
and competitive growth*

Oliver M. Westall

Manchester University Press
Manchester and New York

Distributed exclusively in the USA
and Canada by St. Martin's Press

Copyright © Oliver M. Westall, P. F. Scott and Provincial plc 1992

Published by Manchester University Press
Oxford Road, Manchester M13 9PL, UK
and Room 400, 175 Fifth Avenue, New York, New York, NY 10010, USA

Distributed exclusively in the USA and Canada
by St. Martin's Press, Inc., 175 Fifth Avenue, New York, NY 10010, USA

British Library Cataloguing-in-Publication Data
A catalogue record of this book is available from the British Library.

Library of Congress Cataloging-in-Publication Data
applied for

ISBN 0 7190 3637 2 *hardback*

Typeset in Aldus
by Koinonia Limited, Manchester
Printed in Great Britain
by Bell & Bain Limited, Glasgow

Contents

Tables and diagrams

DIAGRAMS

Illustrations

Acknowledgements

This history of the Provincial Insurance Company has been written at the request of Peter Scott, then Chairman and now President of the Company. My first obligation is therefore to thank him, Charles Shakerley, the current chairman, and the company, for supporting my research and allowing me access to the company's historical documents. Once it was agreed that I should cover the period from 1903 to 1938, I have been encouraged to write as frankly as I wished and the text is published exactly as I have written it. Beyond this, Peter Scott has provided steady, patient, personal encouragement when sometimes the mass of paper generated by an insurance company has threatened to overwhelm me, so my gratitude to him is more than formal.

Two other members of the Scott family have helped me. At an early stage of my work I had an opportunity to discuss the Provincial's development with Francis Scott, the central figure in this book. It was an extraordinary opportunity to discuss insurance as far back as 1903 with someone who could relive its circumstances so vividly and so shrewdly. Sir Oliver Scott, Bart., Sir Samuel Scott's son, has also been generous in showing me family papers and allowing me time to discuss the Provincial's history.

In the course of my research I have met many members of the Provincial's staff, both present and retired. Some have discussed their careers in the Provincial at length, providing points of detail and atmosphere that could never be found in documents. I list these in a note on sources at the end of the book. Some have helped me search for documents in the furthest recesses of the company's head office. Others have explained some of the technicalities of insurance and accounting to me. They have invariably been friendly and helpful and I am grateful to them all. I hope they will forgive me if I do not attempt to mention them by name, for there are so many that to attempt a list would be unwise. I hope I will be forgiven if I make one exception. Ernest Beeston, formerly Peter Scott's personal assistant, has been a continual source of wise and practical advice.

Much of what passes for originality in academic work derives from the accidents that have shaped the writer's professional training and outlook. I gratefully acknowledge a debt to three scholars who taught me: Professor F. J. Fisher, who showed me the intellectual excitement of economic history; Professor D. C. Coleman, who has provided a model of analytically muscular business history; and Professor P. W. S. Andrews, who demonstrated the illuminating power of a properly conceived theory of industrial economics.

I have also been assisted more directly by professional colleagues. Despite

having no conceivable obligation to do so, Professor B. Supple read an early draft and provided both constructive criticism and encouragement. Professor B. W. E. Alford provided advice at a critical moment. I have been most fortunate in working in the Department of Economics at the University of Lancaster where business history is practised in an atmosphere which encourages its relationship to economic theory and management studies. My colleagues there have provided all manner of forms of support, including reading drafts and discussing issues in ways that have helped to clear my mind. The late Harry Dutton, Mary Rose, Maurice Kirby, Robert Rothschild and Nicholas Snowden have been particularly helpful. Beyond my department, Roger Ryan has provided the type of help that can only come from a fellow scholar carrying out work in a closely related area. Professor John Butt has generously sent me unpublished data from his own researches and Professor Ken Peasnell has cleared my mind on technical (to me!) aspects of accounting. But among my professional colleagues I would like to single out two in particular. The late Professor Elizabeth Brunner and Professor V. N. Balasubramanyam have provided a blend of intellectual and personal encouragement without which this book would not have been completed. I have been fortunate to have two such friends.

Every historian owes a debt to those who facilitate his work in record offices and libraries. I would like to thank Robert Cunnew and the staff of the library of the Chartered Insurance Institute for helping me to use its excellent resources to best advantage. The Keeper of Manuscripts and staff at the Guildhall Library in the City of London assisted me to use their outstanding collection of insurance archives. Miss Sheila Macpherson and her staff in the Cumbria County Record Office have always been helpful beyond the call of duty.

Doris Loft assisted me by carrying out an excellent survey of documentation pertaining to foreign business. Charles Purvis collected statistical information relevant to Chapter Four.

I must acknowledge permission from the Editors of *Business History* and Frank Cass and Company, Ltd. to base part of Chapter 10.3 on an article published in that journal; and from the Royal Economic Society, the Editors and the Macmillan Press to reproduce material from *The Collected Writings of John Maynard Keynes*. I am also grateful to the Trustees of the Keynes papers, then held in the Marshall Library, Cambridge, for permission to consult them, and to the Provost and Scholars of King's College Cambridge, who now hold the papers and their copyright, for allowing me to consult them again and granting me permission to quote from them. I must also thank the Guardian Royal Exchange and the Commercial Union for allowing me to study their records deposited in the Guildhall Library, London.

My greatest obligation is to my family. By remaining largely indifferent to their father's curious obsession, Rebecca and Rosina have preserved my sense of proportion. My wife, Karen, has supported me with her mathematical and editorial skills, encouraged me through all difficulties, and shared many of the costs of the task, without participating in its pleasures. For this – and much more besides – I thank her.

Oliver M. Westall

Note on sources, abbreviations and technical terms

Sources The archives of the Provincial Insurance Company and the Scott family are not available for public inspection. The only important exception to this is that some correspondence and other documentation relating to J. M. Keynes held by the company was made available for *The Collected Writings of John Maynard Keynes* and is cited from that source for convenience. Apart from this, the references at the end of the book are restricted to material in public archives or secondary sources. A more fully referenced manuscript has been placed in Lancaster University Library. A description of the company and family sources used is provided on page 446.

Abbreviations Throughout the text the abbreviations FOC and AOA are used for the Fire Offices Committee and the Accident Offices Association.

Technical terms The glossary on page 428 explains the use of the terms gross premium income, net premium income and corrected loss ratio.

Introduction

Three themes dominate the history of the Provincial Insurance Company: family; markets; and corporate growth.

James Scott founded the Provincial in 1903. He had reached late middle age after a successful career in the cotton industry which had made him a wealthy man. His main objective in forming the company was to create a vehicle that would transmit this wealth to later generations of his family, with some prospect that it would fructify. He said, of the Provincial, that 'it will be nothing for me, but it will be a good thing for my sons, and it will be a splendid thing for my grandchildren.' This intention was fulfilled. The company has remained almost entirely in the hands of his descendants and during its first fifty years of operation its gross assets grew more than one hundred fold from a substantial initial base.

This continued ownership and its intention would in itself mean that the company's history can only be understood in terms of the objectives of the Scott family. These have determined the financial resources placed at the company's disposal and the strategy pursued. However, the relationship has been closer still. The Scotts have not only determined strategy, but supervised its implementation through the management of the company. James Scott hoped from the start that the Provincial would provide a congenial career for his sons.

In fact, members of the family have remained continuously involved in the control of the company to the present day. Until his death in 1913, James Scott supervised the infant concern, while his sons served an apprenticeship to the business world under his guidance. Subsequently his elder son Samuel Scott succeeded him as chairman and his younger son, Francis Scott, soon became managing director. Both took a close interest in the management of the company. However, while Samuel Scott played a crucial role in the Provincial's early days, especially when his brother was absent for long periods for health reasons, his contribution eventually became one of advice and consultation. Francis Scott was the driving force behind the Provincial. He became a respected adept of the insurance world and, throughout a long career, assumed responsibility for every aspect of the company's affairs – a task he relished and found a fulfilling life's work.

He succeeded his brother as chairman in 1946, but this implied no relaxation in his daily involvement. Indeed, even after his retirement from this post in 1956, he continued to take a close interest in the details of the Provincial's performance until his death at the advanced age of ninety-eight in 1979. Samuel Scott, with characteristic grace and modesty, described his brother's achievement in a letter he wrote to him after the company had been in operation for some fifty years: 'The Provincial is your creation; had you not been there we should still be a small company; it has been built up by your enterprise and energy.'

Subsequent generations have sustained the family link. Francis Scott's son, Peter Scott, joined the company's management in 1946 and he succeeded his father as chairman in 1957. He, in turn, was followed in this office in 1977 by Charles Shakerley, a great grandson of the founder. Through ownership, control and management therefore, the connection between the Scott family and the Provincial is continuous and intimate and the company's history can only be understood in the light of family objectives, attitudes and personalities.

The Provincial's history is equally interlocked, in the most profound way, with the history of the general insurance business within which it has operated.[1] Of course, it would be impossible to appreciate its methods of operation without reference to the technical and administrative procedures that are common to the marketing and underwriting arrangements of all insurance companies. Similarly, the Provincial's activities and development are almost meaningless unless they can be compared with other companies operating in the same business. This requires its history to be related to the environment of general insurance. Yet the relationship is more fundamental than that alone. The company's history cannot be understood apart from the proliferation of markets within the business and the competitive structure they created.

Initially the Provincial wrote fire insurance exclusively, but as the scope and interconnections of general insurance underwriting widened, it diversified, taking advantage of new opportunities. Before the First World War it undertook accident insurance underwriting on a modest basis and ventured tentatively into foreign markets. During the war it opened a marine insurance department and tasted motor insurance. After 1920 the latter exploded at home and abroad, providing the main basis for the Provincial's own remarkable growth. At the same time the company widened the geographical and product range of its business such that by 1938 it accepted all forms of insurance, except those associated with life assurance, and was well established in a number of foreign markets.

This expansion in the number and scale of markets was obviously of the

greatest importance to the Provincial's development, but the connection is not a simple one. Its success was dependent on external factors and also had implications for the company's organisation. Each market within general insurance had its own competitive structure, even if this was to some extent influenced by competitive factors which swept across the whole insurance business. To a very large extent the speed and balance of market expansion was produced by the Provincial's capacity to exploit each one successfully. Of course, in this respect the company did not remain a passive recipient of competitive circumstances. It could actively intervene, using the variables of price, product and marketing as inducements to encourage business.

Throughout its history, the Provincial's use of these devices has been dominated by one consideration. That has been the difficulty it has had in breaking through the market power of long-established, large companies, created by their goodwill in the market and the scale and the effectiveness of their marketing organisations. The Provincial has remained a relatively small concern competing with giants. For reasons that will be explained, this has meant that the Provincial has had to preserve discretion over the level at which it has set its premium rates. This has brought it into conflict with the 'tariff' organisations which, until quite recently, have been so important in controlling premium rate competition in general insurance.[2] This 'non-tariff' policy has been imposed on the Provincial by market structure, but has enabled the company to achieve a degree of market penetration otherwise impossible.

At the same time, premium rate competition was not always successful in attracting business. Some markets could only be exploited in other ways, pre-eminently through an expansion in the Provincial's marketing organisation. Furthermore, most new markets created technical and administrative problems of a sufficiently specialised type to require the creation of separate underwriting departments, increasing the complexity, as well as the scale of the company's central organisation. Thus, while organisational development has always been subject to resource constraints, it has in large measure been led and shaped by the proliferation of markets and their competitive structure.

For all these reasons, the Provincial is as much a product of its environment as of the intentions of its owners. It has only survived and developed by responding successfully to the opportunities of the market. This has shaped its external dimensions, its competitive stance and its internal organisation. In short, the Provincial exemplifies Andrews's vivid metaphor that small firms are 'stressed members' through which the pressures of their industrial environment are transmitted.[3]

Corporate growth forms the final and unifying theme in the Pro-
vincial's history relating, as it does, the Scotts' objectives to the company's
actual market performance. James Scott's intention that the Provincial
should become a source of expanding wealth for his family was accom-
plished by his sons to an extent that certainly satisfied, if not surprised,
them. By the outbreak of the Second World War the family's initial
involvement of £75,000 had been converted into a company with
conservatively estimated published gross assets of over £2 million, a net
premium income of over £1 1/2 million, a staff of over 750 and it paid, on an
extremely cautious basis, a gross annual dividend of £55,000.

Yet these are the statistics of celebration rather than understanding. It
would be easy to point to more dramatic growth by other companies, not
least in insurance, where such concerns as the General Accident and the
Eagle Star achieved far more dramatic expansion in a similar period.
There were also phases when the pace of growth varied significantly.
What is more important is the task of analysis, to try to appreciate the way
in which growth took place, within a framework established by family
objectives and management capability, command over resources, and the
opportunities markets offered. The task of this book is to explain the
interplay between men, resources and opportunities which created the
particular pattern of growth the Provincial exhibited.

This theme also integrates the other main aspects of the company's
development. In the first place it provides a framework within which to
assess the contribution of the Scotts as the company's entrepreneurs and
managers. Their skill, experience and administrative capacity formed the
Provincial's central resource and the company's growth was wholly
dependent on their effectiveness in planning initiatives, implementing
them and then controlling the subsequently enlarged organisation. They
set the company's objective of long-term growth with minimum risk to
family assets and its achievement was largely in their hands. It is therefore
reasonable to measure the quality of their decision taking and the strength
of their management skills by the way in which these contributed to
successful growth.

Of course, they could only direct the company towards growth within
the limitations of the resources at their disposal. The second integrating
function of the growth theme is the way in which it requires the com-
pany's exploitation of markets to be firmly linked to the accumulation of
the human and financial resources necessary to market, accept and
administer a given premium income successfully. These could not be
expanded at will, for there were often limits to the extent to which they
could be acquired in external markets. The Scotts' determination to retain

control of the company and enjoy to the maximum the fruits of their success severely restricted the scope for utilising wider sources of finance. This probably created the most important limit on growth, for other insurance companies prepared to obtain such support grew far more quickly. Furthermore, as a small, family controlled insurance company, the Provincial sometimes found it difficult to attract good quality staff irrespective of salary. Newly recruited staff took time to win the confidence of colleagues and employers and to understand the methods and problems of the Provincial. Long-established staff sometimes created difficulties of their own. This meant that growth was usually only possible at a pace determined by the speed at which the company could utilise its resources more efficiently or generate additional capacity internally, whether human or financial. Focusing on this important aspect of growth thus draws into the analysis the development of the company's resources and internal organisation.

In fact, the acquisition of resources was ultimately dependent on the effective management of the company on a year by year basis. Only the expansion of profitable revenue within the existing resources could provide the surpluses to nourish financial reserves and adequate cover for larger overhead costs. Thus an explanation of growth inevitably involves an emphasis on the short-term foundations of long-term expansion. The quarterly battle by managers and their staffs to increase revenue and margins and reduce relative costs in competitive markets was as important for the pace of growth as the issues of high strategy which are the more common content of discussions of business growth.

These three themes of family, markets and growth are not only imposed by the subject matter of the Provincial's history; they also relate it to the wider issues of market efficiency and corporate growth in business history and industrial economics.

The existing literature of twentieth-century business history has given a disproportionate emphasis to large firms and the emergence of 'managerial' control.[4] This has happened for a number of reasons. Large and successful companies have been more likely to encourage the publication of corporate histories – and they are more likely to have outgrown family control.[5] Contemporary family businesses are sometimes shy of advertising their success. Historical questions of importance have also been involved, for the significance of the modern managerial corporation gives its genesis in Britain an obvious importance. The work of Chandler and Hannah has particularly sharpened interest by providing a stimulating analytical and comparative framework, nourished by much new general information.[6]

Yet, while to this extent justified, there are dangers in this bias, for it may distort historical interpretation. While the main conclusion has been to see Britain as a case where the family firm enjoyed prolonged survival in far more sectors than in the United States or Germany, there have been few studies of concerns where family ownership and control were retained unimpaired into the twentieth century. Those available are almost all accounts of family businesses which grew to a substantial scale, usually metamorphosising into managerial corporations. Perhaps of even greater importance, by concentrating on large concerns, the most influential writing has been mainly restricted to firms with great market power, for this has been the usual route to large scale operation in Britain. In these circumstances a distinctive view of competition has been formed. Relations between companies have been seen as intensely collusive, often, as diversification has become more common, across a series of product or geographical markets. Of course, such arrangements have often been so implicit that they are difficult for the historian to trace. Yet when explicit, they have taken the form of strategic negotiations between firms aimed at dividing and controlling markets and avoiding price competition at all costs. Even when competition has occurred, it has usually taken the form of innovation, product differentiation and the creation of marketing organisations.

Given this, the main determinants of corporate growth have appeared to be the aggregate size of the markets controlled, the success companies have had in protecting their positions through clever negotiation and in discovering new directions for diversification. Their main problems have been those of mobilising resources and organising them efficiently. This is really the message of Chandler's work, for despite his emphasis on markets, his theme is the way in which they are internalised to remove inefficiency and uncertainty.[7]

From corporate histories and comparative work the view of the firm is the same – its control over markets is so great that it encapsulates them. Its internal history is the history of the industry and relations with other concerns are a matter of diplomacy between securely founded sources of market power.

When the business historian consults the considerable theoretical literature on the firm over the long period, he finds this emphasis reinforced rather than balanced. Penrose, whose earlier but accessible *Theory of the Growth of the Firm* has had the greatest influence, initiated an emphasis on internal resources and motives as the determinants of corporate growth.[8] By contrast her model tells us little about the relationship with the external environment which is seen as a limited set

of static scenarios. Small firms may face 'special opportunities' or 'interstices', while large firms grow by diversification, as expansion in each market runs into declining profitability. Whatever criticisms Marris and other prominent writers have made in the subsequent discussions, they have all accepted similarly restrictive assumptions about the markets facing firms, giving little impression as to how 'interstices' or diversification arise in a competitive environment.[9]

Just as business historians can justify their interest in large firms by reference to the social importance of the modern corporation, so the theorists can argue that closing their models to market structure is a necessary cost if they are to construct a determinate growth path for the firm. Relaxing this restriction opens the Pandora's box of oligopoly, with all the intractable uncertainties that releases. There has in any case been an assumption in their work that market structure is not an important consideration for the 'monopoly' corporations in which they are principally interested. It is true that in the last decade or so industrial economists have realised this difficulty. As a result they have taken a fresh interest in oligopoly, using games theory to spell out with more precision the implications of potentially collusive market situations. This may prove the basis for a more powerful analysis of industrial behaviour and corporate growth, but as yet it remains at a level of abstraction that poses difficulty for any empirical work.[10]

However, the fact remains that the large scale, diversified and monopolistic corporation was quite unrepresentative of British business in the first half of this century. The single product firm, family owned and taking a modest market share was predominant.[11] While collusion and non-price competition were usually present, such firms were profoundly influenced by the more basic processes of price competition. Much of their energy was directed towards reducing this susceptibility by creating and hanging on to some degree of market power, rather than exploiting a strong established position. To view British business almost exclusively through the limiting case of overwhelming market power, rather than the far more common weak oligopoly, is therefore misleading. Family firms have faced special internal problems as well. As large managerial corporations emerged, scale and professional management seemed to become more important in ensuring efficiency and competitive survival. Attitudes towards the private ownership of wealth and corporate power have also changed, with implications for public policy and labour relations. These issues concerning the competitive environment of small and family firms have assumed a new importance with the increasing realisation that the competitive situation of British business was a crucial element in the

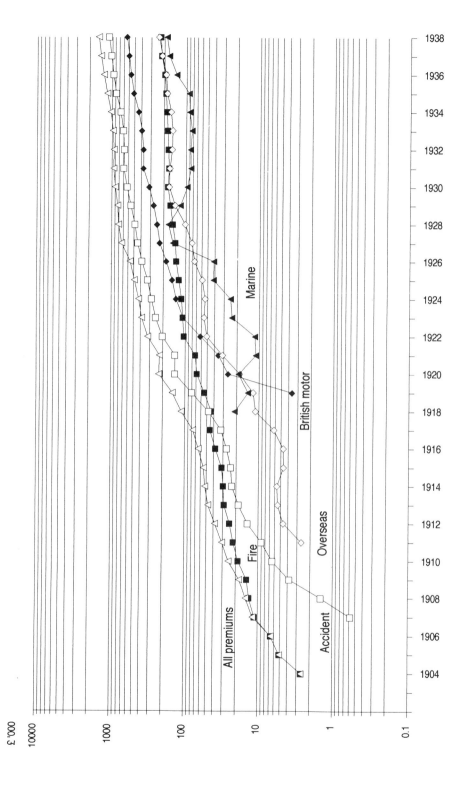

£ '000

difficulties it faced in modernising. Elbaum and Lazonick have added this institutional dimension to the analysis of apparent British economic decline. Weakly oligopolistic markets leading to price warfare and low profitability that could not support innovation, or the development of scale through acquisition, now lie at the heart of this debate.

It is hoped that the Provincial's history will help to appreciate the scope and problems of these far more representative smaller family owned concerns. Of course the company is not 'typical'. No family is quite like any other, and the Scotts in particular started with the unusual advantage of established family wealth. All markets differ and financial service markets certainly have their own particular characteristics which set them apart from manufacturing industry (though these differences can be more apparent than real). Unlike most small manufacturing concerns the Provincial diversified across several markets within the insurance 'industry'. But it did share the more important representative characteristics of the majority of its contemporaries. It remained family owned and managed, with most of the constraints this implied; it was sufficiently small to be deeply susceptible to competitive pressures and faced the stereotypical British business environment of an oligopolistic market interpenetrated by moderately successful collusive agreements. Unlike most of the companies whose histories have been written in the last forty years or so, it remained deeply vulnerable to the competitive climate and this shaped its history, rather than the discovery of an innovation or some other source of market power that could provide a long-run competitive advantage.

In addition to contributing to historical balance in this way, the study may be of interest to students of corporate growth. A single *ex post* analysis cannot provide any basis for generalisation of course. However, by emphasising the theme of business development in a competitive environment, it may encourage an analysis of the external determinants of growth. The Provincial's expansion across a series of markets enables this theme to be explored in a variety of different environments, while the process of diversification itself directly relates to the existing discussion of the growth of the firm.

Finally, the continued emphasis on the company's markets enables the important issue of consumer welfare, so often ignored in business history, to be faced. The broad dimensions of change within general insurance have been magisterially surveyed by Supple, who has described the many new markets successfully developed in the fifty years after 1880 as insurers offered new forms of cover.[12] This 'product' innovation provided

[facing] DIAGRAM 1 Provincial Insurance Company: net premium income, 1904–38

£ '000

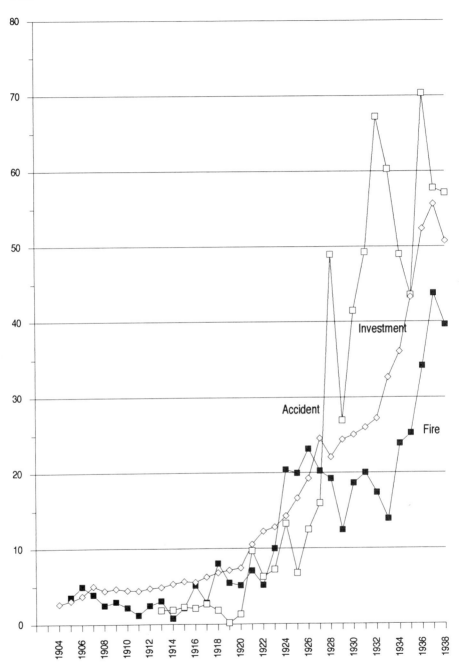

DIAGRAM 2 Provincial Insurance Company: sources of profitability – fire and
accident underwriting and net investment income, 1904–38

consumers with valuable benefits. The large fire offices eventually entered the new markets after 1900 and attempted to control competition within them in the way they had tried to manage the fire market. However, in most they were faced by a number of younger and smaller scale insurers that adopted a more competitive posture. Although insurance is often associated with large scale operation, it proved possible for some of these latter concerns to develop successfully.[13] This was of great consequence for consumers. It prevented most of the new markets from becoming so dominated by restrictive practices, encouraging a greater emphasis on premium rate competition. Furthermore, a closer linking of different markets within the insurance industry reflected these competitive forces back into the older markets. How far this competitive pressure went in improving consumer welfare is a question that has not been investigated in the historical literature.

The Provincial's history evolved at the centre of these developments. Its small size and attempts to grow placed it on the cusp of competition. It therefore provides a vantage point – superior to that provided by the larger tariff companies – from which to view these changes and assess the most important question to be faced in all industrial histories – how far did the organisation and structure of the markets considered serve the consumer? And this provides the context in which the company's own wider social significance can itself be considered.

This book studies the period from the Provincial's formation in 1903 until the outbreak of war in 1939. This saw the establishment of the company as a substantial and respected insurer, operating in all general insurance markets. Diagram 1 provides a long-term perspective of the development of business. Initially progress was made with fire business obtained in the British market, though accident insurance was soon added to the company's offerings from 1907 and an overseas venture began in 1911. Premium income faltered a little on the outbreak of the First World War, but then accelerated rapidly, partly as a result of the onset of inflation. During the war a marine insurance department was opened and motor insurance started. With the end of the war growth began on a far larger scale, though this owed little to fire insurance which languished. Motor insurance was the overwhelmingly important contributor to this growth, especially within the British market. As early as 1924 motor premiums overtook fire and continued to expand to contribute nearly half of the company's premium income in 1938.

Diagram 2 illustrates the relative importance of the three main sources of profitability. Fire insurance earned a higher margin than accident insurance, so its proportionate contribution to profitability was greater

than to premium income and remained significant in the inter-war years. Its underwriting surplus was also more stable than that secured from accident insurance. Indeed, although accident insurance eventually contributed the largest share of profitability, its volatility made this scale a risky element in the company's accounts. Most stable of all, the investment earnings secured on the company's reserves grew broadly in proportion with underwriting profits, providing a powerful flywheel which stabilised the company's profitability, guaranteeing shareholders' dividends.

The period covered by the book falls into three distinct phases: the buoyant Edwardian years in Lancashire when the Scotts learned the insurance business in relatively easy circumstances; the interruption and dis-location of the First World War; and then the years between the wars when, after a redirection of the company's activities, a period of substantial sustained growth in new markets was achieved. These phases form the three parts of this book, each being introduced by a preamble which sketches its main features and sets it in the context of the company's development.

PART
I

An apprenticeship
to insurance

The Provincial was founded to serve the objectives of the Scott family. These shaped its origins, the resources it could utilise, and its subsequent development, so it is important to understand them clearly. We begin therefore with accounts of the family's background and how it came to establish an insurance company.

However, the company's subsequent success depended entirely on the extent to which the family's objectives could be satisfactorily fulfilled in the competitive world of general insurance. Chapter Two therefore provides an account of the structure of this business and the important changes that took place in it in the years surrounding the company's formation. These were important for the erosion of the power of restrictive practices and the expansion of accident insurance opened up special opportunities for new companies. This sets the scene for Chapter Three, which shows how a strategy was evolved which brought family objectives and market opportunities together through entry and expansion.

The remainder of Part I describes the ways in which this strategy was pursued in the years to 1913. Diagram 3 illustrates the main dimensions of expansion. Chapter Four shows how development took place on a

modest scale. By that year the company's net premium income had only reached £47,360, but behind this lay a far more important qualitative development. Francis Scott had discovered that he had the powers necessary to manage and control an independent business. Under his father's guidance, and with his brother's enthusiastic support, he had begun to develop the company's real potential. At first fire premium income was obtained mainly through market intermediaries. But quite quickly the company began to build its own embryonic marketing organisation. The first branch office was opened in 1905, and by 1913 it had been supplemented by four more. As the diagram shows, the company entered the accident insurance market in 1907 and by 1913 this business was contributing two-fifths of net premium income. Some foreign fire insurance premium income was obtained from the start, but from 1911 a foreign department was established in London to exploit the home foreign insurance market there. Through these modest ventures Francis Scott expanded his perception and experience of the insurance business. The small scale on which development took place was appropriate to the company's modest

1, Acresfield, Bolton (head office, 1904–09)

£ '000

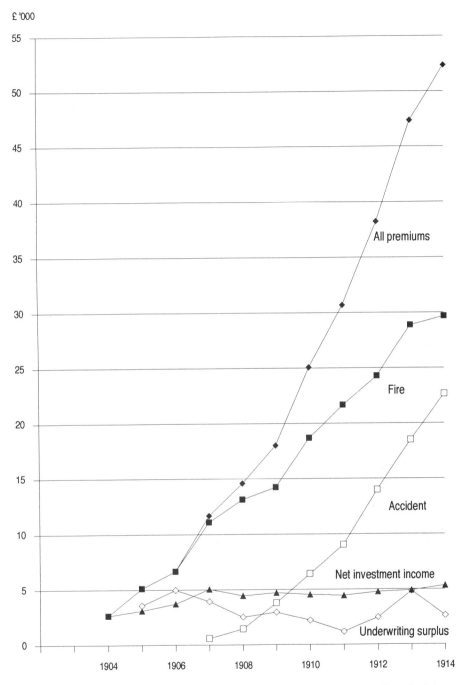

DIAGRAM 3 Provincial Insurance Company: net premium income and profitability,
1904–14

managerial and financial resources. It was a necessary but valuable apprenticeship to be served before more ambitious developments could be contemplated.

1

The origins of the Provincial

1.1 The Scott family

In 1833 John Georg Schott migrated from Frankfort-am-Main to Manchester to find an opening in the cotton trade. Eventually he became a partner in a firm engaged in exporting cotton yarn to his home country. In Manchester, through the Unitarian Chapel which he attended, he met and married Sarah Ann Kinder, a young woman whose family had been involved in various branches of trade in Lancashire, and was linked with the ubiquitous Holts of Liverpool. James William Scott, their second son, was born in 1844.

John Georg Schott was not a successful businessman. After bankruptcy in 1845, he spent the rest of his life in a series of unsatisfactory ventures attempting to restore his fortune. During one of these, while trying to establish an Anglo-Canadian trading connection in Toronto in 1858, he died, leaving his wife and young family with little financial support. During his early years therefore, James Scott suffered from poverty which, while never acute, was doubtless painful, because of the contrast it offered with the middle class society in which his mother continued to move and from which the family received benevolence. Along with his elder brother Samuel, he was required to assume responsibilities at an age that enforced a precocious maturity. It seems reasonable to suggest that these early experiences contributed towards his strong personality and his lifelong determination to create an unassailable economic security for his own family.[1]

James Scott demonstrated ability and initiative at an early age. This first took a literary turn. When only nineteen he published a short story in the *St. James Magazine*, which took work from such established authors as Trollope.[2] But he entered a cotton firm as an apprentice clerk and at the age of twenty-one, in 1865, graduated to a post as salesman. He quickly became an outstandingly successful dealer on the Manchester Cotton Exchange; by 1872 he was offered a partnership in the large cotton business owned by Sir William Coddington of Blackburn.[3]

With this secure position, in 1874 he married Anne Jane Haslam, a

member of one of the leading cotton and Unitarian families of Bolton, whose
brother he had come to know at Chorlton High School. During the difficult
years for the cotton trade in the late 1870s, the Haslam business ran into
threatening problems. His wife's brothers invited Scott to join them, in
the hope that the brilliant young businessman would save the family
concern. He was successful in this task, largely by breaking the compon-
ents of an over-integrated concern into smaller units that were required to
be independently profitable. Alongside these heavy executive responsibili-
ties, he remained at heart a cotton exchange dealer, speculating in cotton
futures, sometimes to an extent that led to moods of retrospective remorse.

With a growing reputation in the cotton world, he began to assume a
position of importance in the life of Bolton. When the Bank of Bolton was
threatened with collapse in the 1890s, he was called in as a new director to
help save it. He became a trustee of the town's leading Unitarian chapel; a
borough councillor and President of the local Liberal Association; in a
variety of ways he led philanthropic work in the town. In 1909 his public
career was crowned by the honour of a baronetcy as a member of the
Edwardian Lancashire Liberal 'Camelot'.

Despite this success in public and business life, James Scott's greatest
fulfilment and deepest obligations lay with his family. On occasion this
involved him in tedious, time-consuming involvement in the business
affairs of relations who faced shipwreck. He suffered continual frustration
in managing the Haslam business in collaboration with his individualistic
brothers-in-law. He escaped from these problems and responsibilities at
his family home, Beech House, in Bolton's most select suburb, adjacent to
the Chorley New Road.

Later, the shrine of family life moved to Yews, an old farmhouse near
Windermere, which he bought and gradually renovated and extended
from 1894. Here he enjoyed with his family the beauty of lake and
countryside, the fun of picnics and expeditions and the domestic and
cultural pleasures of planning the improvement and embellishment of his
house and grounds. To this was added the excitement of sailing on the lake
with his sons. His family could indulge in the social felicities of the self-
confident weekend resort society which grew up around Windermere at
this time, composed of wealthy families, mainly drawn from industrial
and commercial Lancashire.[4]

James Scott's concern for his family stretched beyond the provision of a
pleasant, privileged domestic life. He was always anxious, sometimes to an
extreme degree, to ensure that the wealth he had accumulated should be
preserved to continue to provide security for his issue. Yet he did not want
his sons to become the sybaritic drones often produced by wealthy cotton

families. These two considerations led him to establish a family business in the hope that it would provide a fruitful vehicle for family funds and a worthwhile but congenial interest for his sons.

1.2 The idea of insurance

These family considerations can be seen in the timing of the decision to establish a business. James Scott's elder son, Samuel, had not shown much interest in business before the Provincial was founded. Since coming down from Oxford in 1899, he had been more interested in literary and artistic pursuits which prejudiced him against a business career. His father did not attempt to alter this attitude and thought in terms of purchasing an estate that would provide him with an adequate income and a congenial way of life. Not long before the Provincial was founded, Samuel Scott went to inspect a two thousand acre estate in Berkshire, though nothing came of this expedition.

Francis Scott, the younger son, was different. He had shown interest and potential in business matters. His father therefore planned that he would use this in a career that would both secure the objective of developing family resources and provide him with a career. When he left Oxford in the summer of 1903 the question of how this intention was to be carried out was precipitated.

An obvious possibility would have been to place him with a reputable established firm for training, but James Scott did not consider this. He believed that '... if a young man can command capital his best opportunity is a business of his own '. There may have been a note of chagrin in this view. James Scott had always been involved in concerns where he had carried great responsibilities, but been allowed little freedom of action. The opportunity to establish his own business must have been attractive, especially when it could be combined with the pleasure of personally introducing his son to the business world. The question of Francis Scott's future therefore became that of which type of business it would be best to buy or initiate.

Once again, the most obvious step was not taken. James Scott's reputation and expertise in the cotton trade would have been an enormous asset to a new business. However, embarrassment might have arisen from his close connections with other firms. In any case, he did not want his son to become too closely involved in the Haslam business and this might have been difficult to resist if he had become an expert cotton man.

None the less, links with cotton were not entirely ignored. In August 1903 James Scott, accompanied by his sons, visited Appleton's bleach-

works at Turton, near Bolton, with a view to purchase. The consideration of this alternative so soon before the Provincial was launched illustrates the openness of mind that still existed, and indicates some of the considerations governing the final choice of business.

James Scott's connections in cotton would undoubtedly have helped a bleachworks, but there were other factors in the Scotts' minds. It was '... an easy and not anxious business ... depending mainly on old water rights and established connections. Moreover, it was often situated in comparatively pleasant surroundings.' Security, an undemanding management routine that could be left to employees, and a congenial location were the attractions.

It is not entirely clear why this possibility was not adopted. Francis Scott, the most directly concerned, was attracted to it. The main opposition came from his brother Samuel. It is difficult to see why his views were given such weight, for there was no definite suggestion that he would be personally involved and his father did not normally place much value on his elder son's business judgement. None the less, the evidence points to his opposition leading to the rejection of the scheme. He did not want to be associated with a manufacturing concern, or live too close to an industrial town; but the main force of his argument was of wider relevance. He argued that '... funds in cash could always be realisable, whereas a business might not be saleable.' Perhaps his views were taken into account because his father hoped that both sons would become involved in the new project; perhaps James Scott was already more committed to the idea of an insurance company to which 'funds in cash' referred. In any case, the fact that the argument was advanced and found powerful, indicates the importance of security, found, in this case, through high liquidity.

The moment when the idea of starting an insurance company became settled is not known. The participants themselves may have found it difficult to pinpoint in retrospect the moment when tentative thought crystalised into firm decision. Yet it is clear that once the idea of purchasing the bleachworks was rejected, the decision to form an insurance company was taken quickly, for it was certainly settled by the beginning of October 1903.

This speed suggests that the idea was not entirely new. Years before, as a young man, James Scott had watched insurance shares, noting how the great mercantile families of Liverpool had placed their money in the offices based in that city, and seen it multiply to great opulence. These vague impressions had been reinforced by a nearer example. The Bolton Cotton Trade Mutual, familiarly known as the Bolton Mutual, had been formed by local cotton spinners in 1876 to provide mutual insurance for

their mills. While there is no evidence that Scott was ever directly involved in the concern, its accounts must have given him food for thought. With a modest premium income, it turned in highly profitable results, with only an occasional bad year made inevitable by its narrow spread of risks. This approach was undoubtedly in his mind and the Bolton Mutual acted as a model for the Provincial's earliest operations.

In what was apparently his characteristic style, James Scott consulted as widely as possible in the weeks after inspecting the bleachworks. Incredulity was the most common reaction to the suggestion that he was thinking of starting an insurance company. He had no special knowledge of insurance and his sons had no business experience. His solicitor poured cold water on the scheme, but admitted that his client had '... never yet touched anything that was not successful.' His accountant was asked to analyse a series of insurance company accounts in order to provide a more sober basis for decision. An interview was arranged with the editor of an insurance periodical in Manchester, who proved highly sceptical.

None of this daunted James Scott. While he went through the motions of consultation, it is clear that his decision was made with more conviction and enthusiasm than was simply the product of sober business judgement. The new company held out many attractive possibilities. It promised an absorbing interest for his later years in which he could recapture the excitement of youth, working closely with his sons. It offered a longed for opportunity to turn his ability and energy to create something worthwhile for his close family, with no interference from any other consideration.

Insurance seemed appropriate. With no factory or mill to consider, his family would remain free to live where they liked. Samuel Scott seemed more interested in the idea of insurance than any other possibility. It appeared to offer more scope for the delegation of routine management than most businesses. For the family, insurance offered the security of easily saleable financial assets. There was obvious scope for Scott to use his influence in Lancashire and the cotton trade to encourage custom, without cutting across any wider family interests. Finally, it had potential. While there is little doubt that at this early stage Scott thought in modest terms, more of an underwriting syndicate than a full-blown company, there was no reason why it should not develop. In short, it appeared to fulfil closely the objectives of conveying his wealth to his children safely, potentially productively and in a way that his sons might find appealing in terms of an active, but not too demanding business career. It was, as he said himself, the 'ewe lamb' of his later years.

It is tempting to relate the decision of a cotton man to move into insurance to the wider historical discussion of the 'decline in the industrial

spirit' in Britain at the end of the nineteenth century. Of course, Scott's motives were personal, but so were those of his contemporaries. The desire to seek a safer and more congenial home for capital was certainly consistent with a more general tendency towards gentrification by other wealthy industrial families. They withdrew from direct contact with manufacturing, invested in landed estates or security portfolios, and employed themselves, if at all, in the higher professions. There was something of this in the insurance option. It seemed less taxing than industrial management; it would allow the Scotts to enjoy country life. But at its root, it demonstrated a commitment that was profoundly at variance with any anti-industrial spirit. James Scott had no doubt about the social value of profitable business. Beyond this, he believed strongly that at the personal level, the pursuit of success in the market-place could be, in itself, fulfilling and worthwhile.

The decision suggests another complication. Whatever the general pattern of withdrawal from industry, the Edwardian years saw the last great boom in cotton, which attracted entry and expansion on an unprecedented scale.[5] Superficially, the Scotts turned their face against opportunities from which many of the families with whom they associated were to reap glittering rewards in the years to 1914. In fact, as later chapters will show, their links with industrial Lancashire remained intimate, for the Provincial's early development depended heavily on cotton Lancashire and enjoyed in full measure the beneficial reverberations of the county's bonanza. The relations between individuals and movements are usually more complicated than historians' generalisations.

1.3 The formation of the company

The first definite move actually preceded the formation of the Provincial. In order to obtain the Michaelmas premium renewals on several properties whose custom he could influence, James Scott undertook temporary cover in his own name. This provoked controversial publicity. The Policy-holder commented in early October that:

A new non–tariff fire office – the Provincial by name – will shortly be operating Perhaps we are hardly correct in using the future tense for, in a manner, the concern is already operating – at any rate, certain gentlemen are already writing risks on its behalf. The position created is decidedly peculiar; but, we presume, the gentlemen who have placed their business with the uncreated Provincial know what they are doing. Accepting premiums is one thing, but paying losses is another; and it would be interesting to see how the latter be done in the event of a claim arising. The whole proceeding, to our mind, is most improper.[6]

Head office reception at 1, Acresfield, Bolton

Fortunately for James Scott the question raised by these prim remarks did
not require an answer.

The new company was formally inaugurated on the 27 October 1903
and was called the Provincial Fire Insurance Company.[7] Careful thought
was given to the choice of name, for it was intended to indicate the nature
of the company's operations and, if possible, to do so in a way that would
influence business. An appeal to local sentiment using the name Bolton
was ruled out by the existence of the Bolton Mutual. James Scott rather
unimaginatively suggested the Local and General or the New. Samuel
Scott came up with the final choice. He argued that the name Provincial
suggested local links, maturity and respectability. This caused a minor
problem because the Central had recently purchased a small similarly
named office. When they complained, an apology was dispatched, but with
no suggestion that the decision would be amended.[8]

The appointment of a board of directors was used as a further opportun-
ity to enhance the company's local links. James Scott became chairman,
with Samuel Scott as a director and Francis Scott, company secretary.
William Haslam, one of Anne Scott's brothers, was invited to represent
the old Liberal establishment of Bolton and George Hesketh, a friend of

the Scotts, the Conservative interest, which had its own special strength in the town. This careful weighing of opposing camps was taken a step further, by giving George Harwood and William Hesketh, Liberal and Conservative leaders respectively, the opportunity to become nominal shareholders. Political divisions were important in Bolton.

The company was constituted as a fire insurance company with a nominal capital of £250,000 in £10 shares, £150,000 of which was subscribed and one-half, £75,000, paid up. This round sum was determined by the price that had been asked for the bleachworks. At first James Scott held over 13,000 of the subscribed shares, Samuel Scott, 1476 and Francis Scott, 210; the other directors took 100 each and the nominal shareholders and the company's professional advisers one each. In practice, if the uncalled liability was taken into account, James Scott was personally liable for over £130,000. The mechanics of the subscription were extremely simple in that he and his sons transferred an appropriate portion of their private investments to the Provincial which became the company's investment portfolio.

Behind this formal facade, the modest reality took shape. As company secretary, Francis Scott was provided with a room and a share in a clerk at the offices of the company's accountants until proper accommodation was taken at 1, Acresfield, Bolton in January, 1904. Thus installed, he began to deal with daily routine and engage in the task of teaching himself the intricacies of insurance.

He began this apprenticeship by sitting down with files of insurance periodicals and company accounts which between them disclosed the public characteristics of fire insurance. He compiled extensive notes that were carefully indexed. The more private and subtle aspects of practice were learned less formally. James Scott invited friendly insurance officials to Bolton to discuss the business. In these ways the Scotts tried to understand the tides and currents into which they had launched their venture. The next chapter will describe what they found.

2

General insurance before 1914

The Edwardian years were to see striking changes in general insurance as accident business grew rapidly in scale and became integrated with fire insurance to form a composite market. The second section of this chapter will describe these changes. However, when the Provincial was established in 1903, the fire market remained overwhelmingly important and largely unaffected by the new developments. Its institutional and competitive characteristics established the problems which the Scotts had to solve if the Provincial's entry and early development were to be successful.

2.1 *Fire insurance at the end of the nineteenth century*

The £20.2 million of fire premium income obtained by British companies in 1899 was ten times larger than all other types of non-life insurance summed together.[1] It had grown some five-fold in the previous thirty years, but the greater part of this increase had been obtained abroad. The habit of fire insurance had penetrated the British property market by 1870. Subsequent growth at home could only take place at a rate determined by general economic growth. This was not insignificant; home fire business probably doubled in this period; but it could not match the opportunities abroad, based on the expansion of the international economy. By 1900 some two-thirds of British companies' fire revenue came from overseas, and two-thirds of this came from the United States.[2]

The market was dominated by a group of large companies. The nine largest, listed in Table 2.1, controlled fifty-five per cent of all premium income in 1899.[3] Their significance did not derive from any absolute barrier to entry. This occurred continuously and, while subject to a high mortality, a significant number of entrants survived to ensure that concentration never grew beyond moderately high levels. Seventeen of the sixty-one companies operating in 1899 had been formed since 1890 and the tenth largest had only been in operation since 1889.[4] The statistical evidence suggests no cost advantages in large scale operation. A wide dispersion of company size was a permanent feature of the market and some small firms were perfectly successful over the long run.[5]

TABLE 2.1 *Nine largest British fire insurance companies, 1899*

	Formed	Fire premium income £'000	Market share %
Royal	1843	2027	10.0
Liverpool, London and Globe	1836	1509	7.5
North British and Mercantile	1862	1447	7.2
Phoenix	1782	1188	5.9
Commercial Union	1862	1150	5.7
Sun	1710	1028	5.1
Norwich Union	1792	962	4.8
Manchester	1771	927	4.6
London and Lancashire	1861	841	4.2
Total			55.0

Source: Post Magazine, 1901

While there were no insuperable barriers to entry or small scale operation, there were limits to the ease of expansion, especially for small and new concerns like the Provincial. The competitive structure of the market created advantages for established insurers and it was these that were responsible for the concentration described above. They were able to compete on a preferential basis because of the strength of the goodwill they were able to develop. This was because opportunities to attack it by the usual competitive means were inhibited. Collusive agreements restricted the scope for premium rate competition and the development of marketing organisations created scale economy barriers for companies seeking growth, when they sought to widen the range of market segments from which they drew business. These three aspects of market structure and conduct – goodwill, collusion and the problems of organisational expansion – formed the critical problems for the Scotts in planning and managing the Provincial's expansion.

Goodwill developed naturally with sustained operation. It normally created a reputation for reliability and integrity, which was of great importance in a business where the product – indemnity from loss – was provided only after the premium had been paid.[6]

Time also developed inertia in relations with policyholders. These were almost exclusively channelled through agents. This method of organisation had developed in the eighteenth century, when the market was too diffused and disintegrated for the companies to carry the cost of direct

representation in each local market. Without it, fire insurance would never have spread beyond London and a few other large urban centres.[7]

Agents represented company interests by encouraging business, surveying risks and handling claims, all perhaps in a rudimentary way. Established to encourage market penetration, they became sources of competitive strength. Many policyholders were prepared to accept the insurances provided by a reputable local agent without concerning themselves too much with the competitiveness of his rates. The cost of discovering alternative rates was often too high in relation to the premium paid to make enquiry worthwhile, especially if it led to placing the business with a little-known intermediary, serving an unknown company.

Established agents were, therefore, able to carry much of their business without worrying overly about the competitiveness of rates. Their companies shared their local influence, and intruding concerns found intervention difficult. Higher commission rates were expensive and ineffective when paid on small accounts. Similarly, remuneration by commission meant that as long as an agent's business was safe, he had little interest in lower premium rates. In any case, agents became familiar with, and loyal to, the methods and personalities of their company and this was encouraged by helpful accommodations in the course of daily business. Agency organisations thus fortified the goodwill possessed by established companies and provided them with a core of stable business made profitable by the uncompetitive market in which it was obtained and its insulation from other companies seeking expansion.

For these reasons companies established early were endowed with a natural advantage in competition with any later entrant. It was not always sufficiently strong to prevent entry, but it certainly allowed older companies to grow more easily and this itself added a further benefit. Larger companies also tended to be favourably differentiated in the market. While not strictly rationally, many equated the absolute scale of reserves with financial strength. More reasonably, larger companies could accept larger individual risks with safety and this made them more attractive for agents with such business to place.

Age and scale therefore combined to create a powerful market position for the eighteenth-century fire offices. They were thus able to retain a high proportion of business in the domestic market right through the nineteenth century, despite considerable entry by new companies.[8] This was because goodwill remained an important obstacle to competitive expansion in the markets – known as non-hazardous – covering private houses and smaller business premises, where the total premium paid was small. Yet the development of larger industrial and mercantile risks,

containing potentially hazardous materials and processes, brought larger premiums to meet the sums at risk and the dangers involved. As premiums grew, policyholders became more concerned to reduce them. It also became easier to offer significant savings on the payments involved by making only modest reductions in the premium rate charged.

The competitive history of early nineteenth-century fire insurance can be seen in terms of the spread of larger and more dangerous risks to a wider range of trades and industries. The concomitant fire insurance markets – known as hazardous – became increasingly open to premium rate competition which could cut through goodwill. The protection this had provided established companies was put at risk. Even agents in such markets had to begin to tack between companies in a brisker competitive environment.

This development contained potentially serious consequences for the established companies. Indeed, considerable entry took place in the early nineteenth century. In 1805 the ten largest offices controlled eighty-nine per cent of the domestic business; by the 1860s this had fallen to fifty-nine per cent and the tight control of the traditional eighteenth-century offices had been relaxed.[9] However, even this degree of concentration made them extremely sensitive to one another's marketing strategies. Furthermore, each tended to specialise in particular market segments where their market share was both large and profitable. They were prepared to defend these with determination, intensifying the sensitivity. If aggressive rate reductions proved effective, an attacked company would respond quickly with matching reductions. The resulting rate war might prove long and costly. Losses in one market segment could be carried by profitability across a whole underwriting account. The receipt of premiums before claims had to be met created a tempting financial tolerance of temporary losses.

At best such an episode would lead to a similar division of business with lower premium rates. This might be attractive if it increased business by drawing into the market previously uninsured risks. However this was unlikely in the hazardous markets affected by competition. Owners of large risks were the least likely to omit to insure them, so there was little scope for market expansion. Lower rates therefore implied lower revenues and, with claims and administrative costs unaffected, lower profitability. At worst it could lead to a serious disturbance of market shares, as new companies established market positions and destroyed traditional sources of profitability for older companies. In both cases the period of instability was likely to produce underwriting losses.

The established companies set out to meet this challenge by attempting

to control rate competition. This came first with collusion on an *ad hoc* basis in the 1780s, predictably on classes of risk where scale and hazard were large and cover was essential.[10] By the 1840s there were tariffs covering most of the more hazardous classes. As non-insurance disappeared from the fire insurance market in the following twenty or so years, the pressure for complete market control grew.[11]

Collusion might have remained informal if it had not been for two special characteristics of insurance. Companies had never been able to establish a really reliable basis for rating on their own experience alone. The small number of risks available and their variability made this impossible. As risks became more complex it became even harder to ascertain appropriate rates *en bloc*. There were enormous advantages in pooling experience to establish sound rates. In any case, from the competitive point of view, companies would only be able to quote strictly comparable rates if they had access to detailed regulations fixing them for every aspect of a risk. Without this, collusion would break down.

The substantial entry of new fire offices during the early nineteenth century also weakened the oligopolistic structure of the market.[12] Collusion could no longer be an implicit matter between the Sun, the Royal Exchange Assurance and the Phoenix. While all established companies had an interest in market stability, this was sometimes insufficient to overcome their individual interest in growth, which might destroy it. Even large companies might try to increase their share of a market segment where they were under-represented. The temptation was of course especially strong for small companies. In the mid 1860s the forty-three smallest companies shared forty-one per cent of the home market and this penumbra weakened the implicit restraints on rate competition.[13] It was the only way in which they could attack the powerful goodwill of their established competitors. If they did so there was little chance that a large company would respond. The impact on its business would be too small to make retaliation worthwhile when lower premium rates might mean lost revenue across a whole class of business. Yet it could none the less create an insidious haemorrhage of revenue and profitability for larger concerns. If it became cumulative, it could transmit pressure right through the competitive spectrum and eventually lead to a breakdown of collusion.

This need for systematic rate regulation and the establishment of industrial discipline encouraged collusion to become more formal and explicit during the middle decades of the century.[14] The larger companies moved from agreements on specific rates to a permanent organisation which required formal membership and strict adherence to its regulations

in all markets. Regional committees were formed in 1858 and in 1868 the Fire Offices Committee (FOC) was established. During the following thirty years a formidable system of market control was consolidated. In 1869 forty tariffs were administered; by 1903 an array of committees, served by a professional staff, controlled seventy-three tariffs covering virtually every class of fire insurance. These specified in detail the form policies should take and the minimum premium rates to be charged for each aspect of a risk.[15]

This development was of the greatest importance. If the FOC could prevent rate competition, it would remove the most effective solvent of the bonds of goodwill which protected established companies from competitors trying to build up a new market share. Four factors strengthened its capacity to impose discipline on the market.

As risks became increasingly complex, a detailed guide to rating their various components became essential. Cross-market control meant that in principle it was impossible for a company to discriminate by rate cutting in some segments but not others. If it wished to support rate stability in any direction, it was bound to observe it in all.

FOC members also discovered an opportunity for increasing market control through the growth of reinsurance. This technique, whereby a proportion of a risk was passed on to another company, enabled an underwriter to accept larger risks than would otherwise be prudent. Co-insurance, when large risks were split between a number of companies by an agent or leading company, was relatively cumbersome and risked disclosing one's connections to competitors. Reinsurance, especially when arranged on a treaty basis which covered a whole account, rather than risk by risk, retained control and was flexible and efficient in operation. Introduced first by the Phoenix to protect itself in foreign underwriting, as the number and scale of large risks in the home market increased, it became an essential feature of underwriting, enabling a company to offer a competitively adequate scale of cover and reduce internal costs.[16]

The FOC used this by forbidding its members to cede or accept reinsurance business from non-tariff companies. As long as they monopolised reinsurance capacity, it would be impossible for non-members to underwrite more than a modest business, for they would be unable to offer agents acceptance facilities for large risks. Existing tariff companies were even more strictly controlled. Their marketing strategy would be destroyed if they left the organisation and lost reinsurance facilities.

Finally, rate competition was implicitly filtered by the FOC's rating policy. This was ostensibly cloaked in mystery, but was, in fact widely discussed. It was believed to be based on a 'target' loss ratio that would

amount to some fifty-five per cent of the anticipated premium income on any class; thirty-five per cent was allowed to cover expenses and commissions to agents; leaving an expected underwriting surplus of ten per cent. Such a convention performed two functions. It suggested, and this was argued publicly, that the rating procedures were a purely technical matter, with a reasonable service charge paid to the companies that took on such an onerous social obligation. This helped to forestall public criticism of rate collusion and suggested that lower rates implied an unsound basis for underwriting. Secondly, potential rate cutters had to think carefully if they took the procedure seriously. If only a modest surplus was available over and above the claims estimated on the basis of the FOC's uniquely reliable pooled statistics, they would have to be clear how they proposed to write lower rates profitably.

The FOC established itself as a sophisticated instrument of market control in the late nineteenth century. By attempting to neutralise the corrosive implications of rate competition for the market shares and profitability of the traditional offices, it created a major barrier to the expansion of small and new companies.

Changes in the market compounded this problem. Before 1870 new companies had been able to evade the problem of goodwill by growing with the spread of fire insurance. New risks had been available free of prior company or agency connections. Older concerns were able to capture a good proportion of such business, but its existence weakened their market control. By attacking free risks, new agents and companies were able to intervene on more equal terms. While this opportunity never disappeared, it became increasingly limited after 1870. A slower rate of industrial change and limited opportunities to increase market penetration, because of the virtual end of non-insurance, reduced the rate of market expansion. The market became far tighter; most new business arose from the expansion of risks or policyholders already involved with an office.[17]

Companies formed in the middle decades of the century and after were therefore faced by the solid market connections of well-established offices, had little opportunity to find business free from the protection of goodwill, and were apparently deprived of the weapon of rate competition with which to attack it. Attempts to circumvent these problems dominated the competitive development of fire insurance for the rest of the century.

A simple solution was to purchase an older company with an established agency organisation. This became a standard tactic whereby market penetration could be improved or an irritating rival removed. It could achieve such objectives, but only at a high price paid to shareholders that

heavily discounted the eventual yield. More generally, companies seeking growth tried two other approaches: the construction of the new institutional form of the company branch office organisation and the development of business overseas.

Branch office organisation evolved from the agency system.[18] That had included men whose links with a particular company were especially close and successful and who, in return, were given special terms including the payment of some expenses. From the middle of the century this forward integration became gradually more formal. This was encouraged by several considerations. The greater complexity of risks required more direct involvement by companies in risk assessment and claims' settlements. Transport and communication improvements, together with increasing urbanisation, increased the size of market areas and enabled the overhead costs implicit in each branch office to be carried more easily. The concomitant growth in life insurance, which required branch organisations to support hard selling, close supervision and technical knowledge, enabled some expense to be spread between the two accounts.

However, the overwhelmingly important consideration was the need to intensify and redirect competitive effort. Company inspectors, working from local branch offices, could cultivate agents in the hope of inspiring them to greater efforts; they could try to entice the agents of other companies to transfer their allegiance by direct canvass. As new business and new agents became more difficult to win, a more direct approach to the market and its intermediaries became an obvious strategy.

Branch organisations were first initiated by companies formed in the middle decades of the century. Older offices were often slow to develop them, partly from an inherent conservatism, partly because they already had a good spread of business, but mainly because they had special agreements with agents that would be disrupted by branch offices. Yet eventually they did respond, for the same oligopolistic pressures that were implicit in rate competition were evident in this new area of conflict. Throughout the late nineteenth century the scale of organisation escalated as company matched company across the provincial towns of Great Britain. Yet while the speed and efficiency with which they implemented the new approach could improve their relative position, most effort was duplicated and market shares were rarely radically changed.

This impasse changed the nature of the agency organisation. As inspectors realised the futility of chasing one another in and out of the same agents' offices, they pushed further forward to the consumer. The idea of the agent was diluted to include anyone who controlled a block of business for which it was worth paying the commission. By 1900 there

were few professional and commercial concerns without an agency. At the extreme, from the 1870s the market saw the beginnings of the 'own case' agent; a proprietor or official of a concern requiring large insurances who was given an agency to provide commission as an effective discount off the tariff rate.

These agents could only be attracted by direct canvassing by company staff and required constant service and attention. Inspectors became retail salesman and, as a result, organisational costs and commission rates climbed. Yet, once again, as offices matched one anothers' efforts, the yields became sparse. The new methods taxed profitability, yet at the end of the nineteenth century, the traditional eighteenth-century offices still controlled a disproportionate share of many segments of the British domestic fire insurance market.

Facing these problems at home, many newer offices looked elsewhere for business. Many of them had mercantile or Liverpool origins and it was therefore natural for them to turn to the overseas market and especially to the United States.[19] Indigenous insurance companies, especially outside Europe, were immature. British technical expertise, financial strength and integrity provided a powerful competitive edge in markets that were growing far faster than those at home. As investment accumulated abroad, British companies obtained special access to its insurance.

The important, complicated story of the foreign expansion of British fire insurance cannot be recounted here. What is clear is that it became the main route to company expansion. Pioneered by the Phoenix in an earlier generation, younger companies like the Royal, the Liverpool, London and Globe and the North British and Mercantile rapidly overhauled the traditional offices, as Table 2.1 shows. By the 1890s many of the latter had realised how far they had been left behind, and were making efforts to try to build a foreign account.[20]

These two strategies of branch office extension and overseas growth, which dominated the business after 1870, had similar effects in further restricting the opportunities for competitive growth for later generations of companies. However little the branch offices affected the relative market shares between established companies, they greatly increased their market power in relation to subsequent new entrants. They found themselves competing with well-founded marketing organisations, often still expanding, which enabled the older companies to consolidate and protect their agency links, stimulate them to extra efficiency and approach policyholders more directly.

New companies had considerable difficulty in matching this organisational strength. The cost of agents – commission – was directly

proportional to the revenue they supplied. In contrast, branch offices involved overhead costs. Staff had to be employed and offices obtained. The expense could be modest, but attempts to economise by employing a small or poorly paid staff, inexpensive premises in obscure sites, or making branches cover larger market areas, would be reflected in reduced efficiency. On the other hand, a new branch office opened by a small, little-known company, could not win a large revenue easily and quickly. It took time to develop business in a new district. In these circumstances, overhead costs had to be carried in advance of revenue. This need to invest in development slowed the pace of expansion. Conventionally, insurance companies were expected to carry all organisational costs on their current underwriting accounts. An ambitious programme of branch expansion therefore squeezed profitability and was limited by the extent to which this was acceptable to the owners of the company, and the policyholders, nervous of the security of their indemnity.

Similar considerations applied in overseas markets, If anything, foreign branches involved higher fixed costs. Managers had to be of higher quality for the difficulties of communication and control meant that reliability, flair and motivation were essential. To this had to be added the cost of a specialist underwriting department in the company's head office. Furthermore, many countries began to impose substantial deposits as a condition for allowing foreign companies to enter their market.[21] All these overheads became so large that even tariff companies economised by forming joint arrangements with one another to enter smaller overseas markets.

These institutional developments therefore created the third important constraint on expansion. While it was always possible for small companies to find interstices in the market, within which they could operate competitively, the moment they began to expand they faced considerable difficulties. The FOC, so assiduous to prevent rate competition, made no attempt to control the proliferation of branch organisations, which was a redirection of the competitive drive thwarted by rate control. This was because the cost of the new branches provided a further bastion against the entry and expansion of new companies. As long as the FOC was made safe by this and its other defences, the extra cost of organisations could be passed on to the policyholder in the form of higher premiums. This implied no cost to the tariff companies because the highly inelastic demand for insurance facilities in aggregate meant that there would be little or no reduction in business as a result.

Thus the goodwill of the older companies and the effectiveness of their collusive arrangements, both reinforced by their capacity to operate large branch organisations, placed great power in their hands. They competed

among themselves, by office extension and other non-rate means, but the more they did so, the greater the apparent problems for companies which wished to grow.

2.2 *The transformation of general insurance*

The framework of competition described above remained important through the Edwardian years and beyond. None the less, the business changed in ways that opened up opportunities for new companies to expand. These were the result of two changes. The first was the partial resolution of the competitive stresses of the late nineteenth century by amalgamation. The second was the integration of accident and fire insurance to form one insurance 'industry', in which competitive equilibrium could no longer be seen exclusively in terms of its separate markets.

From 1898 a phase of concentration took place which can be seen as an outcome of the problems that had developed since 1870. The new methods of acquiring business and their additional cost have been described above. Although fire managers had been able to carry this against the relatively inelastic market demand schedule, public opinion was becoming critical of organisational costs in insurance. In any case the extra expenditure yielded little competitive benefit to individual companies.

Yet pressures for company growth increased. The overhead costs implicit in branch organisations and advertising could be more easily serviced by larger revenues. Shareholders increasingly preferred large diversified underwriting portfolios that provided stable profits. The 1890s' merger boom in British industry created bigger individual risks that strained the acceptance limits of some companies and forced them to relinquish potentially profitable income.[22] All these factors strengthened the traditional attractions of size for fire insurance companies.[23]

Company boards realised that the cost of organisational competition had risen to a point where it was less expensive to purchase other companies in order to achieve growth. The extraordinary low cost of capital and consequent buoyancy of equity prices was doubtless also important. Initial purchases stimulated strategic responses by other companies to match competitors' expansion. Between 1898 and 1907 twelve of the thirty largest fire companies at the earlier date disappeared through amalgamation and purchase. The average international fire premium income of the nine largest companies in the market rose from £1,231,000 in 1899 to £2,045,000 in 1907 and their aggregate market share rose from fifty-five to seventy-four per cent over the same period.[24]

As far as competition between tariff companies was concerned, the market that resulted from this process was much tighter. Larger companies could be more confident that their similarly enlarged competitors would be less inclined than previously to antagonise them by aggressive marketing. The pressure to expand office organisations was relaxed and there were opportunities for reducing them as redundant branches were closed. Their magnified market power enabled them to carry far more business without worrying about rate competitiveness. Yet in other ways the change created fresh openings for interlopers.

In the first place, this reduced sensitivity itself facilitated business winning opportunities. It encouraged the larger companies to take a more relaxed view of incursions which now formed a more modest tax on their bigger premium incomes. From an institutional point of view, the problems of branch office and acceptance portfolio rationalisation absorbed the energies of management at all levels and distracted attention from initially modest losses of business.

Furthermore, no amalgamation was able to carry all the business of its constituent companies. It was difficult to retain goodwill among agents and policyholders when staff were laid off to make the cost savings that were one of the motives of mergers. They often took business that had been attracted by their personal influence. Old established and smaller companies often had special links with regions, trades or professions, that could be lost in a merger. Technical considerations also meant that when two risk portfolios were combined, it was necessary to discard overlapping acceptances that would create too concentrated a retention on one risk or in one conflagration area. Some could be reinsured, but not all.

Thus amalgamation disrupted traditional business patterns and allowed new companies to win business. The significance of this can be seen by the reduction in the business of merged companies in relation to the premium incomes of the individual companies prior to merger. For example, three mergers in the first three years of the century – the purchase of the Palatine by the Commercial Union, the Imperial by the Alliance and the Lancashire by the Royal – released over £1 million premium income in this way.[25] While some may have been reinsured, much came on to the market freed from links which had previously tied it to an established company.

Accident insurance provided another opportunity for small companies to grow. This market grew from relative insignificance with a premium of less than £2 million in 1895, to reach some £16.7 million in 1914. In the 1890s it had still been dominated by the offices that had innovated the various forms of policy in the previous fifty or so years, whose specialist

nature was suggested by their names: the Railway Passengers', the Vulcan Boiler and the Employer's Liability; for example. Underwriting techniques were little understood outside such concerns and their marketing channels were quite separate from fire insurance. In 1898, not one of the largest dozen fire offices mentioned accident insurance in its published accounts, in nearly all cases because they did not transact it.[26]

Innovative underwriting and changes in the business environment changed this position in the following decade. New forms of cover such as burglary, all risks, block and credit insurance, were regarded as dangerous speculations by traditional underwriters, but by 1914 no substantial office could afford to ignore them.

The most dramatic changes were brought about by developments outside insurance itself. From 1896 vehicle insurance began its rise to predominance as a source of accident premium income. By 1914 there were over a quarter of a million vehicles in Great Britain and the annual premium income paid on them had risen to over £1 million.[27]

However, the most important catalyst of change was the explosion in employer's liability insurance. From 1880 to 1906 a series of acts placed increasing liability on a widening range of employers for the injuries or industrial diseases suffered by their employees. Their anxiety to obtain indemnity created a demand for insurance, while the large number of employees involved and their occupational classification, made under-writing feasible. Before 1897 the market was small and specialised, but the inclusion in that year of accidents arising from an employee's negligence, the later addition in 1900 of agricultural labourers and then of nearly all employees in 1906, revolutionised its scale and changed its nature.

Employer's liability premium income, which had been just one com-ponent of an accident business of £1.8 million in 1895, reached £2.6 million on its own by 1908, the first year in which all the effects of the various new pieces of legislation was felt.[28] At the same time, the business entered a new market – that of the well-to-do householder and small shopkeeper – for they both required cover as employers of domestic servants and shop assistants respectively. Once drawn into the accident market in this way, they became susceptible in various ways to the appeal of burglary, all risks, public liability and plate glass insurance.

The rapid growth of accident revenue brought to the market a buoyant business free of traditional links. This allowed less well-established com-panies to use rate competition to grow with the market. The penetration of small scale risks was equally important. Their policyholders preferred to place all their business with one company in order to simplify their arrangements. This tying together of fire and accident business provided

interlopers with a key to unlock the door of the profitable market in non-hazardous fire insurance. If they could offer an extended range of cover more quickly than the traditional offices, then they could use this to attack long-standing fire connections with greater effectiveness than for decades.

In these circumstances it is not surprising that considerable entry took place. In the years between 1900 and 1907 there was a significant expansion in non-tariff underwriting in the fire insurance market. Later companies formed to take advantage of the opportunities in the accident market almost always essayed the fire market as well. Similarly, from 1906 existing fire companies quickly entered the accident market to protect or expand their fire connections. For both, the extra revenue from accident insurance eased the problems of expansion by increasing the potential revenue available to each branch office they opened. Above all, it provided a once and for all chance to create a successful business with an established stake in both fire and accident insurance.

Of course, the opportunities for growth remained effective only as long as it took the larger companies to respond. They did so quickly because they were sensitive to the incursion into their best business, and saw scope in the new market to reduce the weight of overhead costs. All the traditional offices entered accident insurance between 1897 and 1910. They often did so by purchasing an existing accident office in order to obtain underwriting expertise quickly, though this could create serious short-term management difficulties as the new concern was integrated and its separate overhead costs absorbed.

As a result of these changes and opportunities, the decade or so before the war saw a disturbance in the equilibrium of general insurance. Its principal symptom was extreme rate competition in some branches of accident insurance which squeezed profitability dry. FOC members supported the formation of an accident tariff in 1906, but this had little success until the outbreak of war.[29] This is not hard to understand. The attempts to open up new market positions in a rapidly expanding business by using accident insurance as a lever on fire insurance were too tempting. Such an opportunity might not come again, and nearly all underwriters, whatever their company size, were happy to sacrifice short-term profitability in the hope of strategic gain.

The tariff offices were determined and had enormous financial strength to support them in carrying below cost underwriting. Many of the new entrants were financially weak, but tried to sustain themselves by continued rate cuts which scooped in a revenue that kept them temporarily afloat. This had a disastrous effect on rates. Because the fire market was now linked with accident, it too was affected by weak underwriting which

forced rates in some markets down below cost. As a result, accident business was wholly unprofitable until after 1914.[30] Many smaller concerns were eventually forced into liquidation. But some smaller companies survived and benefited from this temporary crumbling of what had seemed to be, a decade before, a market structure that had fossilised too hard for them to scratch.

3
The development of strategy

The Provincial's development depended on the evolution of a strategy designed to avoid the problems of goodwill, collusion and organisational development which characterised the market in which it had to compete. The form this took was determined within the company, by the entrepreneurial response made by the Scotts, as they reconciled their family objectives and the resources at the company's disposal with market possibilities.

At first this response took place on an *ad hoc* basis, but as their perception and experience of the market grew, a series of policies crystallised. These rarely took the form of an explicit plan; they were more an expanding set of assumptions about how the company should operate – sometimes all the firmer for not receiving any formal statement – the unquestioned *modus operandi* in the Scotts' minds. In some respects it was distinctively their own; in others they followed closely models that were provided by other companies. Without suggesting it was a carefully pre-conceived programme, this can be seen retrospectively as a development strategy.

3.1 *Family ownership and control*

Strategy inevitably revolved around James Scott and his sons, acting as the entrepreneurial group. It had to serve their objectives as the Provincial's owners; it was dependent on the resources they were prepared to provide; and it was created by a process of decision taking which reflected their respective temperaments, experience and the information at their disposal.

The grand objective was to transmit James Scott's wealth in an augmented form to subsequent generations of his family. This could not be a specific target within a time limit. It was more an expression of intention that the Scotts would not seek an immediate yield on their investment, but use profitability to finance further growth.

Growth was to take place within three important constraints. The Provincial formed such a significant proportion of the Scotts' assets that its security must remain safe beyond any conceivable risk. The safety offered by the liquidity of insurance assets had, after all, been one of the

In the four [words] C [had grown] [larger] than my [British?]

City – home to [Shenstone], [Jasper], [Rocks], [Rosel?],

[Cornhills?], A.H. Gen Elec. An example of [words that] [Rend?]

[Xiu?] to [convey] to high [of?] in the country.

[Man] [native] [connected] with [regions] [types] of [adepts]

S of [skull] L – [the] [compound] by 3 other [faults] 1)

[inadequate] [housing] S ; 2) [inadequate] [inadequate] [resources],

[failed] [had] an [by] [afford] [causing] [rapid] [cospt];

3 [mission] of [better] [prayer]

①

1y- WM region 5m inhabitant 31/2m lives in 3
x great chunks of town centred on Brno, (over 5 e
Sicke 53% invest in many (38% rental)

Over 20% of forled' makes units manpower empl
in the WM while his under 10% of the nation mm

x Over of the 1970 manufactures dusts employs over 10
people in Brno; 1478 m % employs fewer than
100 works. Only 109 employed over 500 (probably 5%

attractions of the business. Underwriting was to be cautious, never pressing against financial or management capacity.

Secondly, ownership was to be restricted to the Scott family. James Scott wished to free himself and his sons from the need to take responsibility for other shareholders. This would allow family interests to be pursued without distraction and simplify management. But it meant that the company was cut off from external sources of equity finance. Furthermore, after one modest injection of capital in 1905, the Scotts were, broadly speaking, unwilling to devote additional resources to the company. In so far as the pace of development was determined by financial considerations, it was limited by internally generated funds, in short, profitability. Long-term objectives could only be achieved by short-term success.

The third constraint placed the control of the company exclusively in the hands of the Scotts. After all, one of its subsidiary objectives had been to provide Francis Scott with an independent business career. In any case, James Scott was suspicious of professional management. Apart from the risk of malfeasance, he believed that it would lead to a dilution of emphasis on family objectives. Thus, although staff were recruited and, in time, it became necessary to delegate considerable managerial powers to employees, all control remained with the Scotts. The inevitable corollary was that the company's future depended on their entrepreneurial drive and capacity to build and manage a larger organisation.

In these ways the Provincial remained unique among significant British insurance companies. While others were dominated by a particular family, as the Mountains controlled Eagle Star, or the Norie-Millers the General Accident, they shared ownership with shareholders whose interests they were bound to serve and they raised funds in the public capital markets.[1] The Provincial more closely resembled the myriad of family firms on which British industrial and commercial economic expansion had been based. What distinguished it was the positive resources with which it was initially endowed. James Scott's wealth ensured that the company was amply financed from the start and allowed him to make good his commitment to forego immediate returns. His business experience also ensured a mature approach to development, created confidence among associates and customers, and his reputation attracted business.

Objectives and constraints were originally spelled out by James Scott, but they were shared by his sons and kept before them all their lives. His personal influence was so strong that years after his death they still discussed the company in terms that he had established. But the coalescence of approach rested on deeper foundations. Both shared their father's

values, which emphasised the importance of family, on its prosperity and happiness, which they all saw as being achieved by a combination of responsible work leading to the creation of wealth and security. They saw no future for a family whose members were rootless, useless and preoccupied with the pursuit of leisure. This would end in personal unhappiness and the eventual dissipation of wealth. Owning and taking responsibility for the Provincial was a common-sense expression of this view and James Scott's sons were carried along by its logic.

The evolution of strategy was naturally marked by the personality and capacity of the members of the family who carried it out. They offered a blend of experience, enthusiasm and detachment.

James Scott's business experience ensured the quality of general management of the company, though he was as much a novice in the finer points of insurance as his sons. Having gradually familiarised himself with the scope of this new business, his judgement took an optimistic turn. The company could become far more substantial than the underwriting syndicate he had originally envisaged. Towards this end he initiated the first steps in development, feeling his way carefully, taking extensive advice, yet ultimately acting with a decision and confidence based on a long and successful business career.

His optimism was particularly marked in his attitude towards underwriting. He was not temperamentally attracted to the requirements of cautious and systematic underwriting. Calling on his long experience in the cotton markets, where he had won and lost large sums in speculation, he continued to see it as a form of speculation in which reasonable risks might legitimately be taken. He continually pressed for a more adventurous acceptance policy than professional underwriters would contemplate, never arguing in favour of acceptances that were intrinsically unsound, but for very large acceptances on risks where there seemed every prospect of good results. Yet, in other directions he maintained the utmost caution, worrying about his sons' inexperience and competence, for his relationship with them was not one that encouraged their self-confidence. While his concern was only judicious at first, it became less rational as Francis Scott's capacity grew. This tendency became more marked after a stroke in 1909, which ended much of his earlier ebullience.

When the company was formed, Samuel and Francis Scott were twenty-eight and twenty-two respectively. Neither had any business experience. The early years of the company thus saw them serving an apprenticeship under their father's direction. This took two forms: all important decisions were discussed by father and sons; at a more basic level, they became closely involved in routine insurance work.

Samuel Scott later described the former process. 'Every Sunday...
[James Scott] and his two sons discussed the week's events after lunch, and
only by my mother's protests were they banned from talk over the meal.'
The two brothers were introduced to the problems of business manage-
ment and policy by a series of tutorials in which strategy was formulated
and refined. Meanwhile, in the office each week they handled the detailed
aspects of insurance and company administration.

The Provincial had been formed in the expectation that Francis Scott
would play the main role in its development. He responded to the
challenge, setting himself the task of becoming technically proficient
through reading insurance texts and periodicals. He also undertook the
main responsibility for daily management. By 1913 his admission to a
fellowship of the recently established Chartered Insurance Institute,
though, like many of his contemporaries, not based on examination,
signified his professional commitment. Of even greater importance, ten
years of handling company correspondence at all levels and executing all
aspects of internal management, meant that he had become not merely
technically proficient, but an experienced practical manager. It became
apparent that he had inherited his father's business capacity. Impossible to
define, it included a flair for market opportunity, a straightforward and
effective personal touch in negotiation, an appetite for assiduous attention
to every detail of the company's affairs and energy in pursuing them.
What was more, he handled his responsibilities with ease and relish.

Samuel Scott became more involved in the Provincial than he or his
family might reasonably have imagined in 1903. He became increasingly
attracted to the idea of a family business, especially as it was not associated
with manufacturing. The fact that he was needed to help the new concern
may also have been a stimulus to a young man who had become rather
indeterminate in his way of life. His involvement with the company gave
him a pattern of daily work, increasing his sense of usefulness and self-
confidence. He attended the office regularly, handling correspondence and
routine matters, especially when Francis Scott was ill or on holiday. He
became the Provincial's first inspector, canvassing potential agents in
Bolton. During his regular visits to London he visited the city to carry out
tasks for the company. Generally, he played a full part in all policy
discussions.

In these he always remained more cautious than his brother. His vivid
imagination could always picture disaster more clearly than opportunity.
For him the Provincial remained one interesting occupation among several;
a means to an end rather than an end in itself. He always emphasised that
the family's interests were not indissolubly linked with the company.

Francis Scott would never have denied this in principle, but in practice he was far more committed. It was as if it were self-evident to him that the Provincial was the best way in which to fulfil family objectives, perhaps because for him, the company was an absorbing interest in its own right.

These different approaches combined to form an entrepreneurial group that was cautious, but progressive. At first all decisions were taken by James Scott. As Francis Scott's acquaintance with the market and its possibilities grew, he became the principal initiator of new projects. Yet this did not lead to sudden developments. His enthusiasm was always balanced by his father's caution and his brother's detached apprehension. Yet there was no dispute. Francis Scott accepted restraint because it was reasonable in view of the company's resources. In any case, it would never have occurred to him to upset family harmony or question his father's judgement. On the other hand, his father and brother increasingly recognised his capacity and were prepared to back it by expansion. Thus, there was always an agenda of expansion before the family, but it was invariably subject to anxious discussion and consultation, in which all joined.

The Scotts' lack of insurance experience, made it inevitable that they should use external advice and information extensively. Their sources strongly influenced strategy.

James Scott's distinguished business background gave him access to advice otherwise unavailable. Once an initial link had been formed, the Provincial's unusual financial strength, its connections in the cotton trade and the obvious integrity of its owners, made it an attractive business association. Beyond this, it was continually remarked that the Scotts had a gift for injecting a personal charm into business relations which cemented them securely and persuaded insurance associates to be forthcoming.

Scott invited insurance men to Bolton. 'The managers of other small companies would be asked to lunch at the little club in Bolton, and over cigars we would sit open mouthed, drinking in scraps of information, with all the excitement of a collector making a new acquisition.' Such men were happy to come. Attention from a man like James Scott was flattering. There was always the possibility of arranging beneficial reinsurance treaties or even establishing a link that might lead to the purchase of the company with its valuable connections, if the Scotts became bored with the scheme.

These interviews provided models of company development for them to consider, ranging from the cut-throat methods of the Central which was growing rapidly under H. Lewis, later to become general manager of the Liverpool, London and Globe, to the more sober, selective rate discounting of the National of Great Britain. The subsequent history of the Provincial

indicates how influential Glen, the manager of the latter, was in his prescriptions for success. Francis Scott always took detailed notes and wrote them up afterwards.

Brokers provided more sustained information on market opportunities. Of course, they had their own interests to pursue, so their proposals and suggestions had to be carefully scrutinised. However, in three cases, self-interest and personal relations combined to build a special link.

Willis Faber, who placed the Provincial's reinsurance treaty as brokers, was especially important. Their responsibility for this gave them an interest in supporting the young company's inexperienced management, but other considerations were important. James Scott developed an especial respect for Walter Faber, one of the best known fire underwriters at Lloyd's. Francis Scott became friendly with Raymond Willis, another member of the firm. An extensive correspondence developed between the two concerns as the Provincial was guided into the London market and, later, foreign insurance.

A.W. Bain and Sons of Leeds was another source of information.[2] One of the largest brokers outside London, the Bains' business was to place attractive opportunities before small companies like the Provincial. But the correspondence which grew out of this developed eventually into an exchange of views, information and, occasionally, consultation. Both sides took a long-term view of the relationship and mutual assistance oiled the gears of normal commercial intercourse. The family management of both firms and the relative proximity of Leeds to the Lake District (and its golf courses) encouraged the development.

Finally, the Scotts received a stream of ideas on marketing from A. R. Stenhouse, a dynamic young broker who had opened an office in Glasgow just after the Provincial was begun.[3] Anxious to make his way and full of schemes, ability and energy, he continually proposed suggestions as to how the two concerns could grow together. Once again, with time, correspondence increasingly contained information and consultation from which both sides learned.

Such channels supplied a broader view of the opportunities and problems facing the Provincial and provided much of the buoyancy in its early development.

3.2 The possibilities for growth

The objectives and possibilities for growth described in the previous section were, of course, limited by the market environment. The previous chapter has described the market power of the large tariff companies, based

on their goodwill and branch organisations and the collusive practices which protected these from rate competition. These combined to create formidable obstacles for small concerns. It was impossible for them to attract more than a tiny business, influenced by special considerations, unless they offered lower premium rates to overcome their competitors' great institutional strength. This implied that they must operate outside the FOC, for whatever the advantages of membership, they were out-weighed by the need to accept rate control. Yet the previous chapter has also outlined the methods by which the tariff companies created market discipline by gathering all potential competitors into their organisation. They restricted access to tariff rate levels and reinsurance facilities, then purportedly set their rates, at a level that would make it difficult for rate cutters to survive. How was it possible for small companies to grow in the face of all these obstacles?[4]

Access to tariff rates was crucial, for the margins within which non-tariff underwriters operated were too fine to allow for error. These were easily established in the non-hazardous market, where company publicity often quoted rates for what were usually homogeneous risks. Yet this was because rate discounting was so ineffective in a market largely controlled by agents. In the hazardous market, where rate competition might be successful, risks were far more complicated. It might be very difficult for an underwriter to deduce the rates paid on the separate components of a risk when trying to establish a basis for future quotations.

In practice rate information could be obtained. The most important leakage came through the recruitment of former tariff company staff by non-tariff companies, who thus obtained fresh rating data. Brokers would often divulge tariff information in order to obtain more competitive quotations for their clients, though wise non-tariff underwriters would exercise discretion in assessing its reliability. Tariff rates might also be revealed in the documentation provided when a non-tariff company obtained a share on a co-insurance schedule. Finally, there was the gossip which took place between associates in the business and occasional refer-ences in the insurance press. In practice, it was usually possible for non-tariff companies to obtain a fair idea of the rates they had to discount. However, the actual profitability of individual classes remained far more speculative.

Reinsurance was a far more complicated problem which could not be dealt with on the same informal basis because it involved enforceable contracts. Barred by tariff rules from obtaining any assistance from all the large British companies, this requirement for successful underwriting certainly posed the biggest problem for non-tariff companies. Even the

facilities of the large continental reinsurance offices were unavailable, for FOC members passed on substantial business to them, making it a condition that they did not deal with British non-tariff offices.

Some reinsurance was effected between non-tariff offices, but their size and number was such that their mutual resources were very limited. In any case, more reputable underwriters were often apprehensive about the methods and financial security of some of their contemporaries. A reinsurance treaty could easily provide another company with a shopping list of risks for their inspectors.

However, from the closing decades of the nineteenth century, the tariff monopoly of reinsurance was eroded.[5] Led by the great C. E. Heath, Lloyd's brokers began to place the reinsurance business of non-tariff companies.[6] In solving the major obstacle of reinsurance, this provided the foundation of successful non-tariff underwriting from the mid 1880s. Yet the facility was delicate and limited. Any difficulty with an underwriting syndicate could easily lead to the withdrawal of all Lloyd's support and thus destroy a company. In any case, Lloyd's acceptance capacity was too small to allow a company to grow to any substantial size.

These problems could in some measure be overcome. However, the whole essence of successful non-tariff underwriting lay in the resolution of one final problem. Was it possible to discount tariff rates, when they were supposedly set on the basis of providing reasonable profits on costs established by the authoritative information at the disposal of the FOC? The answer lay in what underwriters termed 'selection'. Lower rates could be sustained if the tariff companies did not adjust their rates in line with experience, or if particular risks within a class could be identified as having a better than average loss experience.[7]

In principle selection should only have been possible on a transitory basis. The tariffs ought to have been adjusted to take account of any imperfections, leaving no scope for discounting. Yet they never reached this equilibrium. In the first place, it was difficult for the tariff documents, complex as they were, to reflect all the complications of underwriting experience. Even if all the physical differences between risks were comprehended – and this was sometimes difficult – the 'moral hazard' (all the non-material circumstances such as the likelihood of arson, the quality of management, the precise type of business conducted and the integrity of the proprietor) was far harder to capture. Such distinctions were always susceptible to perceptive selection.

Secondly, tariff rates always lagged behind experience. This was inevitable for significant changes could only be detected retrospectively as statistics became available. Even then it was sometimes difficult for the

FOC to reduce rates. Once cut it would be difficult to raise them again without incurring the displeasure of agents and policyholders. There were usually tariff members whose experience in a particular class was unrepresentatively bad and who might therefore wish to retain a higher rate. Indeed, the more successful a non-tariff incursion, the less the FOC's own evidence would reflect any better than average experience.

Thirdly, tariff rates might not move with experience simply because FOC members believed that they could carry them against any external competition because of their market strength and the restrictions on non-tariff activity. Even if they foresaw a marginal loss of business, it would be irrational for them to cut premium rates across a whole class and thus lose revenue that was not at risk. The more powerful the tariff companies believed themselves to be, the greater the margin that could open up between costs and premiums, allowing scope for successful entry.

Selection was used by all underwriters to improve their results. Indeed, tariff underwriters were better able to discriminate because of their access to FOC statistics. But non-tariff companies held a further, critical advantage. If selected risks offered higher profitability, then it was possible to attract them by the positive inducement of a lower premium rate. If the market responded well to this, then non-tariff companies would be able to cream off superior risks for as long as the FOC did not cut tariff rates. In this way, non-tariff companies could grow profitably and serve a wider interest by cutting the cost of insurance to consumers, where this was justified.

Scope for profitable non-tariff underwriting depended therefore on four considerations: an ability to identify individual risks that were over-charged at tariff rates; any tendency for risk improvement to lead to a sustained fall in claims; an unwillingness on the part of the tariff offices to reduce rates accordingly; and a responsiveness by the market to rate discounting.

Underwriting by individual risk or sub-group was largely a matter of personal flair or access to special information and can therefore only be examined on a company by company basis. The other opportunities were more a matter of market wide changes and, in fact, combined to create special opportunities for successful non-tariff expansion during the Edwardian years.

General risk improvement operated with particular force in the years between 1890 and 1914. Across the whole domestic market the incidence and severity of fires was reduced. The building boom of the 1890s and revived industrial investment modernised risks and eliminated much old and unsafe property. FOC regulations encouraged the construction of

fireproof factories. The spread of electricity, especially as its installation was governed by new safety rules, reduced the terrible fire hazard in gas and oil lighting. It also enabled the use of the telephone and electric fire alarm to summon assistance – which increasingly came in the form of faster, motorised fire engines.[8]

These general improvements provided a foundation for the more specific contribution provided by the innovation of automatic fire sprinklers. Effective protection became available in 1885 when Mather and Platt purchased the British rights to manufacture the American 'Grinnell' sprinkler. This was so effective in reducing fire losses that in the cotton mills insurance market, where it was particularly efficacious, the tariff collapsed. From 1888 to 1892, in the free market which subsequently developed, discounts for protected risks rose to eighty per cent. In the latter year, when the FOC restored the tariff, incorporating substantial discounts, these were also included on a modest basis in some other tariffs for hazardous risks.

As a result, sprinkler protection began to spread more quickly to other industries. After several serious fires in protected risks in 1898, the FOC introduced strict regulations governing sprinkler installation and main-tenance which improved their efficiency. In the following fifteen years claims experience enjoyed the benefits of this reform and the diffusion of sprinkler protection to a widening range of industrial and commercial buildings, as engineers adapted them to the special circumstances of particular uses.[9]

It was unlikely that tariff rates would be able to keep pace with reducing claims during such a dramatic phase of risk improvement. Beyond this, it is clear that there was a marked unwillingness on the part of the FOC to reflect lower claims in its rates. There were a number of reasons for this. The amalgamation phase described in the previous chapter undoubtedly distracted the larger tariff companies from the impact of marginal com-petition, and gave them a temporarily inflated impression of their market power. The series of fires in 1898 prejudiced them against sprinkler pro-tection. Above all, it is clear that the companies were frightened by the scale of sprinkler discounts. They promised to eat up premium income when they were applied, as they would be, to the large classes of hazard-ous business which provided the bulk of their revenue. In the face of this, marketing and processing costs would remain at least the same. Indeed, it was recognised that if sprinklers were to be effective, they would require regular and expensive inspection. Short-term financial reserves and staff commissions would fall in line with lower revenues as well.

In these circumstances it is not surprising that the tariff companies were not keen to encourage sprinkler discounts. Around 1900 there were

several reports that they were discouraging their installation as 'not worthwhile'. If they could prevent widespread rate discounting, they could avoid its high costs.[10]

Their ability to do so depended on their market power. If goodwill, reinforced by branch organisations, was sufficiently strong, then the tariff companies could hold on to most of their sprinkler protected risks. The rate discounts necessary for non-tariff companies to attract sufficient business might be so great that they would leave no margin for adequate profitability.

In fact, institutional change in the market improved the responsiveness of hazardous business to rate cuts in this same period. Brokers had operated in the fire market from the middle decades of the century. Some had been recognised as 'tariff' brokers in the early stages of the FOC's development. The tightening control of the tariffs had encouraged their growth. Their business was based on the new large risks in industry and commerce, offering policyholders a superior knowledge of market rates and bargaining power with the companies, which they claimed enabled them to offer considerable rate reductions. This was important with really large company schedules. Brokers could place these with a selection of insurance companies, including some non-tariff concerns, in order to reduce the average premium rate paid. In return they received the substantial commissions generated by such large premiums, which they often augmented by negotiating preferential commission rates. This income enabled some of them to build large and effective marketing organisations, together with the provision of such services as risk surveying, the handling of premium payments, the negotiation of claims and advice on fire protection.

Some brokers originated in the Lloyd's market in London, especially after the development of direct fire underwriting at Lloyd's. Others grew in the provinces, specialising in the risks associated with local trades and industries.[11] They enormously improved the efficiency of the market in supplying competitive premium rates to large policyholders. Just as in other ways, the FOC's efforts could not eliminate competition, only restrain it until it broke out through new institutional channels.

Brokers became enthusiastic supporters of non-tariff companies, for these firms provided an opportunity for more competitive rates to be offered, thus improving the brokers' own opportunities for growth. On the other hand, with their own sources of business, they created an opportunity for small companies to win a substantial premium income, without the need for a large scale marketing organisation. They could thereby circumvent a critical element in the market power of the large companies.

Controlling brokers and the breach they made in market control became one of the intractable problems facing the FOC after 1890.

Of course, brokers of this type were only really effective in the hazardous market within Britain. They made little attempt to capture smaller scale risks. Yet other considerations provided some opportunity to attack them. The escalation of direct representation by the large tariff companies was largely a response to premium rate control by the FOC. The enormous expense it involved by the turn of the century was only justified in that context. Rate discounting threatened its rationale. Of course, lower rates would not eliminate the need for a marketing organisation entirely. In the non-hazardous markets it remained essential.

In the hazardous markets policyholders and brokers could only be attracted if they were made aware of competitive rates and provided with a minimum level of service by way of policy and claims processing. Yet this could be very sketchy in some market segments where, for example, policyholders could be approached through some sort of association, club or society; or when brokers were competing fiercely and saw advantage in offering lower rates. Across a broad spectrum of markets, a blend of discounted rates and a modest organisation offered some scope for non-tariff underwriters, especially if the former were more than compensated for by expenditure savings on the latter. With lower premium rates it was not absolutely necessary to match the inflated branch organisational expenditure of the tariff companies. They were in large measure a product of the artificial competition they had generated between themselves.

In these ways opportunities existed for small company growth and expansion. But they were limited and required a careful balancing act between the need to develop a sufficiently competitive marketing stance and the necessity to remain profitable.

3.3 Safety first

Given all these considerations, what strategy did the Scotts choose to reconcile their objectives with market opportunities? Later chapters will look as each area of management separately, but it is important to see how marketing, organisational and financial policies were interdependent and understood as such by the Scotts. Similarly, their commitment to long-term growth may seem rather intangible, but it was clearly reflected in more immediate decisions.

Strategy started from the need to win profitable business. There were three ways of doing this in principle: by competitive adjustments in premium rates; by the development of new types of policies; or by the

building of market power through branch organisations and publicity. Goodwill could add strength to these methods, but that came either as an endowment – as it did to a degree for the Provincial – or would require time to develop through sustained reputable and accommodating operation with agents and policyholders.

These approaches could be combined in various ways, but it was clear that the Provincial would have to offer some financial incentive to potential policyholders. An inexperienced management could not hope to lead the market in policy innovations and it would be impossible to match the reputations, goodwill and organisational strength of the large, established companies, except in special and limited directions. There was therefore no doubt that the main emphasis in the company's marketing policy was that it would have to offer competitive non-tariff premium rates, and accept all the consequences that have been explained above.

Yet this could not in itself be a basis for sustained development. Without creating the other influences over business, the company would be forced to accept modest underwriting margins and no security of tenure on its business. A marketing organisation, publicity, an attractive range of policies, and the reputation and goodwill that could be built through such channels, would enable the Provincial to carry business in the face of more severe rate competition and thereby increase its profitability and stability. In any case, the segmentation of the market meant that many types of business, especially those controlled by smaller brokers and agents, were simply unobtainable without a marketing organisation.

The more rapidly the Provincial was able to expand its marketing organisation or support new forms of underwriting, the faster its revenue and profitability were likely to grow. But there was a critical short-term constraint to this process. Organisational and publicity expenditures were conventionally carried on the current underwriting account. Any attempt to raise them squeezed short-term profitability and market opinion would not countenance a company which published unfavourable results, even if its owners were happy to finance them in the hope of prospective benefits. So selling and organisational costs of all kinds had to remain a relatively fixed proportion of revenue and could therefore only grow at a similar rate. As the previous chapter showed, this placed growing companies at a severe disadvantage. Improved market penetration almost always involved the commitment of overhead costs in advance of anticipated revenue. Furthermore, a good proportion of establishment costs for a new company had to be devoted to developing an adequate head office staff. By contrast, large companies with established organisations enjoyed falling expense ratios as their revenues grew.

With organisational development limited by revenue growth, the burden of competitive effort fell back on rate reductions. The pace at which the company could grow was determined by the responsiveness of the market to such incentives and the extent to which the Scotts were prepared to reduce underwriting margins, to increase competitiveness. The faster they could win revenue, the faster they could build an organisation that would reduce their dependence on rate reductions.

Yet despite this, the Scotts made no attempt to accelerate revenue growth in this way. Far from this, they adopted an austere policy of trying to maintain as high a proportionate margin on their underwriting as their most conservative competitors. As they were offering discounts below tariff rates, this implied a distinctly superior claims experience. Business producing such safe and profitable results was not easily available, especially to new companies with no established agency network, trying to win business in markets that were essentially rate competitive rather than protected by goodwill. The policy ensured that revenue would grow slowly with a consequential limit on the flow of funds available for marketing development and other selling costs.

This approach was adopted because high margins satisfied several of the Scotts' subsidiary objectives. It provided a high degree of safety by offering a substantial cushion against any unexpected fluctuation in experience. It committed the company's underwriting to a fastidious approach to acceptances, steering away from speculative or unprofitable classes of business, which was especially sensible as the Scotts learned the business. Fine tuning in underwriting is impossible and clear cut conventions of this kind were a useful guide. At the same time it performed a marketing function. The publication of unimpeachable underwriting results provided the market with an assurance that the Provincial was more effectively managed than its inexperienced management might suggest.

Safety beyond all risk was clearly one factor behind this premium rating policy, but its implications for organisational development point to another constraint that was no less important for being hard to specify precisely. Continued increases in organisational expenditure would almost certainly not yield proportional improvements in effectiveness. Because the Scotts insisted on retaining control, the company's organisation could only grow in line with their capacity to manage it. Initially they concentrated on mastering the technicalities of insurance, its competitive practices and the administration of the company. Each new market segment they entered required appraisal before they could move on with confidence. This process provided an excellent training, especially for Francis Scott, but it took time and had to be mastered before the more

extended responsibilities of managing a large organisation could be added. Even then, the first requirement was the head office, before the more complicated problem of controlling staff in branches, who were bound to operate largely independently, could be contemplated.

The modest growth in revenue also meant that another potential limit on growth was never pressed. The capacity to accept business depended ultimately on the possession of financial strength. This had to be sufficient to provide policyholders with security against threats to the company's integrity from fluctuations in loss experience or investment values. This was initially provided by shareholders' capital and then developed by the creation of reserve funds. Sophisticated policyholders and agents looked to the ratio between premium income and such funds – the solvency ratio – as the test of security. Throughout its first ten years the Provincial's ratio remained far more conservative than was conceivably necessary. Most reputable companies maintained an asset base of between one and two times their net revenue. As late as 1909 the Provincial's assets covered its net premium income eight times. Even in 1913 the cover was still as high as four, making no allowance for the company's uncalled liability which practically doubled the security offered.

It was inevitable that in any well managed company the solvency ratio would remain high at first, when the company was writing a tiny income in relation to its shareholders' funds. Yet this position was maintained throughout the initial phase of the Provincial's growth. It was not a planned matter, more an unintended consequence of underwriting policy. Of course, there were some positive advantages. It provided the 'superabundant financial strength' that the Scotts sought. It also acted as a powerful marketing device. In the absence of a record of achievement, the continuing strength of the Provincial's accounts provided important testimony to the integrity of management in negotiations with brokers and in insurance periodical comment. Yet even when most stretched, in 1913, the company could still have doubled its premium income and yet continued to offer a security that would have been beyond reproach. The rapid fall in the solvency ratio between 1909 and 1913 suggests that it was not subject to careful adjustment and that the Scotts were aware that they were always, in this period, operating well within any reasonable safety margin. In fact, it seems more sensible to suggest that they were happy to maintain this financial security and used it to encourage the market to have confidence in the new company. Financial resources did not create an effective limit on growth before the First World War.

Despite this the main outlines of financial policy were laid down in this early period, and in no direction was the Scotts' commitment to the future

more apparent. This was so in two respects. The high solvency ratio implied a low yield on shareholders' funds and one that would have normally been unacceptable to a body of shareholders. They would have pressed for a far more intensive use of the company's financial capacity.

Secondly, there was the issue of how surpluses were to be allocated. Here again, the Scotts were prepared to take a relaxed approach guided by their long-term objectives and made possible by their wealth. In the early days they took no dividend at all, allowing all the underwriting surpluses and the investment income to be devoted to increasing the company's reserves. When the first dividend was paid in 1907, a simple rule was adopted to allocate surpluses between reinvestment and dividends. This was the convention, used by some companies, but by no means universally, that dividends were paid exclusively out of the yield on the company's invested funds and all underwriting surpluses were devoted to increasing reserves. In practice, dividends remained a little more modest, allowing slightly greater reserve growth than the strict application of the rule would suggest.

The company's dividends were thus placed on a path of gradual, stable expansion, unaffected by fluctuations in the underwriting account and reflecting the income that would be available if the company was sold up and the minimum value of its assets invested. At the same time, the company's capacity to accept business was regularly and substantially developed. By 1913 reserves had grown to £25,000, expanding the initial asset base by one-third. Of course, this was not a particularly dramatic achievement, for it was limited by the conservative approach to underwriting. Yet it was the product of a policy that would guarantee that for as long as surpluses remained stable, their steady accumulation would mean that reserves would grow at a proportionately faster rate than revenue. In time, steady revenue growth would be easily supported by the concomitant growth in reserves.

In this respect, financial policy reflected the whole direction of strategy in the first ten years. As was perhaps appropriate in a phase of apprenticeship, the company's actual performance was exceedingly cautious. Yet it took place within a framework laid down by the Scotts as their overall strategy, which was inherently dynamic. At whatever pace revenue grew, scope was opened up for organisational development, which held the potential for accelerating that growth, whether by expansion in branch offices or by increasing the range of underwriting facilities at head office. At the same time, as long as profitability was maintained, reserve funds would accumulate, pushing out the limit of secure growth. The Provincial was thus set on a path that meant that growth would be at an increasing

rate – if only it could develop an initial business that was profitable. The following chapters will describe the establishment of a foothold in the market within the constraints of the strict underwriting terms the Scotts set themselves, and then the use they made of the potential for further growth this generated.

4

A foothold in the market

By 1913, as Table 4.1 shows, the Provincial had developed a net premium income of £47,361. This came from a gradually widening range of sources. From the start, the company was able to capitalise on the special links its owners possessed in the Lancashire cotton trade and the town of Bolton. Large brokers also provided an important source of early revenue. Within a few years, the changes in the accident market opened up new scope for business. This helped support the modest attempts to expand the company's influence through the opening of small branch offices and a foreign department in London. The growth in business was by no means dramatic in comparison with some non-tariff competitors. The company remained small and of little significance in the market in 1913. But it retained the important distinction that growth had been accompanied by careful control of profitability. It had not even risked the disaster that had overcome many of its contemporaries; and its financial strength and reputation were beyond reproach.

TABLE 4.1 *Provincial Insurance Company: net premium income, 1904–13 (£'000)*

	Net home fire premiums	Net foreign fire premiums	Net Canadian fire premiums	Net home accident premiums	Total net premiums
1904	2.6				2.6
1905	5.1				5.1
1906	6.6				6.6
1907	11.1			0.6	11.7
1908	13.1			1.4	14.5
1909	14.2			3.8	18.0
1910	18.7			6.4	25.1
1911	19.0	1.4	1.2	9.0	30.7
1912	19.7	3.4	1.2	14.0	38.3
1913	23.4	3.9	1.6	18.5	47.4

4.1 *The Scott connection*

James Scott's business activities had created a reputation as a successful
and straightforward man of affairs throughout cotton Lancashire. In Bolton,

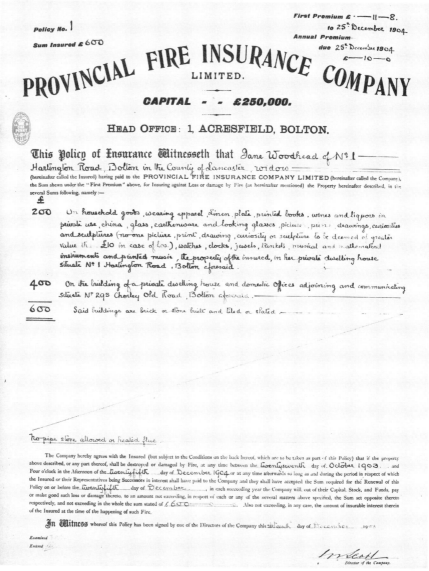

Provincial Fire Insurance Company, Policy No. 1, 1903. This indicates the
modest scale on which the company originally operated. The description of the
risk is written in Francis Scott's hand and the policy is signed personally by Sir
James Scott.

his position in the town's political and social life had made him well known and respected. This personal influence provided the Provincial with its most distinctive initial marketing resource, creating an opportunity to develop insurance business in a regional economy given great buoyancy by the indian summer of the cotton industry in the Edwardian years. It gave preferential access to some of the most attractive large scale industrial and commercial insurances, as well as to less accessible small scale non-hazardous insurances.

The first large risks insured by the Provincial were those Scott could influence directly. Among the first policies were those of the various factory and warehouse premises associated with the Haslam family business, together with the local branch of the Manchester and County Bank, Sackville Estates, a commercial property company with which Scott was associated, and the Cellular Clothing Company, of which he was director. During the first few quarters such risks accounted for more than half of the total. At first the Provincial was, in a sense, an 'in house' insurer.

But Scott's connections ranged more widely. By 1906 the company had obtained a modest share in seven of the nine largest cotton spinners in Bolton, and the other two were, significantly, combines whose insurances were placed by head offices outside the town. It seems reasonable to suggest that the share the Provincial obtained in the insurance of the Tillotson publishing empire, with works all over Lancashire, must have been affected by the friendship between the two families.

It is impossible to trace the impact of Scott's name outside Bolton, for the origins of proposals are unknown, but he made strenuous efforts on the company's behalf. When he heard that a concern in the cotton trade was approaching the renewal date on its insurances, he would arrange to meet one of the principals on the cotton exchange in Manchester. Where personal introductions were unavailable, the business links of the Haslam firm were used. Through this source the company obtained shares in risks in many of the largest cotton manufacturing and mercantile concerns in Lancashire and the Midland hosiery district.

Friendships made during recreation were also utilised. The two Crossley families, with whom the Scotts sailed on Windermere, owned large industrial concerns, in carpet weaving and engineering, and they both appeared on the Provincial's books, no doubt after a word in the saloon car travelling north before a holiday weekend.[1]

A clear thread of personal influence ran through some of the most substantial accounts obtained in the first years of operation. It provided buoyancy for revenue, but its benefits for profitability were more important. Much was written at tariff rates. Friends did not insist on fully

competitive discounts. Furthermore, James Scott knew the men and the firms with whom he was dealing and only sought those where management and reputation were of the highest, reducing the moral hazard that was the most intractable problem of fire underwriting. The Provincial was thus able to obtain select hazardous insurances, at rates that were normally only available to tariff companies. This provided a gilt edged core for the company's underwriting account which was the envy of its non-tariff competitors and placed its bulk business on a profitable foundation.

The family's connections also helped to create a non-hazardous underwriting account. With policyholders insensitive to rates, this normally required potential agents to be regularly canvassed by inspectors. This meant high initial costs, but eventually high profits. Loss ratios could be as low as thirty per cent over the long run.

Scott's name and influence in Bolton brought fluidity to agency connections which could be exploited at a modest cost from the small, embryonic head office. James Scott's central position in the town's life allowed the Provincial to be seen as a family concern whose roots lay deep in local society; as late as 1912 a visitor found that the name 'Provincial' was unknown to a local cab driver, but 'Scott's Company' placed it immediately.

The Provincial at the Royal Lancashire Agricultural Show, possibly 1912. From left to right: W. O. Worrall (accounts department), V. Tonge (accident department) and F. E. Hodkinson (inspector).

The company was undoubtedly seen as a child of the wealthy local Liberal establishment, despite attempts to avoid this by inviting local Conservatives on to the board. Yet it would be wrong to underestimate the strength of local consciousness in the Lancashire cotton towns, especially in this period of their greatest relative prosperity. The Provincial's progress bears out the suggestion of civic particularity and pride in a local concern. This was no doubt strongest among those who owned insurable property and the smaller number of commercial and professional men who acted as insurance agents, all of whom would have been susceptible to the appeal of a successful local man.

As a result, the manager of the Sun in Manchester wrote to his superiors soon after the Provincial was formed, anticipating that '… we shall meet with considerable competition for our business in the Bolton district'.[2] With local connections, the Provincial was able to attract a growing non-hazardous account in competition with the larger, metropolitan companies. No attempt was made to discount rates, except for the offer of a premium rebate after seven years of claims' free cover. Extra commission was only offered to agents who provided particularly large or profitable accounts.

Initial business was obtained from agencies held by the company's own solicitors and accountants. The development of a proper local agency network began on two fronts. When business was won through personal links, this was used as an introduction to the agent who had previously placed the risk. Francis Scott wrote along these lines to J. Standring, who was to become a successful local broker for the company,

We have taken one insurance …which has previously gone through your agency. We shall be glad to allow you commission on this as on any other business that we may get through you. You will see that we are dealing in a straightforward way with agents, being unwilling to take business away from any agent in this town … . I think that it will be to our mutual advantage to work together and I hope that you will do your best for a local company – Bolton capital and Bolton men.

This method was supplemented by the direct canvass of likely agents. Initially the family and local nature of the company was emphasised by Samuel Scott taking this on himself, visiting '…practically every solicitor or accountant in the town.' It is easy to imagine that the cultivated son of one of the town's most eminent citizens could hardly be treated as brusquely as the usual insurance inspector. In 1905 a full-time inspector was appointed to encourage the smaller agents in the town. By the end of 1904 the company had seventy-six agents, nearly all in Bolton, the majority being solicitors and accountants, but also including bank managers,

retailers, builders and a few full-time agents – the precursors of the modern small broker.

The bulk of the risks obtained through them were residential and retailing properties in Bolton. Some agents provided risks outside the town, and there were a number of smaller industrial premises such as workshops, foundries, laundries and farming risks. There were some especially attractive opportunities: a local firm of solicitors managed the affairs of a small building society and directed all its mortgaged property to the Provincial.

The Bolton connection was also used to approach another highly profitable branch of the non-hazardous market – the insurance of public buildings. James Scott's public position must have provided introductions but Francis Scott set himself to obtain them by direct application. He wrote to the chairman of Bolton Infirmary requesting permission to quote for its insurance. 'The company,' he wrote, 'is worked entirely with local capital and we venture to think that you would favour a local office.' Custom was also solicited from local authorities. The Scotts' political associations ensured that the Provincial obtained the insurance of the local Liberal Association's premises and the Bolton Reform Club.

In this way the Provincial acquired a core of profitable and normally inaccessible risks for its underwriting account. Local and personal links allowed it to penetrate the really profitable area of underwriting, without the normal need for an expensive organisation. The town remained the principal source of non-hazardous insurance business until after the First World War. Furthermore, it enabled the Scotts to learn how to run an agency network at first hand and taught them the skills of branch management under particularly easy circumstances.

4.2 *The brokers and the hazardous market*

Non-hazardous business, though profitable, could never create real buoyancy in revenue; the premiums earned were too small. And it was essential for revenue to grow if a larger organisation was to be financed, so that the company could expand its agency network beyond Bolton. To do this it was necessary to move into the more bracing atmosphere of the hazardous fire insurance market. We have seen that Scott was able to attract some large risks through personal influence, but this was a finite resource that could not form the basis of sustained growth.

In the hard headed world of large scale insurances, premium rates were of crucial importance and their manipulation lay at the heart of the Provincial's non-tariff marketing policy. None the less, the market was not

perfect. While businessmen were anxious to reduce their premiums, they were rarely in a position, from the point of view of time or expertise, to ascertain the most competitive rate available or the most reliable insurer. This enabled companies and intermediaries to make competing offers through their various organisations.

Marketing took two forms. Chapter Two described the expansion in branch organisations, produced by the intensification of non-rate competition during the closing decades of the nineteenth century. This had made possible the direct canvassing of risks by company inspectors who offered what amounted to a discount by making the businessman the agent. By the First World War this system was described by Francis Scott as covering:

...practically every cotton mill, the majority of weaving sheds, many Yorkshire woollen mills, nearly every cotton and other merchant in Liverpool, the majority of merchant houses in Manchester, and many in London and a large number of the larger industrial firms up and down the country.

This posed difficulties for a non-tariff company like the Provincial. The 'own agency' system eliminated much of the incentive created by the standard non-tariff ten per cent discount. At the same time, it was difficult to match the marketing campaign of the tariff offices for all the reasons of expense described in Chapter Two. The Provincial was effectively barred from competing through branch organisation and therefore made a virtue in publicity of supporting 'proper' agents, by never offering commission to the insured.

Fortunately there was the alternative of the large brokers whose rationale and growth within the fire market has also been described above. Non-tariff companies and Lloyd's provided the only way of evading tariff rates and the brokers tried to force their rates down as far as possible to make themselves in turn more attractive to potential clients. In return, they passed on risks to such underwriters, fully processed with surveys, regular inspections and premiums collected. The Provincial could thus siphon off, with no significant marketing organisation, a share in the insurances of some of the largest British companies.

The first contact was made when the Provincial obtained risks through family influence. As with the smaller Bolton agents, the brokers who had previously placed the business were offered the commission and invited to pass on further business. In this way accounts were initiated with prominent Manchester brokers who provided risks from Manchester and industrial Lancashire outside Liverpool, which operated as a separate

insurance market. But the really important connections were those with large companies with Manchester headquarters. Among these, the Provincial received shares in the insurances of the Calico Printers' Association and the Bleachers' Association, the fifth and ninth largest British industrial companies in 1905. By 1906 it was normally given four per cent on any Bleachers' Association risk available. Similar scheduled business came from the Wallpaper Manufacturers' Association, the British Cotton and Wool Dyers' Association, Tootal Broadhurst and the Manchester Ship Canal Company.

The second group of brokers were in London. Soon after an early visit by James Scott to investigate reinsurance facilities through Lloyd's, they began to send lines on commercial and industrial premises in London, the southern counties and even abroad.

The third important opening came with the Leeds firm of A.W. Bain and Sons.[3] Specialising in sprinkler protected risks, their most fruitful market at this time was in the Yorkshire woollen and worsted industry, but they watched the market carefully and moved quickly into any new opportunity created by the spread of sprinkler protection to new classes of risk. During the Provincial's early years these included drapers' premises and printers' workshops. Above all, they placed the insurances of large firms with a high degree of sprinkler protection. Through them the Provincial received a share in the insurances of Joseph Rank, the grain millers. Most important of all, from 1906, they provided lines on the risks they placed for Lever Brothers, the soap combine. These included cover on the vast stocks held by Lever's in docks and warehouses throughout the country, the firm's factories, commercial premises and even Leverhulme's private homes. In the first year of the account, this line grew to form seven per cent of the number of all hazardous risks accepted.

Finally, the Scotts' business grew with that of A. R. Stenhouse.[4] His initially tiny business in Glasgow created a different type of relationship in which the Provincial was less dependent. The Scotts took a broader view of acceptances, supporting Stenhouse whenever they could; paying for circulars to be sent to sprinkler protected risks and making acceptances that might normally be rejected. In this way they developed goodwill in a fruitful direction. Stenhouse was an exceptional broker. His business grew rapidly and the Provincial shared in its expansion. Through him they obtained an expanding supply of Scottish risks, nearly all sprinkler protected, including sawmills, cabinet makers, brassfounders, drapers, boot and shoe warehouses and whisky stores. Up till 1911 Stenhouse contributed a steady five per cent of all direct premium income.

In these ways the brokers supplied an adequate and diverse range of

hazardous risks. While the North West remained overwhelmingly important, significant concentrations of business came from Yorkshire and Scotland, together with a thinner spread across the whole country.

However, in solving the marketing problem, the brokers threw the burden of management back on underwriting. They pared rates to fine margins and charged commissions which pressed profitability even further. The Bains, for example, required a twenty-five per cent commission on sprinklered risks and an additional ten per cent profit commission across the whole account. Even Stenhouse obtained twenty per cent on his less select risks.

In these circumstances the Scotts' caution was necessary and evident. Far more business could have been obtained but Francis Scott explained the Provincial's policy to a potential broker:

...I had better say frankly that we do not wish to cultivate a rather indifferent general business. Our policy at present is to cultivate a business on large schedules – sprinklered if possible – that can be worked without cost from our Head Office We are not necessarily disposed to accept a rate which the Central may be willing to accept; in fact, I may say in confidence that we generally expect a much better rate and do not approve of the 'cutting' of that company. Our methods are careful and conservative.

He went on to describe the Provincial's underwriting policy in more positive terms, '...we are prepared to cut a rate whenever a tariff may, in our opinion, operate unfairly. In all other cases we expect to get the same as a tariff company, recognising that an enterprising office like the Commercial Union will take a risk at the lowest remunerative rate.' Classes of risk that were not tariff rated were rarely accepted on the grounds that rates would be cut to the finest margins that remained profitable by the tariff companies. Some tariff classes were regarded as allowing too little scope for rate discounting, though adjustments by the FOC might change the position completely. In the early years the notoriously bad classes, including hosiery, lace and boot factories, were normally only accepted to accommodate an agent. Tariff classes with scope for discounting were offered a ten per cent reduction, though stocks and other contents paid tariff rates.

The great exception which overrode this conservative approach was the special consideration given to sprinkler protected risks. Like other non-tariff underwriters, the Scotts were convinced that these could carry substantially greater discounts. As a result they were prepared, despite their normal extreme caution, to adopt a relatively adventurous approach towards them.

There is no doubt that Glen of the National of Great Britain, the Bains and Stenhouse were influential. They reinforced the local knowledge that James Scott must have had of the operation of sprinklers in the cotton trade. Bolton had been the first town in Britain where they had been installed effectively.[5] Furthermore, their benefits varied in different sectors of the cotton trade for technical reasons associated with fine and coarse spinning, providing quite different salvage possibilities after their operation. Scott was in an excellent position to assess these, with his expert knowledge of the trade. Finally, their effect was almost to eliminate the threat of a total loss on a risk. This was especially attractive to a small company, for it enabled it to retain a far higher proportion of a large risk, rather than pass on much of the revenue by way of reinsurance. This raised the average revenue per risk, reducing proportionate overhead costs, and gave greater dynamism to revenue.

As a result, the Provincial sought sprinklered business above all other. The Scotts were fortunate that they had entered the market when such business was in ample supply and when, for a few years at least, FOC rates and discounts were extremely uncompetitive.[6] Before a general adjustment in tariffs in 1906, the company was able to offer discounts as high as fifty per cent and pay the high commissions the Bains sought on such desirable business. After this, discounts were reduced to between fifteen and twenty per cent, but this was still a significant incentive. It provided the opportunity to achieve underwriting results in the hazardous market that were only rarely available in the history of fire insurance. The FOC reluctance to lose premium income on sprinkler discounts was the making of the Provincial's general business.

4.3 Entry into accident insurance

Chapter Two described the transformation wrought in general insurance by the Workman's Compensation Act of 1906. Before that the Provincial, like many competitors, did not offer accident insurance, except occasional burglary cover with fire policies for private houses and this had been entirely reinsured with a specialist company.

As for the market as a whole, the legislation created a new situation for the Provincial. The obligations placed on householders and small business men of all kinds, meant that fire connections in the non-hazardous market were now assailed by new competitive possibilities.

The Provincial was bound to offer the new forms of cover required. It had to protect its own connections in the market from others who would use product range competition to attack them. By the same token, it

TABLE 4.2 *Provincial Insurance Company: net accident premium income,*
1907–13 (£'000)

	Employer's liability net premiums	Personal accident net premiums	General accident net premiums	Total net premiums
1907				0.6
1908	1.2		0.2	1.4
1909	2.3		1.5	3.8
1910	3.9	0.6	1.9	6.4
1911	5.3	0.9	2.8	9.0
1912	9.2	1.6	3.2	14.0
1913	13.0	1.3	4.1	18.5

was bound to seize the opportunity to invade the preserves of the older companies. There were other less obvious incentives. By obtaining two premiums from policyholders who had previously only provided one, the company's revenue could grow more rapidly and the larger revenue reduced the proportionate cost associated with each transaction. All these considerations were strengthened by the low reinsurance requirements for accident business which meant that nearly all the revenue obtained was clear income.

The Provincial accepted Workman's Compensation insurance from July 1907 when the new legislation came into effect. The event was used to mount a major local advertising campaign in Bolton where the company was best placed to develop non-hazardous business. Placards were taken throughout the district and advertisements placed in local newspapers. Special new policies were devised with appropriate documents. A comprehensive householders' policy was offered, providing cover against fire, burglary and domestic servant liability risks in one package. Pamphlets were issued publicising terms for shop assistants and clerks. At the same time the company advertised its willingness to underwrite a wider range of accident policies including personal accident, public liability, fidelity guarantee and plate glass insurance, all of which were required to reinforce the appeal to particular segments of the non-hazardous market. Along with a ventilation of the new products available, the opportunity was taken to reiterate the special benefits of the Provincial's non-tariff status with its rate discounts and seven year rebate for household risks.

Table 4.2 delineates the subsequent growth in accident business. By 1913 gross premium income received had reached £18,500. While this was important for the company, it represented relatively cautious develop-

ment. This is not hard to understand for the ferocious competition in the market as new and old companies tried to establish positions, drove rates down well below costs, especially on larger risks.

The larger companies tried to control these problems by forming a tariff.[7] Yet little progress was made in stabilising the market until a substantial number of new entrants were forced into liquidation. This began to improve circumstances for those that remained and by 1912 rates began to rise. By 1914 the *Post Magazine* admitted that 'rates of premium at last gave signs of having reached a stage at which, with careful underwriting, a reasonable margin of profit might be expected.[8]

In these testing conditions the Scotts restricted acceptances carefully to those areas which they believed to be safe and of greatest importance to their fire business. In the first instance they only wrote it for classes directly linked to non-hazardous fire risks. With time and experience they began to make experimental departures that they could never have contemplated in the fire market. This was possible because the liability on all but a few special risks was relatively small and the number of cases, especially in workman's compensation business, provided a basis for estimating likely experience far more easily. Thus, rather in a spirit of taking the market's temperature, always watching Accident Offices Association (AOA) rate movements, and listening for gossip about other company's experience on particular classes, the Provincial began to expand its range of acceptances gradually.

There were strong pressures to do so, whatever the profitability of business. As the company broadened its agency connections, it became important to offer an adequate range of cover if they were to be retained. It would be impossible to deal with smaller brokers on the basis of taking their best fire risks but rejecting unprofitable accident risks.

Francis Scott's handling of such problems can be illustrated by an episode in 1911, when an agent who provided a superior fire account among the boot and shoe and hosiery factories of Leicester, complained about the Provincial's uncompetitive rates for the accident business associated with such risks. Because the trade associations concerned preferred to deal with one broker, this threatened him with the loss of the whole connection. Scott was unhappy to make any concession because he was convinced that the Provincial's rates were no more than adequate to cover likely experience. Despite this, to protect the agent and the company's fire account, he offered a reduction in rates on the better quality risks involved, emphasising that they would not be a paying proposition. He explained his firmness to the local branch manager,

Even if we miss much business this year, I am confident that next year will see us with less competition to face and a stronger position for carrying our own rates. I think also it will be easier to get business at our own rates next year than to raise rates we may have passed this year in competition. To have to do this is always a source of friction to all concerned.

By 1913 a combination of modest experiment and agency pressure had widened the range of accident risks on the Provincial's books. There were limits. Any business involving hazardous work or dangerous machinery was excluded, including cotton spinning, woollen mills, ironworks, heavy engineering and woodworking. The possibility of a catastrophic loss was also excluded by ruling out quarries and mines. Within this framework, Scott was prepared to consider classes of business in the light of any special information that might be available. But he did not seek it by rate cuts or any other method. This was hardly surprising, for as with nearly all companies, the Provincial's accident account did not show a profit until 1912 when rates began to rise. None the less, it became an essential component of the company's underwriting. By 1913 the net accident premium income of £18,500 was fast approaching the net fire premium income of £21,700. Without it the fire account would certainly have languished, lacking support from product variety for agents and brokers. The scale of the business supported market penetration in a far more direct way as well. By that year thirty-eight per cent of the Provincial's organisational costs were carried on its accident account. Of course, some of these were specific to the new business, but a high proportion were joint costs in branches where the scale of business did not allow much scope for specialisation. To this extent the accident account allowed branch development to take place more rapidly, effectively and profitably than would otherwise have been possible.

4.4 The foundation of a branch organisation

Branch organisations allowed a company to differentiate itself by coming into closer contact with the market, with agents and policyholders, by providing a better service and the working relationships and mutual accommodations from which goodwill grew. In this way it could begin to insulate itself from the competitive pressures on premium rates and commissions which led to modest margins and insecure revenues. While it might be necessary for the Provincial to emphasise rate competition in its marketing policy, there was every reason for it to attempt to shift the balance of its business in directions that relied less on this lever.

Larger brokers could be cultivated more successfully from local offices. Easy access to a responsible official who could give a quick decision on the acceptance of individual risks was important. Personal contact encouraged the flexibility and understanding which promoted good business relations, as both sides began to appreciate each others' attitudes and problems more clearly.

Smaller brokers and agents could only be approached when a local branch could offer them service and flexibility in acceptances. They provided the only access to markets like the Midlands metal trades, hosiery, bootmaking or even cotton weaving, where the representative firm was of modest scale. In return goodwill allowed less competitive rates to be carried, increasing the profitability and stability of income. Beyond them, small scale non-hazardous insurance was practically unobtainable without the vigorous canvassing of the professional and commercial men who controlled it by inspectors controlled by a local manager.

But branch development required resources. It could only be undertaken as revenue grew sufficiently to cover its cost, and then after the essential requirements of adequate head office administration had been met. The overhead costs of a manager's salary and office costs made this a particular difficulty. Furthermore, it would only be successful if managers of an acceptable quality could be recruited and the problems of controlling a diffused organisation successfully resolved. Branch managers' success depended on their capacity to operate with freedom and self-discipline out in the market, so they could not be controlled directly, yet they could involve the company in substantial commitments. Its safety therefore depended on good appointments. The small scale of Provincial branches required a range of skills that could be met by a team of specialists in a large branch. A manager therefore had to be honest, technically competent in all general insurance markets, a good salesman and administrator in the office. Yet the company was too young to be able to promote its own staff, so appointments involved the risk of unknown men. This was risky because new branches could not support an attractive salary. In any case, able men were rarely attracted to a small non-tariff company. With no established reputation, the company's representation was uphill work; the high mortality rate among small companies was also discouraging. In these circumstances, it was not only difficult to open new branches, but their success was largely dependent on the quality of managers recruited. And it was necessary for them to gain the confidence of the Scotts before they could be trusted to operate with the freedom necessary for success.

Because of these costs and difficulties, more economical ways of extending business were tried at first. Gray, the company's first clerk, was

TABLE 4.3 *Provincial Insurance Company: net premium income by branch office, 1913 (£'000)*

	Net fire premiums	Net accident premiums	All net premium income
Head office	9.1	7.6	16.6
Manchester	5.0	4.3	9.4
London	2.4	2.2	4.6
Liverpool	0.7	1.3	2.0
Birmingham	0.8	2.1	2.9
Hastings	0.5	1.0	1.4

released from his responsibilities at Bolton, to become a peripatetic representative. This probably began on an occasional basis in 1905 and by 1908 he was almost wholly employed in the canvassing of more distant areas, trying to obtain agents.

Another approach was the 'special agency', sometimes graced by the title 'district representative' or even 'branch office'. An agent was paid a fixed fee on the understanding that the Provincial had first call on his fire business. The first such arrangement was in Oldham in 1906 when an agent was offered a salary of £50 to tie his connections to the Provincial. Similar schemes were entered into with brokers in Edinburgh, Burnley, Cardiff, Leicester and Nottingham and later in Aberdeen and Belfast.

Attempts were also made to broaden the sources of business by the use of circulars. During 1908, for example, they were sent to 400 Unitarian Churches, 250 Oldham cotton mills, 1800 cotton mills and 500 prospective agents. There was rarely more than a trivial response to these ventures, but the cost was modest and the company received general publicity.

These methods could not compare with the marketing benefits of properly constituted branch offices and quite quickly the Scotts moved to establish them. By 1913 fifty-three per cent of all home gross fire premium income and fifty-nine per cent of home gross accident income passed through the five branches that had been established. Table 4.3 illustrates the sources and distribution of branch business in that year.

The first move was made in 1905 when the Scotts opened a branch in Manchester. The logic was straightforward. The company already had a good flow of business from local brokers, so the necessary overhead costs could be set against a reduction in administrative work at Bolton. These established connections also suggested that a local office would receive extra business quickly, reducing the expense ratio. Finally, the Scotts were frequently in Manchester and could oversee the branch with ease.

After an unsatisfactory first manager, real development began in 1906 with the appointment of W. O. Oswald. An office was taken in Charlotte Street, in the heart of the city's financial area and three supporting staff appointed. Business with brokers flourished and the branch became the most important source of mercantile and industrial insurances. As early as 1909 it was contributing thirty per cent of all gross fire revenue, though because of its hazardous nature a relatively high proportion was reinsured. In that year, when Oswald's health broke down, Gray replaced him. At the same time an inspector was appointed to specialise in developing non-hazardous business.

Initially all dealings with London agents had been by correspondence, supplemented by an occasional visit from one of the Scotts or Gray. By 1908 the company had become sufficiently familiar with its brokers for an office to guarantee an expansion in business. On James Scott's insistence rather splendid offices were taken in the main city insurance area at 6, Old Jewry. Francis Scott described Butterfield, the manager appointed, as 'a gentleman and as such lends some distinction to the office, which in London is of more consideration than elsewhere.' With a salary of £400 he was the company's highest paid official and within a short time controlled eight staff.

Although some of the income anticipated from brokers came and attempts were made to develop business outside the city area, particularly through a 'District Agent' at Plumstead in the south-eastern suburbs, Francis Scott remained dissatisfied with the progress in London before the war. Its premium income only reached £5,200 by 1913, half that of Manchester, in a market that had promised far more. This was an especial problem because its costs were high, remaining at forty-six per cent of premium income, when Manchester's had fallen to twenty-eight per cent. The problems emanated largely from the manager. His social grace and confidence were not matched by technical ability, organisational powers or judgement, and this inhibited the progress of the branch. He neither impressed the city professionals, nor had the capacity to organise an agency network.

London and Manchester exhausted the possibilities of founding branches with the security of an assured existing and likely potential business. Subsequent ventures were inevitably more speculative.

Liverpool seemed an obvious choice, for the city offered an enormous volume of insurance business and the Scotts might have some influence with cotton merchants. An office was opened in 1909 with a manager chosen to cultivate business through the cotton exchange. His existing connections provided a rapid initial growth in income, but once this was

exhausted premium income began to stagnate. The man had little interest in developing an all-round branch business, having no technical training in insurance or experience outside the cotton trade. At the same time he faced difficulties which the Scotts had perhaps not anticipated adequately. The Liverpool hazardous fire insurance market, though enormous, was tightly bound to the huge local tariff offices by interlocking directorships which made progress difficult for a small non-tariff company.

By 1913 Liverpool fire premium income was actually falling and a new manager took a different tack. He set himself the task of building business among smaller agents with non-hazardous risks outside the mercantile market. While this could not lead to dramatic development, revenue made steady progress, especially on the accident account and this enabled costs to be covered more adequately.

In the Midlands, a District Representative had been appointed in Leicester but there was little other business apart from that brought in by Gray's occasional trips. The market was a difficult one because there were already several local non-tariff companies; it covered an enormous range of types of industry; industrial risks were smaller than in the textile districts, creating higher overheads and less sensitivity to rate competition; and the regional trades were less suitable for sprinkler protection.

Francis Scott appointed Dale Evans to open a new office at the beginning of 1911. A young man with a broadly based technical experience and personality for business winning, he was attracted by the possibility that his ability would be recognised more quickly in the Provincial than in the large companies where he had worked previously. The success of the branch was largely due to his capacity.

With a woman assistant and a bicycle he faced the task of developing business in an area from Bristol to Lincolnshire and Bedfordshire to Derbyshire. He began by following up lists of prospective agents prepared by Gray and producing pamphlets emphasising the Provincial's financial strength, in order to break down prejudice against a new small company. He was most successful among the Birmingham brokers whom he was best placed to cultivate, who derived business from throughout the region. Regular links with agents elsewhere were harder to maintain. Special agency terms offering extra commission and sometimes the sole right to accept Provincial business in a specified area were a solution used in Leicester and Cardiff. However, this could damage relations with other potential agents, especially if the extra commission was used to cut rates. Sole rights might also inhibit future development. Special terms were usually only offered in country areas where it was unlikely that other sources of business would become attractive.

Otherwise, Evans concentrated on a direct canvass of the sprinkler protected risks he was most likely to win, pooling his knowledge by canvassing sometimes with a National of Great Britain inspector. Francis Scott fed him with information on recent installations; he studied technical periodicals to find references to them; and became sensitised to the tell-tale sign of the red sprinkler gong on the outside of buildings.

Support was offered by any influence the Scotts could muster. He was introduced to the Nottingham representative of Haslam's, which led to a series of interviews with lace and hosiery firms. Francis Scott came down to visit brokers or undertake important negotiations such as an interview with the broker who controlled the insurances of Boot's chemists shops. By 1913 gross fire and accident premiums had reached £4,500 and this was achieved at a modest cost, for the expense ratio had fallen to thirty-four per cent, well below that of London and Liverpool.

The importance of the individual manager was seen even more clearly in the eccentric opening of an office in Hastings. This was a blind bet on its manager, Barrett-Lennard, who had been a local official of a non-tariff company that had been taken over by the Atlas. The Scotts interviewed him and were so impressed that they gave him the rural South East as a territory to work from his home town. He proved to have a genius in dealing with small country agents. The scale of business he obtained was modest but highly profitable, being mainly non-hazardous. On this basis he provided a clear profit within three years of opening.

The last branch opened before the war was at Bradford. In 1910 local director, who managed a large Bradford wool importers, had been appointed. He transferred much of his own firm's insurances to the Provincial, encouraged business associates to do the same, and introduced Gray to local businessmen through membership of the Bradford Exchange. When the Manchester branch began to absorb more of Gray's time and the potential of the branch became apparent, A. W. Dodds was appointed Yorkshire manager in 1914, with an office in the Bradford Exchange. With such good local support through the local director's business, church and masonic activities, revenue grew quickly reaching £700 in the first year.

The one surprising gap in the Provincial's early branch organisation was Glasgow. It was an attractive market because the local tariffs were uncompetitive and the early connection with Stenhouse and other Glasgow brokers, had created a substantial premium income. The omission is probably explained by prolonged negotiations to purchase the Royal Scottish, a local non-tariff company. It offered the Provincial office premises in Glasgow, Edinburgh and Dundee, together with a ready made local premium income. Yet obtaining the concern proved of byzantine

difficulty. At first it was purchased by another non-tariff company, which itself went into liquidation. The Royal Scottish could not be released until the affairs of the larger concern were wound up. Then the Scotts had to deal with a third company which bought up the liquidated concern, before finally negotiating with the liquidator himself.

The complications were not one-sided. James Scott was worried that the purchase would strain the Provincial's management and erode market confidence in its sound development. After his death in 1913 his sons made a firm offer but this was declined because they would not accept uncertain American liabilities. Francis Scott was prepared to continue negotiations, but Samuel Scott, no doubt remembering his father's caution, prevailed. In any event, for as long as purchase seemed a possibility, the establishment of a Glasgow branch was ruled out.

While branches took up the running after 1907, the head office continued to develop business. While it no longer handled London or Manchester brokers directly, it did deal with the Bains in Leeds, Stenhouse in Glasgow and other brokers from parts of the country not served by local offices. As business grew, a larger head office staff became necessary and in 1909 they were moved to new premises, previously owned by the Manchester and County Bank in Hotel Street, Bolton. This prominent position must have fixed even more firmly in the minds of local people the significance of their indigenous insurer and thus further encouraged local business.

Unfortunately it is impossible to analyse branch business precisely. By 1913 the company was certainly obtaining hazardous brokers' business from a widening range of geographical sources. This provided the revenue that carried the cost of development. However, while efforts had been made to expand non-hazardous business outside of Bolton, notably in Manchester, Liverpool and Hastings, it remained modest in scale. Its successful development depended on the ability to employ far more inspectors in each branch to drum up business from small agents. The company's revenue was not yet sufficient for this. A beginning had been made, but no more.

4.5 Opening a foreign account

In view of the enormous international business transacted by British fire insurance companies, it is not surprising that the Scotts should consider foreign underwriting. However, obtaining such business directly posed, in an extreme form, the problems associated with a home branch organisation. Control became more difficult as communication was extended and it

General office, Provincial Buildings, Hotel Street, Bolton (head office, 1909–19).
Formerly the Bolton branch of the Manchester and County Bank.

was impossible to form an appreciation of market conditions or the men
with whom the company was dealing, without costly extended absences
from home. Over and above the usual problems of branch overhead costs,
overseas marketing involved higher travelling expenses and the special
problem of deposit requirements imposed by many foreign governments.
All these considerations inhibited the establishment of direct entry by
small companies. Yet despite these obstacles, there were alternative
channels and methods which allowed the Provincial to establish a modest
foreign account by 1913.

From an early stage, the Provincial accepted individual foreign risks. By
1906, when the San Francisco conflagration prompted Samuel Scott to list
risks carried in cities outside Europe, he found them in one New Zealand,
thirteen American, four Canadian, three South African and two Aus-
tralian cities. Risks had also been accepted in France, Holland, Italy and
Portugal.

While the Scotts discussed the implications of these commitments, they
were not the result of an explicit decision to enter the foreign market.

They had come almost coincidentally from large brokers and were written on the same individual basis at Bolton as those from the home market. The main source was the London 'home foreign' market which provided an easy indirect route to foreign risks. These included the overseas properties of British companies or companies with strong financial links with London, risks sent to London to seek more competitive rates or because of a lack of insurance capacity in small markets abroad, and the reinsurance business of foreign companies. The market was competitive from the point of view of rates and brokers' commissions, and expertise was necessary because many risks came to London because they were, for good reason, uninsurable in their countries of origin. Yet within these limits, it provided a source of foreign revenue and an opportunity to learn about overseas markets.

Foreign risks were supplied by most of the company's larger brokers, but a special relationship developed in this direction, as others, with Willis Faber. The Scotts moved cautiously, resisting many suggestions made as to opportunities for more rapid development, but the success achieved with this firm developed their confidence in a way that laid a foundation for more substantial developments.

In addition to providing individual sprinklered risks, Willis Faber began to offer a more general business. They provided a share in a small, but extremely profitable, reinsurance treaty with the Russian Mutual of Moscow, which insured sprinklered risks in Russia and Poland. From 1905 they opened the door to what was to become the single most important foreign account, H. J. O'Brien, a Chicago broker, who controlled good American sprinklered risks and always had ample surplus lines to place. The business grew quickly and caused the Scotts some concern, especially as the distance involved meant that O'Brien was allowed some degree of underwriting discretion. Samuel Scott argued that '…there seems to be a certain inconsistency in giving to a broker in the U.S.A. a power to bind us which we should not think it right to give to any broker at home.' Despite this, the O'Brien business continued on a modest basis, accounting for about £500 gross premium income each year.

In 1907 Walter Faber, the broker's fire manager, tried to place the relationship on a more formal basis by inviting the Scotts to place all their company's foreign underwriting with his firm. He suggested that '… in conjunction with the Cornhill [Willis Faber's house company] we should get a very good show.' Once again the Scotts were hesitant. Francis Scott replied, 'We are for all practical purposes confining ourselves to sprinklered business and in that I think you will admit we cannot go very wrong. This being the case you will agree that our foreign agency is

hardly worth your consideration for the present.' Despite this, in the following year Faber was, through his firm, appointed sole agent for the Provincial's American business. This presaged the two important changes on which the company's serious entry into foreign business was based, which were both founded on the Willis Faber link.

In 1911, Walter Faber retired from the firm because of ill health, but continued to underwrite at Lloyd's for a private syndicate and for the Provincial. In a separate arrangement, the Scotts established a Canadian branch under the management of the new Willis Faber office in Montreal.

The Scotts agreed that Faber should underwrite business in the 'home foreign' market for the Provincial on the same basis as for his syndicate, up to a limit of £500 on any risk. Faber increased his acceptance capacity. In return the Provincial obtained his experience, technical ability and connections. Furthermore, being of independent means, he had no temptation to write speculatively. Apart from commission, the Provincial only had to find his expenses and the salary of a clerk to handle paperwork. Furthermore, Francis Scott would have an opportunity through correspondence to learn about foreign insurance and the London market from a man who could deploy his knowledge in pungent terms on paper.

The new arrangement began in April 1911. Faber began by arranging lines on East Indies tobacco estates, proposed a reinsurance treaty with an American mutual insuring lumber risks, and investigated warehouse business in Alexandria. The Scotts became alarmed. Francis Scott wrote,

…we are all feeling we do not want to be in too great a hurry to build up a foreign income …when the non-tariff offices are not in too good odour and the cause is usually put down to foreign business, we should not run the risk of showing a considerable rise in premium income, which would be known to be due to foreign business, and should we have a serious misfortune would prejudice us for home business. Our wish is to go slow.

Faber replied with scarcely veiled exasperation;

We are going dead slow. The question in my mind has always been – shall we …obtain sufficient business – a premium income – to pay? …what surprises me is that you have raised the question of too much foreign business before we have a 'living' income …a very small premium income is insufficient 'average' to meet the average of losses; and that is practically betting that of the risks written none will be totally destroyed. That is not underwriting.

Francis Scott was suitably conciliatory in replying to this rebuke.

I can quite understand that we seem to you extraordinarily afraid of business and wanting in pluck … . You do however understand I think the peculiar position we are in, having as we do the bulk of the capital of the company. This being so, it makes us unusually anxious to avoid catastrophe …as we know we have a nice little business which will gradually yield a substantial profit.

In the event there was no real problem. Scott hoped that foreign income would not reach £5,000 in the first year which Faber assured him would not happen, even though he continued to argue that this was inadequate for sound underwriting. In fact, gross direct premium income reached only £1,400 in the first year and by 1913 had only grown to £7,300, leaving a retained income of £3,200, which even when supplemented by the reinsurance account of £700 was far short of his preferred income.

Overseas business came through a number of channels. Much of it was obtained through London brokers. In this way the Provincial had lines on such risks as South African railways, Galician and Romanian oil wells, New Zealand drapers, Russian cold stores and Marseilles vegetable oil manufacturers. In addition, reinsurance business was accepted. Some came from other British non-tariff companies; otherwise, Francis Scott preferred to restrict overseas reinsurance to mutual companies. Such arrangements were made with concerns in Germany and central Europe, where trade associations were important in insurance. The one American mutual treaty, with the Lumberman's Indemnity Exchange, proved disastrous and was quickly terminated.

Business obtained in the competitive London market, would never yield great profits. Greater opportunities were only possible by dealing directly with foreign markets, operating in a less competitive environment and eliminating some of the commission that intervened as business passed to London.

Direct representation could not yet be contemplated, but local agents were appointed. The Scotts were wary of such arrangements but the connection with H. J. O'Brien of Chicago remained important. O'Brien was recommended on all sides; he controlled the sprinklered risks of some of the largest and most reputable companies in the United States. Business with him had languished when Faber took over because the etiquette of the insurance market prescribed that it would still have to pass through Willis Faber. When the Scotts discovered this, they obtained permission from Willis Faber to approach O'Brien directly and he responded enthusiastically. In August 1912 he was appointed the Provincial's United States manager and was given powers to accept up to $50,000 on any sprinklered

risk. Business grew well and profitably. By 1914 it had reached an annual gross premium income of over £4,000 and accounted for more than half of Faber's business. This was despite a careful injunction, dispatched by Faber, who was now well schooled in the Scotts' attitudes:

...we shall never press you on the question of premium income. This company has in this country a most excellent connection for profitable business and there-fore it is not under any necessity to be eager for premium income abroad, but on the contrary, a large income abroad, resulting in a high loss ratio, would be absolutely detrimental to the company's business here.

The O'Brien appointment was an important sign of a more expansive attitude towards foreign business. It was a new level of delegation to have an American agent issuing Provincial policies on his own authority, sub-ject only to eventual scrutiny by Faber when the papers reached London. It was only matched in some degree by the Canadian branch which was growing in parallel with Faber's activities.

In 1909 Raymond Willis of Willis Faber established an office in Mon-treal, mainly to handle Canadian marine business. Canada was a boom economy.[9] The rise in grain prices since the turn of the century had brought heavy investment into the country, creating opportunities for fire insurance. Willis invited the Scotts to establish a Canadian branch under his management.

Francis Scott visited the country in 1910 to investigate the proposal. It seemed an excellent opportunity. The Provincial would be represented by a concern in which they had great confidence; their affairs would be managed by Willis, with whom Francis Scott had established a close rapport. Once again, the Provincial would obtain superior management, without the cost this normally implied. With the exception of the deposit required by the Canadian government, the branch would be run on a commission basis, so costs would be proportional to revenue.

Willis Faber and Company of Canada was appointed general manager for the Provincial in Canada from November 1910. The limits within which risks could be accepted were carefully specified. In special cases, Willis was authorised to exceed these limits by fifty per cent when some specially favourable feature existed. Because of the timber construction of most properties outside urban areas and the absence of any fire fighting facilities, country risks were to be declined.

In return Willis Faber received commission on all business they pro-vided, together with one-third profit commission. Further protection for the Provincial was provided by an arrangement whereby one-third of all premium income was to be ceded to the Cornhill, Willis Faber's own

company, providing an additional interest in the success of the venture and strengthening acceptance capacity.

Willis proposed to develop the Provincial's business on similar lines to that at home – to discount selectively the tariff rates set by the Fire Underwriters' Associations in the various Canadian provinces. This was an innovation locally. A dispersed population meant that branch organisations and intensive marketing were expensive. Business was therefore concentrated in the hands of agents whose numbers were limited by government licence. Non-tariff entry was difficult for most agents were tied to tariff companies, and as licensing restricted inter-agent competition, there was no incentive for them to change company. Indeed, few would be interested in lower rates when this would reduce their commissions.

In short, the market was unused to the aggressive broking characteristic of the British market which Willis Faber proposed to introduce. It would require energetic, experienced and independent management to disrupt the *modus operandi* of Canadian fire insurance. Willis's contribution was essential for he would be able to deal with negotiations at the highest level and act with complete discretion, possessing the full confidence of his firm in London and the Scotts.

The potential that existed was suggested by some of the important accounts Willis managed to attract. He obtained a line on the insurances of the Hudson's Bay Company, which he later described as 'One of the finest, if not the finest account in Canada and [it] is practically all done on the lead of the Provincial.' The largest companies were most attracted by the possibility of rate discounts offered by a secure insurance company and the Hudson's Bay Company, with its expanding chain of retail stores across the dominion was a logical target.

With these developments in hand, it was a considerable blow when Francis Scott learned in November 1911 that Willis was returning to London, leaving the management of the branch in the hands of an inexperienced fire clerk who would be generally supervised by the manager of the marine brokerage business. While Willis continued to visit Canada from time to time, the scheme had lost its most attractive feature.

Dettmers, the young fire clerk, was in no position to develop business on the same grand basis. He was left with sole responsibility for underwriting within the original policy framework, with a few agents, mainly in Toronto and Montreal. The Scotts had been prepared to allow Willis discretion in interpreting that policy; with Dettmers, they could not be so confident. Without personal influence, experience or discretionary powers, it was difficult to see him making much progress.

In fact, the Provincial's account grew slowly. A net premium income of £1,182 had been obtained in 1911; by 1913 this had only grown to £1,573. Even this was only achieved by a less selective underwriting policy than was pursued at home. Non-tariff discounts seemed necessary to attract average risks, rather than select business, and this was beginning to show in underwriting results by 1913 when the loss ratio rose to fifty-seven per cent, largely because of four losses on the Hudson's Bay account which Willis had hailed as such a coup. The Canadian account had become an asset of dubious value. It was demonstrating the problems that would face the Provincial in direct foreign underwriting. How could it find managers of adequate quality to control overseas branches independently when revenue was bound to be small and insufficient to cover large salaries and expenses? How could such operations be supervised when the responsible management of the Provincial was limited to the Scotts and they were already stretched by home business? The years after 1913 were to raise these questions more severely still.

5
The profitability of business

Three management responsibilities were necessary to ensure that the revenue obtained proved profitable: the establishment of underwriting arrangements that would control the level and variability of losses; the creation of an efficient organisation within the limits set by an acceptable expense ratio; and the effective handling of the funds at the company's disposal.

5.1 *Underwriting*

The underwriting policy of accepting sprinkler protected risks at substantial discounts; other desirable risks at a ten per cent discount; declining risks where competition was not controlled by a tariff; and taking non-hazardous risks at full tariff rates, with extra commission for agents, was straightforward enough in principle, but practice was more complicated. The growth and profitability of the company depended on judgements at the margin. Underwriting had to assess the hazard associated with individual risks, examining construction, ownership and situation, the latter particularly as it related to other acceptances. Profitability depended on a scrutiny of all acceptances, sifting out those where there was reason to fear special hazard. If necessary, a survey would be required on larger risks to provide the basis for an informed decision.

This task required experience, skill and a systematic approach, but it could not be a matter of technical judgement alone. Branch managers would try to push underwriting policy to its limits to win business from agents who would not deal with companies that only accepted gilt edged risks. Over-zealous underwriting might blunt the company's marketing edge. Of course, good underwriters realised this, but there was a natural tendency for them to look to loss ratios rather than the scale of business. They were the guardians of the integrity of underwriting. Thus, the risks the Provincial actually accepted were a compromise between market pressures and the formal objectives of policy. This reflected the personal qualities of the men involved as much as any strictly rational consideration.

Successful underwriting also involved the implementation of appropriate reinsurance arrangements. While premium rates were set to cover claims over the long run, the absolute size of individual losses could create a highly volatile annual loss ratio. This would make underwriting surpluses chancy, prejudice the market against the company's management, and even, with extreme losses, threaten liquidity and survival.

At first the Scotts appear to have been unaware of these considerations. Their methods copied those of the Bolton Cotton Trade Mutual and were amateur, ignoring reinsurance entirely. When Gray was appointed the company's first insurance clerk, when offices were opened at 1, Acresfield, Bolton in January 1904, he was taken aback at what he found. Orders and policies were being recorded in foolscap notebooks. He advised the institution of the conventional bookkeeping arrangements he was used to at the Co-operative in Manchester. The appropriate books were made up by a local stationer, James Scott being particularly taken aback at the size of the Loss Book when it was displayed in their window.

But it was the absence of reinsurance arrangements that particularly shook Gray. The Provincial's tiny revenue provided no scope for carrying losses that could only be avoided by chance. The existence of substantial reserves was no solution, for market opinion would look askance at a company that intermittently made substantial losses on its underwriting account. Gray discovered that £20,000 had been retained on a cotton mill – over one-quarter of the paid up capital of the company; 'I explained the system of reinsurance, which was granted a good idea'.

Initially reinsurance was placed with other small non-tariff offices, but these arrangements were not straightforward. They were often involved in the same risks and did not wish to increase their exposure. In any case, their capacity was limited and they were not all financially secure.

Given the FOC restrictions on reinsurance with tariff companies, the only alternative was Lloyd's. James Scott obtained advice from the Bank of England as to reputable brokers to approach. Having taken a strong dislike to the first suggestion, partly on the ground that it was unwise to trust businessmen who covered the walls of their offices with biblical texts, he eventually came to an agreement with Willis Faber. They placed reinsurance at Lloyd's from July 1904 and by 1905 about two-thirds of all reinsurance passed through their accounts.

At the same time, the Provincial's underwriting was being re-organised on a more professional basis. A Manchester broker who had initially advised the Scotts was dropped and they turned to T. J. Milnes, a retired insurance official. He had written offering his services as a surveyor in 1903 and acted as such in the following year. But his contribution became

far more important. He provided the first real expertise in underwriting, for he had been a branch manager with a substantial company. Beyond this, his thoughtful, patient approach made him an ideal teacher. Samuel Scott wrote, Francis Scott

... had the good fortune to have the tuition of a retired insurance surveyor of wide experience and level judgement who was engaged to make special surveys and to act in an advisory capacity. The sound foundation of the Provincial's business in our early years is largely due to him and the course of events might have been very different if it had not been for his fatherly care of his young charges.

From 1904 Milnes carried out all important surveys for the company, including the preparation of long reports on the state of acceptances in particular markets and recommendations on the rating of risks. His suggestions on retentions gradually grew into the company's first limits book. Francis Scott later acknowledged the significance of his work; '... while it has not been altogether adhered to it still forms the groundwork on which retentions are based'.

Under his influence, underwriting became more orthodox. As Table 5.1 shows, the proportion of revenue retained fell steadily from ninety-three per cent in 1904 to sixty-eight per cent in 1907. This greater volume required more formal administration. The initial arrangement with Willis Faber had been on a facultative basis: individual risks had been reinsured when necessary. Milnes recommended a treaty by which reinsurers agreed to accept a specified surplus on any risk automatically, before detailed information on each risk was passed on, thus providing greater flexibility and economy in administration.

Willis Faber arranged a treaty from 1906. The Provincial passed on proportions of each risk in terms of multiples of its own retention, known as limits. This protected the reinsurers by involving the Provincial to a known extent on each risk. While the exact terms of the original treaty are unknown, it is probable that in 1906 and 1907 it allowed two limits to be passed on. The company could automatically accept three times its own retention without detailed negotiations. Beyond this, facultative arrangements would be necessary. In return the Provincial received commission on the premiums it passed on. The treaty substantially increased acceptance capacity. The only constraint, and it was an important one, was the responsibility it created. Lloyd's would only renew a profitable treaty and cancellation would now have disastrous implications for business.

Unfortunately Milnes suffered from ill health from 1907 which restricted his Provincial activities. In 1905 J. A. Barber had been appointed to handle the administration of acceptances and reinsurance. In the following year

TABLE 5.1 *Provincial Insurance Company: home fire reinsurance business, 1904–13*

	Home gross fire premiums £'000	Home net fire premiums £'000	Proportion reinsured %
1904	2.8	2.6	93
1905	6.0	5.1	85
1906	8.9	6.6	74
1907	16.3	11.1	68
1908	20.9	13.1	63
1909	24.8	14.2	57
1910	30.1	18.7	62
1911	34.2	19.0	56
1912	41.5	19.7	47
1913	50.8	23.4	46

Willcock was taken on as surveyor. But as the scale and diversity of business grew, the effective implementation of underwriting policy required someone to apply themselves to the detail of individual risks and routine administration in a way that was now impossible for Francis Scott. In 1908 R. R. Baillie was appointed chief fire order clerk. Though young, he had experienced underwriting in the head office of the Atlas. Under Francis Scott's supervision, he assumed control over acceptances, rating and the determination of retentions on risks. A close, cautious Scot, happy to concentrate on detail, he was well suited to the responsibility of protecting a company concerned with security from dangerous liabilities.

Baillie's first task, beyond the daily routine of scrutinising acceptances, was to prepare a limit book which defined the company's acceptance policy. His knowledge of the methods of the Atlas must have been helpful, but the Provincial's tiny revenue meant that limits had to be far smaller. Its concentration of risks in cotton also created special problems. The guide he produced must have been in part a formalisation of Milnes' earlier recommendations, but its existence was essential if branch officials were to apply a consistent and appropriate underwriting policy. If anything, he advocated smaller retentions than Milnes and the reduction in the proportion of business retained in 1908 and 1909, shown in Table 5.1, can be attributed to his influence. The extra reinsurance income this created, justified a renegotiation of the company's treaty which was extended to four limits in 1909. This temporarily increased the proportion retained, but subsequently it continued to fall, possibly because during the cotton boom, much additional premium income came from risks where the Provincial's limit was already full.

In effect underwriting worked on the basis of being able to carry a loss of £1,000 on a risk in the event of a serious fire. This principle gave rise to a variety of actual retentions, for the probable net loss varied with different types of construction, salvage possibilities and forms of fire protection. Thus the £1,000 target led to retentions of up to £5,000 on sprinklered cotton mills, £3,000 on Manchester sprinklered warehouses, £2,500 on bleachworks, but only £750 on drapers' shops. Sprinkler protection normally doubled the retention on any risk. If risks were of good construction, situation and moral hazard, then limits were fully utilised; if they were not, they were rejected rather than reduced.

James Scott begrudged the loss of premium income reinsurance implied. He continued to advocate the acceptance of large lines on risks which seemed a reasonable speculation. While this conflicted with the continual emphasis on security, there was always an element of ambivalence in his approach. He had always speculated, especially in the cotton markets, valuing intuition above science. He was certainly quite happy with the early large retentions and until his death was prepared to cover the company against large losses on a private basis which did not appear in the accounts.

Another complication for the historian was created by the gradual creation of hidden reserves from unreported investment profits and the understatement of underwriting profits in exceptionally good years, by creating larger than necessary reserves to cover outstanding claims. When net premium income fell in 1909 as a result of the more controlled underwriting policy, this was used to introduce a more adventurous note, aimed at improving results. A special 'additional retentions' policy was instituted. With the sanction of the Scotts or all three senior head office staff, the retention on really good quality risks could be increased by one-third. It was realised that this might lead to a more volatile loss ratio, but this could now be accommodated by drawing on reserves to dampen the impact of large losses on published accounts. By 1910 this had restored growth to net premium income.

Having established a formal underwriting policy, Baillie created a classification system designed to assess underwriting success. The company's business was too small to provide an adequate number of risks to make the detailed classes used by large companies useful. Business was therefore grouped into broad divisions which were large enough to provide a sensible analysis of experience.

Thus, by 1913, the Provincial's fire underwriting had the appurtenances of professionalism. Progress had been made from the stage when James Scott had accepted risks on his own name with no survey, no

reinsurance and a simple acceptance of the market rate. Acceptances and retentions were clearly defined and administered in a way that allowed results to be monitored. Its daily administration was carried out by a man who was accumulating a special knowledge of the Provincial's risk portfolio.

Establishing an accident underwriting department was a simpler matter. The larger number of individual risks and their relative homogeneity made it easier to estimate experience, allowing a small company to select the classes to write more easily. The great bulk of claims were far smaller, so there was little possibility of a heavy loss distorting experience and therefore less need to reinsure. This was only necessary for death benefits and large burglary risks. In the first case the Provincial limited its liability to £500 by reinsurance, while all burglary reinsurance was passed on to a specialist office.

Accident underwriting had its own difficulties however. Claims settlements were the most important of these, especially in the employer's liability branch of the business.[2] While Francis Scott surprised his staff by insisting on the payment of full compensation, irrespective of the ignorance or timidity of the claimant, he was well aware that profitability was dependent on hard headed settlements. The business was plagued by the casual certification of incapacity by doctors; entrepreneurial solicitors who sought to blackmail companies in the hope of large fees; and the inevitable malingering, all of which inflated claims. This was a field requiring shrewdness, diplomacy and specialist knowledge of law and medicine.

There was also the problem of assessing liabilities. The unpredictability of the course of ill health and the outcome of legal actions or negotiations meant that the drawing up of accounts at the end of each year was extremely conjectural. Even using the most conservative methods, the Provincial once seriously underestimated its future liabilities and was only saved by the accumulation of hidden reserves from having to carry a large deficit. Such problems dragged down many small accident offices with careless managements and shareholders anxious for a rapid return.

Before 1907 the company reinsured all its accident and burglary business, but when it was decided to start employer's liability insurance, F. G. Hughes was appointed accident superintendent. He had little experience, but only business associated with non-hazardous policies was initially contemplated. When the range and sale of business expanded, A. Collins was recruited as accident underwriter and Hughes specialised in claims settlement. They were well balanced. Collins was a quick Londoner with self-confidence and a willingness to undertake new ventures, in contrast to Baillie in the fire department. This was particularly appropriate in a

TABLE 5.2 *Provincial Insurance Company: comparative British fire loss ratios,*
1904–13
(Corrected home loss ratio, %)

	Provincial	Non-tariff (a)	Commercial Union (b)	Royal Exchange Assurance (c)
1904	66.5	34.0	43.5	34.9
1905	73.5	38.7	37.8	35.9
1906	43.3	43.6	48.8	36.7
1907	43.9	38.1	39.8	37.8
1908	38.6	46.7	38.8	39.2
1909	32.1	43.0	38.0	40.8
1910	44.7	39.4	36.0	40.1
1911	57.9	50.4	48.0	43.3
1912	45.6	46.8	41.3	44.4
1913	72.5	52.4	46.5	45.0
Average	51.9	43.3	41.9	39.8

Sources:
(a) Non-tariff is the average of the published fire loss ratios of the Fine Art and General, the National of Great Britain, the Leather Trades and General (later the North-Western) and the National British and Millers (till 1908), taken from the *PMA*.
(b) Commercial Union: Guildhall Library, MS. 14,026.
(c) Royal Exchange Assurance: Guildhall Library, MS. 16,248.

market where potential liabilities were not so great and new opportunities were continually opening up. Hughes had a cooler temperament which was suited to his work negotiating with solicitors and trade union officials. Francis Scott used this complementarity, testing Collins' ideas for underwriting with Hughes. He undertook all the estimation of liabilities himself.

The success of underwriting can be seen in the level and fluctuations in the loss ratios it produced. These were, however, subject to a process of filtration through fluctuations in the level of hidden reserves and, in the case of the Provincial, James Scott's willingness to camouflage very occasional bad results by private, and sometimes retrospective reinsurance.

Fire experience is indicated in Table 5.2, which suggests that the average loss ratio obtained by the Provincial was rather better than both the average of a group of similar non-tariff companies and that realised by the Commercial Union and the Royal Exchange Assurance on their home business. Indeed, the Provincial's results were superior to the former group in each separate year, to the Commercial Union in seven years out

TABLE 5.3 *Provincial Insurance Company: employer's liability insurance loss ratio compared with all-market ratio (%)*

	Provincial loss ratio	All-market ratio
1908	17.1	61.3
1909	40.8	60.3
1910	50.6	59.6
1911	53.1	57.3
1912	42.4	52.1
1913	40.7	46.4

Source: PMA.

of ten and the Royal Exchange Assurance in eight years out of ten. Thus, allowing for the behind the scenes manipulation of the accounts, which was almost certainly only important on a few occasions, the principal objective of securing a sound basis for underwriting in the face of rate discounting was clearly obtained.

Accident underwriting results followed a pattern determined largely by market experience. Losses remained moderate in the first two years of business when its scope was restricted. At all times, the Provincial obtained an experience that was superior to the market as a whole, as Table 5.3 shows. Pressure from the market to expand underwriting and the competitive environment which depressed rates, led to a deterioration in 1910 and 1911 in employer's liability insurance, compensated to some extent by personal and general accident underwriting. However, the disappearance of so many rate cutting companies and the success of the AOA, eased the pressure on employer's liability business and even allowed the account as a whole to show some profit in the years immediately before the war.

5.2 Organisation and control

Although the Provincial remained a small company in 1913, its growth had required the beginning of systematic organisation. By 1913 the company employed sixty-one men and women in several dispersed offices. The pace of growth was determined partly by the cost that could be carried by revenue growth and its profitability, but not entirely. Organisational capacity could also be expanded by improving control, efficiency and co-operation as well as by taking on more staff.

The initial problem lay in the recruitment of satisfactory staff. Men of ability and experience were unlikely to seek employment with a small

non-tariff company. Established insurance officials had seen such concerns come and go and would be apprehensive about employment prospects. The Provincial's situation in Bolton was a further disincentive, for it cut professional men off from the main insurance centres and isolated them from alternative employment. The company's modest revenue exacerbated the problem, for it constrained the size of the salaries that could be carried on the revenue accounts. Applicants for posts were therefore often of dubious quality, with some flaw which, if and when discovered, would make them unacceptable from the point of view of trust or confidence. These problems were always important, but especially so in branch offices where activity could not be closely monitored. As a result, the pace and direction of development was determined more by the availability of suitable staff than any more general logic.

Provincial cricket team, 1907. The group emphasises the youthfulness of the early staff. Left to right standing: A. Willcock (head office fire clerk, later fire surveyor), unknown, F. G. Hughes (head office Accident Superintendent), unknown, W. K. Ramsden (head office inspector), unknown, F. G. Hunt (Manchester surveyor), F. D. Peate (Manchester); seated: W. Gray (head office, later Manager of the Manchester branch and the Drapers' and General), S. H. Scott, J. A. Barber (head office Assistant Secretary); in front: Carlton Rothwell (head office and later Bolton Branch Manager), J. Sidebottom (head office).

By design or chance, the Scotts resolved their recruitment problems by
employing young men. Gray, the first clerk employed, who developed
from general factotum into Manchester branch manager in 1909, was only
twenty-three when appointed; Barber, who was transferred from fire
order clerk to assistant secretary, was twenty-one; Baillie, fire manager,
twenty-four; Collins, accident underwriter, twenty-three; Evans and
Merriman, two early branch managers, both in their early twenties. The
only older man appointed on a full salaried basis was Butterfield in Lon-
don, and it is significant that this branch had the greatest difficulty in
covering its salary bill, of which his pay was a major component.

The Scott brothers must have found it easier to deal with staff of their
own generation. They discovered early that older insurance men could use
their experience to bamboozle them and resist the more flexible approach
that the Provincial's special circumstances required. But the main advan-
tage lay in the smaller salaries that young men were prepared to accept. In
the Royal Exchange Assurance in the 1890s, youths started at seventeen
or eighteen with a salary of about £90; by their mid twenties this had risen
to about £150; by early middle age £400, and they retired at around £600.[3]
By these standards the Provincial paid its staff reasonably. When they
were taken on, at the ages mentioned above, Gray was paid £115,
Barber £85, Baillie £150, and Collins £120; the average salary paid when
each was aged twenty-five was £145, almost precisely the Royal Exchange
Assurance level.

The difference lay in their responsibilities. While they were in no way
comparable to senior officials in a large company, these were well beyond
the routine tasks of a normal head office clerk. But this extra scope was
no disincentive to an independent-minded young man. There was the
prospect that as the company grew, so would their responsibilities and
remuneration. When Francis Scott appointed Evans to the Birmingham
office he told him that '... in his appointments he was hoping to find men
who, in regard to pay, would be prepared to look to the future more than
the present.' In this way, the Scotts were able to obtain the services of an
ambitious young man at less than half the salary paid to Butterfield in
London. Thus, in all aspects of the company's work, young men reduced
salary expenses without leading to the employment of the mediocrities
that might have been the result of salaries below market rates.

Yet reliance on recruiting young staff created special problems.
Appointments were based largely on intuition and expectation, rather
than more solid evidence of past experience and achievement. James Scott
retained control over all appointments for the first years. His success or
good fortune was remarkable. The first three trained men taken on –

Gray, Barber and Baillie – remained with the company until their retirement as principal executives many years later.

These young men, who founded the company's management capacity, were supplemented after 1906 by clerical assistance in purely routine tasks. This work was mostly undertaken by the young; reasonably educated youths of seventeen or so, though lads of fourteen were employed as office boys, to be introduced to clerical work eventually. They were found locally in Bolton from the general pool of clerical labour. Salaries were low; the first office boy was paid six shillings each week; the normal rule seems to have been to pay a salary of about £20 at sixteen and to raise it by annual increments of £10 until it reached about £60 when he was twenty; after that it would settle between that and £100, unless he was promoted to a post of responsibility. By 1911 the company employed twenty such staff, all under twenty-two and earning less than £100.

With some trepidation, the employment of women was undertaken. Gray first suggested such a move and Samuel Scott recalled that 'We were rather shaken ... but Mr Gray assured us that he had in mind a most discreet lady, and in due course Miss Isabella MacDonald arrived'. Discreet or not, the experiment was a success, for by 1911, six more women had been employed, mainly as typists, although some undertook other work. Miss Berry at Birmingham was the most enterprising for she virtually controlled the branch's accident business.

This clerical staff formed an important resource. The difficulties of recruiting and integrating staff into the Provincial's organisation, made it important to train and develop them to fill positions of greater responsibility. They were a known quantity to the Scotts and were immersed in the company's ways, so were more valuable than the speculation of new recruits.

The most important form of staff development took place through the supervised extension of responsibility. The expansion of business created opportunities for juniors to undertake new work. Yet technical aspects of insurance benefited from systematic study, partly because the business was changing so much. It was for this reason that the insurance institutes had joined together in 1897 to provide training and examination procedures, but non-tariff employees were excluded.[4] The company therefore made its own arrangements. Gray provided his library of insurance texts for general use and, with the Scotts, formed the Provincial Fire Insurance Club. At first this was informal with the Scotts, Gray and a few local agents gathering to learn from Milnes. As the company's staff grew, it became more organised. A wider range of lecturers provided a varied technical fare. Some must have been authoritative. One of the Bains spoke

on 'Relations between the Insurance Broker and the Insurance Company'; other topics such as the legal aspects of employer's liability insurance, sprinkler protection or very technical matters like the conditions of average were covered. Gray, Collins and Baillie provided papers which must have been as useful an exercise for them as their audience. This could not compare with systematic preparation for examination, but it indicates an awareness of the need to satisfy the company's hunger for staff development.

At first the staff was so small that management control could be entirely personal. From 1906, the establishment of branches and a larger head office staff required the beginning of a more systematic approach to responsibilities. While Francis Scott intervened at any aspect of affairs and the organisation remained too small to need a formal structure, a simple pattern of responsibilities had evolved by 1913. At head office Baillie and Collins were responsible for routine underwriting in their respective departments; Barber carried out the administration of all remaining routine work: general correspondence, accounts, agency supervision, fire claims and reinsurance, general statistics, advertising and stationery; he was also responsible for good order and efficiency in the office and on occasion was sent to branches to investigate arrangements and appoint junior staff.

All three men were in continuous contact with Francis Scott who kept regular office hours. When he was travelling or unwell, Samuel Scott stood in for him and was, in any case, often in the office. Such involvement meant that head office staff were closely monitored and it was difficult for antagonisms to develop between them. Independent internal checks on the underwriters were obtained by consulting Willcock, the fire surveyor, and Hughes, the accident claims settler. Indeed control may have been too tight, preventing them from developing the self-confidence to act imaginatively.

Branch development posed new control problems for they could not be supervised personally. The most detailed control was through the screening of acceptances by the underwriters and the branch and agency accounts by Barber. Any dramatic departure would be picked up and referred to Francis Scott.

Within this there was a natural tension. Branch managers were principally concerned with cultivating agents and winning revenue. They would naturally tend to relax terms of acceptances and commissions and settle claims generously. Within limits they would increase expenditure in pursuit of business. On the other hand, head office managers were judged by their efficiency in controlling loss ratios. While it is a simplification, branches sought growth first, and head office departments, profitability.

As a result, head office departments often appeared narrow, cautious and obstructionist to branch managers. While this was partly a proper attempt to impose the requirements of the whole business on its constituent parts, there is little doubt that the problem was exacerbated by Baillie's personality. Tensions arose in his early years, as he imposed stricter limits on gross acceptances. Branch managers had to justify this to agents, who disliked the disruption it involved; they also saw hard-earned revenue evaporating with painful implications for branch overhead costs. As a propitiatory gesture, Baillie toasted the branch managers at their annual conference dinner in 1911;

The process of revision, he said, was one that sometimes gave an impression of their being unduly strict, and of sometimes acting too much on a hard and fast rule. He could only say that the head office officials quite entered into the feelings of those who were endeavouring to open up new fields in the way of business, and that any criticism from head office was not meant in any carping or unsympathetic spirit.

It does not take much imagination to envisage the correspondence that lay behind such remarks.

Underwriting practice emerged from these tensions as the conflicts between central policy and peripheral ambition, between profitability and growth, were resolved in the course of daily correspondence. Branch managers might win some concessions, but when agreement could not be reached, decisions automatically went to Francis Scott for arbitration. He had to bear in mind the problems of the branch managers and was well aware of Baillie's natural caution. Yet the latter could present his case personally; the branch manager could only appeal through correspondence.

While these systems created a safety net, it was rather negative; concerned with particular cases rather than overall branch performance, designed to control rashness rather than encourage initiative. Of course, no external assistance could turn a poor manager into a success, but Francis Scott endeavoured to keep them alert by monitoring their performance. At head office his three most important tools were the figures of the new business obtained by branches, expenses as a ratio of branch revenue and the statistics that traced the business provided by each agent. The first indicated the energy with which business was being pursued; the second the efficiency with which branch resources were managed; and the third allowed a more detailed probing of the reasons for problems. They were all kept up to date on a quarterly basis and, from at least as early as 1909, entered on branch statistical cards. This enabled Francis Scott to carry on a regular correspondence with branch managers on their

performance. While this could be admonitory, he also dispatched letters to congratulate them on successful coups or to commiserate on unlucky losses. He visited branches, encouraging business by meeting important agents and supporting his local manager in significant interviews. In this way he obtained a feel for their morale and efficiency. Contact was also provided by the institution of an annual conference at which changes in policy, worries about branch performance and possible new developments could be discussed, managers could learn from each others' experience, meet head office staff and, no doubt, be scrutinised by the Scotts.

These were the explicit methods of management control, but efficiency depended as much on staff morale and willing effort. Most received regular annual salary increases. Those earning less than £150 could reckon on a £10 increment; those earning more, £15. These supplements do not seem to have varied with merit; once appointed, a man could normally expect these standard increases. Of course, branch managers received profit commission which reflected their personal success and some inspectors were sufficiently successful in winning business to improve their bargaining position.

Family control gave staff a focus for loyalty which seems to have been of genuine importance. One early recruit became so notorious for his lectures on the virtues of the Scott family that a business associate raised his hat every time James Scott's name was mentioned. Such behaviour should not be hard to understand. The company was small and its young staff were thrown into daily contact with a family whose wealth and way of life were far removed from their own. Sir James Scott was a man of evident distinction and charm who took a personal interest in each new employee and gave them a sense of personal value that would not have existed in a large or impersonal concern. When the company paid its first dividend, he slipped the office boy a £5 note. Gestures of that sort created a commitment that could never have been purchased by high salaries.

The Scotts encouraged a family or paternalist atmosphere: cricket matches were arranged on the pitch at their home; staff arranged country rambles; on auspicious occasions, like the fifth anniversary of the company's formation, a dinner was held at the Pack Horse Hotel in Bolton. When a member of staff became physically run-down, he was sent up to the Scotts' country house at Windermere to recuperate. When Samuel Scott and his sister were both married in 1905, the Provincial staff joined the entertainment and dinner provided for employees of the Haslam's cotton mills in the Town Hall and Victoria Hall, Bolton. In 1907 Samuel Scott started a magazine to draw staff in the various branches together.

In these ways loyalty to the company and its owners was developed. Of

TABLE 5.4 *Provincial Insurance Company: management expenses as a proportion of revenue, 1904–13 (%)*

	Salaries	Rents	General expenses	All management expenses
1904	5.0	4.3	15.8	25.1
1905	6.2	4.1	10.6	20.9
1906	12.0	3.9	12.3	28.2
1907	11.2	3.3	8.4	22.9
1908	12.8	3.4	9.9	26.1
1909	18.1	3.8	7.7	29.6
1910	15.7	5.0	5.7	26.4
1911	16.8	5.0	7.0	28.8
1912	16.0	4.3	8.6	28.9
1913	12.9	3.7	8.7	25.3

course, we may imagine that not all were wholly imbued with such feelings; though it probably was the case that most found a coalescence of individual interest with the success of the company, because it guaranteed their security and opened up opportunities for advancement. Yet it is clear that many who spent long careers with the Provincial preferred an atmosphere in which they were offered the security and recognition possible in a paternalistic concern. While no formal arrangements existed, loyal employees were paid pensions; in personal difficulty the Scotts, acting outside the context of the business, would support them financially, or in other ways. Whether it meant that the company attracted and retained the most able and ambitious men is doubtful, but this may have not been wholly uncongenial to a man like Francis Scott, who wished to pursue cautious policies and retain absolute control himself.

These less tangible factors were of the greatest importance in determining the success of the Provincial's organisation, but it always remained constrained by clearer issues of expense, which had to move closely in line with the revenue to support it. Table 5.4 illustrates the changes in the distribution of expenditure over the period. At first salaries constituted a modest proportion as so much business came through brokers on a commission basis, and surveying was undertaken on a fee basis. As the company developed its own staff, salaries increased. The extension of head office staff in 1906 and 1909 led to particularly sharp rises, but then it stabilised. This suggests that by 1910 a basic head office organisation had been created that could handle the various forms of business transacted and that subsequently this could be used more intensively, yielding

economies. By then, the head office had fire and accident departments and the two main branches had a complement of specialist officials.

However, the company's expense ratio remained high. Table 5.4 shows that in most years it substantially exceeded the conventional twenty per cent allowed by the tariff companies in their rate fixing calculations, averaging twenty-six per cent, and rising as high as twenty-eight or twenty-nine per cent in 1906, 1909, 1911 and 1912. This cannot be entirely explained by the company's small scale, for the National of Great Britain, which had provided a model for the company's early development, operated with far lower relative costs. The explanation lay in the Provincial's commitment to long-term development. New branch offices were almost always an investment in future development that would only yield revenue sufficient to cover their overhead costs in time. Meanwhile, it was inevitable that they would carry high expense ratios. In 1913, only the head office and the Manchester branch had been able to bring this down below thirty per cent; London, Liverpool and Hastings were over forty per cent. This provided another reason for protecting the superior underwriting results described above. Without these, the company would be unable to make the same commitment to development, without squeezing profitability, and thus eroding market credibility and constraining financial development.

5.3 The deployment of funds

The Provincial's funds, whether shareholders' capital or accumulated reserves, were required to serve three purposes: provide security for policyholders; maintain liquidity to absorb temporary fluctuations in profitability; and a source of income to increase the two latter and provide dividends for shareholders.[5] James Scott handled them with the freedom he was accustomed to exercise in his private affairs, making no concession to their insurance purposes beyond ensuring that cash balances were available to ensure liquidity. The remaining assets he managed as though they were a family portfolio arranged with a view to security, but none the less designed to maximise yield within a realistic, rather than a conventional view of that limitation.

This gave the Provincial's investments a distinctive character that contrasted with those of most insurance companies. Their portfolios were dominated by their close association with the London capital market. Scott's approach was that of the Lancashire businessman. His background and connections led him to operate through the Manchester stock market and the regional investments in which it specialised.

His style can be illustrated by the company's original portfolio, which had been his own. Over three-quarters of the assets were the securities of commercial and industrial firms, when the generality of insurance companies had no more than two-fifths invested in this form. Furthermore, the overwhelming proportion was held in Lancashire firms – this even being true of the railway equities – including several firms in which Scott had a directorial interest, such as the Haslam cotton businesses and Sackville Estates, a Manchester mercantile property company. In most cases the securities were preference shares, but the portfolio included both debentures and ordinary equities.

Unfortunately it is impossible to trace changes in the fund's market value. Published accounts provided book values, as long as these were below market value. As several of the securities were not publicly quoted, no realistic alternative estimate can now be made. Security price depreciation only required the published value to be written down after the financial crisis in 1907. At other times appreciation created hidden reserves. The portfolio's growth from the original endowment in 1903 of £75,000, to a book value of £142,800 in 1913, can therefore only be traced in terms of the additional funds transferred rather than improvements in the value of existing assets.

The most important single increment came in 1905 when James Scott provided an additional £15,000 by taking up 3,000 extra shares. Otherwise, the growth in funds depended on the accumulation of reserves. This took two forms: short-term contingency reserves and long-term general reserves. The former, covering unexpired liability on a yearly basis, was fixed at the conventionally safe level of forty per cent of premium income, and therefore grew in direct proportion with it.[6] By 1913 the fire and accident short-term reserves amounted to £18,900. There is no doubt that this reserve basis was sufficiently cautious to ensure that it contained a significant element of profit that would be available to the company if the account was run off. General reserves were created by discretionary payments from underwriting or investment profits. In the first few years these were entirely retained. They were consolidated to start the general reserve by two allocations of £5,000 in 1907 and 1908. Subsequently, a steady £3,000 was transferred each year, except in 1911, when poor underwriting results reduced it to £2,000.

It was important to retain sufficient liquidity to meet the possibility of unexpectedly bad underwriting results. The need to liquidate investments suddenly could prove costly. On the other hand, a high liquidity ratio sacrificed yield. The balance between cash and invested securities therefore had to be carefully managed. Many general insurance companies

TABLE 5.5 *Provincial Insurance Company: the use of funds, 1904–13 (£'000)*

	Invested funds	Cash and at call	Office assets	All assets	Contingency funds
1904	72	6	0.3	79	
1905	93	4	0.4	98	
1906	101	2	1	103	
1907	105	5	1	111	5
1908	106	7	1	114	6
1909	111	6	2	120	8
1910	112	11	1	125	10
1911	114	13	2	129	12
1912	119	14	2	135	15
1913	119	22	2	143	19

tended to hold most of their funds in a reasonably accessible form to cover this liability. By contrast, Scott held cash at a sufficiently high level to cover the company against all likely eventualities, allowing the remaining investments to be placed with freedom. Table 5.5 shows how closely cash holdings were matched to short-term contingency funds. During the early years of the business the cash ratio remained high. The sharp fall in 1909 was the result of the purchase of a new head office and a decision to allow cash to take some of the strain involved. This link between cash and premium income meant that because the latter started at a low level in relation to the company's funds, and then grew more quickly than assets, the need for cash was bound to grow similarly and absorb a greater proportion of funds. This rose from four per cent in 1907 to fifteen per cent in 1913, inevitably depressing yield.

Relieved of any need to provide liquidity, other funds were placed entirely with a view to secure yield. A modest gesture was made to convention by the purchase of a small holding of consols, but this was not augmented until 1911. For the rest, there were only modest changes in the portfolio. Perhaps as a further move towards orthodoxy, the proportion of British railway securities rose from just over one-quarter to two-fifths of the portfolio. In 1909 debentures were sold to finance the purchase of the company's new head office. This was serviced by appropriations from the revenue accounts, which amounted to a return of four per cent on the purchase price. Finally, in 1911, a substantial purchase of consols was required as a deposit for the Canadian branch, again reducing yield.

James Scott thus backed his judgement through higher yielding prefer-ence shares. Of course, with knowledge of the local firms involved, the

TABLE 5.6 *Provincial Insurance Company: investment yield, 1904–13*

	Investment income	Yield on funds (book value)	Premium over consols
	£	%	%
1904	2633	3.6	0.8
1905	3109	3.4	0.6
1906	3723	3.7	0.9
1907 (a)	5039	3.8	0.8
1908	4432	4.2	1.9
1909	4702	4.2	1.2
1910	4521	4.0	0.9
1911	4443	3.9	0.7
1912	4784	4.0	0.7
1913	4912	4.1	0.7

Note (a) 1907 included five quarters.

risk was modest. The book valuation of insurance investments makes it impossible to compare his success with other concerns. For what it is worth, Table 5.6 provides the yield on book value and the premium above the market rate on consols that this represented. Leaving aside the two years after the writing down of investments in 1907, this remained between 0.6 per cent and 0.9 per cent. However, the general market improvement in yield over the period allowed this to contribute over a quarter of the growth in investment income, with the remainder provided by the expansion in funds invested. This was interrupted, in 1910 and 1911, by the purchase of consols and the greater cash holdings required by premium income growth. Yet by 1912 investment income was resumed and the high yields of 1913 continued the acceleration of income.

5.4 Casting a balance

Table 5.7 illustrates the various sources of the Provincial's profitability between 1904 and 1913. No significant profit was obtained from accident underwriting until 1913, so fluctuations in underwriting results were wholly determined by the fire account until that year. The predominant feature was that, although the proportionate margin fluctuated and showed some tendency to fall, the absolute size of the surplus increased steadily with the scale of the revenue obtained. Similarly, although the yield on investments varied with the distribution of investments and market rates, the policy of expanding reserves swelled investment income.

TABLE 5.7 *Provincial Insurance Company: profitability, 1904–13*

	Fire surplus	Accident surplus (loss)	Investment income	Total profit	Yield on book assets
	£	£	£	£	%
1904	825		2633	3458	4.4
1905	454		3109	3563	3.6
1906	1260		3723	4983	4.8
1907 (a)	3925		5039	8964	6.5
1908	2488		4432	6920	6.1
1909	2955		4702	7657	6.4
1910	2195	(109)	4521	6716	5.4
1911	1156	(31)	4443	5599	4.3
1912	2460	34	4784	7278	5.4
1913	3063	1778	4912	9753	6.8

Note (a) 1907 included five quarters; the yield is adjusted as if it had included only four quarters.

This revenue and reserve growth improved the yield on book assets to 1909. In the two following years competition in the fire market, and a reduction in investment income, interrupted this trend. Subsequently, fire underwriting stabilised, investment income began to grow again, and the accident account began to contribute to profitability, so the company finished this phase of development in 1913 on a high note, with its highest overall surplus and yield on book assets.

There are a number of ways in which the results of this first phase of business can be assessed. The most obvious are the quantitative measures. The least illuminating is that of the dividends the Scotts received from the company. After placing all the profits to reserves at first, a dividend of two per cent was made for the first time in 1906. This was raised to three per cent in 1907, four per cent in 1908 and five per cent in 1910, where it remained until 1918.

However, these modest payments reflected the Scotts' objective of retaining most funds in the company. Its underlying value is difficult to estimate. At a minimum, the book value of assets had grown to nearly £143,000 by 1913, but this hid substantial reserves and the goodwill implicit in the company's growing reputation, market connections and staff loyalty. An estimate of its market value in 1913 suggests a minimum sale price of some £138,000. If the dividend disbursements made in the intervening years are added to this, and valued as if they had been invested in

consols, the internal rate of return over the ten years of operation was 6.7 per cent in a period when the average yield on consols was 3.1 per cent. While this yield is by no means dramatic, this reflects the fact that through the ten years the company was scarcely using its capital to capacity, as business developed slowly.[7]

However, these measures greatly underestimate the real value of the concern. It had a long-run potential that cannot be reflected in careful calculations. The substantial surplus in 1913 was earned over costs that included investment in new branch development that could only yield profitability in the future. The young head office staff were developing experience and efficiency that would be able to cope with a larger business than the Provincial currently transacted. Francis Scott had become an habitue of the insurance world, capable of dealing with technical complexity and controlling organisational development, both of which he was anxious to attempt on a more ambitious basis. These were the assets that formed the company's real value, and suggested the potential for an even more successful future. What could not be foreseen was that the next phase of development was to be cramped by circumstances over which the Scotts had no control.

PART

II

War

Before 1913 the development of the Provincial had proceeded along a steady and logical path. With the guidance of their father, Samuel and Francis Scott had mastered the elements of insurance practice. Bolton and the large brokers had provided a basis for successful initial operation. Then they had turned to building an organisation that would enable business to be drawn from a wider range of markets.

By 1913, this development was still at an early stage. The branch offices remained modest in scope and, outside Bolton, obtained little business beyond that provided by larger brokers. Foreign business was limited to an underwriter with one clerk to assist him in London and an unsatisfactory managing agency arrangement in Canada. In short, the company was only at the beginning of a long phase of organisational development. There were many markets which the Scotts had yet to discover and they had much to learn about the problems of managing a larger and devolved business.

The war years after 1913 forced an intermission in this process of development. Although many issues of long-term strategy were discussed, Chapter Six shows how implementation had to be shelved because they

nearly always involved additional resources, especially staff, that the war made unavailable. Indeed, pressure on the company's existing resources, both capital and labour, was severe, particularly because it was so small and so young. The Provincial survived, but sometimes only by the skin of its teeth.

On the other hand Chapter Six also shows how the war created many new opportunities for insurers who were able to take advantage of them. If they could do so, they often found themselves operating in rapidly expanding and profitable markets. Because the Provincial survived, it was able to do so. Chapter Seven describes the development of business under the temporary, hectic circumstances of the war. Diagram 4 illustrates the course of expansion. By 1919 premium income had grown to £148,592, nearly three times the 1913 level. Part of this was accounted for by rapid wartime inflation; but part was real growth, especially in the accident market, whose proportion of net premium income rose from two-fifths in 1913 to three-fifths in 1919. A new branch was established in South Africa and a marine department opened to take advantage of the wartime boom in that business. Chapter Eight assesses the consequences of this phase of development.

This rapidly changing environment meant that many of the policy assumptions that had developed before the war were no longer valid and decisions had to be made that required entrepreneurial confidence. This posed special difficulties because Sir James Scott died in 1913 and Samuel and Francis Scott had to face the new problems without their father's support.

£ '000

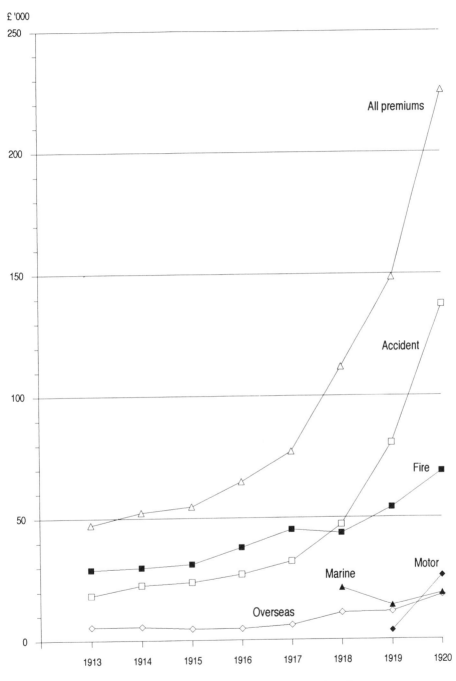

DIAGRAM 4 Provincial Insurance Company: net premium income, 1913–20

6

Uncertainty, war and an interruption to development

6.1 New problems for a new management

Sir James Scott died in August 1913.[1] It was not unexpected, for he had been in poor health for several years. Yet his involvement in the Provincial's management until a few days before his death meant that complete responsibility came to his two sons suddenly. As the new baronet and elder brother, Samuel Scott became chairman, while Francis Scott took the title of managing director in 1915, formalising his position at the centre of the company's affairs.

Although they were both in their thirties, the brothers found the assumption of independent control a difficult transition. Their father had overseen everything; his judgement had been final and he had carried ultimate responsibility. It was more a matter of confidence than expertise. Samuel Scott had little faith in his powers as a businessman. He recalled his father telling him '... that he often lay awake at night in a perspiration, thinking what my end would be and how I should lose all my money.' Francis Scott's technical expertise and attention to detail was not, in itself, an adequate basis for the new responsibilities. Their father's forceful and omnicompetent presence never left them. Years after his death Samuel Scott would discuss the affairs of the company in terms of his father's *obiter dicta*, attempting to suggest courses of action he would have taken if alive. Francis Scott would accept this framework of discussion and argue within it. He was always happiest when his decisions could be confirmed by the approval of a trusted adviser. Such consultation was often so prolonged that it seems to have been more concerned with generating the self-confidence to act than the collection and assessment of information and opinion. Both remained deeply susceptible to the appeal of the confident man of affairs. A shared apprehension was perhaps the price they paid for the gift of the Provincial from their father, for they never felt the security of knowing that it was their own creation, even in later years when it became a business beyond their father's imagining.

Their ability to cope was quickly tested. In July 1913, a suffragette had burnt down the private house built by Sir William Lever, the soap magnate,

at Rivington Pike, near Bolton, during a royal visit to Lancashire.[2] The Provincial was heavily involved in the loss but a complicated situation arose. Lever's private insurances were handled by the insurance manager at Port Sunlight. He had not specified in the policy documentation the extensive cover on which he now based his claim. When the Scotts pointed this out and declined to pay the claim, the official refused to accept the position, as he did their suggestion to put the matter to Lever's personal arbitration. They travelled to Leeds to discuss the matter with the Bains, who were involved as brokers. If they did not pay the full amount, they would receive no more business from Lever Brothers, one of the largest British companies and one whose insurances had formed a foundation of the Provincial's underwriting account. After arranging to share the costs of an *ex gratia* payment with the Bains and their reinsurers, the Scotts capitulated.

The significance of the episode lay as much in the Scotts' reactions, as in what actually occurred. The negotiations brought home the loss of their father in a direct way. With his self-confidence, established position and knowledge of the ways of business, would he have been treated in the same way? Could his diplomacy have found a more honourable solution to the dilemma? Of course, he might not have been any more successful than his sons. Yet the incident etched itself on their minds as they felt, for the first time, the cold winds of a harsh commercial world, untempered by their father's protection. It was not a propitious start to their independent career, although the damage was psychological rather than financial. Their father had ensured this. Before he died he had realised that the 1913 loss ratio was likely to be high and he had entered into an agreement to reinsure losses above a reasonable level. In the event his executors paid the company £6,000 on this account.

The war was to bring many new problems that emphasised the loss of their father, but one important possible difficulty was ruled out. Both brothers were exempt from military service because of age and ill health. If this had not been so, it is probable that the Provincial would have been sold. There would have been no alternative family management. Even so, illness spoiled the previously relaxed atmosphere. Francis Scott suffered increasingly from hip trouble from 1912 and was forced to spend long periods away from Bolton, as doctors tried to diagnose and treat the problem. In 1914 he spent some months on a trip to Egypt; in 1916 he went to Bath for several months; having found this efficacious, he returned in subsequent years. Eventually the problem was resolved by an operation which itself meant a long absence from business. He tried to keep in touch with affairs by voluminous correspondence, but it was

inevitable that the responsibility for daily management should fall on his brother for long periods.

Samuel Scott was himself under strain. His wife had been advised to live away from Bolton's damp atmosphere, which was thought to contribute to her persistent ill health. While a move to a Lancashire coastal resort was considered, Samuel Scott's real wish, shared with his brother, was to move to Westmorland, where both had so many interests and friends, and where they believed Samuel Scott's wife and Francis Scott would find a healthier climate. By 1913 they had practically decided to move the head office to make this possible, but the scheme was postponed. In the last years of his life, James Scott developed a sudden and unexpected antipathy to the idea of leaving Bolton. Then the war made it impossible to proceed. However, his wife's pressing need to move and the conviction that the company would eventually leave Bolton led Samuel Scott to take a home at Bowness. Thus, for much of the war he spent a good deal of time travelling between there and Bolton, where he stayed with Haslam relations or in lodgings.

In the face of these difficulties and the new circumstances of wartime business, Samuel Scott became responsible for the Provincial's management for long periods. He took to it energetically, working long hours on management problems and assisting in routine clerical work when the pressure of business on an attenuated staff became severe. Apart from coping with daily administration, he brought his own touch to management. When the War Office attempted to commandeer the Manchester office, for reasons he thought inadequate, he fought bureaucracy inch by inch, to the point when the company was threatened with eviction by a military detachment. He managed to postpone this until after the armistice by interviewing the permanent head of the Office of Works. The matter was later settled in the company's favour. This affair brought into play all his combative instinct, aroused by a sense of injustice in the face of mindless and inequitable interference by civil servants in private business affairs. He had similar tussles over exemptions from conscription. In addition, he became involved in long-term planning, spending time considering the re-organisation of the company's capital structure and undertaking the bulk of the work of investigating and planning the proposed removal of the head office to Westmorland.

While this contribution was critical from the management point of view, Francis Scott retained control of all specifically insurance aspects of planning. Samuel Scott's one serious attempt to introduce a new form of business – industrial life assurance – came to nothing. The Scotts, after investigation, regarded the business as '...nothing but a plunder of the

poor working man, wasteful in collection of premiums and fruitful in dishonest insurance … only in the event of … some more beneficent scheme being proved practical and actuarially sound, would the promoters of the Provincial care to be associated with the business.' All the detailed work in connection with the problems of the Canadian branch, a new South African branch and marine insurance was undertaken by Francis Scott, as was a new departure in employer's liability insurance. Samuel Scott was brought into consultation when information had been gathered and a final decision or meetings with new associates were necessary. However, between 1913 and 1920 he was, for long periods, the effective manager of the Provincial's daily routine and demonstrated the capacity to hold the company together under extremely difficult circumstances, in which business conditions changed rapidly in unexpected ways, and the company's staff required careful leadership when working under great strain.

6.2 The First World War and general insurance

The immediate effects of the outbreak of war in 1914 on general insurance were ominous. The value of company investment portfolios collapsed in anticipation of the effect of heavy government borrowing on interest rates; the disruption of trade raised fire losses, as stocks were cleared at fire insurers' expense. Yet the subsequent course of the war, though creating special difficulties for some companies, generated highly profitable business for the majority. Investment values continued to fall and assets had to be written down by some fifteen to twenty per cent over the war period, but this was a short-term difficulty for most companies. Solid concerns remained secure and it was assumed that portfolio values would be restored after the war. Above all, the buoyant business engendered by high government spending created boom conditions that were ideal for the general insurance market. Dislocations and adjustments were inevitable in wartime, but these were almost always submerged by the expansion in insured values, associated with low loss ratios.[3]

 Table 6.1 shows the fire premium income of British companies growing by nearly three-quarters between 1914 and 1919.[4] Within this aggregate, home business rose by just over half, while foreign revenue grew more quickly, especially after 1917.[5] After an initial period of adjustment to wartime patterns of production, fire insurance began to settle into a more stable expansion path. Price inflation, induced by the methods of wartime finance and excess demand, raised the value of all insured property and thus increased the money value of the premium income available in the

TABLE 6.1 *British companies' general insurance premium income, 1914–19*
(£ million)

	Fire premiums	Employer's liability premiums	Miscellaneous accident premiums
1914	28.9	5.8	10.9
1915	30.0	5.7	n.k.
1916	31.9	5.9	13.1
1917	36.0	6.5	15.8
1918	41.7	7.4	19.2
1919	49.5	8.9	23.7

Source: Supple, *REA*, p. 427 and *PMA*.
Note Employer's liability includes personal accident and miscellaneous includes motor vehicle.

market, especially after 1916. Between 1913 and 1919 the price of capital goods rose by 121 per cent and consumer goods by 123 per cent, the bulk of the growth in both coming after 1916.[6] It was not to be expected that sums insured would match this change closely, but the scale of inflation was sufficient to prompt a substantial revaluation by policyholders. Real expansion also played a part. The economy was driven intensively to serve war demands, which led to the major expansion of some industries, such as engineering, shipbuilding, and some parts of the clothing trades. This was offset to some extent after 1916 by increasing government intervention, which occasionally led to the authorities bearing risk themselves and thus removing business from the insurance market.[7] Income was supplemented by a government scheme, introduced in 1915, to provide cover against the losses caused by enemy aircraft action that were excluded from fire policies. Insurance companies acted as agents for the business, receiving ten per cent commission, which proved to be so profitable that the government eventually cut back the premium rates payable.[8] From 1916 premium income began a rapid climb which lasted for the rest of the war.

Loss experience was favourable. Inflation intensified the problem of under-insurance, as policyholders expected companies to make good partial losses, even when the values insured had not been increased. But the severity of this problem, after inflation set in from 1916, forced companies to carry 'subject to average' clauses with greater vigour.[9] This encouraged policyholders to increase sums assured and therefore premium income. At first there had been concern that the intensive work necessitated by the war, often by inexperienced hands, would increase the fire hazard. Yet if

this was a problem, it was more than offset by the strong incentive to protect stocks and plant from fire, when prices were rising and demand buoyant.[10] Thus, after an initial rise in the home loss ratio in 1914 and 1915, it remained in line with pre-war experience until 1919.[11] Inflation then accelerated sufficiently to make it impossible to resist the pressure from inflated claims paid in the year after premiums were paid. Furthermore, the end of the war brought dislocations similar to that at its beginning, increasing moral hazard in industries suffering falling demand.

Foreign fire business with enemy or occupied countries was lost for the duration of the war. Apart from this loss of direct business, they were also cut off from the specialist German and Austrian companies that had accepted some sixty-five per cent of their pre-war reinsurance business.[12] It was assumed that treaties would be honoured after the war, but in the interim, British companies had to maintain liquidity until settlements were made with the continental offices in 1921.

In compensation for this reduction in business, British companies were presented with splendid opportunities in allied countries where German insurers had previously been important competitors. This was especially beneficial after the United States entered the war in 1917 and British companies had a clear run in a market where German competitors had previously been a significant force and where economic expansion was rapid in response to war demand and high agricultural prices.[13]

Accident insurance enjoyed similar advantages abroad and this must account for much of the growth in premium income in the miscellaneous accident revenue shown in Table 6.1. With petrol rationing and the conscription of many drivers, there can have been little scope for motor insurance at home. The number of vehicles in use fell sharply after 1916.[14] The changing pattern of employment meant that many sources of employer's liability premium income dried up. Many employees transferred to the forces and growing sectors such as munitions were either unattractive or directly managed by the government and thus not privately insured. The contraction of domestic service affected what had been the most profitable of pre-war sources of the business. Employer's liability revenue therefore stagnated during the early years of the war, as Table 6.1 shows. From 1916, however, it began to expand under the influence of wage inflation (for premiums were based on wage bills), and a rise in premium rates resulting from additional obligations for employers, imposed by legislation. While it had been anticipated that the heavy recruitment of inexperienced and female labour would lead to a deterioration in loss experience, claims remained moderate. The insurance press explained this as being caused by high wages, which reduced the attraction of sick leave.[15]

Marine insurance was the class of insurance most dramatically affected by the war.[16] A pre-war committee's recommendation that the government should intervene was adopted immediately. The state shared the insurance of hulls with several shipowners' mutual clubs formed for the purpose, relieving the commercial market of risks that were virtually unplaceable with the advent of the torpedo and submarine. A government office also provided cover for cargoes at a standard rate, irrespective of risk. This presented marine insurers with glittering opportunities. They were able to cream off better business, leaving the government to pick up less attractive risks. Freed from war risks, the marine market took advantage of the international boom in shipping and the rise in cargo values caused by inflation.

Between 1915 and 1918 the large marine companies regularly obtained a surplus of about thirty per cent, rising to forty per cent in some years. This hastened the final consolidation of the composite company. Those offices without a marine department rapidly established one, or bought a specialist concern. Many new marine companies were floated. Of course, Lloyd's obtained the best business. Its historian wrote, '… the market had been allowed to make too big a profit and both Lloyd's Underwriters and the companies might have been better without the money'.[17]

Thus the effects of the war on the revenue of general insurers were on balance far from unfavourable. The greatest difficulties arose in the internal organisation of companies. Voluntary enlistment quickly took many younger men. Assuming that the war would only last for months, many offices continued to pay their salaries and carried on with remaining staff. When it became clear that the war would last far longer and that there would be a continued loss of staff through two years of voluntary recruitment and then, in 1916, conscription, management began to adapt to circumstances. Retirements were postponed and pensioners returned to work. But it was also necessary to employ new, inexperienced employees, mainly women, but also boys below recruitment age.[18] This did not affect efficiency as much as had been anticipated and expense ratios were in no way disproportionate. Indeed, when inflation began to increase premium income with no matching increase in the administrative work involved, there was a considerable improvement in productivity in relation to revenue. This was not matched by any need to raise wages in line with the cost of living until 1917, for they were controlled. Even after the concessions made to wage levels in that year, the costs of the companies remained moderate, because the women, boys and pensioners who replaced serving staff, were paid far lower salaries than would have been necessary for men.[19]

The shortage of staff was one among a series of consequences of the war that changed the competitive environment of general insurance. Companies found that without the younger men who had traditionally been employed as inspectors, it was impossible to mount aggressive marketing campaigns. The *Post Magazine* commented, 'Under existing conditions it is impossible to open out in new directions or even actively promote the more recent departments. At best business must mark time'.[20] This relaxation in competition was also encouraged by the disappearance of many small non-tariff companies. They were least able to adjust to the loss of staff because they were unable to spread work among remaining staff. For many, a branch office was simply one representative and, if he was recruited, the office closed. At head offices, underwriting was similarly dependent on a single manager with no deputies or senior clerks capable of taking over.

Inflation brought a financial dimension to these difficulties. Small non-tariff companies often operated close to their financial limits and their reserves quickly became inadequate as they were stretched between a depreciation in investment values and inflation fuelled growth in premium income. Furthermore, they found that the growth in revenue exceeded their reinsurance limits, yet Lloyd's was unwilling to expand its facilities as its underwriters' capacity was stretched by marine business and they were becoming increasingly interested in obtaining fire revenue direct from the market.

As a result, many non-tariff companies disappeared. One-fifth closed in the first year of war. In 1917 three of the most prestigious: the Fine Art and General, the National of Great Britain, and the Car and General; were all purchased by tariff companies, flush with cash from wartime profitability. By 1919 only thirty-three of the ninety or so that had been in operation in 1914 remained.[21] Entry was blocked for all the same reasons. A new company could not find staff or adequate reinsurance facilities and Treasury control of the new issue market prevented new issues to raise capital.

Thus the competitive structure of general insurance changed. Outside the tariff, the small, weak companies that had often forced fire and accident rates down in the years before the war, disappeared. They were replaced by two new giants, the General Accident, which had left the tariffs in 1909, and the Eagle Star, which had emerged from a series of purchases based around the British Dominions, under the control of Sir Edward Mountain, a Lloyd's underwriter.[22] They were both too large to ignore the repercussions of their marketing policy on tariff and non-tariff competition and so, while aggressive, tempered their approach with regard

to the long-run stability of the market. In their shadow were a small group of well-founded, modestly sized firms which had, for one reason or another, weathered the storms of wartime insurance. The British General, the Co-operative and the Provincial pursued a cautious existence, discounting tariff rates without wishing to spoil a market that was offering opportunities for profitable non-tariff underwriting.

Inflation had other competitive consequences as well. The substantial growth in premium income allowed all companies to be more selective in their underwriting, as they found their limits easily filled with good quality risks. This, combined with the virtual disappearance of aggressive branch marketing, hardened premium rates. In 1916 the FOC raised the tariff on cotton mills, one of the largest and most competitive markets, despite the fact that the war had forced contraction on the industry. Rates rose in several other markets, the insurance press noticing this in woollen mills, bleachworks, mercantile warehouses and tanneries. Across the board 'subject to average' clauses were carried increasingly successfully.[23]

Premium rates were thus maintained and even raised in the face of reasonable loss experience. Furthermore, from 1916 expense ratios fell. Even net commissions were reduced considerably by the relaxation in competition and the money earned from the government's aircraft damage scheme. These movements produced profitable underwriting for the companies. British fire insurers obtained average profits of some fifteen per cent between 1915 and 1918; employer's liability insurance averaged an outstanding twenty-three per cent in the same period. For those that could remain in operation, the war years were a bonanza. This was reflected in the stock market. Insurance securities maintained values well above those of the equity market as a whole. By the end of the war they had advanced one-quarter above their level in early 1914, despite heavy taxation, far higher interest rates and a general fall in security prices over the same period of one-fifth.[24]

The surviving non-tariff companies naturally benefited from higher premium rates and profitability. It increased the scope for safe rate discounting. Furthermore, few of the established companies raised their acceptance limits on individual risks in line with inflation. They therefore tended increasingly to decline business as their limits were filled. Brokers were forced to redistribute it to a wider range of companies, disturbing settled channels of business, as non-tariff underwriters obtained access to risks previously sewn up by the tariff offices. The staider non-tariff companies that had continued to operate were able to develop their business satisfactorily without prejudicing market stability. But the opportunities were so obvious that the business attracted vigorous entry from Lloyd's,

the only other possible source under war conditions. Only constrained by the high profitability of marine insurance, which absorbed much of its energy and acceptance capacity, it began to provide severe competition for the companies where aggressive rate cutting could short circuit the need for an established branch organisation. This limited its impact to a few specific markets and it was therefore insufficient to spoil the business, but the development was an important augury for the future development of general insurance.

6.3 The effect of the war on the Provincial's resources

From the economic point of view the war involved an unprecedented re-allocation of labour and capital from that induced by the market to that directed to secure victory. From the human point of view it involved horror and death at the front and strain, deprivation and depression at home. The Provincial's two most important resources, its staff and its funds, were both affected by these circumstances.

The immediate effect on staff was slight. Two young men volunteered immediately, but Francis Scott discouraged others from following too quickly. He wrote to Dale Evans in December 1914, '...we are not at the present time called upon to allow all our officials to go without any consideration to the business.' During 1915 the position became more difficult. Younger men became sensitive to popular patriotic feeling. Evans wrote in October, '...pressure is becoming more insistent upon us in Birmingham ... I feel I must put the matter to you in view of the National Call.' Affairs were brought to a head by the Derby scheme for the attestation of all men under forty-one in the next month, and the subsequent introduction of conscription early in 1916.[25]

This focused the problem facing the Provincial dramatically. The company's policy of employing younger men now rebounded, for nearly all staff were of military age. By early 1916 half of the pre-war staff had enlisted, including ten at head office and six from the branches. If only married men were exempted, the company would be left with only one trained official at head office, two inspectors and three branch representatives. Conscription threatened the existence of the Provincial in a way that would not apply to larger, longer established companies with greater scope for re-organisation and a more balanced age distribution.

If the company was to survive it was necessary to protect its organisation and introduce arrangements to cover lost employees. Samuel Scott was mainly responsible for the unpleasant task of postponing the loss of staff to the services. 'The conflicting claims of duty to the country and of

[above and facing] Provincial head office staff during the First World War. The groups emphasise the dependence of the Provincial on women staff during the war years. Unfortunately none of them can be named. The men are (sitting from left to right): J. McGuckin (Claims Manager), A. Collins (Accident Underwriter), J. A. Barber (Assistant Secretary), R. R. Baillie (Fire Underwriter), A. Willcock (fire surveyor), F. E. Hodkinson (inspector); (standing) left, unknown, right, W. K. Ramsden (inspector).

the obligation to see that the company was not unfairly treated made the whole problem most perplexing and distasteful', he wrote. It was made more embarrassing because both Scotts were medically exempt. These inhibitions were purged to some extent by the unreasoning and personally hostile attitude of the local Bolton committee, established to advise the Military Tribunal that considered exemptions. This had been formed on a political basis and the Labour representatives, led by a vigorous munitions worker, opposed exemptions for the company, regarding all clerical work as inessential or requiring no skill.

After the first encounter with this committee, Samuel Scott decided to go straight to the Military Tribunal in future. Francis Scott wrote to Sir Harold Elverston, who represented insurance interests in parliament, pointing out the difficulties conscription posed for small companies like

the Provincial, and contrasting the company's position with that of Lloyd's, whose staff had obtained extensive exemptions. Elverston subsequently helped to arrange a scheme with the Board of Trade, by which a special tribunal advised on exemptions for insurance work.[26] This led to a more favourable local attitude, but there was still a steady loss of men. By the end of 1916 there were no policy drafters left at head office and it seemed likely that Collins and Dale Evans would have to go.

Francis Scott obtained interviews with a senior official at the War Office and Sir Maurice Bonham-Carter, formerly Asquith's private secretary, in order to represent the company's case. Lewis Haslam, a maternal uncle, asked a question in the House of Commons about policy on insurance officials and exemption from military service.[27] Counsel was employed to act before the Tribunal. In the event all the exemptions were granted.

In 1918 the Manpower Bill seemed to threaten more stringent conditions still, which Samuel Scott thought would mean ' ... an end to the Provincial ...', for it promised to take both Baillie and Collins, removing both underwriters. By chance, they escaped through a technicality which reduced their medical grade. Having survived these crises, American troops and the successes at the front relaxed the pressure to release men until the armistice in November 1918 which brought an end to recruitment.

The loss of staff had to be compensated as far as possible. As early as 1915, the number of women staff had risen from seven to fifteen and they began to undertake technical work. Their success surprised Francis Scott, who realised the possibilities this revealed; '...this war', he wrote, 'is teaching us all how much can be done by untrained and unskilled staff.' When local schools were closed during an influenza epidemic, two teachers were employed temporarily. Samuel Scott took on routine clerical work when pressure became acute, working long hours on top of his managerial work. 'I lent a hand with the Aircraft Renewals, which on examination appeared to me to represent some 50 hours work on top of the ordinary work, to be got through in 4 or 5 days ... and Baillie and Miss Harfield were let off this tiresome detail work. I did go at it like a demon.'

Despite these stratagems, the strain on employees and owners was marked. Long hours were worked, late into the night. Samuel Scott recalled

The miserableness of these days can hardly be imagined. Late hours were now habitual; the streets were in complete darkness after six o'clock ... [this] increased the difficulty of keeping young women in the office till a late hour, and much

organising was required to ensure that those living in the same direction should go in company and be met by their friends. Food restrictions ... were expected and the military situation was very dark.

In November 1916 Hughes died and it seemed hard to resist the suggestion that overwork had contributed to his death. It was a black moment for his colleagues. Samuel Scott wrote,' We are going through a terrible time, everyone [is] overworked and suffering in health ... one feels it a duty to be cheerful and yet ... to divert one's thoughts from all the misery and suffering is a kind of callousness.' Of course, life in Bolton could not compare with the tragedies at the front, but it was none the less a grim time. When eyes could be lifted temporarily from the grind of excessive clerical work, war only seemed to promise more death and destruction and the postponement or end of so many private dreams and expectations.

Francis Scott could only encourage staff by asking them to look to the future when, with greater opportunities for the company, they would be given scope to find more opportunity for personal success and satisfaction in their work and the means to enjoy family life. He wrote to the Birmingham branch at Christmas 1917,

... increasing strain and anxiety and the uncertainty and difficulties of the year that lies ahead of us demand a closer sympathy between head office and the branches ... our main task is to keep going and to look to the future rather than the present for our reward ... never were the future prospects of the Provincial brighter than now. We have fourteen years behind us, a solid and self-made business, a reputation which I think I might almost boast is the envy of every other non-tariff office.

Keeping the future in mind, he also kept in touch with staff in the forces. The company made up salaries to their pre-war level and Scott wrote on appropriate occasions. Quite apart from any personal consideration, this helped to hold together the company's principal asset – staff with experience of its methods and attitudes, whose capacities and character were known to the Scotts.

At home, remuneration was the central issue in maintaining morale. From 1915, when price inflation began, the Provincial resisted permanent wage increases, but offered bonuses.[28] These were paid on the understanding that they were temporary and dependent on the company's prosperity. A bonus of £700 was allocated to staff from the profit and loss account in 1915 – supplementing the annual wage bill by eight per cent – and paid in proportion to seniority and only to established employees. In subsequent years, as Table 6.2 shows, this was raised to reach £2,000 in 1918,

TABLE 6.2 *Provincial Insurance Company: management expenses as a proportion of revenue, 1913–19*

	Management expenses £'000	War bonuses £'000	Proportion of net premiums %
1913	12.0		25.3
1914	14.0		26.8
1915	14.5	0.7	27.8
1916	13.6	1.0	22.5
1917	17.4	1.5	24.5
1918	21.3	2.0	25.7
1919	34.3		25.5

representing an additional thirteen per cent on a wage bill that had doubled since 1914.

These payments were insufficient to prevent the Provincial being affected by the general atmosphere of dissatisfaction in industrial relations, as inflation accelerated towards the end of the war. In September 1918 seventeen women in the head office threatened to strike for higher wages. A round robin was presented to Samuel Scott in which they requested a standard scale based on years of service, rising from twenty-five shillings a week at first to fifty shillings after six years' employment. They based their claim on price increases and the higher wages paid elsewhere. Scott's attitude combined sympathetic perplexity with an individualist refusal to countenance collective action. He responded by regretting their method of approach, expressing sympathy for their case, but insisting that they must be dealt with on an individual basis at the end of the year. But there was a sting in the tail. He wrote that it was 'Difficult to take seriously, but it caused a lot of time to be wasted. Miss Farnworth, the ringleader, is tearful and regretful, but [I] fear it is necessary that she should go.'

Additional staff required payment over and above the continued wages paid to those on active service. As Table 6.2 shows, this raised the expense ratio quite sharply in 1914 and 1915 in the face of the stagnation in premium income. Yet from 1916 the fresh buoyancy given to revenue by inflation and a wider accident underwriting policy, began to bring the expense ratio down. Only in 1917 and 1918, when large wage bonuses were paid, did it reach pre-war levels. The Provincial's underwriting accounts thus shared in the moderate costs of transacting business that characterised the war years.

The loss of staff during the war was paralleled by a similar loss in value

TABLE 6.3 *Provincial Insurance Company; investment portfolio, 1914–20*

	Estimated minimum value of portfolio £'000	Addition to portfolio £'000	Estimated change in value %
1914	131		
1915	130	8	-7.1
1916	130	5	-4.1
1917	147	22	-3.8
1918	181	31	2.6
1919	194	24	-6.1
1920	242	47	0.5

of the Provincial's other principal asset – its investment portfolio. The high interest rates created by government borrowing forced security prices down. Table 6.3 estimates the fall in the value of the Provincial's investments between 1914 and 1919. In addition, substantial losses were made on foreign exchange in 1917 and 1918 in connection with the company's Russian Mutual treaty and the collapse of the rouble during the revolution.

If the Provincial had operated close to its financial margins in the years before the war, this depreciation might have strained the security it offered policyholders. Problems of this sort closed many small companies or encouraged their sale. Yet the more than ample cover the Provincial had maintained as the result of modest revenue growth, meant that it retained scope for carrying a contraction in its portfolio. Indeed, even with the rapid rise in premium income after 1916, the assets available for insurance liabilities never approached parity with premium income, the standard for the industry. In 1919 they were still thirty per cent higher.

Investment depreciation had to be covered from the profit and loss account. In each year from 1915 to 1919, except 1918, substantial sums amounting to £25,000, were devoted to this purpose. Yet these were largely paper transactions. While the published reserves were reduced, when the war was over and security prices returned to more normal levels, the company would find itself with assets substantially in excess of their quoted value, forming hidden reserves.

Although the book value of reserves had to be written down in this way, the company's investment portfolio none the less grew substantially from 1916; £65,000 being added to its book value by 1919. This was partly because the rapid growth in premium income generated short-term reserves to be held against unexpired liabilities. These grew by some

TABLE 6.4 *Provincial Insurance Company: investment yield, 1914–19*

	Gross investment income £'000	Net investment income (less tax) £'000	Net yield on minimum valuation %	Premium over yield on consols %
1914	5.8	5.4	4.1	0.8
1915	6.7	5.7	4.3	0.5
1916	7.4	5.5	4.3	0.0
1917	8.3	6.3	4.3	−0.3
1918	9.7	6.8	3.8	−0.6
1919	10.2	7.1	3.7	−0.9

£42,000 over the three years. Given that the proportion of funds held in cash remained at about one-fifth, this contributed about a half of the expansion in the portfolio. To this was added further liabilities created by the slower final settlement of the now more important accident and marine accounts, whose claims were sometimes only paid off after several months or even years. This necessitated the retention of further funds from premium income, over and above the normal reserves. Finally, the company adjusted its liquidity position from the relaxed attitude before the war when short-term assets covered similar liabilities some four or five times, to one where they became broadly equal. It seems likely that this was partly the result of a large overdraft that was arranged in connection with the marine branch, and also a tendency to pass on reinsurance premiums more slowly.

The growth in the investment portfolio was almost wholly devoted to the purchase of government stock. Other securities were rather unattractive under wartime circumstances, but the reason for this policy lay in the pressure on insurance companies to support the government's financial policies, which raised the national debt from £700 million to £8,000 million over the war period. In any case, government stock was issued on terms that were hard to resist.

Investment decisions became a matter of public relations as much as straightforward financial appraisal. It even became entangled with the question of conscription. At the tribunal a military representative commented favourably on the Provincial's patriotic attitude in subscribing so generously to war stocks. When 'Tank Week' schemes were mounted to sell war bonds, local pride was stimulated by the publication of the comparative sums raised in different towns. The Provincial played an important role in the Bolton effort by subscribing a prize of £1,000 to be

distributed to the purchasers of numbered bonds. The company also invested £20,000 in war loan in the course of the local campaign.

Provincial purchases of war stock began in 1915, initially on a small scale. At the beginning of 1917, £40,000 was subscribed to war loan, £25,000 of which was 'new money'. This sum was gradually paid up in the course of the ensuing two years, together with the further £25,000 subscribed in the 'Tank Week'. Along with other incidental purchases, the company's holding of government stock rose by nearly £70,000 between 1915 and 1919 to form thirty-eight per cent of the investment portfolio. A similarly motivated purchase of French government stock in 1916 practically completed the addition to investments for the whole of the war years, although quite substantial short-term loans were made to Haslam's from time to time, no doubt to help the firm cope with the inflation in cotton prices. Finally, between 1917 and 1919, the purchase of Sand Aire House at Kendal, a new London office and houses for staff at Kendal, increased the property element in the portfolio by nearly £15,000.

Despite the enormous effort put into marketing government loans, the actual yields offered were very attractive. First floated at 4.5 per cent, rather above the yield on consols, this was raised in successive issues, so even city opinion regarded the terms as generous. Table 6.4 shows that the gross yield on the minimum market valuation remained at over five per cent from 1915 to 1919, superior to pre-war experience.

However the Treasury clawed back in taxation much of what it had given in interest. Tax payable, which had never risen above 1s 3d in the £ before the war, advanced from 1s 8d in 1914 to 3s 0d in the following year, 5s 0d in 1916 and 1917 and 6s 0d in 1918.[29] As Table 6.4 shows, the effect was to bring net yields back to pre-war levels. This was most noticeable in 1918 and 1919, though the falling yield was partly a result of the investment in new offices for which no reimbursement was made to the investment account until 1920.

So yield compared favourably with that obtained before the war and on a far larger portfolio. From the financial point of view the war did the company little damage. Its initial strength was more than sufficient to preserve it from the problems that beset many otherwise similar concerns. And the maintenance of comparable yields on a greatly augmented portfolio allowed investment income to grow in every year except 1916. By 1919 it had reached over £7,000, one-third higher than in 1914, providing a far larger pool from which dividends could be paid.

7
Business in wartime

The Provincial's net premium income from all sources trebled between 1914 and 1919. Much of this was a windfall created by circumstances outside the company. The most important of these was the rapid inflation which affected all aspects of economic life, especially after 1916. Then there was the real growth in business generated by the war economy. Fire and accident revenue accounts both benefited from these sources and this was made easier by the relaxation in competitive conditions. Policy initiatives contributed to growth as well. Employer's liability business was accepted on a wider basis and the company began to take motor vehicle insurance in 1916. As a result, net accident premium income, which had only approached the scale of fire income in 1913, overhauled it from 1918. By 1919 it had reached some £78,000, while net fire business, despite considerable growth, remained at £45,000. While its real significance could only be realised after the war, when staff recruitment again became possible, the later years of the war demonstrated the potential of accident insurance for the company's development. At the same time, the higher underwriting margins earned on fire business meant that it continued to provide the core of profitability.

7.1 The home fire market

The Provincial's home fire revenue grew at an unprecedented rate between 1914 and 1919. While this can be attributed partly to inflation, business expanded more rapidly than two of the large tariff companies whose home underwriting accounts are available, despite the company's relative difficulties in staffing. Between 1914 and 1919 the Provincial's net home premium income grew by seventy-five per cent, in comparison with the Commercial Union's fifty-two per cent and the Royal Exchange Assurance's sixty-four per cent.[1]

Table 7.1 indicates the growth in gross and net fire revenue. It is impossible to be as specific about the sources of growth as before 1914, but it is clear that this expansion was more dependent on the market environment than internal changes or organisational development. No new

TABLE 7.1 *Provincial Insurance Company: British gross and net fire premiums,*
1914–19 (£'000)

	Gross fire premiums	Net fire premiums
1914	52.0	24.1
1915	54.0	26.4
1916	68.6	33.2
1917	85.1	39.0
1918	103.6	32.5
1919	125.6	42.1

Note These figures exclude all foreign fire premium income.

branches were opened during the war; as early as February 1916 the
London branch had lost two staff to the services and Manchester three.

 Three considerations allowed market changes to be turned to good
account: some branches were well placed to obtain business created by
military and other special war demands; relaxed competitive conditions
encouraged growth; and the company benefited disproportionately from
the inflation in commodity values in the later years of the war.

 1914 saw the most modest growth in revenue, probably as much the result
of falling premium rates as the outbreak of war. Non-tariff companies
suffered especially from anxiety about the effect of the collapse in security
prices on their solvency ratio. In August 1915 a special memorandum was
sent to branches providing voluminous information on the company's
financial strength. That year saw a changing balance of business produced
by the war. Manchester, Liverpool and head office business saw little
growth with the depression in cotton caused by the difficulty of obtaining
raw cotton imports, the disappearance of European markets, and the
absence of any substantial war demand for cotton products. The regional
bias towards Lancashire meant that aggregate business scarcely grew.[2]

 By contrast, trades serving the demands for military supplies boomed.
Growth in woollens, hosiery, clothing, leather, boots and engineering
shifted the emphasis in business towards Yorkshire and the Midlands. It
was fortunate that the Yorkshire branch had been established in the
last year of peace. Unaffected by recruitment, the local manager took
advantage of local opportunities, nearly doubling business in 1915.
Similar prospects opened up for the Midlands branch in the area around
Birmingham, where the metal trades benefited from the stimulus of
munitions production, and in the East Midlands where the hosiery and

boot trades enjoyed large government orders. There were problems however. The small scale of firms in all these industries meant that their insurances tended to be controlled by the professional men who administered trade associations and chambers of commerce, and it was uphill work building up business under such circumstances. The branch was also hampered by its Birmingham base. The company's special representative in Leicester was rather inadequate, having no influence over hazardous risks. The only useful lever in this direction was through Haslam's agent in the city, who put in a good word for the Provincial with hosiery manufacturers who bought his company's yarn.

Behind the more dramatic consequences of the war, some more mundane forms of business development were possible. Special agencies were arranged in Bournemouth and Dublin. A new system of communication between junior branch staff and head office was instituted, whereby inspectors completed a form in which they described their work, explained any special difficulties they encountered and suggested improvements in their arrangements. Francis Scott followed up recommendations to write personal letters of encouragement to specific agents, but we may imagine that he was less enthusiastic when the young Birmingham inspector strongly advised the purchase of a 'light car' for his personal use. Branch expenses were watched carefully early in the war, for the stagnation in revenue meant that they might easily destroy profitability. In January 1915 Francis Scott wrote to all branch managers impressing on them the 'exceptional need for retrenchment this year' in view of the possibility of reduced business. There was some response to this, but subsequently the acceleration in premium income was sufficient to bring the expense ratio down.

After an initial period of adjustment to wartime patterns of production, the Provincial's fire business began to settle into a more stable expansion path determined by inflation, output growth and the opportunities created by the more relaxed competitive environment. As Table 7.1 indicates, from 1916 premium income began a rapid climb which lasted for the rest of the war. Buoyant business enabled the Provincial to grow with relative ease, even by winning risks and classes of business that were normally tightly tied to tariff companies. Tariff premium rate increases made non-tariff discounts more attractive, and surplus business became more easily available, as larger companies reached their acceptance limits on particular risks.

It is difficult to trace the impact of these market developments in any general way, though specific examples can illustrate the opportunities that existed. The whisky market provided such a stimulus. From 1916 the value of the spirit rose and the normal insurance arrangements, almost

entirely conducted through tariff channels, broke through their accept-
ance limits. Large surplus lines became available at attractive rates because
of the shortage of acceptance capacity. Baillie took advantage of this,
writing £20,000 of business in the latter years of the war, incurring an
embarrassing loss ratio of no more than some five per cent.

The disappearance of several of the Provincial's most important non-
tariff competitors created further opportunities. While FOC rules allowed
non-tariff companies purchased by tariff offices to provide discounts for a
while on existing policies, all new business had to be accepted at tariff
rates. Many agents, whose business had been based on rate competitive
marketing, anxiously sought alternative companies, creating opportuni-
ties for the remaining non-tariff companies like the Provincial.

Careful arrangements were made to take advantage of the disappear-
ance of the Fine Art and General, the National of Great Britain, and the Car
and General in 1917. The Birmingham branch manager enthusiastically
courted a prominent Northamptonshire broker who had dealt with both
the Fine Art and the Car and General, and controlled a valuable business
in the boot and shoe trade. Evans posted him cuttings from *The Times*
announcing the closure of the former company and this was backed up by
a personal letter from Francis Scott. When he requested far larger acceptances
than the Provincial normally took, Scott invited him up to Bolton for
negotiations where the matter was successfully resolved. Similarly
successful special arrangements were made when Evans scrambled for the
business of the Kettering Boot Manufacturers' Association, previously
held by the Fine Art and General, but sought with equal avidity by the
Provincial's main non-tariff competitor, the British Dominions.

Despite developments elsewhere, experience in the cotton industry
continued to overshadow the Provincial's fire business. It formed an
important direct element in premium income, but, beyond this, its
fortunes determined insurance business of all kinds throughout industrial
Lancashire, which continued to form the backbone of the company's
business.

The early years of the war saw the difficulties for the industry that have
been mentioned above. Furthermore, its insurance was beset by losses
which reduced the profitability of business. However, from 1916, the
situation was transformed. Poor underwriting experience and the reduc-
tion in competition encouraged the tariff companies to raise their
premium rates by some fifty per cent and attempt to impose a compulsory
average clause on all business, which effectively forced all prudent policy-
holders to raise their sums insured. In the same year, the difficulties of
obtaining raw cotton supplies, and the restraints exercised by the Cotton

Control Board, led to high cotton prices. In 1916, for example, on far smaller quantities, export values exceeded those in 1913, the *annus mirabilis* of the cotton trade.[3]

The Provincial gradually re-rated renewals at the new rates less agreed discounts, increasing its revenue. At the same time, it benefited from the dissatisfaction created by the higher rates among disgruntled tariff policy-holders. Circumstances were set fair for the Provincial to exploit a market that continued to see an expansion in insured values until 1920, when the value of exports was well over three times that in 1913.[4] Cotton insurances began to flourish again, as new business was won and established business generated more premium income. In 1916 new business at Manchester rose by thirty-eight per cent and at Bolton by sixty-four per cent. In 1917 net fire premium income at the Bolton office was forty-one per cent higher than in 1915; at Manchester in was thirty per cent higher.

However, even during wartime, such juicy opportunities attracted entry. The companies had over-played their hand. By raising rates and imposing average clauses at the same time, they had compounded the increase in premiums obtained. Immediately after the increase, Lloyd's began to canvass Lancashire cotton mills. The cotton industry was well suited to these methods. It was easy to pick off such a geographically concentrated market by appointing a surveyor, and thereby offering a reasonable service to local brokers and policyholders. A firm of Manchester brokers were induced to assist through the threat that if they did not, Lloyd's would establish its own regional office.

The canvass was particularly antipathetic to the Provincial's interests. It posed the threat of a powerful competitor, known to take a short-run view of premium rate cutting, intervening in a market in which the Provincial regarded itself as the principal non-tariff element and from which it derived the bulk of its large scale revenue. A Lloyd's campaign was likely to create instability in rates and market shares that might force the tariff companies to respond; at best the Provincial might lose some individual risks; at worst its main market would be plunged into a rate war that would eliminate profitability. Furthermore, Lloyd's was subverting some of the Provincial's closest allies – the regional brokers to whom it had extended special terms and commissions over the years. If they entered into special arrangements with Lloyd's, goodwill would be lost and the company would no longer receive preferential offers of business, or even continue to be given established lines on existing risks.

As soon as the canvass was noticed, Gray, the Manchester branch manager, discussed it with the brokers concerned. 'I saw Broadbent on 'change,' he wrote to Baillie,

... I put it to him that I did not think it would be to the interest of any Broker to push 'Lloyd's', ... that having built up our connections in this and Bolton districts we should naturally make every effort to retain our business if we thought for a moment he was in any way displaying antagonism towards us ... he must also consider that if we pay the commission terms we are at present doing, we must also consider what is to our best interests in the circumstances and that if Scholfields' are going out for either 'Lloyd's' or offices, without giving us at least a fair proportion of the business, agency terms must be reconsidered.

Scholfields' representative was interviewed at the Provincial's head office by Samuel Scott and Baillie where, the former reported to his brother, 'I endeavoured to show him that we could put an efficient spoke in their wheel as regards business in Bolton if they made a set at our business and I think I emphasised to him that they would do themselves more harm than good by making enemies of us.' A private understanding was reached. Scholfields' would stop broadcasting circulars mentioning Lloyd's and no circular would be issued to any firm in which the Provincial was interested; they also agreed to preserve the Provincial's interests on any risks coming to them. In return, the Provincial would not compete on any risks where Scholfields' were quoting. This agreement was formalised in 1918.

Lloyd's instituted another campaign in 1917, which Francis Scott found particularly objectionable. It was aimed at the average clause, which they stated they were prepared to waive. Scott wrote to David Willis,

I believe that the Tariff offices are gradually but very slowly working towards ... what is after all the only logical basis for all fire insurance contracts, the universal application of the Average Clause. It is the only method which will make all people insure up to the hilt and will ensure in the long run a reduction in rates While I strongly favour competition and regard the activities of Lloyd's and such offices as the Provincial as healthy, I strongly deprecate competition which is based on unsound lines as in this instance and which only tends to prolong an evil I think it is a pity that a few of the more responsible Lloyd's underwriters do not look at these questions from a wider standpoint than their immediate personal gain and while I admit the proposed canvassing campaign possesses a strong canvassing card, ... in the long run [it] is equally against the interests of Lloyd's underwriters.

Lloyd's success cannot be assessed with any accuracy, but they must have established a foothold for, as a later chapter will show, the tariff offices mounted a special campaign to drive the brokers out after the war.[5] In the short run the Provincial was not seriously affected. Between 1915 and 1918 one-third of all new home business came through the Manchester branch. The campaign's significance lay in the longer term, which

illustrated the company's changing competitive position and developing maturity. It was no longer purely a pirate, out for business at rates and commissions that were set without heed to other concerns. Its established position gave it as much interest in market stability as any tariff company. It also brought home the company's heavy dependence on one market. However profitable, where the Provincial could win business by rate competition, so could competitors. Indeed, the more profitable it was, the more likely it was that this would occur. This emphasised the importance of diversification over as broad a range of markets as possible, and a move away from competition by premium rate, to competition by means that would be less susceptible to rapid erosion by new entrants.

Dynamised by the growth in cotton revenue, premium income grew rapidly in 1916 and 1917, as shown in Table 7.1. In 1918, net premium income slumped. The reasons for this are not entirely clear. Gross business continued to grow rapidly, but most of this was on existing risks and had to be passed on as reinsurance. In part it was the result of the severe staff shortage, which prevented new business winning by the branches and slowed down administration sufficiently to affect the figures. In 1919 the momentum generated by war production faltered, reducing growth in Birmingham and Yorkshire. However, peace brought new sources of demand. After war-induced inflation, came that produced by soaring demand at home and abroad, eager to satisfy the requirements postponed during hostilities. By early 1919 'a boom of astonishing dimensions' developed, lasting until March 1920.[6] Thus 1919 saw the Provincial accept a gross home premium income of some £94,000, well over double its pre-war level and a net home premium income of £42,111, three-quarters higher than in 1914.

7.2 Accident insurance

The relative significance of accident insurance in the Provincial's revenue was transformed during the war. Gross acceptances grew twice as quickly as fire insurance so that by 1919 they were three-quarters of the latter; yet this underestimated the account's importance, for the far lower proportion of accident insurance reinsured meant that net accident premium income greatly exceeded net fire business by 1918. Employer's liability insurance was principally responsible for this growth; from 1916 motor vehicle insurance grew quickly, but it was almost entirely reinsured at first, so its contribution to net income was limited.

Growth was not achieved by organisational development, for this was impossible during the war; nor was it obtained abroad. It was won by

TABLE 7.2 *Provincial Insurance Company: British net accident premiums,*
1914–19 (£'000)

	Employer's liability premiums	General accident premiums	Total accident premiums
1914	16.2	6.5	22.7
1915	17.2	6.5	23.7
1916	18.9	8.0	26.9
1917	24.4	7.7	32.0
1918	37.6	9.6	47.2
1919	58.3	22.2	80.5

Note General accident includes personal accident.

policy changes forced on the company by the market. These affected the Provincial's employer's liability business in several ways. Military recruitment reduced the labour force. Many workers in industries serving war needs came under government control and were therefore removed from the market for private insurance.[7] These changes, the generally hazardous nature of war production, and the transfer of so many women domestic servants into industrial employment, meant that the non-hazardous employer's liability insurance the Provincial had previously sought was disproportionately reduced. As a result, as Table 7.2 shows, accident business remained almost static during 1915 and 1916. Several branches, including Manchester, London and even Birmingham, saw accident revenue fall in those years.

The problem seemed progressive. Francis Scott faced the problem that a whole class of insurance might gradually evaporate, for the introduction of attestation and conscription in 1916 suggested that the sources of the difficulty would continue for the foreseeable future. This possibility forced him to reconsider the company's cautious acceptance policy. It had been formulated in the highly competitive early years of the employer's liability market, when there had been enthusiastic entry by many small companies and larger concerns had seen it largely as a 'loss leader' serving fire business. Immediately before the war the position had improved as some of the more disreputable companies disappeared and this had encouraged the AOA to carry higher rates. In 1914 the *Post Magazine* had admitted that 'rates of premium at last gave signs of having reached a stage at which, with careful underwriting, a reasonable margin of profit might be expected.'[8] Aggregate results bear this out. The profitability on employer's liability insurance business transacted within the United

Kingdom rose from eleven per cent in 1913 to twenty-one per cent in 1916.[9] The difficulties of wartime operation for small companies must have hardened rates further. By 1916 they were double the level that had prevailed at the height of the competitive battle between 1908 and 1910. As a result Francis Scott came to the conclusion that '... there is abundant evidence that the tariff rates are in many cases excessive and that the companies are earning an undue profit.'

He therefore decided to combat falling business by adopting what he termed 'an enlarged policy' from July 1916. Branches were informed that, contrary to their previous instructions, they could now accept any class of business, including such hazardous occupations as cotton and woollen mills, ironworks, heavy engineering and woodworking. The only risks excluded were those where there existed the chance of a catastrophic loss of life in one accident, as sometimes happened in collieries and quarries. Generally the Provincial would quote rates at about ten per cent below the tariff, reserving the right to select against classes where experience seemed bad. On the other hand, special rates would be quoted where good evidence of a long and satisfactory claims record could be produced. This was possible because the large number of individuals often at risk under one policy meant that it was possible to come to some conclusion about experience on recent claims evidence. Furthermore, as long as the company reinsured against the event of death, there was little possibility of a major loss as the result of experimental underwriting. It was a different world which suited the Provincial better than fire insurance, where risks were far larger and the incidence of loss was revealed so slowly.

The new policy made immediate headway. The Yorkshire branch advertised inviting fire and accident business from woollen and worsted mills and by the end of August had already received a good response. By the end of the year the branch accident revenue was already up by three-quarters on 1915. The Birmingham branch manager made similar plans to approach factories in the Leicester and Nottingham areas. An agreement was reached with the Bains to add a general employer's liability account to the fire business they provided. Overall, however, the new policy was insufficient to offset the poor performance in the first two quarters of the year and the continued contraction in the labour force. Gross and net revenues rose only imperceptibly over 1916 as a whole.

In the following two years the benefits of the new policy became more apparent. The market expanded as a result of the relaxation of wage control in the summer of 1917, after which wage inflation rapidly raised the values on which premiums were based. The disappearance of non-tariff companies in 1917 was even more advantageous than in the fire

market, because there was no problem of gross limits. The Provincial could take as much as seemed reasonably profitable. The new policy allowed the company to take full advantage of these new opportunities. In 1917 gross revenue grew by nearly one-quarter over the previous year and in 1918 this was exceeded by a further expansion of some two-thirds.

It is impossible to provide a precise indication of the types of business obtained, but some impression can be formed from the records of the claims that were paid. By the end of 1917 these included such trades and industries as cotton spinning and warehousing, boot manufacturing, motor engineers, paper manufacturers, potters, biscuit manufacturers and masons. Between 1916 and 1918 head office accident business grew by sixty-six per cent and Manchester by 100 per cent with the new capacity to exploit their cotton connections in this way; but London achieved 204 per cent.

In 1919 peace brought the demobilisation of some four million men, a rapid expansion in the labour force, and a boom that inflated wages to an unprecedented extent.[10] Employer's liability net premium income rose by fifty-five per cent in that year alone, to reach £58,344. This experience was shared in some measure by all branches, but the cotton boom allowed Manchester to lead with an increase of ninety-five per cent.

By the end of the war the success of the new policy was clear. Employer's liability income had risen three times since it had been introduced in 1916. The growth was obtained by a more intensive use of the same channels through which fire revenue was obtained, without the need to greatly enlarge the company's organisation. Of course, it was made possible by the reduced competition in the war years, which created scope for the Provincial's cautious non-tariff rating. Yet the opportunity had been successfully seized and the Provincial was established as a careful underwriter of a general employer's liability business.

The second important departure also occurred in 1916, when Francis Scott decided to begin motor insurance acceptances. He had watched the market with interest, no doubt partly because of his own fascination with cars. Agents had begun to look for motor cover for their clients, and this encouraged him to provide policies to protect his market connections. He began to look into the possibilities of providing cover in 1915. Taking a long-term view of the market, he wrote:

The conclusion of the War will see a large increase in car insurance and we are anxious to have some organisation ready to take a share in the business offering. There is also some ground for thinking that as it is a branch of insurance of increasing importance, it would be a mistake to allow business to become too

settled in certain channels and that one might find it a harder matter to disturb connections in our favour if we left matters too long.

The difficulty was that the company had no one capable of underwriting the business and little prospect of obtaining anyone until the war was over.

A solution was found by reinsuring all motor vehicle business with the Excess and motor cycle business with the Scottish Metropolitan for a commission graduated according to underwriting results. 'By these means,' Francis Scott wrote, 'in addition to securing a trial of the business for a nominal outlay, we shall have the opportunity of building up a connection, of gauging the value of the business and of learning something of the methods on which such a business should be conducted.'

Private cars were to be accepted at tariff rates; while commercial vehicles were offered a ten per cent discount. This was not because the Provincial was less interested in the former. Scott had been informed that the tariff rate had been set very low to moderate non-tariff competition. However, it was expected that tariff rates would be bound to rise before long, so branch managers were encouraged to obtain as much business as possible.

Motor insurance was quickly justified. Gross premiums rose from just under £4,000 in 1917 to nearly £19,000 in 1919, although the reinsurance arrangements meant that the Provincial's direct income in that year was only £3,596. Unfortunately it is impossible to analyse the sources of business systematically. In the first two years the overwhelming bulk of revenue passed through the head office, with the rest spread broadly in proportion to other branch business, except for disproportionately large amounts supplied by Liverpool and Hastings. As vehicles returned to the roads at the end of the war, the principal beneficiaries were the London and Manchester offices.

Within three years the new class of insurance had developed a gross premium income which exceeded that from any other form of general accident insurance. This growth was achieved under the guidance of the Excess and Plisson and Lysberg, the brokers who had placed the business for the Provincial. By 1919 however, Francis Scott had come to the condszclusion that the company was capable of managing its own motor account, and a Provincial motor prospectus was issued. This was to provide the foundation of the development that was to transform the whole scale and balance of the Provincial's business in the post-war period.

7.3 *The home foreign market*

Walter Faber faced the outbreak of war with a vigorous self-confidence that scorned the timidity of his underwriting colleagues at Lloyd's,

who bid fair to injure Lloyd's as a fire market by their procedure at the present time … . All the principal Underwriters except myself have signed a general intimation to brokers … to be accepted as notice to terminate all the fire contracts at the expiry thereof … the proceeding is not reasonable and will, I should think, result in the loss of the business … while, of course, increased caution and discretion are necessary. I am of opinion that the sound policy is to accept business, with due regard to possible moral hazard. I think this will also greatly add to our reputation.'

Despite this bold attitude, it was inevitable that home foreign business should be in short supply in the early years of the war, for many of the risks that had previously come to London had originated in parts of Europe now cut off by hostilities. Thus, as Table 7.3 shows, home foreign business fell off from 1914 and only recovered its 1913 level in 1918, though in that year it reached a level double the earlier year.

Of course, it was possible to accept business from parts of the world not directly affected by the war. Faber did so, underwriting risks from such diverse sources as China, Latin America and East Africa, as well as the more usual markets in the United States and unoccupied Europe. Even these felt some indirect repercussions. In the United States, brokers and policyholders were anxious about British companies' financial security and this was fanned by American insurers. Anti-British feeling was also exhibited by those sympathetic to Germany or Ireland.

This temporarily affected the flow of revenue from O'Brien in Chicago, and Francis Scott sanctioned a special arrangement whereby a proportion of revenue was retained there to form an American reserve fund to maintain confidence. Business none the less fell off in 1915, but it revived in the following year and grew quite quickly for the rest of the war. O'Brien benefited from the disappearance of German companies after the United States entered the war in 1917. But the quality of his risks began to deteriorate. From 1916 he began to lose sprinklered risks to mutual companies operating on long-term contracts with very low administrative costs. The competition also reduced premium rates. The account became smaller and distinctly less profitable after 1916, revenue only being maintained by his substituting less favourable classes of business. This raised the problem of control that had always worried Samuel Scott. The distance involved made it impossible for Faber to discriminate between acceptances.

TABLE 7.3 *Provincial Insurance Company: foreign net premiums, 1914–19 (£'000)*

	Home foreign and South Africa	Canada
1914	3.5	2.1
1915	2.5	2.1
1916	2.7	2.0
1917	2.7	3.5
1918	7.0	4.1
1919	6.3	5.6

The account was retained until after the war, but its unhappy later years contributed to Francis Scott's prejudice against American business. In discussion with Faber he agreed that the American market required a local directly controlled organisation of a scale and complexity that was well beyond the scope of the Provincial. It required a local management that could control underwriting and investment, for the profitability of American business depended on the two being operated in combination.

Reinsurance provided compensating revenue after 1916. The contraction of their continental reinsurance facilities encouraged the tariff offices to relax their normally prohibitive attitude towards reinsurance with non-tariff concerns. The Provincial was able to obtain a quite different scale and class of foreign business than previously possible. The first and best opportunity of this type was a treaty arranged with the Sun in 1916, to accept one-tenth of a limit on its American business, and thus participate in the underwriting of one of the most conservative and reputable British fire offices. In the same year half a limit was accepted from the L'Union, a prominent French company, on both French and general international business.

The most important departure however, was a second surplus treaty with the North British and Mercantile, one of the largest tariff offices. The sums involved were substantial, covering risks from all over the world, excluding only the United States, Canada, and South Africa, where they might conflict with the Provincial's other commitments. The Provincial accepted one-half of the North British and Mercantile's retention up to a maximum of £3,000. Arrangements were made to pass on one-half of this acceptance to the British Fire, another non-tariff company, whenever this was desired by the Provincial. Francis Scott was buoyant. He estimated that the treaty would bring in an annual profit of between £500 and

£1,000 each year. The treaty was the most important reason for the rapid growth in business shown in 1918 in Table 7.3.

The new connection raised other issues as well. The general manager of the North British and Mercantile suggested that, if the Provincial would accept tariff rates and conditions abroad, it could be given access to his company's foreign agencies and be given business on joint schedules. It was a tempting proposition, for Francis Scott had already considered joining the foreign tariff. In the event, he declined, deciding to wait until the end of the war clarified the opportunities open to the company.

In any case, the treaty went ahead and Faber was soon reporting substantial retentions on risks as widely dispersed as refrigerated warehouses in Nankin, godowns in Japan and Mombassa, sawmills in Russia and flour mills and brickworks in Salonica. Faber would have declined these latter, for his private records showed the port to be subject to 'disastrous, constant conflagrations'. It was therefore galling that they involved the Provincial in its first serious conflagration loss within a month or so. Many larger companies lost six figure sums; even the Sun lost £290,000. The effect on the Scotts can be imagined, especially when they were told by Faber that some of the risks in which they were involved had only been notified to Faber after the fire. Fortunately the Provincial's loss was relatively modest, though it did lead to a significant rise in the 1917 loss ratio.

Francis Scott was prepared to treat Salonica as a once and for all disaster, though Faber was far more critical of what he regarded as bad underwriting. At the same time they decided to fully utilise the facility with the British Fire, not least because the scale of business coming through was so large. This effectively reduced the Provincial's commitment to a quarter limit. Yet the treaty continued to run badly. By the end of November 1917 losses of some £2,000 had been advised, excluding Salonica, thus more than eliminating the year's estimated income of £3,000. 'I wish we could get a fair trial with this contract but, unfortunately, we are getting a foul trial.' Faber wrote. He explained to Francis Scott that it was becoming apparent that the North British and Mercantile had taken on extra reinsurance facilities to expand its overseas revenue at an unprecedented rate and that this was leading to a disastrous decline in the character of its underwriting. He became increasingly unhappy with the risks supplied and by early 1919 notice had been given to quit the treaty.

At the same time as this costly experiment, one of the early foundations of the Provincial's foreign reinsurance account crumbled. The profitable treaty with the Russian Mutual was washed away in the aftermath of the revolution, with the added cost of a large loss on foreign exchange with

the collapse in the rouble, which necessitated writing off some £4,500 over two years.

So, home foreign business contracted, American surplus line insurance turned sour and reinsurance proved a poisoned chalice. The war years were not successful for the London foreign office, for reasons beyond Faber's control. As in so many other directions, the Scotts looked to the end of hostilities for new opportunities for development. But Faber could not feature in these plans for he made it clear that he was now inclined to retire.

7.4 Foreign branch business

The Canadian branch posed Francis Scott frustrating problems on the eve of the war. In 1914 underwriting deteriorated seriously. The Hudson's Bay Company insurances, that had seemed such a valuable account, remained so unprofitable that Francis Scott asked for them to be declined on renewal. Early in the year, Raymond Willis visited Canada to take in hand the winding up of the affairs of the Central Canada Manufacturers' Mutual Fire Insurance Company. The idea was that he would sift through its portfolio of industrial risks in the Toronto area and pass on to the Provincial its more acceptable business. The price was that the account had to include for a while some of the bad risks as well.

We are cancelling a good deal of the business which we don't want and needn't take, but we are also taking some very small lines on bad risks and also extending our general basis of operations somewhat. You will see some strange risks ... but please ask Mr Baillie to suspend individual criticism until he is impressed, as I am, with the unique opportunity that has come our way.

Willis placed some 300 risks with the Provincial, drawn from the industrial classes that were so hard to obtain in Canada. However, there were among them some very 'strange risks' indeed, and after Raymond Willis left business for military service in 1914, his brother David admitted that the portfolio required an extensive revision to halt an escalation in claims.

Throughout the war the position remained difficult. With Raymond Willis at the front there was no qualified management on the British side and Francis Scott was unable to visit Canada to assess the capacity of Dettmers, the fire surveyor in charge of affairs. Instead he corresponded with David Willis in London, who had no special knowledge of the country, and with Dettmers, whose replies often took a month or more because of postal delays caused by the war.

Non-tariff underwriting had forced Dettmers to write a more general

business than Francis Scott regarded as desirable. He had attempted to control this by excluding timber framed houses and by imposing tight limits on individual risk retentions and blocks in towns. As a result revenue languished, remaining fixed at some £2,000 in 1914, 1915 and 1916. Yet these difficulties in developing premium income with agents, made profitability vulnerable to the chance of several individual losses in a year. If the company reduced its individual retentions further, this would hamper its attraction to agents even more.

Dettmers argued in favour of expanding revenue by allowing him to accept good quality timber framed buildings, which he believed to be profitable at prevailing rates. Above all, they would allow him to develop business with the country agents who controlled so much business. Timber framed buildings formed the bulk of their business and they would not deal with a company that did not accept this class. When Raymond Willis returned from the front in 1916 to recuperate from a war wound he supported Dettmers;

... frame dwellings are a feature in Canada and cannot be compared to wooden ones here; ... I am a believer in them at the rates obtainable ... it will be a great help ... in his agency arrangements not to have to prohibit them and I know [he] will try and confine acceptances to waterworks towns and will not accept full lines.

Some relaxation was allowed, but Francis Scott was not prepared to underwrite on a new basis until the war had ended and he could form a better appreciation of Dettmers and the future of the market.

Thus, though price inflation gave some buoyancy to revenue from 1917, as Table 7.3 shows, no real growth occurred. Furthermore, profitability remained poor, for in addition to the special difficulties of the Provincial's small account, the general experience of the Canadian market deteriorated. Between 1914 and 1918, only 1915 provided a significant underwriting surplus.

With these problems in Canada, it is surprising that the Scotts opened another foreign branch, in South Africa, during the war. Furthermore, it was a more speculative arrangement from the start, depending on a manager the Scotts had never met, with whom communication was even more difficult than with Canada.

The branch was a response to opportunity, rather than part of a careful plan. As late as September 1914, Francis Scott had written 'We are unlikely to open in South Africa for many years to come'. Yet in March 1915, Glanvill Enthoven, Lloyd's brokers, suggested the opening of a branch to be managed by a non-tariff official who had been laid off by the

General Accident, who were reducing their South African organisation.

Francis Scott corresponded with the candidate. He claimed to have collected a premium income of £5,400 for the National British and Irish Millers in 1913, but suggested that this was an underestimate of the possibilities open to the Provincial. The General Accident and the local Federal, previously the leading local non-tariff offices, were to join the tariff. This would create scope for a well founded new non-tariff concern. Expenses appeared reasonable. A deposit of only £5,000 was required and could be held in interest yielding stocks. The main cost – that of the manager's salary – would be largely proportional to his success, for he was prepared to accept the modest salary of £300, relying on profit commission for the main part of his remuneration.

The Scotts had known the applicant in Manchester and had not been impressed, but Glanvill Enthoven claimed that he had been successful in South Africa. Francis Scott sought, and received, a reference from the General Accident, despite Faber's warning that this would signal the Provincial's likely entry into the market. It was respectable, though anodyne.

Francis Scott remained unhappy about the proposal, but eventually took the papers up to Windermere for the weekend, consulted his brother, and decided to take a chance. Glanvill Enthoven had suggested the formation of a company with local participation. Francis Scott was not attracted. He felt that local businessmen might be more interested in campaigning against tariff rates than in securing profitability. The capital required was too modest for assistance to be necessary, and in any case, if the venture was successful, the Scotts did not wish to share the 'plums'. If local men could be useful in influencing business they could be recruited as local directors, with no power or stake, but an annual fee. This was the scheme eventually settled on – a local branch with local directors and a professional man holding the Provincial's power of attorney to control the manager, who would receive a salary of £300, a profit commission of one-third, £100 of which would be guaranteed for the first two years.

Underwriting would be supervised by Faber in London. Rates would be fixed in South Africa, but he would fix gross retentions on the basis that the Provincial would reinsure five limits, three going through Glanvill Enthoven and two through Willis Faber. The objective was to write a select and profitable income that would not provoke a response from the local tariff. This implied cautious individual retentions, for as in Canada, a small premium income would not bear large individual losses. In any case, Francis Scott was unwilling to give the new manager too much responsibility until he had proved himself. Acceptances were to be concentrated

in the Cape Town area, with agents in the principal cities elsewhere. Again as in Canada, Francis Scott preferred to exclude country risks on the grounds of poor construction and the absence of fire brigades. The same response was met, the manager pointing out that he would be unable to build up an agency network if this restriction was imposed, so he was allowed to operate throughout the Cape Colony.

Business began with a circular contrasting the Provincial with other South African offices, as 'pre-eminently the sound, sane non-tariff company … one which has always been non-tariff and at the same time preserved a steady, unfluctuating prosperity and good reputation'. Some edge came into Francis Scott's hopes for the branch when his Manchester bankers told him that they thought him 'daring' to enter South Africa, the 'land of sharks' and when he heard that Glen, of the National of Great Britain, 'had expressed the view that we should burn our.fingers in South Africa … I should like to prove Mr Glen wrong.'

In the first few months thirty-three agents were appointed in the Cape Province and a prominent Cape Town businessman, George Smart, made a local director. However, business came slowly and by April 1916 Francis Scott was becoming anxious. He requested a progress report from the manager, who replied that the war was affecting business; that his gross limits were inadequate; that being restricted to fire insurance alone was inhibiting agency development; and that the competitive situation was now dominated by the fact that, contrary to expectation, the General Accident had remained outside the tariff and was continuing to cut rates severely.

Francis Scott found these arguments unconvincing and became anxious, for no power of attorney had yet been granted to someone in a position to provide him with independent local advice on the manager's performance. This was an especial concern because his expenses were more than double the £405 premium income he had obtained by the end of 1916.

Eventually David Bean, a Cape Town accountant, was recommended by a local bank, and given power of attorney. Francis Scott requested an immediate audit and confidential report. Postal delays and the manager's absence on business delayed this until early in 1917. Meanwhile, the Scotts' confidence was shaken by a frightening piece of mismanagement. Through inadequate instruction, an agent accepted a £100,000 risk, greatly beyond the gross acceptance limit. For technical reasons it could not be reinsured in London and communication delays meant that it could not be cancelled for several weeks.

Bean's report increased concern. He confirmed that the man was not an effective business winner and that his expenses were not clearly justified.

Later reports hardened this opinion. By June 1917 he taxed the manager on the question of his expenses for 'the manager of the largest insurance company in South Africa would not have put in the amounts he charged'. Bean had also discovered that he was being dunned by tradesmen. As a precaution, all cheques were to be countersigned by himself or the local director.

Francis Scott found himself in a quandary. He was not prepared to continue with such a manager, but the agreement had not expired, and as he would not obtain another post in South Africa, the man would probably go to court to enforce his rights if sacked. In any case, it would be impossible to find a substitute quickly, so dismissal would mean the end of South African business. As a holding measure, Scott asked Bean to control expenses and make it clear that the man's performance was regarded as very unsatisfactory. Yet the position was delicate. A manager inevitably retained a good deal of discretion in acceptances so, if alienated, could embarrass the company.

By the end of 1917, the net premium income of £842 was still exceeded by expenses – without including claims – and receipt of the figures forced Francis Scott to face the question of the future of the branch. He instituted enquiries on a scale that ought to have taken place in 1915, writing to Stenhouse, Sir Ernest Bain, the foreign manager of the Guardian, and a friendly director of Mather and Platt, who had knowledge of sprinkler installations abroad. The replies were discouraging. The General Accident was continuing its struggle with the local tariff; some rates had more than halved in ten years. The small market responded quickly to such campaigns, yet also gave rise to high expenses when only a small revenue was obtained in small, widely diffused colonial towns. Even Cape Town itself yielded a premium income no more than a modest English provincial centre such as Worcester.

He prepared a gloomy memorandum which he sent to Bean and Smart. Would South Africa revert to a purely pastoral economy when the gold mines were exhausted? Alternatively, would the acquisition of the German colonies present new opportunities? Could the burden of expenses be reduced by the Provincial sharing its underwriting with another company? Would the coming boom in motor car ownership bring revenue that could reduce overhead costs? At the same time he asked them to terminate the agreement with the manager, arranging for him to remain at a month's notice, under close supervision.

Bean replied more optimistically, suggesting a bright industrial future. The country had large coal and iron deposits and 'We have very large sources of semi-skilled and non-skilled coloured labour at our command

and in view of the wave of Socialism that will sweep over the older countries when hostilities cease, this country ought to be able to manufacture in certain lines to compete with Europe.' This impressed Francis Scott sufficiently for him to consider a new appointment, yet this would be impossible until peace and demobilisation. So, similarly to Canada, the last year or so of the war formed a hiatus with affairs drifting unsatisfactorily. Everyone involved, including agents, realised that a change would be affected as soon as the war was over, except the manager himself, who seems to have lived in hopes that delay suggested a reprieve.

In retrospect the formation of the South African branch, at the time and in the way it was, seems a folly. The Scotts relied on a man in whom they had little confidence. Their investigation of the market was cursory until affairs turned sour. Under any circumstances direct operation would have been difficult in wartime, when correspondence sometimes took twelve weeks to secure replies. Finally, they opened before a reputable professional man could be given authority to watch their interests.

The reasons for all this are not clear. Faber's advice was misunderstood. Samuel Scott believed him to be enthusiastic, but he claimed later that it had always been more subtle. If the Scotts wished to enter South Africa, the opportunity was their best chance; but he left the former clause implicit. Francis Scott claimed that he had relied on advice from Glanvill Enthoven, because they were to be so heavily involved in the placing of the reinsurance. This hardly strikes the note of sceptical independence that normally characterised his attitude. Perhaps the opportunity was taken because it arose early in the war when business was seriously depleted and this made it seem particularly attractive. The failure of the General Accident to join the tariff was clearly a blow. The best that can be said is that the branch provided valuable experience in the problems of foreign business which nourished the formulation of strategy after the war. But this was expensively bought: by the end of 1919 net premium had only grown to £1,150 and the branch had lost the company over £3,000.

At the end of the war the Scotts nursed wounds incurred in transacting various types of foreign business. The home foreign market was clearly competitive and profitable foreign development therefore involved direct underwriting abroad. Yet Canada and South Africa had demonstrated the difficulties this implied. It seemed unclear whether small markets could support the sophisticated market institutions and stable market structures which allowed non-tariff underwriting to be successful in Britain. Furthermore, if the Provincial's limits and revenue remained modest, it was difficult for foreign branches to support inevitably high costs in diffused areas. This problem arose at home as well. With Faber set on retiring, the control

of foreign business, both in London and abroad, required consideration. Could a man of ability be retained by the company without his salary swamping any revenue the company obtained? These interlocking problems revolved in Francis Scott's mind as he considered post-war possibilities.

7.5 *Marine underwriting*

The most important extension of business undertaken in the war was the opening of a marine underwriting department in 1918. In 1914 the Scotts had approached their Lloyd's brokers, Willis Faber, reputed to be the largest marine brokers in the London market, to ask if the Provincial could be provided with marine reinsurance premium income. Such was the lack of expectation of the dramatic future for the market, that this suggestion was declined on the grounds that there was insufficient business to spread over their existing reinsurers.

As Chapter 6.2 has explained, the effect of the war was to create soaring marine revenue and profitability. This posed a problem for the Scotts. It seemed wrong to let an opportunity for profitable business pass by, but it was clear that when the war ended marine insurance would contract and less well-established underwriters would suffer the full blast of falling premiums, rates and profitability.

As the boom developed, Francis Scott toyed with this conundrum. He enquired about entry. The most attractive method was to be taken under the wing of a first class marine underwriter and use his experience and connections to learn the business, paying for the privilege with a substantial commission on the reinsurance business ceded. Alternatively, the Provincial could establish its own underwriting department. This could be contemplated, even in wartime, because of the small staff required for marine underwriting. It was quite unlike any other form of insurance. The facilities of the London market allowed every vessel to be assessed from central records. It was brokers who sought underwriters rather than the reverse; no marketing staff were required. The secret of success lay in finding an able underwriter.

During 1916 Francis Scott discussed potential underwriters with his friend Raymond Willis, when he was home on medical leave. This raised the possibility of an arrangement with Willis Faber again. Raymond Willis supported this, but his brother Henry, who controlled marine underwriting, remained opposed. He wrote,

... We haven't room for another parlour account. At the present time there is sufficient business for everybody but after the war there will be a scramble for

business and rates will come down. If we took them we should want to make a profit for them which we could not do unless we wrote a picker account; and with the reduced volume of best business going after the war and everybody running the much bigger lines the war business has accustomed them to, we could only feed them at the expense of our other friends who have the first claim on it.

At this stage Francis Scott still asserted that he was unconvinced that the proposition was worth pursuing. 'The last two years have been exceedingly profitable to Underwriters' he wrote,

but we are not particularly anxious to open now, as the view is commonly expressed, that post-war conditions will be unfavourable, especially to small companies, in view of the great decline that will take place in rates and premiums, due to the absence of war risks, lower cargo values and the increased competition that will result from existing companies. Our attitude is therefore to keep an open mind now and to avoid making any arrangement unless the opportunity seems exceptionally good.

In view of these remarks, the course of events is surprising. Early in March 1918, Scott was approached by Thomas Fletcher of Plisson and Lysberg, the Lloyd's brokers who managed the reinsurance of the Provincial's new motor insurance account. Fletcher proposed that the Provincial should enter into a joint arrangement with his firm and its associated company, the British Fire, to open a marine department under the management of an experienced underwriter. Scott responded positively. The underwriter concerned was C. H. Thomas, the Cardiff underwriter of the recently purchased Northern Maritime. After obtaining evidence that Thomas was well thought of in Cardiff, the Scott brothers met him and were 'favourably taken ... he is a man to whom one instinctively takes a liking and in whom one has trust.' On this basis they made an offer which he accepted and the main heads of the agreement with Plisson and Lysberg were settled within a month of the original letter.

Was this the 'exceptionally good' opportunity that Francis Scott had sought? By 1918 the marine market had become even more inflated than in 1916. He received several opinions that the market would turn extremely sour when peace came, but while he tentatively suggested reasons why this might not occur, he seems to have relied on the view that if underwriting was undertaken cautiously, harsh conditions could be met. Yet Thomas's experience had been entirely in Cardiff. When Henry Willis was consulted, he pointed out that 'One has never looked on Cardiff as a marine insurance market but there may be a certain amount of cargo and war risk business to be obtained; anyhow the

experience to be gained must of necessity be restricted and I think there is a good deal in the impression you have as to its weighing against anyone seeking a London post over a man with a London experience.' Francis Scott was clearly aware of 'the necessity of having someone whose personality was known to and respected on the London marine market.' Against this, the Scotts set their personal attraction to the man. And the agreement with Plisson and Lysberg offered advantages. The firm had experience in the marine market through broking, and its connections with Welsh coal interests suggested the foundation of a premium income. While the Provincial became responsible for all underwriting arrangements, Plisson and Lysberg would accept double the Provincial's retention, handle reinsurance arrangements, and share expenses in a way that would make the Provincial responsible for only a quarter.

The selection of an office was critical, for success depended on brokers, and they would only attend offices convenient to Lloyd's. Within days a possibility presented itself in Cowper's Court, a few minutes from Lloyd's, and surrounded by some prominent marine insurance concerns. 'Unless we take this place,' Fletcher wrote, 'we must be content with rooms on the outer fringe, …. This would mean, however, a considerably less show of business, and furthermore the probability that we should only come in at the tail end of the slip.'

Francis Scott was shocked by the premium and rent required for the premises, and although he allowed himself to be rushed into agreement, used the occasion to emphasise the Provincial's approach;

I cannot help feeling that you are inclined to be carried away from the original intention of the arrangement, which was to start in a conservative manner and to avoid for the first few years any attempt to write in the general market. We were to rely on a few good connections and notably on your own account to supply a reasonable income. I know how easily it is to be gradually led into bigger schemes which at first consideration would have been condemned as too ambitious and I think it is well to refresh one's mind by referring back to the original intentions.

Perhaps there was, behind the vigorous phrases Scott used, a note of apprehension, for he now found himself committed to a new venture that was by no means the solid proposition previously regarded a prerequisite for marine market entry. The speed with which the Scotts had taken to Thomas, and their willingness to ignore the advice that they could face great difficulties shortly, suggests that they had become impatient to open after four years of discussion and consultation. This may have obscured the evidence that it was becoming an increasingly risky departure. Francis Scott even ignored an offer from Willis Faber to

provide marine business, made during discussions of the new scheme. It seems curiously out of character that an offer from such a gilt edged source was rejected in favour of a commitment to a new man with ill-established credentials.

The Provincial began marine business in June 1918 and in the following month joined Lloyd's. Faber provided introductions for Thomas in the London market, for he was still well known in the marine market. Business came sufficiently freely for Francis Scott to suffer characteristic apprehension, writing to Thomas after a couple of months,

I am not altogether satisfied that we are proceeding on the cautious lines which it was our original intention to adopt, at all events until you have made yourself familiar with the London market conditions and I am a little anxious not only as to the final result but also as to the reputation we may be acquiring Your own appreciation of the fact that you had much to learn of London market conditions was no inconsiderable factor with me in the confidence I felt in making the appointment, but I have the impression that the amount of business offered has to a certain extent carried you away.

By the end of the year the net premium income of the Provincial alone reached £21,205 even with its low acceptance limit of £750 on any one risk and the restriction of underwriting to total hull and cargo loss risks. A deputy underwriter was appointed in September, and in succeeding months negotiations took place to establish branch agencies in several provincial marine centres.

However, in the closing months of 1918, an ominous note was struck. Thomas had been heavily dependent on war risks business and after the armistice this collapsed. The company's Liverpool marine agent wrote in November, '... business is wretchedly slack at present'. This continued into 1919 as rates and revenue fell. During the year premium income fell to £14,028, one-third of the rate at which it had been obtained in the second half of the previous year, despite several attempts to sustain it. Additional reinsurance facilities were obtained to increase the company's gross acceptance, and the initially austere standards of underwriting were relaxed to encourage brokers. None of this made much difference and Francis Scott wrote to Fletcher suggesting that there was more to the poor results than market conditions. He suggested that both of them ought to enquire from a few of the more prominent brokers whether 'we were justified in regarding Mr Thomas's management as an obstruction to the progress of the Marine office'.

No subsequent evidence indicates the result of this investigation. However, it is difficult to see how it was possible to blame Thomas

personally. The Scotts had employed him in the full knowledge of his Cardiff background and limited London connections and experience. When the war ended, and business contracted, it was inevitable that he would be among those to be cut out of underwriting first. The cautious approach to underwriting did not make him any more competitive. The Scotts had knowingly taken advantage of a temporary market opportunity. That had been the easy step. They were to face the real problems of the venture as they tried to sustain it in a far less propitious post-war environment.

8

Profitability in wartime

Despite the disruption to its organisation and development, the Provincial remained a profitable asset for the Scotts throughout the war years. This was because underwriting remained more than sufficiently profitable to cover the depreciation in investments, with the reasonable expectation that after the war the latter would return to their normal level, providing an effective increase in reserves.

In the early years of the war Francis Scott was faced with a technical underwriting difficulty that was sufficiently serious to threaten the Provincial's non-tariff policy. Since 1909 the company's reinsurance treaty had been arranged on the basis of individual lines with four Lloyd's syndicates, each prepared to accept as much as the Provincial. Unfortunately, this was not well suited to the distribution of the Provincial's risk portfolio. Most of the company's very profitable non-hazardous risks were too small to require reinsurance. The remainder consisted of a large number of small and a few very large risks, especially from the cotton trade. This meant that each reinsurer received a rather modest income, on which a few large risks had to be carried. The reinsurers' results were thus very sensitive to a loss on such risks. In the long run, the treaty ought to be profitable, but results in individual years might fluctuate unacceptably. By 1913 and 1914, for example, each line was receiving only £4,000 to £5,000 premium income, though it carried a liability as high as £2,000 to £3,000 on some risks. In 1913 these problems were realised. For reasons that are not clear, the company suffered a generally bad experience through serious losses on large risks in classes that were in principle perfectly eligible. In that year results were also exacerbated by the outcome of the burning of the Lever bungalow, which involved the reinsurers in a substantial loss. The trend continued into 1914 with three large losses on Lancashire risks in safe classes, on which large acceptances had been made. The reinsurance syndicates had to accept a second unprofitable year. On renewal, some were inclined to give up the treaty.

This possibility was extremely serious. If other Lloyd's underwriters drew their own conclusions, the company might be unable to obtain reinsurance outside the tariff. The fire reinsurance market was in any case

TABLE 8.1 *Provincial Insurance Company: fire underwriting results, 1914–19*
(Corrected loss ratio, %)

	Home	Foreign	Canada	Total
1914	57.5	50.3	98.8	59.6
1915	54.3	53.7	18.8	51.8
1916	51.9	57.8	110.0	55.4
1917	58.0	40.1	103.4	60.4
1918	29.0	112.6	62.0	45.5
1919	44.0	122.4	35.0	52.2

becoming tighter. Underwriters were becoming more interested in fire business direct from the market and the war created opportunities in the marine market.

Francis Scott arranged that the treaty be reduced to three limits, increasing the revenue given to each to nearly £7,000, to moderate the variability of the loss ratio. This facilitated the placing of the treaty for 1915, although a second surplus treaty had to be arranged with a group of seven small non-tariff offices to provide sufficient reinsurance capacity for the largest gross acceptances. At the same time, Scott determined that surplus business must be written far more carefully; 'We are endeavouring' he wrote, ' to limit the gross losses by a more rigid determination not to write large lines except on the very best classes of risk.' This remained necessary, for a loss of £2,000 would still mean that over one-quarter of a limit's revenue had been eliminated. Of course, such caution inhibited the freedom with which acceptances could be undertaken and must have added to the problems of revenue development in 1915.

The dramatic expansion in gross premium income from 1916 helped to resolve the problem. As inflation encouraged established policyholders to increase the valuation of property and stocks, retention limits became full and surplus business spilled over into the reinsurance treaty. Acceptance limits were not adjusted in line with prices. In 1916 each line received £8,000; by 1919 this had risen to £20,000, and a £2,000 loss no longer assumed the same importance. With the technical problem removed, the success of the treaty depended on the general quality of underwriting.

Table 8.1 shows that the corrected fire loss ratio was higher during the war than in earlier years. In the two five-year periods before 1914, it had averaged fifty-three and fifty per cent. In the five war years (1914-18) this rose to fifty-five per cent. However, the same table indicates that the increase was entirely caused by the problems of foreign business: the

difficulties in Canada and South Africa and the losses on foreign reinsurance treaties, especially in the Salonica conflagration. Home underwriting maintained a corrected loss ratio with an annual average of fifty per cent which differed insignificantly from the fifty-one per cent obtained in the five pre-war years. Comparable figures from the two large tariff companies' home business are inconclusive. The Royal Exchange Assurance's corrected home fire loss ratio rose substantially from forty-one to fifty per cent between the same two five-year periods, while the Commercial Union's uncorrected loss ratio remained steady, rising insignificantly from averaging forty-two to forty-three per cent.[1]

This experience was particularly striking in view of the Provincial's heavy commitment to the cotton industry. In the early years of the war the loss ratio remained rather high, mainly because of losses from this market. The general underwriting experience of the industry was severe. The Bolton Cotton Trade Mutual, which only accepted cotton risks, suffered a corrected loss ratio of 102 per cent in 1915 and this only fell a little to eighty-three per cent in 1916.[2] More generally 'Cotton losses have been a feature of the year,' the *Post Magazine* commented on 1915.[3] This experience continued into 1916 and led the FOC to raise tariff rates on cotton risks by as much as fifty per cent, though even this did not solve the problem. The *Post Magazine* reported that 'Cotton Mills have more than sustained their reputation, despite the increase of rates effected in 1916, and, although the tariff offices now insist on the applications of average to all cotton mill policies, it is doubtful whether this will put the hazards on a remunerative basis.'[4] The difficulties faced by manufacturers in obtaining labour and cotton at reasonable prices after 1916 sustained the problems of moral hazard; rapid price inflation strained loss settlements, even after the tariff had enforced the subject to average clause; and Lloyd's competition concentrated on offering policies without this condition, forcing the companies to meet competition and lose premium income in a period when losses were rising rapidly. The Bolton Cotton Trade Mutual's corrected loss ratio averaged sixty-two per cent for the war years (1914–18 inclusive) in comparison with an average of only seventeen per cent for the five years before the war. However, apart from rather high losses in 1917, the home ratio tended to fall from 1916, reaching the extraordinarily low twenty-nine per cent in 1918. This was partly created by the release of reserves as net premiums fell, but even uncorrected losses remained very low. The capacity of the Provincial to maintain a reasonable loss ratio, despite the deterioration in its principal market, provides strong evidence of the care taken in underwriting, especially in selection against moral hazard.

TABLE 8.2 *Provincial Insurance Company: fire revenue account, 1914–19*
(Proportion of fire revenue)

	Corrected claims	Commission	Expenses	Profit	Profit
	%	%	%	%	£'000
1914	59.6	13.1	27.7	2.5	0.8
1915	51.8	12.6	28.8	6.8	2.1
1916	55.4	11.2	22.8	13.6	5.1
1917	60.4	10.3	23.0	6.3	2.8
1918	45.5	10.6	25.6	18.3	8.0
1919	52.2	10.3	27.4	10.1	5.5

Despite some increase in the overall fire loss ratio, Table 8.2 shows that fire underwriting became more profitable because of reductions in the other charges on revenue. The commission ratio fell, though not because agents and brokers received less, for those that remained in business were able to force up their remuneration. Gross fire commission rose from twenty-three per cent of premium income at the beginning of the war to nearly twenty-seven per cent in 1918. However this was offset in two ways.

The insurance companies handled the administration of the government scheme to underwrite property against enemy action in return for a commission.[5] While this created administrative problems, with a rush to obtain cover after a Zeppelin raid on Bolton in 1916, it provided an embarrassingly ample income. Even though the government cut the premiums in 1917, the Provincial earned £12,000 during the war years, concentrated in 1915 and 1916. This more than offset the rise in gross commission in those years.

After 1916 the expansion in reinsurance, on which the Provincial received 27.5 per cent revenue commission and profit commission, provided further offsetting income, which by 1918 covered sixty per cent of the commissions paid out by the company. The income from these two sources reduced net commission steadily from thirteen per cent in 1913 to ten per cent in 1919.

Chapter 6.3 has shown how, after early concern about overheads in the face of stagnant premium income, the rapid growth in business from 1916, together with the halt to organisational expansion, reduced the management expense ratio. Table 8.2 shows how it fell to some twenty-three per cent in 1916 and 1917, before rising again as peace allowed staff recruitment from 1918.

TABLE 8.3 *Provincial Insurance Company: British accident underwriting results*
(Corrected loss ratio, %)

	Employer's liability	General accident	Total
1914	52.4	44.5	50.7
1915	50.1	43.9	48.2
1916	55.8	52.3	54.5
1917	57.4	43.4	54.4
1918	62.1	46.5	58.9
1919	60.5	72.8	63.3

The same table illustrates the contributions to fire account profitability remaining after these charges on revenue. High administrative costs and losses made the early war years unprofitable, but the gradual reduction in expenses, commissions and losses provided the largest surplus earned to date in the company's history in 1916 and the highest proportionate profit on fire revenue since 1909. In 1917 the disastrous loss ratio eliminated the gains that continued to be made in levels of commissions and expenses, but underwriting improvement in 1918 provided another record year, with a fire surplus of some £8,000. In 1919 the loss and management cost ratios rose again, but the smaller proportionate margin was obtained on a far larger income and thus the surplus remained almost as large.

Reinsurance was not an important feature of accident insurance. Apart from the special arrangement to reinsure nearly all motor vehicle insurance, premium income was almost entirely retained because the loss involved on any risk was usually small in relation to the revenue obtained, minimising loss ratio fluctuations. The only exceptions were the reinsurance of death benefits under employer's liability insurance, and burglary insurance, where the expertise of a specialist company was useful. Neither of these arrangements reduced premium income by much. In 1919 only two per cent of employer's liability business was reinsured, and, leaving motor insurance on one side, only six per cent of all accident income. Thus the growth in accident business, especially as the result of the freer acceptance of employer's liability risks from 1916, was almost all available to contribute to revenue.

Table 8.3 indicates the Provincial's corrected loss ratio on employer's liability insurance, illustrating the inevitable deterioration in the loss ratio resulting from that change in underwriting policy. In comparison with a market ratio that remained relatively stable between forty-eight and fifty per cent throughout the war, the Provincial's ratio rose from fifty per cent

TABLE 8.4 *Provincial Insurance Company: accident revenue account, 1914–19*
(Proportion of accident revenue)

	Corrected claims %	Commission %	Expenses %	Profit %	Profit £'000
1914	50.7	15.6	25.5	8.1	1.8
1915	48.2	15.7	26.5	9.5	2.3
1916	54.5	15.6	22.1	7.8	2.1
1917	54.4	15.4	21.9	8.3	2.7
1918	58.9	14.9	21.5	3.9	1.8
1919	63.3	12.8	24.2	0.2	0.2

in 1915 to sixty-two per cent in 1918 and remained at sixty-one per cent in 1919. This may exaggerate the problem, because Francis Scott insisted on a very conservative estimation of outstanding claims, and the rapid rise in income implied a large unexpired liability allowance. None the less, the decline emphasised the difficulty of relaxing underwriting standards safely, for it is always hard to determine in advance how far concessions should go. Once undertaken, it then becomes difficult to tighten up without antagonising branches, brokers and policyholders.

Although the general accident business was still written on a selected basis and therefore provided a superior experience to employer's liability, the scale of the latter meant that it continued to dominate the accident account. In the early war years, before the change in underwriting policy, the loss ratio remained low, providing relatively profitable business, though on a small scale. As Table 8.4 shows, after 1917 the rise in the claims ratio was only partly offset by falling relative expenses, and so profitability began to fall and the account barely broke even in 1919. The combination of modest profitability and a far larger account meant that for the first time the company's prospects were heavily committed to the success of accident underwriting. It could no longer be regarded as a marginal complement to fire insurance, for even a modest proportionate loss on the account could seriously reduce the company's overall profitability.

This is emphasised in Table 8.5, which brings together all the contributions to the company's profitability. Investment income grew steadily. From 1914 to 1918 the accident surplus changed little as an expanding income was discounted by falling margins. The overall surplus therefore moved in step with fire profits, improving to 1916, collapsing in 1917 with the serious fire losses of that year, and then improving again in 1918 with

TABLE 8.5 *Provincial Insurance Company: sources of profitability, 1914–19*
(£'000)

	Fire surplus	Accident surplus	Investment income	Total surplus
1914	0.8	1.8	5.3	7.9
1915	2.1	2.3	5.7	10.0
1916	5.1	2.1	5.5	12.8
1917	2.8	2.7	6.3	11.8
1918	8.0	1.8	6.8	16.6
1919	5.5	0.2	7.1	12.7

the remarkable recovery in that account to reach a wartime peak of £16,600. However, in 1919, the fall in fire profitability was matched by the collapse in accident profitability, which reduced the surplus to the level of 1916 at £12,700. Yet this was no more than an ominous portent for the future. The fact remained that the Provincial continued to underwrite sufficiently profitably to remain in business, and that was the crucial objective.

Dividend policy was governed by two considerations. The profit and loss account had to carry the cost of writing down the investment portfolio in five of the six years from 1914 to 1919. This absorbed all underwriting profit, so that the Scotts could not have broken their convention of only paying dividends from investment earnings, even if they had wished to do so. Indeed, in 1916 it was only possible to maintain the level of dividend payments by reducing the profit and loss balance. The dividend remained at the five per cent level established before the war, until 1918, when investment income had grown sufficiently to cover a ten per cent payment. No further depreciation in the portfolio had occurred, underwriting profits were favourable, and the end of the war seemed to offer security against further difficulties. It was even possible to increase the company's reserves by £5,000 and write off a loss of £2,500 on foreign exchange dealings caused by the collapse of the rouble and the disappearance of the Russian Mutual reinsurance treaty. Despite further investment depreciation in 1919, the new dividend level was maintained.

Estimating the developing capital value of the company is difficult. Its book valuation suggests a minimum of £118,342 of shareholders' funds, after the deduction of the £6,000 shortfall in investments, only some £3,000 more than in 1913. But this was because investments had been written down and book reserves had not been increased. If the book depreciation is viewed optimistically as a temporary wartime problem,

then it could be regarded as an addition to the reserve fund and would suggest a company net value of £143,342. This can be compared with the more realistic method outlined in Appendix B. This suggests a minimum market value for the company of £240,000 in 1919. Supplementing this with the dividend disbursements made suggests an internal rate of return of 10.6 per cent for the years between 1913 and 1919, when the average yield on consols rose to 4.1 per cent.[6] The returns on the Scotts' investment were rising in comparison with the 6.7 per cent achieved before 1914. The reason was simple. It lay in the continued expansion of revenue in relation to assets. In 1913 underwriting revenue had only amounted to one-third of assets; by 1919 it had risen to two-thirds, on which, with the exception of 1919, a significant surplus had been earned on both the fire and accident accounts.

The Provincial remained a desirable property. In 1917, when several other well founded non-tariff companies were purchased, two approaches were made to the Scotts. The foreign reinsurance treaty arrangements with the North British and Mercantile were accompanied by 'thinly veiled overtures', while shortly afterwards, Sir Charles Behrens was commissioned by the Commercial Union to sound Samuel Scott out as to a sale.

Later, in 1919, Lord Leverhulme proposed that he should take over the Provincial by purchasing control and giving the Scotts preference shares. They rejected this offer, but suggested that he take ten per cent of the Provincial's ordinary shares and put his son on the board. However, Leverhulme was not interested in an arrangement where he did not have complete control.

The only direct evidence as to the Provincial's value arose a little after the end of the war, in the course of negotiations for the purchase of the Drapers' and General in 1921. Francis Scott argued that if Provincial ordinary shares were released, he would value them at £3. This placed a value of some £270,000 at that date, after discounting an extra £50,000 incorporated into the capital structure in 1920. Allowing for his interest in a good deal and the compensation he would seek for the loss of independence, this seems reasonably in line with the estimate of the value in 1919 offered above.

These suggestions confirm that the Provincial had weathered a period of great difficulty with comparative success. It had continued to expand into new markets and sustain profitability. This had been made possible by the fact that neither of the Scotts nor several of their principal officials had been called up. Given Francis Scott's ill health, his brother's availability as an active and willing alternative executive had been essential. Women had proved more than capable of taking the place of men recruited

for the army. Without these conditions, the Provincial would almost certainly have disappeared into the ownership of a large tariff company. Continued operation allowed the company to take advantage of market expansion; in several years underwriting profitability was more than adequate; and the investment market provided an ample yields.

Problems discounted these benefits. The Lancashire cotton industry was beset by severe competition which threatened the Provincial's most profitable and secure business. There was little to be done to rectify this situation, beyond a resolve that when the war ended, the company must diversify the sources of its business. The other difficulties were self-imposed. The South African branch and the marine department were both rather impulsive responses to the apparent shortage of premium income in the early war years. By 1919 they were becoming serious problems. And the commitment to expand employer's liability business had begun to run into difficulties that could only be assessed when peace and normal industrial conditions returned.

With the end of the war it was hoped that these problems could be resolved and a wide range of new schemes considered, which depended on the availability of experienced and able staff. Having survived the strains of war, the Scotts turned to the opportunities they hoped to develop in peace.

PART

III

Competitive expansion

With the end of the war it became possible to contemplate expansion again; normal occupations were resumed and markets re-adjusted to peacetime conditions. In the two subsequent decades the Provincial's business was to grow to an unprecedented scale. Diagram 5 shows how between 1920 and 1938 net premium income rose from £225,000 to £1,518,000, in a period when prices fell. The Scotts could scarcely have anticipated this expansion when they laid their plans for post-war development, for it was achieved in a quite different market environment from that within which the Provincial had developed before 1914.

Of course, the Scotts did not foresee the scale and nature of all this development. The characteristics of the new market environment were only revealed during the early 1920s. It would therefore be foolish to suggest that they planned the Provincial's development. However, the company's growth was at least as much the result of deliberate strategy as a passive response to market developments. The most important phase of strategic development took place in the immediate post-war years. The Scotts were at last able to institute some of the schemes they had contemplated, but

had been unable to realise, during the war years. They were seized of the importance of creating as quickly as possible a more ambitious framework of operation that would place the Provincial in the best possible position to take advantage of any new peacetime opportunities that might arise. These proved to be consonant in direction, if not scale, with the subsequent course of events.

Francis Scott had taken the Provincial into the motor insurance market in 1916, explicitly to ensure that it gained sufficient experience to be able to develop the business later. Immediately after the war, he freed the company from reliance on its initial mentor, the Excess. A major expansion of the company's branch office organisation was set in hand, so that by 1922 the Provincial was represented in every British city with a population of over 250,000. In 1920 foreign underwriting was placed on a new basis designed to allow it to grow more freely and expand its direct operations in overseas markets. A new marine underwriter was appointed. In the motor insurance, foreign and marine markets, the company entered into special arrangements with British Fire, another small, reputable non-tariff company, in order to share some of the overhead costs that bore heavily on small insurers. In 1923 the Drapers' and General Insurance Company was purchased, in the hope that its trade connections would strengthen opportunities for developing business among retailers.

Alongside these commercial developments, the Scotts also placed the relationship between themselves and the company on a more secure basis. Chapter Nine describes how the Provincial's head office was moved to Kendal in 1919, near their Lake District homes, and its capital was re-organised to ensure that growth could continue to take place without prejudicing the security of family assets. Perhaps partly to compensate for this retreat to Arcadia, the company's connections with London were strengthened. A more imposing London office was taken at 32, Old Jewry in 1920. The management of its financial affairs was transferred to London from Manchester. J. M. Keynes and O. T. Falk were invited to join the board to introduce the company to the City of London. Chapter Fifteen shows how Keynes's subsequent influence on financial management was dramatic, placing the company among the pioneers of equity investment among insurance companies.

Within this new framework the Provincial faced drastically changed new circumstances, for the war ended the conditions that had determined the environment of Edwardian insurance. Declining world demand for British exports and domestic financial policies meant that in the inter-war years the traditional industries that had provided the bulk of demand for fire and employer's liability insurance suffered from a profound and

If you drive a car

These rates will interest YOU

IMPORTANT PROVINCIAL BENEFITS INCLUDE :

- Personal accident benefit to both Owner AND WIFE.

- Generous "NO-CLAIMS" Bonus — 15%, First Year, 20%, Second Year and each successive year.

- Transfer without loss of bonus.

- Special rates for country residents (5% reduction for approved areas).

- Up to 25 guineas Medical Expenses.

- Repairs can be commenced AT ONCE by insured's selected repairer.

EXAMPLES OF COUNTRY RATES.

"COVER ALL" INSURANCE			
MAKE	10 h.p. £200 value	12 h.p. £200 value	15 h.p. £300 value
Morris and Austin	£10 7 0	£10 18 3	£13 3 3
Other makes (except Fords)	£10 18 6	£11 10 6	£13 17 9
	8 h.p. £200 value	14.9 and 24 h.p. £200 value	30 h.p. £250 value
Fords	£9 19 6	£11 10 6	£14 19 3

PROVINCIAL
INSURANCE COMPANY LTD.
CHIEF OFFICES : 32 OLD JEWRY, E.C.2, & STRAMONGATE, KENDAL

'If You Drive a Car' (motor insurance advertisement, 1935)

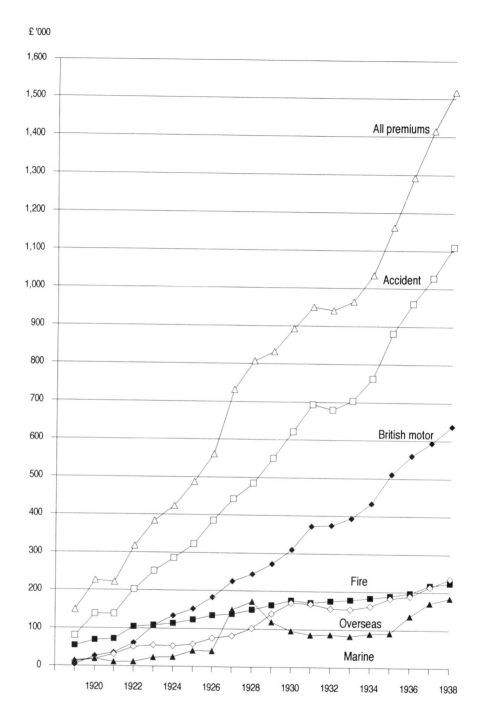

£ '000

DIAGRAM 5 Provincial Insurance Company: net premium income, 1919–38

prolonged reduction in output. Chapter Ten shows how this reduced the scale of premium income available and the profitability of underwriting. Foreign and marine insurance were similarly beset by international depression and currency instability.

The Provincial was disproportionately affected by these problems. It was heavily committed to the cotton trade and, as a new, marginal interloper in marine and foreign insurance was naturally at a disadvantage. Before the war the company's business had been borne along by the swell of the last great boom in Lancashire cotton. The rather artificial conditions of the post-war boom briefly re-established this emphasis. However, Chapter Eleven describes how the subsequent collapse in the trade created serious problems for its fire and accident insurers. As a result of falling revenue and profitability, by 1928 the Provincial had almost entirely given up the writing of cotton fire risks. Beyond this, the general fire and accident account in Lancashire, which had formed the central core of revenue and profitability before 1914, had been severely affected by the wider consequences of cotton's collapse. Thus, just as the company adopted a more metropolitan perspective in the handling of its financial assets, Bolton and Lancashire became of diminishing significance in the company's underwriting accounts. Beyond the county, similar circumstances affected the insurance business it had written in other traditional industries. As a result home fire and general accident premiums (excluding motor insurance business) fell from seventy-eight per cent of all premium income in 1920 to twenty-one per cent in 1938.

Chapter Ten explains how the insurance market found some compensation through new fire and accident insurance policies. But this was of little significance compared with the explosive growth in motor insurance which created buoyant new business for the companies at home and abroad. Between 1920 and 1938 British companies' motor business grew from between £6 million to £38 million. The Provincial seized this opportunity. Diagram 5 shows how by 1938 its home motor insurance business had grown to £699,000 and accounted for nearly half of the company's net premium income. A significant motor business was obtained abroad as well.

This success was only possible because the market grew so quickly, but it was by no means a passive response to external changes. Partly because of its rapid growth, the motor insurance market was intensely competitive, yet Chapter Eleven explains how the Provincial was able to devise marketing policies which allowed it to expand its market share significantly.

This achievement was so substantial that it brought its own problems.

32, Old Jewry (Provincial London office, 1920–37)

By the late 1930s the Provincial was widely regarded as a specialist motor insurer and many intermediaries were scarcely aware that the company transacted other classes of business. The increasingly heavy commitment to the motor insurance market brought special risks. Motor insurance was underwritten on margins so slim that they were difficult to maintain when competition became severe. This was especially difficult because the company was in competition with longer established insurers who used large and profitable accounts in other markets to treat the motor insurance market as a 'loss leader'. By contrast, such a large proportion of the Provincial's business was derived from motor insurance that it was essential for the company's survival that it be underwritten profitably.

On the other hand, motor insurance allowed a far wider geographical range of markets to be exploited. The Provincial's successful motor underwriting attracted sufficient revenue to support the cost of an organisational development which consolidated marketing strength. Chapter Twelve tries to explain the mechanism which lay behind the expansion of a marketing organisation which by 1938 directly represented the company in local markets throughout the United Kingdom, from the north of Scotland to the far south-west of England. This more intensive representation extended revenue winning capacity. While it was financed by motor insurance business, and principally directed towards servicing it, the wider representation created the possibility of a broader basis for business winning for all classes of business and helped to insulate the company from competitive pressure, raising underwriting margins in all markets.

Chapter Thirteen describes how motor insurance also provided the most important element in the company's development of a far larger overseas business. The modest overseas account had only reached £18,000 in 1920. In the early 1920s little growth was achieved in the face of the extreme international economic and financial difficulties which had such a serious effect on the traditional sources of business. Diagram 5 illustrates that by 1938 it had grown to £235,000, providing some twenty per cent of the company's underwriting income. This was only made possible by the creation of a more extensive organisation at home, foreign agencies, and an important branch organisation in South Africa which complemented the managing agency in Canada, all of which were largely dependent on motor insurance. Chapter Fourteen traces the rather less satisfactory experience in the marine insurance market where the wartime entry, under temporary boom conditions, proved hard to justify in the depressed maritime conditions between the wars. Despite this, Francis Scott stubbornly continued to try to place the business on a profitable basis, rather than cut his losses. In the course of this the Provincial purchased

the Hull Underwriters' Association a marine insurance company originally based in that port.

Growth was therefore the central objective of the company's development in this period, as learning had dominated the years before the war, and resource constraints, the war itself. The engine driving this development was the company's capacity to compete successfully and profitably in the various markets in which it operated. This was especially the case because, although the Provincial did diversify into new markets such as South African motor insurance and Goods in Transit insurance, the crucial element in the company's growth lay in its increasing success in a narrow range of markets within which it combined revenue growth with maintained profitability. While pre-eminently true of the home motor insurance market, it was also the case in a shift towards more profitable underwriting in the fire and accident insurance markets as well. This strategy was only successful because the Provincial pursued underwriting and marketing policies that were well suited to the opportunities offered by the competitive structure in each market, described in Chapter Ten.

9

Family concerns and wider horizons

Although the Scotts maintained their ownership and control of the Provincial through the inter-war years, the relationship developed in new ways. This was partly because their personal circumstances changed; partly because the sustained growth of the company raised problems which could only be resolved by new approaches to organisation.

The most obvious consequence of family ownership resulted from the Scotts' wish to live in Westmorland, yet continue to manage the Provincial directly. Both brothers also became aware that their increasing age and family responsibilities required them to consider the future management of the company, especially bearing in mind its increasing scale and complexity. Ultimately they were forced to plan to protect their families and the company against the eventuality of either of them dying unexpectedly.

The family ownership of the Provincial raised practical busines problems as well. Other companies generated business through their directors and shareholders, who had an incentive to support the company energetically. If the direction and ownership of the Provincial was monopolised too closely, it would operate at a considerable disadvantage in this direction.

These problems lay behind a number of important changes in the company. The Provincial's head office was transferred from Bolton to Kendal in 1919. The company's capital structure was transformed in 1920 and again in 1933 in ways that allowed a broadening of share ownership and some protection against the more frightening consequences of the death of either Scott brother. The board of directors was considerably expanded, partly with a view to increasing the company's influence, partly to draw others into its direction, especially that of financial management. There were changes in the general management of the company as well. In 1933 a senior executive was appointed at head office to assist Francis Scott. By 1939 he had been given the title of general manager.

However, there should be no misunderstanding. These changes in ownership and control were adjustments that in no way conceded any more than was necessary to protect and strengthen the fundamental basis of the Provincial, which was that it remained almost exclusively the property of

the Scott family and Francis Scott continued to exercise a close central control over all its affairs.

9.1 *The move to Kendal*

The first of these changes – the transfer of the head office to Kendal – was planned during the war and implemented quickly in 1919. It symbolised a sense of the energy that had been pent up during the war years, but could now be released in the pursuit of long-considered objectives. At the same time, a new generation of branch offices were opened and new arrangements made for the organisation of motor, foreign and marine underwriting. A new phase of development could begin.

James Scott had often thought about moving from Bolton to a country estate that might be managed and eventually inherited by Samuel Scott. The idea of linking this with a Provincial head office caught Samuel Scott's imagination and recruited him to the Garden City movement in vogue after the publication of Howard's *Tomorrow* in 1898.[1] He wrote,

it is in accordance with the trend of things – Lever – Cadbury – Garden Cities. The concentration of the population in towns is deplored generally … it becomes almost a duty, wherever it is possible, to counteract (even in a small degree) this unfortunate state of things. The garden city idea is a practical expression of this.

Francis Scott suggested that a model village could be built to house staff and a large shed erected to serve as a main office. From time to time various estates on the market were inspected, particularly in the home counties and the Dukeries.

The premise behind this idea was that the two brothers wished to live in close proximity and retain close control of the company. Francis Scott was emphatic in dismissing the alternative of a general manager, for this would mean

the nullifying of the whole object for the foundation of the Provincial viz: to provide a family business under the active control of the family. It would reduce my position to one of merely general and directorial control and take away the daily touch with business which it had always been and is, as strongly today as ever, my wish to exercise.

The move to Kendal was therefore founded on these personal considerations and no more elaborate rationale is necessary.

Inconsequential discussions took place for a number of years. After James Scott's stroke in 1909, he became less willing to contemplate major

disruptions in his life. The idea of purchasing an estate further south evaporated and instead, he concentrated on the development of his Windermere farmhouse.

This did not disappoint his sons.[2] Since their childhood they had enjoyed Westmorland. There was the small farm to manage. They shared their father's enthusiasm for sailing on Windermere and took part in the usual round of country sports. Samuel Scott concentrated on less athletic interests, developing a passion for topography that became an expression of his affection for the Westmorland countryside. In 1904 he published what became a classic study of the Westmorland village of Troutbeck.[3] He became involved in conservation, playing an important role in the early days of the National Trust. He supervised the construction of a new wing for his father's house near Windermere in 1910 and selected suitable period furniture.[4]

The two brothers were also accumulating family responsibilities. Samuel Scott married Carmen Heuer in 1905; Francis Scott married Frieda Jager in 1911. By 1913 they both had young families and were anxious to establish settled homes. Both felt it impossible to remain in Bolton; 'The town ... had changed greatly in character ... since the older generation of the Haslam family had been living there, in houses then in the country, at some distance from the encroaching town.' Matters were brought to a head by medical considerations. Samuel Scott's wife and Francis Scott both suffered from ill health which their doctors advised them would be helped if they moved from Bolton's damp atmosphere. The two brothers therefore approached their father with the proposal that the Provincial's offices be moved to Westmorland.

James Scott was taken aback. He was less robust after his stroke, but it is easy to feel sympathy for his reaction. Samuel Scott described this, 'In his later years [James Scott] ... went back on his earlier ideas, and became more and more imbued with the feeling of duty to the community in which one's money has been made.' He procrastinated, arguing that he was too old for such a move; that it would harm the family connection in Bolton and such institutions as the local bank. Then he compromised, suggesting that the move be postponed until his proposed retirement in 1915, when he would be 70. His sons accepted his view philosophically, agreeing that it was not entirely rational, but a 'not unnatural instinct' and 'the move might after all come off earlier than the two years if father got used to the idea.' So, although the move was postponed, it became clear that it would be to Westmorland. Samuel Scott purchased Linthwaite, near his father's house, for his family. Francis Scott later moved to nearby Matson Ground in 1915.

James Scott's death later in 1913 removed personal obstacles to the move, but the war postponed implementation. Instead its contemplation and planning became a pleasant escape from reality. Francis Scott presented the idea to the board in 1915. While its members had no control over the company, they represented Bolton interests and it was important to handle them carefully if the company's connection in the town was to be protected.

Francis Scott balanced advantages and disadvantages. The benefits for the business sounded rather thin. There would be economies in rents, rates and some salaries, though qualified staff might require more to be persuaded to move to an isolated town. More solidly, he suggested that a new head office would give an 'impression of permanence Any official who is on the outside staff will at once admit that one of the commonest objections in the mind of the General Public is the conviction that the Company will follow sooner or later the course of so many others – amalgamation.'

The disadvantages were quickly discounted. Kendal was no more isolated from new movements in insurance than Bolton. Important interviews could take place at the London or Manchester branches which could feed back insurance news. The task of head office was to carry out administration that could be done within a day's post of all the main business centres. A recent lecture to the Insurance Institute of London had recommended the decentralisation of administrative work to provincial centres.[5] Senior staff would increasingly be found by internal promotion from branches and men found in this way would happily come to Kendal.

The risk to the company's Bolton connection was now less important as local business only amounted to about one-sixth of the company's net premium income. It was less dependent on personal influence since James Scott's death and more a business matter with well-established agents.

Finally, Francis Scott assessed the financial implications of a move. If £6,500 were allowed for a new head office in Kendal, there would still be a saving of £50 each year, because of the saving in capital costs and rates on the existing Bolton head office. The important extra expenses would be those of a separate branch at Bolton of some £400 annually, and a £450 bonus to staff moving to Kendal. Thus the company would be involved in extra annual expenses of £850, offset by the additional premium income available through the office in Westmorland, previously untouched by the company's marketing. At worst, he estimated, the expense ratio would rise by one per cent.

Colonel Hesketh and William Haslam raised no objection. The courtesies had been performed and they had no inclination to interfere in what was

the Scotts' affair. The former soon left the board and the latter died. At least their presence had made Francis Scott mount a systematic justification of the decision, though it is impossible to relate his estimates to the actual course of events because of subsequent inflation, which transformed all costs.

Once decided in principle, the next step was to find a suitable office. Despite the earlier romantic notions of a model village in rural surroundings, it was decided to open in Kendal, in order to take advantage of the insurance business the town offered. To make the most of this, Francis Scott persuaded his brother that they ought to look for 'a large and substantial Office building and a good situation' despite Samuel's worry that expensive offices might be a dead asset if they came to sell the company. It was a return to the old theme of security in liquidity and their differing commitment to the company. Eventually he consoled himself with the thought that 'one's pride and pleasure and personal prestige may be worth paying for.'

Sand Aire House, 1917 when the Scotts purchased it.

Samuel Scott became responsible for the search for premises because of his brother's ill health and as he was more regularly in Kendal. Although it was unlikely that any move would take place until after the war, he obtained initial suggestions from local estate agents in February 1915. Several properties were examined with the help of J. F. Curwen, an antiquarian friend of Samuel Scott who was a local architect. They included sites next but one to Kendal Town Hall, which was thought too expensive, in Stricklandgate and Stramongate, and two on either side of Stramongate Bridge. In most cases they were undeveloped or currently occupied by poor property that could be demolished inexpensively. However, between the two Stramongate Bridge possibilities stood what Samuel Scott described as a 'large stone mansion' upon which he 'cast envious eyes from the first'. As early as October 1915, agents were asked to enquire whether its owner would consider selling, but he was not interested. In 1916 it was almost decided to settle on a house in Stricklandgate, when the owner of the 'mansion' died. After a little delay, his executors opened negotiations for sale. Francis Scott was in Bath undergoing medical treatment, but as soon as he returned the two brothers went to Kendal in March 1917 and concluded the sale in a day, paying £1,350. 'Once having seen the right place', Samuel Scott wrote, 'we made up our minds with decision and rapidity – in contrast to the indecision of the past, which was quite justified'.

It is easy to understand their enthusiasm. Sand Aire House combined utility and atmosphere. It offered ample space for the transfer of head office staff with spacious rooms on three floors and enough surrounding land for the construction of planned extensions. But beyond this, 'It is a fine house …. The dining room is a beautiful room …. It is good looking and details have a pleasant late Georgian flavour, i.e. pretty cornice of wreaths round the dining room, but nothing really striking as it is too late – 1827.' The facade hit the right note; '… the entrance shows well from Stramongate. It is an ordinary door, with characteristic pilasters. It is hardly wide enough for an important appearance but not inconsistent with such a place as an old fashioned country bank.' Thus the Scotts found a house which ideally suited their taste for understated distinction and well within their earlier estimate of £6,500.

Samuel Scott set in hand the fitting out of the house for the eventual move when the war was over. He wrote to his brother with relish,

There is no doubt that one has to make up one's mind as to what is required, and that the architects are only useful in working out details. One finds this even in a private house, and it is much more so in the case of a business, where the

architects cannot possibly be familiar with the requirements. I think that it is advisable to make up our minds on the general scheme of what we may call the 1920 building, so that any alterations necessary for our temporary habitation may be in conformity.

Curwen, the local man, and the Scotts' Bolton architect were commissioned to work up suggestions into plans and did so by October. Then delays began, for a building licence could not be obtained. A limited scheme, not requiring rationed materials, was pieced together.

Even these modest works proceeded slowly under wartime conditions. Curwen, who oversaw it, reported 'The work is going on but woefully slow. The few men that are left to the trades go from one job to another, trying to please everybody, but actually pleasing none. You cannot flog them and unfortunately it is known that we are not in a vital hurry'. The announcement of the armistice in November 1918 was a spur to complete arrangements and by March 1919 the final touches were being put to decoration.

These last stages were hurried because in January it had been decided to move at Easter. The first trip was made on 17 April, when Francis Scott and Barber travelled up from Bolton with financial securities. The next day the first van arrived with the main body of documents and furniture. By 23 April Samuel Scott could record in his diary, 'Yesterday some sort of order appeared out of the chaos at Sand Aire. Today F[rancis] and I left by the 9 a.m. train and got out at Kendal for the first time. Both of us enjoyed our first day at work in the new board room. Great fun getting things into order.'

A demonstration of the Provincial's new presence in Kendal was provided by a champagne reception for local notables; the local press announced 'Kendal to become Insurance Centre.'[6] A measure of their local impact was provided by the opening of several new branch offices by other companies.

Thus the Scotts achieved their objective. From the purely personal point of view it was a great success. Samuel Scott wrote shortly after,

I am deeply in love with Kendal and delight in its quaint old streets and the pleasant leisurely life and being among gentlemen again. The motor run [from Windermere] is a great pleasure and what a country it is to have as one's real home, not just a residence, but the scene of one's work and life Sitting in our beautiful board room, with the window thrown open and the sun pouring in, seems like heaven after Bolton.

The planning of the move had provided him with an absorbing task well

suited to his interests and talents and had been a token of better times during the dark days of the war. Sadly, the months before the move had been disastrously overshadowed by the sudden early death of his wife. The new life at Kendal provided a fresh start for him, although it was all too easy for him to imagine 'how happy it might have been '.

Twenty-three staff moved from Bolton and accommodation was found for them without great difficulty. Senior staff bought houses with loans from the company, while younger staff were placed in lodgings. A few, no doubt homesick, returned to Bolton, but demobilisation made it easy to recruit locally. Within a short while the new office employed some fifty staff, nearly all young men, and had begun to make an impact on the local labour market.

9.2 Capital, ownership and control

Before 1920 there had been no dilution in the Scotts' ownership and control of the Provincial. It would be misleading to suggest that this took place to any significant degree during the two following decades. None the less their exclusive proprietorship began to raise problems that required resolution if it was to be maintained. The most important of these arose from the passing of time. By 1938 Samuel Scott was sixty-three and Francis Scott fifty-seven. During the inter-war years they thus passed from an age when mortality is acknowledged to that when it has to be faced. This had implications for their ownership and control of the company.

The first of these became apparent during the war years. James Scott had owned practically all the shares in the Provincial. On his death, they had been divided into three broadly equal parts held by his widow and two sons. It was soon realised that this created complications. On the formation of the company an uncalled liability of £90,000 had seemed an attractive way of utilising James Scott's wealth to create an appearance of substance for a young company. But this became an embarrassment for his sons. If either were to die, their executors would probably be unwilling to hold such a liability and be forced to sell shares and a substantial degree of family control and participation in future profitability would be lost.

Samuel Scott raised this with the family's financial advisers in 1916. For several years the two brothers engaged in complicated consultations. The alternatives appeared to be to pay up the uncalled liability, sell shares or obtain court approval to write down the company's capital.

The first was unattractive because it would increase the family commitment and require the liquidation of other assets. Francis Scott was particularly keen to retain his funds for private investment ventures; ' ... I

see decided advantages for myself when I have more loose cash to invest and I think without speculating, I can make money.' A scheme whereby the uncalled liability would be paid off by bonuses declared on shares was also rejected because it would take time and slow the growth of reserve funds.

Selling shares was also rejected. Francis Scott wrote,

…the company is earning substantial profits, and the shares have already doubled in value. As the company is only just beginning to reap the reward of fifteen years' patient work, it is considered that the potential value of the shares is still greater. The simple procedure of selling shares at to-day's price does not commend itself. The family desire to hand on to the next generation this valuable property and to retain the profits in their own hands.

Writing down the uncalled liability was also ruled out because the Chancery Court would require the approval of all policyholders. The prospect of circularising them for permission could not be contemplated, for unfavourable comment would certainly arise and unanimous approval be unlikely.

Eventually Stenhouse, the Glasgow broker, produced a clever solution. Three new types of shares were created and exchanged for the existing £10 share on which £5 had been paid: 50,000 £1 cumulative participating preference shares fully paid; 16,000 £5 'A' ordinary shares with 37s 6d paid with strong voting rights and 10,000 £5 'B' ordinary shares with £1 paid and weak voting rights. This covered the £90,000 already paid up. Then the Scotts called up a fresh £50,000 on their new 'A' ordinary shares which eliminated that element of the uncalled liability. They now held a substantial block of their shares in the form of preference shares which could be sold to cover the money raised to pay up the ordinary 'A' shares, without mortgaging their interest in future profitability or control. They also had transferred the whole of the remaining liability to 'B' ordinary shares with modest voting rights, which could be sold without endangering control and in sufficiently small holdings that the owners would not feel the uncalled portion a liability. Table 9.1 illustrates the change.

The re-organisation not only reduced their commitment. Francis Scott wrote to his brother,

One of the greatest weaknesses of the Provincial is, … that it has so little connection to work upon other than what it is making as it goes along. I cannot help being impressed with the volume of business the British Fire has derived from its directorate and to a considerable extent from its shareholders, more particularly on the agency side.

TABLE 9.1 *Provincial Insurance Company: capital re-organisation, 1920*
(Issued capital)

	Funds	Uncalled liability
Original structure		
18,000 £10 ordinary shares with £5 paid	£90,000	£90,000
New capital structure		
50,000 8% £1 cumulative preference shares fully paid	£50,000	
16,000 £5 'A' ordinary shares 37s 6d paid	£30,000	£50,000
10,000 £5 'B' ordinary shares £1 paid	£10,000	£40,000
Uncalled liability on £5 'A' ordinary shares paid up	£50,000	less £50,000
Total (new capital structure)	£140,000	£40,000

The Provincial needed new points of influence. A more widely held equity, especially by brokers and agents, would be an important asset. Francis Scott envisaged a wide sale of preference shares and the careful distribution of 'B' shares to the best agents.

In fact, this took place in a way not originally envisaged. The preference shares were used to buy the Drapers' and General in 1921. In this way they came into the hands of 600 separate shareholders. The 'B' ordinary shares, carrying full rights to participate in profits, were only released on a modest basis, possibly because the sale of the Haslam cotton business in 1920 provided the Scotts with sufficient liquid funds for the time being. They retained control over their transfer and preserved an option to repurchase. One-third were sold during the 1920s, and when repurchases are taken into account, rarely more than one-quarter were outside the family at any time. The principal beneficiary was A. R. Stenhouse, who received 100 in 1922 as a gift for facilitating the purchase of the Drapers' and General and purchased others later. The only other brokers to participate were the Bains, Stenhouse's partners and W. H. Harris of London.

Directors and local directors purchased holdings on election, but relinquished them on resignation. W. H. Haslam, a cousin of the Scotts, who became a director in 1923, was the only individual allowed to buy 'A' ordinary shares, though a few senior employees held them as a result of the conversion terms in 1920, having held small blocks of the original shares.

By the early 1930s however, a similar difficulty arose. Through the 1920s the implications of estate duty became more apparent. There were sharp increases in the rates payable on large estates in 1919, 1925, and particularly in 1930.[7] This raised the issue as to whether it would be possible for the Scott brothers to continue to control the Provincial. In principle, on the death of either, it would be necessary for substantial duties to be paid in cash. Even if this could be raised outside the company, it would have the undesirable effect of substantially increasing the family's commitment to the company over the generations and could not be maintained indefinitely. The alternative, of realising Provincial shares, would quickly erode control and sacrifice participation in profitability that had been built up over many years.

This exercised the two brothers sufficiently to raise the question as to whether it would not be better to sell the Provincial and develop some alternative arrangement for family resources. There was little doubt that an attractive price could have been obtained as its success in the motor insurance market became apparent. Had the advantages of sole proprietorship evaporated? Would it be better to sell out and then use an investment trust to carry the family assets? Even the private company form was disadvantageous when it made the company liable for surtax.

With this in mind, the brothers went back to first principles and reconsidered the issues that had made the idea of an insurance company attractive twenty-five years before. On balance, even Samuel Scott was convinced that it was better to stay with the Provincial. Experience had shown that managing an insurance company was far less demanding than the general run of industrial or commercial concerns. Much of its dynamism depended on the ability of a large group of branch managers who were unlikely all to make bad mistakes at the same time; the spread of business across a number of markets also increased security as they were unlikely to all become unprofitable at the same time; the need for careful investment management provided a protection for family funds and investment in an active company gave a dynamism to family wealth unlikely in a purely investment trust. In any event it was unlikely that the company would become any less easy to sell over time, so that if the personal advantages diminished, it would not become any more difficult to

liquidate. The only serious difficulty which offset these advantages was the long gap in management succession created by the age of their sons, but this could be accommodated in ways that will be described below.

Having established a firm continuing commitment, plans were set in hand to re-organise the company's capital structure to protect its owners against a sudden need for liquid funds. In 1933 and 1936 two re-organisations converted existing ordinary shares into new 25% Cumulative Preference Shares. These could be sold at any time for cash, without relinquishing any voting control or sacrificing a major element of the growth in future profitability. If and when either brother died, they could be sold to cover the cost of death duties.

This arrangement provided another advantage. The company's rapid growth through the inter-war years had required substantial finance which had been provided by the continued retention of a large proportion of profits to build reserves. Furthermore, increases in the taxation of income had discouraged the payment of high dividends. This had placed the Scotts in the paradoxical position that they owned an asset of very substantial worth, in which they were continually investing for their children's benefit. Yet this meant that their income in no way reflected the company's capital value. As they became older, they both began to feel that the commitment to the future was becoming rather overdone. Both wished to obtain funds to enjoy in their own lifetime or invest elsewhere. The creation of the new preference shares provided an asset that could be sold without sacrificing future profitability or control. Substantial blocks were sold to the British Shareholders' Trust to raise funds in this way.[8]

The Scott brothers' increasing age also required them to face up to the issues of retirement and management succession. Samuel Scott withdrew from active involvement in daily management in the 1920s, though his broader interest in the company's affairs remained keen. He continued as Chairman and, as such, attended board, finance, marine and foreign committee meetings with regularity. He was frequently involved in work on the company's behalf in London and appraised all candidates for senior positions. He played a central role in negotiations for the purchase of the Drapers' and General and the Hull Underwriters' Association in the 1920s. He took a close interest in the development of the company's properties, especially the head office at Kendal and the new London office. Beyond this he engaged in a continuing discussion with his brother on company strategy and the way in which the Provincial served its owners' interests, in a way appropriate between an non-executive chairman and managing director. However, he expanded his commitment to a wide

Sir Samuel Haslam Scott, Bart., 1940 (1875–1960), Provincial Director 1903–60 and Chairman 1913–46 (after W. Rothenstein).

range of other interests that were more congenial than daily work at the Provincial. His happy second marriage in 1920 and resulting second son must have proved a powerful counter-attraction. He published several books, which met with critical success, and joined the board of a London publisher.[9] He continued to be involved in a number of benevolent institutions in Bolton and financed a major investigation into cancer. In Westmorland he took his place as a leading local landowner, becoming Chairman of the Westmorland Agricultural Society and President of the Fell Sheep Breeders' Association. In 1926 he served as High Sheriff of the county. His early involvement in the National Trust developed. He played a crucial role in the major purchases made by the Trust in the Lake District in the inter-war decades, both by helping to organise appeals and by personal gifts of great munificence. One authority wrote that '...with the single exception of Mrs William Heelis, [Beatrix Potter] no single benefactor has ever done so much for the preservation of the scenery of Lakeland.'[10]

Francis Scott had his own interests away from business. He continued to enjoy shooting, fishing and sailing. He also became an aficionado of powerful cars driven at high speed. He managed the small farm estate surrounding his home, Matson Ground. In the later 1930s he made his own contribution towards the conservation of the Lake District, by the strategically crucial purchase of an estate at the north end of Windermere that would otherwise have been 'developed'. He also acted as chairman of Lake District Farm Estates, a company originated by Lord Chorley to purchase fell farms and provide supportive estate management to help tenants continue the agriculture that had created the characteristic local landscape.[11] In his middle years he rediscovered a strong Christian conviction and this became a powerful drive behind local parochial activities and an involvement in Toc H and the Cumberland and Westmorland Association of Boys' Clubs. He also served his turn as High Sheriff in 1934. He believed that his commitment to the business relaxed very substantially from the early 1920s, but it is unlikely that anyone else noticed much change. Extramural pursuits were never allowed to conflict with an active business life. It was only in the war years and after that he became far more committed to public and benevolent activity in Cumbria. In the 1920s and 1930s he continued to control all management affairs, willingly accepting an arduous regime of detailed attention to the management of home business from Kendal. Monthly visits were required to London, to spend several days discussing foreign, marine and investment affairs with fellow directors and staff at the London head office. In addition he regularly visited home branches and made occasional

F. C. Scott in the 1930s (1881–1979), Provincial Company Secretary, 1903–33,
Managing Director, 1915–51, Chairman, 1946–56.

trips abroad to examine foreign ventures. At home he worked on Provincial affairs through long evenings; he continued business correspondence while on holiday; and quite openly admitted that the company was never far from his thoughts, even when shaving in the morning. It was no burden to him. He would have had it no other way.

By the early 1930s Samuel Scott was becoming concerned with the implications of this situation. Both brothers assumed that their sons would eventually take some part in the business. Characteristically, Samuel Scott tended to see his son Philip as taking the role of a non-executive chairman, while Francis Scott thought in terms of his son Peter following him in a more direct involvement. Yet these possibilities lay far in the future for both were still schoolboys, unable to assume independent management responsibility for several decades.

Samuel Scott's concern fastened on the gap in management succession thus created. Was Francis Scott assuming that he would monopolise management control until his eighth decade? Was it not possible that as he grew older, he would wish to devote himself more to other interests? Above all, what would happen if he were to die before the next generation were ready? Samuel Scott was certain that he would not be able to take over the management of the company, and that there was, at present, no one else in a position to do so.

In any case, controlling the Provincial was becoming a far more complex task as its departments and their problems proliferated. The complications of home business and a far larger branch organisation were exacerbated by the need for a detailed assessment of the many markets involved in developing a foreign department, the vexations of a permanently unprofitable marine account, and the need to keep in touch with a large investment portfolio. While the thought was never expressed, it seems reasonable to suggest that Samuel Scott may have imagined that if the Provincial continued to expand at the same pace, it would be increasingly difficult for an aging man to retain the same taut control of management. At the very least it was only reasonable for him to receive some serious support.

In principle, Francis Scott accepted this argument. Indeed, he accepted that in the future professional management would play a far greater part in the Provincial. This led to the appointment of J. M. Crook in 1933 as Deputy Manager, with the prospect of promotion to a more central position if he proved successful. Crook came from the London and Lancashire where he had been a superintendent in the Foreign department. Samuel Scott described him on first meeting: ' … a clever face, a well balanced head and a manner that gave the impression of a clear, logical and thoughtful man … a very reliable man, of vigorous physique, and calm

judgement.' At thirty-nine, his comparative youth was a concession to the older senior managers, for it was advertised to them that he would at first under-study Francis Scott and only gradually move into a more senior position as this became appropriate. There is little doubt that the appointment none the less caused some heartache among men who had spent the best years of their life attuning themselves to Francis Scott's approach to business, and now saw this investment becoming a wasting asset.

From his appointment Crook began to relieve Francis Scott of much of the detailed general management of insurance affairs. He began to handle correspondence from the branches, prepared briefs on policy decisions, sat in on interviews and prepared memoranda of their results. His experience in foreign insurance qualified him to work closely with Crofts in developing new connections, and he also took a close interest in the recruitment of Horner to the marine department from his former company's marine subsidiary. His only serious disadvantage was a lack of experience in handling a home organisation, which sometimes prevented him from carrying sufficient weight with branch managers.

Although gradually promoted to reach the position of General Manager in 1939, Crook remained Francis Scott's chief adviser and executant rather than an independent source of policy and decision. All papers continued to pass before Scott's eyes and he still intervened at every level, 'chairing' the meetings of branch managers, interviewing them on the detailed aspects of their results and expenditure, handling all the negotiations over foreign business and Crook had no contact with investment management. Francis Scott had perhaps been more honest than he knew when, in announcing Crook's appointment, he had written, 'It is no easy task for me to surrender any part of that full and complete responsibility which has gradually devolved upon me'. Samuel Scott was critical of this under-utilisation of an able man. He described Crook's position as 'that of a sub-manager – carrying out your [Francis Scott's] policy and executing your decisions; encouraged to offer comments or even suggestions, but very definitely relieved of a sense of ultimate responsibility and not called upon to initiate a policy or to plan as if we were not there.' This he regarded as unsatisfactory, and in the late 1930s he tried to persuade his brother to pass over more responsibility. Without this, the company would not obtain full value from Crook; Francis Scott would not begin to contemplate retirement; and the Scott family and the company would not be properly protected against the eventuality of Francis Scott's death. Yet the force of this logic broke against the rock of Francis Scott's personality which he rationalised by his opposition to the passing of responsibility from proprietors to 'irresponsible' salaried management. It is not hard to

feel some sympathy for Samuel Scott's view. Who could have predicted that Francis Scott was to continue to be actively involved in the company's affairs on a formal basis until his seventy-fifth year, and perfectly capable of absorbing detailed company results for another twenty years or so after that?[12]

Despite this unwillingness to surrender authority over the detail of insurance affairs, circumstances led Francis Scott to receive more support and delegate far more authority to a fellow director than might have been anticipated. The Scotts had invited outsiders to join the board from the start, but this had been done to emphasise Bolton links and there had been no intention that such men should exercise responsibility. In fact, when the protection of the Bolton connection became particularly important, after the move to Kendal, this approach broke down. Colonel Hesketh resigned in 1920, leaving only family directors, together with Butterfield the former London manager, who had been appointed a director in 1917 to preserve his goodwill after retirement. At first Francis Scott looked for replacements who could bring business. A recently retired local government official was appointed to encourage municipal insurances. He brought little business and eventually resigned.

However, the function of the board was transformed in the early 1920s, through a fortuitous family connection. In 1923 W. H. Haslam, a maternal cousin of the Scotts, replaced his brother Oliver as a family director. Chapter Fifteen will describe how Will Haslam opened up a new world to the Scotts. He had left Bolton at the beginning of the war and not returned subsequently, deciding to take his chance in the City of London, working with J. M. Keynes, whom he had met during the immediate post-war period. On becoming a director of the Provincial, he decided that its affairs required a more metropolitan perspective and suggested that Keynes and his associate O. T. Falk, an actuary who was a partner in Buckmaster and Moore, a city stockbroking firm, should be invited to join the Provincial board. This resulted in a relationship which was to have the most profound importance for the Provincial's financial affairs. Keynes eventually took over responsibility for the company's investment portfolio adopting strikingly innovative policies that will be described in Chapter Fifteen.

10

The general insurance market between the wars

During the inter-war years the domestic markets in which the Provincial operated underwent sharply contrasting experiences of growth, but all shared severely competitive conditions. While it is impossible to provide exact measures of market size, the general picture is clear. Diagram 6 illustrates the international premium income obtained by British companies in the various classes of insurance business. This indicates the striking contrast between stagnation in the traditional markets, and the dramatic expansion in motor insurance. Within the British market business cannot have been much different. Though fluctuating from year to year, the home fire market cannot have changed much in size between 1920 and 1938. Employer's liability insurance evaporated. By contrast, British motor vehicle insurance premium income probably grew more than eight-fold between 1920 and 1938.

Stagnation in traditional markets allowed little scope for individual insurers to grow. Some adopted aggressive tactics to maintain or expand their revenue, but this set off sharp contests which drove down premium rates. A continued fall in fire losses encouraged rate reductions, but these collided with rising expense ratios as falling revenues had to meet the same overheads.

These problems interacted with the motor insurance market which, by contrast, offered glittering opportunities for expansion. All companies sought business eagerly to consolidate a stake before the market stabilised. Revenue growth allowed overhead costs to be carried without difficulty. On the other hand, motor insurance involved more expensive servicing of agents and policyholders, increasing the expense ratio, and the spread of motoring was accompanied by rising claims. However, the thirst for revenue, lack of tight tariff control and over-capacity meant that under-writers were loathe to increase premium rates and thus motor insurance remained less profitable than fire insurance. Competition took two forms: rate increases were postponed in an attempt to force out weaker concerns; and risks with a superior claims experience were identified, so that they could be attracted by exempting them from rate increases.

£ million

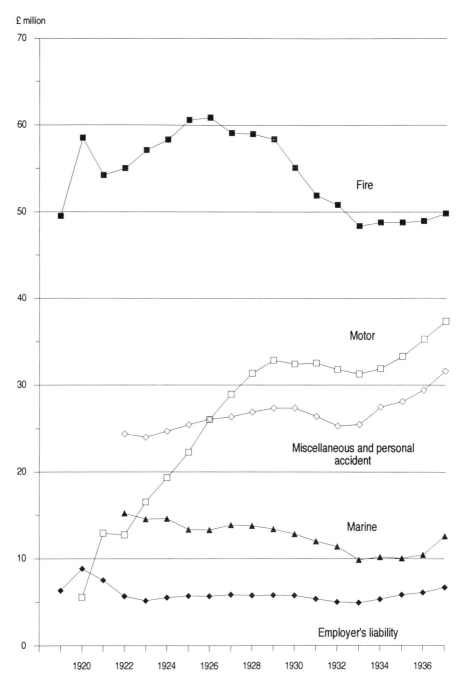

DIAGRAM 6 British insurance companies' general premium income, 1919–37
Note Motor and miscellaneous premium income is estimated before 1931. See Westall,
'The invisible hand'.
Source: PMA, *passim*

The growth of the motor account affected the equilibrium of the general insurance 'industry'. Established companies accepted low profitability in motor insurance because its buoyant revenue relieved the overhead cost burden on home underwriting. At the same time, branches financed and made necessary by motor insurance expansion increased competitive edge in the difficult traditional markets.

Competition was also intensified by the easy entry and expansion which the motor market offered. Marketing channels were now so closely linked through brokers, agents and company branch offices, that motor insurance provided an opportunity for expansion in all general insurance markets. And because the new market was less susceptible to tariff control it allowed a considerable non-tariff expansion, energised by the financial strength and organisational development motor insurance provided, which spilled over into other markets. In these ways, the new 'composite' market meant that individual classes of insurance could not be written in isolation. Companies operated across the whole spectrum of insurance, using profitable or expanding markets to subsidise underwriting in more competitive areas in which they felt obliged to operate for strategic reasons.

However, the most profound challenge to the competitive equilibrium in general insurance was mounted by Lloyd's. Its strength was based on a more speculative, individualistic approach to underwriting and extremely low organisational costs. In both respects its underwriters and brokers were able to undercut company underwriters, so many of whom were constrained by the need for caution to satisfy shareholders and whose operating costs were swollen by years of non-rate competition.

10.1 Competition in the British fire insurance market, 1920–38

Although no source is available to provide firm statistical support, it seems clear that British companies' home fire revenue suffered sharp reverses in the early 1920s and the early 1930s.[1] Despite some recovery later in the 1930s, it probably only just recovered its 1920 level. The competitive problems of adjusting to declining demand would have been difficult enough, but they were increased by the expansion of new competitors, eager for business and operating outside the tariff. In these circumstances it was inevitable that tariff control would be tested. Premium rates fell in many markets, accelerating the evaporation of revenue and the scale of underwriting surpluses. Some compensation was derived from falling claims ratios, which enabled profit margins to remain healthy, as long as overhead costs could be cut in line with reduced revenue. It was here, of

course, that the tariff offices, with their organisations geared to large revenues and organisational competition, were at a particular disadvantage.

Price deflation combined with failing markets for traditional export trades, to make a fall in demand for fire insurance inevitable. Falling prices reduced the values on which premiums were based. New investment dried up, while long-standing insurance connections contracted as firms closed, stocks were reduced and businessmen sought to reduce their premiums as overheads were scrutinised for potential economies.

In the early 1920s these difficulties were particularly acute because they followed the post-war boom in which prices and output had reached fabulous levels.[2] Insurance companies, like the rest of the business community, had expanded their organisations on the assumption that these conditions would continue. Some measure of the subsequent collapse is provided by the only direct evidence on market size available, the sums assured in the metropolitan district around London.[3] In 1922 this fell for the first time since 1886, and the 1921 level was not reached again until 1925. And London would have been less affected than the industrial North. Pressure on rates reduced revenues even more. The home fire premium income of the Commercial Union fell by fourteen per cent in 1922.[4] In the later 1920s some recovery was achieved, but the economic crisis of the early 1930s brought the return of similar difficulties. The amounts insured in London in 1931 were not achieved again until 1935, and in 1932 and 1933 there were the first two successive reductions in values insured since the statistical series began in 1866. Only with the upswing in the economy before the war did modest expansion occur.

Reduced revenue meant smaller underwriting surpluses; organisational costs climbed as a proportion of revenue, eating into profitability. Managements became obsessed with the problems of reducing administrative costs through wage reductions, greater efficiency and the reallocation of resources to other uses. However, these were long-term solutions to an immediate problem, and the most obvious tactic was to defend existing business as fiercely as possible. Companies with large reserves, an account well lined by profitable business, or with support from other classes of insurance, began to regard the maintenance of the level of revenue as more important than the profitability of acceptances.

This created difficulties between the tariff companies. Several bid aggressively for business in the early 1920s.[5] This might have been resolved within the FOC, if it had not been for the complication of new entry. Within the tariff, the mighty Prudential, the largest industrial life office, entered fire insurance in 1919 and used its vast organisation to

build up a large fire business in the following twenty years. By 1937 it had obtained over three per cent of the sums assured in London, placing it among the ten largest insurers in that market, and there is no reason to doubt that this was representative of its national performance.[6]

Non-tariff companies also offered a more powerful threat. In place of small companies exploiting special opportunities, non-tariff fire under-writing became dominated by larger companies, with national organisations offering policyholders perfectly reasonable security and service. The General Accident was, after all, the largest British accident office and used the marketing advantages derived from that position in the fire market.[7] Similarly, the Eagle Star, constructed by Sir Edward Mountain through the purchase of older offices, was able to use its connections in accident, life, and marine business to become the most important non-tariff fire company.[8] By 1937 it was the ninth largest company in the London fire market, overtaking many tariff offices.[9] Smaller non-tariff companies, such as the Co-operative,[10] Provincial and the Cornhill, were able to use the motor market to build a branch organisation which could be used to effect in the fire market.[11] All started with modest organisations whose growth was then financed by motor insurance, relieving their fire accounts of the cost of the inflated organisations carried by the tariff offices.

Lloyd's intervened as well. Before the war its members had written some direct business but mainly only large or specialised risks. During the war they had established a bridgehead in several hazardous fire markets which they developed in the inter-war years.[12] Without a branch organisation, their costs were low but their markets were restricted to those in which individual risks were large, or where a number of smaller risks were collected together in a single account. This strategy suited the period. Businessmen anxious to economise were attracted by heavily discounted rates; service seemed a luxury. The amalgamations of the early 1920s and the spread of trade associations facilitated the broker's task by disrupting traditional connections between tariff companies and policy-holders and parcelling risks together in a way convenient to Lloyd's marketing methods.[13]

Thus, as tariff companies struggled to retain business to control their expense ratios, they found themselves undercut by underwriters whose overheads were of a quite different order. It is impossible to provide an accurate estimate of the market share captured by Lloyd's in the inter-war period as no accounts were published. Within London it rose from three per cent in 1913 to six per cent in 1920 and eight per cent in 1938, making Lloyd's second only to the Alliance.[14] There is little doubt that in the markets for large scale industrial and commercial risks, its proportion was

higher. By 1925, the *Post Magazine* concluded that '... it has become evident that Lloyd's has become a permanent institution for fire insurance'.[15]

Competitive pressures from these sources meant that it was impossible for the FOC to exercise a decisive role in maintaining premium rates without prejudicing its members' survival as effective fire underwriters. If it did not respond, they would suffer a falling share of a static or smaller market. Its role became one of organising a more or less orderly retreat, minimising competition between its members, serving their strategic interests and ensuring that the rate reductions that were conceded were as rational as possible.

The burden of rate competition was borne by the hazardous fire insurance markets. One authority, writing at the end of the 1920s, described its severity in dramatic terms, '... when competition is keen, statistics usually take a back seat; and certainly in some quarters competition has been carried almost to an absurd degree so that the rate charged is merely that which the insured is willing to pay and not that which he ought to pay'.[16]

The course of the struggle can most easily be traced by the FOC's response to non-tariff incursions. In the aftermath of the 1920 boom reductions were made in premium rates on cotton mills, calico printing works, lace factories, grain mills, London textile warehouses, Scottish flax mills, drapers' shops and petrol depots. Widespread reductions became common in the succeeding years down to 1935. In the cotton mills tariff, for example, the 1921 reduction was followed by another of twenty-five per cent in 1925 and further adjustments in 1927, 1930 and 1934. In addition to tariff reductions, risks not covered by tariffs reached a common minimum level, irrespective of the risks involved.[17]

Discounts were also offered to large companies and trade associations who could provide substantial accounts or who were prepared to guarantee long-term renewal of policies over a number of years.[18] Both were rationalised by the suggestion of savings in administration, but there was no doubt in the minds of contemporaries that they were another way to meet the non-tariff challenge. The FOC authorised large scale discounts in 1927 and they became the prime source of subsequent premium reduction.[19] The Provincial's underwriter estimated that rates on large scale insurances fell by between thirty and fifty per cent in the following ten years. The Commercial Union's net home fire premium income never again reached its 1927 level before the Second World War.[20]

New policies were introduced which, however justified, further reduced the premium paid. Lloyd's had pioneered the 'adjustable' or 'declaration' policy, which allowed adjustments in the sum assured during its term.

Introduced to cope with the problems of wartime inflation, it became popular in the deflationary and cost conscious 1920s. Lloyd's used it to offer large savings to policyholders holding stocks whose values were falling. Tariff companies resisted the innovation, fearing the costs of administration, moral hazard and the loss of revenue. More or less ingenious schemes were proposed to evade the threat, but the FOC capitulated in 1924.[21]

Despite these moves, the FOC found it impossible to prevent its members losing business. The importance of the foreign market makes it impossible to measure this except for the London market, where the share of the five largest non-tariff companies and Lloyd's grew from nine per cent in 1920 to eleven per cent in 1929 and fifteen per cent in 1937.[22] All this was achieved in a static market with the tariff companies attempting to meet every challenge with vigour.

The constraints on non-tariff activity before 1914 had been mainly created by the barriers to expansion provided by the marketing organisations of the established tariff companies. The growth of the motor market relaxed this by allowing non-tariff companies to build branch organisations with relative ease. Over-capacity at Lloyd's, as marine insurance contracted with the decline in international trade, encouraged its underwriters to provide fire reinsurance facilities, thus further encouraging non-tariff underwriting.

The tariff companies tried to develop new methods of market control. They co-operated through a Non-tariff Competition Committee which authorised the cutting of rates on particular risks to forestall a loss to a non-tariff company. This involved an expansion in the FOC's organisation to make such rulings quickly and effectively.[23]

Even more important was the Competition Agreement which governed relations between tariff companies and their non-tariff competitors from 1930. Most large risks could only be carried by co-insurance schedules in which a number of companies shared a proportion of the risk, following the lead of the company which handled the arrangements. The Agreement committed tariff members to stabilise the share of business each held on such schedules, even if one managed to attract away the lead from another or if the sum assured was reduced. It also reduced the share given to non-tariff insurers. The agreement was hardened in 1932. Non-tariff insurers were not to be allowed more than thirty-five per cent of any schedule in which tariff members were involved. This became increasingly effective, for the scale of risks grew quickly in the 1930s with the spread of mass assembly production. As it was impossible for non-tariff insurers to cover the largest risks on their own, the thirty-five per cent rule gradually

became more effective in containing their intervention on the largest risks.[24] Along with the recovery of industrial activity in the late 1930s, this relieved the pressure of competition and accounts for the references to a 'friendlier' atmosphere between the offices. But there is no doubt that premium rates in the hazardous markets remained low.

This had serious consequences for the companies' revenues, but it had more impact on expense than loss ratios. While the economic crises of the early 1920s and the early 1930s brought a predictable backwash of high losses, as businessmen sought liquidity at the expense of the insurance companies, these were balanced by moderate overall loss ratios during the rest of the period, despite falling premium rates. Despite suffering falling revenues for most of the period, the Commercial Union's loss ratio, averaged for the 1920s and 1930s separately, was not significantly different from the years before the war. It would have been impossible for such a large company's experience to run counter to the market.[25]

These underwriting results were produced by risk improvement and the growing importance of more profitable classes of business. Risk improvement is impossible to measure precisely, but there is little doubt it occurred. The ratio between large fire losses reported in *The Times* and an estimate of sums assured in Britain fell in relation to the few pre-war years for which we have evidence.[26] Buildings were being built to higher standards; electricity replaced oil and gas; methods of fire extinction became more efficient. Industrial change accelerated improvements as outmoded factory premises in the old industrial staples closed, and were replaced by new premises, often in industrial estate conditions. These new and often larger types of risk brought their own problems, but they were a distinct improvement.[27] The residential housing boom of the 1930s transformed the quality of non-hazardous underwriting. Continued depression brought other bonuses. It weeded out less well-founded businesses and reduced the problem of moral hazard. The low level of utilisation in many industries similarly reduced losses.[28]

Loss ratios were also stabilised by market segments less affected by rate competition. The most important of these was non-hazardous business where rates were stable. Lloyd's and the non-tariff companies were less able to capture this business, protected as it was by the older companies' strong agency connections. However, they both made progress in developing appropriate methods; the companies through organisational development and Lloyd's by advertising and direct marketing through trade unions and other occupational associations.

Non-hazardous business grew, relatively, because of the decline in hazardous revenue, and absolutely, because of demand and supply

changes. The building boom of the 1930s, with its associated growth in consumer durable ownership, must have increased the demand for household insurance.[29] Competition also led to policy extensions. The tariff was forced to offer a comprehensive householder's policy in 1920.[30] These proliferated to such an extent that by 1938 the comprehensive policy typically offered, in addition to the usual fire, theft and employer's liability clauses, protection against risks associated with public liability, riots, flood damage, accidental damage, aircraft damage, explosion, mirror breakage, subsidence and burst water pipes.[31] Several of these were written by accident departments, but others were retained by fire underwriters and this swelled revenue, for so house proud and cautious was the new generation of property owners, that it proved possible to carry higher rates with these comprehensive policies.

Another source of additional income was found in 'loss of profits' or 'consequential' insurance, protecting the businessman against the costs of an interruption in trading after a fire. Lloyd's had introduced this cover, using it to attract new connections.[32] This proved sufficiently effective to force the tariff companies to undertake grudgingly what they regarded as a dangerously speculative insurance. Once offered by all companies, it became seen as a supplement to basic fire cover and carried remunerative rates, adding to revenue and profitability and thus reducing average loss and cost ratios.[33]

For these reasons, a reasonable proportionate underwriting margin could be obtained on fire insurance if companies shifted the balance of their business to less competitive market segments. But this did little to reduce revenue loss, which squeezed profitability by making it difficult to carry organisational costs, eroding income generating short-term reserves and reducing the absolute size of underwriting surpluses. If these problems were to be resolved, insurers would have to find compensation in other markets.

10.2 General accident insurance

The same depressed economic conditions, that led to falling demand in fire insurance, created unemployment and wage cuts which reduced employer's liability insurance revenue. It fell from a peak of £8.85 million in 1920 to between £5 and £6 million until 1933 when it fell to its lowest inter-war level of £4.9 million. Subsequently it rose with economic recovery to remain above £6 million from 1936.[34] As in the fire market, the contraction placed premium rates under pressure, but in contrast, claims rose. The squeeze on profitability this created was increased by unprecedented

government intervention and the growth of new forms of competition, both of which prevented established companies from finding compensation through rate increases.

These problems were brought upon the companies by a combination of circumstances between 1916 and 1921. Chapter Seven has shown how competitive conditions allowed companies to make large profits in the later years of the war. In 1917 and 1919 legislative extensions of employer's liability were used as a reason for raising premium rates by ten per cent twice.[35] Yet as there was no concomitant rise in claims, an embarrassingly high level of profitability was achieved, which reached nineteen per cent of revenue in 1920. With the collapse in premium income in the following year the reduction in reserves inflated profit rates to thirty-two per cent.[36]

Even before these bonanza years public comment had arisen, for it was felt that the business should not be such a good thing for the companies when it had been created by the state to satisfy a social need. A departmental committee recommended state control of rates in 1920. The companies attempted to forestall this by introducing two successive reductions of ten per cent in 1921 and 1922. This did not satisfy public concern and in 1923 the Home Office negotiated an agreement with the AOA whereby any sum by which claims fell short of a specified loss ratio should be refunded to policyholders by a rebate in the following year. Individual offices could still enjoy superior profitability, for the rebate was calculated as an average across all tariff business and a standard discount allowed by all companies. By superior selection any company could obtain a lower loss ratio than average. Yet the agreement eliminated the possibility of sustained high profits by all companies. Initially forty per cent was allowed to cover expenses, commissions and profit and this was subsequently reduced to 37.5 per cent, allowing a claims ratio of 62.5 per cent. In the opening years of the arrangement the rebate remained around six per cent, but when an improvement in experience occurred in the slump between 1929 and 1932, it rose to a peak of fourteen per cent in 1931 and averaged twelve per cent, a substantial discount on premium income.[37]

This raised greater difficulties for non-tariff offices than AOA members. While they were not party to the agreement, they had no option but to bend to its intention, for they could only compete successfully by taking into account the rebate policyholders anticipated they would receive from the tariff offices. This was a serious problem, for in some years the rebate exceeded the usual non-tariff discount of ten per cent. As a result, they relied increasingly on commission payments to bring in business.

A new element in the market squeezed profitability further. Mutual associations grew in importance, acting in a similar way to Lloyd's in the fire market. Based on employer's trade associations, they possessed powerful advantages. They did not need to attract business by organisational expenditure or commissions; they were often able to make extremely economical administrative arrangements by synchronising renewal dates; with their trade connections they were able to assess risks with expert discrimination and mount a more vigorous opposition to dubious claims; with a mutual basis they were able to delegate minor claims to members in return for rebates; operating within one industry or district, overheads were low; with no shareholders, surpluses could be entirely devoted to reserves. In some cases such associations were able to carry claims ratios of over ninety per cent without difficulty and thus offer premiums or rebates of a quite different order to proprietary companies.[38]

While mutual associations had operated before the war, the high profitability and rate increases described above encouraged their expansion and the formation of new concerns. They became the most aggressive element in the market, forcing the companies to reduce rates, yet quickly absorbing most of the business in the special markets in which they operated. While formal reductions in tariff rates were infrequent after 1923, the offices preferring large rebates under the Home Office scheme, the AOA regularly sanctioned special reductions to meet non-tariff competition on specific risks and discounts on large scale risks. Yet between 1922 and 1934 the share of the home market controlled by non-tariff mutual offices (one, the Iron Trades Employers, joined the tariff) rose from ten per cent to twenty-four per cent and it remained at about a quarter of the market until 1938.[39] In effect, most hazardous industrial employer's liability insurance either passed to the mutuals or was only retained by companies at dramatically reduced rates. On the other hand, business from smaller employers, in less hazardous trades, or where mutual organisations were hard to organise, remained with the companies, serviced by branch o rganisations.

Thus the companies suffered a marked fall in their share of a market which was itself contracting and in which rates were falling. In fact, underwriting margins were eased by reductions in the commissions paid to agents and brokers. Between 1924 and 1929 profits averaged fourteen per cent of revenue, yet this can have brought little comfort to the tariff companies when they contemplated the fall in the absolute surplus obtained from the business. Between 1918 and 1922 this had averaged some £1.7 million. During the following seven years it fell to an average of £0.8 million and their share of this had fallen some sixty per cent lower

than in the post-war years. The fall in revenue in the depression after 1930 reduced this still further.[40] Having been presented with a golden opportunity by legislation at the beginning of the century, the tariff offices had foolishly exploited the public and now paid a price exacted by a measure of public control and consumer retaliation through mutual organisations.

From 1934 economic recovery revived premium income which by 1937 had risen by thirty-six per cent.[41] However claims rose to such an extent that underwriting surpluses were even smaller than they had been in the late 1920s. Insurance officials attributed this to the return to work of men after long years of unemployment which made them more accident prone.[42] But the most striking change was not in the number of accidents, but in their average cost. This was partly because legislative changes extended the benefits allowed to injured workers in 1925 and 1931.[43] But a more important contribution came from the increasing use of the worker's right to sue his employer through the common law courts. Judicial opinion began to place a far higher value on health and human life and claims rose sharply. The rebate paid under the Home Office agreement fell from an average of eleven per cent between 1929 and 1933 to four per cent in the following five years and by 1937 the pressure on profitability was such that rates began to harden.[44]

No statistical evidence is available as to the purely domestic business transacted in other classes of accident insurance. It seems unlikely that there was any very significant growth however, for the international business obtained by British companies saw only modest change. Miscellaneous accident insurance, mainly burglary and personal liability policies, only rose from an estimated £23.3 million in 1920 to an estimated £24.4 million in 1929 and an actual £27.1 million in 1937.[45] Personal accident business grew rather more rapidly, rising from £27.3 million in 1920 to £39.5 million in 1929 and £45.1 million in 1937.[46]

No doubt falling prices through the period contributed towards this lack of buoyancy, but there was another consideration, which points to the competitive circumstances in these markets. Most of these forms of cover were regarded by policyholders as discretionary and a high proportion were purchased by small businessmen. It was therefore to be expected that their sales would suffer during the difficulties of the early 1920s and 1930s. From this point of view, it was significant that they proved more buoyant in the late 1930s' recovery.

Yet the lack of scope for growth did not lead to the same severe rate cutting that destroyed profitability in the fire and employer's liability market. Premiums were rarely large enough to be a factor. The AOA had no success in creating tariffs in either burglary or personal accident

insurance.[47] Instead business was obtained through active selling by agents, whose business was then competed for by the companies through commission rates and the quality of service or vigour of canvassing provided by their branch organisations. Alternatively, the presentation of the attractive comprehensive policies for householders described in the previous section, generated a flow of business in which the premium paid for the burglary and other accident insurance elements was so insignificant, that there was no competitive pressure on rates at all. For all these reasons the business generated an extremely low loss ratio, though it could only be enjoyed by those companies which had organisations sufficiently well developed to attract it.[48]

10.3 The British motor insurance market, 1920–38

Motor insurance expanded rapidly after its first introduction by a few specialist insurers in the 1890s. By 1914 Supple suggests that premium income probably exceeded £1 million. During the First World War private motoring was constrained by petrol shortages. But from 1919 the situation was transformed as the potential of motor insurance was realised.[49] The expansion in the use of motor vehicles between the wars is too well known to require any extensive description. Mass production reduced the cost of vehicles and technical changes improved their efficiency; petrol prices fell; roads were improved to facilitate vehicle use. These changes transformed motor vehicle ownership from a perquisite of the rich to a necessity for the middle class, whose growing incomes were able to finance this extension of consumption. Beyond this, commercial passenger motor vehicles served a wider market in town and country. The period also saw rapid developments in the design and usefulness of haulage vehicles. In short, internal combustion vehicles became an essential element in social, commercial and industrial life.[50]

As a result of this transport revolution, motor vehicle insurance enjoyed a dramatic growth in demand. Table 10.1 indicates the resulting growth in the international motor insurance business of British insurance companies from 1931 to 1938, as provided by statutory returns. It also provides estimates of the same business from 1920 to 1930 and the amount obtained in the domestic market alone for the whole period. The latter appears to have grown more than eight times from some £3.4 million in 1920 to £28.8 million in 1938. This expansion was principally created by the growth in the number of vehicles, but increases in the average premium paid and inelasticity in the demand for motor insurance were also important.[51]

TABLE 10.1 *Motor insurance net premiums of British companies, 1920–38*

	International motor net premiums	British motor net premiums	Rate of growth of British net premiums
	£m.	£m.	%
1920	5.55	3.43	
1921	12.88	4.89	42.5
1922	12.70	5.81	18.8
1923	16.51	6.83	17.6
1924	19.32	8.03	17.6
1925	22.26	9.38	16.7
1926	26.08	10.77	14.9
1927	28.94	12.01	11.5
1928	31.34	14.05	16.9
1929	32.88	15.36	9.3
1930	32.42	16.44	7.0
1931	32.53	18.40	11.9
1932	31.76	19.02	3.4
1933	31.27	19.54	2.7
1934	31.88	20.47	4.8
1935	33.34	23.00	12.4
1936	35.30	25.04	8.9
1937	37.37	26.98	7.7
1938	37.90	28.81	6.8

Source: Westall, 'The invisible hand'.
Note International business is estimated from 1920 to 1930 (inclusive) and British business is entirely estimated. The estimate of the British market differs from international business in that it attempts to include non-company underwriters, i.e. Lloyd's.

The number of vehicles taxed in Britain rose from 650,000 in 1920 to 3,085,000 in 1938. Growth was most rapid in the early 1920s, for the number had passed two million by 1928. In the early 1930s depression brought two years when apparent ownership actually fell, though this was substantially caused by a reduction in the number of motor bicycles taxed. Subsequent growth was slower than in the previous decade. However, economic recovery in the mid 1930s revived private car sales and the slower growth in the number of commercial vehicles was partly a result of their increasing size.[52]

Premium income was given additional buoyancy by rising premium rates. Despite strong competition, these were forced up by costs. Many

factors contributed to a deterioration in loss experience. Motor insurers believed that as motoring spread to lower income groups and attracted a high proportion of first time drivers, this lowered standards of driving and maintenance. Falling car prices and greater mechanical efficiency eroded the integrity of premium rates based on value and horsepower. More motorists produced congestion, especially in urban areas, which increased the incidence of accidents. Mechanical improvements allowed greater speeds on unimproved roads. Both combined to create the accident crisis of the late 1920s. The introduction of compulsory insurance in 1931 forced the companies to insure motorists they would have preferred to decline, raising claims costs. At the same time, the documentation required and the increase in the proportion of small premium motor cycle policies raised the burden of administrative costs. In the 1930s, partly because of public attitudes towards motoring, the courts placed a higher value on human life and incapacity, raising the level of the most expensive claims. While standardisation reduced repair costs in the 1920s, the introduction of saloons in place of open top cars and 'streamlining' in the 1930s raised them again.[53]

As a result, tariff premium rates rose as illustrated in Table 10.2, which provides examples from a far more detailed matrix. New post-war motoring conditions were reflected by increases in 1920 and 1921 which took rates up by between one-half and two-thirds. Rates on smaller cars, where the effects of inexperienced driving and new classes of owner were concentrated, were raised by one-third in 1928. In 1935 the extra costs of congested urban motoring were covered by increases of between twenty and eighty per cent for motorists in London, Glasgow, Manchester and Liverpool.[54]

These increases were not entirely reflected in the average premium paid. With premiums based on the value and horsepower of cars, the popularity of smaller engined and cheaper cars dampened the impact of rate increases, though this was offset in the 1930s by the increase in the size of commercial vehicles. Competition also forced up the level of the no claims bonus. The 1913 tariff had offered a ten per cent reduction; by 1933 the tariff offered twenty per cent after three claims-free years.[55] In any case, higher premium rates had little impact on aggregate market demand which remained relatively inelastic. In 1931, against the wishes of the companies, legislation imposed compulsory third party insurance on motorists. They feared the claims cost of irresponsible motorists, and the possibility that compulsory cover might open the way to wider state regulation. However, the change only affected a minority of private motorists, for about ninety per cent were probably already insured. The

TABLE 10.2 *Accident Offices' Association tariff premium rates, 1913–38*

Private motor vehicles

Horsepower Value	9 £200	12 £200	17 £400	20 £500
	£. s. d.	£. s. d.	£. s. d.	£. s. d.
1913	6. 0. 0.	7.10. 0.	10.10. 0.	11.15. 0.
1 Jan. 1920	7. 4. 0.	9. 0. 0.	12.12. 0.	14. 2. 0.
1 May 1920	9. 0. 0.	11. 5. 0.	15.15. 0.	17.12. 6.
1 Mar. 1921	10. 4. 6.	13. 2. 6.	16.10. 0.	17.12. 6.
1 Apr. 1922	9.17. 0.	12.12. 6.	16. 5. 0.	17.12. 6.
1 Mar. 1928	12. 2. 6.	12.12. 6.	16. 5. 0.	17.12. 6.

1 Dec. 1932 No claims bonus raised from 10% to cumulative 10%–15%–20%

1 Jan. 1935				
District A	12. 2. 6.	12.12. 6.	16. 5. 0.	17.12. 6.
District B	13. 6. 9.	13.17. 9.	17.17. 6.	19. 7. 9.
District C	14.11. 0.	15. 3. 0.	19.10. 0.	21. 3. 0.

Source: Post Magazine, 15 October 1938.

high value of vehicles and the liabilities in which they could involve their owners, especially through third party claims, made insurance a necessity for largely middle-class motorists. The expansion in hire purchase facilities imposed an insurance requirement on those who used them. More generally, greater discretion was probably exercised over the extension to comprehensive cover, though this none the less probably accounted for about half the premium income in the 1930s. The main impact of the requirement to insure was on motor cyclists, possibly only thirty-three per cent of whom were previously covered, and their premiums were tiny compared with cars and lorries.[56]

As a result, Table 10.1 suggests a market that grew very rapidly in the early 1920s when vehicle numbers and the average premium rate were both rising most rapidly. Revenue expansion decelerated later in the decade until the modest spurts created by the higher rates for small cars in 1928 and the imposition of compulsory insurance in 1931. The impact of the economic depression on vehicle numbers combined with rate competition and the resulting introduction of a more generous no claims bonus to create much slower growth in the early 1930s. However, from 1935 the revival in vehicle ownership growth, reinforced by higher premium rates in the larger conurbations, fed renewed acceleration.

The competitive structure of motor insurance was sufficiently similar to fire insurance to encourage the tariff offices to try to replicate the policies they had practised there, but sufficiently different to ensure that they were less successful. They had responded in the familiar way. After an early phase of fierce competition the AOA had instituted, between 1913 and 1915, a system of premium rate control in the motor insurance market. Its tariff for private vehicles operated within a framework of 'horsepower cum value'. Rates were set for the classes established by these two variables which comprehended two important factors affecting risk. While it did not reflect experience entirely, it had the important advantage of simplicity in operation for agents. Similar, though more complicated classifications were used in the commercial vehicle market. Rate control worked well when competition was relaxed and vehicle use constrained during the war. But from 1919, the rapid growth in the market created a more bracing environment.[57]

With falling revenues, earnings on reserve funds, and rising expense ratios in other markets, general insurers became anxious to win as much business in motor insurance as possible. Motor insurance's potential for growth promised to restore revenue and reserves, and finance the continued expansion of branches. Furthermore, as the new business expanded, it became clear that companies without a significant stake would also suffer major competitive disadvantages. They would not be able to offer a range of cover that would satisfy agents' and brokers' demands. They would also sacrifice the opportunity to develop their branch organisations provided by burgeoning motor revenue. Thus, all the large composite companies sought motor revenue avidly with only half an eye on its immediate profitability. In addition, the post-war years saw a determined effort by new and small companies to use motor insurance to establish themselves. By 1921 there were some 120 companies accepting motor risks, of whom twenty-three had been formed since 1918.[58]

Goodwill and branch organisations gave the established tariff companies a head start. The resulting concentration of business cannot be measured for the home market, but five companies controlled fifty-one per cent of British companies' international motor business in 1931.[59] The distribution of business at home would not have been very different. It was the weakly oligopolistic environment so familiar to the fire offices, implying sufficient sensitivity to one another's marketing policies to create costly rate competition, but insufficient to ensure implicit collusion. Furthermore, the inelasticity of aggregate demand meant that lower rates would not expand the market. This was why the tariff companies modelled the AOA on the collusion that had been successful in the fire market.

However, the new market differed in two important respects. It was far more rate competitive and it proved harder to prevent operation outside the tariff.

In contrast to the inelastic aggregate demand schedule, individual insurers' demand schedules were relatively elastic. The rapid growth in motoring meant that in the early 1920s up to one-third of all policy-holders were new to the market, with no connection with any company. The replacement of vehicles provided regular opportunities for motorists to reconsider insurance arrangements. Many required little encouragement to do so. Premiums, ranging from £5 to £20, on top of other motoring costs, were large enough to interest them in savings and meant that small proportionate variations created significant absolute differences. This was especially so with commercial vehicles and multiple policies for vehicle fleets. There was little difficulty in obtaining alternative rates. The tide of motor insurance and motorists' search for competitive rates floated a buoyant supply of intermediaries. There were small brokers competing on every High Street and garage proprietor agents were conveniently placed at the point of vehicle sale.[60]

Insurers tried to insulate themselves from the harshest pressures of rate competition by differentiation. They increased the cover offered by their policies. Through the 1920s, policies were gradually extended to include protection against the theft of personal property in cars, accidental injury to the motorist's wife or chauffeur, or engine frost damage.[61] Most importantly, they operated through branch organisations. Agents required assiduous canvassing, brokers, because they were assailed by so many competing inspectors, and garage owners, because of indifference to a marginal and complicated source of income. The management of agents posed problems as well. The growth in the motor trade attracted many to both occupations who were under-capitalised or unfamiliar with either insurance or business management. Inspectors were needed to help with technical problems, chase up the settlement of accounts, and sort out claims, especially when the garage agents had an interest in repair work.

Branches also enabled companies to provide a better service to policy-holders. Motorists were sensitive to the speed and generosity with which claims were settled, so this became a consideration in competitive policy. But well-managed companies retained control over claims by only exercising discretion when desirable. The greater incidence of claims, albeit modest in scale, increased the incentive to provide direct control rather than the use of independent assessors. This could best be carried out locally where damaged vehicles could be inspected, participants assessed, and negotiations determined. The rapid provision of documentation

became important after the introduction of compulsory cover in 1931, opening up another competitive role for efficient organisation.[62]

Unable to compete by premium rate, tariff companies concentrated on competition among themselves in these other ways. However, the oligopolistic structure of business meant that much of the energy expended in this way was wasted. This was because policy variations were quickly copied, forcing up claims costs. In 1928 the AOA imposed a standard policy on its members to prevent a form of competition easily copied by non-tariff companies.[63] Branch extension suffered from similar problems, with large companies matching one another's strategic moves. Between 1921 and 1935, for example, the Commercial Union opened sixty new offices and the Royal fifty-two.[64] The expense incurred produced little benefit relative to other tariff competitors. However, if it meant that the AOA could control the market successfully because barriers to non-tariff entry were increased by the cost of organisational expansion, this did not matter. An inelastic aggregate demand would mean that rates could be adjusted to make motorists bear its costs.

In practice, however, it proved difficult to impose tariff membership. The inducements to join, created by restricting rating and other information and reinsurance to members, were far weaker than in fire insurance.[65] The simplicity of rating schemes and the ease with which risks could be classified, allowed any underwriter to quote appropriate rates from easily available tariff documentation. The large number of risks in homogeneous classes allowed quite small or new companies to rely on their own data to assess experience. The modest liabilities associated with each risk reduced the need for reinsurance, restricting it to cover the relatively infrequent major loss through serious injury or death. These contrasts with the fire market weakened the methods by which the FOC had imposed market control and made non-tariff underwriting on an extensive scale quite feasible. The tariff was thus thrown back on the inherent market power of its members, based on their goodwill and branch organisations. These proved inadequate in the face of motorists' sensitivity to premium rates.

This could be exploited by discounting tariff premium rates. Two opportunities existed for doing so profitably: by discovering factors affecting experience that were inadequately reflected in the tariff rating schedules; and by operating with lower administrative costs. Beyond this, independent underwriters could use their freedom from tariff control to develop effective marketing ploys. Over the long-term they could strengthen the effectiveness of their selection of desirable risks by quoting reduced premiums, just as independent insurers in the fire insurance market. They were also able to engage in short-term rate discounting

designed to disrupt market shares. In the 1920s some companies offered a free first year's insurance for the purchasers of particular car marques to attract business.[66]

Selective rate discounting took two forms. A general discount could be offered to encourage a good flow of business, from which risks were carefully selected, to improve average loss experience. Such underwriters' nightmares as young drivers, bookmakers, journalists, young army officers, the handicapped, or the 'artisan' motorist, could be discouraged by premium loadings or excluded by administrative selection.

Alternatively, special discounts could be offered to attract identifiable classes. For example, variations in driving ability, care, annual mileage, or occupation, were difficult to incorporate into a tariff, not least because they made it too complicated for agents to operate. The solution was the no claims bonus, which also discouraged small claims, saving administrative costs. The ten per cent bonus allowed initially by the tariff proved inadequate. By 1926 fourteen non-tariff companies were offering bonuses rising over varying periods to twenty per cent. By 1929 twenty had raised the maximum to twenty-five per cent. The tariff did not raise its maximum allowance to twenty per cent until 1932. Some non-tariff companies immediately raised their offer to thirty-three per cent. Throughout the period the search for the better motorist yielded excellent opportunities for independent insurers.[67]

There were also known to be geographical variations in experience. Losses in towns were significantly higher than elsewhere. The contrast was particularly marked in the larger conurbations, with their congested traffic, heavy car use, concentration of working-class owners, high repair costs, thefts, and entrepreneurial solicitors pressing for high claims. Initially the tariff quoted the same premium rate for all areas. There can be little doubt that some well-managed companies used administrative methods to select against urban risks. Some independent underwriters went a stage further by discounting tariff rates in country areas. Instead of following them down, the tariff raised rates by up to eighty per cent in the largest conurbations in 1935, allowing country rate discounting to continue.[68]

Tariff changes could entirely transform the attraction of underwriting a particular class of business. Smaller private vehicles posed serious underwriting problems in the early 1920s. As the main source of growth in the market it was impossible to ignore a fruitful source of business, but, despite the premium rate increases in the early 1920s, tariff rates did not cover the cost of claims adequately. These cars reflected in a concentrated way the new characteristics of post-war motoring, rather than the easy-

going pre-war days of rich men with chauffeurs. In 1928 the tariff raised its rates by a quarter on cars with a smaller engine capacity. Before that date larger cars offered better opportunities for profitable underwriting. Afterwards, small cars became a more acceptable risk, especially if under-written with discrimination.

The continual upward pressure on claims meant that the tariff spent most of its time trying to find ways of raising rates rather than cutting them to meet competition. Tariff rate adjustments therefore tended to create opportunities for discounting rather than eliminate them. The one important exception was the commercial vehicle market. In the 1920s the tariff had been placed on a broad brush basis, for it was often difficult to discriminate between the particular uses to which vehicles might be put. This created scope for selective underwriting based on special knowledge of the particular vehicle proposed. The Road and Rail Traffic Act of 1933 changed this by introducing licensing requirements which specified the use to which the vehicle would be put. The tariff was able to use this to refine its rates considerably and thus squeeze the scope for selection and discounting.[69]

Of course, many tariff underwriters were well aware of the many opportunities for selective underwriting. They undoubtedly loaded premiums and selected administratively against inferior risks within the tariff classes. But the higher rates they were forced to quote discouraged business in general; and rate control prevented them from positively attracting better quality motorists by selective discounts. It was therefore inevitable that there was a steady loss of such risks to independent insurers.

The AOA responded slowly to this competition. The rapid growth in the market meant that many tariff companies, flush with business, cannot have fully realised the growing market share won by non-tariff rivals. Even when legislation required motor revenue to be separately specified in returns from 1931, the aggregation of home and foreign business fogged the issue. When non-tariff companies creamed off the best risks, combined tariff loss experience exaggerated the level of claims. Tariff companies with a poor portfolio of risks were unable to carry lower rates. Above all, larger companies' market power enabled them to carry business at tariff rates. Some tariff companies strong in traditional markets regarded motor insurance as an unprofitable market only to be written to accommodate business connections. They might therefore have little interest in striking a competitive posture that could reduce profitability. In any case, with their market power, a reduction in the tariff rate might lead to a greater loss of revenue than that created by independent incursions. It was here that the absence of clear information on market shares must have

TABLE 10.3 *British non-tariff companies' international motor net premium income, 1931–38*

	Non-tariff companies' net motor premiums	Share of all British companies' international net premiums
	£'000	%
1931	8186	27.35
1932	7827	27.55
1933	8377	29.69
1934	8436	29.68
1935	9942	32.86
1936	10842	33.77
1937	11671	34.27
1938	11904	34.86

Source: PM, Annual reports on motor insurance business.

Note The data on British companies' international business are not precisely consistent with the source used in Table 10.1.

created the greatest difficulties for tariff companies, making such calculations highly speculative. In any event, there was undoubtedly much controversy over strategy within the tariff between the more and less successful companies, which on occasion nearly led to the break up of the agreement.[70]

However, the market power of the tariff companies depended in part on their large and expensive organisations, designed principally to meet organisational competition from other tariff companies. Lower premiums could therefore also be carried by lower administrative costs. Independent underwriters were able to combine more modest organisations with rate discounts in the blend they considered most effective. Although non-tariff underwriters received lower premiums and often paid higher commissions to agents, their combined expense ratio was significantly lower than the tariff companies. Between 1934 and 1938 their annual expense ratio averaged 37.5 per cent in comparison with the tariff forty per cent.[71]

These possibilities provided the basis of successful operation for a substantial group of independent companies. In 1938 there were thirty-nine tariff and twenty-seven significant independent motor insurers.[72] The tariff companies had a far larger motor premium income on average. None the less, the independent General Accident was the largest British motor insurer, and there were two other independents among the dozen largest concerns. As Table 10.3 shows, independent companies attracted a

TABLE 10.4 *British domestic net motor premium income of major non-tariff insurers, 1920–38 (£'000)*

	General Accident	Eagle Star	Co-operative	Cornhill	Lloyd's	Provincial
1920	n.k.	220	36	n.k.	n.k.	26
1921	n.k.	365	51	n.k.	n.k.	35
1922	n.k.	403	64	n.k.	n.k.	66
1923	n.k.	409	114	n.k.	n.k.	108
1924	n.k.	410	266	n.k.	n.k.	134
1925	n.k.	441	391	115	898	163
1926	n.k.	549	499	130	1008	197
1927	n.k.	564	559	144	1238	244
1628	n.k.	626	686	171	1571	267
1929	n.k.	674	626	191	1888	298
1930	n.k.	733	567	248	2390	341
1931	1492	813	610	305	2175	410
1932	1436	778	553	279	1883	415
1933	1449	770	612	283	1862	436
1934	1400	851	732	376	2414	479
1935	1573	1159	847	501	n.k.	566
1936	1710	1338	944	522	n.k.	618
1937	1818	1354	1052	527	n.k.	652
1938	1864	1325	1084	514	n.k.	699

Source: Westall, 'The invisible hand'.

revenue which rose to one-third of the international motor insurance business obtained by British companies in the 1930s. When Lloyd's motor business is added, the proportion rises from 27.4 per cent to 34.6 per cent in 1931. This was on a quite different scale to the marginal non-tariff activity in the fire insurance market before 1914, when the proportion only exceptionally rose as high as six per cent of the home market. Unfortunately it has not been possible to measure the independent share of the home market precisely. However, Table 10.4 suggests the substantial scale of home business written by five of the larger companies involved and the business written by Lloyd's, which was apparently almost entirely domestic. In 1934 this group probably controlled 30.5 per cent of the home market.[73]

Independent underwriters utilised various marketing strategies which varied with their market strength and thirst for growth. They fell into three groups. The most important consisted of several companies that had been established before the war, but had not developed sufficient market

strength to satisfy their managements with the scale, range, or profitability of their business. They were determined to seize the opportunities for growth presented by the motor market, partly for its own sake, but also to finance a larger organisation that would increase their presence in other markets. Tariff membership, which had to cover all markets or none, would prevent them from discounting premium rates elsewhere, and therefore make growth impossible in competition with established tariff companies.

Among them the General Accident was pre-eminent in scale. Under the dynamic leadership of Francis Norie-Miller it had established a prominent position as a specialist accident insurer before 1914. It had created the framework of a national organisation, notable for the Scots economy with which it was administered. Its strategy now demonstrated a determination to diversify across all insurance markets. This excluded it from tariff membership, despite its powerful position in the motor insurance market. By 1938 it had acquired an international motor insurance business of over £6 million, the largest among all British insurers, and a home motor revenue of possibly £1.9 million. Its branch organisation was the most extensive of all companies, with 128 offices in 1935.[74]

Although the Eagle Star (under its original title of British Dominions) had underwritten motor insurance before 1914, it had mushroomed from a primarily marine insurance company during the war years. This had been accomplished through a series of audacious purchases of life and general companies by Sir Edward Mountain. His determination to expand, combined with his Lloyd's origins, kept the Eagle Star clear of tariff connections. By 1935 the company's organisation, with sixty-six offices, matched most of the large tariff companies in number, and was supported by a formidable network of local directors and brilliantly innovative publicity. By 1938 it had become the seventh largest British motor insurer, attracting a home motor premium income of about £1.3 million.[75]

The Co-operative, Cornhill and Provincial, well-established, but modest concerns at the end of the war, pursued similar, if more cautious strategies. Another important group were the mutual offices formed mainly to operate in the employer's liability insurance market, as discussed in the previous section of this chapter. They also moved into motor insurance, operating outside the tariff, with the National Employers' Mutual attracting a substantial premium income by 1938.[76]

Lloyd's formed another major competitor for the tariff. Its individualistic organisation allowed its underwriters to operate with far lower costs, offer attractive commissions to brokers, quote competitive premium rates and support extensive direct advertising. This helped overcome its lack of

forward market integration through branch offices. Lloyd's brokers also developed successful schemes using occupational associations and trade unions to approach such groups as teachers, the police, or local government officers directly. By the early 1930s Lloyd's had captured some seven per cent of the British international motor business, and almost all this business was apparently obtained in the home market.[77]

These insurers pressed the tariff, but rarely too hard. They were as interested in the maintenance of premium rates and a stable market as the most conservative tariff office. If they provoked the tariff into a rate reduction, they would lose profitability and scope for growth. At worst, if the tariff collapsed and premium rate warfare broke out, they might become very uncompetitive in relation to the tariff offices' goodwill and large organisations. They therefore took a cautious long-term view, allowing the tariff to set and maintain prices which they followed in varying degrees. The greater their market power, the more careful they had to be. In 1938, for example, the General Accident, which carried most weight in the market, offered a discount of only seven per cent. The Eagle Star, more aggressive and rather smaller, made sure that it knocked about half a crown off most General Accident rates. The Co-operative, with less business and a smaller marketing organisation, offered a reduction of more than £1 below the Eagle Star.[78]

If these had been the only market elements, premium rates might have remained reasonably stable and profitable. But easy entry, controlled by no more that a modest deposit unrelated to the scale of business transacted, and the opportunities for winning revenue through rate reductions, attracted new companies. These exercised an influence disproportionate to their scale.

This was most obvious in the early 1930s when several tried to use the introduction of compulsory insurance to establish themselves. The South-East Lancashire, the North and South, the Port of Manchester, the Anglian and the London General were all opportunistic concerns controlled by inexperienced or shady managements. Their insecure finances and vestigial organisations forced them to win business by severe rate discounting, monthly premiums, or hair-raising acceptances. By setting out their stall for the motorists forced to insure by legislation, they accumulated risk portfolios containing the least responsible motorists and a high proportion of motor cyclists. The London General even offered insurance against fines for dangerous driving, attracting the worst risks.

Their rapid growth, despite the dubious security they offered, confirms the effectiveness of rate discounts with many policyholders and brokers. Initially incompetent underwriting created unprofitable business. This

forced them into even crazier discounting and acceptances, as their appetite for revenue became pathologically stimulated by the need to keep revenue ahead of the tidal wave of claims that chased it. Their problems were intensified by the hesitation in market growth during these years of economic depression. However, by 1933 their combined business had grown to £572,000 or over three per cent of the home market. Eventually all went into liquidation in 1933 or 1934.[79]

The incursion demonstrated how quickly weak or aggressive rate competition could be transmitted across the market. Even though it must have been evident that these companies could not last, the tariff was forced to concede a substantial increase in its no claims bonus in 1932. Significantly, soon after their disappearance, the tariff moved to recapture revenue by raising rates in the conurbations from the beginning of 1935.[80]

Premium rate formation was therefore critically weakened by the threat and existence of entry. The only weapon the tariff could use to control the market was to restrict profitability. New entrants rarely had the financial reserves or profitability in other markets which allowed established companies to contemplate the possibility of temporary motor underwriting losses. This did not always require rate reductions. Rising claims, commissions and organisational expenses placed continual pressure on profitability and so entry could be controlled by a cautious attitude towards rate increases. This was encouraged by the fact that the tariff companies usually lost business to non-tariff companies after a rate increase any way. The increase in the no claims bonus was the only significant rate concession the tariff made throughout the inter-war period, forced on it by the semi-fraudulent entry described above.

Profitability therefore remained much lower than in the traditional classes of insurance. On the international business written by British companies in the 1930s the annual average underwriting margin was 3.2 per cent, in comparison with the tariff target of ten per cent. Half the tariff companies normally suffered an underwriting loss. This was the price they paid for market stability. Only three of the twenty-three new motor insurers that entered the market between 1918 and 1921 remained in 1931. No significant entirely new insurance company emerged as the result of entry during the period.[81]

Why did the tariff companies remain in such an unsatisfactory market? The most obvious answer is that they could not leave it. By the 1930s motor revenue had become central to their operation in general insurance. Its dramatic growth was in sharp contrast with traditional fire and accident business, devastated by British economic difficulties in the 1920s, and American depression in the 1930s. As a result, by 1938 it carried one-

quarter of British general insurance companies' overhead costs and its reserve funds contributed one-sixth of investment income.[82] Its provision was essential in building goodwill with most agents and brokers. Without it, most companies would have become hopelessly uncompetitive in other general insurance markets and their ability to service equity would have been crippled.

However, the competitive structure of the domestic motor insurance market in this period was well suited to the growth of established non-tariff companies. The market grew so quickly that moderate rate competition was effective, in the short run because of consumers' sensitivity, and in the long run because the tariff companies were able to attract sufficient revenue to prevent any perception that they were losing business to competition. However, independent underwriters had to be clear as to how they would sustain their business over the long run, for it was clear that the older offices were prepared to underwrite on margins that were so fine that unprofitability was an ever present possibility. These slim margins discouraged broad brush discounting by even the most powerful non-tariff companies. There was the finest dividing line between profitable and unprofitable underwriting; approaching it too closely could be disastrous if market experience suddenly deteriorated. Competitive rates could only be justified by the most careful selection of risks. The tariff companies could remain in the market because financial strength generated outside the motor market allowed them this luxury and in return they obtained all the benefits of expanding revenue. Less well established concerns had to be clear as to how they would operate in these circumstances. Did they also have external resources, or would they have to discover the secret of profitable underwriting in such unpropitious circumstances?

11

The Provincial's home business between the wars

11.1 The transformation of the home fire account, 1920–38

The problems of fire insurance hit the Provincial with special force because some of the areas of acute competition and contraction were those in which it had previously obtained the bulk of its revenue and profit. It was therefore inevitable that the fire account should be overshadowed by the dramatic expansion in motor insurance. Yet this obscures the fact that despite difficult conditions, the Provincial's net home fire premium income practically doubled between 1920 and 1938 and produced some extra-ordinarily profitable results for the company.

Table 11.1 demonstrates that while gross premiums fell sharply in the early 1920s and mid 1930s, and only showed growth in the years before the Second War, net premiums developed in a far steadier and more powerful way. Between 1920 and 1938 gross premiums grew by one-quarter, while net premiums doubled. The change in the retention ratio accounts for over two-thirds of the growth in net income. This was not the result of a simple decision to raise retentions in order to achieve growth. That would have implied a casual attitude towards underwriting technique. It was a consequence of a fundamental change in the character, number and scale of the risks accepted and the scale of the account as a whole. It is to these we must look for the rise from well below forty per cent retained in the early 1920s to above fifty per cent in the late 1930s. Behind this lies a transformation in the balance of the Provincial's business.

The most dramatic change was a retreat from cotton insurances. Earlier chapters have shown how the company developed a privileged position in this market. During the war years the difficulties faced by the industry temporarily reduced its relative importance, but it shared in the post-war cotton boom to an extent that brought the class back to a more prominent position than since the company's first few years.

The boom grew to extraordinary proportions which distorted its insurances as much as the industry itself. Most of the growth came through existing policies as the value of stocks spiralled. Much of the additional

TABLE 11.1 *Provincial Insurance Company: British gross and net fire premiums,*
1920–38

	Gross fire premiums £'000	Net fire premiums £'000	Proportion reinsured %
1920	144.3	50.5	35
1921	128.3	47.6	37
1922	115.8	52.9	46
1923	127.7	55.8	44
1924	129.0	57.2	44
1925	134.1	60.4	45
1926	139.6	63.2	45
1927	139.7	65.5	47
1928	147.7	69.8	47
1929	143.5	70.6	49
1930	146.9	72.6	49
1931	144.6	75.2	52
1932	150.3	77.1	51
1933	147.8	81.3	55
1934	148.7	82.2	55
1935	152.1	87.1	57
1936	164.8	92.4	56
1937	177.2	100.6	57
1938	183.9	103.8	56

Note These figures do not include the Drapers' and General business or the reinsurance
premium income obtained.

income therefore had to be passed on in reinsurance as the Provincial's net
limits were quickly filled. Thus the proportion of premiums retained fell
to the extraordinarily low level of thirty-four per cent.

The unhappy subsequent story of the cotton industry is well known.
The boom was followed by a crisis in which demand and prices plum-
meted.[1] Despite some modest recovery, the industry offered little prospect
for insurance in the following two decades. Perhaps the simplest measure
of insurance opportunity is the value of raw cotton imported into the U.K.,
which fell from £257 million in 1920 to £73 million in 1921. During the
rest of the decade (1922–29) the average annual value imported was no
more than £94 million and this then fell to average £38 million in the
1930s (1930–38). Capacity fell also: spindleage was reduced by one-third
and looms by over two-fifths between 1920 and 1938.[2]

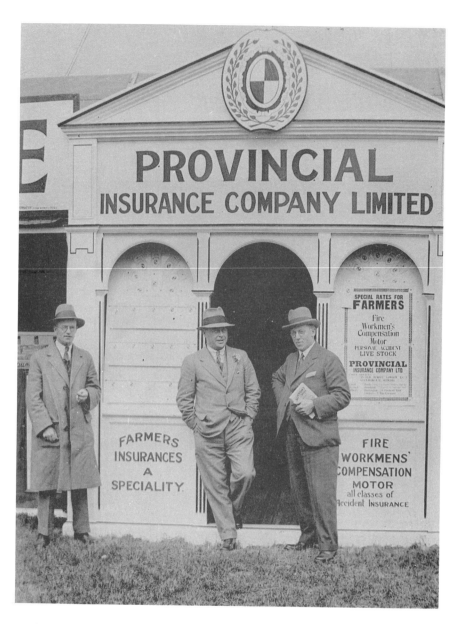

Marketing at an agricultural show between the wars. Left to right: C. Parkinson (Northallerton representative, later Bristol Manager); J. Tait (Leeds Manager); F. Robinson (Carlisle Manager).

All the factors intensifying competition in the hazardous fire insurance markets described in the previous chapter applied with special force to cotton insurances because of this collapse in business. It had always been an especially competitive market, and two other considerations now exacerbated this further. The re-organisation of ownership caused by the many mergers in the 1920s destroyed links between insurers and the family firms which disappeared into the new combines, ideally suited to approaches by interlopers, especially Lloyd's.[3] For this reason and because its brokers had made such progress in the cotton market during the war, the FOC decided to make a determined effort to drive them out, even at the cost of a campaign that would mean a period of very unprofitable underwriting.

This destroyed what had been the most successful element in the Provincial's underwriting account. Cotton premium rates collapsed in the 1920s as the tariff companies and Lloyd's fought over a contracting market. Tariff rates were cut in 1921 and again in 1925 when a reduction of twenty-five per cent was made for mills and fifteen per cent for stocks.[4] Many of the new policies and special discounts introduced in the 1920s, described in Chapter 10.1, were designed with the cotton market in mind. The abolition of short period rates and the introduction of the 'declaration' policy made deep inroads into the premium income obtained from cotton stocks.[5] The discounts for large accounts applied to the amalgamations. As a result, Baillie, the Provincial's fire underwriter, reckoned that by the early 1930s, cotton industry premium rates had fallen by one-third, with underwriters ignoring immediate profitability.

The consequences for the company were serious. Its most important market was suffering from an unprecedented contraction, below cost rate cutting and many of the old family firms with whom the company had established links had disappeared. It is impossible to identify the loss of cotton premium income precisely, but some suggestion is provided by the fact that between 1920 and 1923 the two branches concerned with the cotton industry, Bolton and Manchester, lost one-third of their joint gross premium income and this ensured that the company's home gross fire premiums fell by eleven per cent in those years.

Attempts were made to meet competition. When tariff rates were cut in 1921 and 1925, the Provincial followed, continuing to offer a non-tariff discount. Policy innovations were offered, forestalling the tariff by a few months; short period rates were abandoned and a 'declaration' policy offered. Premium was maintained by increasing the company's limits. Yet there was an ambivalence in the company's position. Having lost most of its special personal links with the industry, it could not compete with the

influence of the tariff offices in any way other than by rate competition;
yet Francis Scott was not prepared to cut rates to compete with Lloyd's
who led them down, for he believed that even tariff rates were unprofit-
able.

Until 1925 cotton business was sought with energy, but the tariff rate
reduction in that year precipitated the first sign of caution. Baillie cut
limits on cotton risks to reduce exposure in a market that now appeared
unsafe. Experience over the following three years, worsened by the large
scale discounts introduced by the tariff in 1927 and dramatised by a series
of big losses on sprinklered cotton mills in 1927 and 1928, confirmed this
impression.[6] With no prospect of change in the prosperity of the industry
or the competition for its insurances, the modest restrictions of 1925
looked inadequate and a change of policy was introduced for reasons
which Baillie later recalled:

> ... I made a report in which it was emphasised – (a) the passing of the old time
> private firms by incorporation with big combines had and would worsen fire
> experience, (b) the rates had been reduced to something like one-third of what
> had obtained previously, and (c) the industry was not prosperous. In view of the
> foregoing, particularly the changes in control and reduced rating – the latter
> representing a luxury campaign by the Tariff offices against Lloyd's primarily – I
> strongly pressed for coming out of the business except in regard to old private
> firms with whom we had long connections, and in all such to insist on full tariff
> rates and still further reduced retentions.

In other words, from 1928, the Provincial abandoned the cotton insur-
ance market, except when it could obtain business on the most favourable
terms possible and even then Baillie would only retain a modest limit. The
effect on revenue was immediate. In 1929, despite growth in other forms
of business and the eight year attrition that cotton revenue had suffered,
gross premium income fell by nine per cent. By that year the gross
premium income obtained through the Bolton and Manchester branches
had fallen to half its 1920 level and the proportion they contributed to the
company's fire account from forty-one per cent to twenty per cent. The
diversification of the Provincial's business from its regional origins was
not accomplished by a steady growth in revenue from other sources, but
by a decision to cut losses in a market that no longer offered the opportun-
ities that had made it such a splendid foundation in the Edwardian years.

Whatever the profitability of cotton insurances, the revenue they had
provided had made a crucial contribution to overhead costs. While all
hazardous fire insurance markets suffered to some degree from similar
problems, they were rarely so acute, and the company was obliged to look

to such business from brokers and branches for compensating revenue. Baillie worked through all existing risks of this type on the company's books, and found it possible to increase the company's net retentions on twenty per cent of them, immediately adding £3,000 to net premium income. In subsequent years the company was able to expand both net and gross acceptances. Francis Scott arranged that Bains should be supplied with the additional gross retentions now acceptable when each policy obtained through them came up for renewal and Sir Ernest Bain agreed that they would be given serious consideration.

Yet these developments were set at nought by the evolution of market. In the early 1920s the company found it extremely difficult to retain business. In 1923 premium income fell seriously and Francis Scott and Baillie engaged in a complete review of the company's underwriting policy to try to discover scope for maintaining revenue. This was before the potential of motor insurance had become apparent and the implications of a falling fire revenue appeared to be catastrophic for the expense ratio, and therefore the maintenance, let alone the expansion, of a branch organisation.

Their survey made it clear that the Provincial had responded to competitive pressure cautiously and certainly had not matched Lloyd's or even several non-tariff companies. The question was whether caution was essential, or whether it was self-destructive timidity. Francis Scott realised that some brokers and branch managers thought '…that we are more 'tariff' than our tariff opponents and that we insist on our own terms and conditions to a degree that none of the other non-tariff offices do and few of the tariff.' Baillie argued that the fall in premium income was not due to uncompetitiveness, but simply a reflection of market contraction: concessions consistent with profitability had been made; larger acceptance limits allowed; the range of risks accepted widened to include virtually all tariff rated risks; and special discounts made available for large blocks of business or to encourage valuable new agencies. Flexibility was, and would be exercised in acceptances if its specific advantages could be shown, but not as a general policy. Eventually Francis Scott's inherent caution was convinced by these arguments. He concluded that the Provincial's success would have to depend on branch managers taking more advantage of Baillie's judicious liberality and generating more energy and commitment among inspectors.

This was all very well, but it ignored two difficulties. Hazardous risks were obtained in highly competitive markets where the goodwill generated by eager canvassing took second place to commercial advantage and the more secure connection founded on genuine give and take in the

placing of business. Even the most successful outside man could not over-come the disadvantage of an underwriting policy that set itself against following competition, especially in the difficult conditions of the 1920s.

Baillie's flexibility was therefore less apparent to the branches. It was dependent on a discretion that he used grudgingly. Branch officials found it difficult to offer brokers the accommodations they sought and a steadily negative attitude from head office built up unwillingness on their part to put effort into what they had found so often to be a lost cause. Baillie suggested that the problem lay with his junior staff, but the truth was more likely to be that he transmitted an attitude that was the product of a cautious nature whose mistakes were subjected to close and critical scrutiny by Francis Scott. Relations at head office did not encourage the broad brush approach that might have given the branches the scope they sought. In these circumstances it is not surprising that hazardous insurance business grew sluggishly in the later 1920s. There were exceptions: the Bains provided some excellent lines, including one from the London and North Eastern Railway which brought a large and profit-able income. Yet Baillie's hope that economic recovery would restore premium income was dashed; even at branches like Birmingham and London, in areas unaffected by collapsing traditional industries, the 1925 upswing only saw the most modest improvement. After that gross premiums remained much the same under the pressure of competition and falling rates, justifying the emphasis on the profitability of underwriting.

The market for hazardous business was transformed by the FOC's decision to grant large scale discounts in 1927.[7] This, and the activities of the Non-tariff Rating Committee, largely eliminated the Provincial's rating advantage, making it impossible to intervene in tariff business. From 1929 this more difficult market again contracted with the beginnings of another and more severe depression. By 1931 A. E. Bain wrote to Francis Scott, 'We are up against the appalling reductions which are taking place, and which nullify for the time being all effort in the direction of new business ... we are very busy; we are never more active or more successful, but the struggle is to maintain figures.' By that year the Bains' account with the Provincial had fallen twenty per cent below the 1929 level. Even in the prosperous Midlands and South it is likely that the company's large scale insurances fell by between ten and twenty per cent.

Baillie reckoned that in the years after 1927 the premium income paid on the general run of brokers' business fell by between thirty per cent and fifty per cent. Allowing this, the volume of the Provincial's business must have been reasonably well maintained, but the implications for profitabil-ity were far more serious. Even within the cautious framework which

Baillie operated, the new conditions produced disastrous results. The average loss ratio on non-sprinklered manufacturing risks rose to ninety-six per cent in the years from 1929 to 1933, from the seventy-two per cent that had prevailed in all the company's previous experience. Non-sprinklered warehouse risks showed an even greater deterioration from fifty-seven per cent to ninety-five per cent.

These results were sufficiently worrying, but another related issue brought matters to a head. The collapse in cotton underwriting, the contraction in general hazardous underwriting, and its lack of profitability, had combined to affect the company's reinsurance treaty. The high proportion of cotton business reinsured had meant that it had borne the loss of business disproportionately; by 1929 the reinsurance account had fallen to £68,000 from the peak level of £80,000 in 1920; it continued to languish at this level into the early 1930s. While this had no direct effect on the Provincial's accounts, beyond the loss of commission, it none the less threatened the company. As the main loss had been of sprinklered cotton mills, the treaty now carried a small number of large risks. This increased the probability of wide variations in annual results because the contingency of a large loss on one of the few remaining risks would have to be carried against a smaller premium income. This exacerbated the problem that as the profitability of hazardous business declined, it was carried in an undiluted form by the reinsurance treaty which was almost entirely composed of such risks. For these reasons the possibility that the treaty would be unprofitable rose after the revision of the cotton business in 1928 and, in fact, it did suffer a series of unfavourable years. The likely consequences of this have been explained in earlier chapters.[8] If a Lloyd's treaty was cancelled, it would be difficult and certainly expensive to place another.

To protect the company, Baillie re-organised its underwriting policy by reducing acceptance limits for hazardous business and therefore the lines it placed with its reinsurers. Gross and net premium income previously obtained from very large risks was discarded, but the smaller business placed with reinsurers no longer had to cover a few large risks and its likely variability of experience was thereby reduced. He also encouraged branches to search out the more modest industrial and commercial risks of values between £2,000 and £10,000, believing that they were not only protected from the fiercest competition, by not being open to the tariff large scale discounts, but that their smaller size would make a more suitable contribution to the company's reinsurance account by not creating over-concentrated liabilities.

The new policy involved heavy costs. It dealt the Provincial's reputation as an active element in the fire market, already tarnished by the restrictions

of the 1920s, a severe blow. The smaller limits inconvenienced brokers, who were unwilling to complicate their business by splitting risks unnecessarily. Their goodwill passed to other non-tariff companies such as the Cornhill or the General Accident, who were more accommodating. If the Provincial was unhelpful, it could not expect the choicest risks.

Thus the revision seriously antagonised the company's connections among larger brokers, whose view of the Provincial as difficult to deal with and over-particular was confirmed. Inspectors and branch managers were discouraged. By 1936, Tait of Leeds was reported as saying, 'Head office ... had antagonised brokers and agents on the fire side, and there was a necessity for increased help in acceptances ... we have lost our place ...'; Fraser of Glasgow was franker, suggesting that the Provincial was ' ... not regarded as a fire company'. In short, by the end of the 1930s, the Provincial had become a largely passive participant in the hazardous fire market. At a time when economic recovery was beginning to restore industrial capacity and output, the company's annual average gross premium income from hazardous industrial and mercantile risks fell by nine per cent between the quinquenniums 1929–33 and 1934–38. Falling premium rates may have accounted for some of this reduction, but the fall in market share which must have occurred was the result of the revision of business and its longer term consequences for competitiveness.

In these ways the Provincial almost discarded the two original components of its fire revenue with a striking impact on its gross premium income. It achieved the growth in net premium income almost entirely from the more successful development of non-hazardous insurances that were subject to hardly any reinsurance. Francis Scott had always recognised this as the most profitable area of underwriting from the claims perspective, yet because it could only be won by the acquisition and servicing of smaller agents and brokers, through a branch organisation, the Provincial's opportunities had been limited before and during the war. During the inter-war period the position was transformed by an expanding organisation which made it possible to attract business from a far wider range of sources. As early as 1923 Baillie grasped the way that competitive pressures were changing the market and that they were by-passing the non-hazardous business where rate competition had never been effective. He suggested, '... Branches should be instructed to become particularly active :- (a) In suburban and country districts (b) for dwelling house, shop and small tradesmen's insurances generally as being a class where competition has not been and will not be as rife, as it is only premiums of great moment that are attacked'. His judgement was that in this class the Provincial was particularly weak,

'... in regard to the larger brokers and agents throughout the country in the majority of cases we had at least as large a share of the fire business ... as most non-tariff companies It seemed equally clear ... that in comparison with other non-tariff companies, we were not so favourably placed in respect of smaller town and country agents The future development of the fire department is entirely in the hands of the field men and their efforts must be directed towards securing a live agent in each and every town and village in their district, such agent being able to cultivate and secure small fire cases and thus ensure a steady and continuous flow of fire business.

This theme was to dominate the approach to fire development throughout the period. Indeed the commitment to non-hazardous business intensified as its improving experience became apparent. It changed the scope of underwriting. Risk assessment, rating and discounting were of less importance than the presentation of attractive policies which extracted the maximum premium from the policyholder, and appropriate commission rates and servicing for agents. Successful development was more dependent on the efficiency of branch organisations which will be discussed in Chapter Twelve.

Policy innovation became important. The Provincial popularised its policies under the brand name of the 'Coverall' policy. This was used to distinguish Provincial policies across the whole range of fire and accident underwriting and, as the title implied, involved the presentation of a range of forms of cover within one package. If the policyholder chose a sufficient number of options, then a discount was allowed on the premium charged for the non-fire components. From the company's point of view, the 'Coverall' policies encouraged policyholders to take out more cover than otherwise, and place all their insurances with the Provincial. This increased profitable premium income generally; increased the average premium obtained on each policy transaction, reducing proportionate administrative costs for the company; and appealed to agents by increasing their potential commission.

Two forms of 'Coverall' policy were particularly important for the fire department. A scheme for shopkeepers was introduced in 1922, offering seven optional sections covering such risks as employer's liability, public liability, personal accident, burglary, motor vehicle and plate glass insurance. A discount was available if four of the additional sections were selected, along with fire cover. Later, loss of profits was offered as a major component. Branch managers found that the 'Coverall' for shopkeepers gave the Provincial a significant competitive edge, especially suited to the Drapers' and General connection. By 1928 the two companies received between them fire premiums of over £8,000 through such schemes, three-

quarters of which passed through the Drapers' and General. Furthermore, the accident department took £17,000. In both cases, of course, virtually all the revenue was retained.

A similar policy was developed for householders, offering a smaller range of four options in addition to fire, only providing a discount if they were all taken up, including motor insurance. Along with the rest of the market, the Provincial gradually extended the range of its special perils insurance, covering flood, riot, and earthquake, at an additional premium. This provided a source of additional buoyancy for premium income and some competitive edge over the tariff companies. By the early 1930s, the Householders' 'Coverall' policy was attracting an extra £1,500 each year. However, this was probably due more to marketing strength than the special policy feature, for many companies were offering similar terms, including tariff offices. In addition, from 1928 agents were given an extra five per cent commission on 'Coverall' policies, and large non-hazardous accounts could receive a twenty-five per cent commission.

With these policies the greatly enlarged branch organisation was able to expand non-hazardous fire premium income substantially. It is impossible to provide an annual account of its growth, but the broad outline is clear. In the twenty-five years to 1928 the Provincial had obtained £155,000 non-hazardous premium income; it matched this almost precisely from 1929 to 1933 and then pushed it up to £227,000 from 1934 to 1938. The business from shop premises rose even more dramatically: from 1929 to 1933 £239,000 was obtained in comparison with £140,000 in the whole previous twenty-five years; subsequently it grew less quickly to reach £251,000 between 1934 and 1938.

This remarkable growth had dramatic consequences for the balance of business. Before 1928, the two classes of business specified above had only accounted for twenty-two per cent of all gross premiums the Provincial received. In the years 1929 to 1933 it rose to forty-four per cent, and then from 1934 to 1938, it continued to rise to forty-nine per cent. If the classification is widened to include sprinklered risks, the swing round in business is even more remarkable. In the pre-1929 period desirable business had accounted for forty per cent of all gross premium income. By the five years ending in 1938 it had risen to sixty-two per cent.

This had two important consequences. The absolute growth in non-hazardous business more than compensated for the fall in hazardous insurances as far as the net underwriting account was concerned, mainly because it required virtually no reinsurance. Thus it provided the important continued expansion in the Provincial's net premium income that was such a feature of the period. Even more strikingly, it greatly improved loss

experience. By the years 1934 to 1938 the company obtained an average fire loss ratio of only thirty-five per cent on shop risks and twenty-one per cent on general non-hazardous business.

As such underwriting increased proportionately, the overall loss ratio benefited. In comparison with the steady forty-six per cent loss ratio obtained in the decade before 1914 and fifty-three per cent during the war years, the loss ratio fell to average forty-one per cent between 1922 and 1929 and forty per cent in the years 1930 to 1938. In 1926 it fell as low as thirty-one per cent and in 1937 to thirty per cent across the whole account. Of course, the additional costs of obtaining smaller scale business have to be set against this, but it was none the less a remarkable phase combining growth and profitability in an environment that appeared to offer little scope for either.

11.2 The general accident account: competitive contrasts

Between the wars the balance of the Provincial's general accident account changed quite distinctly. Employer's liability insurance remained the most important component, still contributing well over half of revenue in 1938. But in the early 1920s and early 1930s it was subject to absolute reductions that were only compensated in the late 1930s. By contrast, the other miscellaneous classes of accident insurance, principally burglary, public liability, personal accident and plate glass insurance, enjoyed steady unspectacular growth, passing through the economic traumas of the period almost untouched. As a result, between 1920 and 1938 they grew relatively from seventeen to forty-three per cent of net general accident premium income.

This contrasting experience reflected the markets in which both types of insurance were obtained. This was as true of the competitive environment as the scale of business. Employer's liability insurance suffered from intense rate competition and increasing claims costs, especially in the 1930s, and thus shared the worst features of the fire and motor insurance markets.[9] As a result, from 1920 to 1938 the Provincial's corrected claims ratio averaged fifty-eight per cent and the business contributed little to profitability. On the other hand, the other types of cover were relatively immune from severe rate competition, and proved exceptionally profitable from the point of view of underwriting, producing an average corrected loss ratio of only forty-four per cent during the same period.

In principle, this suggests that an even greater shift in the relative proportions of business might have been beneficial, but the market did not allow such a choice. Even if employer's liability insurance yielded little

profit, its revenue made an important contribution to overheads. In any case, it was impossible to give up a form of insurance which agents and brokers needed to offer and most large policyholders required to purchase. It was these considerations which kept all companies in the market and forced down the level of profitability.

The reverse was true of the other forms of cover. In many cases, policies involved modest premiums. The cover often had to be sold positively for it was highly discretionary for the individual or business. Where larger premiums were involved, the risks often required specialist assessment and service. These circumstances made the business less sensitive to rate competition. With the exception of the specialist market at Lloyd's, it was the perquisite of the insurer with the company organisation that could market it effectively. That was why it was so profitable. But for that same reason it could not be attracted easily. Growth was slow and dependent on policy presentation, organisational growth and the motivation of company inspectors and agents rather than the result of judicious rate reductions. The Provincial's increasing success over the period reflected its expanding organisation.

Within this miscellaneous group of forms of accident cover, the Provincial developed one partial exception to these constraints. From 1923 the company led the market in establishing a new form of cover – goods in transit insurance. As an innovation, it enjoyed profitability and growth, contributing eight per cent of the Provincial's general accident insurance income in 1938, though it will be clear that the market for such cover remained modest in comparison with its growth after the Second World War.

Between the wars the Provincial's employer's liability business followed a similar pattern to that in home fire underwriting. The two markets' experience was sufficiently similar for it to be not surprising that the Provincial's response was in parallel.

The 1920 boom had seen remarkable increases in net premium income to £90,380, not reached again until the late 1930s. As Table 11.2 shows, by 1922 the account had fallen to £56,360, over one-third lower. It recovered to hover just above £70,000 for the remainder of the decade, but then fell back again to £66,250 in 1933 with economic depression. From then recovery was such that by 1938 net premium income had grown to £116,620.

Chapter 10.2 has sketched the reasons for falling business. As in fire, these fell heavily on the Provincial because of its commitment to cotton, which created the swollen revenues of the post-war boom and exaggerated the subsequent collapse and continuing lack of buoyancy until the late 1930s.

WORKMEN

—in the event of an accident in the course of their employment—are the responsibility of the Employer.

Employers should be satisfied that their Employers' Liability Insurance is placed with an office where

Rates are as low as possible, consistent with security.

Security is more than ample for all contingencies.

Settlements are expeditious and equitable.

Provincial Policies fill these requirements.

Workman's compensation advertisement (1934)

TABLE 11.2 *Provincial Insurance Company: British accident premium income, 1920–38 (£'000)*

	Employer's liability premiums	Burglary premiums	Goods in transit premiums	Miscellaneous accident premiums	Total accident premiums
1920	90.4	5.5	–	13.4	109.3
1921	77.0	5.2	–	13.7	95.9
1922	56.4	6.7	–	15.1	80.0
1923	56.4	8.8	0.4	18.6	84.3
1924	64.0	7.3	1.3	20.3	92.9
1925	73.1	7.6	1.7	23.1	105.4
1926	74.1	10.9	11.7	26.2	122.8
1927	73.7	10.6	9.3	29.4	122.9
1928	76.7	11.5	7.2	30.3	125.8
1929	74.0	13.2	8.0	32.1	127.2
1930	76.7	14.1	10.8	32.6	134.2
1931	72.7	14.4	12.5	33.7	133.2
1932	66.8	15.5	12.9	33.6	128.9
1933	66.2	16.1	13.4	34.1	129.9
1934	72.4	16.4	15.0	36.1	139.9
1935	82.1	17.5	15.9	39.7	155.2
1936	92.6	18.2	17.9	44.4	173.1
1937	107.3	20.7	16.8	46.5	191.3
1938	116.6	21.9	16.6	50.1	205.2

Note This table excludes all motor premium income.

The Provincial's opportunities to make headway in this environment were at least as restricted as, and certainly more complicated than, in the home fire market. It was squeezed by competition from opposite directions. The established offices retained their tight hold on the profitable small scale risks through their branch organisations. On the other hand, the scope for discounting premium rates on larger risks was severely reduced from the early 1920s.

The rebate the tariff offices paid under the Home Office agreement in 1922, described in Chapter 10.2, offered tariff company policyholders an apparently large discount. To overcome this, the Provincial was forced to raise its tariff discount as high as twenty per cent. Even this could not compete with the pressure created by the rise of the mutual offices, with their very low expense ratios, comparable to Lloyd's in the fire market. They forced premium rates down on the larger risks to which their methods were suited, and took an increasing market share which became so substantial as to provoke a severe rate cutting response from the tariff.

In short, it became difficult for the Provincial to discount rates profitably. Yet, while the market for such business became unattractive to the company, it could not leave it, for agents would become disenchanted with a company that did not offer a full range of cover, and individual risks that were of importance to the fire account might be lost if other companies were allowed to gain entry by successfully quoting for employer's liability business.

Furthermore, the sudden collapse of revenue in all markets in the early 1920s had such dangerous implications for covering overhead costs that revenue became important for its own sake. One direction in which vigorous attempts were made to stem the tide was by a free acceptance of employer's liability business, including the large industrial risks that brought in big premiums. However, the consequences of this policy, no doubt reinforced by the effect of the 1922 Home Office agreement, were unfortunate. The corrected loss ratio, which had fallen to thirty-eight per cent in 1921, rose catastrophically, from forty-two per cent in 1922 to seventy-eight per cent in 1925, with heavy losses in the textile areas covered by the Manchester, Bolton, Leeds and Bradford branches. It became essential to take remedial steps, and during 1926 and 1927 many undesirable risks were weeded out.

Despite this, the level of annual net premium income was well maintained by the successful implementation of a drive for new business. As in the fire market, the company set itself the task of attacking the market in smaller scale risks, largely controlled by the old tariff office organisations, where the competitive pressure on rates was not so great and the need for reinsurance negligible. This was made easier by the expansion of its branch organisation in the early 1920s, for such business could only be obtained by active selling by inspectors and well-motivated agents. Within this framework, higher commissions were offered for smaller employer's liability risks. The introduction of the shopkeepers' multiple policy, offering a discount if several different types of accident insurance were combined with fire cover, proved successful in ensuring that such businesses placed all their insurances with the Provincial. By 1928, Francis Scott was able to claim that 'We are now writing an entirely different class of business to what was written say three years ago'. The risks now retained were lighter in losses and easier to retain because they rarely involved negotiation over rates at renewal. As a result, revenue not only stabilised, but by 1928 the corrected loss ratio had fallen to 51.3 per cent.

However, pressure from the mutual companies and the economic contraction of the early 1930s led to a further reduction in business from £76,660 in 1930 to £66,250 in 1933. The same issues of revenue and the

conservation of connections that had arisen a decade before, again seemed important, even though scope for profitability remained limited. A decision was made to encourage business again. Standards of acceptance were relaxed. Discounts on premium rates were pushed as high as twenty per cent on non-hazardous business, and fifteen per cent on hazardous business, and in 1935 commission rates to agents were increased substantially. These changes, no doubt helped by the upswing in economic activity, created remarkably rapid premium growth after 1933. In 1936 the 1920 peak level was passed for the first time and by 1938 premium income had reached £116,620.

This growth was not costless. The Provincial's change of policy had again been made at the wrong moment from the point of view of the trend of experience. The rise in the number and particularly the size of claims across the market described in Chapter 10.2 was inevitably reflected in the Provincial's underwriting and reinforced by freer acceptances. The corrected loss ratio rose above sixty per cent again, with especially heavy losses in 1935 and 1937.

J. W. Tolfree, responsible for employer's liability underwriting at head office, saw little likelihood of a reduction in this pressure, as higher accident and death settlements in the courts was forcing up the scale of claims. He predicted a hardening of market rates as loss ratios rose above the 62.5 per cent 'target' set by the Home Office, which would eliminate the tariff rebate. With this in mind, in 1938 the Provincial's rates on new business were brought closer to the tariff with a reduction in the discount to a straightforward ten per cent. A revision began to weed out the risks accumulated since 1933 on the basis of 'taking a chance' or solely to protect a fire connection. All the latter cases were reviewed by the executive of the company.

Once these actions were taken, Tolfree was relatively optimistic about the company's prospects. The bulk of the risks in the account were perfectly reasonable. But he reiterated the theme that had gradually gathered force through the previous eighteen years, in this market as in others. The Provincial should not market itself on price. 'We must learn to shun 'cheapness' as the chief plank in our platform and be prepared to argue that the test of good insurance is not the price but the security and the service.'

This applied *a fortiori* in the market for miscellaneous accident cover, where rate competition played a more modest role in winning business. The Provincial usually charged the same rates as the tariff offices, relying on the energy of inspectors and agency connections to carry what business it could obtain. Much income was derived from the small scale non-

hazardous risks among householders and small shopkeepers where multiple policies, packaging various types of cover into one, were especially effective. The Provincial lost the non-tariff advantage of the householders' comprehensive policy in the early 1920s, but throughout that decade successfully utilised a multiple policy for shopkeepers. The 'Coverall' schemes for householders and shopkeepers were actively publicised and specially devised to persuade policyholders to take up less obvious forms of cover in return for the discount that was only available if a sufficient number of types of cover were purchased.

Special campaigns were mounted from time to time. Extra commission was paid to agents who produced a substantial flow of personal accident policies in 1925; in 1932 the profitability of this type of business persuaded the company to cut its rates by a straightforward twenty per cent. In 1928 competition forced down burglary rates. In the plate glass market, goodwill was so important that the company asked branch managers to look out for opportunities to purchase local mutual plate glass insurance companies.

Constant attempts were made to develop such profitable business but these ran into the problem that success depended almost entirely on effort by inspectors, but the commissions they could earn were tiny in relation to the effort involved. In the late 1930s, head office staff were sent out to the branches to instruct and motivate inspectors. Branch managers' conferences were constantly hearing pleas from head office to expand general accident business, but the repetition of these pleas was a measure of their ineffectiveness in an area where success depended largely on general market demand and the scale and quality of the company's agency connections. The latter could only grow in pace with the scale and strength of the branch network. Its increasing capacity is therefore loosely reflected in the steady accumulation of business. As Table 11.2 shows, burglary and miscellaneous accident business both grew at very similar rates, the former rising by 138 per cent and the latter by 139 per cent between 1920 and 1929; between 1929 and 1938 burglary rose by sixty-six per cent and miscellaneous accident by fifty-six per cent. The two accounts added £53,000 to premium income over the two decades, but beyond this generated a generous underwriting surplus. Between 1922 and 1938, for example, the uncorrected average annual loss ratio obtained on burglary business was as low as thirty-three per cent; and the comparable ratio for public liability underwriting was only thirty-eight per cent. It was this that encouraged Francis Scott to continually press for more to offset the narrower margins on employer's liability and especially motor insurance.

During this period the Provincial led the market in the provision of a

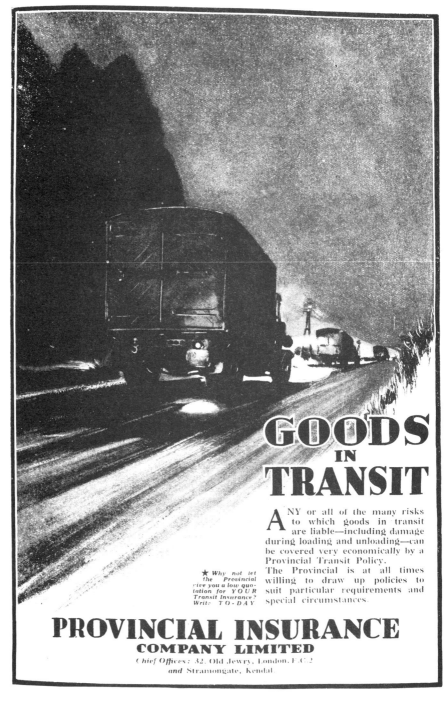

Goods in transit advertisement (1934)

new form of insurance, goods in transit, that was to become extremely important in later years. 'All Risks' insurance had developed, initially at Lloyd's, at the beginning of the century. 'Goods in Transit' was essentially a specialised development of this, covering the risk of fire, accidental damage and theft while goods were being transported.[10] A young Liverpool insurance broker, Aled Roberts, began to develop the business after the First World War. Realising that he required the support of a company organisation to market it successfully, he came to an arrangement with the Provincial to establish a largely autonomous department in Liverpool in 1923. After three years of experimental underwriting, during which much of the revenue was reinsured at Lloyd's, a more permanent basis for operation was arranged. The Provincial accepted all the liability except that of the large loss from a single fire involving several vehicles and this reduction in reinsurance immediately provided a more reasonable net income of £11,720 in 1926.

The potential for growth was enormous with the increased use of lorries and vans, where damage or loss could often occur as the result of carelessness on the part of drivers, especially during loading and unloading. Demand was increased among the owners of transported goods by the tendency for some carriers to exclude liability. Subsequently, some carriers used the acceptance of liability as a way of winning business in their own extremely competitive market. Furthermore, there was practically no competition for the Provincial until the late 1920s, when Lloyd's began to take an interest in the market and compete with rates that proved unprofitable.

However, the main constraint on growth was that the form of policy was so new that few potential policyholders were aware of its existence and it proved difficult to sell. The Provincial used its connections in the commercial motor insurance market to develop its potential. Information was included with proposal forms. But although the Provincial quickly established a reputation for important innovation and was widely recognised as the leading company in the market, this was only convertible into a relatively modest revenue in the period.

As Table 11.2 shows, after some initial problems, business grew steadily from £7,230 in 1928 to £17,850 in 1936, after which a modest reduction to £16,620 in 1938 was caused by the elimination of undesirable risks and rate cutting by Lloyd's which the Provincial did not wish to follow. The account proved marvellously profitable but revenue remained at a modest enough level. It continued to improve, especially as a result of the control of road transport introduced by the Road and Rail Traffic Act in 1933. As a result, Francis Scott continually enjoined branches to push it harder. An

inspector was appointed to assist Roberts from 1926 who was available to visit branches. Special meetings to discuss the business were arranged on a regional basis. Yet the sporadic nature of business from individual branches seemed to suggest that the business came as the result of a temporary enthusiasm. As with other general accident policies, the main problem appears to have been that of motivating the branch organisation to try to win business that required a modest degree of expertise, but, of greater significance, required hard selling and did not yield the easy results that were possible in motor insurance.

11.3 Motor insurance: the key to growth

One market – the underwriting of British motor insurance – became the key to the Provincial's growth during the inter-war years. The company entered this market in 1916 because Francis Scott wanted to be ready for the growth he anticipated after the war.[11] Of course, this was based on no more than an intuition about the direction of general insurance; the eight-fold growth in motor insurance premium income between the wars must have surprised him as much as it did others in the business. None the less, it provided a glittering opportunity which allowed the Provincial's net premium income from all markets to grow seven times between 1920 and 1938, when the general insurance premium income of all British offices rose by only one-fifth. Motor insurance provided two-thirds of the additional business and by 1938 half of all the Provincial's overall revenue was obtained in the British motor insurance market alone. This was a notable achievement, for in motor insurance the company overtook such long established concerns as the Alliance, the Atlas, the Guardian and the Norwich Union. It became the fourteenth largest British motor insurer despite writing a relatively small overseas motor account, amounting to only one-fifth of its motor premium income, rather than the one-half British companies as a whole obtained abroad.[12]

Yet revenue growth as such was not the real achievement. Chapter 10.3 showed that there was little difficulty in attracting motor insurance business, for motorists responded quickly to lower premium rates or policy concessions. The Provincial's success lay in combining growth with profitability.

This was particularly difficult because many other companies were prepared to subsidise underwriting losses in the motor market from other markets and this forced margins down. By contrast, motor insurance premiums formed such an increasing proportion of the Provincial's business, that even small proportionate losses could sabotage the company's

overall profitability. Furthermore, 'fine tuning' was impossible. Motor underwriting had to be based on a margin sufficient to withstand unpredictable changes in experience. The company had to devise a method of underwriting more profitable and more competitive than other insurers.

Motor insurance methods contrasted with traditional underwriting. The large number of risks and the subtle variations in their circumstances meant that the cost of accurate individual scrutiny was impossibly high. Competitive pressures forced underwriters to identify a few important determinants of risk to assess premium rates or reject proposals. Pressure from agents ruled out pettifogging selection that cut across the broad run of business.

The Provincial used premium rating as a selective filter. It was prepared to accept most motor risks, but established a rating structure that attracted business in proportion to its desirability. Undesirable risks tended to go elsewhere in search of lower rates. The balance of the company's risk portfolio was therefore moved towards better quality risks, without the expense of an administrative system that was bound to be inefficient and disrupt agency connections. Marketing and underwriting therefore became different aspects of the same management responsibility, as discrimination passed down the line to be decided in the market place. This contrasted with the tariff companies, who attempted to select risks by scrutinising inevitably bland proposal forms. Most non-tariff insurers operated in a similar way, albeit with discounted rates.

Attracting good risks by discounting rates was the way in which the Provincial had grown in the fire market. The difference lay in using rates to discourage bad risks. There were always some risks the Provincial tried to exclude by administrative means – the familiar underwriting bogies of the young driver, occupational groups such as army officers, bookmakers or journalists, or vehicles that attracted bad risk drivers such as sports cars. But the trend was always towards using loaded premium rates – sometimes above tariff levels – to reduce the administrative burden. This approach meant that rating and acceptance policies had to be vigilantly responsive to competitors' policies. Desirable classes of business from the Provincial's point of view might be created or ruined if the AOA adjusted rates. It was important that the company remained distinctly uncompetitive in unprofitable directions, otherwise it might collect unattractive risks.

Marketing was not restricted to premium rates. Higher commissions were paid to agents and brokers, especially when their business proved profitable. Policy terms could be used to attract desirable motorists. Office development was also important. Not only did it provide a wider

geographical range of agents to be approached, but it allowed the company to traverse the competitive spectrum. As the Provincial's marketing organisation, reputation and goodwill grew, underwriting margins rose as the need to compete on rates relaxed. This held underwriting advantages as well. The lowest rate on the market could attract motorists who were costly in claims and likely to be lost quickly to a more competitive concern. The motorist who took account of service was likely to be a better risk, easier to deal with in the event of a claim, and a more stable addition to the company's account.

In 1919 the company ended the reinsurance arrangement with the Excess and issued its first independent prospectus, in co-operation with the British Fire, which had in T. W. Fletcher a relatively experienced motor insurer. The first five post-war years were experimental for all underwriters. The new motoring conditions described in Chapter 10.3 necessitated several large increases in tariff premium rates. The Provincial followed them, benefiting from the antagonism they engendered among policyholders by delaying its own increases a little. After these adjustments, the market environment seemed sufficiently improved to allow a more imaginative approach.

By 1924 an approach implicitly based on the principles outlined above had evolved. The simplest way of describing it is to sketch the Provincial's ideal private motorist. Perhaps it is no coincidence that he bore a close resemblance to Francis Scott – himself an enthusiastic motorist. The company sought policyholders who were more interested in adequate cover than low rates, with a clean record, a large car and who lived in the country.

It did so by quoting basic premium rates that were not highly competitive. Small cars received no tariff discount. Larger cars were offered one which rose with the size of vehicle to a maximum of about seven per cent. Francis Scott believed that they were owned by motorists whose characteristics reflected those of pre-war motoring: men with the money to look after cars properly, sometimes with chauffeurs to drive them. Furthermore, the proportionate discounts on larger premiums were more effective than on smaller cars where they were often tiny, sacrificing revenue for no significant competitive gain. Larger premiums were also attractive when all policies involved the same administrative processing.

This basic premium could, however, be reduced in two ways. A no claims bonus was offered of fifteen per cent in the first and twenty per cent in the second claims free year, in comparison with the tariff flat ten per cent discount. When the Provincial first made this offer in 1919 (almost certainly suggested by Fletcher of the British Fire) it was the most

Motor Insurance

Suggest there is room for rate discrimination in favour of cars treated in country districts i.e. reduced collision risk.

See Chartered Insurance Institute Journal " Automobile Insurance. P. 42

———

Country discount memorandum. This is the note made by Francis Scott from which the discount for country motorists grew.

generous bonus available on the market and remained so until 1929. It strengthened the dual logic of the bonus in attracting drivers with better experience and discouraging them from making small claims.

A further discount of five per cent was offered to motorists who lived in the country or towns with a population of under 50,000. This innovation can be attributed directly to Francis Scott. A note in his hand refers to an article he had read in the *Journal of the Chartered Insurance Institute* on motor insurance in the United States, published in 1918, which mentioned the lower premium rates paid in rural states.[13] He wrote ' ... suggest there is room for rate discrimination in favour of cars located in country districts i.e. reduced collision risk '. Therein lay the kernel of an idea that was to provide a source of great profitability and competitive advantage for the Provincial throughout the inter-war period and beyond. Its effectiveness lay in the completely different nature of claims experience in less congested rural areas and in the far less competitive market in insurance in country towns.

Finally, cautious drivers were attracted by a 1s 6d discount per cent if they carried fire extinguishers, and personal accident cover and frost protection insurance were both offered within the basic premium. The Provincial led the market in these extensions, though they were both quickly copied.

The commercial vehicle market was more complicated because of the variety of vehicle type and use. About half of the business classified in this way actually came from private type cars, only differing in the business use to which they were put. With these, the Provincial used its private car rates, loading them by up to fifty per cent – the extreme being for commercial travellers. For lorries and vans the company took an orthodox non-tariff approach, offering discounts for specific classes. Heavy goods vehicles were initially selected as being too highly rated by the tariff. Vehicles owned and operated by concerns carrying their own goods as opposed to commercial haulage firms, a distinction unrecognised by the tariff, were also offered lower rates. A different structure of no claims bonus – rising over three years by ten, fifteen and twenty per cent – was available, along with the distinctive five per cent discount for some country district vehicles.

The company thus maintained basic rates that were moderately attractive for their preferred risks – large cars. It would normally only receive smaller cars from agents and policyholders who were as prepared to place their business with the Provincial as a large tariff company, with no rate incentive; and then the Provincial would receive the full tariff premium. Its rates here were higher than the main body of non-tariff companies that

offered an across the board ten per cent discount. Yet they became progressively more competitive as risks more closely approximated the company's ideal. Small car owners with a two year claims free record would obtain the preferential bonus; if they lived in the country they would also enjoy the additional discount. In fact, the discounts could build up to a maximum of seventeen per cent below the tariff for smaller and twenty-two per cent for larger cars. It made the Provincial's rates for smaller cars very comparable with normal non-tariff rates, when they enjoyed the characteristics the Provincial sought. Similar considerations applied in the commercial vehicle market. The company only exercised competitive appeal in proportion to its perception of the desirability of a risk.

This largely intuitive approach anticipated some of the main trends in experience in the inter-war motor insurance market. In some cases, competitive pressures led to this being demonstrated in the most obvious way, as the market followed the Provincial's lead. While this was flattering, it reduced the Provincial's competitive advantage. If adopted by a few non-tariff companies, it might reduce revenue growth; if the tariff adjusted its rates, then the whole basis of profitably underwriting a class of business might be destroyed.

This happened with the no claims bonus. It proved so effective that through the 1920s more and more non-tariff companies pushed their bonus up to the fifteen and then twenty per cent allowed by the Provincial.[14] The company was partially protected by variations in the speed and structure with which the bonus built up. As late as 1929 only one company gave a higher final bonus of twenty-five per cent; only seven gave fifteen per cent in the first year and six of those built up more gradually by giving 17.5 per cent in the second and twenty per cent in the third year. While the principal non-tariff companies, the Eagle Star and General Accident, both rose to twenty per cent, that was only after three and four years respectively. The innovative nature of the Provincial's original bonus was such that pressure was only felt in the early 1930s. Severe competition created by semi-fraudulent companies forced the tariff companies to raise their bonus to build up by ten, fifteen and twenty per cent over three years. The Provincial's relative position was transformed. Although its bonus still built up more quickly, its maximum was no higher than the tariff, and several non-tariff companies responded by raising their maximum bonus to twenty-five or even 33.3 per cent. There can be little doubt that this seriously reduced the Provincial's competitive edge and contributed towards the slower rate of premium income growth in the 1930s. Some Provincial officials wanted to match the increases but the company's bonus was not changed, for reasons that will become apparent below.

10%

FOR

THE AUSTIN
OWNER

Living in the country

The special Provincial concession of 10% for Morris owners living in certain country districts, is now extended to Austin cars. This should enable you to get more of this class of business.

★ *Ask for details.*

PROVINCIAL INSURANCE CO. LTD.
CHIEF OFFICES:
32, OLD JEWRY, E C 2 & STRAMONGATE, KENDAL

P. 1018

'10% for the Austin owner' (motor insurance advertisement, 1934)

However, this erosion of competitive advantage did not occur with the Provincial's other marketing targets. The tariff response to the problems of small cars and urban motorists created more opportunities than it destroyed.

Faced with a climbing loss experience from small cars, the tariff raised the relevant rates by nearly one-quarter in 1928. This allowed the Provincial to extend a seven per cent discount to smaller cars for the first time. Before this the loss ratios on larger cars were significantly lower, subsequently, this ceased to be so clearly the case.

Finally, the country discount was practically untouched by competition in the inter-war years. No other company introduced a comparable discount before 1931; in 1933 it was restricted to eight small non-tariff companies. This did not mean that other underwriters were unaware of the opportunities that the Provincial was exploiting. No doubt the best tried to select risks outside cities. But tariff underwriters rationalised a refusal to allow a reduced rate by arguing that it was impossible to be sure that a country resident did not motor into towns. If this was argued in good faith, it demonstrates the extent to which tariff underwriters were operating on a priori rationalisation, rather than statistical evidence. Indeed, it is possible that only the Provincial had the detailed statistical evidence which demonstrated the lower claims cost of rural motorists. In 1926, the variation was striking: town vehicles produced an uncorrected loss ratio of fifty-seven per cent, while country enjoyed one of only thirty-two per cent, despite the five per cent discount. This was maintained in later years. Despite increases in the country discount to ten per cent for Morris and Austin cars, and its gradual extension in the late 1930s to a wider range of county towns, the earned loss ratio on private cars in towns from 1934 to 1938 averaged sixty-three per cent, while that on country cars was fifty-two per cent. In the commercial market the same comparison yielded fifty-nine per cent on urban vehicles and forty-seven per cent in the country.

Yet even if they had known this, the consideration uppermost in most underwriters' minds was the low and declining profitability of motor insurance. The high claims costs in large cities became a focus of attention and this operated to the Provincial's advantage. When the variation in experience was eventually recognised by the tariff in 1935, it took the form of major increases in rates for motorists in the conurbations. As Chapter 10.3 indicated, rates in London, Glasgow and the Lancashire conurbations were raised by between ten and twenty per cent. It is hard to resist the suggestion that the AOA was seeking to restore some of the revenue it had lost through the raising of no claims bonuses in 1933. For

TABLE 11.3 *Provincial Insurance Company: British net motor premiums,*
1920–38

	Motor net premiums	Annual growth rate	Corrected loss ratio	Provincial share of British motor insurance market
	£'000	%	%	%
1920	26.0	623.6	104.6	0.74
1921	35.0	34.4	55.7	0.71
1922	61.6	76.0	58.2	1.06
1923	107.6	74.9	62.0	1.63
1924	134.0	24.5	55.9	1.77
1925	152.0	13.5	54.1	1.73
1926	182.4	20.0	54.5	1.81
1927	224.2	22.9	57.6	2.01
1928	243.8	8.7	52.2	1.87
1929	272.1	11.6	54.3	1.93
1930	310.5	14.1	50.2	2.05
1931	371.7	19.7	48.9	2.30
1932	374.4	0.7	44.9	2.22
1933	393.6	5.1	49.3	2.27
1934	433.0	10.0	52.4	2.34
1935	510.8	18.0	55.1	2.44
1936	559.8	9.6	48.0	2.46
1937	592.9	5.9	50.5	2.43
1938	637.3	7.5	55.4	2.44

Note The Provincial's market share is calculated as a proportion of British domestic net
motor premiums indicated in Table 10.1. The Provincial's net motor premiums exclude
the Drapers' and General's motor business which is included in Table 10.4 above.

most of its members the pressure of claims was too severe to contemplate
reductions. The competitive appeal of the country discount therefore
remained unaffected.

Perhaps this was in part because it was clear to the larger tariff com-
panies that country motorists formed a relatively uncompetitive section of
the market. In contrast to the fiercely competitive insurance markets in
the towns, rural areas had fewer garage agents or brokers and it was
expensive for smaller companies to provide local branch offices or direct
representation. The large offices, with their powerful marketing organisa-
tions, probably believed themselves to be less vulnerable to competition

and were therefore unwilling to give away premium income on business that was relatively profitable.

But this strengthened the Provincial's hand. The country discount did not cut across the normal run of a country agent's account for it was available on practically all his risks including some local commercial vehicles. This provided an incentive for him to give the Provincial all his business. Over the long run underwriting and marketing combined to encourage the development of good country agency connections – which continued the flow of such risks in the future and gave the Provincial strength in this uncompetitive market. This enabled it to become the leading non-tariff competitor in rural areas and small towns, where the tariff companies normally had free run. Even when some small non-tariff companies adopted the country discount in the early 1930s, they did not have the marketing organisation to make this a serious threat to the now well established Provincial rural agency connection. The overall success of this strategy in terms of revenue growth is clear. The company's performance relative to many long established companies has been described above. The company grew substantially faster than a market which itself grew nearly eight times. As Table 11.3 shows, the Provincial's market share rose more than three and a half times between 1920 and 1938 from 0.74 per cent in 1920 to 2.44 per cent in 1938. Diagram 7 illustrates the relationship between this expansion in market share and the growth in the British market as a whole. Growth was most rapid in the 1920s when rapid market growth and a rising market share combined to produce an average annual growth rate of thirty-two per cent; in the 1930s the market grew more slowly and the market share remained relatively stable, leading to a slower average annual growth rate of ten per cent.

Success in underwriting terms is less easy to demonstrate conclusively. If the exceptional result in 1920 is ignored, the years from 1921 to 1929 produced an average corrected loss ratio of fifty-six per cent; the comparable figure for 1930 to 1938 was fifty-one per cent. With the combined expense and commission ratio remaining steadily at about forty per cent, this allowed a margin of some four per cent in the first decade and nearly ten per cent in the second. In isolation, this suggests a satisfactory result. In fact, there can be little doubt that it was distinctly superior to the majority of British companies. Statistical comparisons can only be made through published accounts which are only available from 1931 when legislation required the disclosure of motor revenue accounts. Even then the picture is not clear because most companies wrote abroad and their foreign results, obtained in very different circumstances, are included. With these qualifications in mind, some broad comparisons can be made.

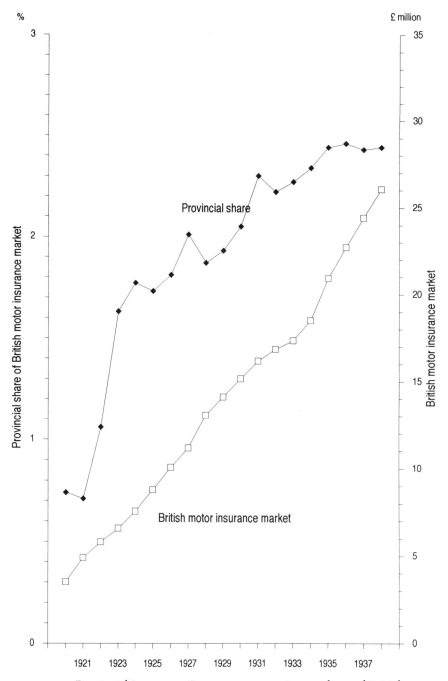

DIAGRAM 7 Provincial Insurance Company: proportionate share of British motor
insurance market, 1920–38
Source Tables 10.1 and 11.3

The Provincial's published corrected loss ratio across home and foreign motor business and including the Drapers' and General subsidiary, averaged fifty-three per cent for the available years from 1932 to 1938 inclusive. This was significantly superior to the comparable average for all tariff companies of fifty-seven per cent and non-tariff companies of fifty-nine per cent. Focusing more specifically on comparable non-tariff concerns with modest overseas motor insurance involvement, the Eagle Star averaged fifty-six per cent and the Cornhill sixty-two per cent. Two other companies were practically restricted to the British market: the Co-operative and the Road Transport and General, a subsidiary of the General Accident. The Co-operative averaged sixty-two per cent and the Road Transport fifty-eight per cent. The comparable Provincial average ratio for the British market alone was fifty-one per cent. These comparisons are obviously partial and not wholly satisfactory. In particular, it is impossible to provide a comparative measure of the Provincial's performance in the 1920s, when its loss ratio was rather higher. None the less, the evidence available suggests that the Provincial maintained an underwriting record that was distinctly superior to its most obvious non-tariff rivals and, despite their higher premium rates, the generality of tariff companies.[15]

Growth and profitability not only formed the objectives of policy, but determined the more detailed sequence of development. This was because the pace of growth varied with market expansion and the changing strength of the Provincial's competitive edge, and the latter was constrained by considerations of profitability. The essence of management lay in the choices that this trade-off created. In broad terms this provides an explanation for the pattern of rapid growth in the 1920s associated with higher loss ratios, and slower growth in the 1930s with lower loss ratios, but the story is more complicated than that.

Large premium rate increases and the rapid acceleration in vehicle numbers meant that 1920 and 1921 saw very high rates of business growth, even though the Provincial's market share remained much the same. In 1922 and 1923 as the Provincial's competitive marketing policy began to bite and new branch offices developed their agency connections, this growth was sustained through an increased market share.

However, the Provincial was too competitive. In 1922 and 1923 its motor account proved seriously unprofitable, especially when combined with high expenses and commissions. There were two problems. In this experimental period, premium rates and policy terms, taken together, were too generous. The consequent growth in the scale and complexity of business seems to have run beyond the capacity of the existing head office staff. Insufficient care was exercised in the appraisal of proposals and

granting of concessions on acceptances and commission terms. From fifty-six per cent in 1921, the corrected loss ratio rose to fifty-eight per cent in 1922 and sixty-two per cent in 1923. Commission payments rose as well, from fifteen per cent in 1921 to eighteen per cent in 1923, probably because of a free acceptance of business from large brokers. In a period when falling income in other markets was increasing the problem of overhead costs, this became sufficiently serious for Francis Scott to take action.

In May 1924 rates were raised nearer the tariff to assume the levels described in detail above. David Glass, who had been appointed earlier to handle accident claims settlement, was given sole charge of accident under-writing. He instituted a revision of the motor business on the books and re-organised the management of the motor department to provide both stricter control over acceptances and the collection of more systematic statistical data on which to base selection in the future. As a result, from 1924 the hectic growth in the Provincial's market share was moderated with beneficial consequences for the loss ratio, which fell back to fifty-six per cent in 1924 and remained below that level in the following two years.

However, the General Accident began to place an unacceptable competitive pressure on the company, by offering new owners of Morris cars with a free first year's policy. Morris cars appeared to provide low claims costs because of their standardised manufacture and it must have been tempting to become as competitive as possible for a make whose ownership was expanding so rapidly.[16] From 1925 the Provincial offered special Morris terms and these were extended in 1926.

As far as revenue growth was concerned, the move was successful. Between 1925 and 1927 the premium income derived from Morris cars more than quadrupled, rising from twelve per cent of all private car income to thirty-two per cent. But once again, promising growth ran into the sands of unprofitability. Morris cars' earned claims ratio rose to seventy-eight per cent in 1927 contributing to a rise back to fifty-eight per cent in the motor loss ratio. The special rates were cancelled but replaced by a doubling in the country discount to ten per cent for Morris cars alone.

This proved a decisive move. It made the company uncompetitive in towns. Morris town income fell substantially in 1928 and 1929, contributing to the reduction in the company's market share in those years when tariff rate increases were expanding motor premium income in that same direction. On the other hand, Morris country business grew by half in those two years, leading a more general development which saw country private vehicle income rise by thirty-five per cent from 1928 to 1929,

TABLE 11.4 *Provincial Insurance Company: private, commercial and country rated motor premiums, 1925–38*

	Private rated premiums	Proportion of private country rated	Commercial rated risks	Proportion of commercial country rated	All motor premiums	Proportion of all country rated
	£'000	%	£'000	%	£'000	%
1925	76.3		79.0		155.3	
1926	95.1	25.1	91.4		186.5	
1927	122.8		105.9		228.7	
1928	133.5	29.5	113.3		246.8	
1929	151.6	35.2	128.8	36.2	280.4	35.6
1930	167.5		151.8		319.3	
1931	197.1		185.4		382.5	
1932	205.8		176.8		382.6	
1933	207.7	44.0	199.5		407.2	
1934	227.0	47.0	219.9	47.9	446.9	47.4
1935	276.3	47.2	257.8	44.6	534.1	45.9
1936	300.8	47.2	282.7	41.4	583.5	44.4
1937	319.6	45.8	298.2	33.7	617.8	39.9
1938	345.6	47.6	315.8	35.1	661.4	41.6

Note This information is only partially available from 1925. It is taken from the classification of underwriting statistics which leads to inconsistencies with the accounting results reported in Table 11.3.

when the same business in the towns rose by only five per cent. The special appeal of the Morris country discount was reinforced by the tariff rate increase in small private cars in 1928 which allowed the Provincial to offer a discount of some seven per cent for the first time for this class. This seems to have made the company particularly competitive when it was combined with the country discount.

The shifting balance of business was equally encouraged by far slower growth in the towns. The Provincial's rates were by no means so competitive in such markets where it was in any case far easier for other non-tariff companies, including some relatively new entrants, to establish marketing organisations. Table 11.4 indicates the strength of the relative change. In 1926 the proportion of country rated private vehicles was twenty-five per cent; in 1928 it had risen to thirty per cent; but by 1929 it was as high as thirty-five per cent, closely matched by commercial business where the proportion was thirty-six per cent.

The decision to concentrate on country Morris cars and the opportunity to attack the market for small country cars more generally marked an important turning point. There is no evidence that the country discount had previously been particularly effective in winning business. In the following years to 1934 the company was able to exploit it to great effect. By that year the proportion of country rated business had risen to forty-seven per cent for private and forty-eight per cent for commercial vehicles. No doubt the success of the development was closely linked with the opening of a number of district offices in rural areas in those years. It certainly proved beneficial for the company's underwriting. In 1929 the corrected loss ratio on private town cars was seventy-one per cent, while the comparable ratio for country vehicles was only fifty-six per cent. From 1930 to 1933 the company's loss ratio remained at an unprecedentedly low level, falling to forty-five per cent in 1932. No doubt the depression reduced car use, but the changing balance towards country business must have made an important contribution.

Through 1930 and 1931 this improved underwriting was combined with sustained premium growth. In the latter year, of course, the imposition of compulsory insurance provided a once and for all accession of business. However, the subsequent years saw a marked deceleration in revenue growth. This was partly a reflection of the market's reaction to the depression, but the Provincial's market share began to fall as well. As has been explained in the previous chapter, competition set off an escalation in the no claims bonus which eroded any major advantage the Provincial retained from this device. In 1933 the tariff was forced to raise its bonus to a level which provided the same maximum discount as the Provincial, though after four years instead of two. Special problems arose in the commercial market as well. Haulage risks became so unprofitable that tariff rates were quoted to try to exclude them. In 1933 the Road and Rail Traffic Act re-organised commercial transport by licensing vehicles in classes which made it easier for the tariff to discriminate in its rating between vehicles used for different purposes. This reduced the scope for the selection of several types of commercial vehicle including especially the 'own goods' haulage risks which had proved both a competitive opportunity and profitable for the Provincial.

The stagnation in business this created began to test the commitment to selective growth. Scott and Glass became seriously concerned about the reduction in revenue. From the general management point of view, it threatened the flow of revenue on which organisational development was based. Stern injunctions were issued to branches to remember profitability, yet at annual conferences branch managers were required to cudgel

their brains to devise ways of making the Provincial more competitive. Some wished to match the escalation in no claims bonuses. But the actual patterning of the Provincial's bonus, with the fifteen per cent reduction in the first year, meant that the loss of risks caused by not following other non-tariff companies up to a final twenty-five or 33.3 per cent was not as obvious as the definite loss of revenue that would occur on existing policies. In any case, it was argued, only the less profitable brokers' business was sensitive to higher bonuses, and the more profitable smaller agents' income was relatively unaffected. The matter was continually discussed, but no change made. Other concessions were found. In 1932 instructions were given to rate the ten horsepower Austin and Morris cars at nine horsepower. In 1933 the ten per cent country discount was extended to Austins.

This atmosphere of concern for growth explains the response to the tariff decision in 1935 to increase rates for private cars in the large conurbations. The Provincial followed them with a modest discount in London, but not in urban Lancashire and Glasgow. Glass argued,

... with Lancashire we are dealing with a somewhat different type to the type met with in Central London. In the latter place are to be found a large number of people either not engaged in any occupation or who are more or less playing at business ... in Lancashire one meets an entirely different type of insured because in that county there is not, nor has there ever been, the same proportion of the population without occupation and the men engaged in business there are of a much more hard headed type ... the class of agent we have in some of the Lancashire districts ... are intensely loyal to the Provincial In Glasgow ... the same conditions prevail as in Lancashire... the Company is established in Glasgow with a name second to none and there are certain firms in Glasgow who now look upon the Provincial as their first non-tariff office ... they are all of the long headed and deep thinking type.

Thus the company offered unchanged premium rates which provided a twenty per cent discount in Glasgow and ten per cent in urban Lancashire.

These proved a potent incentive when offered to motorists antagonised by higher rates. It was compounded by the collapse of two large non-tariff companies which released on to the market a flood of business seeking new cover. In 1935 the rate of growth of net premium income rose to eighteen per cent. The source was clear. For the first time in at least a decade, premium income from private town cars grew as quickly as that from country areas. The ratio of country private vehicles, shown in Table 11.4, stabilised at forty-seven per cent until 1938. More dramatically, in the commercial vehicle market, the proportion of country business fell

from forty-eight per cent in 1934 to thirty-five per cent in 1938. Glasgow business featured most prominently geographically, and commercial travellers' risks by class in the increased flow of business. The Provincial's competitive rates had made it a magnet for such risks.

This development restored growth to the account, but it proved a poisoned chalice. Shifting the balance away from the country was bound to reduce profitability, given the higher claims ratio on all urban business. The new Glasgow and Lancashire private risks proved disastrously un-profitable, producing in 1938 an earned loss ratio of seventy-seven per cent and 102 per cent respectively, in comparison with the equivalent urban loss ratio, outside the conurbations, of seventy per cent. Further-more, in the commercial market, commercial travellers' risks were notori-ously expensive, and proved so in Glasgow where in 1938 they turned in an earned loss ratio of 121 per cent.

These problems were intensified by the general deterioration in loss experience in the late 1930s. This is not fully reflected in the net results indicated in Table 11.3. Much of the increase was the result of large individual claims caused by higher third party settlements, due to legal changes. A good proportion of the increase was therefore covered by reinsurance, but this inevitably threatened a rise in the cost of such protection.

Francis Scott became anxious. The tremendous growth in motor insurance had pushed the Provincial into an exposed position. Half of the company's revenue now came from a market in which there was only a fine balance between profit and loss, even when carefully written. From 1937 attempts began to rectify the position. Branches were encouraged to redirect effort towards general accident and fire insurance business. The importance of cultivating smaller agents who were not exclusively inter-ested in motor risks was emphasised.

These exhortations proved relatively ineffective. More positive measures were necessary within the motor account to restore the emphasis on country business. In 1937 all new business and renewals from South Lancashire and Glasgow that had been subject to a claim were quoted increased rates. In 1938 rates were raised on all such business and on town motor traders' business to discourage their agencies. The scope of the country discount was also extended. In 1935 Bath and Gloucester, two cities with populations of over 50,000, were included; by 1937 twenty-seven such towns had been added; in the same year some private vehicles used for business purposes were allowed a country discount for the first time. Continued pressure from some branch managers to increase the no claims bonus to meet competition was rejected on the grounds that the

Who could have foretold, thirty years ago, that traffic would develop in volume and speed to to-day's proportions? Roads were safer then and compulsory insurance against road risks was undreamed of. At that time the Provincial Insurance Company was founded; so its growth is contemporary with that of Motoring itself. And, as motoring conditions have changed, the Provincial has accordingly revised the conditions of its policies to meet motorists' needs. Thus, to-day, the Provincial COVER-ALL Policy gives fuller protection than ever at lower rates. It is the up-to-date form of economical Comprehensive Motoring Insurance with considerate concessions and generous benefits which include: Personal Accident to Owner AND WIFE; Medical Expenses any occupant up to 25 guineas; Fire and Theft of Rugs, Wraps and Luggage; Frost Damage; Special Rates for Country Residents (10% reduction in premiums for Austin and Morris owners); Transfer without Loss of Bonus; No Claims Bonus—15% First Year, 20% SECOND YEAR and each successive year. The Provincial's reputation for fair dealing and prompt claims settlement are added inducements to every thoughtful motorist to find out more about this attractive policy.

★ *Write TODAY for a Prospectus and see exactly what is offered by the COVER-ALL*

PROVINCIAL INSURANCE COMPANY

Chief Offices: 32, Old Jewry, London, E.C.2. and Stramongate, Kendal.

'Thirty Years Ago' (motor insurance advertisement, 1934)

company did not want to become more competitive in the towns. Finally, in 1938 the country discount was raised to ten per cent on all private and some commercial vehicles.

As in the past, these moves to restore profitability slowed the growth of business. In 1937 the Provincial's market share fell and it did not rise significantly in 1938. Growth in revenue decelerated. Yet this investment began slowly to yield the desired objective. In 1938 country business began to grow more rapidly than town again. The company had returned to the underlying strategy that had given it competitive strength based on secure profitability.

This last phase of growth re-emphasises that the choice between growth and profitability was more apparent than real. If growth was not profitable, then it could not be sustained in a market where so many aspects of costs were unpredictable and volatile. It underlines the importance of the 'quest for country business'. This proved the trump card for the Provincial in that it was well founded on the reality of underwriting experience and competitive effectiveness. In the late 1920s it protected the Provincial against the deterioration in profitability; in the early 1930s it staved off the worst effects of competition. When the Provincial moved away from this strategy in the mid 1930s, it learned the hard lesson that the rapid growth achieved in earlier years was as much a product of the quality of its underwriting as the straightforward winning of business. D. W. Holloway, who was brought to head office from the Bristol branch in the late 1930s to control motor underwriting, portrayed the situation graphically in 1939, ' ... our position is this: in all classes of business we have a country income of nearly £300,000 which still yields, on 1938 figures, over £28,000 gross profit. Our problem is to prevent the rest of the business showing a loss.' The Provincial's dramatic expansion in the motor market in the inter-war years was founded on the successful understanding, even if it was intuitive on the part of those who achieved it, that underwriting and marketing could no longer be seen as the two separate activities they had been in traditional insurance markets.

12

The development of
the Provincial's organisation

12.1 The expense ratio

Between 1920 and 1938 the combined efforts of all the Provincial's home underwriting departments produced the expansion in revenue shown in Table 12.1. Supporting this growth, and essential to its scale, composition and profitability, was the construction of an organisation designed to win, hold and service business competitively. Table 12.2 shows that between 1920 and 1938 the number of branch and sub-offices rose from fifteen to fifty-six. At its simplest, this extended the area over which business could be won, but it also allowed more intensive marketing as well. It provided the local service and control required by motor insurance. In that market it allowed the agency development that enabled country motorists' policies to be won and competitive pressures from premium rate competition to be resisted. In the fire and general accident markets it allowed the balance to be shifted from the large scale, rate competitive classes towards small scale less hazardous risks. In these ways it was an essential component of the Provincial's strategy of diversifying and taking firmer control of its business and thus feeding profitability at the same time as growth.

This process was not without its problems. Organisational competition could be as fierce as that by rate. Other companies used motor revenue to expand their organisations, so the Provincial's competitive strength depended on its growth relative to competitors. A larger organisation also created problems of control and management if its objectives were to be satisfactorily secured. Above all, the cost of organisational growth became a crucial consideration.

This created a reciprocal relationship. Organisational development encouraged future revenue growth and profitability. But its cost had to be met from current revenue. Francis Scott discovered the force of this constraint in the early 1920s when the expense ratio rose to absorb over one-third of revenue, threatening profitability. He subsequently sought to reduce it to twenty per cent. Table 12.1 shows that this was not entirely achieved, but that the ratio fell and remained relatively stable between twenty-two and twenty-four per cent after 1925. In broad terms organisational expenditure had to grow at the same rate as revenue.

TABLE 12.1 *Provincial Insurance Company: expenses of management, 1920–38*

	All British premiums	Branch expenses	Proportion of premiums	Head office expenses	Proportion of premiums	All expenses	Proportion of premiums
	£'000	£'000	%	£'000	%	£'000	%
1920	186.1	34.3	18.4	22.2	11.9	56.5	30.4
1921	177.1	39.5	22.3	23.5	13.3	63.1	35.6
1922	185.1	42.7	23.0	20.0	10.8	62.6	33.8
1923	247.3	42.6	17.2	18.3	7.4	60.9	24.6
1924	283.5	46.9	16.5	23.1	8.2	70.1	24.7
1925	318.9	52.7	16.5	26.4	8.3	79.1	24.8
1926	369.4	58.7	15.9	24.4	6.6	83.1	22.5
1927	414.6	68.3	16.5	25.9	6.3	94.3	22.7
1928	441.8	73.6	16.7	25.8	5.8	99.3	22.5
1929	472.2	84.9	18.0	27.3	5.8	112.3	23.8
1930	521.2	94.3	18.1	30.4	5.8	124.7	23.9
1931	581.7	98.4	16.9	34.5	5.9	132.9	22.9
1932	582.3	101.7	17.5	33.6	5.8	135.3	23.2
1933	604.5	104.6	17.3	36.5	6.0	141.2	23.4
1934	657.8	110.3	16.8	41.4	6.3	151.8	23.1
1935	753.6	118.3	15.7	44.7	5.9	163.0	21.6
1936	825.6	128.4	15.6	48.6	5.9	177.0	21.4
1937	885.8	140.2	15.8	52.3	5.9	192.5	21.7
1938	948.1	150.2	15.8	52.5	5.5	202.7	21.4

Note The 1920 and 1921 figures are from a different source from the subsequent data and are not precisely consistent. Apparent errors are due to rounding.

The problem was that branch development was an investment that could not yield immediate results. It took time to exploit new opportunities. In the short run therefore, it was limited by the pressure it placed on the expense ratio. In the long run, it depended on the efficiency of the existing organisation. If this improved, reducing costs, new branches could be funded within a stable expense ratio.

Francis Scott therefore continually returned to the theme of organisational efficiency as the practical expression of his commitment to organisational expansion. It implied strict control of salaries, though this could be pressed to the point where efficiency was reduced by the difficulty of retaining good staff. It also led him to scour the details of branch expenditure, pressing managers for economies in administration and more effective business winning by inspectors. At the 1931 Branch Managers' Conference he argued,

TABLE 12.2 *Provincial Insurance Company: branch organisation development*

Branch offices open before 1919

Manchester (1905)
London (1908)
Liverpool (1909)
Birmingham (1910)
Hastings (1911)
Bradford (1914)

New premises opened

1919	CARLISLE, GLASGOW, Hull, Kendal, LEEDS, Leicester (a full branch in 1927), NEWCASTLE , Norwich, Reading.
1920	Nottingham (a full branch between 1933 and 1935).
1921	BRISTOL , Canterbury.
1922	CARDIFF, Edinburgh (previously an agency at Leith and became a full branch in 1924), Sheffield, Southampton, Redhill (closed 1925).
1923	–
1924	–
1925	Ilford.
1926	–
1927	Lancaster.
1928	Dumfries, Ipswich, Preston.
1929	Darlington, Dundee, Exeter, Huddersfield, Penrith, Swansea.
1930	Brighton, Hanley, Wilmslow (from 1937 Macclesfield), Shrewsbury, Tonbridge, Glossop (closed 1932).
1931	–
1932	Northallerton.
1933	Dorchester, Northampton, Wolverhampton.
1934	Edgware.
1935	Worcester.
1936	Chester, Hexham, Inverness.
1937	Blackburn, Cambridge, Oxford, Scarborough.
1938	Barrow, Derby, Peterborough, Skipton, Thurso.

Note Full branch offices are in CAPITALS. The Bristol branch came under the control of London from 1936.

A careful Economy and Improvement in Method may do some small part in this, but in the main it is a question of the staff remuneration and the staff output of work or new business, and the efficient handling of our labour supply. Are we really satisfied we are getting the maximum service and maximum output from our staff? I think we must honestly answer 'No', and that we have a great deal to work at in this direction What are the Remedies? ... Consideration and unceasing questioning of our individual Management, determination always to

criticise ourselves and our methods, and to seek for perpetual improvement, and more resolute determination, not only to do our daily job, but to do more hard thinking and planning and scheming in off-moments, when we are away from the officeTo demand a very high standard of efficiency, and to encourage every effort in our staff to this end. To refuse to tolerate any slackness, and to let the staff see that there is a totally different standard of reward.

Tight control of expenses and the encouragement of initiative and hard work was no doubt necessary and made its contribution to development. But the most important source of efficiency improvement came from the revenue growth generated by market expansion and competitiveness. Inspectors found themselves bringing in more premium income with little additional effort or expense. The extra administration of policies could be accommodated as staff spare capacity was squeezed, longer hours worked at minimal extra cost and marginal reductions in the quality of service accepted.

In the long run, such revenue growth generated efficiency in other ways. A larger head or branch office could employ more trained staff. They could specialise, delegating routine work to clerical assistants who themselves specialised in specific routines. The costs of senior managers and office premises remained much the same over wide ranges of revenue, thus falling proportionally with revenue growth. Marketing could also be improved. More inspectors allowed the company to be represented in new markets or more effectively in existing markets as they concentrated on smaller districts or particular classes of insurance.

Success in the market could therefore become the driving force behind organisational expansion by reducing costs and thus allowing investment in new branches. And this could become dynamic as a more effective organisation fed back a larger and more profitable premium income. Conversely, without growth a larger organisation was impossible. Indeed some was necessary to stabilise the expense ratio because of a steady upward pressure on costs as younger staff looked for salary improvements.

This was why the company's success in the motor market was so important. The buoyancy in revenue it normally provided sustained sufficient efficiency improvement to support new development. When motor revenue faltered in the early 1930s, the expense ratio rose and organisational development had to be restricted.[1]

The expense ratio was as important in allocating resources within the company as it was in determining overall expenditure. It provided a simple but effective management tool for assessing the efficiency of individual cost centres and allocating development funds to those that demonstrated

Provincial head office, Kendal, 1935. The 1935 extension (to the left) carefully repeated the appearance of the original Sand Aire House (to the right).

opportunity. All company and branch accounts were available in a form that related even tiny elements of expenditure to revenue. While never applied mechanically, it provided a framework within which allocation decisions could be considered. The broadest of these was the division between head office and the branches. In 1923 Francis Scott, in adopting a target ratio of twenty per cent, suggested 7.5 per cent to the former and 12.5 per cent to the latter.

Administration at head office was conducted with increasing efficiency which improved on this target. As Table 12.1 shows, before 1922 it absorbed more than ten per cent of the company's revenue. By 1929 this had fallen to 5.8 per cent and it remained close to that level throughout the 1930s. Despite the increasing demands of motor insurance, including the introduction of compulsory cover with its associated documentation in 1931, staff were employed with greater efficiency throughout the period. The ratio of head office salaries to company revenue fell from 5.3 per cent in 1923 to 4.2 per cent in 1929 and 3.7 per cent in 1938. The senior

management structure established by 1923 remained largely unchanged and its members did not enjoy salary increases proportional to revenue growth. Much of the additional work was handled by less expensive clerical staff. In the 1920s other overhead costs were reduced. After the purchase of the Drapers' and General in 1923, that company paid for the head office services it received from Kendal, though this was a once and for all effect, as the subsidiary grew more slowly than the Provincial. The new large general office, opened in 1924, housed staff for the remainder of that decade and its annual cost therefore fell proportionately. In the 1930s two major extensions of Sand Aire House became necessary in 1931 and 1935. This offset the continued fall in relative salary costs, explaining the stability in the head office cost ratio. None the less, it remained below the target level thus releasing resources for branch development.

In principle, the 12.5 per cent target for branch expenditure was applied to each branch individually. In practice, the commitment to growth was sufficient to ensure that the level never fell that low. Special circumstances were also taken into account. New offices were allowed a notional five years to develop their local markets sufficiently to bring overheads down to a reasonable level, but some branches maintained permanently higher or lower levels. Bolton, with its long established agency connections and compact market, operated at below ten per cent. London, with the expense of premises and salaries in the city, and the heavy costs of cultivating the whole of the south of England, never fell below twenty-one per cent. However, the likelihood of such variations makes the relative uniformity quite striking. By 1929 the average branch expense ratio was twenty-two per cent, and only four remained over twenty-five per cent: the unsuccessful branches at Bristol, Cardiff and Newcastle, and London, with its proliferating sub-office organisation, which none the less had fallen to twenty-five per cent. By 1938 the average had fallen to seventeen per cent, with London the highest at twenty-two per cent.

This uniformity was because the expense ratio provided a management discipline which channelled resources to branches in proportion to the efficiency with which they won business and the speed with which this was achieved. Success was reinforced and failure penalised to maximise the overall efficiency of the company.

The success of this approach to development was partly dependent on the framework within which it was operated. If the branch organisation had been geographically restricted, development would have remained concentrated, missing opportunities for extending business into new regions. This was why it was so important that a national framework of branch operation was created in the immediate post-war years. Francis

Scott argued later that development was never planned. It may not have followed a conscious policy. None the less, by 1922 the Provincial was represented in every British city with a population of over 250,000, with other offices covering East Anglia, South Wales and the Home Counties. Only the sparse insurance markets in the far South West, rural Wales and the South Midlands were in practice not covered. All significant markets came within the areas allocated to branches and their development was the responsibility of local managers who could assess possibilities and nurture them more successfully than head office, building on earlier development work.

Subsequent development took place largely through this same framework, for, as Table 12.2 shows, only three new full branch offices were opened between 1922 and 1938. This increased efficiency by concentrating control in the hands of the able and experienced branch managers and administration in offices that could handle it more productively. As each branch demonstrated the capacity to develop business efficiently, it was provided with additional resources to build on this success.

These could be used in a variety of ways to increase the effectiveness of business winning. Inspectors operated from the branch itself, covering larger markets as local transport improved in the 1920s with the introduction of bus services or, for the privileged, the car. Francis Scott was extremely suspicious of the expense and utility of cars, believing that they could insulate inspectors from the bustle and opportunity of the local High Street. But by 1927 the company owned twenty-seven cars, finding the Austin Seven the best value. By 1938 the number had grown to fifty-six owned by the company, and sixty-four owned by staff, but used for company purposes. Between them they covered nearly 1,600,000 miles on the company's behalf, an average of 13,200 miles each.

Branches covering large regions placed resident inspectors in more distant markets. As they proved successful, sub-offices were opened. This encouraged local brokers by providing at least a secretary to keep regular hours, handle routine paperwork, answer simple enquiries, arrange appointments, and generally allow the inspector to spend more time outside the office winning business. Service to the agent was devolved, but the control of underwriting, claims settlement and policy provision remained with a responsible branch manager, supported by a staff whose efficiency gained from the concentration of administrative work. Only when business grew to a substantial scale and a suitable candidate for the managership emerged was a sub-office converted into a full branch. This only occurred at Leicester, Nottingham and Edinburgh, and even these were still supervised to some extent by parent branches.

These possibilities led to the emergence of a variety of forms of branch organisation. Bolton's small market area required no sub-offices and it concentrated mainly on increasing the number of inspectors who worked from one branch office. Some smaller branches were responsible for such large areas that resident inspectors and sub-offices became necessary. By 1938 the Carlisle branch had established sub-offices at Lancaster, Barrow and Penrith. However, the business of the company was dominated by the emergence of four large regional branches: London, which controlled the whole south of England; Leeds, which controlled Yorkshire; Birmingham, the Midlands; and Glasgow, Scotland. Each of these built up a series of sub-offices, by 1938, thirteen under London; five under Leeds, five under Birmingham and six under Glasgow (including Edinburgh for some purposes). These supplied sufficient business to support substantial administrative staffs in the central office: at London fifty-nine; Glasgow thirty-one; Yorkshire thirty-four; and Birmingham twenty-three. This allowed them to provide some of the specialist services previously only available from head office. The Glasgow office handled claims for the whole of Scotland and was able to employ a solicitor and motor engineer to supervise this work. At Leeds the manager was assisted by a senior accident claims official, a professionally qualified cashier, two motor claims inspectors, chief clerks to control fire and accident acceptances and a fire surveyor. In some cases this made it necessary to provide larger office premises, as business reached a far larger scale in the 1930s. Additional or new premises became necessary at Birmingham and Glasgow in 1935, Leeds and Liverpool in 1936 and in 1937, as part of a major re-organisation of all the London departments, including the Drapers' and General, a new office was provided at 100, Cannon Street.

The interaction between revenue growth and this organisational structure produced two phases of growth in the two decades. Immediately after the war Francis Scott initiated a programme of rapid branch development. He began with unfinished business from before the war. Glasgow, where the establishment of a branch had been frustrated by the protracted negotiations to purchase the Royal Scottish, was an obvious proposition, and opened in 1919.[2] It already provided a large income, especially from Stenhouse; it possessed a substantial but compact insurance market; and the recent purchase of the National of Great Britain suggested that brokers might appreciate a new non-tariff presence.[3]

The Yorkshire branch was re-organised. Whitehead, the local director, had left the mercantile firm in Bradford which had made him such an attractive connection. This made it seem sensible to move to Leeds, a bigger market, where the large brokerage business from the Bains could be

handled more directly. The Bradford office was retained under a more junior manager.

After tidying away these loose ends, new development of a more speculative nature was begun. As Table 12.2 shows, by 1922 six new branches and eleven sub-offices had been opened, all in areas where the Provincial had previously little or no business. This took place at a time when substantial salary increases became necessary to cope with the effects of rapid inflation and older branches were re-employing staff as well. As a result, the company's expenses rose from some £35,000 in 1919 to £55,000 in 1920, approximately half of the increase being attributable to salary increases and half to new branch development. The optimism engendered

The PROVINCIAL have pleasure in announcing that their new building is now completed at Provincial House, 100, Cannon Street, E.C.4, and that their chief London Offices, as under, have been moved to this address.

The Offices are :—
LONDON HEAD OFFICE : formerly at 32, OLD JEWRY, E.C.2.

FOREIGN OFFICE : formerly at 6, OLD JEWRY, E.C.2.

MARINE ACCOUNTS, CLAIMS AND POLICY DEPT. : formerly at SACKVILLE HOUSE, FENCHURCH STREET, E.C.3.

PROVINCIAL INSURANCE CO., LTD.

NEW OFFICES :

PROVINCIAL HOUSE, 100, CANNON STREET, LONDON, E.C.4

PROVINCIAL

100, Cannon Street (Provincial London office from 1937). An advertisement announcing its opening.

by the post-war boom and the one-third increase in premium income in
1920 must have encouraged Francis Scott to feel that the development
would eventually be carried with ease.

In the event, as Table 12.1 shows, it grounded as the tide of revenue
turned in 1921 and ebbed in 1922. The expense ratio climbed to thirty-five
per cent and thirty-four per cent in those years. This precipitated a crisis.
All development was stopped, many staff salaries were cut, and some staff
left. It was this experience which encouraged Francis Scott to emphasise
his objective of the twenty per cent expense ratio.

While development expenditure was not the sole source of the problem,
it had risen substantially ahead of revenue. The problem was that even in
a small branch, the cost of a manager with supporting staff and premises
formed a significant overhead of about £1,500. Incurring this in advance of
income made a major contribution to the cost crisis, especially when
revenue had been slow to grow. In 1922 the Bristol branch expense ratio
was sixty-three per cent, Cardiff fifty per cent and Newcastle forty-one
per cent, in comparison with the branch average of twenty-five per cent,
itself double the required level. Even after four or five years' operation,
these three branches still had expense ratios over twenty-five per cent.

The economy campaign therefore focused on restricting office develop-
ment. Between 1923 and 1927 only one sub-office (at Ilford) was opened.
The substantial revenue growth during those years was channelled
through the existing organisation, bringing down overheads, operating
offices at fuller capacity and thus improving efficiency. 'Inside' branch
salaries (excluding inspectors) fell from 10.3 per cent of revenue in 1924 to
8.7 per cent in 1927.

The increase in premium income which yielded these benefits was
provided by the remarkable growth of the company in the motor market,
which produced annual rates of growth in aggregate revenue of well over
ten per cent. This allowed organisational expenditure to grow at the same
time as the expense ratio fell. This, combined with the efficiency improve-
ments in branch administration, financed a striking increase in the
number of company inspectors from ten in 1923 to fifty-one in 1927.
Operating from existing offices, they were deliberately placed to encour-
age the acquisition of country business, providing the most cost efficient
means of winning business in such thinly diffused markets.

As these inspectors established themselves, some demonstrated suffi-
cient potential to suggest that it would be worthwhile to consolidate their
position. As Table 12.2 shows, between 1928 and 1931 fifteen new sub-
offices were opened. At the same time, the number of inspectors continued
to grow. Eighteen were recruited in those same years, raising the total to

eighty-one in 1930. Leicester and Nottingham were raised to branch status in 1929.

While sub-offices were less expensive than full branches, costing only about £500 annually, this acceleration of development overtook revenue in 1929 and 1930 and Table 12.1 shows that the expense ratio rose to its highest level since 1925. Francis Scott became apprehensive. No further sub-offices were opened in 1931 and the number of inspectors was cut to seventy-six, despite the rapid growth in revenue caused by the introduction of compulsory motor insurance.

It was as well that he called a halt, for the early 1930s must have provided a strong sense of *deja vu*. Just as a decade before, ambitious development in advance of business was threatened by an intermission in revenue growth, this time caused by the depression and severe competition in the motor market. The pause in sub-office development continued into 1932 and inspectors continued to leave the company. But Francis Scott's response contrasted with that in 1922 and 1923. Instead of cuts, he argued, ' ... the real solution to the expense ratio, could only come through a more active and successful new business production.' Consonant with this, before revenue growth was restored, modest development took place in 1933 with the opening of three sub-offices and the appointment of eleven additional inspectors, raising the expense ratio again. At the same time, underwriting departments were pressed to write to encourage income growth, particularly in the employer's liability and motor accounts.

The rise in motor premium income in 1934 and 1935 and the economic recovery to 1937 provided revenue that relieved these problems. Table 12.2 illustrates a phasing similar to that in the previous decade. From 1934 to 1938 twenty-nine new inspectors were appointed, mainly in the first two of those years. In the same period, thirteen new sub-offices were opened, mainly in 1937 and 1938, when revenue growth seemed assured and the inspectors' work had borne fruit. The location of these appointments was in some cases designed to encourage motor business in areas that seemed to offer particularly profitable business, especially associated with the more ambitious use of the motor country discount by D. W. Holloway, the company's new motor underwriter. The impact of the rise in premium rates in the conurbations in 1935 and the decision of the Provincial to take competitive advantage of this in some areas to win business, was so dramatic that revenue in that year rose by fifteen per cent, reducing the expense ratio to twenty-two per cent. This rate of revenue growth was not maintained in the following years, as the Provincial moved to protect the profitability of its motor account. None the less,

business was still sufficiently ample for this final phase of organisational development, including major expenditures expanding the London and Kendal office premises, to be accomplished with the company expense ratio remaining below twenty-two per cent, the lowest level of the whole inter-war period.

12.2 A national business

The organisation created in this way increased the Provincial's market power with the results for business winning that have been described in the chapters examining departmental underwriting. It also allowed the company to draw its business from a widening geographical range which, by 1938, might be considered national, replacing the regional emphasis on Lancashire that was so important until 1920. Table 12.3 illustrates the growth and distribution of branch business between 1920, 1929 and 1938. Its most striking feature is the success of all branches in expanding business, mainly reflecting the Provincial's capacity to win motor revenue. This meant that even in the least promising markets, organisational development was possible. Geographical diversification was therefore characterised by differential growth, rather than expansion compensating contraction. Variations arose from differences in regional prosperity, the size and nature of the market allocated to the branch by the Provincial's organisation, the extent to which it had already been exploited, and the quality of management.

These combined to inhibit relative growth in Lancashire. The business from its three branches, Bolton, Manchester and Liverpool, rose at an average annual rate of nine per cent between 1920 and 1938, from £71,100 to £184,200. Yet their share of total revenue fell from forty-three per cent in 1920 to twenty-three per cent in 1929 and to twenty per cent in 1938.

The most obvious reason was the collapse in the Lancashire cotton industry from which the company had derived so much of its earlier momentum. Chapter Ten has shown how, after the last boom in the industry in 1920, it suffered falling output and prices throughout the inter-war years, which severely reduced its demand for insurance and made its underwriting unprofitable. This was felt particularly at Manchester, where fire revenue fell in the 1920s, though Bolton managed to salvage a modest gain by 1929. In the 1930s the relative fall in business was much less marked.

Beyond the direct effects of the collapse of cotton however, there was the more widespread depression it caused throughout the regional economy. This meant that other insurance markets, less directly associated with

TABLE 12.3 *Provincial Insurance Company: distribution of branch office revenue, 1920, 1929 and 1938*

Aggregate net fire and accident premiums

	1920		1929		1938	
	£'000	%	£'000	%	£'000	%
Liverpool	12.5	7.6	19.9	4.2	41.5	4.4
Manchester	38.8	23.6	53.7	11.4	83.4	8.8
Birmingham	14.7	8.9	36.1	7.6	68.0	7.2
Bolton	19.8	12.0	33.5	7.1	59.4	6.3
London	27.1	16.5	90.4	19.1	187.7	19.8
Carlisle	6.3	3.8	36.5	7.7	58.8	6.2
Newcastle	1.1	0.6	8.2	1.7	35.2	3.7
Glasgow	12.3	7.5	49.5	10.5	108.4	11.4
Leeds	20.7	12.6	65.0	13.8	129.7	13.7
Bradford	5.6	3.4	21.9	4.6	36.7	3.9
Cardiff	–	–	8.6	1.8	26.8	2.8
Edinburgh	–	–	6.4	1.4	14.9	1.6
Leicester	–	–	8.8	1.9	24.3	2.6
Nottingham	–	–	–	–	20.7	2.2
Head office	5.6	3.4	33.6	7.1	52.5	5.5
Home total	164.3	100.0	472.2	100.0	948.1	100.0

Note Apparent errors due to rounding.

cotton, grew more slowly than elsewhere. The Lancashire branches' share of motor revenue fell from twenty-five per cent in 1922 to twenty-two per cent in 1929 and twenty per cent in 1938, despite the special attempt made to capture Lancashire motor business after the tariff raised rates in the Manchester–Liverpool conurbation in 1935.

This problem was intensified by the Provincial's geographical organisation which drew the boundaries of these branches' markets closely round the edges of the industrial areas. This provided little scope for compensating business from country districts less affected by industrial problems, where the Provincial's motor business was particularly competitive. The Manchester office developed suburban business through the sub-office it opened in Wilmslow and attacked the Lancashire coast from the sub-office at Preston. Liverpool had its best opportunities in rural Cheshire, along the North Wales coast and on the Isle of Man, which allowed it to grow more successfully, to expand its share of home revenue in the 1930s.

Finally, earlier development around Bolton and Manchester before the war had exploited the most obvious local opportunities for agency

development, reducing the scope for rapid expansion. Instead, the emphasis moved to the strengthening of goodwill among existing agents and the deeper penetration of the network of potential small agents. This meant business grew slowly, but it was profitable. The Provincial's agency connection in Lancashire was of a high quality. This, combined with the limited scope for extra organisational expenditure, enabled these branches to maintain a superior profitability, even in the face of the losses on cotton in the 1920s, and the difficulties in the Lancashire motor insurance market in the 1930s. At Bolton, the small agency business that provided this strength was lovingly cultivated by Carlton Rothwell. The company's first office boy in 1904, he had taken over the Bolton branch when the head office moved to Kendal. As a local man, employed from his first working day by the Scotts, he proved well suited to the task of preserving the emphasis on the Provincial's local family links and encouraging the small agents who were the backbone of that branch's business.

The possibilities in previously unexploited territory in the North, beyond the industrial areas, are illustrated by the Carlisle branch. It was only established in 1919, with a market which stretched as far south as Lancaster, including the district that could be influenced by the Kendal head office. In its first full year it achieved a remarkable revenue of £6,300, half that at Liverpool after a decade of operation and Glasgow with its tremendous potential. In the 1920s the company's focus on country motor business enabled this to be sustained and by 1929 it had become the sixth largest branch, overtaking Liverpool, Bolton and Bradford, to provide eight per cent of all revenue. In 1927 a sub-office was opened at Lancaster and in 1938 at Barrow.

However, the most important development took place through the four large regional branches previously described: London; Birmingham; Glasgow; and Leeds. It was through these branches that the company developed its national dimension.

The most important reason for their success was that, apart from Birmingham, no serious development had been undertaken in any of their markets before 1919. Earlier managers at London had not attempted to create an agency organisation outside the metropolis and its immediate suburbs. Yorkshire business, apart from the Bradford area, had been almost entirely obtained through the Bains and in Scotland the company had relied on the powerful Glasgow brokers, especially Stenhouse, and a special representative in Aberdeen.

This provided the scope for growth; and the company was fortunate in employing four managers who were capable of exploiting it. C. Dale Evans continued to supervise the development of business in the Midlands, and

in the immediate post-war years, three new men: J. W. Lang in London; J. Tait at Leeds; and T. Fraser at Glasgow; were recruited who became, with him, the regional proconsuls of the Provincial's home business. Their capacity was such that there was little incentive to devolve business to new smaller branches as it grew in scale.

J. W. Lang was originally appointed to the new Glasgow branch when it was opened in 1919, but left shortly afterwards to join another company. When G. Y. Tose left the London branch in 1922 to become a stockbroker, Lang returned to succeed him. He proved a successful combination of the different skills of his two predecessors, having Butterfield's public persona, so important in a branch where the manager represented the company to the insurance world and major city institutions, but also Tose's enthusiasm for winning business. To this he added a technical and organisational expertise which neither had possessed. These talents he used to build up the Provincial's organisation across the whole of the south of England for the first time and establish its reputation in the city insurance markets.

John Tait was appointed the manager of the Leeds branch, when its former manager was moved to Manchester in 1922. Francis Scott regarded it as a calculated risk to appoint an accident specialist to branch managership, but Tait quickly established a strong and independent branch. A business winner rather than a technician or administrator, his success was based in part on his negotiating skills, but also on his enormous influence in Yorkshire. His connections permeated every aspect of local life: he was for many years a city councillor in Leeds, eventually becoming Deputy Lord Mayor and a prominent figure in Conservative circles; he captained a local cricket team and golf club and was a director of Leeds United; he reached the dizziest heights of Masonic eminence and sat on a multitude of local charitable committees.

Fraser, Lang's successor at Glasgow, proved another important recruit from the British Dominions, the most aggressive of the reputable non-tariff companies. A tough, ruthless Glaswegian, a former fighter pilot, he brought an abrasive dynamism to the management of Scottish business, driving his staff hard to win business.

These substantial characters provided the drive to exploit the large markets they were offered. Of course, there was some variation in experience. London grew most substantially, to become the largest branch, with twenty per cent of business by 1938, but this was scarcely surprising. Its market covered all the southern counties, as well as the metropolis itself, which enjoyed relative prosperity as new industries developed and suburban building boomed. From his appointment in 1922 Lang began by

operating as a superior inspector, developing business with provincial brokers. This supported the development of an expanding organisation of inspectors and sub-offices. By 1938 he controlled a dozen of the latter, spread across the South from Exeter to Tunbridge Wells, and Southampton to Cambridge. Some of these had grown in size themselves. Ilford employed seven staff, while the Exeter sub-branch was itself responsible for other small offices and resident inspectors in the far South West. Bristol remained a problem. Although it was started as a branch in 1921, its business remained so modest that it was eventually placed under the supervision of London in 1936.

Leeds became one of the largest branches immediately on its foundation in 1919, through inheriting the large brokerage business from the Bains. Its subsequent growth no more than kept pace with company expansion, as it sought compensation from rural Yorkshire for the falling income from the woollen and worsted areas. Its share of business remained stable at thirteen per cent in 1920 and fourteen per cent in 1938. Birmingham, in the prosperous Midlands, was able to expand its share more substantially from nine to twelve per cent over the same period, though this included the virtually independent branches at Leicester and Nottingham. Glasgow grew fastest, from only eight per cent in 1920 to eleven per cent in 1938, though this performance was heavily influenced by the especially competitive motor premium rates in the city in the late 1930s.

The direction and scope of growth is suggested by their sub-office development shown in Table 12.2. Following the pattern sketched in the previous section, this emphasised the more obvious industrial centres in the 1920s, but subsequently tended to move on to county towns from which country business could be sought. From Leeds, sub-offices were first opened in Sheffield and Hull, then later in Northallerton, Scarborough and Huddersfield. Birmingham began with Leicester and Nottingham, and then Hanley, Worcester, Peterborough, Wolverhampton, Shrewsbury and Northampton. Glasgow had early sub-offices at Edinburgh and Aberdeen, then followed with Dundee, Dumfries, Inverness and Thurso.

The success of the four largest branches meant that business became increasingly concentrated through them. As a result, their share of the Provincial's home business rose from forty-two per cent of revenue in 1920 to fifty-two per cent in 1929 and fifty-seven per cent in 1938. This was no accident. They were all controlled by strong and capable managers who sought to keep a firm hold on the opportunities these large markets provided. After all, it was upon this that their salaries and profit commissions depended. This suited Francis Scott. The difficulty of obtaining able

managers made him happy to operate on this regional basis, with branch management in their hands. He believed that with successful branch managers developing business in their own interest, the Provincial would develop a momentum of its own, irrespective of management at the top. This strengthened the case for the Provincial as a family concern. Whatever the family succession to management, there would be powerful forces sustaining growth and profitability.

Elsewhere, Bradford, Newcastle, and Cardiff provided only modest revenues, but of different quality. Bradford's market area was small; it was worked intensively from one office; and, in a rather similar way to Bolton, used this to maintain a high profitability throughout the period. By contrast, Newcastle and Cardiff covered wide areas; the North East and South Wales respectively; which raised costs, but did not generate sufficient business to cover them. Both were unprofitable throughout the period. The reasons for this are not clear. Perhaps it is not coincidental that both operated in severely depressed coal and heavy industry based economies. Quite apart from the lack of local prosperity, these generated insurance business that was either inaccessible or undesirable for the Provincial, being controlled by mutual companies or liable to substantial concentrations of loss.

In this way, the Provincial's organisation gradually diffused throughout the country. By 1938 the furthest limits had been reached, for in that year a resident inspector was appointed in Plymouth, and the sub-office was opened in Thurso. Between these two there remained no part of Britain that was beyond the reach of a Provincial inspector. The framework that had been sketched out in the early 1920s had become filled out by a national organisation.

12.3 The management and control of the Provincial's organisation

This organisation required management and control. Of course, there were the formal channels. The winning of business in the branches was supervised by the local managers; the business so obtained was submitted to the underwriting managers at head office who determined acceptances. Francis Scott oversaw the laying down of underwriting policy and, by controlling all staff appointments and major expenditure decisions, shaped the pace and direction of organisational development.

However, this simple framework ignores many of the practical problems that actually determined the nature of the process or its success. These involved issues of personality and human relations that are difficult to reconstruct after the event, but were none the less important. Control

could not be absolute and direct. It also involved the reconciliation of conflicting objectives which raised issues of judgement for all involved.

The critical relationship was that between head office and the branch. The former, removed from the immediate realities of the market, remained intent on applying underwriting or expenditure policy; the latter faced daily difficulties which involved the satisfaction of a wide range of different and conflicting objectives, that could not yield an ideal, only a second best solution. This led to a natural tension. At the branches there was pressure to seize the opportunities that arose; head office usually preferred to wait for the business that would fulfil the requirements of policy. In the branches there were brokers and agents to sweeten by the acceptance of the bad with the good; at head office this merely breached policy. These problems focused the issues of control on the relationship between head office and the branch managers through which these tensions were resolved.

At Kendal, Francis Scott remained at the heart of management, involving himself in all the details of underwriting policy, if not its execution, and solely responsible for staff management and decisions concerning organisational development. From 1919 a head office 'executive' committee was established, consisting of most of the departmental managers. It fulfilled the useful function of allowing Francis Scott to obtain helpful comments from his senior staff on new ideas, administrative arrangements and the general management of the head office itself, but it rarely considered policy and had no power independent of him.

His central role and continual presence was important for the nature of head office management at Kendal. The principal managers who had grown up with the company since its early days remained with it throughout the inter-war years for they had been appointed at an early age. J. A. Barber retained his secretarial position; R. R. Baillie remained Fire Manager; and W. Gray, despite his transfer from the Manchester branch to the managership of the Drapers' and General, was still generally involved in marketing.

The only major change in the 1920s was the disappearance of Collins,

[facing] Principal Provincial officials at the opening of the new London office, 1937. Left to right standing: J. W. Lang (London Manager), D. Glass (head office Accident Manager), J. A. Barber (Company Secretary), B. L. Evans (Assistant Foreign Manager), S. W. F. Crofts (Foreign Manager), R. R. Baillie (Fire Manager), J. M. Crook (Provincial Manager); seated: W. Gray (Manager and Company Secretary, Drapers' and General), Sir W. Goode (Provincial Director), Sir S. H. Scott, Bart. (Provincial Chairman), F. C. Scott (Provincial Managing Director), Philip Scott (Sir S. H. Scott's son).

the original accident manager. It was perhaps not surprising that a man who had grown up in the old world of accident insurance should find it difficult to adjust to the extraordinary changes and growth in motor business in the early 1920s. The secret of underwriting became the efficient administration of an enormous number of policies and claims. It became clear in the early 1920s that this transition was becoming difficult for the Provincial. The department was taken over in stages by David Glass, a solicitor, originally recruited in 1922 as Claims Manager from the General Accident, but who by 1924 had become responsible for all accident underwriting. He instituted new systems that provided a framework for accident administration that lasted for a generation or more.

The retention of the close working relationship between Scott, Baillie and Barber, preserved much of the distinctive atmosphere of the Bolton days. Those infected by it retained more of the attitude of clerks beholden to Francis Scott personally, than that of professional managers. Their position was insecure, for even by the standards of the period, their professional training was modest. It sometimes made them seem to others subservient and unhappy men, who did not have the self-confidence to strike out in original approaches to business and were ungenerous with their junior staff. They remained careful and cautious, not least because they worked closest to Francis Scott and felt his personal criticism when mistakes were made.

Baillie's tenacity and thoroughness in keeping tight control over the standard of acceptance of fire risks created the remarkable record of profitability the company enjoyed in that account. But the cost of this record was a sensitive matter for branch managers. They believed that it had been achieved by such a cautious approach to underwriting that the company had ceased to be seriously regarded as a contender in the hazardous fire market. This continually eroded their position with intermediaries. It was of a piece with the way in which they saw the man. He seemed by nature unhappy with innovation. Original proposals from younger staff were interpreted as a challenge rather than an opportunity and no one emerged as his obvious potential successor.

Glass, as a recruit from a larger company, with independent professional qualifications, was free from these inhibitions. This was as much a

[facing] Provincial branch managers' conference, 1920. Left to right standing: T. Frazer (Glasgow), A. Dodds (Leeds), A. Barrett-Lennard (Hastings), A. Collins (Accident Manager), J. A. Barber (Assistant Secretary), G. Y. Tose (London), A. Mackie (Liverpool), W. C. Rothwell (Bolton), J. McGuckin (Claims Manager); seated: C. Dale Evans (Birmingham), W. Gray (Manchester), Sir S. H. Scott, Bart., F. Robinson (Carlisle), J. Tait (Leeds).

matter of temperament as anything. He preserved a certain cynicism, detachment and relaxed individuality which he expressed forcefully but subtly, preventing his integration with the longer serving and tenser members of staff. As a professional claims negotiator, he was cleverer than them and watched his own interests more obviously. This prevented him gaining Francis Scott's confidence in the same degree. They doubtless disagreed privately as to who was responsible for the Provincial's remarkable success in the motor insurance market.

With this relaxed attitude, Glass was more willing to encourage his juniors. Two became valuable company officials under his supervision. J. W. Tolfree was appointed Casualty Superintendent in 1935; D. W. Holloway came to head office from the Bristol branch to take charge of motor business as Chief Clerk under Glass in 1936. Both were highly qualified professionally, achieving Fellowships of the Chartered Insurance Institute, Holloway winning the Rutter Gold Medal as the most successful candidate in the Institute's examinations.[4] It was a new and different world from that of the small office in Bolton before the war.

Crook's appointment in 1933, discussed in Chapter Nine, might be thought to have provided a major stimulus to new ways of looking at general management and the relationship between head office and the branches in the 1930s. Whether this was so or not, there is little evidence that this proved to be the case. Crook's foreign experience and his underwriting bias seem to have given him little authority with the longer established branch managers. Francis Scott remained the central figure, with Crook filtering important decisions to him and sitting in on his interviews with managers.

A more bracing atmosphere blew into head office from the branches however. Before 1920 the only branch manager of consequence had been Gray, with whom Baillie and Barber had worked since they came to the company. However, the subsequent development of the branch organisation adjusted the balance of power for it was managed by men with professional competence, character and their own interests to fulfil. The most important among these were Lang, Evans, Tait and Fraser, described above.

These men dominated the Provincial's branch organisation and the competence with which they developed its business provided the company with much of its stability and success. They controlled their markets with an authority ultimately subject only to Francis Scott. Their experience, ability and personality, and the responsibilities they were given, made it inevitable that they would acquire a powerful position in management, and this was bound to change the atmosphere of operations. They saw their objective as the development of their branch's business and they

were prepared to fight hard to protect its interests. After all, their own remuneration, the scale of the organisation they controlled, and their personal status depended on the size and profitability of income. They therefore negotiated with head office departments with vigour and relative equality. They sought to win concessions in underwriting policy and in day by day acceptance decisions that would allow their staff to win more business, and they were not prepared to see valuable connections sacrificed or hard earned business lost needlessly by arbitrary or idiosyncratic decisions at Kendal. Each had his own approach. Fraser was a fighter by temperament who advised younger colleagues to 'fight the buggers'. Tait was a diplomat who would charm head office managers into agreement even when they thought their case rock solid, and his hand was strengthened by the strong personal influence he exercised over his branch business. Lang was an experienced insurance professional whose expertise matched any official at head office. Indeed, it was widely believed that he was disappointed when Crook was appointed to the senior management position in 1933. Dale Evans had a long-standing relationship with the older head office staff which he used, along with a specialised technique of continuing to follow his own independent line whatever the head office attitude. All had held responsible positions in reputable offices before coming to the Provincial and this gave them a certain objectivity and perspective about the company's attitudes and methods and self-confidence in advancing their own opinion. They were not alone in this. As the Provincial's organisation expanded, other younger managers such as Richard Brown of Liverpool or Frank Robinson of Carlisle were in a similar position.

This more aggressive approach naturally contrasted with the attitudes that still characterised much that took place at head office. The atmosphere of relations between the branches and Kendal therefore changed over the inter-war years. The new branch managers thought naturally in terms of a tension between themselves and head office and were prepared, indeed thought it their duty, to challenge, criticise and attempt to expand the scope of underwriting policy to create greater scope for business development. The managers at Kendal found themselves under a far more formidable battery of criticism in which they were forced to defend themselves and emerge from the security of the careful performance of specified tasks. This opened up decision making to fresh influences and gave greater strength to the forces for profitable expansion in the company.

This could occur in a number of directions, most importantly in the day by day interpretation of underwriting policy as risks and claims settlements were dispatched to head office from the branches for approval. It

was here that conflict continually arose as managers tried to satisfy brokers and agents with acceptances and settlements that were more generous than the underwriting managers were prepared to accept. At the end of the day underwriting managers were responsible, but they could sometimes be worn down by powerful managers. Ultimately, appeal could be made to Francis Scott, no doubt at the cost of goodwill with the head office official. Sometimes concerted attacks were organised on underwriting policy at branch managers' meetings.

While Francis Scott was happy to encourage tensions which gave the company momentum, this did not mean that he relaxed his control over branch development and efficiency. This he undertook as his principal responsibility for he would not have believed that any salaried manager would be capable of carrying out the task with the care and rigour of a proprietor. In any case many of the branch managers would not have deferred to any other official.

The work involved Scott in taxing detail. Advised by Barber, he checked branch statistics to investigate the smallest detail of revenue development or excess expenditure. Couched in ratio terms, these provided the basic framework of efficiency assessment, but this was qualified by more qualitative evidence through branch visits or interviews with managers, carried out at least once each year at the branch managers' conference in the spring. This enabled him to discuss branch problems and opportunities with branch managers, dissect their revenue claims and expenses with them on the most detailed level, prior to handing them their profit commission cheque. He usually found some mode of encouragement. After complimenting one manager on a particularly profitable year, it is said, he pointed out that his plate glass income had not grown much. In these ways he could monitor performance and direct resources into the channels that would best serve strategy. Thus, from the late 1920s he could begin to focus development on the country districts that would bring the business the Provincial sought.

However, there were limits to the extent of positive control. Efficiency could be controlled in the negative sense that branches which performed poorly could be chased, not allowed additional resources and eventually poor staff could be sacked. But it was a harder matter to encourage positive performance in pursuit of the company's objectives. It was easy for branches, seeking each day to wrest some achievement from a competitive market place, to concentrate on maximising revenue. Fulfilling more complex objectives, such as searching for more profitable risks, or rejecting hard won, but undesirable risks, was less easy.

This was an important issue throughout the period, for the rapid

growth of motor business meant that branches were usually able to scoop in a large premium income from that source and were happy to do so. Yet from the point of view of underwriting the company sought to attract at least a select motor business and beyond this non-hazardous fire and general accident risks.

Francis Scott, encouraged, naturally enough, by his underwriting managers, was never satisfied that the marketing force were sufficiently committed to these objectives. It became a continuing theme at branch managers' conferences, but it became clear that admonition was insufficient because the pressures on managers to accept business as it came were hard to resist.

A number of methods were tried to encourage branches to win the business sought. The most dramatic attempt to shift the balance of business was a 'direct canvass' system introduced in the early 1920s by Gray. Lists of addresses of potential small business policyholders were compiled from directories and a period set aside for them to be canvassed directly by local Provincial inspectors. It was hoped that this would raise the number of small scale policies the Provincial accepted and introduce the company to agents who controlled them. Intensive work was carried out to prepare the lists and branch managers pressed to divert their staff to complete complicated returns reporting on each call. It was unpopular, for the information on which it was based was often out of date, and the individuals canvassed proved cost ineffective in terms of the business obtained. Although sustained over several years, the method lost the support of managers because of the difficulty of persuading staff to take it seriously, and it was eventually abandoned after the expenditure of large quantities of staff time which they thought largely wasted.

Other approaches were tried as well. Targets were adopted for each inspector to win a certain number of policies in each of the desired classes. From at least 1929 competition between inspectors was encouraged by publicising the leading new business producers each month, distinguishing between those in towns and in the country, and offering prizes for the top achievers in difficult business areas. They were told that promotion depended on their success in profitable areas of business, not just on bringing in a large motor income. From 1933 four special drives were arranged each year to concentrate for a week on multiple shop policies, householders' comprehensive and small scale employer's liability risks. Branch managers were asked to provide one new fire order a day, without holding some back to achieve this target, and their relative success was reported to Francis Scott and publicised at branch managers' conferences.

These administrative attempts to direct marketing were largely ineffective. Inspectors in the branches were well able to see that, whatever was said by head office or their managers, the investment of their time in the laborious attraction of small and desirable risks or the hard selling of the more discretionary general accident policies, was rarely worth the candle. If they perceived a genuine opportunity for such a sale, no doubt they would pursue it, but searching for it cold was unrewarding work, at the cost of easier achievement in the motor insurance market. In any case, agents had to be cultivated by the acceptance of a general business, without which they would scarcely provide the cream of their risks. Higher commissions or bonuses were offered on some special classes of risk, but even these seemed to be relatively ineffective in encouraging inspectors to make a significant reallocation of their time. Indeed, this suggests a more fundamental problem. When Francis Scott encouraged the pursuit of profitable business, he usually only cited the loss ratios that had been achieved. The organisational costs involved were allocated across all accident or fire business on a conventional basis. No information was available then or now, on the profitability of each type of risk, after the true cost associated with obtaining and administering it had been taken into account. It seems reasonable to suggest that the attitude of the inspectors partly reflected the high acquisition costs of the apparently more profitable types of policy. To this must be added the relatively high proportionate cost of processing small scale policies and settling specialist claims. Perhaps branch staff were more rational than those at head office, largely insulated from the laborious task of winning and servicing business.

Meanwhile, the main burden of achieving underwriting profitability had to be borne by the creation of policy and rating packages that were so attractive to the market that inspectors had no difficulty in selling them. This was the message of the motor insurance market where, implicitly, marketing and underwriting had gone hand in hand. This had shown how all the administrative effort involved in the direction of staff could be eliminated when they were led by market forces to serve company interests.

In the years immediately before the war attempts were made to adopt this approach in the general accident market when Tolfree devised the 'Unity' policy, which packaged all the insurance requirements of a small shopkeeper into one policy with one premium. In the post-war years this was to prove highly competitive in a way that encouraged branches to concentrate their efforts on it. For the time being however, it was stalled by objections from the fire department until the war postponed all new developments.

TABLE 12.4 *Provincial Insurance Company: salaries and staff numbers, 1920–38*

	Salaries paid (a)	Proportion of home premiums	Staff numbers (b)	Average salary paid
	£'000	%		£
1920	32.8	18.9		
1921	38.1	21.1		
1922	40.2	21.4		
1923	39.9	16.2		
1924	45.2	15.9	223	202
1925	52.3	16.3	250	209
1926	53.5	14.5	292	183
1927	60.2	14.5	321	187
1928	65.1	14.7	333	195
1929	71.8	15.2	365	196
1930	79.9	15.1	400	199
1931	83.5	14.6	421	198
1932	86.6	14.9	445	194
1933	90.2	15.0	458	196
1934	97.5	15.0	482	202
1935	103.6	13.9	541	191
1936	112.4	13.7	584	192
1937	122.2	13.8	655	186
1938	128.6	13.7	687	187

Notes
(a) The salaries exclude bonuses.
(b) Staff numbers exclude the marine department and the Drapers' and General. Staff numbers are not known before 1924.

Without market incentives of this type, attempts to direct the branch organisation proved ineffective. Only the burgeoning scale of the company's organisation, and the gradual strengthening of the goodwill it built over time could provide a richer flow of small scale and other more profitable business. Management proved more successful in exercising negative control than positive direction.

12.4 Staff

The most important element in organisational growth was the people the Provincial employed. This was true when considered in terms of their cost, which normally absorbed some two-thirds of all expenditure, or their

quality and commitment, for this determined the company's success. At the same time, as more staff were employed, new problems arose which required different solutions to those that had been appropriate in the small concern before 1920.

Table 12.4 shows how numbers of staff expanded, largely in pace with the phasing of development described in the previous section. Unfortunately the record of staff numbers is incomplete for the years at the end of the war, but some idea of the expansion at that time is suggested by the increase from fifty-six in 1918 to 223 in 1924. By 1929 the number had grown to 365 and by 1938 to 687. In 1928 thirty-two per cent of staff were women. This transformation in scale inevitably affected the nature of staff relations.

The cost of staff – their remuneration – is less easy to measure. The use of an age related salary scale and its very flexible implementation meant that for most individuals, remuneration was determined as much by location, responsibility, age and ability as by any changes in remuneration common to all staff. In fact only one major change in the general level of salaries took place. In monetary terms the salaries paid for similar types of work and responsibility remained much the same throughout the period. Some impression of this is provided by the average cost of each employee indicated in Table 12.4. This remained relatively stable around £200, despite the changing composition of the staff by responsibility and age.

Evidence as to the level of the salary scales is uncertain in detail, but the broad picture is fairly clear. Rapid price inflation during the post-war boom made it necessary to consolidate the bonuses paid during the war into the basic clerical scales. In 1920 for men this stretched from £40 at fifteen, £90 at eighteen, and offered the promise of rising to £250 at twenty-eight. This contributed to the expense ratio problem of the subsequent years with salaries rising well above twenty per cent of revenue. Staff must have enjoyed substantial improvements in their real incomes with retail prices falling by thirty per cent between 1920 and 1923.[5] Francis Scott raised the issue at the branch managers' meeting in 1922 urging that the problem should be resolved by revenue expansion. By the following year it was clear that this had not been successful and at their annual meeting he again asked the branch managers to consider the problem. It is said that he left the room and returned to find that the managers proposed a salary cut of ten per cent for all senior staff, excluding married men receiving less than £300, unmarried men less than £150, and women less than £100. Branch and departmental managers' profit commission was also reduced from five to 2.5 per cent. Table 12.4 shows that this held the total salary bill steady in the face of a substantial increase in revenue,

reducing salaries as a proportion of income from twenty-one to sixteen per cent in 1923, even though the cuts were only introduced from April.

The cut was a temporary matter for most managers. Within a few years most received salaries significantly higher than the level before 1923. However, although lower paid staff were exempt from wage reductions, it appears that the salary scale itself was reduced, though no definite evidence confirms when this took place. Certainly, by 1928 the scale stretched from £20 per annum at age fifteen, to £55 at eighteen and rose to £220 at thirty-one, indicating reductions that were substantial, but in no way disproportionate to the falling cost of living. Women staff in the same year were engaged up to the age of twenty at salaries between £39 and £52, which rose to a normal maximum of between £156 and £180 in their twenties. In subsequent years there is no evidence that any of the basic pay scales were reduced. Indeed, in the mid 1930s the scale was raised for women and junior male staff in London. In common with most other white collar employees in work, the Provincial's staff thus benefited from the continued reduction in retail prices, which fell by twenty per cent from 1923 to a trough in 1933, and then only rose by eleven per cent to 1938.[6] There can be little doubt that the real reward paid to Provincial staff improved during most of the period, even if this was not reflected in money terms.

In principle, this should have represented an increasing cost to the company, for its business was transacted in monetary terms and would fall as the value of the assets insured fell. This was made irrelevant by the rapid growth of motor insurance revenue and its relative profitability. Francis Scott made it clear that this meant that while he was aware of the improving standard of living of his staff, there could be no question of reducing their salaries in line with deflation. Even if he had wished to do so, the impact of motor insurance on all the other companies supported the wages they were prepared to pay staff, and the Provincial was operating in a competitive market as far as professional staff and those in London and other large cities were concerned.

The scale provided a basic framework for establishing salaries, but there were considerable variations determined by the type of work carried out and its location. The most obvious exceptions were the managerial staff at head office and in the branches. While their salaries were negotiated individually by Francis Scott, allowing discretion to be exercised in relation to personal performance, Scott appears to have kept at the back of his mind a simple test designed to control company costs. A manager should not normally receive a salary of more than five per cent of his branch revenue. This led to a wide range of salaries. At the beginning of the period these ranged from a minimum of £200 for junior managers in small

branches, to £700 at the largest. In addition, responsible staff received profit commission, which was normally five per cent calculated on the average for the three previous years for the branch managers. Through the 1920s the growth in branch business meant that the minimum salary for a full branch manager rose to some £500; at the larger branches substantially greater salaries could be earned. By 1928 the London branch manager was paid £1,500; Leeds and Manchester £1,000; and Birmingham £900. Senior head office managers received between £1,000 and £1,500 and it seems likely that these were fixed to provide parity with the senior branch managers with whom they had to deal. By the late 1930s the senior head office managers' salaries were about £2,000. While these all represented substantial increases for the individuals involved, they assumed a smaller proportion of revenue, reducing the impact on the expense ratio. On the other hand, in the large regional branches, managers were increasingly supported by departmental heads whose salaries might reasonably be included in the managerial five per cent.

The salary scales for more junior staff were applied equally flexibly, with an eye to the market for an individual's services and desirability of encouraging and retaining them. The scale described above was supposed to serve as a minimum for clerks at head office. Despite this, in 1928, the actual salaries paid to men from eighteen to twenty-two were significantly lower, averaging, for example, £91 for twenty-one year olds, instead of the scale's £105. This was because the company seems to have had little difficulty in recruiting staff in Kendal where the company's pay and conditions were attractive by local standards. The company offered an opportunity for local young men to qualify and obtain promotion remaining in their home town, or escaping to a wider world, in ways that were often barred to them in the older professions.

Those with greater responsibility in Kendal or in more competitive insurance centres could normally reckon on more. In London especially there was competition for staff which required higher levels of remuneration and a special scale to provide this was introduced in 1935. While comparisons are limited by the different structure of employment in both offices, in 1938 the average salary paid to 'inside' staff in London, after making some allowance for the high salaries paid to departmental heads, was seven per cent higher than that paid in Kendal. To this extent, the company benefited from its Westmorland head office, but the saving was insignificant, only amounting to 1.4 per cent of the total salary bill. The cost of office accommodation in London and the high turnover of staff must have been far more important considerations.

The premiums above the basic scale for responsibility and location were

significant, creating average salaries that were one-third higher than the
scale. At its top point at age thirty-two, for example, when the scale
offered £220, the actual average salary in 1929 was £308. Even though the
salary scale stopped at that age, increments continued to be paid for
satisfactory work.

The use of incremental scales combined with the Provincial's youth and
rapid expansion to create special cost problems. In 1929 ninety per cent of
its male non-managerial and probably ninety-eight per cent of the women
staff were aged less than thirty-eight, all of whom were on a salary scale
that normally allowed them an annual age related increase. These ranged
from fifteen per cent around the age of twenty-one to five per cent at the
upper end of the age range. This created a steady upward pressure on the
Provincial's salary bill, which added to the expense ratio problem when
business growth slackened, as it did in the early 1930s, increasing the
incentive to secure revenue growth.

Despite the relative buoyancy of real rewards, the Provincial recruited
in a competitive market with other insurance companies. Although the
company found recruitment in Kendal relatively straightforward, it
proved more difficult to obtain able men as inspectors or branch managers
elsewhere. While this might from time to time have been the result of
uncompetitive salaries, other issues were equally important. Employment
with the Provincial remained unattractive for most insurance profession-
als. It did not offer the easy administration of the well established business
of a tariff concern. It must have seemed far less secure, for non-tariff
companies were notoriously subject to purchase by tariff companies, at
great risk to their staff. And in some important respects, such as the
provision of a pension, the conditions of service were less attractive in the
1920s. These considerations meant that offering more competitive salaries
would probably not have resolved the problem entirely. In principle, they
meant that the company would have had to pay more than the tariff
companies to attract men of equal ability, and the company could not have
carried the cost on its expense ratio.

None the less, the consequence was that the inability to recruit good
staff was among the most important constraints on development. In the
early 1920s it restricted the opening of offices, even though it proved
possible to promote a number of the Provincial's own employees to
managerial positions, such as Carlton Rothwell at Bolton, Richard Brown
to Liverpool and J. Tait to Leeds.

In the later years of that decade the rapid expansion in the numbers of
inspectors greatly disappointed Francis Scott. He believed that the dimin-
ishing returns that set in with this form of development were largely

attributable to the poor quality of men recruited, arguing in 1930 that the company would benefit if it laid off half its inspectors and replaced them with a smaller number of better men. This was probably why the opportunity was taken in the early 1930s to reduce temporarily the size of the inspectorate by terminating some men's employment. The limited number of new branches created was a direct reflection of this, for the new recruits contained almost no one of adequate quality to manage an independent branch.

Many aspects of this problem could only be resolved as the company grew in scale and reputation, but some moves, made as part of the broader approach to company–staff relations, helped to improve the situation.

Staff development was one direction in which the company could obtain better value for money. Of course, the most important element in this was bound to be straightforward experience, but the quality of inspectors was so low that special training courses designed by some of the more active branch managers were arranged at head office from 1931. Staff were also encouraged to qualify professionally by the payment of prizes to those who passed the examinations of the Chartered Insurance Institute or other appropriate bodies. From 1935 all junior clerks recruited were informed that they were expected to begin training through the Institute. More generally there is no doubt that the Scotts wished to preserve an atmosphere in which their relations with individual members of staff were unimpeded by any collective rules or agreements, and their relationship with staff as a whole was benevolently paternal. However, it became clear that the increasing scale of the company, its need to recruit able professional staff and the general changes in social attitudes towards employment made this approach less effective or desirable. As a result, they looked for a compromise that would retain its benefits while bowing to new realities.

As far as staff themselves were concerned, it is impossible to form a reliable view of their views. Older men retained the attitudes they had acquired at Bolton and these were undoubtedly transmitted to some new staff. This was made clear by the presentation to the Scotts by staff of two silver caskets to celebrate the company's Twenty-first Anniversary in 1924. A young official who attended the event recalled that 'the proceedings were enlightening, not only in the manifestation of 'Provincial spirit', but by a dominant theme expressed in the few speeches that upon serving the company one must think of something higher than mere labour and reward.' There is evidence that younger staff were no longer so willing to accept these assumptions that had made their predecessors content to become so personally dependent on and beholden to the Scott family. Of

course, it is impossible to disassociate such feelings from those that would have existed among young staff in any company towards senior management, whether family or not.

No separate staff department was created. In principle, Francis Scott continued to manage all staff matters as though they were purely a personal matter between individual employees and himself. He was only assisted in such matters by his private secretary Miss Hiron, who took charge of all personal files. This was most evident in his handling of salaries, in which no collective negotiations took place. Even when salary scales existed, it was emphasised that these were a guide and no commitment as far as any particular employee was concerned.

On the other hand, by 1938 the company employed 653 staff, spread over more than fifty separate offices. The overwhelming majority were young men and women who had little knowledge of or interest in the company's early days and who were imbued with the spirit of greater independence created by the war years. It became increasingly unrealistic for Francis Scott to assess individual staff with direct knowledge or establish the

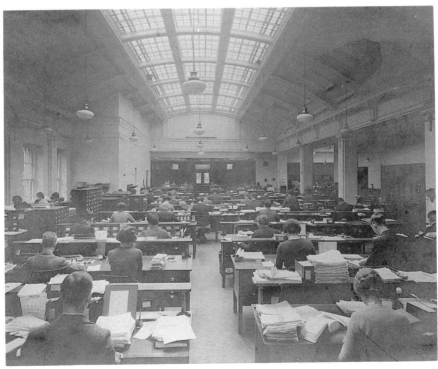

General office, Provincial head office, Kendal, 1935. This gives some impression of the highy organised atmosphere at head office in the inter-war years.

personal relationship that had been possible with most staff before 1919.

This was true of both head office and the branches, but it took a different form in each. At Kendal Francis Scott's presence remained important, but the growth in staff numbers to 176 by 1938 meant that control took place through a more bureaucratic system of control. Departmental managers necessarily played an increasingly important role in determining the organisation and regulation of staff, sometimes collectively through the head office 'executive'. But relations were rarely individual. The large general office encouraged an inelastic, classroom attitude towards the control of junior clerks, no doubt encouraged by their youth. They were permanently under the close supervision of senior clerks, themselves watched by a management, some of whose members were scarcely relaxed men.[7] Hours of work and behaviour in the office were controlled by an extensive set of formal regulations. When the work load was heavy, extra hours were worked with no overtime payments beyond 'tea-money'. It was possible to maintain this disciplined atmosphere because the great majority of staff realised that if they wished to remain in Kendal, the Provincial offered better prospects that any other form of white-collar employment. Memories of staff relations at head office are therefore of an authoritarian regime, dominated by depart-mental managers who had a greater interest in pleasing Francis Scott by convincing him that staff conditions were adequate, than in trying to persuade him to deal with them in a more generous spirit. Of course, this was probably characteristic of comparable work in other companies during the period.

By contrast, the atmosphere in most branches was more relaxed. This was especially so when they were small and relationships were more personal, but in addition, the branch manager was frequently away on business, and work was often more sporadic. Furthermore, for staff the connection with the Provincial and the Scotts was more tenuous. They could often move to other company branch offices in the same locality. Loyalty, when it existed, was focused on the branch manager, whose recommendations were bound to weigh with Francis Scott in matters of salary and promotion.

In these different ways, the loyalty and personal connections that had undoubtedly been a significant factor in the Scotts' relations with their staff before 1919 began to evaporate. They tried to sustain them. Francis Scott continued to exercise private benevolence to staff in personal diffi-culties outside the framework of management control. Material relating to the Scotts' social life, including such events as Francis Scott's service as High Sheriff of Westmorland, appeared in *White and Red*, the company's

staff magazine. But few, including the Scotts themselves, can have taken this very seriously.

In these circumstances Francis Scott began to look for other means of associating staff with the company's success. He wrote in 1927,

We have had under consideration for some time the question of profit sharing as a means of stimulating the interest of the Staff in the welfare of the company and as a solution of the relations between the Proprietors and the Employees of the Company in their respective claims to participate in its success.

... while opinions may differ as to the practical application of profit-sharing to ordinary industrial business, where labour plays almost a mechanical part in production and profits are very largely due to the enterprise and shrewdness of the controlling heads, ... there seems far stronger grounds for profit sharing in Insurance business which is so largely influenced by the individual brain efforts of the rank and file of the staff. In principle too we are inclined to look on the introduction of such a scheme into the Provincial as a step and an example in the right direction

A staff bonus has been declared in the past in one or two exceptional years ... but it is felt that the definite allocation of a percentage of the profits is a far more satisfactory basis to adopt and avoids all question of arbitrary and inconsistent decisions.[8]

Scott corresponded with Keynes who supported the proposal enthusiastically, writing 'I think there is everything to be said for a fluctuating remuneration of this character.' It was consistent with the ideas he was developing at that time in his involvement with the Liberal Industrial Inquiry which subsequently argued that 'The real purpose of profit sharing, ... is to show that the worker is treated as a partner, and that the division of the proceeds of industry is not a mystery concealed from him, but is based upon known and established rules to which he is a party.'[9]

The problem facing Scott was that senior staff were far more interested in a pension scheme that would place their long-term security on a par with the large tariff companies than a relatively modest annual cash bonus. And if this was so, it would be in the company's interest to undertake a scheme of this type, that would encourage the recruitment and retention of better quality staff. But Scott could not see how the company could afford to make provision for both proposals. Eventually they were combined. At the beginning of 1930 a pension scheme was introduced. Staff with a salary of over £200 contributed five per cent of their salary, giving them a legal right to a pension, free of any company intervention. At the same time a complementary profit sharing scheme was arranged, under which they received a fixed percentage of company profits which would normally amount to a little less than one month's

salary and would therefore more than meet this payment. Staff with lower salaries were admitted to the pension scheme on a non-contributory basis. Through the 1930s regular payments were made from the profit and loss account to build up a sufficient fund to cover the liabilities assumed on behalf of existing staff when the fund was established.

This was a genuine attempt on the part of the Scotts at a form of partnership with staff, but by its constitution and nature it was only likely to appeal to more senior employees, with most of whom their relationship remained close and personal. While junior staff were members of the pension fund on a non-contributory basis, this was unlikely to influence the attitudes of young men and women. Relations with them had to be placed on a different basis and their loyalty sought in different ways.

In 1929 a Staff Welfare Committee was established at head office as a form of communication between the majority of staff and the management. The initial description of its purposes indicated the priorities of the management in its establishment. It was to consider and make recommendations to the Executive 'on all matters relating to (1) office discipline and routine, (2) staff welfare and (3) general matters concerning the staff.' The methods by which its membership was selected are not known, but the results were scarcely directly representative of junior staff. While no members of the management executive served, membership included relatively senior staff such as Miss MacDonald, who was responsible for the management of women staff and J. W. Tolfree, the Casualty Superintendent. The committee was certainly regarded as being representative of head office staff, but its activities were scarcely disruptive of the Scotts' personal view of company relations. In 1930 it organised a presentation to thank them for the new pension and profit sharing arrangements. Sometimes it was more an arm of management. In 1931 it engaged in a revision of the regulations that controlled working conditions at head office and it was suggested that committee members should be responsible for enforcing them.

This was therefore scarcely a move towards an alternative model of company–staff relations. Indeed, most change in this direction was essentially a new interpretation of the paternalist theme. The building extensions to Sand Aire House in the early 1930s incorporated major improvements in dining and other facilities for staff. Through the 1930s the Staff Welfare Committee increasingly concentrated on the provision of social and sporting activities that would build cohesion among younger staff, raise morale, and provide a recreational life that made employment with the company attractive.

It would be unreasonable to expect any more radical change in the

Scotts' attitudes. While collective action on the part of insurance staffs in London began to develop from the early 1920s, this concentrated on the large companies, especially those in the industrial life business. Few composite companies conceded recognition to external organisations, though staff associations were sometimes sponsored as a form of protection against more threatening developments.[10] In these circumstances it was not to be expected that a relatively small family-managed concern should take the lead. Its owners would be unlikely to concede what its staff, under normal circumstances, were least likely to demand. None the less, relations were not always harmonious. In 1931, for example, management control broke down when three problems were encountered at the same time. The documentation associated with the new compulsory motor insurance legislation placed extreme demands on the accident department staff; new bookkeeping machines were introduced to the accounts department; and staff were forced to work surrounded by the construction of the new general office. There was a crack in the facade. After working twelve-hour days, Saturdays and Sundays over an extended period, with management refusing to recognise any right to overtime payments, staff became restless. The details of the episode are not clear but the eventual upshot was an extra week's salary to each clerk with a specified minimum number of hours of overtime worked.

By 1937 unrest among clerical workers in banking and finance elsewhere created sufficient excitement to make the Scotts face the possibility that they might one day have to accept collective organisation.[11] But this was only to become a serious threat during the special circumstances of the war years. For better or worse, modified paternalism characterised the Provincial's relations with its staff throughout the inter-war period.

12.5 The Drapers' and General

While the development of a branch organisation was in the long run the most important way of increasing the company's influence, Francis Scott was aware that his larger competitors were able to use a range of other means to bring in business on favourable terms. Life companies could use their large investments in property to control the placing of their fire insurance; most of the large tariff companies packed their boards with directors whose main role was to influence the insurances of their companies or estates. Public companies even benefited from the interest of their small shareholders.

In 1922, in an attempt to extend the Provincial's influence in this way, the Drapers' and General insurance company was purchased. Francis Scott

had been following its affairs since 1918. It had been established in 1909 by a group of drapers connected with their trade's association, because they felt that the tariff was not adequately reflecting the impact of sprinkler protection on their premises. Its trading results had remained bleak throughout its history, the company never paying a dividend, but it fulfilled its main object of forcing a reduction in tariff rates and remained a permanent protection against the FOC.[12]

Scott's interest had a number of motives, common to insurance company merger, if usually on a larger scale. The concern would provide a large and attractive connection to work on through its existing policy-holders, its shareholders and the 5–6,000 members of the drapers' trade association who were not already insured by the company. Purchase would enable an immediate expansion in business, for both companies would be able to exchange surplus business presently passed on to reinsurers. Administrative expenses could be reduced by running the business through the Provincial's existing organisation.

Through Stenhouse, it was ascertained that the most active directors of the Drapers' and General were interested in a sale. After eleven years without a dividend they would be happy to get out if trade interests could be protected. An offer was made, half in cash and half in the new Provincial preference shares. Negotiations proved tricky, but eventually Stenhouse provided the basis of a deal. The participating element in the preference shares was improved; the Drapers' board was allowed to purchase additional ordinary shares for themselves; and the Provincial committed itself to continuing to discount tariff rates for drapers' risks. The deal was recommended to shareholders and by the closing date of the offer in November 1921, more than the required eighty-five per cent had accepted and the Drapers' and General became a Provincial subsidiary.

Meanwhile, Provincial officials had been sent to London to investigate the concern. They found an amateur management with no systematic procedures and an ignorance of the company's position on the part of staff. The company's investment income in 1920 had been overstated by one-fifth due to the incompetence of the auditors. Yet this tended to increase optimism. If the company had survived under such a regime, effective management could surely make something worthwhile of it. Its connections were strong. Ninety per cent of its fire and seventy-five per cent of its accident business came from the drapery trade, almost entirely without intervening agency commission. Nearly half of the accident account consisted of the very profitable plate glass insurance and the bulk of the remainder came from the relatively attractive workmen's compensation insurance derived from retailers' risks.

TABLE 12.5 *Drapers' and General Insurance Company: fire and accident premiums, 1921–38*

	Net fire premiums	Corrected claims ratio	Net accident premiums	Corrected claims ratio	Surplus	Interest earned
	£'000	%	£'000	%	£'000	£'000
1921	17.7	n.k.	29.8	n.k.	n.k.	1.9
1922	28.9	54.8	31.2	40.8	3.7	2.0
1923	23.8	53.5	32.7	44.8	1.9	2.4
1924	25.7	43.7	34.5	43.8	9.8	2.9
1925	28.2	35.5	39.8	44.7	12.7	3.9
1926	29.3	35.4	47.5	47.9	13.3	4.8
1927	30.3	45.9	53.3	49.9	9.6	5.2
1928	31.6	49.9	58.6	45.8	12.7	6.3
1929	32.3	55.6	63.0	48.2	10.7	6.8
1930	34.6	43.1	69.0	51.6	13.3	6.5
1931	34.0	40.0	78.5	52.2	14.5	6.8
1932	34.5	47.5	81.3	51.1	14.7	6.8
1933	35.0	46.8	85.2	54.6	12.4	7.0
1934	35.8	45.2	89.4	54.7	13.0	6.4
1935	34.3	48.3	97.2	52.4	12.8	8.8
1936	34.8	44.1	103.1	53.1	13.3	9.7
1937	36.9	33.3	104.0	50.5	19.8	10.8
1938	35.1	37.1	109.4	53.7	15.1	9.4

Having secured control its more efficient management was planned. Affairs at the Drapers' and General head office were complicated. The existing manager was too inadequate to retain, but it was important not to antagonise all the staff by harsh action. In the following year, after the Scotts had joined the Drapers' board, he was replaced by Gray, the Provincial's Manchester manager. Underwriting was entirely moved to Kendal to be undertaken by Provincial departmental managers, applying precisely the same procedures as they did on other business. All branches were coalesced with the local Provincial branch, retaining the local manager when such existed, and appointing a Drapers' and General resident secretary to larger Provincial branches. In return the Drapers' made a contribution towards the Provincial's general expenses which significantly reduced its expense ratio, especially at head office. The Provincial's reinsurance treaties were re-organised to place a line on most larger risks with the Drapers', which reciprocated by reinsuring its business with the Provincial.

With his enthusiasm for salesmanship, Gray was the best man the Scotts employed to run what became essentially a marketing organisation. He began to cultivate the drapery trade through the local boards the company had already created, its trade associations and journals. Francis Scott emphasised the importance of following this up to Provincial branch managers. Goodwill towards the company might not last. It was important to capture as much business as quickly as possible.

Table 12.5 illustrates the development of business. After the first year it fell sharply as Baillie placed fire acceptances on a proper basis. Fire premiums then grew steadily, reaching £32,270 in 1929, thirty-five per cent higher than in 1923, with a claims ratio that was at least on a par with the Provincial's. The accident account, which grew more quickly, by ninety-three per cent over the same period, was even more striking. The company used the Provincial's multiple shopkeepers' package to good effect with drapers in bringing in supplementary business. This provided a relatively large account from highly profitable plate glass and burglary insurances. Indeed, in 1929 the Drapers', with its tiny organisation, obtained almost twice as much plate glass and half as much burglary business as the Provincial. The results were very satisfactory. The company consistently produced underwriting profits well above ten per cent. When the remaining £1 shares were bought out in 1929, the Provincial had to pay £5 1s 0d, instead of the 30s it had paid in 1921, and a dividend of twenty per cent was being paid.

In the 1930s the growth of fire business halted and accident business apart from motor insurance slowed considerably. The drapery trade was changing under the combined pressure of the depression and the re-organisation of retailing. Independent retailers faced a contracting market, in which an increasing share of business was taken by multiples, chain stores and mail order houses. Many disappeared; in 1933 Francis Scott reported that 3,000 had gone in the previous two years. Jefferys estimates that the proportion of clothing and footwear retail sales taken by independent retailers fell from about three-quarters in 1920 to half in 1939.[13] The large firms that replaced them were not susceptible to the blandishments of a small specialist company, but placed their business competitively, no doubt through large brokers. Between 1929 and 1938 fire premium income only grew from £32,265 to £35,098, though accident rose from £63,007 to £109,384.

As these problems became apparent, Francis Scott tried to move the company towards a more general business to maintain momentum. There were problems in doing so. It was difficult to persuade Provincial inspectors and branch managers to place business with the Drapers'. They and

their agents saw little point in placing business with a subsidiary when they could do so with the parent company and thus gain additional financial security. The company's name inspired mild amusement rather than confidence and some brokers were naturally prejudiced against a concern whose origins were mutual, and had therefore bypassed commission payments.

Compromises were attempted whereby more Drapers' inspectors were appointed to Provincial branches where local business could justify it. Yet this proved expensive, for the existing risks and agents were widely spread. Furthermore, the appointment of specialist Drapers' inspectors to branches encouraged Provincial inspectors to give up the cultivation of Drapers' business entirely. Changing the company's name to improve its marketability to a wider public was actively discussed, but raised problems. The core of its profitable business – still sixty per cent in 1938 – remained drapery trade risks and it seemed hazardous to risk losing this when the name was now the only serious connection.

Experimental solutions to these difficulties were attempted throughout the 1930s, without satisfying Francis Scott that the best answer had been obtained. The Drapers' and General inspectors found it easy enough to obtain a general motor income, but it was as difficult for them as for their Provincial colleagues to make much impression on the fire and general accident market. None the less, the company remained a valuable asset, providing a consistently high underwriting surplus throughout the decade, which peaked at £19,840 in 1937, or fourteen per cent of revenue.

13

The Provincial overseas

13.1 The possibilities and problems of foreign business

As the war came to an end, Francis Scott considered the future of foreign business. Faber's wish to retire made this necessary but Scott had become convinced that if the Provincial was to approach the scale of its competitors it must follow them in building a substantial overseas account. It was estimated that British companies obtained about half of their total fire premium income from the United States and some three-quarters abroad in the early 1920s. In the accident market foreign business comprised about half of all premium income.[1] If the Provincial could take advantage of this extra scope, it would increase underwriting profits and swell investment income from larger reserves. There were strategic considerations in Scott's mind as well. A large overseas account would insulate the Provincial against the danger of unprofitability in the home market. This was important, for it was in competition with large companies that could use this advantage aggressively to drive out competitors without such protection. Samuel Scott wrote to Keynes,

…it may be accepted as a premise that there are very definite limits to the ultimate opportunities for an office confined to the United Kingdom ….

Legislation is already threatened, affecting the most profitable section of Accident business – Workmen's Compensation, while in Fire the aggressive competition of Lloyd's had introduced a new and very serious phase.

There is in fact something to be said for spreading our business over a wide field, in which loss in one direction is set of by gain in another.

Undoubtedly this has been a source of strength to the old offices, who have been comparatively unaffected by cycles of bad experience in the Home field ….[2]

Faber's London 'home foreign' business had taught Scott a good deal about insurance overseas, but it could not provide the sole basis for long-term development. It was highly rate competitive, offering little scope for the development of goodwill. The only way to develop an overseas account with the higher margins that would allow the profitable long-run growth that would be a permanent asset for the company, was to win business at

its source by entering foreign markets directly. This provided access to the more profitable risks that were not sent to London and allowed the construction of a local organisation that could give some control over business. Yet direct entry was inhibited by problems of cost, control and competitive structure.

Most overseas markets outside Europe and the eastern United States offered only modest premium incomes, either because of the small size of the countries involved or because their low level of economic development did not generate much insurance business. This made it difficult to cover the necessary overhead costs of a local organisation or the substantial fixed deposits or taxes imposed by many countries on foreign insurers.[3] New entrants were particularly affected because their initial income could only be expected to be small. It made it impossibly expensive to enter some markets; forced them to operate exclusively through independent agents where costs were commission based and therefore directly related to revenue or profitability in others; and even when an organisation could be supported, created high costs which made it difficult to secure profitability.

Inefficient international communication added to these problems. It was difficult and expensive to discover and assess opportunities abroad, creating another high overhead cost for small companies. Management also had to be delegated if markets abroad were to be offered a competitively responsive service. This increased risk by reducing the effectiveness with which foreign branch organisations could be controlled. And these problems were compounded when independent agents were used. Adequate protection could only be created through inflexible agreements, and even these were hard to enforce, especially in countries where commercial and judicial standards were unreliable. Thus, new markets could not be safely entered until apparently reliable staff or agents could be found. Even then, underwriting was at first usually limited to modest acceptances on safe classes of risk, restricting growth until confidence was established.

Competitive conditions also created barriers to entry. Many overseas markets offered limited business diffused over large areas, which could not support marketing organisations on British lines. Outside large cities, there were few intermediaries and they were rarely insurance specialists. There was therefore little incentive for them to compete through premium rates, discouraging non-tariff operation, which could otherwise create opportunities for new companies to build business. New companies found that the best agents had already been secured by longer established British companies and could not be prised away from them.

Francis Scott was aware of these difficulties. What he cannot have anticipated in 1919 was that he was embarking on international expansion at the least propitious time since British insurers began to transact business abroad. The first indication of difficulties came with the end of the post-war boom in 1921. The industrial and financial problems this created in Europe were severe enough, although there was some recovery later in the decade. However, the collapse in the price of agricultural and raw materials continued to depress primary producer economies throughout the inter-war period, and these included many imperial markets where British insurers had previously obtained good business. Despite this, in the 1920s their aggregate foreign revenue grew as a result of the American boom, for the United States provided half of their business.[4] But the price for this was paid after 1929, for the crisis in that economy hit them with corresponding force. The depression dampened economic activity throughout the world, with little recovery in fire insurance markets until the years immediately before 1939. Only motor insurance continued to offer significant scope for growth.

British insurers abroad thus faced problems similar to those at home. As insured values fell in real and monetary terms, premium incomes collapsed. This provoked rate competition which compounded the reduction in revenue, raising loss and expense ratios and reducing profitability. Competitive pressures were transmitted between countries as insurers, especially in the United States, sought recompense by attacking business in more promising markets like motor insurance, forcing down profitability.

Currency instability created by trade imbalance added to these problems. The sterling value of underwriting, investment in overseas subsidiaries, overseas deposits and reserve balances became uncertain and sometimes a source of loss. Furthermore, balance of payments pressures encouraged many governments to increase the barriers to foreign company operation through deposits, licenses and taxes, encouraging the formation of indigenous companies able to compete with lower costs.[5]

13.2 *The framework of business*

Francis Scott had realised some of the problems of writing foreign business directly as the result of his earlier experience in Canada and South Africa. In the closing years of the war he therefore devised a scheme to try to reduce their impact. He arranged with T. W. Fletcher of the British Fire that the two companies should work together abroad, as they were also doing in the marine and motor insurance markets. Both would apply to

join the overseas tariffs and then enter foreign markets alternately. All the resulting foreign business would be thrown into a pool to be managed by a jointly appointed manager and the results shared equally. Only the Provincial's Canadian account would be temporarily excluded.

This co-operation would allow more markets requiring deposits to be entered, underwriting limits to be doubled, and thus the overhead costs in London and abroad to be more easily carried by the larger income obtained. Tariff membership would allow the best agents to be approached and co-operation with British tariff companies abroad. The two companies could pool their connections, including those in the international coal trade provided by the Rhondda group that owned the British Fire.[6] The problems of management would be shared with Fletcher, resident in London and a capable associate.

S. W. F. Crofts, was appointed joint foreign manager and took over from Faber in March 1920. He had represented the General Accident in India and Shanghai before returning to that company's head office as Foreign Superintendent. The Scotts found him a man of presence and character. Samuel Scott described him as a 'sahib' and he came with a reputation for a thorough training in foreign insurance backed by a distinguished war record. With a salary of £1,000 and five per cent profit commission, £250 of which was guaranteed, he became the highest paid servant of the company, along with the marine manager.

Crofts's immediate application for membership of the FOC (Overseas) for both companies was declined unless they were prepared to join the home tariff, but a compromise was eventually offered. They could apply for membership of individual overseas rating associations if they agreed to support all FOC (Overseas) tariffs and gave up non-tariff underwriting in the home foreign market. This satisfied the Provincial, especially when it was discovered that FOC regulations did not apply to Canada. Of course, the agreement also left scope for non-tariff writing in accident markets.

Unfortunately, the potential of the joint agreement was destroyed when the British Fire was sold to the London and Lancashire in 1923. This large tariff company had no interest in arrangements that would complicate its world-wide commitments, especially with a British non-tariff company. They discouraged development and eventually, half-way through 1925, the Provincial terminated the agreement.

Yet before this breach, the confidence generated by the pool agreement supported a series of developments that created the main framework within which the Provincial's foreign business developed through to 1938. Crofts established an office with an assistant manager, B. L. Evans, which the Provincial eventually took over as its own foreign department. He

began to open agencies in a variety of foreign markets and supervised the home foreign business taken over from Faber. At the prompting of the British Fire, an equity stake was taken in a French insurance company, the Lloyd de France, in 1920, which provided in return a large share of its domestic business and joined the foreign pool as an equal partner, providing agencies in the Francophone world. By 1923 the two existing overseas branches had also been placed on a more promising basis. In Canada, Willis Faber was given more scope to develop fire underwriting and the company entered the motor insurance market. In South Africa, stronger local direction and management were created, business undertaken across the whole dominion and a major new opportunity seized in motor insurance.

13.3 The development of business

These four accounts: the general agency and home foreign account, the Lloyd de France agreement, the South African branch and the Canadian agency, were the component parts of the Provincial's foreign business. In the 1920s the business was obtained through various pooling agreements which complicate the accounts. Table 13.1 indicates the business they provided the Provincial alone. Crofts was therefore responsible for a substantially larger income than that indicated. A treaty bringing French business from the Lloyd de France was shared equally with the British Fire until 1929 when it was terminated. From 1920 until half-way through 1925 the General Foreign and South African accounts were pooled by the Provincial, the British Fire and the Lloyd de France. After the break with the British Fire, the Lloyd continued to share that business in a two-company pool with the Provincial until the end of 1929 when the Provincial wrote alone.

The foreign revenue development shown in Table 13.1 naturally reflects the economic problems of the period. An initial net premium income of £17,710 in 1920 grew to a peak of £169,080 in 1930. In the ensuing depression it fell back by some nine per cent to a trough of £153,420 in 1933, but then grew again to a maximum of £235,130 in 1938, providing some twenty per cent of the Provincial's total premium income. While this was a far lower proportion than was obtained by its larger competitors, it seems a reasonable achievement through eighteen exceptionally difficult years, especially when obtained in parallel with such rapid expansion in the home account.

The distribution of business suggests the problems which limited growth and the opportunities which shaped its direction. Table 13.1 shows

TABLE 13.1 *Provincial Insurance Company: overseas net premiums, 1920–38*
(£'000)

	General foreign account (a)	Lloyd de France treaty (b)	South Africa branch (c)	Canada branch (d)	All fire premiums	All accident premiums	All premiums
1920	3.2	3.2	0.7	10.6	14.5	3.2	17.7
1921	4.3	7.4	1.0	16.9	24.6	6.5	29.6
1922	3.8	15.2	0.8	31.2	22.4	28.4	50.9
1923	3.1	12.4	1.6	38.8	29.1	26.6	55.9
1924	2.9	13.7	3.5	33.7	30.6	23.2	53.8
1925	3.5	11.0	6.3	38.2	34.9	24.2	59.0
1926	9.0	14.2	8.3	43.8	42.3	33.0	75.3
1927	15.1	16.5	9.9	40.4	42.8	39.0	81.9
1928	24.2	18.8	12.2	46.7	49.2	52.7	101.9
1929	41.0	26.5	15.4	57.5	59.8	80.5	140.4
1930	61.9		35.3	72.0	68.7	100.4	169.1
1931	57.0		39.6	70.1	60.9	105.8	166.7
1932	50.1		36.6	68.5	62.9	92.2	155.1
1933	48.3		39.2	66.0	61.6	91.8	153.4
1934	51.3		45.9	63.7	65.0	96.8	160.8
1935	59.5		56.6	66.6	67.3	115.3	182.7
1936	65.2		58.4	65.6	69.1	120.0	189.1
1937	73.5		69.5	70.2	79.4	133.8	213.2
1938	79.9		80.3	74.9	84.4	150.8	235.1

Notes This table indicates the net premiums received by the Provincial from the various pools in which it participated. This affects the various elements in the following ways:
(a) General foreign account: from 1920 to mid 1925 the company received a one-third share from a pool with the British Fire and the Lloyd de France. From then until the end of 1929 it received a half share from a pool with the Lloyd de France. Subsequently the Provincial wrote independently.
(b) Lloyd de France: the Provincial received half of a one-third share of the Lloyd de France income. This treaty finished in 1929.
(c) South Africa: this business was shared in the same way as the general foreign account.
(d) Canada: from 1920 the Provincial exchanged fire and from 1922 automobile business with the Cornhill. From 1922 the Cornhill reciprocated this exchange. This arrangement finished at the end of 1929.

that accident business grew more rapidly than fire. It was first written in 1920; by 1929 it was providing fifty-seven per cent of revenue and by 1938, sixty-four per cent. Behind these figures there was another important contrast between the two accounts. Accident business was almost entirely obtained directly from overseas markets, but a high proportion of

fire revenue – approaching half in the early 1930s and one-quarter in 1938 – was obtained through reinsurance in London. It proved extremely difficult to win fire business abroad. It was in this market that the tariffs were strongest, the best agents had already been taken, and the collapse in business made them least interested in obtaining additional agencies. The Provincial was disadvantaged by its size, which prevented it offering the large limits that many foreign agents sought. By contrast, as at home, motor insurance, which formed an overwhelming proportion of the accident account, grew rapidly; it was highly competitive; new agents were emerging to serve motorists; and the Provincial had no problem in accepting any risk offered.

The geographical distribution was also striking. Table 13.1 shows that the company's two original branches in Canada and South Africa remained predominant. Canadian business allowed the company to participate in the North American boom of the 1920s, and this raised its proportion of foreign business as high as sixty-nine per cent in the early years of that decade. Correspondingly, its business stagnated in the 1930s. However, the company had become well established in South Africa by 1929 and it was therefore able to enjoy the benefits of that country's remarkable counter-cyclical boom caused by the rise in the price of gold in 1932.[7] The contribution of these two main markets was therefore conveniently balanced on either side of the world depression. By 1938 each provided about one-third of all foreign premium income.

This concentration remained in the face of continual attempts by Crofts to diversify the range of markets from which business was obtained. There were several obstacles which inhibited him, but the most implacable were the deposit requirements and other restrictions imposed by governments on foreign company operation. These intensified through the period. Deposits varied in size and impact. They usually had to be made in specified securities, often denominated in local currencies. At best this distorted investment portfolios, reducing yield; at worst it risked serious losses through default or currency collapse. In either case they imposed a greater burden on companies like the Provincial with modest funds and on new entrants who would take time to build up an income sufficient to justify the deposits required.

These problems inhibited the Provincial from extending into markets requiring deposits. Keynes in particular resented the deflection of funds that could be better deployed. None the less, by 1932 the Provincial had £143,090 on deposit abroad, in Canada, South Africa, Rhodesia, Holland, Greece and Belgium. The largest were £105,318 in Canada and £20,000 in

South Africa. Keynes was only reluctantly persuaded to agree to a further advance of A£50,000 to enter Australia in 1933. Unhappiness about deposits that could not be made in sterling ruled out entry to the whole of Latin America and several countries in Europe, such as Germany and Italy. Even in markets where the Provincial already operated, such as Canada and Denmark, additional classes of insurance were not written because they required further deposits.

The most important forbidden fruit was the United States. Earlier surplus line writing was ended in 1921 when it became very unprofitable.[8] Re-entry was occasionally discussed in the 1920s, but rejected. The deposits required by individual states made it necessary to purchase an American company, which was beyond the Provincial's scope. This was the most important reason why foreign income did not grow to as large a proportion of total revenue as achieved by most other British companies, for America provided the great bulk of their foreign business. However, it saved the Provincial from the catastrophic fall in revenue and profitability that most suffered after 1929 and which depressed revenues throughout the 1930s.

13.4 The general foreign account

From his appointment in 1920 Crofts began to develop a general foreign business throughout the world, for the various pools until 1929, and then for the Provincial alone. It was here, where the Provincial was trying to expand into new markets, that the barriers to development and economic difficulties described above were felt most severely. Its story is of these obstacles, which shaped development, as much as what was actually achieved. No doubt Francis Scott hoped that it would be possible to develop agency connections in a wide range of markets throughout the world, some of which would gradually develop into directly controlled branches. In practice, the restrictions on the growth of business meant that although a number of agencies were opened, branch development was negligible and the company also reverted to writing a substantial account obtained through the London insurance market. This was why the established South African and Canadian branches remained so important.

Table 13.2 indicates the premium income the Provincial received through these arrangements, the business Crofts actually managed being three times as large to 1925 and double to 1929. The South African branch, which by 1929 was providing just over one-third of the pool income, is not included.

Business grew slowly at first. Within months of Crofts taking over the

TABLE 13.2 *Provincial Insurance Company: general foreign account net premiums, 1920–38 (£'000)*
(Excluding South Africa)

	Net fire premiums	Net accident premiums	All net premiums	Profit or (loss)
1920	3.2	–	3.2	n.k.
1921	4.3	–	4.3	(2.3)
1922	3.8	–	3.8	(0.1)
1923	3.1	–	3.1	(1.4)
1924	2.9	–	2.9	(0.8)
1925	2.9	0.6	3.5	(2.3)
1926	4.5	4.6	9.0	(3.3)
1927	8.6	6.5	15.1	(0.2)
1928	11.8	12.5	24.2	(0.9)
1929	n.k.	n.k.	41.0	(5.8)
1930	26.2	35.7	61.9	(6.2)
1931	19.5	37.5	57.0	(6.4)
1932	20.6	29.4	50.1	7.5
1933	20.5	27.8	48.3	8.2
1934	22.8	29.6	51.3	5.0
1935	23.6	35.9	59.5	9.3
1936	27.2	38.0	65.2	3.7
1937	30.4	43.1	73.5	(4.1)
1938	32.5	47.5	79.9	0.8

department the international slump made it difficult to obtain business and then, from 1923, when it took over the British Fire, the London and Lancashire prevented any serious development. By 1925 the Provincial's share had only reached £3,543, almost entirely derived from the fire market.

Development accelerated under the subsequent two-company pool with the Lloyd de France. There was an immediate rise in 1926 as a result of business being divided between two rather than three companies, but after this, a real growth in both fire and accident premium income was achieved. By 1928, fire revenue had risen to £11,770 and accident, even more strikingly, had overtaken it to reach £12,460, providing £24,230 in all. Furthermore, the accident income, virtually entirely motor based, was almost entirely obtained directly from foreign markets through agencies. By contrast, much of the growth in the fire account was found by writing reinsurance treaties for European companies through the London insurance market. By 1928 these provided a premium income, mostly fire

insurance, of £10,000. This treaty business began in 1925 when the three-company pool ended. While there is no evidence to explain its initiation, it seems likely that it was undertaken when it was realised that fire business was going to remain extremely difficult to obtain directly abroad. Yet it had become particularly important to find more revenue to cover the rise in costs inevitable when overheads had to be shared by two companies rather than three. In 1929 business nearly doubled to £47,500, partly because booming conditions throughout the world raised agency income but also because the Provincial probably stopped passing the treaty income through the pool, retaining the even larger income of some £22,420 for itself.

At the end of 1929 the two-company pool ended with a severance of relations with the Lloyd de France. The buoyant business in that year must have encouraged Francis Scott to hope that the consequent reduction in fire limits and loss of Lloyd agencies would not prevent the Provincial's income rising. But the subsequent depression transformed prospects. The end of business sharing and the start of several new treaties meant that the Provincial received a larger income of £63,850 in 1930, but only two-thirds of the agency business obtained in 1929 by the pool was retained.

The stagnation in business caused by the depression was inevitably reflected in development in the early 1930s and this was intensified by the cancellation of several treaties, reducing this source of income to £14,740 in 1935. Revenue as a whole fell to a trough of £48,270 in 1933. Subsequently, growth was achieved so that by 1938 it reached £79,940, of which £32,480 was fire based and £47,470 accident. However, the contrast remained. Only six per cent of accident, but sixty-one per cent of fire came from treaties.

Agency development was constrained by two practical problems. The first, the problem of deposits, has been discussed above. The second was that even within the markets that remained, it proved difficult to find and secure reliable agents and the progress made was largely opportunistic. From time to time Crofts and Scott surveyed the markets that offered potential, but translating this into the transaction of business was a different matter. Although Crofts spent a good deal of time trying to find ways to enter particular markets, success was not always the result of such an active approach. Positive opportunities could not always be secured in the most desirable markets, but the company sometimes took advantage of chance possibilities.

The Provincial's income was too small to support speculative trips to potential markets in search of new agents. Tours abroad were normally restricted to the inspection of existing connections, though they could

sometimes include convenient diversions, of which the most improbable was Crofts's acquisition of the agency of Captain Mainwaring of the St Helena Motor Company, while on the way to South Africa in 1934.

However, the majority of openings originated in London, through the connections of the Provincial's directors or staff, through London brokers, by being brought to London by potential agents, or as the result of propositions made by other insurance companies. Under the pool arrangements the British Fire and the Lloyd de France provided a number of agencies. Crofts found that advertising in Punch produced good results. The company could not control the opportunities that arrived in these ways; it simply had to assess them and seize any that appeared promising. Guatemala was entered through suggestions made by W. H. Haslam; the Ugandan agent was an old friend of Crofts; the important Australian development arose when a friendly tariff company was asked for advice.

On the other hand, when entry was firmly sought in a particular market, it was often impossible to find a suitable channel. The collapse in fire insurance business in many markets meant that few agents had spare capacity, finding it difficult to satisfy their existing companies. The Provincial had little else to work on. By joining the foreign tariff, it could no longer attract agents by discounting rates, yet it did not have the connections in the City of London and its trading houses that could influence business abroad. Furthermore, Crofts believed that the limits the company allowed on large fire risks were so cautious that they discouraged new agencies who did not want to have to become involved in too many separate placings. He argued in favour of increasing them for this reason and to prevent an unnecessary loss of revenue, but Francis Scott, backed by Baillie at Kendal, refused to concede much. He was determined that the foreign business should not produce a disastrous underwriting record, perhaps partly because Keynes remained so sceptical about a general foreign business.

Indeed, it was dangerous to press development by making do with any agent who was less than the most reputable. The impossibility of exercising adequate control meant that it was dangerous to become impatient because this could lead to serious losses. Quite apart from the special case of the Lloyd de France, which will be looked at in the next section, a rash Hungarian venture in 1925 cost £2,082 to establish in return for a net premium of only £188. Larger companies could afford to take risks in agency appointments and average the results over all their business, but this was not possible on the Provincial's modest account.

So Crofts always had before him a list of interesting markets where development was delayed or never occurred. The most important example

was India, an obvious opportunity given Crofts's direct experience there with the General Accident. From 1920 onwards, a series of approaches were made to the managing agencies in Calcutta which he knew controlled the best business. No progress was made until 1938 when an agency was eventually established in Bombay. Similarly, the Australian market seemed a possibility, given the Provincial's success elsewhere in the Empire. But again, no suitable opportunity arose until 1933.

The agency arrangements that were established took two forms. In less developed economies, where there were few specialist insurance intermediaries, the company sought merchant houses with British connections through trade or ownership, which provided some guarantee of shared commercial standards. In the West Indies, for example, it worked through local export merchants trading with London; in Uganda, through cotton merchants. In the Middle East, with its distinctive commercial practices, an agency was given to the oldest established British merchant house in Constantinople, and to a large cotton merchant in Alexandria. These concerns usually offered a modest account, based mainly on their own business. Insurance was an incidental concern and their involvement was often motivated principally by the discount agency commission provided for their own mercantile fire insurance. They provided the safest way into such markets, though their business was unlikely to become very substantial, unless they discovered opportunities that made insurance a desirable activity in its own right. From 1927, a British merchant house in Casablanca developed a motor account throughout Morocco for the Provincial, which Crofts believed to be the largest in that French Protectorate.

In more sophisticated economies, with larger markets, particularly in Europe, it was easier to find specialist insurance brokers who could act as general agents, responsible for large regions or countries, armed with commission terms that allowed them to develop business with other agents. In Belgium an influential broker developed motor business from 1928. Similar approaches on a smaller scale were initiated in Holland and Denmark at the same time.

In principle, Francis Scott would have wished to have established direct and permanent control over business through branch development. At best, the Provincial's relationship with its agents was no more than contractual. Within that legal framework they could only be expected to pursue their own interests, which might not coincide with the Provincial's. They normally remained free to place business with other companies or devote themselves to other interests at the expense of the Provincial. At worst, agencies could be transferred and business entirely lost. The Provincial had no tenure on the business other than the goodwill

it could develop with the agent concerned. On the other hand, the cost of acquiring business was limited to commission related directly to revenue, or sometimes profit. Branch organisation involved the cost of staff, premises and their expenses. This implied the ability to carry a loss until business had grown sufficiently to carry such overheads with ease. Francis Scott was determined that the foreign account should be self-supporting, and therefore such developments were dependent on profitability.

Compromise arrangements were adopted to encourage and control business in some larger agencies, by making a contribution to office and salary costs on the understanding that the Provincial would receive preferential treatment. The problems of controlling a substantial motor business in Europe were such that trained motor clerks were sent out from Britain to Belgium in 1927 and Holland in 1931 to administer acceptances and claims. A contribution was made to the expenses of the Danish general agent from 1937. These payments were used to justify the title of branch.

Another important development came in 1933. In considering a possible opportunity of entering Australia, the Atlas, a friendly tariff company which had a large business in that country, was asked for advice. To Francis Scott's and Crofts's surprised delight, the response was an offer to organise business there for the Provincial on a managing agency basis similar to the Willis Faber arrangement in Canada. They would build up a separate Provincial agency organisation, receiving in return premium income and profit commission. Business was started in 1933 and by 1938 the net premium income, including a generous proportion from the fire market, had reached £6,000 and was already breaking even.

The only branch in which the Provincial took a substantial responsibility for costs demonstrated the problems of such a move as much as the opportunities. In 1929 a mercantile agency in Alexandria was closed when the firm found that it could obtain more in illicit rebates from other tariff companies than the Provincial was prepared to give in commission. John Doyle, whose local broker's concern had taken a Provincial agency for accident business in the city in the previous year, took over the fire business and was employed to open an Egyptian branch. The costs of staff and offices in Alexandria and Cairo were met, though he was allowed to continue with some insurance work that did not conflict with the Provincial. The hope was that he would be able to develop a profitable fire business in the cotton trade of the country. The collapse in that trade in subsequent years meant that business did not grow as successfully as hoped. Although the branch provided the largest single direct source of fire business in the 1930s, on which an excellent claims ratio was obtained, its revenue could not cover overhead costs adequately. No profit was

earned throughout the decade and the burden this placed on foreign department costs was probably important in preventing any thought of opening other branches.

In principle, the problem of an initially small revenue could be avoided by the purchase of a local company that would provide a core of business, an existing organisation, local goodwill and sometimes avoid the restrictions on foreign companies. This possibility was frequently discussed by Scott and Crofts, but only acted upon briefly in the 1930s when the Metropole, a Portuguese concern with connections in that country's African colonies was purchased. The venture proved a failure. The Portuguese managers fell out and it was beyond Crofts's powers to reconcile them. The Metropole was sold to another British company with stronger Portuguese links in 1939. It is not clear why no other ventures of this type were undertaken. It is possible that Keynes was unhappy about such a diversion of investment resources; the Lloyd de France episode may have left a prejudice against such commitments; perhaps no other suitable opportunities arose. What is certain though, is that the Provincial would not have been able to finance a major growth in business in this way.

Through agency sources the Provincial obtained by 1938 revenue directly from Belgium, Holland, Denmark, Morocco, Greece, the West Indies, Guatemala, Sierra Leone, Singapore, France and a number of smaller agencies throughout the world. The fire business came mainly in small individual accounts, though the Egyptian branch provided one-third and Australia one-quarter of the modest total. Belgium, Morocco, Holland and Greece provided the largest proportions of motor income. This direct business was supplemented by reinsurance treaties with some twenty-three companies, nearly all European, the most important being Dutch, French and Portuguese, but also including a Japanese concern.

Francis Scott sometimes felt that his fellow directors, especially Keynes, regarded his espousal of a general foreign business as his King Charles's head. It was an inappropriate commitment for a company of the Provincial's scale, which taxed investment yield, lost money on underwriting and involved high risks and much worry. In the 1920s he found it hard to rebut this claim and had little response except that he was convinced that it would pay one day, when international economic conditions revived and the connections the Provincial was laboriously building up bore fruit. Unfortunately the evidence does not exist to trace the separate contributions to the general account's profitability throughout the period in detail. The final surplus shown in Table 13.2 only allows a tentative story to be suggested. In the early 1920s the modest income obtained was insufficient to carry overhead costs and this, together with the difficulty of obtaining

quality underwriting, prevented any chance of profitability. After the break with the British Fire in 1925, fire reinsurance treaties and accident agency revenue combined to reduce this problem in the later 1920s. A number of factors contributed to the return of substantial losses around 1930. The ending of Lloyd de France membership of the pool in 1929 raised costs. High fire claims were suffered through some of the treaties and then as the consequence of economic depression. But from 1932 a period of low fire claims, and from 1935 the return of cost reducing income growth, allowed a surplus to be earned for every year but one in the remainder of the decade.

Of course, Francis Scott could not have known that this would take place. In 1932 he described the record of the general account as an 'expensive experiment'. Yet behind his commitment lay the continuing philosophy of Provincial development. There was no reason why the company should not eventually achieve anything that other insurance companies had accomplished. It might require a long period of investment, but this was not so important when the Scotts were prepared to carry that. As long as a venture did not carry a risk that could prejudice the whole concern, he continued to keep his eye on the long-term objective, and this, it was clear, involved an overseas account that would provide a continued momentum for growth and sources of compensating profitability, what-ever might happen in the British insurance market. Fortunately, the two existing branches in South Africa and Canada were sufficiently successful to support development elsewhere until the general account moved into profitability itself in the late 1930s. But before examining their success, the Provincial's most substantial disappointment – the interest taken in the Lloyd de France – must be described.

13.5 The Lloyd de France

In the 1920s the Provincial became deeply involved in the affairs of the Lloyd de France. The Scotts invested a substantial sum in the concern; it provided the Provincial with a treaty which contributed as much as twenty-nine per cent of the company's foreign income in the early years of the decade; and it shared with the Provincial in the foreign pool from 1920 to 1929. The relationship was to demonstrate some of the dangers inherent in foreign business.

The Lloyd had been a marine insurance company that ran into difficul-ties at the end of the war. A syndicate of French banks planned to re-finance it to develop general insurance through their connections. In early 1920 Boissarie, the proposed directeur-general, invited the British Fire and the

Provincial to subscribe for shares, supervise underwriting and receive in return a share of the French non-hazardous business it intended to write. The Scotts were apprehensive, but further negotiations by Fletcher in Paris persuaded him to put up the necessary money on the understanding that he would place the Provincial's share elsewhere if necessary. The new pool having just started, the Scotts felt obliged to support him by putting up the necessary £16,000. The heady boom atmosphere of 1920 encouraged all involved to relax their normal caution.

The final arrangements included a further protection. Plisson, a French associate of the Rhonddha group (which owned the British Fire) and the 'coal king' of France, was to put his own money into the Lloyd and represent the two British companies on its board. The Lloyd also agreed not to write any foreign business independently but join the Provincial–British Fire foreign pool as an equal partner, increasing its acceptances and sharing costs. The British companies would receive one-third of what was promised to be the largely non-hazardous French business the Lloyd hoped to write. Somewhere in the negotiations the suggestion that they would control underwriting was lost.

The Scotts were soon assailed by the doubts that often followed a quick decision. The Lloyd could not provide a classification of its business. It quickly tried to break the terms of the agreement by writing its own foreign business. Samuel Scott met Boissarie and disliked him. Plisson crashed in the financial crisis at the end of 1920, fell out with the Rhonddha group, and resigned from the Lloyd's board, removing the protection his position had provided. Finally, the crisis and the development of the Lloyd's affairs made it improbable that the stock the Scotts had been assured could be sold on the bourse would ever be quoted or saleable at a reasonable price. They found themselves locked into a ten-year agreement with a management they neither knew nor trusted, but were forced to support to protect their investment. Indeed, they were soon required to provide extra capital to cover continuing liabilities from earlier marine underwriting and fund larger reserves imposed by French legislation, eventually increasing their commitment to nearly £30,000. Affairs deteriorated further when the collapse in the franc in 1924 seriously reduced the sterling value of their investment. The arrival of Keynes as director enabled franc covers to be arranged, on which a modest profit was eventually made, but there was little prospect of recouping the initial loss.

The underwriting performance of the company was the most important consideration, for one-third of this was passed on to the Provincial and it determined the Lloyd's investment value. It proved mediocre. The French banks' connections did not live up to expectation. Fire business provided

TABLE 13.3 *Provincial Insurance Company: Lloyd de France quota treaty,*
1920–29

	Net premiums fr.'000	Net premiums £'000	Profit or (loss) £'000
1920	191.2	3.2	(1.8)
1921	800.7	7.4	(3.8)
1922	1035.4	15.2	0.3
1923	1138.2	12.4	1.1
1924	1304.9	13.7	(1.4)
1925	1546.8	11.0	1.1
1926	1852.8	14.2	(3.0)
1927	2191.4	16.5	0.2
1928	2475.4	18.8	0.6
1929	5333.0	27.0	n.k.

Note No figures are available for 1929. The estimate is based on references in
correspondence.

no more than about one-fifth of the portfolio. Instead, rapid but unpro-
fitable growth took place in the accident market. This unbalanced the
Provincial's accounts for a while, with Lloyd revenue providing £15,170 as
soon as 1922, as Table 13.3 shows. Sustained growth on this scale would
have been disastrous, but fortunately, although the business in France
continued to expand at much the same rate, from 1923 the fall in the franc
reduced revenue and liabilities. The quality of business did not improve
and over the nine years of the treaty for which underwriting data is
available, a loss of £6,900 on underwriting and exchange was made. The
few good years often seemed more the result of ingenious accounting than
underwriting capacity. It was almost impossible to discover what was
going on or persuade Boissarie to change his methods. The Scotts became
'... weary of M. Boissarie with his irritating optimism, his unreliability
and ineffectiveness in regard to figures, his volubility and verbosity, and
want of candour and straightforwardness that was not merely reprehen-
sible but foolish in dealing with people who were his partners'.
 The pooling arrangement did not work well either. When its costs were
high before 1925, Boissarie insisted that the Lloyd was relieved of some of
its share, which increased those of its two partners. The balance of business
became increasingly unfavourable. By the late 1920s pool income was
growing satisfactorily and the South African branch was bringing it into
profit. The Lloyd was receiving a profitable income double the size of the

mediocre account it provided. The only consolation was that this helped to improve the Lloyd's underwriting accounts and therefore its apparent value.

The underwriting agreement was due to end in 1929, but the Provincial would remain locked into the Lloyd through its shares. From time to time attempts were made to sell them to other British companies who might take over the whole concern as a subsidiary. Scott and Crofts even briefly discussed this option for the Provincial.

Eventually, in 1929 the shares were sold to a French–Latin American group who sought control of the Lloyd. Boissarie was sent to Buenos Aires. Despite the profit made on franc covers, an investment loss of £11,742 was added to that on underwriting. Samuel Scott concluded '... the venture was a colossal mistake ... no brief summary gives an adequate idea of the time expended, the vexation, and the difficulties of this unfortunate episode.' All connections with the Lloyd, except the continual chasing of bad debts due on reinsurance treaties, finished at the end of that year. The company was eventually liquidated in the 1930s.

13.6 *South Africa*

The first few years of the South African branch had been disastrous. As late as 1923, heavy costs and a tiny fire revenue had continued a record of large losses. However, in that year the Provincial took advantage of an opportunity that transformed the business and made it the most successful foreign venture undertaken by the company in the inter-war years.

At the end of the war David Bean, who held the Provincial's power of attorney in South Africa, visited England and impressed the Scotts sufficiently to give them confidence in the integrity of the branch under his general guidance. He encouraged them to remain in the Union, arguing that it promised a prosperous future.

In 1920 the ineffectual wartime manager was replaced by a young man whose father was widely known in South African insurance. He managed to secure the business of a small but influential local insurance company in Bredasdorp, which opened a connection with the Afrikaaner community, policies being issued in that language. However he resigned in 1923 after difficulties with Bean and was replaced by S. M. Goodson, who proved a more robust appointment in every sense. Goodson was an extrovert personality who had been born in South Africa and was sympathetic with the Afrikaaners, whose language he spoke. This approach had been strengthened in his previous employment with the Suidafrikaanse Nasionale Trust en Assurance Maatskappy Beperk (S.A.N.T.A.M.) which had been opened after the war to cultivate Nationalist business.

Whatever his personal qualities, Goodson faced formidable difficulties. The Provincial's entry to the foreign fire tariff prevented the use of discounted rates and there were special local rules restricting the number of agents that could be appointed in each town. This strengthened companies with good established connections, for new tariff insurers could not compete by appointing several less powerful agents. On the other hand, a small revenue could not support much expenditure on the direct marketing that was the alternative method of influencing business. This meant that even when South African insurance legislation was consolidated in 1923 to require only one deposit for operation throughout the Union, it remained difficult to actually attack the new markets opened up.[9]

Within the Cape Province, development was organised from a head office in Cape Town. Goodson's personality and Afrikaaner sympathies allowed him to move through its rural districts from dorp to dorp, taking the local attorney out to lunch, offering advice on farmers' insurances without obligation, gradually building up a local agency organisation. However, this could only yield premium income slowly and in the more sophisticated atmosphere of Cape Town, where revenue was on a larger scale, his salty idiosyncratic manner was less successful in encouraging business.

Outside Cape Province development was placed in the hands of principal agents. Suitable firms were difficult to find because the best were tied to older companies and there were few specialist insurance brokers. In Natal W. F. Johnstone and Co., Ltd. was the best firm that could be found, despite the hazardous risks their interests in timber brought. In the Transvaal, African Shipping of Johannesburg was chosen. Both firms offered their own insurance business, but had no expertise in insurance affairs to offer and the energy of their staff was inevitably directed towards their own business interests, especially when winning business for the Provincial proved difficult.

The way out of this impasse was provided by Sir Alfred Hennessy, a member of a local board of businessmen organised by Bean for the Provincial. An accountant, he had been Chief Agent of the South African Unionist party from 1911 to 1921, and was now an influential businessman, most prominently as Chairman and Managing Director of the Cape Portland Cement Company. He had also founded and was chairman of the South African Royal Automobile Club, an organisation predominantly based in the Cape Province. The main incentive for membership was the provision of inexpensive motor insurance for members, rationalised on the basis that they were a select group of motorists providing above average experience.

In 1922 a motor insurance tariff was established in South Africa partly to prevent the discounts the RAC had negotiated. The Employer's Liability, which had provided the Club's policy, agreed to join the tariff if all other motor insurers followed. The Provincial was not involved in these arrangements as it had not begun to write motor business in the dominion.

As RAC Chairman, Hennessy invited the Provincial to quote for its business. It did so and was successful in obtaining a five-year contract from 1923. This was not popular. Other motor insurers saw the Provincial as brazenly exploiting the formation of the tariff. The Provincial found itself involved in a morass of conflicting interests. The contract offered an opportunity to obtain adequate revenue for the branch by providing direct access to policyholders in a growing market, bypassing intermediaries. But it also created embarrassment by prejudicing relations with the foreign fire tariff. It posed special problems with the London and Lancashire, which had just bought the British Fire and was now a partner in the foreign pool and would benefit from South African business. Furthermore, having captured the RAC contract, Francis Scott was as keen as any other motor insurer to protect profitability. The last thing he wanted was to destroy the motor tariff.

The Provincial proposed a compromise that was accepted. It joined the tariff on condition that its RAC contract could stand for five years. In return it would write all other motor business at tariff rates and would renew the RAC contract at that level. Tariff companies could also quote reduced rates to RAC members.

Hennessy was not happy about this capitulation. But he and the Provincial were forced back into alliance by the tariff. Its members found that they could not overcome the Provincial's hold over Club members, and agreed in July 1924 to cut all motor premium rates throughout Cape Province by one-third – below the Club rate, though with more restricted cover. It was a deliberate attempt to destroy the benefits of the Provincial's agreement with the RAC. Francis Scott deeply resented this, believing it to breach the agreement which had brought the Provincial into the tariff. He used what influence he had at home, hinting to business associates that it might permanently prevent the Provincial joining the home tariff and circulating the general managers of tariff companies with copies of relevant documents.

Hennessy took up cudgels on behalf of the Club and the Provincial in the South African press, threatening to introduce legislation into the South African parliament to make pricing agreements illegal. He was determined to smash the tariff. This frightened Francis Scott into an extremely revealing statement,

... we cannot welcome the prospect of the break-up of the Motor Car Tariff in South Africa, However foolish one may think the Offices have been, one has always got to consider what are going to be the practical results ... we have everything to lose by reverting to a condition of open and independent competition by each Office in Cape Town It would unquestionably ... mean a cheapening of the insurance market for the motor community but ... experience elsewhere has shown that ... the general public have had to recuperate the Companies for this loss in higher rates of premium than was actually justified ... the regulation of rates by Tariff is economical and beneficial both to the Companies and to the public.

The Provincial was as dependent on a tariff to establish itself in South Africa, as it was at home.

Meanwhile, the tariff attack was proving less successful than had originally been feared. RAC members, encouraged by the more generous policy terms offered, proved sufficiently loyal to withstand rate competition. When a tariff competitor inaccurately advertised that it offered as good a policy as the Provincial at lower rates, Crofts advised against pointing out the error, as this might draw to its attention the effectiveness of the Provincial policy.

In 1926 Hennessy reminded the Provincial that its agreement with the tariff implied that in 1928 RAC members would be quoted tariff rates. If this was to be so, he wished to begin making new arrangements, perhaps with Lloyd's. If the Provincial continued to offer special terms, it would have to leave the tariff. Once again, Francis Scott's main concern was to preserve the tariff and prevent unrestrained competition. Crofts reckoned that even if the tariff collapsed, the Provincial would keep most RAC business because of the goodwill that had developed towards the company. Hennessy thought that the Provincial's business was too small to concern the tariff. Scott was not so sure that they would be rational if they saw a chance to '... break the position of the RAC' In the event, the Provincial sent in a letter of resignation well in advance, in order to signal the consequences if no compromise was possible over the RAC issue. There was no response and so the Provincial entered into a new ten-year agreement with the Club in 1928. This included the important addition of a no claims bonus of up to thirty-five per cent after five years.

The RAC contract provided a new basis for developing the branch. It offered a way in which the whole problem of the initial development of an agency network could be bypassed. The RAC membership could be approached directly. The tiny acquisition cost this involved helped to carry the highly competitive terms offered which made the policy so attractive. This enabled an agency organisation to be developed, firstly because

agents were given a modest commission on RAC policies; secondly, because the revenue generated could carry the costs of marketing and organisational development. Finally, it was hoped that RAC members would prove a fruitful group to cultivate for other classes of insurance.

Motor business developed rapidly. In the first year of the contract sixty per cent of RAC members took Provincial policies. Table 13.4 shows how motor revenue grew to £13,710 by 1927. With the even more competitive terms of the second contract, including the no claims bonus, it rose to £33,970 in 1931, with the company taking 4.85 per cent of the South African market.[10] In 1932 there was a pause in growth caused by a combination of economic depression and the introduction of a no claims bonus by the tariff which reduced revenue to £31,780. However, in that year the government left the gold standard, and this created a completely new

TABLE 13.4 *Provincial Insurance Company: South African branch net premiums, 1920–38 (£'000)*

	Net fire premiums	Net motor premiums	Net accident premiums	All net premiums	Profit or (loss)
1920	2.2			2.2	n.k.
1921	2.8		0.1	3.0	(1.2)
1922	2.3		0.1	2.4	(1.0)
1923	2.7	n.k.	2.2	4.9	(1.3)
1924	3.9	5.9	0.5	10.3	0.3
1925	4.5	8.9	1.7	15.1	1.5
1926	3.6	11.1	1.9	16.6	1.5
1927	4.0	13.7	2.0	19.7	2.2
1928	3.8	17.9	2.6	24.3	2.6
1929	4.2	23.6	3.1	30.8	3.6
1930	2.9	29.7	2.7	35.3	6.5
1931	3.1	34.0	2.5	39.6	7.0
1932	3.1	31.8	1.7	36.6	3.7
1933	3.0	34.3	1.9	39.2	1.5
1934	3.6	39.5	2.6	45.7	3.1
1935	3.8	44.3	8.4	56.6	1.0
1936	4.1	48.9	5.4	58.4	4.9
1937	4.8	57.9	6.8	69.5	3.2
1938	5.7	68.2	6.4	80.2	3.0

Source: Union of South Africa, U.G. Series, Annexes to Votes and Proceedings of the South African Parliament, Report of the Registrar of Insurance Companies, passim.
Note Motor premium income is included in accident premium income in 1923.

economic environment. In the following years to the Second World War South Africa enjoyed a prolonged boom based on the higher gold price.[11] The impact on motor insurance was dramatic. Market premium income grew by 120 per cent from 1932 to 1938.[12] The Provincial, by maintaining its market share, enjoyed a similar rate of growth, motor premium income reaching £68,170 in the latter year. In the 1930s the company was normally the fifth largest motor insurer in the Union. This was almost entirely the result of the RAC contract because the Provincial normally only wrote other motor business at the full tariff rates. In the 1930s, RAC members consistently contributed some eighty per cent of all motor net premium income.

This privileged position in a growing market transformed the performance of the branch. As soon as 1924 it produced a profit and in 1925 Francis Scott was delighted to receive a tangible symbol of success in the form of £2,000 cabled home. As Table 13.4 shows, profitability was achieved each year for the rest of the period to 1938. Beyond this, the business allowed the strengthening of the branch organisation. In 1926 a principal agent was appointed in Rhodesia. In the same year the principal agent in Durban was provided with half the cost of appointing a specialist insurance clerk. A similar arrangement was undertaken in Johannesburg in 1927. In fact, in the following year, when difficulties arose with African Shipping, the clerk appointed established his own separate firm to handle the Provincial's business. In 1928 J. Richardson, formerly a claims inspector in Manchester, was sent out to help Goodson with administration in the Cape Town office. By the late 1930s both principal agents were employing modest staffs, including young inspectors, with financial help from the company, and the Cape Town office had grown to employ twenty-seven staff, including two inspectors.

Organisational development and a more prominent position in the insurance market were supposed to provide the basis by which business could be diversified into other, more profitable classes of insurance. Yet this did not happen. Table 13.4 shows that net fire premium income showed little development in the 1920s, fell back in the early 1930s, and only showed some signs of buoyancy in the late 1930s, to reach a modest £5,700. A high proportion of this was provided by the directors, particularly Hennessy, and the principal agents, through their own business interests. The general accident account remained equally insignificant until the mid 1930s when the introduction of compulsory workman's compensation legislation in 1934 created a rush of easy business which took revenue to £6,390 in 1938.[13]

There is no doubt that Goodson was faced with problems in developing

these less rate competitive forms of insurance in the tightly controlled South African market. Most large concerns were associated with insurance companies or held their own agency. Non-hazardous business was controlled by attorneys and building societies who had their own insurance arrangements. It could not be won without direct marketing. The Provincial's acceptance limits were tiny compared with most competitors, and cut in 1930 when the two-company pool ended, creating an immediate loss of business.

In the 1930s the agency network Goodson had built up in the Cape remained uncultivated as he was forced to remain in the office, coping with the flood of motor business, especially when Richardson's health broke down. Elsewhere, he was in the hands of his principal agents. In Johannesburg the company's representative was, apparently, too quiet and nice a man to make much impression in the flashy, club oriented business community of that city. In Durban the clerk handling insurance affairs for the principal agent received commission on any business not provided by agents, thus discouraging him from creating competition from additional agents. As a result, there were only twelve agents outside Durban in the whole of Natal, with none in Ladysmith, the third largest town. The company was also the victim of its own success, for it became known as a motor insurance specialist and many were surprised when told that it was anxious to develop other business. This was in part because the agency development took place largely through RAC impetus, with the Provincial's representatives often becoming the Club's local 'consul' and the two organisations sharing offices. The only long-term solution to all these problems was the establishment of directly controlled branch offices, but this was impeded by the cost and the possibility of losing the goodwill, and therefore the business, of the existing principal agents.

The result was that with inadequate development in other directions, the RAC business provided a steady seventy per cent of income, thus dominating the branch account. This raised serious problems. Without the RAC contract, branch income would not cover costs and, at the very least, it would be necessary to re-organise the whole venture, if not sell it. This made the company dependent on retaining the Club's goodwill, weakening its bargaining position as it approached 1938 when the contract would have to be re-negotiated.

This problem was exacerbated by underwriting trends. When the business had first been written in the 1920s, RAC membership had been mainly restricted to middle-class motorists in the towns of Cape Province. Subsequent development had taken place in country districts. This had provided excellent claims ratios, despite the competitive rates quoted.

From 1925 to 1929 the annual average corrected loss ratio on all net motor premium income had been fifty-five per cent; from 1930 to 1934 depression and country development had reduced this to fifty per cent. It was this that had allowed the branch to become so profitable so quickly, producing sustained high margins from nine to eighteen per cent on all business between 1925 and 1931.

However, the dramatic growth in motor revenue from 1932 had taken place in the booming gold economy around Johannesburg in the Transvaal. This urban business produced a far higher claims ratio. In fact, the tariff reflected this by introducing differential rates for various districts. The Provincial was prevented from following them by the terms of its RAC contract, which imposed a standard national rate. The membership in the Transvaal was naturally extremely vocal in its opposition to any modification. Thus, ironically, the company that had most successfully developed the country discount for motorists in Britain found itself forced to take an increasing volume of urban business swelled by the gold boom and diverted towards the Provincial because its flat rate made it especially competitive for business it did not seek. Transvaal town business produced such serious losses and formed such a large proportion of the account that the annual average corrected loss ratio rose to 62.5 per cent from 1935 to 1938. The approach to the renewal of the contract in 1938 was therefore delicate. The Provincial could not afford to lose the business, but it seemed locked into terms that made it decreasingly attractive. A branch had been established and remarkable profits had been produced, but the icing on the cake had gone. While the branch remained profitable down to 1938, it did so on far slimmer margins.

13.7 Canada

Before 1920 Canada had contributed about half of the Provincial's foreign business, but this had been a modest enough affair with premium income only reaching £5,600 by 1919. Table 13.5 shows that in the immediate post-war years its scale was transformed. It grew to £43,780 by 1926, paused, and then rose rapidly to £71,970 in 1930. However in the following decade little progress was made. Revenue fell back to a trough of £63,670 in 1934, recovering to £74,940 in 1938, only a little above the business obtained in 1930. This reflected in some part changing Canadian economic prosperity as this moved in sympathy with its American neighbour, but the effect of competition proved as important.

Willis Faber continued to act as managing agents for the Provincial throughout the period. This conflicted with the objective of increasing the

TABLE 13.5 *Provincial Insurance Company: Canadian branch net premiums,*
1920–38 (£'000)

	Net fire premiums	Net motor premiums	All net premiums	Profit or (loss)
1920	10.6	–	10.6	(0.5)
1921	16.9	–	16.9	2.6
1922	15.7	15.5	31.2	2.6
1923	22.8	16.0	38.8	3.1
1924	23.9	9.8	33.7	6.3
1925	28.3	9.9	38.2	(0.9)
1926	33.7	10.1	43.8	(0.5)
1927	29.9	10.5	40.4	3.4
1928	33.0	13.8	46.7	5.7
1929	36.5	20.9	57.5	5.7
1930	39.6	32.3	72.0	7.7
1931	38.3	31.8	70.1	5.7
1932	39.2	29.3	68.5	(3.4)
1933	38.1	27.9	66.0	3.4
1934	38.5	25.1	63.7	5.0
1935	39.9	26.6	66.6	2.4
1936	37.8	27.7	65.6	4.4
1937	44.2	25.9	70.2	4.4
1938	46.2	28.7	74.9	2.3

Note These figures include the consequences of the exchange arrangements with the
Cornhill in the 1920s. From 1920 the Provincial passed one-third of its fire business to the
Cornhill and from 1922 one-third of its motor business. From 1922 the Cornhill
reciprocated this exchange from its fire account and from 1925 from its motor account.
The exchange finished at the end of 1929.

company's control over its own business and certainly had disadvantages.
It seems unlikely that much genuinely independent goodwill developed
among agents, so the whole venture was dependent on continuing with
Willis Faber. They had their own interests and those of the other com-
panies with which they worked to serve in appointing agents and placing
business. Francis Scott had little doubt that growth would have been more
dynamic if it had been controlled directly. But this was not practical. The
costs of operation in such a geographically diffused market were so high
that even large British companies operated in fleets or syndicates to share
costs. The only possibility would have been to buy an existing company to
provide sufficient income to cover overheads. This was beyond the scope
of the Provincial in the early 1920s, and if it had been undertaken, would

probably have caused serious difficulties when income stopped growing in the 1930s.

So, while frequently discussed, direct operation in Canada was never a possibility. For the Provincial, the managing agency method proved an acceptable alternative. It provided skilled and experienced underwriting, essential if the complexities of the Canadian fire tariff structure were to be navigated. The large premium income Willis Faber placed, and the many connections they had built up, gave them an influence that an independent Provincial would have taken decades to create. Above all, by relating the cost of obtaining business to its quantity and quality through revenue and profit commission, it proved economical. As early as 1922 Crofts discovered that the Provincial paid a lower acquisition cost than any other British company in Canada. In the late 1930s business was acquired at a commission and expense ratio that was nine percentage points below the average for all British companies in Canada.

Success depended on the growth of the Provincial's confidence in its managing agents. This would allow them to relax the control imposed by formal agreements, and give Willis Faber scope to use discretion in responding to local opportunities vigorously. In the long run this could only be created by the evidence of a successful account, but it was also a matter of developing good personal relations to encourage efficient communication and a willingness to delegate. This began immediately after the war. O. W. Dettmers, the Willis Faber official responsible for the Provincial's business, visited Britain in 1919 and immediately impressed the Scotts. In 1923 Crofts visited Canada to consider development pro-spects. After extensive enquiries and a close examination of Willis Faber's organisation, he reported back enthusiastically on their influence and methods. Over the following years regular visits took place in both directions cementing personal relations between Dettmers, Francis Scott and Crofts. The careful way in which Willis Faber developed the account, despite serious market problems, reinforced this confidence. While Francis Scott always bore in mind that it might be in the Provincial's interest eventually to write independently in Canada, the company's relationship with Willis Faber of Canada was probably as close, confident and satis-factory as was possible between two independent concerns separated by the Atlantic.

The early development of this confidence was illustrated by several important new directions taken in the immediate post-war years which provided a framework within which business was able to develop rapidly. In 1919 Dettmers at last persuaded the Scotts to allow him to accept timber frame risks. The earlier prohibition had created an insuperable barrier to development, for agents would not deal with a company that

was not prepared to take such a ubiquitous risk. In 1922 the Provincial entered the automobile market on a non-tariff basis under the management of Willis Faber's office at Toronto. Finally, in 1924, Crofts changed the commission agreement with Willis Faber to allow greater discretion in the commission it paid to agents from whom it took business. Previously the agreement had limited this to protect the Provincial, but as competition emerged Canadian agents used their power to push up commission levels and Willis Faber's inability to respond to this constricted development.

These changes in underwriting arrangements were supplemented in another direction. The Cornhill, Willis Faber's house company, entered the Canadian fire insurance market in 1922 and automobile in 1925. In order to protect the Provincial against the risk that the Cornhill might be favoured by Willis Faber of Canada, it was agreed that it would reciprocate the third share of underwriting the Provincial had given it since starting in both markets. This provided an extra buoyancy to business beyond the Provincial's own underwriting.

Fire business responded quickly to the new possibilities. The Provincial's gross fire premium income doubled between 1920 and 1926 in a market that scarcely grew. It was more strongly based. Instead of coming from a small number of large agents in Canada's larger cities, far more business now came through smaller agents spread through the Quebec hinterland of Willis Faber's Montreal office. In 1920 only twenty per cent of business had come from that province; by 1924 it had risen to thirty per cent; and in 1929, forty-three per cent. They provided such a good flow of non-hazardous business that dwelling houses formed the fastest growing class of revenue, and the largest, except for retail stores. Yet evidence of Dettmers's care was provided by the fact that the account was not overburdened with timber framed risks and acceptances almost entirely avoided towns with no efficient fire brigade protection.

Progress in the motor market was meteoric. In the first year of operation net premium income reached £23,300, virtually as large as the fire account, even though business was initially entirely restricted to Toronto and Montreal and was a selected account to justify discounted rates.

Success in both markets was partly because the Provincial faced little non-tariff competition. In the early 1920s the number of independent Canadian companies fell, partly through their purchase by tariff concerns. In 1922 only twelve remained in the fire market among the 172 companies underwriting; in motor only three among seventy, and the two other than the Provincial were financially dubious. This enabled the tariffs to maintain rates and the Provincial faced little competition in modest rate discounting. This allowed rapid growth without prejudicing profitability.

However, this did not last. Profitable business in expanding markets was too tempting. In the more rate competitive motor market, the tariff collapsed in 1924. Severe rate competition broke out with some companies discounting the original tariff rates by as much as fifty per cent. This continued until 1928 when rising losses forced the market to agree to the restoration of control.

In the fire market, falling claims ratios in the late 1920s attracted entry. Between 1922 and 1929 the number of fire insurers grew from 172 to 224 and many of these worked outside the tariff. They were mainly Canadian mutual offices or American companies and between them they began to eat into business. The mutuals forced premium rates down by avoiding commission payments, while the Americans were prepared to force commissions up to establish a market position. As a result, although demand for cover rose substantially through the decade, a falling premium rate prevented the market expanding until the boom years of 1928 and 1929.

These competitive conditions made it extremely difficult to sustain growth. Willis Faber protected profitability by not following competition down in the motor market, resisting rate reductions as best it could. The Provincial quickly lost business. By 1927 net motor premium income had fallen to £12,580, half the level in 1923 and even so produced a corrected loss ratio of seventy-one per cent. This was the measure of the problem that led to the restoration of the tariff in 1928, which immediately restored the Provincial's capacity for profitable growth. Net motor premium income doubled between 1927 and 1929 to £25,155 as this was used to take advantage of the economic boom.

A similarly cautious policy was followed in the fire market. In 1920 the Provincial's average premium rate had been below the market average; by 1929 it was twenty-two per cent higher.[14] Between 1920 and 1926 the company's gross business had grown almost twice as fast as the market. Subsequently it only grew proportionally with the boom in 1928 and 1929.

So the decade that had begun so favourably ended on a less certain note. Premium income, including the Cornhill exchange, rose eight times between 1919 and 1926 to reach £43,800. Competition forced a deceleration and only the restoration of the motor tariff and the boom were able to push it up to £57,460 in 1929. Francis Scott visited Canada in that year to weigh up the situation. He came to the conclusion that there was no longer any need for the Provincial to require the guarantee of Willis Faber's good faith provided by the exchange treaty with the Cornhill. Its business was smaller and not as profitable. The growth in both company's incomes had created the problem that each might not be able to keep

careful track of its conflagration liabilities. At the end of that year it was terminated.

This decision helped revenue to weather the immediate impact of the American crash, for nearly a half of the large increase in branch revenue to £71,970 in 1930 came from the decision to end the exchange. However, the 1930s offered little scope for further growth. The economy remained depressed until 1937; the value of fire policies in force did not recover their 1930 level until that year.[15] Furthermore the market went through another cycle of rate control and collapse. In the fire market rates were maintained during the depression by the high claims produced by economic difficulty. In the motor market the tariff managed to preserve its control until 1933. The Provincial benefited from this respite. In both markets it increased its market share sufficiently to preserve fire revenue at a stable level between £38,000 and £40,000; though in motor, where the market contracted more severely, this was insufficient to prevent a falling income which by 1933 was only £27,910, fourteen per cent below 1930.[16]

However, competition could not be contained indefinitely. It re-emerged first in the motor market. In the depression, in contrast to the fire market, reduced vehicle use had led to low loss ratios. This encouraged rate discounting which forced the tariff to introduce a no claims bonus in 1934, but this did not solve the problem. Discounting continued led by British Lloyd's brokers and commission rates rose as agents were able to charge more for their hold on business. Once again pressure on rates forced Willis Faber to restrict underwriting to protect profitability yet sacrifice market share. None the less, the corrected loss ratio was forced up to seventy-two per cent in 1936. By 1937 low profitability across the market led to the tariff withdrawing the no claims bonus and a general agreement between all underwriters to maintain rates, allowing motor revenue to grow again in 1938.

The fire market also saw the revival of competition. After the worst years of the depression businesses operating below capacity, the elimination of many undesirable risks and the reduction in the proportion of hazardous risks to the whole, lowered loss ratios. The incurred loss ratio rose to a peak of sixty-four per cent in 1932, but then fell to average thirty-eight per cent from 1934 to 1938. Fire underwriting became attractive again. Entry continued with the number of fire companies rising from 224 in 1929 to 274 in 1937.[17] Their appetite for this profitable business operated in two directions. Many classes of previously highly profitable business saw premium rates fall. At the same time, the power of the agents ensured that they took their part of the cream by forcing higher commissions on the companies. By 1935 Dettmers reported that he was

being asked by agents to raise commission from thirty to thirty-five or forty per cent. At first he refused to give way, but business remained stuck at the 1930 level. It became increasingly clear that he was losing business to companies prepared to pay more. The problem was masked in 1935 and 1937 by raising acceptance limits, but in 1937 he was eventually forced to concede substantially more generous terms to some agents. Between 1934 and 1939 commission paid on fire business rose from 23.7 per cent to 26.6 per cent of revenue.

The 1930s therefore saw competition intensify as more companies chased a declining income and this exacerbated the difficulties by reducing premium rates and raising commissions. In these circumstances, Scott and Crofts accepted that it was inevitable that Willis Faber could not achieve much growth. They helped as they could, raising the commission terms allowed in their agreement to give Willis Faber scope to make the essential increases to their agents, but this came too late to make a dramatic impact on the problem and by 1938 the branch income of £74,940 had only advanced four per cent on that obtained in 1930.

After the rapid growth of the early 1920s, the subsequent development of the Provincial's revenue does not form a dramatic story, but behind it lies achievement. Dettmers was perhaps the only agent regarded within the Provincial as too cautious. Yet operating in a highly competitive market, squeezed by rising commissions and falling premium rates, Willis Faber of Canada provided the backbone of the profitability of the Provincial's foreign business, especially in the 1920s. The expense ratio remained remarkably economical. It began as low as 37.4 per cent in the early 1920s, rose steadily through the period as commissions were forced up, but still only averaged 42.1 per cent in the late 1930s. It was this that allowed a substantial income to be written for it could carry claims ratios that were at or above the market average without sacrificing profitability. In fact, in the fire market, the Provincial approximated the market average in the 1920s and then moved significantly above it in the 1930s. In the motor market the Provincial probably obtained a lower than average loss ratio. By good fortune the phases of high losses in each market – in motor in the late 1920s and late 1930s, in fire in the early 1930s – coincided with moderate ratios in the other account. Table 13.5 indicates the annual surpluses. It provided a consistent record with only one serious loss in 1932. During the 1920s an accumulated surplus of £27,640 was obtained; in the 1930s this was matched by one of £31,830. More revenue might have been achieved with a branch organisation, but it is hard to see ways in which it could have produced such a record of profitability in this period.

TABLE 13.6 *Provincial Insurance Company: sources of overseas profitability,*
1920 –38 (£'000)

	General foreign account	Lloyd de France treaty	South African branch	Canadian branch	All profit or (loss)
1920	n.k.	(1.8)	n.k.	(0.5)	3.2
1921	(2.3)	(3.8)	(0.4)	2.6	(3.8)
1922	(0.1)	0.3	(0.3)	2.6	2.4
1923	(1.4)	1.1	(0.4)	3.1	2.4
1924	(0.8)	(1.4)	0.1	6.3	4.2
1925	(2.3)	1.1	0.5	(0.9)	(1.6)
1926	(3.3)	(3.0)	0.8	(0.5)	(6.0)
1927	(0.2)	0.2	1.1	3.4	4.5
1928	(0.9)	0.6	1.3	5.7	6.7
1929	(5.8)	n.k.	1.8	5.7	1.7
1930	(6.2)		6.5	7.7	8.0
1931	(6.4)		7.0	5.7	6.3
1932	7.5		3.7	(3.4)	7.8
1933	8.2		1.5	3.4	13.2
1934	5.0		3.1	5.0	13.1
1935	9.3		1.0	2.4	12.7
1936	3.7		4.9	4.4	12.9
1937	(4.1)		3.2	4.4	3.5
1938	0.8		3.0	2.3	6.1

Notes
(a) Apparent errors due to rounding.
(b) The general foreign surplus is calculated as a residual.
(c) General foreign in 1929 includes the Lloyd de France treaty.

13.8 *The profitability of business*

Table 13.6 draws together the results of the various accounts to provide a
view of their contribution to the success of foreign business as a whole.
The broad pattern is one of almost consistent profitability in Canada and
in South Africa from 1925, supporting substantial losses elsewhere until
the early 1930s, after which all the accounts normally provided a surplus:
The two original branches carried the cost of the initial development
elsewhere. Of course, in the 1920s it could be argued that the company
was sacrificing profitability on a fruitless venture to develop elsewhere;
only in the 1930s could the earlier efforts to develop a general account be
regarded as worthwhile.

Furthermore, the business provided other benefits as well. Its accounts

were charged a contribution to the general overhead costs of the company. But most importantly, as underwriting reserves grew in step with revenue, they made a substantial contribution to the company's assets, a proportion of which could be held in the company's investment portfolio. In principle, by 1938 this amounted to £100,980. Escaping from the accounts to measure success in more hard-headed terms, between 1921 and 1938 overseas sources had remitted to head office in profits and for investment, £195,860.

This provides the principal justification for Francis Scott's decision to open the business. It did not all work out in the way he anticipated, but behind all the arguments was a common sense view that it was usually possible to make something of a business, even if this required flexibility and the capacity to live through hard times. In the long run all markets returned to profitability and the Provincial's capacity to carry the cost of investment in temporarily unprofitable ventures allowed the temporary difficulties of entry and development to be accepted. The judgement came in deciding how much should be carried at one time. This limited branch development. On the other side of the account was the problem that the most successful developments – in Canada and South Africa – were potentially fragile. In Canada the company remained in the hands of managing agents whom it trusted but could not control. In South Africa the branch relied almost entirely on a contract that could be lost at a stroke. However the period showed that problems that might carry severe risks in principle, could usually be survived through flexibility and muddling through. The management of foreign business required precisely this self-confidence to undertake risks in which not all the loose ends could be tied up or success guaranteed, but whatever transpired could be coped with successfully. Francis Scott's commitment through the 1920s was a measure of the extent to which he was increasingly prepared to undertake such risks.

14

The Provincial at sea

The Provincial had entered the marine insurance market in 1918 to take advantage of a boom.[1] War conditions had led to an explosion in business, creating extreme market undercapacity. This attracted many new concerns which, like the Provincial, saw an opportunity to enjoy profitable premium rates and use them to establish a permanent position in the market. The Scotts were warned by marine insurance friends that they were making a dangerous move. This advice was borne out in the post-war years. The market became unprofitable for all, but especially new entrants. Yet Francis Scott remained determined to continue operation. This was perhaps partly through an irrational desire to prove that the original decision had been correct, partly because of the financial problems implicit in leaving the market, but probably fundamentally for the same reason that had guided his refusal to give up foreign business. If other companies could operate a marine account successfully, there was no reason why the Provincial should not do so. Indeed, it was necessary to diversify the sources of underwriting to provide greater stability and security against problems in particular markets. However, again as in the foreign market, he was attempting to develop marine insurance at an extraordinarily unpropitious time. The inter-war years provided unremitting problems for the most experienced marine insurers. He persevered in trying to devise new approaches in the hope that one would provide a satisfactory basis for business. All these efforts were unsuccessful and as a result the marine business cost the company serious underwriting losses that were not recouped and the fruitless diversion of senior management capacity. Right through to 1939 Francis Scott was still considering whether the department should be closed, though he could not bring himself to make the decision.

After the war and immediate post-war boom, marine premiums collapsed. The scale of the reduction is difficult to assess because the important share of business transacted by Lloyd's was not reported and company underwriting results were not officially collated until 1922. Some idea can be conveyed by the net marine premium income written by six of the largest marine companies. In 1918 this group had obtained £14.5

TABLE 14.1 *Provincial Insurance Company: marine business, 1920–38*

	British companies' marine business	Provincial net premiums	Claims ratio including claims from all previous years	Ratio of marine fund to premiums	Transfers from company profit and loss account
	£m	£'000	%	%	£'000
1920	n.k.	19.0	89.4	78.8	
1921	n.k.	11.1	126.1	111.6	
1922	15.2	11.5	86.0	119.4	
1923	14.5	23.5	75.7	76.5	
1924	14.6	24.5	113.2	55.6	
1925	13.3	41.6	91.5	80.4	20
1926	13.3	41.2	106.6	60.7	
1927	13.8	149.7	111.2	80.3	20
1928	13.8	172.1	93.5	79.9	20
1929	13.4	118.7	130.7	83.0	10
1930	12.8	96.3	109.7	83.1	
1931	12.0	86.0	99.4	81.5	
1932	11.4	87.1	82.2	94.5	8
1933	9.9	82.9	80.2	104.4	
1934	10.2	89.6	75.4	107.3	
1935	10.1	91.5	83.2	108.5	
1936	10.5	136.3	54.8	108.7	
1937	12.6	171.0	78.3	102.4	
1938	n.k.	184.6	88.8	103.1	

million. With the end of hostilities and war premium rates in 1919 this fell to £11.6 million. Price inflation and the boom in world trade pushed premium income back to £14.4 million in 1920. Deflation and economic contraction forced a sharp fall to only £8.1 million in 1921 and to £7.2 million in 1922, obtained by companies better placed than most to protect their revenue.[2] From 1922 the business transacted by all companies (but not Lloyd's), provided in Table 14.1, shows an almost unrelieved continuous drift down from £15.2 million in 1922 to a trough of £9.9 million in 1933. In subsequent years there was some recovery, but even by the peak in 1937, a premium income of £12.6 million had not restored business to the level achieved in the initial slump year of 1930.[3]

There had been no doubt in experienced marine insurers' minds that there would be a major contraction in business after the war. The end of

the war risk element in rates and the stoking up of international trade by special war demands and dislocations made this inevitable. But none can have expected that the collapse would be prolonged through two decades by an international depression in world trade. The problems of industrial economies in Europe and primary producers elsewhere combined to increase attempts to achieve national self-reliance. The only focus of strong growth in the 1920s was the United States, which remained relatively independent of world trade. In the 1930s even that economy collapsed and the pressures for protection strengthened elsewhere.

World shipping became the most obvious casualty of this decline in international commerce. The number of cargoes carried fell and price deflation reduced their value. This inevitably led to a falling use of vessels, with many being taken out of service or scrapped, and the remaining suffering reductions in their value. The two broad classes of marine insurance, cargo and hull insurance, both therefore suffered falling demand from the point of view of both the number and the value of risks insured.

Capacity adjusted slowly to this falling demand. It had expanded to such an extent in the war years that considerable attrition was necessary. This process was prolonged because it was difficult to leave the market. Marine business operates on a long and uncertain claims 'tail'. The cost of hull repairs was often only notified and settled two, three or more years after the policy had expired. The sums involved were uncertain because repair costs fluctuated with cycles in ship building activity, inflation or exchange rate variations. However technically solvent marine underwriters might be, they often relied on the cash flow from a continuing account to cover such eventualities. And if they were writing at a loss, there was a greater incentive to remain in business to postpone or escape insolvency. Closing down was never attractive. It required the creation of a fund to meet outstanding liabilities until they were extinguished. This had to include the administrative costs of settlement that could no longer be 'lost' in the overheads of a continuing account. It therefore usually seemed easier to hope that business would recover, provide protection against unexpected volatility in claims settlements and pay the costs of settling claims. This kept many underwriters in the market wishing, against the odds, that conditions would improve. And the more underwriting deteriorated, the greater the incentive to try to continue underwriting to keep premium income ahead of claims until credit was entirely destroyed.

These problems of adjustment naturally placed premium rates under great downward pressure, as insurers tried to maintain their business. There must also have been serious difficulties of moral hazard as shipowners faced a catastrophic collapse in the demand for their vessels.

Underwriting in the 1920s was certainly very unprofitable. Table 14.1 indicates the very high claims ratios met by British marine companies. From 1922 to 1929 these averaged 93.8 per cent across the company market.[4] The business did not secure an overall underwriting profit in any year from 1922 until 1929, though some companies reported profits by drawing on reserves accumulated in earlier years. The problems were most acute in the early years of the decade. Many marine insurers were hit hard by the collapse of the City Equitable, a major marine reinsurance company, in 1921, which precipitated other failures by companies whose affairs had been closely associated with it through treaties.[5]

In the later 1920s underwriting improved a little as capacity eventually fell and the collapse in demand decelerated. Despite an apparently highly competitive structure based on Lloyd's syndicates, attempts to control rates in the hull insurance market had some success. The Joint Hull Committee, established before the war and led for many years by Sir Edward Mountain, had been unable to restrain competition in the early 1920s.[6] However, from 1925 it was more successful. Late in that year three of the largest marine company underwriters agreed to raise rates. In 1926 the Committee secured agreement to respect existing 'leads' on hull contracts. In return the lines accepted by 'lead' underwriters were limited to allow business to be shared more widely, to reduce the incentive to cut rates. Rates were also raised on some classes where experience had been poor. In 1928, a temporary halt to the reduction in demand, created no doubt by the revival in trade, enabled the Committee to secure a ten per cent increase in rates on all risks. This modest success in the hull market was not matched in the cargo market which was far less structured and therefore more difficult to organise. It remained less profitable with rates drifting down without check until the late 1930s.[7]

Economic depression from 1929 renewed the decline in international trade and demand for marine insurance. This put intolerable pressure on hull premium rate control again. The rating agreement collapsed in 1933, only reviving in 1937 when international trade began to recover and war risk insurance increased demand again.[8] None the less underwriting improved through the 1930s. Once the initial shock of the slump had passed, with its inevitable consequences for moral hazard, the decade's stagnant trade meant that less maritime activity reduced claims. Vessels on time contracts were involved in fewer voyages and lower demand meant that on average voyages were undertaken by better class vessels. There was less congestion in ports and shipping lanes and the lack of work in shipyards meant that repairs were cheaper. The claims ratio for British marine companies cited above as averaging ninety-four per cent in the

1920s, fell to seventy-seven per cent from 1930 to 1937, only rising above eighty per cent in 1930 and 1932.[9] British companies as a group therefore obtained underwriting surpluses through the 1930s, though with the finest of margins.

These market conditions created severe problems for established companies, but were especially incongenial for a recent entrant, operating on a small scale, like the Provincial. In the marine market success was heavily dependent upon the quality of a company's underwriter. This was partly a matter of technical expertise in selecting and rating risks. But it was also important that he should have developed the goodwill that would attract a good flow of good quality from brokers. Men with these capacities were in great demand, attracting large salaries and commissions. This placed the Provincial at a disadvantage. The Scotts wished to adopt a cautious approach to the growth of marine income and a small revenue could scarcely support a generous salary. It also meant that acceptances on individual risks had to be limited so that losses were not too volatile. This created further problems for an underwriter by making the company unattractive to brokers, who naturally sought to fill their lists as simply and quickly as possible with large acceptances by reputable underwriters.

The situation at the end of the war demonstrated these problems. The original underwriter appointed, C. H. Thomas, with his Cardiff background, did not have sufficient goodwill in London to protect his account when the market collapsed. The company had agreed to operate in tandem with the British Fire, to increase acceptance limits and share costs. Yet even on this basis, the two companies remained unattractive and uncompetitive with the brokers, especially in a fiercely competitive market.

Thomas left the company in 1920. The possibility of leaving the market was considered, but it was rejected. Thomas's deputy, A. W. Morgan, was appointed Underwriter to operate a more cautious policy with the size of the direct lines he could accept cut by half. As a result the Provincial's share of the pool fell sharply from £18,985 in 1920 to £11,084 in the slump of 1921 and claims in that year greatly exceeded income. To increase business, especially outside the competitive London market, agencies were opened in provincial centres in Britain and abroad, in Holland, Belgium, Denmark, Egypt and the United States. However, as Table 14.1 shows, business did not improve significantly, especially through defaults by companies with whom reinsurance treaties had been undertaken.[10] Their collapse also forced the company to reduce the scale of the gross lines the company could accept. No profits were obtained between 1920 and 1925 and in the latter year £20,000 had to be transferred from the company's profit and loss account to support the marine fund.

The purchase of the British Fire by the London and Lancashire in 1925 again raised the issue of whether the Provincial should continue in marine insurance. Attempts were made to obtain a place in one of the groups of companies that operated as syndicates under expert managing agents, but over-capacity meant that none were prepared to find room for the Provincial. As Table 14.1 shows, revenue increased substantially to £41,610 in 1925, but not as rapidly as expenses, now that the Provincial had to carry all overhead costs. The expense ratio rose from 4.5 per cent in 1924 to 8.9 per cent in 1925, and again to 14.0 per cent in 1926, the first full year of separate operation. At first reinsurance facilities were extended to preserve the level of gross acceptances, to help earn revenue to carry costs. However this problem, together with dissatisfaction with Morgan's underwriting capacity, forced the Scotts to think hard about the need for a more radical change in arrangements.

In casting around for a better basis for operation, Francis Scott eventually hit on the idea of purchasing one of the few remaining small independent marine insurance companies. The Hull Underwriters' Association had been established for some fifty years in that port, since 1893 as a limited company. It was owned by local shipping and mercantile interests which suggested that it was able to obtain business not generally available. A Manchester connection of the Provincial thought highly of the ability of the Association's underwriter in Liverpool, A. G. Smith. If the concern could be purchased at a reasonable price, it seemed an opportunity to obtain the services of a good underwriter and a substantially larger income to support the costs of management.

Sir Samuel Scott and Barber met Smith to discuss the possibility of purchase. The account he provided of the company seemed reasonable. It had underwritten at a loss during the difficult years since the war and had been seriously hit by the collapse of the City Equitable in 1921, with which it had been substantially reinsured. This loss had now been written off from reserves, so was no longer a problem. However, with the unpromising prospect for marine insurance, some prominent shareholders were concerned about the uncalled liability on their shares, and this might persuade them to sell out.

The business of the company seemed as healthy as could be expected in the state of the marine market. It underwrote a net premium income of some £100,000 through three offices at Hull, Liverpool and London. In Hull, where some twenty per cent of the business was obtained, business was controlled by independent local agents on a commission basis. Business there included specially profitable connections with local fleets that had proved excellent classes of risk and had remained profitable. In Liver-

pool, Smith wrote some forty per cent of the Association's business, including some from agencies in Manchester, Glasgow and Dundee. This branch had remained profitable. The main problem seemed to exist in London, where the remainder of business had been written through brokers who had produced substantial losses for the company. As a result, the Association had decided to reduce its London business from 1926.

Samuel Scott and Barber were both impressed by Smith. The fact that he would have a continuing commitment to the concern suggested that it was in his interest to be straightforward. The proposition offered the attractive likelihood of a straightforward purchase as there were only thirty-eight shareholders, several in family or other groups. An offer was made on the basis of a modest allowance for goodwill over the company's asset value. This was quickly recommended by the directors and by the end of January 1927 the Provincial had purchased the company. For all practical purposes, the Provincial's marine department was entirely merged into the new subsidiary. The Association's three branches were retained. Smith remained in Liverpool, but was given complete control of underwriting for the whole operation. This involved the elimination of some business, as overlapping commitments between the three branches and the Provincial's old account were rationalised. None the less, as Table 14.1 shows, in 1927 the combined net premium income was £149,720, a little more than the aggregate business of the two concerns in the previous year, and in 1928 it rose to £172,080.

However, it was not long before problems became apparent. When the Association was purchased, it had been necessary to form some estimate of the claims outstanding on policies already accepted. With the long claims 'tail' in marine insurance this is never an exact matter. Professional advice had been sought but the estimate provided had been thought too pessimistic. It soon became apparent that the more cautious view had been correct. More had been paid for the Association than had been wise, no doubt explaining the ease with which the speedy purchase had been accomplished. In 1927 claims rose to 111 per cent of revenue. A temporary fall to ninety-four per cent in 1928 was probably mainly due to the rapid rise in premiums. But this brought an even more dramatic increase in its wake in 1929 when the resulting claims began to arise and the claims ratio rose to 131 per cent. This was despite the general improvement in underwriting, particularly in the hull market, during the late 1920s.

In later years the problem was focused in the minds of the Scotts as being a combination of the unexpectedly heavy claims accumulated by the purchased company and the failure of Smith to live up to their expectations as an underwriter. The lack of evidence makes it difficult to assess

these views. The difficulties were particularly acute in London where Smith had had no direct responsibility for underwriting before the merger and where his control and influence was subsequently weakest. Under-writing was in the hands of a subordinate official who could not hope to compete with the full-blown company underwriters. Smith took the pessi-mistic view that the best London business was reserved for a favoured inner circle of companies and underwriters that the Provincial would be unable to penetrate. Otherwise, much of what was available consisted of bad risks that were sent to London because they could not obtain econo-mical cover in their home ports as their dubious nature was well known. It was perhaps unreasonable to expect a Liverpool based underwriter to make much headway in London. In any event, underwriting there proved disastrous. Unfortunately complete branch accounts are not available for the period but the scale of the problem is indicated by the experience on 1928 underwriting there where claims eventually exceeded the net premium income of £75,920 by £25,570. Marine reserves had to be supported by allocations totalling £50,000 from the general profits of the Provincial in 1927, 1928 and 1929.

Restrictions were introduced to limit damage. When the 1928 results became available it was decided that London income should be cut to one-half of that year's level, and that all business there over £40,000 should be reinsured with the Sun. At Liverpool, Smith was to restrict himself to the more profitable hull market. All foreign agencies were cancelled. As a result, as Table 14.1 indicates, net premium income fell from £172,080 in 1928 to £118,670 in 1929 and these constraints combined with the general reduction in marine revenue during the depression to reduce the com-pany's business to £82,890 in 1933.

These controls, the gradual elimination of the claims 'tail' on business written in the late 1920s, and the improvement in market experience during the early 1930s, successfully reduced the claims ratio. By 1933 it had fallen to eighty per cent. But the reduction in business emphasised another problem faced by the account. A subsidiary motive in purchasing the Hull Underwriters' Association had been to increase revenue suffi-ciently to reduce administrative costs. In fact, the expense of maintaining three branches had meant that little had been gained. The expense ratio remained above ten per cent, significantly higher than the levels achieved when the business had been run jointly with the British Fire. There seemed little prospect of cutting costs substantially unless the London office was closed, for Liverpool and Hull provided the main opportunity for profitable underwriting to offset the continuing London losses. As revenue fell from 1929 this problem intensified with the expense ratio

rising as high as nineteen per cent in 1933. As a result, despite improve-
ments in underwriting, profitability continued to be elusive. The marine
fund only exceeded net premiums for the first time since 1922 in 1933,
and then more because of the reduction in the premiums than any
dramatic increase in the fund itself.

Despite the general improvement in the marine market, the mid 1930s
therefore found the Provincial's marine underwriting in a scarcely more
satisfactory state than before the purchase of the Hull Underwriters'
Association. The problems were concentrated in London where branch
underwriting remained unprofitable despite the general improvement in
experience. This suggested that when the marine underwriting cycle
deteriorated again, as could be expected, the company's account would be
in serious trouble. The Scotts became convinced that Smith was not going
to provide an adequate solution for their marine department problems. In
any case, he was approaching retirement.

In 1935 G. A. Horner, the Deputy-Underwriter of the Standard Marine,
a Liverpool based London and Lancashire marine subsidiary, was asked
to inspect the London office. It is not clear whether this was arranged
deliberately to interest him. It seems probable that he was introduced by
Crook through his former company connections. In any event he opened
the door to negotiations in a rather back-handed way by volunteering that
he would not take over the Provincial's London account for a salary of
£5,000. After much coy negotiation he was persuaded to take the title of
Marine Underwriter to the Provincial in London for a salary of £2,500
with additional profit commission. At the same time the Provincial re-
tained the services of Smith, who, despite ruffled feathers, admitted that
Horner was a good catch and agreed to continue as Underwriter to the
Hull Underwriters' Association in Liverpool, independent of Horner.

Given the central role of the underwriter, the appointment seemed to
promise, once again, a new and more fruitful basis for operation in London.
Francis Scott and Crook believed that they had managed to attract a man
with the potential to become a leading underwriter. Horner had an
excellent reputation in Liverpool as being responsible for the active under-
writing of the Standard Marine's account. He was expected to succeed as
that company's chief underwriter and thus assume a prominent position
in the marine market in writing for such a substantial concern, backed by
the prestigious London and Lancashire. For Horner the attractions of the
Provincial appointment were that he would receive a substantial immedi-
ate increase in salary, instead of the expectation of a senior position in up
to ten years' time. There was the attraction of making a reputation as an
independent underwriter. Furthermore, he wished to move to London for

he believed that the Liverpool marine market was becoming a backwater.

Under Horner's management, London business was quickly trans-
formed. He began writing with a freedom and panache to which the
Provincial was unaccustomed. London business, which had fallen to some
£25,000 in 1934, rose to £64,765 in 1936. Francis Scott became apprehen-
sive about the scale and content of the account as early as the autumn of
that year. The company had also been embarrassed by Horner accepting
risks that had been declined by the home and foreign departments, for he
had begun to write the non-marine risks placed in the London market.
Among these he was dabbling, if on a small scale, with some of the more
exotic Lloyd's risks such as Coronation and Film Finance insurance. After
discussion it was agreed that he was to be allowed to continue with the
more orthodox forms of non-marine insurance, with a limit of £7,500
premium income, but that he had no discretion to write 'fancy' business at
all.

In the early months of 1937 Scott became concerned again, but now
more generally about the size of the account. He worried that Horner's
ambition to become a leading underwriter in London had led him 'to be
carried a little off [his] feet by the flattering friendship of certain brokers'.
He expounded the Provincial's philosophy:

... we have reaped the benefit over and over again of having built up a reputation
for prudent and cautious management, and of a policy based on underwriting
profit and not on underwriting income, and speaking not for the company but for
your success as an underwriter, I cannot conceive of any principle more important
to you in these early years of building up your personal reputation on the London
market.

He pointed out to Horner that such a substantial increase in marine
business was likely to lay the company open to criticism and that the
outlook for marine insurance was insufficiently buoyant to encourage
expansion. Furthermore, in his own interest he should remember that
confidence between an underwriter and his management was very deli-
cate, taking years to build up and easily destroyed by a disaster.

Horner initially resented these criticisms, arguing that he had been
offered a free hand when appointed and that his reception and support in
London had exceeded all expectations. He justified his free acceptances by
arguing that marine market rates were likely to improve in the near future
and that it would then be difficult to obtain classes of business that were
presently available. However, eventually, after tense interviews with
Francis Scott and Crook, he was forced to accept the principle of company

control, but his attitude was significant. Marine underwriters seem to have tended to be prima donnas. They operated in a world of their own, responsible at one and the same time for the quality of individual acceptances, the overall balance of the account, and its reinsurance. All this had to be carried in a fast moving market in which opportunities were offered once and not again. It was understandable that they sought freedom from interference from a general management that appeared to impose controls that were unhelpful and irrelevant to their own carefully balanced objectives. It appears that the Standard Marine had operated at a remove from its London and Lancashire proprietors. Other companies, such as the Royal Exchange Assurance had difficulties in controlling their marine departments in the same way as other operating departments.[11]

Yet from Francis Scott's point of view, the problem of control was equally difficult. It was not in his temperament to allow a component of the Provincial to act with virtual independence, especially when it could incur large liabilities and had only produced substantial losses for the company in the past. But it was extremely difficult to exercise management control. It was practically impossible for Scott or Crook to form any reliable impression of the business that was being underwritten until the results were available, by which time it was impossible to intervene. Even then a general manager was very largely in the hands of his marine underwriter as to the probable future incidence of claims. Determining these by conventional rules was of little practical usefulness in such an uncertain area.

Horner was undoubtedly an independent character, who either found it difficult or did not wish to have to provide rational accounts of his policy and methods. Perhaps a more sensitive and cautious man might have handled relations more carefully, attempting to develop Scott's confidence in him. However, it is possible that it was more than a matter of personality. There may have been content in Francis Scott's accusation that Horner was pandering to brokers by making free acceptances. Perhaps this was the only way in which he could develop the connections and goodwill that would build a profitable account, especially if he wished to achieve this quickly. It may have been the same story of Thomas and Smith retold; of the company, itself an interloper, employing a provincial outsider to break into the London market where business flowed in established directions, especially when it was limited.

In any event, Horner subsequently followed Scott's views carefully, increasing London business to £97,252 in 1938, just a little less than the £100,000 target that had been agreed. But his early plunge into Lloyd's special policies in 1936 returned to haunt him. The modest premium of

£1,350 he had taken on the insurance of film finance in 1936, to provide cover for film producers against any interruption to their filming schedules, proved a spectacular disaster. By June 1939 it had produced claims of £17,553; by the final close of the account he lost some £26,000. It was precisely the type of incident Francis Scott had suggested would be likely to destroy confidence in his capacity. And as the succeeding years of claims derived from Horner's more general underwriting became apparent, these proved less than successful.

This was important because by the late 1930s there were other problems to face. From 1935 Smith's underwriting at Liverpool and Hull moved into unprofitability as well. The reasons for this are not clear, though as the problem was mainly concentrated on the underwriting of hulls, it may have been caused by the collapse of the Joint Hull agreement in 1933.[12] Francis Scott had hoped that Smith would retire and Horner take over underwriting in all three centres. However, the latter's unfortunate initial experience forced a postponement. Indeed, when the 1936 and 1937 underwriting results became available, it became apparent that the claims ratio would rise again, in fact reaching eighty-nine per cent in 1938. Francis Scott brought himself to face the possibility that if no improvement in underwriting took place in the results for 1938 and 1939, it might be finally necessary to close the marine account.

It is not clear how seriously this suggestion was considered, but the fact remained that the company's experiment in marine insurance had been extremely unfortunate. After twenty years of operation substantial sums had been lost and little had been achieved, even during a phase of modest market recovery. Furthermore, Francis Scott had not managed to attract responsible officials in whom he had proper confidence. A balance sheet of the marine account drawn up at the end of 1938 indicated an overall deficit on marine underwriting, since the account had been opened, of £63,462. Even this was based on optimistic estimates of outstanding claims.

It is difficult to understand Francis Scott's continuing commitment. There were, of course, the difficulties implicit in leaving the marine market associated with the claims 'tail'. But his attitude was probably more affected by similar considerations to those he applied to overseas business. He saw the Provincial's strategy in terms of operating in all the markets that the older composite companies had developed. Implicit in this attitude was the view that the Provincial should be able to follow them in operating profitably in any market where they had developed successfully.

In overseas and marine business this assumption did not work out successfully. This was partly because of the company's scale. It simply was not big enough to undertake acceptances that made it competitive in

markets where this was an important element in attracting the inter-
mediaries who controlled the business. But in a less constrained market
this would not have been such a disadvantage. The fundamental problem
for the Provincial was that it sought to diversify abroad and into marine
underwriting in a period when the condition of the international economy
made this extraordinarily difficult. Fortunately for the company, its
foreign business was saved by the opportunities presented by the rise of
motor insurance, especially in Canada and South Africa.

No such special features were available in the marine market. Here the
Provincial was a late entrant, attracting all the difficulties such a position
implied in a market based so largely on the reputation of companies and
individual underwriters. Its first attempt to overcome this difficulty
through the purchase of the Hull Underwriters' Association proved un-
successful, largely because it involved backing Smith's ability to manage
business in London on the evidence of his success in Liverpool. In retrospect
this may appear surprising in the light of the problems that arose with
Thomas, the company's first Underwriter, who faced serious problems in
transferring from Cardiff to London. What was perhaps more striking was
the decision to employ Horner, another Liverpool underwriter, to re-
establish the London account in 1936. It seems reasonable to suggest that
the early problems he faced may have been partly linked to the need for
him to establish himself with the brokers.

It would be misleading to finish the marine story on this unsatisfactory
note. From 1939 the war was to create a similar boom in marine insurance
to that which had occurred between 1914 and 1918. In these circumstances
Horner was able to manage a marine account that flourished in scale and
profitability. Advantage was taken of these conditions to sell the Hull
Underwriters' Association in 1942, but its new owners agreed to take
advantage of joint management with the marine department that the
Provincial retained. However all this lay in the future as Francis Scott
contemplated his most problematic department at the end of the 1930s.

15
Investment: riding the tiger

The growth in the Provincial's business described in previous chapters generated an unprecedented accumulation of funds which sustained the company's growth and fed its profitability. By 1938 the company's gross assets at book value had risen to £2,405,346, nearly seven times the £358,245 controlled in 1920, most of which had been generated from within the business. The bulk was held in the form of reserves available for investment and it was in their management that Francis Scott was able to involve J. M. Keynes, the economist, with consequences that were both innovative and dramatic.

15.1 *The problem of management*

Investment management had not previously been seen as a problem by the Scotts. Before 1913 the company's investments had been managed almost as Sir James Scott's private portfolio.[1] During the war the overriding demands of public finance had virtually eliminated any management problem by rewarding a patriotic commitment to government stocks with high and secure yields.[2] However, in the inter-war years the scale of the portfolio and the volatile investment environment raised new problems of control.

All the international economic problems described in previous chapters reverberated through financial markets. The high interest rates created by monetary policy in the 1920s raised serious problems in the protection of capital values, especially of the government securities purchased so heavily during the war. Falling profitability for most traditional British businesses created difficulties, even for the more highly secured fixed interest assets which many insurance companies had acquired. The catastrophic slump from 1929 immobilised investment markets by creating unprecedented uncertainty. The subsequent sharp fall in interest rates in the early 1930s reduced yields and encouraged insurance companies to look for more productive uses for their funds.[3]

At the end of the war the Scotts still controlled finance and investment themselves, within the regional context from which the company had emerged. In 1919, for example, the capital conversion scheme had been carried out almost entirely with the advice of Bolton professional men and a Manchester counsel. When Francis Scott wished to obtain information from a London stockbroker in connection with these discussions, he had sought it through a third party.

In retrospect it is almost too easy to see that this situation could not have continued. Before 1914 Manchester had been an expansive, self-confident and independent financial centre. Even so the capacity of its stock market had been limited, concentrating largely on regional stocks, railways and having less advantageous access to government stocks and new issues than the London market.[4] The collapse of cotton and coal in the 1920s destroyed this buoyancy and further limited the city's financial capacity. The increasing scale of the Provincial's investment purchases would have quickly pressed against its limited market and required advice informed by a broader perspective.

The Scotts did not anticipate this potential difficulty. The initiative came from their cousin W. H. Haslam, who replaced his brother Oliver as a Provincial director in 1923. Will Haslam opened up a new world to the Scotts. He had worked in the Haslam cotton business on coming down from Cambridge in 1911, but after leaving Bolton for war service, eventually became Commercial Secretary at the British Embassy in Rome in 1919. He then joined the staff of the Austrian Reparations Commission in Vienna which resulted in an invitation to collaborate with J. M. Keynes on a series of articles for the *Manchester Guardian* on the Balkan economy. Ill health prevented this, but he attended the Genoa Conference in 1922, ostensibly as the *Economist's* correspondent, but actually as Keynes's assistant. Having no special career plans, but flush with funds as a result of the sale of the Haslam business, he was invited to join two new investment companies to be established by Keynes with a group of friends. He took a desk at the stockbroking firm of Buckmaster and Moore, whose senior partner was O. T. Falk, a close wartime Treasury colleague of Keynes, and proceeded to operate in a heady world of security and commodity speculation. On becoming a director of the Provincial he decided that its affairs required a more metropolitan perspective and suggested that Keynes and Falk be invited to join the Provincial board to advise on investment.[5]

It is difficult to imagine how Keynes and Falk must have struck Samuel and Francis Scott at this time. Keynes's subsequent distinction in scholarship and public affairs, which place him among the most remarkable of

Englishmen, cloud judgement.[6] In the early 1920s Keynes provoked mixed and sometimes violently antipathetic reactions in staider business and political circles. His public reputation rested on his 'Economic Consequences of the Peace' which had been widely regarded as brilliant, but seemed to mark a break with the Treasury, where he had been a figure of importance during the war.[7] Prior to those official responsibilities he had

John Maynard Keynes at Matson Ground (Francis Scott's home near Windermere), 1935.

been devoted to teaching, scholarship and government enquiries of a technical nature. His direct experience of business, apart from wartime interventions in the financial and commodity markets on behalf of the Treasury, had only begun seriously in 1919.[8] He had speculated in commodities with disastrous results, though this would not have been generally known. His first formal city responsibility had come in 1919, when he was appointed to the board of the National Mutual Life, on the recommendation of Falk, a wartime colleague.[9] In short, he was not a city figure of long-established reputation, but controversial and potentially dangerous. There was no doubt that he was brilliant; Bertrand Russell stated that 'Keynes's intellect was the sharpest and clearest that I have ever known.'[10] Yet he was equally unconventional; his natural society was that of Bloomsbury with Duncan Grant, Lytton Strachey, Virginia Woolf and the other members of that individualist coterie of artists and writers. All his worlds were far removed from that of Bolton or Windermere. Yet one of his forbears touched those of the Scotts surprisingly closely. His maternal grandfather had been an academically distinguished Congregational minister born and brought up in a Bolton family.[11] It is tempting to speculate that such a connection through his mother provided an instinctive, perhaps unconscious empathy with that part of the Scotts' outlook and attitudes that derived from their Bolton Unitarian roots.

Falk was only superficially more orthodox.[12] While he was a professionally qualified actuary, he had left insurance proper to join Buckmaster and Moore, a city stockbroking partnership. Personally, he shared the brilliance and idiosyncrasy of any member of Keynes's circle. Though a city man, he was deeply interested in the theory of currency and finance; a perceptive collector of modern art; an enthusiastic aficionado of the Russian ballet, introducing Keynes to his future wife, Lydia Lopokova. Yet he was robust in business relations, imbuing them with drama and crisis. He engaged in heated disputes in which 'one always felt that his intellectual violence might end in physical violence' and this impression was given force by his athletic physique, for he had captained Oxford University's golf team.[13]

Through chance circumstance the Scotts thus found themselves advised by two men whose unconventional sophistication in business and social life contrasted strikingly with their own caution and attention to propriety. It was an improbable relationship. Perhaps Keynes's self-confident charm and obvious integrity attracted the two brothers. His appointment to the chair at the National Mutual in 1921 must have encouraged them. Samuel Scott's friendship with the Bonham-Carter family may have helped, for Sir Maurice Bonham-Carter, formerly Private Secretary to

Asquith when Prime Minister, was one of Falk's partners in Buckmaster and Moore.[14] No doubt the relationship remained cautious at first. It was to have its problems, with Falk leaving the Provincial at the end of 1929. But the Scotts gradually realised that they had associated themselves with an extraordinary man in Keynes and their confidence in his advice and judgement grew. Keynes's sympathetic yet commanding personality, combined with public distinction, ruthlessness in judgement and know-ledge of men and affairs, provided a new resource on which the Scotts could draw and derive the security to act. ' ... We felt lost without him,' Samuel Scott wrote later, 'apart from finance, we turned to him for counsel in any difficulty.' Perhaps there was a small element in this, of Keynes's filling the gap left by their father's death. Both brothers con-tinued to suffer in different ways from a lack of confidence. With Samuel Scott it was a general feeling of inadequacy in taking responsibility for large and uncertain projects. With Francis Scott it was betrayed by a difficulty in taking major decisions without enormously lengthy consulta-tions which seem to have been designed to create the confidence to act, by passing responsibility to a consensus of trusted advisers. Keynes's enormous self-confidence was therefore a resource to be valued.

From Keynes's and Falk's point of view, the connection with the Pro-vincial doubtless began on a simple business basis. In the early 1920s Keynes was interested in accumulating consultancy arrangements as a matter of income and Falk, no doubt, was attracted by the prospect of handling the Provincial's security transactions through Buckmaster and Moore. Yet on Keynes's side at least, the relationship developed further. He became increasingly closely involved with the Provincial because, alongside any remuneration, the work was congenial. In contrast with most city concerns, he was dealing with family proprietors who were receptive to new ideas and free to act as they wished, without the need to watch shareholders over their shoulders. Discussions and management were handled on a basis of straightforward and relaxed personal relations, rather than the pomposity of city board rooms. Finally, the responsibilities remained modest. The funds involved never became too large for Keynes to manage personally, without cumbersome administrative arrangements. The management of the Provincial's investments was ideally suited to his requirements and the work was conducted in an atmosphere which he enjoyed and described as 'so straight, so generous and so gay.'

Growing mutual confidence led to Keynes assuming a far more respon-sible and direct involvement in the Provincial's affairs in the 1930s. He chaired a finance committee of the company's board, on the understanding that he should take full responsibility for investment management, rather

than simply act as adviser. Of course, Francis Scott remained in close touch with affairs. But it was a genuine surrender of responsibility on his part, relieving him of what would otherwise have been an onerous obligation to combine investment management with the general management of the company's expanding insurance business. It was an extraordinary testimony to Keynes that Francis Scott, so cautious, so unwilling to surrender control, should have initiated such an arrangement. His reason was simple: 'I would willingly take responsibility for the investment management if I was satisfied I was the best available man, ... when I have the chance of obtaining the services of Keynes's brilliant brain, I should consider myself a fool not to take it .'

Two other directors were appointed in 1928, mainly to strengthen the company's investment capacity, again through Will Haslam's connections. Sir William Goode had been financial adviser to the Austrian government after the Reparations Commission had been disbanded. Later he returned to London to act as an unofficial adviser to the Hungarian government, and operate in the London foreign loans market. 'He never professed much ,technical knowledge, but his social gifts not only earned him countless friends but gave him access to sources from which he could obtain the best advice possible.'[15]

B. H. Binder was the senior partner in Binder Hamlyn, the major city accountancy practice he had founded in 1918. His professional responsibilities brought him into contact with an enormous range of companies, domestic and foreign, as liquidator, adviser or director. He could provide advice on finance or taxation affairs as they affected the Scott family or the company and comment on salaries and other affairs that involved comparison between the Provincial and other concerns.[16] Both men's professional responsibilities and sources of information made them useful commentators on investment policy and individual securities, though they never took the same responsibility as Keynes.

Thus the Scotts surrounded themselves with investment advisers with as great a capacity and breadth of perspective as any in the City of London. Though he spent much of his time in Kendal, Francis Scott was kept in close touch with city information and opinion, filtered through widely informed, sharp and heterodox minds. He engaged in an increasingly frequent correspondence with Keynes and travelled down to London regularly for series of meetings to handle marine, overseas and investment affairs. In this way the management of the Provincial was provided with a window on the wider world of the City of London and international financial affairs.

15.2 The growth in assets

Table 15.1 illustrates the sources of expansion of the Provincial's assets. Paid up equity only rose by a modest £60,000 in two stages – in 1933 and 1937 – as a result of the new capital structure introduced in 1932. The most important element in growth was the expansion of reserve funds, which rose from £132,000 in 1920 to £1,315,000 in 1938 (including the balance held in the profit and loss account). Short-term reserves held against the unexpired liabilities on existing fire and accident policies grew in proportion with premium income from £82,000 in 1920 to £533,000 in 1938. Those covering the long liabilities 'tail' in marine insurance continued to accumulate, rising from £15,000 to £190,000 in the same period. Long-term reserves were steadily expanded by transfers from underwriting profits and therefore depended on its success. (In no year did the company pay more in dividends than it earned from its investments, and usually considerably less.) They therefore grew less steadily, but by the 1930s the scale of premium income had become so large that even modest proportionate margins on underwriting allowed substantial absolute additions to reserves. In 1920 the general reserve had been £30,000; by 1929 it had reached £160,000; by 1938, £550,000. An investment contingency fund created from 1929 to cover depreciation on investments after the crash, was consolidated into the general reserve in 1932 and 1933.

Given the small additions to equity, these increases in general reserves were necessary to allow the company to underwrite a larger premium income with sufficient security for policyholders. The company's solvency ratio – premium income as a proportion of funds available to cover insurance liabilities – had always been maintained below unity before 1922. The subsequent rapid growth in motor revenue modestly outpaced reserve growth. However the ratio never rose above 1.2, except in 1931 when the sharp depreciation in investments pushed it up to 1.3. From 1933 it fell to unity again.

The new staff pension fund also grew quickly through the 1930s with the combined effect of staff contributions and the special allocations from profitability designed to carry the pension liabilities of staff in service when the fund began. Of course, these funds were never included in the company's available reserves, but they were managed along with the company's other funds.

Some assets were employed directly in the business. The most obvious uses were office facilities and the purchase of subsidiaries such as the Drapers' and General and the Hull Underwriters' Association. However, these were all written off the books as quickly as possible and together

TABLE 15.1 *Provincial Insurance Company: book assets and liabilities, 1920–38(a)*

| | Liabilities (£'ooo) | | | | | Investments | Assets (£'ooo) Subsidiary companies | Property (d) | Debts (e) | Cash (f) |
	Equity funds	Reserves (b)	Pension fund	Credit (c)	Total					
1920	140	132	–	86	358	220	–	27	61	50
1921	140	142	–	81	363	241	–	29	55	38
1922	140	196	–	136	472	260	21	39	112	40
1923	140	236	–	118	494	267	22	37	140	28
1924	140	279	–	143	562	332	22	40	141	27
1925	140	323	–	198	661	346	22	47	187	59
1926	140	369	–	205	714	403	12	40	196	63
1927	140	502	–	230	872	535	25	40	237	35
1928	140	563	–	233	936	583	15	41	239	58
1929	140	580	–	264	984	641	15	52	237	39
1930	140	632	18	303	1093	660	15	56	256	106
1931	140	698	26	360	1224	789	15	61	280	79
1932	140	738	50	373	1301	907	15	62	241	76
1933	180	778	72	411	1441	1012	31	64	249	85
1934	180	847	95	450	1572	1131	36	77	249	79
1935	180	940	119	554	1793	1273	29	75	275	141
1936	180	1095	145	645	2065	1485	42	76	321	141
1937	200	1211	173	721	2305	1625	74	141	399	66
1938	200	1315	203	687	2405	1743	112	145	312	93

Notes
(a) These data are taken from the balance sheet in the published accounts and some assets are therefore net of depreciation.
(b) Reserves include the general reserve, the short-term reserves covering the unexpired risk on underwriting, an investment contingency reserve created in 1929 and incorporated into the general reserve in 1932 and the profit and loss balance.
(c) Credit includes outstanding losses and claims, sums due to other companies on reinsurance accounts, sundry creditors and provision for outstanding liabilities, and the dividend due to shareholders.
(d) Property includes freehold and leasehold property and office furniture and fittings.
(e) Debts include agents' balances, outstanding interest due and sundry debtors.
(f) Cash includes that at bankers, branches, at call, and in hand.

never assumed more than 12.7 per cent of all assets during the early 1920s, and fell as low as 5.7 per cent in 1936. Cash was also necessary for transactions, but this never exceeded ten per cent of assets after 1921 and fell as low as 2.9 per cent in 1937. Short-term debts were always financed by short-term credits, except trivial shortfalls in three years in the 1920s. In any event an increasing proportion of the company's assets were available for the investment portfolio. In 1925 this had fallen as low as fifty-two per cent; subsequently it grew in each year except 1930 to exceed seventy per cent after 1931, allowing the investment portfolio to expand more rapidly than the already substantial growth in assets. In 1920 the investment portfolio's published value had been £220,000. It grew by 191 per cent to reach £641,000 in 1929, then a further 172 per cent to reach £1,743,000 in 1938.

Fluctuations in revenue and profitability generated variations in the growth of the portfolio. Table 15.3 illustrates the changes in net book value, the measure of funds coming into the portfolio, as distinct from increases due to profits realised through security trading. In the 1920s the rapid growth in motor business led to a portfolio expansion of 25.4 per cent in 1923 and usually increases of more than ten per cent, except in 1927 when the Hull Underwriters' Association was purchased from assets for £68,000. In the 1930s the rate of growth rose to twenty-one per cent in 1931, remained well above ten per cent in most years until 1937 when it steadied, but by then the far larger sums involved meant that the company normally had to place between £100,000 and £200,000 of new money each year.

Table 15.5 indicates the income the fund generated. This was of first importance to the Provincial's proprietors as it provided the flow from which their dividends were paid. From £8,100 in 1920, investment income, net of tax, rose to reach £29,300 in 1929, a peak of £62,700 in 1937, then fell to £57,400 in 1938. In a period largely characterised by falling prices, this represented a seven-fold increase in income for the company's proprietors.

15.3 Keynes and insurance investment

Keynes lived two lives as an investor in the inter-war years. On his own account and for friends, he speculated in commodities, currencies and securities. His experience was on occasion hair-raising, and not always successful, though over the long run he was to accumulate a substantial private fortune. At the same time, he managed other funds where his responsibilities were more akin to that of a trustee, with safety a pre-eminent

consideration. As Chairman of the National Mutual he was responsible for the investments of a major life insurance institution; from 1920 as Bursar of King's College he controlled its investments; and from 1923, as we have seen, he became increasingly involved in the investment affairs of the Provincial. Each of these concerns raised different problems, but in each he was required to act with greater discretion than he might exercise with his own assets.[17]

However, Keynes's idea of caution was distinctive. Insurance investment was still imbued with the conventions established by the Victorian actuary, A. H. Bailey.[18] His premise had been that the first objective of insurance portfolio management was to protect capital value to guarantee the security of policies. He inferred that securities whose value fluctuated should not be held. These widely shared views saw an emphasis in late nineteenth-century insurance investment on mortgages and local loans. Bailey later condoned debentures, preference shares and bonds, usually with specific repayment dates, when yields began to fall.[19] With their prior claim on assets, debentures were no more than traditional business mortgages, redesigned to be more easily marketed in the age of the public company. The only major innovation was the opportunity the new form provided for overseas investment, allowing higher yielding securities to be purchased, and providing the safest way in which to hold securities abroad as deposits against overseas business liabilities. Government securities, nearly all undated before 1914, were excluded because of the volatility of their capital value in relation to money market conditions. As Table 15.2 shows, by 1890 British government securities accounted for only three per cent of insurance company assets, while mortgages still accounted for fifty-five per cent and debentures eleven per cent. The force of Bailey's principles was borne out between 1896 and 1914, when rising interest rates severely depreciated fixed interest assets, requiring insurance companies to write off substantial losses, especially on undated assets. By 1914 they had reduced their government security and mortgage investment and increased their holdings of debentures to twenty-five per cent.[20]

The position changed during the First World War. Interest rates rose as government borrowing for war purposes pressed against the market's capacity. This wrought even greater havoc with the capital value of investments. To encourage the market, from 1917 the government adopted the policy of raising finance in the more congenial form of short- and medium-term dated stocks, offering greater capital value security.[21] This, reinforced by high yields and direct pressure to support government borrowing, encouraged insurance companies to move heavily into government stock without abandoning the Bailey canon. Table 15.2 shows the proportion of

TABLE 15.2 *British Insurance Companies: proportionate distribution of assets, 1890–1937 (%)*

	1890	1913	1920	1929	1937
Mortgages (b)	54.9	33.3	20.9	23.7	20.8
British government securities	3.0	1.0	31.7	20.1	21.4
Municipal loans	6.1	7.9	6.2	7.8	6.6
Foreign government and municipal loans	1.7	7.4	7.2	7.2	5.3
Debentures	11.0	24.8	10.6	16.1	16.1
Preference shares	} 6.2	5.8	3.2	6.3	8.2
Ordinary shares		3.5	3.0	6.5	9.9
Land, offices and ground rents	7.5	8.7	6.6	4.7	5.5
Cash	4.1	1.6	3.0	2.1	2.4
Miscellaneous	5.5	6.0	7.6	5.5	3.8
Total assets (£ million)	211.3	530.1	712.1	1252.0	1744.7

Source: Sheppard, *The Growth and Role of U.K. Financial Institutions,* pp. 154–6.
Notes
 (a) The figures prior to 1924 do not include the companies that wrote no life business at all, though they do include the non-life funds of companies that wrote life business. The total assets of the former companies were only £39 million in 1922.
 (b) Mortgages include loans on public rates and loans on policy and personal securities.
 (c) 1937 has been chosen because of wartime breaks in data.

government stock rising from one per cent in 1913 to thirty-two per cent in 1920.

The 1920s saw some companies reduce this commitment. Some took advantage of appreciation when interest rates fell briefly early in the decade. However the proportion held in government stock remained significant for yields remained high. Table 15.2 indicates that the proportion of government securities stabilised, being twenty per cent in 1929 and twenty-one per cent in 1937. The reduction was balanced by a return to debentures and preference shares, which between them accounted for twenty-two per cent in 1929 and twenty-four per cent in 1937. Despite the extraordinary changes in the investment environment during the inter-war years, most insurance investment continued to reflect late nineteenth-century conventions.

When Keynes assumed his institutional responsibilities in the early

1920s, he approached the stuffy world of insurance investment with his usual ebullient, analytical iconoclasm. Bailey's approach to investment encouraged lethargic portfolio management. At worst, it consisted of selecting from securities whose capital value appeared to be safe those which offered the highest yield, then locking them away until redemption. Trading to secure capital gain was regarded as dangerously speculative. Some insurance directors assumed that safety was greatest when the portfolio was never touched.

Keynes took a different view. In the 1920s he and Falk became committed to the idea that economists' understanding of the credit cycle could be used for investment purposes. In January 1924 they floated the Independent Investment Company, whose prospectus outlined this approach. It stated, with characteristic assurance,

It is now known that fluctuations in the relative values of long-dated and short-dated fixed-interest securities and also of fixed interest securities generally and of ordinary shares are all affected by a periodic credit cycle. Changes in the short-period rate of interest affect the value of long-dated securities to a greater degree than should strictly be the case, with the result that considerable profits can be made by changing from one class to another at the appropriate phases of the credit cycle. Similar periodic changes also take place in the relative values of money on the one hand and of goods and real property on the other, which are reflected in the relative values of bonds and of shares, ... so that here also the same principle of changing from one class to another at appropriate times can be applied.

The result of accumulated experience ... is to make it clear that the course of events is sufficiently regular to enable those who are in close and constant touch with the financial situation in certain instances to anticipate impending changes in the course of the credit cycle.[22]

Shortly after joining the Provincial, and no doubt as a consequence of considering his responsibilities there, and at the National Mutual, Keynes published an article on insurance investment management in *The Nation*.[23] He accepted the Bailey premise of capital security, but drew different inferences.

The ideal policy for an insurance company is to put itself, so far as it can, into a situation where it is earning a respectable rate of interest on its funds, while securing at the same time that its risk of really serious depreciation in capital value is at a minimum.

To secure this aim, he argued, it was necessary to pursue an 'active' policy, continually adjusting to changing circumstances. He wrote that the

... idea ... that an active policy involves taking more risks than an inactive policy is exactly the opposite of the truth. The inactive investor who takes up an obstinate attitude about his holdings and refuses to change his opinion merely because facts and circumstances have changed is the one who in the long run comes to grievous loss. ... Every investment means committing oneself to one particular side of the market.

Neither could security be found in vacillation. 'Most companies compromise to a certain extent and never back any opinion, however plausible and well founded it may seem, up to the full extent. Nevertheless, it is very unlikely that the same proportionate division of assets between long and short dated securities can always be right.'

These remarks epitomised the investment policy Keynes and Falk advocated for the Provincial. It was active and uncompromising. In both respects this was partly temperamental, for both Falk and Keynes were intensely involved and supremely self-confident. But there was more to it. They were reacting against fudged 'board room' investment, in which directors were allowed their pet investments, in the hope that this would spread risk, and they were locked away until maturity. Keynes and Falk believed that policy should be flexible and backed to the hilt across the whole portfolio.

The other striking aspect of their portfolio management was a commitment to equities. This was a striking departure from the Bailey canon, for their capital value and yields could both fluctuate and the tangible security could be modest. Keynes's interest in equities was initially an element in the 'active' investment approach outlined above, providing an opportunity for a portfolio to be moved into 'goods and real property' at appropriate phases of the trade cycle. However, through the 1920s and early 1930s his position evolved – without much explicit formulation to his colleagues – to advocate a permanent and substantial equity investment. As early as 1925 he enthusiastically reviewed E. L. Smith's widely read study which presented a favourable view of long-term movements in American equities. Keynes called for a parallel study to be made of British equity performance.[24]

H. E. Raynes, an actuary, responded in 1928.[25] This presented the results of a hypothetical investment in a selection of equities in 1912, showing that their income and final capital value would have substantially outperformed other stock market securities through to 1927. Raynes followed this in 1937 with another paper which extended the survey to 1936, showing a continuing, if smaller advantage in favour of equities.[26] However, he pointed to the need for insurance companies to protect the real value of their assets with the introduction of a managed currency after the end of the gold standard in 1931.

Keynes suggested two reasons for equity investment in his Chairman's report to the National Mutual in 1928.[27]

The permanent reason is to be found in the advantage of spreading the fund between assets such as bonds, expressed in terms of money values, and assets representing real values. Formerly, this result could be secured by means of investments in real estate; Today, however, the position is quite different ... the public joint stock company has taken a tremendous leap forward and now offers a field for the investment of funds which simply did not exist even 20 years ago. ... These represent the live large-scale business and investment world of today, and any investment institution which ignores or is not equipped for handling their shares is living in a backwater. ... A 'conservative' investment policy is apt to mean in practice backing the enterprises which were in the van 50 years ago, instead of backing the new ones which are the characteristic achievement of the best business brains of today.

The second reason for investing in ordinary shares is the fact that they are undoubtedly under-valued relatively to bonds after making all due allowance for risk The fact that most well managed and progressive concerns divide substantially less than they make introduces a cumulative, compound interest element which is often overlooked. ... Whether this under-valuation will still remain by the time that all our friends and colleagues in the insurance business have followed our example (i.e., have invested some 20 per cent of their total funds in this way), I am more doubtful.

He also weighed the objections to equities, partly to reinforce his own case through gentle caricature.

... the knowledge required and the care and attention which must be given are much greater, with the result that the burden of work and responsibility which is thrown on the board and on the executive is increased. It means that the directors have serious duties to perform, and in cases where the directors have not performed serious duties for many years, and are perhaps between 70 and 90 years of age, there must always be a doubt whether it is wise to put new duties on them. Moreover, ... it is extraordinarily difficult to acquire enough information to justify a substantial investment. ...

The second objection is to be found in the relative narrowness of the market Out of some 250 commercial, industrial, and produce companies, you will have your work cut out to discover 50 which are *prima facie* attractive and about which you can acquire adequate information. The National Mutual, although our total fund now exceeds £5,000,000, is one of the smaller units amongst insurance offices. With a larger fund the dilemma would soon be reached between having to invest an amount in given companies which is rather too large for the market and having to go outside the range of the detailed information at the disposal of the office.[28]

On the basis of these arguments, the National Mutual had allocated a significant proportion of its funds to equities in the 1920s: in 1918 this had been only three per cent; in 1924 it rose to nearly nineteen per cent; after falling to ten per cent in 1925 – probably reflecting a credit cycle tactic – it then rose again to eighteen per cent in 1927.[29] The Provincial became similarly involved in ways that will be described below. As Table 15.2 shows, this was a distinctive approach to insurance investment; in 1922 only three per cent of the assets of British insurance companies took this form. In fact it was more innovative than that figure suggests, for Keynes and Falk invested in a wide range of commercial and industrial concerns. Most equities held by insurance companies were in insurance subsidiaries or railway equities. As Table 15.2 shows, through the inter-war years the proportion of equities held rose – to 6.5 per cent in 1929, and 9.9 per cent in 1937 – but this was the result of the activities of a few companies, rather than a general movement.

While the National Mutual and the Provincial were important pioneers in this development, they were not alone. The massive Prudential held a large equity portfolio from at least the early 1920s which had grown to £40 million or 11.6 per cent of its total assets by 1938.[30] In the late 1920s some Scottish life offices followed this lead. By 1929 the Standard Life held seventeen per cent and the Scottish Provident nine per cent in ordinary stocks.[31] Among the nine largest insurance companies (by assets) in 1938, four had devoted between ten and 12.5 per cent of their assets to equities and three had less than two per cent.[32] However, many institutions, especially the Prudential, were almost certainly forced into equity investment by their scale, which created great problems through the accumulation of embarrassingly large holdings in individual securities. The National Mutual and the Provincial were both relatively small and could have found adequate opportunities for investment among traditional securities. Keynes moved them into equities through conviction, rather than need.

15.4 Keynes, Falk and portfolio management in the 1920s

Investment management in the 1920s was dominated by the financial consequences of the war and the implications of the instable economic environment. Short-term interest rates remained high for most of the decade. The British government attempted to re-establish and then support the sterling gold standard at its pre-war parity rate, in an international money market that had become far more volatile and competitive. Long-term interest rates remained high because of the large government debt

incurred during the war, borrowed at high rates, and redeemable at par from 1929 onwards.[33] These conditions made investment decisions straightforward for some. Conventional investors accepted high yields happily and continued to concentrate on government stock and debentures. However, there were complications. The government's determination to reduce the high debt burden maintained high tax rates which discounted yields. Furthermore, while interest rates were actually high for much of the period, there were also moments when they moved quickly – as in 1922 – or appeared potentially volatile – as in the late 1920s.[34] This posed problems for investors who sought to pursue an 'active' investment policy.

These circumstances were reflected in the performance of the Provincial's portfolio. Table 15.5 shows that the yield before tax on market value remained high throughout the decade, averaging 7.0 per cent for the Provincial's fund alone from 1923 to 1927, then falling to average 6.0 per cent for the enlarged fund including the Drapers' and General and Hull Underwriters' Association assets from 1927 to 1929. However, taxation cut these returns back to between 5.5 and 4.8 per cent respectively. Prior to the figures available in that table the yield was almost certainly rather higher during the years of post-war boom and subsequent attempts by the government to restore monetary control. The yield on book value was at a decadal high in 1921 and 1922. Yet this dramatic rise in interest rates led to a serious depreciation in the value of the company's assets which were heavily committed to undated securities. £35,000 had been written off investments by the end of 1921. However, from that year the relative easing of interest rates brought buoyancy back to investment values and, as Table 15.3 shows, the market value of the portfolio rose to a premium of 13.5 per cent above its net cost in 1922, and remained more than ten per cent higher in 1923 and 1924. The rapid growth in the portfolio in these years, fuelled by motor insurance expansion, meant that the portfolio became vulnerable to interest rate increases with such a high proportion bought at high market levels. This occurred in 1925 when market rates rose modestly with rising economic activity and bank rate was set to protect the restored gold standard.[35] The portfolio's market value fell to a slight discount and hovered at just above or below its net cost through until 1929. This had important implications for its growth. In 1925, for example, the market value of the average fund invested depreciated by 4.9 per cent, almost eliminating the net income yield on the fund after tax of 5.3 per cent. While this was the most serious example, the potential problem of depreciation discounting yield remained a concern throughout the late 1920s when a rise in interest rates always seemed possible.

Keynes's and Falk's approach to this environment involved aggressive

TABLE 15.3 *Provincial Insurance Company: investment portfolio, 1922–38*

Year end	Net book value (a) £'000	Annual change in net book value %	Market value £'000	Appreciation (depreciation) of market value on net book value %
Provincial only				
1922	148		168	13.5
1923	186	25.4	205	10.5
1924	204	10.0	226	10.9
1925	228	11.8	227	(0.7)
1926	266	16.7	267	0.1
1927	252	(5.2)	250	(1.1)
Provincial, D and G, and HUA (b)				
1926	558		559	0.2
1927	520	(6.8)	525	1.0
1928	569	9.3	576	1.3
1929	625	10.0	607	(2.9)
1930	641	2.5	606	(5.5)
1931	775	21.0	660	(14.9)
1932	856	10.4	888	3.7
1933	984	15.0	1098	11.6
1934	1104	12.1	1356	22.8
1935	1218	10.3	1559	28.1
1936	1414	16.2	1943	37.4
1937	1537	8.7	1739	13.1
1938	1656	7.7	1760	6.3

Notes
(a) Net book value is gross book value less accumulated profits on realisation – a measure of the original fund.
(b) From 1926 the investment funds of two subsidiary companies, the Drapers' and General and the Hull Underwriters' Association are included. In practice Keynes managed the aggregate as one fund.

switches in funds to maximise portfolio performance. It is difficult to capture these in a form that can be easily presented. Table 15.4 provides the year end distribution of securities (at book valuation) which provides some idea, but of course misses many of the more detailed movements within the year, which were the essence of Keynes's and Falk's approach.

Chapter 6.3 showed how the Provincial followed other insurance com-

TABLE 15.4 *Provincial Insurance Company: proportionate distribution of investment portfolio, 1920–29 (%)*

Securities	1920	1921	1922	1923	1924	1925	1926	1927	1928	1929
Mortgages	2.1	3.9	4.0	5.2	5.3	4.5	4.3	2.8	2.3	1.6
British government	46.2	49.8	42.7	38.1	24.6	36.4	39.6	41.8	35.8	39.4
Municipal	0.7	1.2	0.3	18.3	10.2	4.3	4.3	–	–	–
Imperial (a)	10.4	2.8	8.7	3.6	13.7	14.2	12.3	4.9	4.6	4.3
Foreign government	2.6	4.3	7.8	10.3	2.5	5.9	5.7	7.0	8.5	4.4
Debentures	11.6	10.2	9.2	13.6	29.4	24.9	19.0	17.7	18.1	17.3
Preference shares	11.7	11.1	9.7	3.0	1.9	1.6	0.4	11.5	14.6	18.6
Ordinary shares	14.7	16.6	4.3	2.5	7.7	4.7	11.4	12.1	14.2	13.8
Insurance shares (b)	–	–	13.4	5.3	4.7	3.4	2.9	2.2	2.0	0.6
Investment portfolio (£'000)	220	241	260	267	332	346	403	535	583	641

Notes
(a) Imperial includes Indian and colonial government and municipal securities.
(b) Insurance shares includes subsidiaries and other insurance company shares.

panies in accumulating large holdings of government stock during the war. Table 15.4 demonstrates that these continued to grow during 1920 and 1921 to reach 49.8 per cent of the portfolio. This was probably in response to the favourable terms on which funded stock was offered by the government to reduce the unfunded debt that had proved such a problem for monetary control during 1920.[36] During the subsequent slump and reduction in interest rates, part of the large appreciation in these holdings was encashed to diversify into higher yielding colonial and foreign fixed interest stocks. Municipal loans were also purchased, possibly through the influence of Collins, the local government finance expert, briefly a director. Keynes and Falk began advising the Provincial during 1923 and joined the board in December. The portfolio quickly showed the impact of 'active' investment. As economic recovery seemed imminent, £25,000 was invested in an 'industrial index' group of ten ordinary shares representative of British business and commodities. Yield was sought more vigorously. Gilts were sold to purchase colonial stock and industrial and commercial debentures: Table 15.4 shows that the proportion of government stock fell

from 42.7 per cent in 1922 to 24.6 per cent in 1924; during the same period, the proportion of colonial stock rose from 8.7 to 13.7 per cent and that of debentures from 9.2 to 29.4 per cent. Finally, a series of technical switches were carried out to obtain small increases in the yield on gilts.

Economic expansion and the government's evident determination to return to the gold standard, led Keynes and Falk to anticipate interest rate increases through 1924 and 1925. Policy was sharply reversed. In an attempt to minimise depreciation, heavy purchases of short-term government stock and Treasury bills were again made, raising the proportion of gilts to 36.4 per cent by the end of 1925. Funds were also placed on deposit and holdings of ordinary shares were cut back from 7.7 per cent in 1924 to 4.7 per cent at the end of 1925. Keynes was concerned that the return to gold would press on both prices and profits, depressing ordinary shares.[37]

After 1925 strategy was less certain. Keynes was unclear about the future of interest rates.[38] Sometimes it appeared that they might fall, but attempts to protect sterling against the dramatic boom in the United States might force them up. The proportion of assets held in short dates and Treasury bills initially remained high to maintain liquidity and protect capital values. The proportion of gilts remained above thirty-five per cent for the rest of the decade. Despite this, Table 15.3 shows that the margin of appreciation achieved in the early 1920s, was replaced by a market value which hovered just above or below net book value.

Such security threatened yield. Table 15.5 shows how gross yield declined to 6.6 per cent in 1927. From early in that year the board discussed this problem and determined to move outside the range of trustee securities into higher yielding first charge British preference shares, including railway companies. Between 1926 and 1929 Table 25.4 shows these rising from 0.4 per cent of the portfolio to 18.6 per cent. Foreign government stocks were also purchased. In March 1928, Buckmaster and Moore were asked to submit a list of suggested purchases of £50,000 divided equally between debentures (including foreign government stocks) and ordinary and preference shares, to be financed by selling Treasury bonds.

The return to equity investment through the 'industrial index' was equally striking. As Table 15.4 shows, ordinary shares rose from 4.7 per cent of the portfolio in 1925 to 14.2 per cent in 1928. By the end of that year the 'index' consisted of thirty securities spread across a wide range of commodity, industrial and service sector shares. Most were held in units of about £2,000. Some especially safe equities were purchased in large blocks: £7,000 of LMS Railway ordinaries were held, along with units of over £3,000 in ICI, Midland and Lloyd's Banks, Shell and Anglo–American Telegraph. Some of Keynes's subsequent favourites, such as Austin

TABLE 15.5 *Provincial Insurance Company: investment appreciation and yield, 1922–38*

	Annual appreciation (depreciation) % (a)	Net investment income £'000 (b)	Gross yield % (c)	Net yield % (d)
Provincial only				
1920	n.k.	8	n.k.	
1921	n.k.	12	n.k.	
1922		11		
1923	9.8	10	7.5	5.6
1924	5.6	11	6.9	5.3
1925	(4.9)	13	6.9	5.3
1926	8.5	14	7.4	5.9
1927	(3.9)	14	6.6	5.3
Provincial, D and G, and HUA				
1926		25		
1927	(2.7)	25	5.7	4.6
1928	4.8	27	6.1	4.9
1929	0.5	29	6.1	4.9
1930	(1.5)	30	6.1	4.9
1931	(1.9)	30	5.7	4.4
1932	26.8	31	5.8	4.4
1933	15.4	36	5.0	3.8
1934	17.1	39	4.3	3.4
1935	10.4	48	4.4	3.4
1936	17.2	58	4.6	3.5
1937	(13.3)	63	4.1	3.1
1938	(2.1)	57	4.3	3.2

Notes
(a) Annual appreciation calculated as a proportion of the average fund invested.
(b) Investment income published in annual accounts as net of tax.
(c) Investment income as in (b) grossed up by relevant tax rate and expressed as a percentage of the average fund invested.
(d) (b) expressed as percentage of average sum invested.
 The average sum invested is defined as the market value of the fund at the beginning of the year plus half the new money invested (i.e. half of the change in net book value).

and Leyland Motors were already appearing, though the former was held in a small unit of only £1,200. At the end of both 1927 and 1928 the 'index' group were standing at a premium of some thirteen per cent above their net cost, sharing in the equity boom of those years. At the same time dividend income was a little better than on short gilts, yielding five per cent in 1928. Yield improved a little in 1928 and 1929. Without these moves it would have continued to fall.

Falk resigned from the board in 1926, but continued as adviser. His relationship with Keynes had always been lively, but in 1928 and 1929 fundamental disagreements began to emerge.[39] Unfortunately no direct evidence remains as to the course of this disagreement, but partial inferences can be drawn from portfolio movements. During 1928 major switches in government stock probably reflected changing views about the future of interest rates. As rising security prices gathered momentum through the year, short dated stock was sold from March to June to buy long dated government and debenture stock presumably to consolidate gains and anticipate lower interest rates. However, in September it was decided to keep clear of permanent stocks, which were sold and the proceeds invested in Treasury bills of which a large tranche was retained until late in 1929. During this period the yield gap between Treasury bills and long-term gilts narrowed. The government was loath to carry out the funding of government debt when long-term interest rates were so high, so the volume of Treasury bills expanded, forcing their yield up to a level close to that of Consols and in 1929 overtaking it.[40] Falk is known to have followed the view, widespread in the city, that they represented a better buy than any permanent securities.[41] It is not clear whether Keynes supported him in this or not.

In 1929 Falk's views became equally forceful in another direction. As British equities peaked in the first quarter of the year, and then began to become, in his words, 'dull and inactive', he became evangelically committed to the future of American securities.[42] In June he pressed this view, and in July his recommendation to sell British industrial securities to reinvest in America was formally minuted by the board, suggesting that, at the least, it had caused considerable discussion. Some commentators have concluded that his view was so generally held that, along with high short-term interest rates, it was responsible for the London security market peaking well before New York.[43] Falk subsequently spent £17,000 on American bonds and £22,000 on American common shares, even continuing after the Wall Street crash in September, which did not shake his faith.

Keynes did not support this policy, especially after the crash, which

convinced him that a slump was imminent and that equity investment should be avoided, especially in America. His belief in ordinary shares did not mean that they should be bought without regard to their immediate prospects. He stood back and let Falk take charge, later firmly disclaiming responsibility for the American investments purchased in this period.

These disagreements and their consequences for other ventures managed by Keynes and Falk have been recounted elsewhere; the Scotts found their two advisers divided on policy.[44] The detailed story is unclear, but the Scotts appear to have lost faith in Falk as the price of American stocks collapsed catastrophically in the last quarter. By early November their value had fallen twelve per cent below cost, yet still he bought. His resignation was formally considered on 6 November and although he still attended a meeting in December, he took no further part in Provincial affairs. A partner at Buckmaster and Moore, Sir Maurice Bonham-Carter, took his place as adviser until both resigned from that firm in 1932 to form a new investment house.[45]

Meanwhile, depreciation continued. By the end of the year the Provincial's 'industrial index' block had fallen twenty per cent below cost. The portfolio as a whole, protected by short gilts and Treasury bonds, was less dramatically affected, only falling 2.9 per cent below cost. None the less, it became necessary to establish a contingency reserve of £25,000 to cover the impact of the crash.

15.5 Keynes and portfolio management in the 1930s

Falk's departure was made the occasion to place the Provincial's investment management on a new basis. Previously investment matters had been discussed by the full board of the company. Now a finance committee was created, with Keynes as chairman. This formalised a new relationship with the company, in which he took full responsibility for the management of the company's portfolio. An investment secretary, A. G. A. Mackay, was appointed and provided with an office in the premises of Binder Hamlyn, B. H. Binder's city accountancy firm, and this became the Provincial's investment department.

Francis Scott, who was in the best position to know, later described Keynes's subsequent role in unequivocal terms, as

the unquestioned leader and arbiter of the financial policy, deliberately given a free hand, subject only really to the final veto of the family. The Finance Committee was something of a make-believe, except so far as it kept the directors familiar with what was being done.

This was inevitable. Keynes's powerful analytical intellect, his experience of city and financial affairs, and his magical capacity for persuasion, must have been overwhelming.

The Finance Committee met at intervals of a month or so, when Keynes would discuss his proposals on policy and specific investments. Behind the scenes he and Francis Scott corresponded regularly. Yet there was no doubt as to the locus of real control. Francis Scott realised that Keynes was only interested in management on his own terms. The Scotts' willingness to allow wide discretion was an essential element in his continued interest in the company. He was not interested in 'board' investment management. This, combined with his happy personal relations with the Scotts themselves, created a congenial and relaxed environment. Keynes wrote to Francis Scott, 'I have never had business relations so altogether enjoyable as those with the Provincial.'

Keynes's experience of the 1929 crash reinforced the process by which he was re-appraising the role of equity investment. Looking back on this change of view in 1938 he wrote, ' ... we have not proved able to take much advantage of a general systematic movement out of and into ordinary shares as a whole at different phases of the trade cycle.'[46] However this change of view came only gradually. As late as 1932 his colleagues at the Provincial were still thinking in terms of the representative 'industrial index'. One reason for this indeterminacy lay in the uncertainty of the security markets in the 1930s. Discarding the credit cycle approach did not make the timing of purchases unimportant. Through the early 1930s Keynes was clear about the serious implications of the depression for security prices. A representative index of industrial ordinary shares fell thirty-eight per cent from the last quarter of 1929 to the second quarter of 1932.[47] It was therefore entirely reasonable for Keynes to take little interest in them. Table 15.3 shows that the value of the portfolio fell to 14.9 per cent below net cost by the end of 1931, and Table 15.8 shows that American securities were discounted by seventy-two per cent. This had serious implications for the company's published accounts, requiring special reserves to support assets. However, Table 15.5 indicates that performance was not so disastrous when seen in terms of the depreciation on the average portfolio invested, ignoring the historic cost of the investments. In 1929 a small appreciation was achieved, while in 1930 and 1931 the continuing depreciation was 1.5 and 1.9 per cent respectively. The position was helped by large investment purchases in 1931 bought at lower prices.

The two objectives of policy in the early 1930s were to protect the capital value of the portfolio, and position it to benefit from economic recovery. Keynes's expectations were dominated by the conviction that

interest rates must eventually fall. He believed that they had been sus-
tained at high post-war levels through the 1920s by the special monetary
conditions created by the war and its aftermath. During the depression
short-term interest rates fell quickly and dramatically, but yields on long-
term securities did not fall proportionately. Investors were not prepared to
commit themselves because they believed yields would eventually return
to those of the 1920s, imposing severe capital depreciation. Keynes, by
contrast, was convinced that the capital market could not continue to
justify high yields. This view informed his position on public policy, in
which he pressed the government to reduce the long-term rate of interest.
If this could be achieved with conviction, investors would move into
longer term securities at yields comparable to those before the First World
War. This would raise investment and pull the economy out of depression.
Convinced that such a move was inevitable, he committed the Provincial
to long-term assets that would benefit most from such a change in opinion
and meanwhile provide high yields.[48]

This was first apparent in November 1929 when the Provincial's board
minuted their view 'that cheaper money would ensue'. It was decided to
reproportion the large gilt holding from two-thirds short to two-thirds
long dated securities. In March 1930, a further £100,000 of short dated
government stock was exchanged for long dates and a few debentures,
locking the portfolio into higher yields. Scarcely any other class of securi-
ties was purchased.

However, as the slump intensified, the attempts by the British govern-
ment to defend the gold standard and then cope with its collapse in
September 1931, required flexible management. Bank rate was not raised
to defend sterling until July 1931.[49] In May and June, Keynes anticipated
a run on sterling and its likely consequences for short-term interest
rates. He sold gilt long dates heavily, placing the proceeds in three-month
Treasury bills. This avoided the fall in consols from sixty in June to forty-
nine in September.[50] After the gold standard had been abandoned, bank rate
was raised to six per cent to replenish reserves. Short-term money rates in
London rose sharply, encouraging Keynes to keep large sums turning over
in bills. As much as £200,000 was retained in this form as late as March
1932.

Yet the turning point had been reached. In February 1932 the Finance
Committee decided to re-enter the market for ordinary and preference
stocks and committed £20,000 to a representative group of such securities.
After vexed discussion over the recent rises in government securities, it
was decided to convert £100,000 of bills into long dated stock. Keynes
began to anticipate recovery. Bank rate had been cut from six per cent to

five per cent in February, but then fell even more sharply to reach two per cent in May. Consols rose from sixty on 10 March to sixty-seven on 30 June.[51] Even more dramatic events ensued. The main obstacle to lower interest rates remained the enormous holdings of War Loan stock with early redemption dates and a coupon of five per cent. In June the authorities took the opportunity provided by falling interest rates to offer a 3.5 per cent Conversion stock.[52] The project was a complete success and precipitated the change in expectations that Keynes had anticipated and sought. By January 1935 consols peaked at ninety-four.[53] Keynes's prediction had been triumphantly confirmed. Table 15.3 shows that by the end of 1932 the market value of the portfolio again exceeded its net book value by 3.7 per cent, in contrast to the deficit of 5.5 per cent at the end of 1930, and 14.9 per cent at the end of 1931.

From mid 1932 Keynes took the view that the trough had been passed, and began a sustained campaign to purchase those assets that would benefit from recovery in Britain and America. The most striking outcome of this more buoyant attitude was the implementation of his new commitment to equities. Although he had practically abandoned the credit cycle approach, the timing of this strategic decision might be seen as its most successful application. In mid 1932 security markets in Britain and America reached their lowest level.[54] In Britain the conversion operation in June successfully provided a strong background for a revival in security prices. More generally, expectations, and eventually profitability, were transformed by a remarkable economic recovery, based on lower interest rates, a building boom, improving terms of trade, rising real incomes, and new industrial opportunities. Between the last quarter of 1931 and the first quarter of 1935 fixed interest stocks rose by 49.5 per cent. The equity rise was larger and longer sustained: between the second quarter of 1932 and the last of 1936 industrial ordinary shares rose by 116.6 per cent.[55]

In America, investment expectations did not improve as clearly or quickly. Roosevelt's New Deal frightened investors, both before his election, and during its initial implementation. Banking collapses surrounded his inauguration. Eventually the dollar was devalued against gold in April 1933, allowing interest rates to fall. Recovery did not seem assured until 1934, but then security markets began to rise more confidently until a peak, which coincided with that in Britain early in 1937.[56] U.S. industrial common stocks rose 179 per cent from their trough in 1932 to their peak in 1937. High grade corporate bonds rose by 30.6 per cent over the same period.[57]

Diagram 8 shows how through these recovery years Keynes steadily reinforced the equity content of the portfolio. As Table 15.6 shows, in 1932 the published accounts only recorded £76,000 or 12.6 per cent held in

TABLE 15.6 *Provincial Insurance Company: proportionate distribution of investment portfolio, 1929–38 (%)*

Securities	1929	1930	1931	1932	1933	1934	1935	1936	1937	1938
Mortgages	1.6	1.4	0.8	5.2	4.0	3.6	2.7	2.6	3.1	2.9
British government	39.4	33.3	43.5	35.2	35.1	35.8	34.2	31.3	26.5	28.1
Municipal	–	–	–	–	0.4	–	–	–	–	–
Imperial	4.3	3.8	3.3	3.5	3.6	3.1	3.4	2.0	1.8	1.7
Foreign government	4.4	4.1	2.6	1.6	3.6	0.7	1.5	1.6	1.3	1.1
Debentures	17.3	25.2	20.2	19.6	18.8	20.4	18.1	19.7	17.5	18.2
Preference shares	18.6	18.2	15.5	18.7	18.4	16.5	19.6	20.2	19.3	19.3
Ordinary shares	13.8	11.5	12.1	12.6	15.6	19.5	19.8	22.1	30.0	28.4
Insurance shares	0.6	2.6	2.1	3.7	0.6	0.5	0.4	0.4	0.4	0.2
Rentals	–	–	–	–	–	–	0.2	0.2	0.2	0.1
Investment portfolio (£'000)	641	660	789	907	1012	1131	1273	1485	1625	1743

Note See Table 15.5 for classifications.

this form; by 1937 this had risen to £487,000 or 30.0 per cent. The 'industrial index' block of British equities (for which data is not available from 1930 to 1934) rose from a gross book value of £55,000 at the end of 1929 to £399,000 at the end of 1937. American securities, including company bonds and common stocks, rose from a gross book value of $144,000 at the end of 1931 to $1,444,000 or £285,400 at the end of 1937. Catching the turn in the market so successfully generated dramatic capital appreciation. As Table 15.7 shows, in 1929 the performance index of the 'industrial index' had stood six per cent below the 1928 level; it certainly fell significantly below this in the early 1930s, though the data does not exist to illustrate this; but by the end of 1936 it had risen to a premium of fifty-two per cent, and stood at seventy-six per cent above its net book cost. Table 15.8 shows that American securities exceeded this performance. In 1931 those purchased by Falk in 1929 had fallen to seventy-two per cent below their cost; they passed it in 1935, reaching a premium of 130 per cent and then 172 per cent in 1936. The increasing weight these securities held in the portfolio as a whole reinforced their contribution to overall

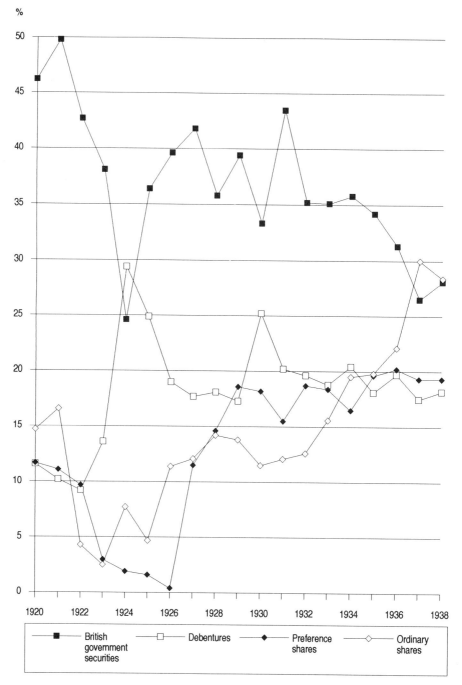

%

DIAGRAM 8 Provincial Insurance Company: proportionate distribution of
investment portfolio, 1920–38 (selected classes at book value)
Source: Tables 15.5 and 15.6

performance. Table 15.3 shows that from 14.9 per cent below cost in 1931, the market value moved to a modest premium of 3.7 per cent at the end of 1932, and then steadily climbed to 37.4 per cent by the end of 1936. Table 15.5 shows that, measured in terms of the appreciation in the portfolio as a proportion of the average fund invested, the most dramatic results were obtained early in the recovery in 1932, when the portfolio appreciated by 26.8 per cent. In subsequent years growth was discounted by the higher prices at which the new funds generated by insurance business had to be invested. None the less, it averaged fifteen per cent in the subsequent four years ending in 1936.

Keynes's strategy can be examined in detail. Investment proceeded cautiously after the first £20,000 in equities in February 1932. At first Keynes concentrated on British railway stocks, which he argued were an ideal hedge at the bottom of a slump, offering the possibility of appreciation whether the gilt market hardened or trade recovered. He also turned his attention to the United States, writing to Francis Scott,

I am at the moment rather strongly of the opinion that shares generally in America are near bed rock and outrageous bargains; indeed, if only one has pluck it is in all probability the chance of a lifetime. Unless the existing financial structure of the country is going to peg out altogether ... it is absolutely out of the question that present prices can be maintained ... double or treble present prices would still represent great bargains.

In July he pressed Francis Scott again, convinced that now the American economy was taking the strain of international monetary adjustment, the disparity between yields in Britain and America would not be maintained indefinitely. Eventually the dollar would be devalued, American interest rates and yields would fall, and security prices rise. Though Francis Scott was apprehensive, substantial purchases of American securities were made. Dollar securities rose from $144,000 at the end of 1931 to $321,000 at the end of 1932. Keynes concentrated on utilities which had sometimes been forced to stop paying interest on preference stocks and whose prices had collapsed. He argued that they would resume payments with economic recovery and then offer safe yields of between ten and fifteen per cent on their current purchase price. American purchases continued into 1933, despite the American banking crisis.

These tentative beginnings were developed more confidently in 1933 with a greater emphasis on British equities. As their prices rose, Keynes tried to improve income by moving from market leaders, where yields were squeezed by popularity, to less obvious companies. This revealed the

TABLE 15.7 *Provincial Insurance Company: sterling equities investment performance, 1926–38 (a)*

Year end	Net book value (b) £'000	Market value £'000	Appreciation of market value on net book value (c) %	Fund index (d)	Bankers' index (e) ⇐ 1928 = 100 ⇒	Actuaries' index (f)
1926	43	44	1		86	
1927	49	56	14	99	93	
1928	50	59	16	100	100	100
1929	36	41	14	94	93	83
1930–34 (g)						
1935	226	328	45		76	80
1936	233	411	76	154	87	90
1937	318	393	24	113	73	74
1938	341	376	10	95	66	62

Notes
(a) This data is based on the Provincial's 'industrial index' block of securities. This included most industrial and commercial equities, but appears to have excluded some ordinary shares, particularly those relating to investment trusts and insurance companies.
(b) Gross book value less cumulated profits on realisation.
(c) Apparent errors due to rounding.
(d) See Appendix A for the method used in calculating this measure which is comparable with market indices.
(e) *Bankers' Magazine* index of variable dividend securities.
(f) Actuaries' index for British equities. This began in 1928. For both indices year end values have been selected to parallel the year end accounting data.
(g) Appendix A explains this gap.

change in his attitude towards equities. Instead of the representative selection of the 'industrial index' he became increasingly selective, looking for companies with higher yields. If their security appeared sound he bought them happily, anticipating capital appreciation when the market revalued them. When convinced about a security he also sought to hold it in quantity, chafing against the idea of standard investment units.

Francis Scott first raised Keynes's new approach to equities in 1932, concerned at the extent of purchases. An informal maximum of between fifteen and twenty per cent of the portfolio was agreed. Furthermore, as a professional insurer, Scott was inclined to spread risk, preferring fifty holdings of £2,000 to thirty-three of £3,000. Matters came to a head in

November 1932 when the Finance Committee placed limits on holdings of securities: £6,000 on bonds and preference stocks, £5,000 on ordinary stocks outside and £3,000 inside the 'industrial index', and no limit on gilts. Significantly, the record noted Keynes's reservation that he could interpret any limits with discretion.

Scott returned to the issue in 1934, provoking a significant response from Keynes who wrote,

As time goes on I get more and more convinced that the right method in investment is to put fairly large sums into enterprises which one thinks one knows something about and in the management of which one thoroughly believes. It is a mistake to think that one limits one's risk by spreading too much between enterprises about which one knows little and has no reason for special confidence.

This was the end of the 'industrial index' as an investment strategy in Keynes's mind. However, Scott continued to worry about the need for a framework to ensure balance and spread within the portfolio. After discussion of a memorandum he presented to the Finance Committee, it was agreed that all sterling equities would be held in units of between £3,000 and £6,000, but that in exceptional cases a maximum limit would be set at two per cent of the total value of the portfolio. It was also agreed that a record should be maintained of the distribution of funds between different industries and commodities.

In practice Keynes paid little attention to these restrictions, committing large sums to favourite stocks. Leyland Motors and British Plaster Boards he regarded as well managed companies that were worth holding over the long run. Austin Motors was a speciality, which he held on a very large scale for his personal account. He persuaded all his institutions to hold it in large units as well, despite a lack of enthusiasm on the part of his colleagues. Francis Scott was continuously unhappy about the investment, reporting unfavourable comments from his local Morris dealer and stockbrokers. Keynes remained stubborn, writing in 1935,

The various investment accounts for which I am more or less responsible have made in the aggregate a profit of something like £250,000 in Austin, most of which is realised profit. Yet, ... I have been on the defensive the whole time, being allowed to keep the shares as a courteous concession to my enthusiasm and the obvious bee in my bonnet. ... And the worst of it is that in all probability a day will come when the shares pass their peak and my critics will point out how right they were in the end.

In the slump he also became enthusiastic about metal shares. This was

partly because he believed that they were a secure investment in real values, but he had special reasons for his interest in the Union Corporation, a South African gold mining concern. This purchase shook Francis Scott, who had been brought up to believe that the 'kaffir circus' was the closest thing to gambling in the city. Keynes reassured him. He was not speculating on the success of particular mines. The Union Corporation was a large and well-managed concern, owning many established mines and diversified into other metals, financial and trading activities. The rationale for the purchase lay in the recent South African devaluation, which would lead to sharp increases in the prices, production and profitability of gold mining.[58] He continued to hold this stock on a scale that often frightened Francis Scott. In the summer of 1934 the company's holding stood at a value of £17,500 or 1.5 per cent of the portfolio.

By the last quarter of 1933 the British capital market had shown a remarkable recovery. Industrial equities had risen by forty-six per cent since the second quarter of 1932.[59] Keynes began to look for ways of protecting yield, in the face of rising prices. He even made some purchases of British government long dates. But this was only a gathering of second wind because in 1934 he resumed the purchase of British and American securities even more enthusiastically. In that year alone, they rose from 15.6 per cent of reported assets to 19.5 per cent – on a total that was now growing rapidly. Francis Scott remained dubious about the impact of the New Deal, but Keynes's argument remained straightforward. Yields on fixed interest securities in America remained some two percentage points higher than in Britain. They continued to offer an opportunity to lock the Provincial into higher yields than could be obtained in Britain, at unimpeachable security as long as the American economy did not completely collapse.

Through 1935 and 1936 the British market continued to ride high, and Keynes's predicted recovery of the American market bore fruit. As early as January 1935 Keynes was '... getting ... scared of markets all round. There seems to everyone no possibility of their turning round, and that is always dangerous since everyone gets just a bit over excited under the influence of success and excitement. But, quite likely, my views are a year too soon.'

Keynes began to guard against over-commitment to a high market. In June 1935 he sold some consols for dated stocks. He began to sell equities in capital goods industries such as iron, steel and heavy electricals, arguing that they became over-valued in booms when they made inflated profits. However, it was one thing to recognise danger, but another to find security. Money kept coming in from the burgeoning insurance business and had to be placed somewhere. At the beginning of 1936 Keynes remained '... perplexed about investment policy, since my feeling is that

almost everything is getting too high and yet, if one begins to sell too soon, there will be a difficult problem of reinvestment.' In that month he believed the American market was becoming particularly risky, so sold dollar securities heavily, moving the funds back to Britain. A temporary collapse on Wall Street in April justified this move. However, conversations with Americans in June convinced him that their market was now safer for at least six months. Francis Scott had lost his anxiety about America replying, ' ... we were right to retain our substantial interests in the States, and I am not at all certain that I should not personally be disposed to increase it, even at the expense of our English gilt-edged holdings.' He was becoming more worried about the European scene. Despite Keynes's prognostications about British industrials, he continued to buy them on a large scale, increasing the sterling 'industrial index' block by £59,000 over the year. American securities, including a high proportion of preferred stocks, grew proportionately more rapidly, from £161,000 to £206,000. By the end of 1936 the market value of the Provincial's portfolio stood at a premium of 37.4 per cent above its net cost. As Tables 15.7 and 15.8 show, British equity and American investments had performed astonishingly well, appreciating by seventy-six and seventy-two per cent above their net cost. The natural speculator in Francis Scott must have been delighted by such enormous gains.

However, in early 1937 British and American security markets both ran into difficulty. At the beginning of the year British government securities began to fall as the borrowing implications of the government's new, more virile approach to rearmament became apparent. The market in industrial equities became uncertain. The promise of heavy government spending bred optimism, but higher yields on gilts eroded confidence in the relative earning power of equities bought at inflated prices in the optimism of 1936.[60] The bleaker international situation also affected expectations. In America the authorities began to tighten credit to control stock market speculation. In March security prices in New York fell sharply. In April suggestions that the American government might not be prepared to continue gold purchases at $35 led to a fall in international commodity prices.[61] In the same month Chamberlain's budget floated the idea of a new National Defence Contribution, a tax to fund rearmament, without clarifying its impact.[62] Both combined to reduce security prices in London. By the last quarter ordinary shares had fallen sixteen per cent below the first quarter and the drift continued into 1938.[63]

Keynes had been convinced that the market would fall in 1937. Early in the year he sold some long dated gilts to consolidate part of the gain that had been made by transferring the proceeds into shorter dated

British debentures and American and British equities. A cautious man would have extended these steps to lock the Provincial into a securer capital value, but Keynes resisted the fall in yield this would impose. He remained optimistic about the possibilities for continued growth in industrial output stimulated by government expenditure. He and Francis Scott were both concerned that the portfolio was over-committed, but remained uncertain as to how to move. The 'gold scare' and the proposed National Defence Contribution seemed temporary influences and the latter provided reason for not realising capital gains that might be heavily taxed. In May Francis Scott argued against too much liquidation, as he believed that the market was likely to improve in the next month or so.

Another, more imponderable circumstance may have lain behind the procrastination. Keynes may have been under strain through the winter. In May he suffered a serious heart attack and was forced into semi-convalescence, not returning to normal routine until October. While he kept his eye on affairs, he could not give them his normal concentrated attention.[64] Perhaps his capacity for decision was affected. In any event, the turn in the markets was missed. In May Keynes was reluctant to sell anything that showed a large book profit. In June he was selling heavily. By October he was writing to Scott,

Unfortunately our pessimism has been only too well justified, and markets have fallen away too quickly for me to make sales ... I should definitely like to see our holdings of Americans reduced before the end of the year, and I feel that the time has come for reducing our holding of base metal shares without being too ambitious about prices.

This shook Scott who replied, '... you are undermining all the faiths which you have built up in me My instinct is to come out of nothing, as ... much of the fall over the last few weeks has nothing at all to do with any real change ... and is almost wholly psychological.' As the American market continued to collapse, Keynes agreed, writing, ' ... the whole market has gone so completely mad that one has lost all one's standards I feel that prices are at such a level that anyone who lives long enough will see them higher. So the Provincial, being immortal, and for other reasons, can afford to stand pat.' Using one of his wife's Russian metaphors, he suggested that he and Scott should ' ... screw on our moustaches'.

Keynes later rationalised his 1937 experience in a letter to F. N. Curzon,

The criticism, if any, to which we are open is not having sold more prior to last August. ... I think it would have required abnormal foresight to act otherwise. ... I was of the opinion that the prices of sterling securities were fully high in the

spring. But I was prevented from taking advantage of this, first of all by the gold scare, and then by the N.D.C. scare, both of which I regarded as temporary influences for the wearing off of which one should wait. Then came the American collapse with a rapidity and on a scale which no one could possibly have foreseen, so that one had not got the time to act which one would have expected. However this may be, I don't feel that one is open to any criticism for not selling after the blow had fallen. As soon as prices had fallen below a reasonable estimate of intrinsic value and long-period probabilities, there was nothing more to be done. It was too late to remedy any defects in previous policy, and the right course was to stand pretty well where one was.[65]

At the end of 1936 the market value of the Provincial's portfolio stood at £1,943,000. During 1937 a further £123,000 was added to the fund, yet by the year end its market value had collapsed to £1,739,000, effectively losing £327,000. The portfolio had lost £30,000 on British government stocks, £48,000 on British industrial and commercial securities, but most dramatically, £72,000 on mining shares and, worst of all, £126,000 on American bonds and commons. Table 15.3 shows that by the end of 1937 the market value of the Provincial's portfolio had fallen to a premium of only 13.1 per cent over net cost, compared with the 37.4 per cent premium in 1936. During 1937 the value of the funds invested depreciated by 13.3 per cent. The depreciation continued into 1938 and by the end of that year the portfolio's market value of £1,760,000 only exceeded its published book value of £1,743,000 by less than one per cent.

By Francis Scott's standards this was scraping by, and it is scarcely surprising that his nerve was severely tested. The portfolio might need to be publicly written down, affecting the company's financial reputation. His confidence in Keynes was shaken. He began to correspond confidentially with Ian Macpherson, the Buckmaster and Moore partner responsible for handling the Provincial's investment business, to obtain independent advice. Macpherson recalled later ' ... Keynes was wrong in 1937-38 for the right reason and to this day I believe he did right in not allowing you to take your profits in 1936, judged from the position at the time and not jobbing backwards; yet this action of his completely shook your faith in his judgement'. This was despite the fact that Francis Scott had supported Keynes's actions throughout 1937. He tried to persuade Keynes to sell the large holding in consols and long dated gilts, which were depreciating rapidly with higher interest rates. Keynes felt that the moment for sale had passed. He

... was firm against accepting the sacrifice of income which would have been involved ... in moving out of our long dated securities, such as consols, into the

dated securities of comparatively short term ... not convinced that the risk of heavier depreciation on the former was great enough to justify the sacrifice of the existing position.

He remained committed to the return of lower interest rates and resisted the loss of income and potential capital appreciation if short dates were bought.

Keynes was certainly disturbed by the situation. His personal net assets fell from £507,000 at the end of 1936 to £215,000 a year later.[66] He frankly admitted ' ... serious mistakes were made ... ' [in 1937],[67] and this prompted him to carry out a post-mortem on his investment activities for the institutions with which he was most closely associated – King's College, the Provincial, and the National Mutual. In this he explained the changes that had taken place in his investment philosophy since the early 1920s, providing an explanation of his management of the Provincial's portfolio through the 1930s.

This demonstrated how far he had moved from the credit cycle approach of the 1920s. Experience had shown him that the critically important selection of turning points in the cycle had proved impossibly difficult to achieve. He wrote to R. F. Kahn, ' ... I was the principal inventor of the credit cycle investment and have seen it tried by five different parties acting in detail on distinctly different lines over a period of nearly twenty years, which has been full of ups and downs; and I have not seen a single case of a success having been made of it.'[68] To the Estates Committee of King's College he reported,

In the past nine years, ... there have been two occasions when the whole body of our holding of such investments have depreciated by 20 to 25 per cent within a few months and we have not been able to escape the movement. Yet on both occasions I foresaw correctly to a certain extent what was ahead. ... As a result of these experiences I am clear that the idea of wholesale shifts is ... impracticable and indeed undesirable.[69]

He now advocated a longer term approach. His first objective was to try to achieve a steady five per cent yield on the market value of the portfolio.[70] This had not been difficult in the 1920s, but the fall in interest rates in the early 1930s required a new approach. Such a yield was impossible from government stock, where yields on long dates fell below three per cent at times and were always below four per cent after early 1932. Keynes rejected the option of raising yields with second grade fixed interest stocks, because the risk of loss was not worth the extra return.[71] The solution lay in holding as high a proportion of equities as consistent with

liquidity and stability.

Equity investment implied greater volatility in portfolio market values. Keynes argued that this should be lived with; that well-selected equities would eventually recover; and that the higher yield they provided offered additional security. He wrote,

If we deal in equities, it is inevitable that there should be large fluctuations. ... Results must be judged by what one does on the round journey If ... we do not hold equities, we must either be content with earning a definitely lower rate of interest, or we shall be tempted, in my judgement, into risks which, while they may be less apparent and take longer to mature, are really much more serious than those of equity holders.[72]

In other words, by concentrating on fixed interest stocks, with their apparent security, a portfolio risked serious depreciations caused by inflation or changes in interest rates. To the conventional, who saw their liabilities, especially in life business, fixed in money terms, this was not important. Keynes, as an economist, could not ignore it.

Section 15.3 above explained how innovatory was this emphasis on equities. Keynes's approach to the selection of equities was equally striking. Safety should not be secured through a spread of equities across the market, to hedge against the risk of bad selection. Those involved in management would know little about many of the securities held. Instead, in his typically self-confident way, Keynes believed that individual companies could be identified that held the prospect of above average yields and growth, and that they should be purchased in large units. He wrote to R. F. Kahn,

My alternative policy undoubtedly assumes the ability to pick specialities which have, on the average, prospects of rising enormously more than an index of market leaders. The discovery which I consider that I have made in the course of experience is that it is altogether unexpectedly easy to do this, and that the proportion of stumers amongst one's ultra favourites is quite small.[73]

Later he commented,

... it is out of these big units of the small number of securities about which one feels absolutely happy that all one's profits are made. I fancy it is true that practically the whole of the appreciation of the Provincial since we started is accounted for by the profits on Austins, and the profits on Electric Power and Light and on United Gas. At any rate, I am sure I could pick out six of my pets, and that much more than the whole of our profit would have been made out of them. Out of the ordinary mixed bag of investments nobody ever makes any-

thing. ... And in the case of my own personal investments, which have done a great deal better than the Provincial's, the sole explanation is that I have held my pets in relatively larger proportions [74]

Concentration on such equities provided a margin to offset the inevitable failures. Security should be achieved by the explicit balancing of specific securities against one another for particular reasons. Gold shares, for example, could be purchased to provide stability in a recession when other equities suffered.

 Within this framework, investment management consisted of shifting the balance of the portfolio between gilts and equities, in the light of the trade cycle, and endeavouring to identify attractive equities and purchase them when they were cheap relative to the rest of the market. He explained to R. F. Kahn, 'I am, of course, in favour of being more heavily invested at the bottom than at the top, if one can manage it (which I never have yet in spite of trying – and (formerly) trying *mainly* for this).'[75] Market fluctuations could be used to pick up specific equities, rather than to shift the portfolio as a whole. This approach ruled out the prior specification of the relative weight of different classes of security or the rigorous application of limits on the scale of holdings in particular companies. He commented on the Provincial's portfolio,

We certainly need minimum percentage in government securities and maximum percentage in ordinary shares. This is required partly for appearances; partly in the case of government securities to provide a satisfactory margin over our large volume of deposited securities, and in the case of ordinary shares to avoid the risk of excessive fluctuations exceeding our investment reserves.

 But apart from these two general principles I am strongly opposed to rigidities in other respects. Fixed percentage ... is surely altogether opposed to having an investment policy at all. The whole art is to vary the emphasis and the centre of gravity of one's portfolio according to circumstances. Subject to a minimum in government securities and a maximum in ordinary shares I would strongly urge the desirability of the greatest possible flexibility.[76]

15.6 *Investment performance*

At the same time as expounding his approach to investment, Keynes set out to appraise his performance during the 1930s.[77] Significantly, he concentrated almost entirely on equities, providing detailed arithmetic assessing their capital appreciation. Evidence on the performance of the whole portfolio was almost treated as a side issue, reflecting the direction in which he felt most sensitive to criticism. None the less the portfolio's

overall performance is both a better test of Keynes's control, and of greater significance for the company.

Three tests can be made of his performance: how he performed in relation to his own objectives; in relation to other institutions; and in comparison with market indices. Two difficulties arise. Such comparisons are less clear cut than might appear at first sight. Yield and capital appreciation can be traded off against one another, with the further complication that yield can be banked annually, whereas capital appreciation may only be a paper gain until securities are realised. Choices must also be made between stability and volatility in capital value and yield. Both these issues were of importance for the Provincial, where investment yield formed the basis of dividend payments, and capital value was crucial for the stability of the reserve funds which provided policyholders with security.

In comparisons between Keynes's management of the Provincial, National Mutual, and King's College funds, the Provincial's portfolio contained a large proportion of gilt edged stock, made necessary by the legal requirements for deposits to transact general insurance business at home and abroad. However, Keynes's policy, explained above, of keeping a high proportion of this in the longest dated gilts, undermined the apparent stability this suggested – even though this appeared to him to be a far more satisfactory long-term policy.

A simple interpretation of Keynes's own objective, derived from the post-mortems he wrote, was to achieve a five per cent yield on the market value of the portfolio, together with at least stability – and hopefully appreciation – on its capital value over the 'round trip' of the investment cycle.[78] In his 1937 post-mortem he calculated an annual average yield before tax of 'almost exactly 5 per cent', probably on net cost, for the nine years ending on 31 December 1937. This ought to be reduced to perhaps 4.5 per cent if based on market value. Unfortunately, the data to test this claim precisely is not available – the gross investment income series Keynes must have used is lost. An estimate based on the adjustment of the net of tax investment income published in the company's annual accounts is probably a reasonable substitute. Table 15.5 indicates an average yield of 4.9 per cent between 1930 and 1938 on the average fund invested in each year. Whatever the precise figure, two things are clear: Keynes achieved a return that was insignificantly short of his five per cent objective; and this also substantially exceeded the yield on consols, which averaged 3.5 per cent in the same period, and even more the yield on stable short dated gilts, where the yield averaged 3.0 per cent.[79]

This yield was supplemented by capital appreciation on the 'round trip' through the investment cycle. Between the end of 1929 and 1937 (both years following security price peaks) the appreciation was 16.1 per cent on the final net book value, or 24.3 per cent on the average net book value invested. While it is difficult to find a relevant comparative index for a mixed portfolio, it is clear that this growth massively outperformed such indices of overall market performance as the *Bankers' Magazine* index of all market securities, which actually depreciated significantly between the late 1920s and the late 1930s, as Table 15.7 indicates.[80]

Through the 1930s, therefore, Keynes demonstrated a striking capacity to achieve capital growth. Table 15.4 expresses this as the annual percentage appreciation on the average fund invested each year. From 1930 to 1938 this averaged 7.6 per cent, which might in some notional sense be added to the five per cent yield. However, averages obscure the problem of volatility and the problem it created for the company's security and reputation. Table 15.3 shows that the market value of the company's portfolio fell significantly below the net book value between 1929 and 1931, reaching a discount of 14.9 per cent below net book value in the latter year, necessitating the creation of the special investment reserve mentioned above. Keynes can scarcely be held responsible for a problem that occurred in the face of the most dramatic crisis that had faced world financial markets, requiring nearly all investment institutions to make special provisions. In any case, he only took responsibility after the blizzard had become inevitable, and was carrying in the portfolio many securities for which he held no brief. The better test of his management of the portfolio came in the subsequent market crisis in 1937. Here he faced an especially severe test because the rapid expansion in the portfolio between 1932 and 1936 meant that a large proportion of the portfolio stood at high purchase prices in the company's books. This problem was increased because a substantial sum was transferred from realised profits on investments, partly to meet the cost of several large new branch offices, reducing the hidden reserve available within the investment account.

While we have seen that the depreciation in long dated gilts contributed to the fall in market values, British and American equities were far more susceptible to market conditions. They had certainly played an important part in the extraordinary success of portfolio management in the market rise to 1937. In his post-mortem Keynes provided detailed evidence on their performance.[81] Unfortunately this is misleading for reasons explained in Appendix A. The evidence for sterling equities has not survived, so it is only possible to appraise their performance for the years included in Table 15.7. They stood at a premium of sixteen and fourteen per cent

above their original cost in 1928 and 1929. In striking contrast, in the security price boom in 1935 and 1936, they rose dramatically to a premium of fifty and seventy-six per cent, reflecting Keynes's success in foreseeing recovery. However, in the subsequent collapse they fell again, remaining at a premium of twenty-four and ten per cent above cost in 1937 and 1938.

These measures included the costs and benefits of investing different levels of new money at particular phases of the investment cycle. In order to enable comparisons to be made with market indices and other companies, Keynes calculated the hypothetical implications of this record for a fixed investment fund. Once again there are problems with his calculations, dealt with in Appendix A. None the less, the recalculation of this measure, shown in Table 15.7 for the years for which this is possible, confirms his extraordinary success in comparison with the market. Taking the peak in the British market at the end of 1928 as the base, by the end of 1936 the Provincial's British equities, standardised in this way, had risen by fifty-four per cent, when the *Investors' Chronicle* index still stood at a discount of three per cent, and the more sophisticated Actuaries' index at a discount of ten per cent. The fall in the two following years was of course dramatic. In 1937 the 'indexed' performance of the Provincial's sterling equities fell to a thirteen per cent premium over 1928, representing a twenty-six per cent fall over the year, in comparison with the *Bankers' Magazine* index which fell by sixteen per cent, and the Actuaries' by eighteen per cent. They continued to fall in 1938 to ninety-five – below the 1928 base level – but this none the less showed a substantial gain on the market indices, as the table shows. Keynes also compared his sterling equities performance with the Prudential, for which information was available. This suggests a substantial lead for his management, with the index for the Prudential only reaching 115 in 1936, in comparison with the Provincial's 154. Unfortunately the Prudential's results are not available for the later years of falling prices.[82]

British equities were therefore considerably more volatile than the market, though on the round trip they still realised net gains. American investments provided even more excitement. Table 15.8 shows how these grew in scale and market value under Keynes's management. In fact, he hedged against dollar sterling fluctuations and the consequences of these transactions are not included. The disastrous implications of Falk's management in 1929 were carried into the early years of the account, with the market to net book value falling to a discount of seventy-two per cent in 1931. From a modest $49,120 in that year, the market value grew five times to $245,623 in 1932, partly because of additional investment but

TABLE 15.8 *Provincial Insurance Company: dollar securities investment performance, 1930–38*

Year end	Net book value (a) $'000	Market value (b) $'000	Appreciation (depreciation) of (b) on (a) %	Fund index (c)	Federal reserve shares index (d) 1931=100
1930	213	141	(34)		
1931	176	49	(72)	100	100
1932	348	246	(29)	103	84
1933	332	257	(23)	193	126
1934	500	446	(11)	206	124
1935	797	1036	30	363	178
1936	842	1445	72	432	226
1937	1299	1204	(7)	218	141
1938	1352	1446	7	264	169

Notes
(a) Gross book value less cumulated profits on realisation.
(c) See Appendix A for method of calculation.
(d) *Federal Reserve Bulletin* (Standard Statistics).

mainly because the depreciation fell to twenty-nine per cent. Through 1933 and 1934 modest improvement continued. However, in 1935 the American securities moved sharply up to a premium of thirty per cent above net book value. This was even though the American portfolio rose by sixty per cent in that year alone , so that it was heavily weighted towards the higher prices. Keynes continued to expand the American portfolio in each successive year. Between 1934 and 1938 its net book value rose from $499,878 to $1,351,824. Its value rose to an even higher premium of seventy-two per cent in 1936, before falling to a discount of seven per cent in 1937 and a premium of seven per cent in 1938. The substantial rise in the scale of the portfolio discounted the real success of Keynes's management. Using the 'level investment' method described above, an index of performance based on 1931 suggests a rise in inherent market values of 332 per cent by 1936. Even in the two following years the premium remained at 118 and 164 per cent. The fall below book value in those years was clearly a result of the heavy purchases through the peak. While it may seem unimpressive to base such an index on the disastrous trough year of 1931, the index value of the shares remained above the level achieved in the recovery years of 1933 and 1934.

Keynes's management of the Provincial's portfolio was undoubtedly

original and brilliant – always in conception and usually in result – but it can reasonably be asked whether it was entirely appropriate for a general insurance company and, more particularly, whether it was appropriate for the Provincial. In terms of modern financial analysis, Keynes's portfolio, with its high commitment to equities and American stocks, and its drive to secure capital gains, carried a high beta risk.[83] Through the 1930s it was designed to secure major capital gains from recovery, but the converse of this was that it suffered major reverses during the collapse at the end of the decade. This was despite Keynes's commitment to gold, energy, and railway securities that should have protected it against serious problems. Francis Scott cannot have been unaware of the risks implicit in allowing Keynes his head, even if he chose to ignore them. A report prepared by an actuary in Buckmaster and Moore's office described the portfolio in these terms as early as 1934:

...the list is arranged to take full advantage of any further fall in interest rates, also there is a relatively large proportion in American low grade fixed interest stocks and common stocks. The holdings of British industrials include a fairly large percentage of those shares which carry the full industrial risk There is, therefore, very little hedging and a high premium is placed on the ability of management to take the right view and also to keep a careful watch on individual securities.

In effect Francis Scott was heavily backing Keynes's ability by allowing him his head to adopt an approach designed to make money, but which provided only the most modest hedge against a failure of strategy or detailed management. The moral was pointed even more directly at the same time by Ian Macpherson, who became responsible for the Provincial's dealings with Buckmaster and Moore, when Falk and Bonham-Carter left that firm. He wrote,

... almost the only consideration of most of the insurance companies with whom we deal is to invest against their obligations, to avoid taking definite views on investments whenever they can and to hedge their risk so far as possible ... you are trying to make money out of your investments and succeeding in doing so to a much greater extent probably than any other company.

He distinguished between the two approaches with forensic clarity, 'Personally, I draw a great distinction between these two policies. In fact, I am not sure that it is not the difference between investment and speculation'. At that time Francis Scott was happy to allow such trenchant comments to pass him by, for he could hardly object to Keynes's management when it

was proving so successful. However, the events of 1937 changed his attitude. He wrote later,

> ... up to 1936 I thought Keynes's control brilliant – since then I have begun to see it has its drawbacks You [Ian Macpherson] say you believe Keynes's policy is sound. I wonder if it would not be more true to say it is not so much sound, in the sense of being prudent and safe, as brilliant in its originality and daring, and over a long enough period likely to show definitely better results than the average – *if one is prepared to accept the violent range of extreme fluctuations.*

The problem was not simply that Keynes wished to carry a substantial element of the portfolio in the form of volatile equities, but that his management always involved a ruthless commitment to his prognosis of the market's future development, with no concession by way of hedging or compromise to the possibility that he might be wrong. In this respect the element in the original 'active investment' approach first outlined in the early 1920s remained as strong as ever, most probably because it was as much a product of his temperament as of his intellect. ' ... Keynes's intellectual integrity is so absolute that you will never get him to agree that what he believes to be black or white can be grey', Macpherson wrote.

It was for this reason that he had continued his commitment to long dated gilts through the late 1930s, despite the temporary problems of depreciation this created in 1937 and 1938 when interest rates rose. He was sure that they would eventually fall again and that to move into shorts would lose yield and risk the loss of prospective capital gain. It was thus that he continued to purchase individual equities on a scale that frightened Francis Scott, when he believed them to be fundamentally sound and standing at an attractive price. After buying one large block which shook Scott he wrote, characteristically, 'Sorry to have gone too large in Elder Dempster ... I was also suffering from my chronic delusion that one good share is safer than ten bad ones, and I am always forgetting that hardly anyone else shares this particular delusion.'[84] He freely admitted that he accepted wide fluctuations and the backing of situations that could make and lose fortunes, an approach which Macpherson pointed out to Scott tartly was ' ... none of your business'.

The problem for Francis Scott was that the speculative side of his personality found it difficult to resist the glittering possibilities this opened up. He wrote to Keynes,

> I am sometimes tempted to think that you would pervert my morals and encourage me in my secret vice to regard capital profits as a definite part of our

investment plan and in fact to regard the investment of funds, not as incidental to our main business – insurance – but as an equally important contributor to our profits of the company.

But then the more cautious side of his nature forced him to remember other obligations.

… our first primary duty is to so invest our funds, which are the security we offer our policyholders for the fulfilment of our contracts, that the public confidence will never be impaired. Our second task is to ensure that the bulk of them are in a semi-liquid form, and the third is to earn a reasonable rate of interest return. Only as incidental to these considerations have we the right to consider capital profits, and our major concern is to reduce the swing of the pendulum between high and low market valuations to the minimum.

These were the words of a man who had burnt his fingers. Before 1937 he had happily lived with the risk when he could only observe its benefits. From that year he saw its potential costs and lost the complete confidence he had previously felt in Keynes's judgement. Just as Keynes's approach to investment was part intellect, part temperament; so Francis Scott's reaction combined professional concern and a temperamental blend of caution and fascination with speculation. Macpherson probably penetrated to the heart of the matter most successfully when he told Francis Scott,

I have long ago told [Keynes] that you and your brother want to sleep in bed at nights, and do not feel safe with the whole of the Provincial funds going right up and down in value. He replied, I think you ought to feel safer, to which I answered that whatever you ought to feel in fact you did not, and to this, of course, he could make no reply.

But this was to ignore the other side of Francis Scott's personality. He may have wanted to 'sleep in bed at nights', but he could not resist the promise of exciting days. But perhaps it was the heady intoxication of climbing security values through 1936 which made the hangover in 1937 and 1938 all the more painful. Pleasures must be paid for and, ' After all' Macpherson wrote, ' it was you, not I, who decided to go for a ride on this particular tiger, although perhaps I now enjoy it more than you do'. It was all a long way from the early days in Bolton when financial security beyond all question had been seen as the overriding objective. For Francis Scott it was a return to the cotton speculation that James Scott had been unable to resist throughout his life.

16

Conclusion

16.1 Inter-war performance

The main features of the Provincial's inter-war business were delineated in Diagram 5 (p. 164). Fire and accident revenue, at home and abroad, rose from £206,200 in 1920 to £713,500 in 1929, and £1,333,200 in 1938. Growth was most rapid in the 1920s. In the 1920s (1920-29) revenue grew by 246 per cent. Recovery in the later 1930s was insufficient to offset the consequences of earlier economic depression and revenue growth slowed to eighty seven per cent for the decade (1929-38). However this deceleration started from a higher base, so the two periods none the less saw a similar absolute increase in revenue, which rose by £507,300 in the 1920s and £619,700 in the 1930s. In both periods the pace was set by accident business. In the 1920s accident revenue grew by 301 per cent, in comparison with a fire growth of 137 per cent; in the 1930s accident growth slowed to 102 per cent and fire to thirty-seven per cent. These were the two accounts on which the Provincial earned its underwriting profits. While marine premium income grew from £19,000 in 1920 to £118,700 in 1929, and £184,600 in 1938, the account made no contribution to profitability, except indirectly, through the interest earned on the marine funds invested. Far from that, transfers were required from profits earned elsewhere to ensure that marine liabilities were adequately covered.

As Diagram 9 and Table 16.1 indicate, the fire and accident underwriting accounts both remained profitable overall. The only source of significant losses was foreign underwriting in the 1920s. The continuing strength of the Provincial's connections, the business obtained through the Drapers' and General, and a cautious approach to underwriting meant that the fire account remained the solid core of profitability. In the 1920s its underwriting surplus averaged 11.8 per cent, rising to 13.6 per cent in the 1930s. Profitability in accident insurance, dominated by the fiercely competitive motor market, could not match this record. In the 1920s its average surplus was only 4.3 per cent, rising to 6.9 per cent in the 1930s. Indeed, in the earlier decade accident underwriting sometimes teetered on the brink of disaster. In 1920 its surplus was only 0.9 per cent, and in 1923

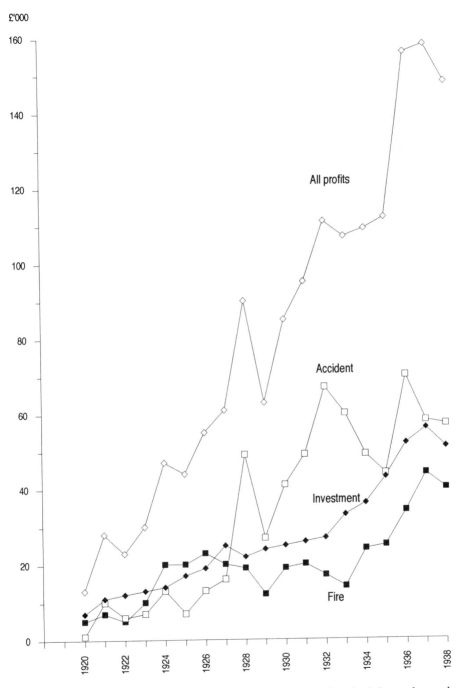

£'000

DIAGRAM 9 Provincial Insurance Company: sources of profitability – fire and
accident underwriting and net investment income, 1920–38

TABLE 16.1 *Provincial Insurance Company: profitability of underwriting,*
1920–38

	Fire underwriting surplus	Proportion of premium income	Accident underwriting surplus	Proportion of premium income	Total underwriting surplus
	£'000	%	£'000	%	£'000
1920	5	7.5	1	0.9	6
1921	7	9.8	10	7.1	17
1922	5	5.0	6	3.1	11
1923	10	9.2	7	2.9	17
1924	20	18.0	13	4.7	34
1925	20	16.1	7	2.1	27
1926	23	17.2	13	3.3	36
1927	20	14.6	16	3.6	36
1928	19	12.8	49	10.1	68
1929	12	7.7	27	4.9	39
1930	19	10.6	41	6.7	60
1931	20	11.8	49	7.1	69
1932	17	10.0	67	9.9	85
1933	14	7.8	60	8.6	74
1934	24	13.1	49	6.4	73
1935	25	13.4	44	4.9	69
1936	34	17.4	70	7.3	105
1937	44	20.2	58	5.6	102
1938	40	17.7	57	5.2	97

and 1925 it fell below three per cent.

This disparity in performance created a tantalising problem, reflected in earlier chapters. As motor insurance grew rapidly, its performance became a far more important determinant of the company's overall underwriting surplus. In the 1920s this averaged only 6.3 per cent, just above half the margin obtained in fire. Despite the improvement in accident underwriting in the 1930s, it only rose to 8.1 per cent. It was this slimming of margins which made Francis Scott so nervous in the 1930s, and so anxious to maintain or even expand fire underwriting. The Provincial had become vulnerable to relatively small adverse movements in the motor account. While margins on accident underwriting were lower, they were obtained on such a substantial revenue that the account contributed an increasing proportion of the company's surplus, rising from an average of forty-six per cent in the 1920s to sixty-eight per cent in the 1930s. In addition, of course, the larger business fed the funds on which investment income was based.

Annual fluctuations in the growth of underwriting profitability were also smoothed by the other source of income, the earnings of invested funds. As short-term reserves grew in pace with revenue, this income imparted a natural buoyancy to profitability. Beyond this, successive allocations to long-term general reserves, made in every year except 1920, further expanded invested funds in a way unaffected by revenue growth. As a result investment income rose from £7,400 in 1920, to £24,400 in 1929, and £50,700 in 1938, peaking in 1937 at £55,700. In the years of difficult underwriting in the early 1920s investment income occasionally exceeded underwriting profits. By the 1930s it was contributing a relatively stable average thirty-two per cent of all profitability.

Diagram 9 shows that total profitability rose from £13,800 in 1920 to £63,800 in 1929 and £147,400 in 1938. Major peaks were achieved in 1928, 1932, and 1937. The Scotts continued to disburse dividends on an extremely conservative basis. The owners of the Provincial received an income (net of tax) which grew steadily from £6,700 in 1920, to £18,400 in 1929, and £39,875 in 1938. In 1920 the dividend paid on ordinary shares was ten per cent. It was raised by successive steps in 1925 (fifteen per cent), 1928 (twenty per cent), 1932 (twenty-five per cent), 1935 (thirty-five per cent) to reach fifty per cent in 1936. From 1920 preference shares of various denominations also required servicing. These dividend payments never exceeded investment income. Indeed, they averaged only seventy-six per cent of that element in profitability over the whole inter-war period, falling as low as fifty-seven per cent in 1927, and rising to a maximum of ninety-two per cent in 1933. By retaining such a high proportion of profits the owners of the Provincial were, in effect , investing tax free. Francis Scott was aware that this should not be pressed too far, as the Inland Revenue might decide to assess taxation on some basis other than the dividends paid. Thrift, abstinence and accumulation were no longer seen as the virtues they had been in the nineteenth century and could now even be held against their practitioners.

Beyond this, the Provincial had converted itself from a marginal and essentially regional concern, into a significant competitive element in the British insurance market. By 1938 it had a presence in all worthwhile general insurance markets. It had developed a marketing organisation that covered the whole of the United Kingdom. It had learned to operate within its limitations in the overseas market. The only area within which it operated which remained obstinately problematic was the marine insurance market, where competitiveness combined with a different culture of management and control to produce an unprofitable operation that did not sit easily within the rest of the Provincial's organisation. Balancing this

failure were two striking successes. In the motor insurance market the Provincial had become a bench-mark of excellence. In this most competitive market it had developed business at a striking rate, while maintaining levels of profitability that were the envy of the industry. It had done so through innovative underwriting and efficient internal organisation. Then, under Keynes's management, the company's commitment to equity investment had been equally innovative in general insurance, and demonstrated the Scotts' willingness to escape from the conventions of the business in a way that the stuffier London based boards of directors would never contemplate.

The only striking gap in its development was the lack of a life department. Francis Scott considered entering the life business occasionally during this period, but there were serious objections. It would have greatly increased the burden of investment management, probably requiring formal organisation of the sort that Keynes would find unattractive. It would have taken the company into new management problems that would have taxed the personal control that Francis Scott preferred. Keynes's anticipation of falling interest rates suggested that life insurance was not an attractive prospect, given the long-term nature of the contracts involved. Even if companies could reduce their bonuses, their would almost certainly be a lag which would squeeze profitability. Discussions took place with the Britannic and the Scottish Life in the late 1920s, but these came to nothing, partly because the Scotts placed such a high value on their ordinary shares in the Provincial.[1]

What did all this mean for the value of the company to its owners? Two estimates have been made at the end of the two previous phases of development.[2] First there is the valuation based on capitalising dividend payments at the yield required for similar publicly quoted companies, with an allowance made for the lack of easy marketability of the shares. This might be considered a market valuation omitting the advantage of management control. Some allowance can also be made for the very low dividend disbursements made by the Scotts by capitalising all investment income on the same basis. This produces upper and lower estimates of the value of the company as a source of immediate income to its owners. In 1919 this had ranged from £180,000 to £204,000; by 1929 the range had risen to between £470,000 and £610,600; by 1938 it had reached between £1,170,000 and £1,488,000.

If we consider the value on a broader basis, allowing for the possibility of its outright sale as a going concern and with management control included, the value is naturally rather higher. In 1919 this had been £240,000; by 1929 it reached £1,003,000; and in 1938 it reached

£2,470,500. Of course, these estimates are not only rough and ready, they are also minimum figures. In a sense they may be thought of as the opportunity cost of selling the concern, a figure below which it would not be worth letting it go. In an actual sale, negotiations would certainly have led to a higher price, for most purchasing concerns would have seen advantages in owning the Provincial beyond those of its straightforward yield. The removal of a prominent and successful non-tariff concern would have been a major benefit to the members of the FOC and AOA, for which it would be well worth paying a premium price.

None the less, on the basis of this sale value, the rate of return to the Provincial's owners can be considered more precisely. To estimate this it is necessary to add the dividend payments made by the Provincial to the capital value, assuming that they were invested in low yielding, but safe consols. This suggests a yield of 13.5 per cent from 1919 to 1929 and 10.4 per cent from 1929 to 1938, or 11.6 per cent for the whole period, on the capital the Scotts had invested in the Provincial. This exceeds the return they would have achieved by investing in any of a selection of other insurance companies. Similar calculations indicate that investment in the shares of three representative tariff companies between 1919 and 1938 – the Phoenix, Royal Exchange Assurance, and the Sun – would have yielded a return of 4.75, 7.07 and 6.9 per cent respectively. Investment in the non-tariff Eagle Star would only have returned 5.6 per cent. The only company with a comparable performance was the General Accident, which grew from a modest pre-1914 base to become the largest British accident insurance company in the inter-war years. None the less its yield of 11.2 per cent was a little less than the Scotts obtained from the Provincial. Comparison with a general index of industrial ordinary shares is even more favourable. If the Scotts had sold the Provincial in 1919 and invested the proceeds (and the subsequent funds they put into the Provincial) into such a portfolio, it would have been worth only £389,681 in 1938, in comparison with the Provincial's potential sale price of £2,470,495. Even when reserves created from the Provincial's profits are deducted from that sum, the remainder is still nearly five times the value of the industrial portfolio.

16.2 The Scotts and the Provincial

This study has traced the development of the Provincial over thirty-six years, from a rather uninformed idea in James Scott's mind, to a company through which his sons had realised his most optimistic hopes. The success of the venture was dependent on a number of different circumstances.

Partly by chance, partly by deliberate design, general insurance proved to be a particularly appropriate business vehicle for the Scotts' circumstances. At the same time, their ownership and management of the company also shaped its development in ways that contributed to its success.

There can be little question that James Scott's first objective – that the company should provide a safe and productive means of transmitting his wealth to subsequent generations of his family – was successful. As we have seen, by 1938 the Provincial had a potential sale value of some £2.5 million. The original £75,000 investment had multiplied some thirty-three fold, in a period when prices rose sharply to the end of the First World War, but then fell back to a level only about fifty per cent higher than their 1903 level in 1938.[3] When the dividends paid out through the period are capitalised at their 1938 value, the rate of return over the whole period, allowing for additional capital injections, was 10.4 per cent, in a period when the yield on consols averaged some three per cent before 1914, and some four per cent from 1914 to 1938.

A comparison with a representative alternative investment opportunity is also extremely favourable. If the Scotts had invested the sums they placed in the Provincial in the stock market and enjoyed the growth represented by an index of security prices, their funds in 1938 would have been worth only £310,500. This compares with the company's minimum value, based on the capitalisation of dividend payments, of £1,170,200, and maximum value, based on the potential sale with control, of £2,470,500. Of course, the Provincial's value depended in part on the creation of large reserves from retained profits to an extent that must have exceeded practically all public companies. Yet even if an extreme assumption is made and all those reserves deducted, assuming that they had also been invested in the stock market in the year they became available, the comparison still remains favourable to the Provincial. Its 1938 capitalised dividend value less invested reserves still exceeded the stock market alternative by seventy per cent, and its potential sale price by 489 per cent.

This successful fulfilment of Scott's plan was dependent in the first place on the competitive opportunities available in general insurance. There is no evidence that at the start James Scott had any idea of the expanding opportunities for non-tariff underwriting, beyond a sketchy impression of the success of the Bolton Cotton Trade Mutual. He was probably thinking of no more than an underwriting syndicate operating on a very restricted basis. Yet by chance, the Provincial was launched at the beginning of a long phase in general insurance during which the tariff system, so laboriously constructed through the nineteenth century, came under pressure from independent underwriting. The opportunity to

reinsure at Lloyd's, the emerging broker network, high tariff margins, and risk improvement, created an ideal niche for non-tariff companies to exploit successfully through premium rate discounting. The resilience of the tariff system, based largely on the market power of its members, sustained this opportunity over a sufficient period to allow a steady unfolding of new opportunities.

In the Edwardian years the company was able to develop in fire insurance, broadening its base from a local connection in Bolton and the Lancashire cotton industry. Yet significantly, when the market in large scale industrial and commercial fire risks became far more competitive after the First World War, and the FOC responded by making aggressive cuts in premium rates, scope for growth in this market segment dried up, demonstrating the company's dependence on the continued success of the tariff. Sustained growth was based on the new motor insurance market. From 1920 this market grew rapidly on the basis of a collusive arrangement that was distinctly weaker than that in the fire insurance market, providing an ideal environment in which the Provincial could grow rapidly. Furthermore, the new market's cost structure offered an opportunity for the Provincial to expand its branch operation, giving the company a national presence and a capacity to rely less on rate discounting and more on strong links with agents and policyholders throughout Great Britain. Without this collusive market structure the company would never have been able to enjoy profitable growth.

Alongside these market opportunities, the structure and conventions of insurance company operation provided a framework for development that suited the Scotts' private objectives. The payment of dividends from investment income alone, which was becoming the convention among reputable insurance companies in the years before the war, meant that the retention of underwriting profits to increase reserves placed the company on an automatic growth path. This ideally suited the family's requirements for a steady commitment to the development of future prosperity, rather than current income. By 1938 the company's general reserves created in this way had accumulated to £550,000 at historic book value, more than double the £200,000 that had been directly invested in the company at various stages. Alongside this, the short-term reserves, which certainly included further hidden reserves, amounted to another £533,000, on which investment income could be earned.

The investment portfolio, nourished by these various funds, provided another advantage for the Scotts. As Samuel Scott quickly realised when the idea of an insurance company was first mooted, it provided the family with additional security and flexibility. Investments were assets whose

value was independent of the success of insurance underwriting. This stabilised income, spread risk and, though this was never necessary, would have provided a continuing secure form of wealth for the family, even if insurance itself became unattractive. This was perhaps why the Scott brothers became so nervous when they realised the implications of Keynes's investment methods in the late 1930s.

Finally, insurance company operation depended to an unusual degree on the activity of others. Even if Francis Scott had not proved such a committed and successful manager of the company's affairs, there was a degree of dynamism built into the company. Branch managers operated on profit commission and were largely managers of their own destinies. Depending so much on marketing effort, the Provincial provided a framework in which it shared in the fruits of the entrepreneurship of its staff to a greater degree than would be normal in an industrial concern. The success of the company did not depend entirely on the capacity of the Scotts themselves.

Beyond these considerations, the Provincial also provided what James Scott had perhaps most wanted for his sons, after their material welfare: fulfilling work in pleasant circumstances. The actual task of management was relatively congenial, freeing Samuel and Francis Scott from any direct connection with industry, allowing them to enjoy the country life they both sought, living in Westmorland, taking part in all the social and recreational activities the county offered. Yet at the same time, it offered scope for the fulfilment of Francis Scott's capacity for business leadership and responsibility. To him the Provincial was 'meat and drink'. Samuel Scott was also able to exercise a decisive role in the company to an extent that probably even surprised himself. He was directly involved in the company until the late 1920s, and after that date, he remained closely involved in its strategy, especially as far as its senior management was concerned. It seems very unlikely that he would have been able, or willing, to have taken such a close hand in a manufacturing concern. In this sense the Provincial more than fulfilled the more idealistic of its founder's objectives, that his sons should work together in an 'easy going business' – though it is clear that Francis Scott never wished it to be exactly that.

The Provincial served the Scotts' purposes well. Of course, in return, they shaped the company through the nature of their ownership and control of the company. The most important aspect of this was not the most obvious. The fact that they retained their ownership of the Provincial throughout the period distinguished the company from nearly all the non-tariff concerns that had been founded at a similar date. While the possibility of a sale was occasionally discussed, it was in the context of the

possibility of the early death of Francis Scott before the next generation was ready to assume responsibility for managerial control. Most of the other non-tariff companies founded around 1900 were sold for a good price to a tariff office once they had collected an attractive underwriting account. Thus the National of Great Britain was sold to the Commercial Union in 1917; the Central to the Liverpool, London and Globe in 1907; the Fine Art and General to the North British and Mercantile in 1917; and the Leather Trades and General (later the North-Western) to the British Dominions (later the Eagle Star) in 1914.[4] The Provincial, along with the General Accident and the Eagle Star, was distinguished by retaining its independence. Significantly, the other two companies were also closely associated with family management.

Beyond their retention of ownership and control, the Scotts were also very loathe to sell any share in the voting equity of the Provincial. This was reserved as a special privilege for close friends of the family or company such as A. R. Stenhouse or J. M. Keynes. Even then, shares were usually released on the understanding that the Scotts would have first refusal if they were resold. This unwillingness was more than a simple desire to retain control. Losing it was out of the question. The consideration was that both brothers felt that the equity of the company was an asset of enormous potential future value, a patrimony that should not be sacrificed. It was difficult to estimate its true value at any particular point, and their strategy of continually investing in future prosperity meant that selling shares was a sacrifice of indefinite size. This was why the various categories of preference shares were created through the inter-war years, to form a currency backed by the Provincial's value, that could be cashed without giving up a share in the company's future growth. They could be used to purchase the Drapers' and General, allow the Scotts to take some cash out of the company, or provide insurance against the possibility that one of the brothers might die and his estate have to meet death duties.

All this meant that the Provincial's scale was limited to that which could be reached with family resources, including retained profits. More money was put into the company in the inter-war years: £50,000 in 1920; £40,000 in 1933; and £20,000 in 1937, but this did not compare with the shareholders' capital some of its competitors could call on. This undoubtedly slowed the company's growth and restricted the scale which it could reach by 1938. Its progress contrasts with the two most prominent non-tariff companies: the General Accident and the Eagle Star, both with strong family interests involved.[5] Both had a far wider equity ownership than the Provincial and used this to raise substantial additional funds in the years around 1920, to purchase other companies. As a result, by 1938

they operated on a far larger scale, with life assurance departments supplementing their general insurance departments. The General Accident attracted a premium income of £9,344,000 and the Eagle Star £3,337,000 in comparison with the Provincial's £1,517,800.

The attractions of more rapid, publicly financed growth are perhaps more superficial than real. While bigger figures could have been achieved, it is by no means clear that the yield was higher, and this was the critical issue as far as the return on family investment was concerned. We have seen that the yield on the Provincial out-performed the General Accident and the Eagle Star during the inter-war years. Beyond this, there would have been heavy costs for Francis Scott in a more public role. He would have had to take responsibility for satisfying the legitimate needs of a large body of shareholders whose objectives were likely to differ from those of the Scott family, especially in respect of their appetite for an immediate return on their shares. A larger organisation would have required a more substantial delegation of control than Francis Scott would have been prepared to live with, given his extreme distrust of professional managers. All this would have severely detracted from the pleasure of management for him, thus inhibiting one of the objectives of the company. No doubt if insurance operation had required a larger scale of operation he would have lived with it. In the event, scale did not appear to be a major consideration and it was possible to focus more clearly on family aims by retaining freedom of action in policy and limiting the burden of management control as a smaller concern.

Alongside ownership, the Scotts' direct involvement in management also decisively shaped the company. The most striking aspect of this was its continuity. The most serious threat to the family firm, the problem of management succession, was avoided because Samuel and Francis Scott grew up with the Provincial from early manhood. Even in 1938 Francis Scott was still only fifty-seven, old enough for management succession to be a serious, but not immediate, issue in his own mind, though it struck his brother as deserving far more serious attention. Of course, this long period of unbroken management was in itself important for the company's character. It implied a singleness of purpose as far as strategy was concerned and a solidifying of relationships within the company. Men who were recruited as youths grew into manhood and middle age with the company, knowing only one controlling figure.

Francis Scott's qualities as the man who made the Provincial have marked every chapter of this study. He was the grand co-ordinator who considered strategy, implemented it, and then endeavoured to make it successful through motivating and then monitoring the company's organisation. He

showed powers as a genuinely original innovator in introducing the motor vehicle insurance country discount. He showed flexibility and imagination in commissioning Keynes to handle the Provincial's investment portfolio and then allowing him his head. He showed determination, perhaps too much, in persevering with foreign and marine departments through the inter-war years, when they created interminable problems and his fellow directors felt he was pursuing his King Charles's head. Behind it all lay an analytical brain that had a clear structured view of the Provincial's competitive environment, the direction in which he wished to take the company, and how this was to be done. But most of all, he retained the Provincial's organisation firmly within his grasp. Through a detailed knowledge of every aspect of the company from its earliest days, supplemented by a flow of statistical data covering its current activities, no one knew more about its affairs, its staff, or its problems and opportunities. This authority was complemented by his personal command over his staff. He had appointed most of them and measured them carefully as their careers developed, observing those at head office on a daily basis, interviewing branch managers individually at each annual conference and visiting them in their branches to inspect their staff and operations.

Personality was undoubtedly an important reason for the success with which he carried off this strong personal control. He was undoubtedly a man of enormous charm and integrity. As owner-manager he had the self-confidence that allowed him to speak directly to all those with whom he had business dealings – whether staff, colleagues from other insurance institutions, or policyholders. He spoke for the company with complete authority and there was no question that they were all clear that what he said was the Provincial's view. Yet, despite his position of authority he dealt with all with an air of apparent diffidence and concern that warmed social contacts. This was especially important in his dealings with important associates of the company. Keynes would not have remained closely linked with the Provincial unless he had found the whole relationship so relaxed and friendly.

These qualities were exercised in a straightforward way designed to try to ensure that the Provincial became an efficient profit maximising machine. Francis Scott's contempt for professional managers was based on his observation that they were principally concerned with their own aggrandisement, at the expense of the proprietors of their companies. In his dual position there was no conflict. He and his brother did not take directors' fees for many years. Their sole interest was profitability, very largely to accelerate the company's growth. No outsider could be trusted to ensure that the Provincial was kept at peak efficiency; it was an essential task for

the family themselves, and in his generation that meant him. There is no doubt that he was considered an authoritarian figure by many of his staff: tight with money and hard driving with his staff. This to him was business. In office hours staff were there to be worked efficiently and hard. Apparently when a new car appeared in the company car park that struck him as unnecessarily ostentatious, he automatically assumed that the manager was being paid too much. Any loss of efficiency was a waste of precious family resources that could otherwise be invested in valuable expansion. Yet the same man who had been dealt with rigorously within the business, might privately receive sympathetic consideration and generous material support, even after he left the company.

This was how Francis Scott's ability and energy made the Provincial, but his long period of control of the company had another side. We have seen that at the head office at Kendal, the senior managers were mostly men recruited when they and the company were young. They grew up in the shadow of Francis Scott's powerful presence and their relationship to him was formed when the small scale of the company made all relationships inevitably personal, rather than professional. Their mistakes were clearly pointed out to them; their decisions were overruled; and their initiative was almost certainly inhibited. Their attitude towards the Scotts was more akin to that of family servants, rather than independent professional managers. They had no future except with the Provincial. There was thus little fresh air at head office in the form of the frank exchange of professional judgement. When it came in with the occasional new senior departmental manager, it was not always appreciated by Francis Scott. He never placed the same confidence in David Glass as in those whose employment went back to the Bolton days. This was partly because of Glass's temperament, partly because he was an independent, professionally qualified insurance official, who could have moved elsewhere with ease, and behaved with the self-confidence that this gave him.

This atmosphere was inevitable during the years at Bolton, when the company remained small and Samuel and Francis Scott could relate to each member of staff personally. It became less appropriate after the move to Kendal, when the company grew so quickly and the number of branches proliferated. Then it became necessary to develop new methods of relating the company to its staff, through profit sharing and pension schemes. This was partly the need to respond to a change in the nature of the company, partly to recognise a change in the wider social environment after the First World War. To be fair, Francis Scott recognised it and initiated the new arrangements himself. But he found it difficult to surrender the old forms of relationship, especially with senior staff. This is perhaps scarcely

surprising when they were based on such long-standing associations, and must be seen as an inevitable consequence of his long service as the company's proprietor manager.

It is scarcely surprising that in this atmosphere, a tight leash was held on all staff down the line. It is difficult to distinguish the Provincial's head office from those of other insurance companies in the inter-war years, but it is clear that staff looked back on those years as being marked by an authoritarian strictness and sometimes narrowness of mind. The impact of this culture at head office was mitigated by the branch structure of the company. Local managers were pretty much gods in their own patch and some were men with considerable force of character of their own. They set the tone with their junior staff and there were as many different branch office atmospheres as there were branch managers. But it must none the less be asked whether by the 1930s, the Provincial might not have benefited from a more detached view at head office from departmental managers able to exercise more independent initiative. Perhaps this was what Samuel Scott had in mind when he begged his brother to turn more work over to a general manager. But, just as Francis Scott had made the Provincial what it was, so the Provincial had entered the marrow of his bones. He found the delegation of real authority impossible. This made changes at head office impossible. Crook, appointed to take over the routine of general management, remained an executant of Francis Scott's decisions, hemmed in by his superior's natural loyalties to staff with whom he had worked for thirty years. It was impossible for him to be expected to think independently and creatively about the company's development if it was clear that he would never be able to exercise real responsibility. Samuel Scott recognised this when he asked his brother whether they were really obtaining good value from Crook's appointment. Family control is always open to the risk of a loss of a sense of perspective on the part of proprietor managers.

Finally, the Provincial was shaped by the Scotts' wish to live in Westmorland. The company's detachment from the main insurance centres, especially London, had two important implications for its development. While staff costs were undoubtedly lower, it was probably more important in the way it allowed the strong paternalist atmosphere at head office to survive. With no alternative comparable employment, the Provincial could exercise firmer control over its staff than might have been possible in London or other larger insurance centres. On the other hand, there was an important sense in which Francis Scott was detached from many of the regular links with other insurance managers that would provide information and opinion. He visited London regularly, but these visits were

tightly organised around Provincial meetings of various kinds. They could not have allowed much time for the helpful casual conversation with other insurance company general managers. However, it is uncertain whether Francis Scott would have admitted to any loss on this account. There is no doubt that he had a low opinion of most general managers. Furthermore, it could be argued that it was as well to be free of the rumours that swept the hothouse City of London, especially about investment. Would Scott have worried more about Keynes's heterodox ideas on investment if he had regularly discussed investment affairs with other, more conservative insurance managers? The best that could be suggested is that he might have accepted defeat earlier in his attempts to persist with the marine department.

16.3 The Provincial and general insurance

How representative? That is the question business historians are always enjoined to ask about the firms they study. For the Provincial the answer is quite simple: it was among the least representative insurance firms that could be selected. It was relatively small and family owned and managed, in a business where most firms were large and corporate in ownership and management. It operated outside the tariff arrangements to which nearly all general insurance companies subscribed. It restricted itself to general insurance in a period when most companies were diversifying to include life insurance in their product range. It was based in a small county town at a great distance from the cities where nearly all insurance companies maintained head offices. Finally, from the 1920s its investment policy was distinctively different from most insurance companies in emphasising equity holdings. It would be possible to find companies that shared one or other of these distinctive characteristics, but none that shared them all.

Despite this, the Provincial's development tells us more about the equilibrium and evolution of the general insurance business than would the history of most more representative companies. Indeed it is always dangerous to assume that any company can be regarded as 'representative'. All are different. What is far more important is that they are all embedded in some way in the competitive structure of their business. An analysis of this fundamental relationship will reveal far more about the circumstances of the industry involved than any attempt to generalise from the individual circumstances of one firm, however 'representative', considered in isolation. The Provincial was forced by its youth, small scale and consequent relative lack of market power, to search for opportunities for growth, sheltering in the lee of the competitive wind created by the

existence of the tariff organisations. Unlike many of the companies that have featured in business histories, it did not possess the advantage of an heroic innovation that allowed it to dominate a market by large cost advantages, control over a product that could not be copied, or market power based on scale, goodwill, or a trade name. Any niche it created was always liable to entry from other insurers, whether as the result of adjustments in the tariff or from other non-tariff operators. This meant that its business never had the solidity that could be cemented by grand strategic alliances. Indeed the whole scope for strategic developments was limited by the extent that it could open up margins on its current business to allow investment in new areas. Without increasing profitability on existing business, it simply could not invest in new initiatives of any kind.

The overriding characteristic of the Provincial's competitive environment was its oligopolistic nature and the collusion this promoted. This in large measure determined the direction and pace of the company's growth. Collusion never eliminated competition from insurance markets. Far from this, it created niches which allowed successful entry and growth through price competition. Beyond this it redirected competition, creating new opportunities for business acquisition by means other than price. However, the nature of oligopolistic markets is often to make such opportunities transitory as they are eliminated by further competitive moves, often strategic in motivation. That is why the competitive process in different markets has been emphasised in this study, to emphasise the sometimes transitory nature of competitive success and the need to protect it when achieved. Sometimes the greatest apparent opportunities evaporated most rapidly and long-term success was dependent on more modest, but defensible strategies. In the motor insurance market larger no claims bonuses were quickly matched across the market, but the more modest country discount survived successfully as a long-term advantage for the Provincial.

Of course, firms will also respond to such a competitive and fast changing environment by building up a more solid basis of operation through the development of goodwill. This allows an escape from the pressures of competition focused entirely on price, through a greater control over business. The Provincial attempted this, but it was a slow and costly process. While the company inherited as its birthright the goodwill James Scott's connections could provide in Lancashire and the cotton trade, this was too narrow a basis for sustained operation. The Provincial quickly began to try to construct its own goodwill, based on the service it could offer through its marketing organisation. However, this process required investment in a branch organisation and then the time it took to confirm its reputation for reliability and flexibility with agents and policyholders.

Only when it could be financed by the rapid growth of motor insurance revenue was it accelerated to provide national coverage.

Industrial equilibrium imposed on the company the need to diversify. This was not an option, but a requirement for successful survival. Significant growth could not be obtained exclusively in one market without disturbing other firms' connections, provoking a competitive response, so it was better to spread expansion across as many markets as possible. Furthermore, the increasing use of branch organisations made it necessary to pass as much business through them as possible, to help carry overhead costs. Without a range of products the burden of one market would be too great, preventing the company from remaining cost competitive with competitors. Finally, profitability in one market allowed strategic development elsewhere. A company restricted to one market, would find its fortunes entirely bound up with it. If it became unprofitable, the company would have to risk losing competitiveness by raising premium rates. A spread of underwriting across several markets allowed it to take a longer term view by temporary cross-subsidisation when competitive conditions became especially unfavourable in one market. Many tariff companies made little or nothing from motor insurance through the inter-war years. They remained in the market because its revenue helped cover the overhead costs of larger branch organisations, and their more profitable underwriting elsewhere covered underwriting losses. This made Francis Scott ambivalent about the rapid growth in the Provincial's motor insurance business. It made the company very vulnerable to a deterioration in underwriting conditions in a market where margins were low and unstable. This is why he so often drove his branch managers and their marketing staff to expand other branches of fire and accident business. It may also have been why he was so insistent on maintaining the foreign and marine departments, despite their problems. In the long run they might provide an essential cushion for problems in the motor department.

The Provincial's development also emphasises the changing equilibrium of the general insurance business after 1900. The redirection of competition into the development of market power was not a matter of chance. This process was just as dynamic as rate competition had been, but it had important advantages for the tariff offices. It did not squeeze profitability so severely, even though it raised operating costs, because it created barriers to entry for new companies, who found it difficult to compete with established branch organisations because of the cost and time involved. This reduction in competitive pressure protected tariff premium rates which could therefore be pitched at a level that covered the raised costs of the new forms of competition.

New entrants could only attract business in competition with these powerful marketing advantages by discounting premium rates below the tariff level. It was for this reason that the Provincial was forced to rely on rate competition to compete successfully with companies with far larger organisations and long-established reputations. However, rate competition proved surprisingly successful, illustrating Marshall's reported dictum that 'Goodwill was not without regard to price'.[6] This exposed the underlying fragility of the cartels, for as with most such formal organisations, they had emerged in markets where implicit pressures to collude were weak and price competition corrosively effective. Relatively modest discounts enabled the Provincial to grow successfully, especially in the notoriously rate sensitive motor insurance market. It was inevitable that in such circumstances the business would eventually see entry, once the special factors restricting reinsurance facilities to tariff members were broken by Lloyd's.[7] The independent element in the general insurance markets grew to an unprecedented significance during the inter-war years. Before 1914 the usual role of the non-tariff company had been short run. Most had been designed to secure eventually a good sale to a tariff company when they had attracted a sufficiently large portfolio of risks to make them worth purchasing. After the First World War it became clear that some were becoming more established features of the market. By 1938 the rapid growth of motor insurance had allowed the Provincial, the General Accident, the Eagle Star, the Co-operative and the Cornhill, together with Lloyd's, to offer a permanent alternative to the tariff, with a far larger share of business than non-tariff companies had ever captured before.[8]

The establishment of this new balance within the market meant that the new entrants, including the Provincial, had to follow the rules of the oligopolistic game if they were to exploit the opportunity for as long as possible. Rate discounting, pushed too far, would destabilise the industrial equilibrium by forcing a defensive tariff response in the form of rate cuts. These might be (perhaps intentionally) sufficiently severe to drive interlopers out of the market, or enough to reduce seriously the profitability of independent operation. In these circumstances, the Provincial's financial strength and its owners' willingness to accept modest growth, as long as it was well founded, placed the company in a strong position adding to market stability. Less secure concerns were more likely to be forced to cut rates dramatically to maintain cash flow. They would eventually disappear, but not before causing considerable disruption, as happened in the motor insurance market in the early 1930s.

In the post-war years this bridgehead was to provide a basis for the steady intensification of competitive pressure in insurance. If the independent

sector had remained in the hands of a few well-founded companies, as it was for the best part of the inter-war years, the tariff might have survived, along with the opportunities for successful rate discounting. However, neither the tariff nor long established non-tariff insurers could control the market. The secret of the easy entry and potential profitability of insurance underwriting was out and the general insurance markets saw sustained entry and competition, often characterised by the need to win large revenues quickly. These severely eroded the strength of the tariffs and the profitability of the market for all, even before the weight of competition policy was brought to bear on the financial services sector. The motor insurance tariff collapsed in 1968. The fire tariff fought a long rearguard action, contracting the range of its activities through the 1970s, before it was finally wound up in 1985.[9]

The industrial equilibrium sketched here raises the important question of consumer welfare, so often left implicit in business history. How well did this industrial structure serve consumer interest? The answer is not straightforward. It is difficult and perhaps unhistorical to imagine the insurance market without the FOC and the AOA. The fragility of price formation and ease of entry made collusion a necessary condition for stability. Without it, rate warfare would have led to regular cycles of entry, severely below cost underwriting, company collapse and consumer loss – particularly as consumers received their indemnity for loss after they had paid their premium. Given the ease of entry, collusion had to be formal and explicit in the sophisticated and complicated form of the FOC and AOA. The only alternative would have been state intervention to regulate rates and policy terms on a scale that would have been well beyond the parameters of late nineteenth- or early twentieth-century British government activity. And as the experience of more *dirigiste* European attempts at insurance regulation showed, the consequences of a more thorough state intervention would probably have been little better than the British private cartel for consumers.[10]

In these circumstances, cartels were probably a reasonable solution, but they were always tempted to exploit their market power, as much as a result of lethargy and letting the least efficient member survive as anything. This market power clearly posed a threat to consumer welfare in the form of unnecessarily high profit margins and an unwillingness to introduce policies that suited customers. This was restrained by the emergence of independent insurers. It was, however, very much a second best solution. The Provincial and its fellow non-tariff companies had a clear interest in only discounting the tariff by the smallest amount sufficient to attract business. They had no interest in destabilising the tariff or

unnecessarily reducing their own profits. The FOC and AOA therefore acted as price leaders whom the non-tariff companies and Lloyd's were happy to follow with as modest a discount as they found necessary. Independent insurers therefore only provided more competitive premium rates for consumers in this limited sense. In effect consumers paid a price for stability through higher premiums.[11]

The implications of this stretch beyond the question of consumer welfare. In so far as the international position of British insurance has been appraised, it has been seen as one of the great successes of the late nineteenth- and early twentieth-century British financial services sector. Certainly British companies developed fire insurance business throughout the world, especially wherever British capital investments flowed. Before it can be assumed that this was the result of the competitive efficiency of the business, the implications of its market structure must be considered. Although the move overseas was initiated by the Phoenix early in the nineteenth century, it was enormously reinforced by the new offices founded in its middle decades.[12] It seems reasonable to suggest that they may have been motivated by the collusive nature of the market. They would certainly have found it difficult to grow at home in competition with the older offices who had such a strong hold over business, especially after their accession to the FOC, which removed their ability to use premium rates as a weapon. Furthermore, as they were gradually followed by more British companies, the level of profitability at home becomes significant. Perhaps it facilitated the costly process of building overseas organisations and covering the greater volatility of its profitability. In short, overseas competitiveness may have been a consequence of domestic protection through cartelisation rather than tariffs. It may have been another example of Britain's 'first mover' advantage in developing sophisticated institutions before follower nations. Only later, from the early twentieth century, did Lloyd's develop a far more premium rate competitive approach to the international business which was to make London the international centre for fire risks.

16.4 The Provincial in British business history

The history of the Provincial in the period covered by this study has a greater significance than its relationship with the Scotts or the insurance business alone. It forms part of the wider pattern of British economic and social history in a number of ways. Its business development reflected the important industrial transition from the traditional nineteenth-century staple industries to those that have dominated the twentieth century. Its

ownership and creation could be seen as part of the story of the with-drawal of the entrepreneurial class from involvement in manufacturing industry. Its role as a competitive firm in a largely collusive industry focuses directly on the issues surrounding the collusive and co-operative nature of British business over the hundred years from 1870. That, and its continued survival as a family firm in a sector predominantly corporate in character, raises questions about Britain's relatively slow move from 'personal capitalism' to 'managerial capitalism' in comparison with its main industrial competitors.

The Provincial was a late child of the Lancashire economy on which British industrialisation had been based. It was founded by a man who had risen to personal prosperity in a lifetime spent in the cotton trade as a dealer on the Manchester Cotton Exchange and then the successful executive head of a complex of cotton firms that had originated in early nineteenth-century Bolton. The company was successfully launched by the privileged access it had to fire insurance business in a Lancashire enjoying the remarkable Edwardian cotton boom, which raised incomes and investment throughout the county. Yet it was the last period of prosperity that the industry was to enjoy. The First World War hit the British cotton industry hard, both immediately, and by creating new long-term conditions of international competition in cotton which destroyed Lancashire's pre-eminence for ever.[13] The Provincial therefore suffered as a result of its regional dependence. The underwriting of large scale indus-trial and mercantile cotton risks which had provided the backbone of its early revenue turned sour. As the cotton business contracted, the market in insuring its risks became far more competitive; under financial pressure the moral hazard element in underwriting rose, increasing claims; the consolidation of cotton businesses in the great merger boom of 1919 gave greater bargaining power to the new combines. Furthermore, the towns that had boomed before 1914 now all shared in recession. Tradi-tional insurance markets in Lancashire no longer offered the same scope for growth. In this the Provincial was no more than sharing, perhaps disproportionately, in the experience of the majority of British general insurance companies which found their traditional markets in both fire and employer's liability insurance contracting severely in the inter-war years.

The continued success of the Provincial was therefore dependent on the discovery and exploitation of new and growing markets. Indeed, even if Lancashire had remained reasonably prosperous, the scope for the Provincial's continued expansion in one region would have been limited. Technological change provided the answer. The insurance business proved to be one of the chief indirect beneficiaries of the spread of motor car

ownership. By 1938 British insurance companies earned a premium income of £38 million from motor insurance, a market that had not existed some forty years before, now contributing nearly one-third of all general insurance premium income.[14]

This restored growth to the whole business, compensating revenue losses elsewhere and helping to maintain organisations and reserve funds. But it created an especially glittering opportunity for the Provincial. A rapidly growing market provided a relatively relaxed competitive environment in which a small company could grow quickly without provoking its larger competitors to retaliate. An immature market provided opportunities for creative marketing and underwriting by a young company, no longer at a disadvantage in relation to the great experience of the traditional offices. From the technical point of view, motor insurance allowed companies to operate outside the tariff more easily than had been the case in fire insurance. The Provincial seized these opportunities. With one leap it removed itself from the inhibiting effects of a close association with the now decaying industries of the nineteenth century and linked its fortunes to one of the major growth industries of the twentieth century. Furthermore, the opportunities motor insurance provided for funding a branch organisation allowed it to escape from its strong regional basis into the wider opportunities of a national market. This was especially important in a period when the South became the main locus of industrial growth after more than a century of northern dominance. This was perhaps the most important reason why the Provincial proved such an excellent investment for the Scotts. Its service basis enabled it to follow growth in the economy wherever it arose, rather than remain constrained by its origins.

Alongside this industrial transition, some have argued, another change was taking place in English society, which had important implications for its economic performance. They have suggested that a 'decline in the industrial spirit' took place during the latter half of the nineteenth century.[15] The entrepreneurial groups that had led industrialisation during the previous hundred years withdrew from direct involvement in manufacturing and turned their energies to other, more pleasant activities. The wealthiest transferred their capital into the ownership of landed estates and the pursuit of leisure or the more prestigious forms of public service; others preferred the expanding professions to industry, becoming lawyers, senior civil servants, diplomats, joining the armed services or the administration of Britain's empire. Industrial management came to be seen as socially unacceptable, and the recourse of the second rate. This, it is argued, drained manufacturing of entrepreneurial and management

talent, contributing to the declining performance of the British economy in the years after 1870.

The Scotts' creation of the Provincial could easily be fitted into just such a thesis. After all, Sir James Scott's explicit intention was to create a business in which his sons would be able to work in comfortable circumstances. One of his original ideas was that the administration of the business could be conducted from offices attached to a landed estate purchased for his elder son in the Midlands or south of England. After his death, the decision of his sons to move the head office to Kendal, so that they could live in Westmorland, participate in county society, and enjoy a wide range of country pursuits is entirely consistent with the idea of 'gentrification'. They were both very clear that a major motive was that they no longer wished to live in industrial Lancashire, partly for reasons of health.

However, there are important reasons for rejecting both the general argument, and the suggestion that the Scotts' provide a clear example in its support. The general argument can be rejected for there is no reason to suppose that this pattern of behaviour was particular to the England of the later nineteenth and early twentieth centuries. Since the Middle Ages successful English businessmen have always sought to capitalise on their fortunes by creating the more permanent wealth associated with land, together with the social and political power it brought. Association with trade or industry has always had a social connotation. Even in the earlier phases of industrialisation, when no one has suggested an absence of entrepreneurial drive in industry, men, such as Arkwright and Peel in the cotton industry or Gladstone in commerce, had created new and more attractive opportunities for their children than they had enjoyed themselves. At the height of the industrial revolution the Haslam family, into which James Scott had married, had lived outside Bolton in a country home selected for its detachment from urban society and its industrial environment.

The crucial point about the later nineteenth century was not that some change took place, but that nothing changed. In moving to Windermere the Scotts were behaving exactly as the families of successful businessmen always had done. In later industrialising countries, such as the United States and Germany, a different process of modernisation allowed the wealthy to adopt new social values and forms of behaviour which sanctioned their continuing close association with industry. This was the change. It did not happen in Britain, but it cannot therefore be used to rationalise some special change which came over British society explaining a decline in industrial dynamism. Perhaps the process of gentrification

became increasingly obvious because more families were acquiring wealth as economic growth proceeded. They were able to purchase land because its value fell through the agricultural depression of the late nineteenth century.

As for the Scotts themselves, while they sought a life separate from industry, there was no sense of any evaporation of entrepreneurial drive. Samuel Scott was perfectly happy to go out canvassing for business from the professional men of Bolton and took the interests of the Provincial exceedingly seriously. Francis Scott was pre-eminently an entrepreneur. He created the Provincial from the germ of an idea in his father's mind and then combined all the classic entrepreneurial functions of innovation, decision taking under risk, strategic planning and management leadership, happily committing his life to the work. While the move was made from cotton into insurance, the reasons for this were more specific than a general distaste for industry as such. After all, the first business proposition seriously considered was the bleach works whose price determined the Provincial's original capital. And the reason why the cotton industry was rejected as an alternative, was that it would have been impossible for Sir James's sons to have worked in the cotton trade without entering the Haslam business and become enmeshed in wider family affairs in a way that Sir James did not wish. In fact, they both became involved in that business after his death, Francis Scott chairing one of the the principal Haslam cotton concerns, but as a family member who had proved his competence elsewhere. Francis Scott was a businessman first, a Westmorland landed proprietor second, and relished both activities.

The Provincial's role, as a relatively small firm in a collusive market, places it at the centre of another theme of British business history that has received less attention than it ought. Between 1870 and 1960 formal collusive agreements permeated British business.[16] Legal opinion became less antagonistic to their existence. During and between the two wars governments positively encouraged them as a response to the economic difficulties of the period. It was only with the introduction of competition legislation after 1945 that they were officially recognised as contrary to the public interest and the majority disappeared in the 1960s in the face of restrictive practices legislation. Thus, as a competitive firm operating in a series of oligopolistic and collusive markets, the Provincial was more representative of the majority of British firms, and probably those producing the larger proportion of national product, than the large scale concerns with substantial market power that have dominated the writing of British business history. A greater interest in the all-pervasive collusive nature of markets may yield as much insight into the evolution of British business

as the recent emphasis on those large firms. Indeed, the main theme of that discussion has been the delayed development of the modern managerial enterprise in Britain, which suggests that an appreciation of the competitive structures which predated it may be as important as subsequent events.

This study indicates a number of starting points in such a re-examination. It suggests that the existence of cartels, price rings and trade associations must not be assumed to be the sign of competitive strength or 'monopoly power' for which they are often taken.[17] They are as likely, even more likely, to have arisen in markets that were 'weakly' collusive, where larger firms suffered the profit draining consequences of price warfare by smaller competitors, but did not have sufficient market power to eliminate them or prevent fresh entry.[18] In such circumstances they were forced to turn to methods of organised control to try to impose a stability and discipline that was not inherent in the market structure. 'Strong' collusion based on market power is far more likely to have led to the forms of implicit collusion that do not require the formal and carefully articulated market control that left obvious signs in the public record or in the archives of an organisation. Automatic and self-disciplining collusion is most likely to succeed, and least likely to be apparent through the existence of an organisation.

Furthermore, collusive arrangements in no way encapsulate the subsequent course of competitive development in a market. They merely form the basis for its new direction. Sometimes this may prove as painful as the initial price competition and attempts are made to extend the collusive agreement to cover the new forms of activity. The insurance tariffs were usually careful to control policy terms to prevent the escalation of concessions that would erode profitability as surely as premium rate competition. On the other hand, firms sometimes implicitly agree to allow competition in an area which will be to their mutual advantage. The tariff companies were content to compete through marketing organisations because this raised the barriers to entry and thereby strengthened their ability to control premium rates.

As these examples suggest, the commonest redirection of competition was into forms of product differentiation, especially through product proliferation or marketing activity. Is it possible that the generally accepted strength of British companies in these two areas was a result of oligopolistic markets?[19] Such a suggestion should perhaps balance the more normal attribution of this emphasis to the segmented nature of the British market, divided by class, income, region, and the multitude of different export markets.[20] This will certainly have played its part, but collusive

markets must have put steady pressure on British firms to find ways of competing by product differentiation and the search for niche, rather than mass, markets where competition would typically be on price alone.

The experience of the general insurance market also reinforces the suggestion that collusive markets may have been important in the distinctive survival of small scale, often family based, firms in Britain. Of course, it is widely recognised that many price agreements were designed to raise prices to a level that would allow small and less efficient firms to survive, in order to secure their allegiance. However, the history of the tariffs in general insurance suggests another possibility. By raising prices above the competitive level, pricing agreements could stimulate the entry of new concerns whose initial survival was dependent on their existence. Perhaps the survival of smaller firms in Britain should be seen as much in this market context as in the preferences of the family proprietors of companies and the pattern of market tastes and preferences. Small firms were not necessarily artefacts of business archaeology retained from an earlier phase of development. The vigour of entry in the insurance market suggests that the sources of new company formation deserve more attention than they have received in the literature.

The issue of corporate scale and growth should also be assessed in the context of market structure. Some critics of British business performance have argued that growth was an insufficiently important objective to many smaller firms in Britain in the late nineteenth and early twentieth centuries.[21] A proper attention to the significance of collusive markets places this suggestion in a different light. Rapid growth threatened market stability and profitability, whether it came from members of the price ring, or from those outside who were as dependent on the ring's survival for their profitability. In these circumstances, as for the larger non-tariff motor insurers in the inter-war years, a modest rate of growth was a better guarantee of long-term success than aggressive moves that would simply force competitors into responses that would destroy profitability for all. Aggressive growth was only possible if a company had access either to an innovation or economies of scale that gave it a competitive advantage that would allow it to cut prices below other firms until they were eliminated. When innovation in new plant might be quickly followed by competitors, there might be strong incentives to avoid the cost by collusion to remain with existing technology.

Consideration of corporate growth and scale leads naturally to the significance of this study for the understanding of the retarded emergence of the modern large scale managerial corporation in Britain. Chandler has argued that Britain was slow to take advantage of the important

innovations in the organisation of the firm that took place in the United States in the late nineteenth and early twentieth centuries. In that country, there was a move towards the development of large scale, often vertically integrated companies, controlled by professional managers through new organisational structures that provided central control along with an efficient functional and product specialisation of management. By contrast, he suggests, in Britain the small family firm remained pre-dominant, and even when firms grew, families retained control, delegating little to professional managers, operating through fuzzy or non-existent organisational structures, with little clear central control. Furthermore, family owners appear to have concentrated on current earnings rather than growth and expansion. In short, British business, which he characterises as a system of 'personal capitalism', did not take advantage of the 'visible hand' of administrative and managerial organisation. It continued to rely on the 'invisible hand' of the market, constrained by collusive arrangements designed to protect family firms from competitive pressure which threatened their profitability. This prevented full advantage being taken of the possibilities for integrating economic activity and generating economies of scale in larger firms.[22]

While Chandler is careful to restrict his generalisations to manufacturing, this interpretation none the less has some resonances with the Provincial's experience. The most obvious are perhaps Francis Scott's relations with his senior staff, and the Scott family's unwillingness to contemplate the use of external finance to fund additional expansion. In both cases, for better or worse, Francis Scott would have his own sharp retort. Managers could not be trusted to serve proprietors and he was not concerned to run a large company, but one that would be secure and profitable for his family. Equally, he would have argued that the Provincial's successful competitiveness in the market was at least in part due to his close control of all its affairs and that this would not have been possible if it had grown far larger. Certainly, we have seen above that the long-term yield obtained by the Provincial for its owners compared favourably with that obtained by both other insurance companies, and publicly quoted industrial companies.

Beyond this, however, the Provincial's competitiveness provides a striking counterpoint for Chandler's view of British business. As a small family firm, it grew successfully in a market dominated by what were large managerial corporations by the standards of the time. British insurance companies, rather like railways, provided a precursor of modern corporate organisation from the early nineteenth century and before.[23] Capital requirements meant that there was usually a division between a

financially oriented board of directors, playing little part in daily manage-
ment, and professional managers, whose interest in the company as share-
holders was insignificant. Management became functionally specialised in
head offices through the nineteenth century. While marketing had initially
been entirely in the hands of independent agents, as we have seen, the late
nineteenth century saw companies taking greater control of the process
through branch offices. This vertical integration was given greater
sophistication during the emergence of the multi-product 'composite'
insurance company in the Edwardian years, with the creation of separate
departments to manage fire, accident, marine and life business which gave
at least some appearance of the multi-divisional approach which Chandler
identifies as such an important innovation in American manufacturing
industry in the 1920s.

It was firms of this type, fulfilling in some measure Chandlerian pre-
scriptions, that created the tariff system which dominated the competitive
environment within which the Provincial emerged and grew. Yet, as we
have seen above, through the twentieth century the tariff system was
permanently under pressure, and from a paradoxical source. While it
would be disingenuous to argue that it came exclusively from small family
firms, it remains a striking fact that the General Accident, with a strong
family element in management, the Eagle Star, founded and closely
controlled by the Mountain family, and the Cornhill, founded initially as
a private concern by the families who owned Willis Faber, all played a
key role in this process alongside the Provincial.[24] There were no such
family linked concerns among the large tariff offices. Furthermore,
Lloyd's, the foundation of all independent underwriting through its
reinsurance facilities, and an important direct competitor, was one of the
most explicitly individualistic of economic institutions. Practically all
activities were carried out on a personal basis, mediated by a sophisticated
but extraordinarily informal market, a veritable paragon of the operation
of Adam Smith's 'invisible hand'.[25]

How could these independent underwriters compete so successfully
with the longer established corporate concerns? It was because the vertical
market integration and organisational complexity of the tariff companies
was fuelled far more by their search for market power in a collusive
market than by any cost competitiveness based on additional efficiency.
Protected by the FOC and AOA and their private market power, the tariff
companies practised a competitive process which excluded the offer of
more competitive premium rates or innovative policy terms to the
customer. Much of the profitability provided by tariff premium rates was
expended in the cost of acquiring business by other means, through

branch organisations, commissions, or company purchases, often in ways that served managers better than shareholders. The fundamental need to remain competitive on costs and prices was forgotten. The inexorable growth of independent insurance from the Edwardian period exposed the tariff emperor as having no clothes. Tariff premium rates were shown to be uncompetitive, marketing organisations too inflated, and underwriting complacent and uninnovative.[26]

Thus the general insurance market suggests that agreements to regulate competition were as likely to emerge in businesses associated with managerial corporations as with family firms. This was because collusive agreements were not a product of a particular set of attitudes peculiar to family firms, but a rational response to market structure. When economies of scale and other barriers to entry are of only modest significance, it is likely that markets will be characterised by weakly collusive behaviour. Corporate growth, leading to the predominance of one, or a few large companies, will be difficult because it will not automatically yield greater competitiveness and it will prompt retaliation from competitors. Attempts may be made to develop market power through other means, including forward vertical integration. The incentive for this may be increased in the presence of effective collusion, especially if this raises prices sufficiently to cover the increased costs of more expensive marketing. Integration cannot be assumed to be more efficient just because it takes place. It may survive because of the market power it generates, rather than any additional competitiveness created by cost reduction.

These observations may have a more general applicability. Of course, the lack of economies of scale could be specific to insurance and Chandler's work has been carefully restricted to industrial concerns. However the nature of production and markets in many British industries, especially those that had emerged in the early nineteenth century, was such that the scope for economies of scale was limited. To the extent that this was the case, the oligopolistic markets in which they operated induced them to concentrate on market control through collusion and marketing activities, rather than the growth to predominance of individual firms through cost competitiveness. In this way the history of British business was a rational response to its economic environment, rather than the reprehensible conservatism that is often represented. In these circumstances structural change was extraordinarily difficult and it is simply unhistorical to suggest that a model of corporate growth drawn from a quite different market environment would have been appropriate. As with all good comparative history, Chandler's work, based on American experience, raises important questions about British business history, but provides few answers.[27]

These lines of argument bear closely on the re-interpretation of British economic decline in the early twentieth century initiated by Elbaum and Lazonick.[28] They suggest that the institutional framework of British business, with its predominantly small scale organisation and lack of integration, locked it into an highly competitive environment which prevented it taking full advantage of the technological and organisational innovations that were adopted by American companies in the period. Price warfare squeezed profitability, throttling attempts to innovate or achieve industrial re-organisation. The implication is that external intervention might have been necessary to create an alternative framework within which such innovation would have been possible. Certainly some British industries, such as coal, steel, and cotton, seem to have found themselves in a cul-de-sac created by over-capacity, unprofitability and high costs, based sometimes on inadequate investment, sometimes on an inadequate scale of operation.[29]

While the problems of general insurance and industrial regeneration do not run on parallel tracks, the former does raise pertinent questions for the Elbaum–Lazonick hypothesis. The experience of the general insurance market emphasises that the creation of large scale companies, in the absence of genuine economies of scale, will simply provoke entry by smaller concerns, especially if markets are well segmented. The difficulties of the Lancashire Cotton Corporation are a clear example of the problems of large scale organisation in an industry whose technology and management was simply unsuited to it.[30] Effective intervention would therefore require some form of market control that would prevent entry.

In this case, or when genuine economies of scale prevented entry, another difficulty arises. What mechanism would be used to ensure that the large new concerns would use their market power to social advantage by investment in new technology and more efficient organisation? If market power based on scale had existed, as in the general insurance market in the heyday of the FOC, it is likely that its beneficiaries would have similarly either enjoyed the superior profitability it provided in the form of higher dividends or expended some part of this in forms of non-price competition that would have been of only dubious benefit to the consumer. The experience of the British steel industry after the provision of generous tariff protection offers an industrial example of precisely this problem.[31] Scale does not necessarily imply efficiency or enterprise. It may imply barriers to entry, implicit collusion and opportunities for managements to exploit market power at the expense of consumers.

This has been a long book about a company that was small in relation to the business in which it operated. Those who think it disproportionate

should remember that the complexities facing a family company can be just as great as those facing a large business. Indeed, they may be greater if modest size limits market power and renders the environment less easily controlled. Furthermore, the issues facing small family companies – their competitiveness, survival and growth and the subtle distinctions in the way in which they relate to their markets through competition or co-operation – are far closer to the heart of British business history in the period from the industrial revolution until the 1960s than those of large corporations. If this book has emphasised and illuminated these issues, it will have served its purpose.

Beyond this, the book has drawn together the history of a family, a business, an industry and a society. It has tried to integrate them by showing how the ambitions of individuals have been played out in the context of the internal organisation of a firm and the market structures of an industry, both of which have been shaped by social, technological and economic changes in the wider world. At the same time it has tried to set these historical developments within a framework of industrial analysis that provides understanding. Seen this way, business history can never become a narrow and specialist area of study. How can it, when its objective is to draw together all these ways of observing individuals transacting the 'ordinary business of life'?

Appendix A
Keynes's investment arithmetic

I

In 1938 Keynes prepared a memorandum which presented an appraisal of his management of the investment funds of the Provincial Insurance Company. He included comparisons with two other institutions – the National Mutual, a life office, and King's College, Cambridge – where he also held investment responsibilities, with the Prudential, and with market indices. This memorandum, together with an associated paper presented to the King's College Estates Committee, has been published in Keynes's *Collected Writings*, Volume XII, where it provides the most easily accessible evidence on this aspect of Keynes's activities.[1]

In the memorandum statistical evidence was presented on several aspects of the portfolios concerned, but the focus was on the success of investment in sterling equities. Keynes had as a matter of policy committed all the institutions with which he was associated to an unusually large holding of these assets and was concerned to justify this approach after the striking fall in security prices in both Britain and America during 1937 and 1938.

Unfortunately an opportunity to rework the data using some of the original evidence on which it must have been based led to difficulties which suggested a need for clarification and a revision of the evidence as it was presented by Keynes.

II

In the first relevant table in the Provincial post-mortem Keynes presents statistics on the relationship between the market value of sterling equity holdings and their book value in the portfolios of the Prudential, National Mutual, and Provincial as in Table A.1.[2] The Prudential series was based on evidence supplied by a representative of that firm at a discussion following a paper presented to the Institute of Actuaries, and later reported in its Journal.[3] The series for the other two companies were available to Keynes through his official position with them both. Partial data remains for the

TABLE A.1 *British equity investment: a comparison of the Prudential,*
National Mutual and Provincial, 1928–37
Proportion of market value to book value

Year end	Prudential	National Mutual	Provincial
1928	129	123	114
1929	119	99	110
1930	98	84	89
1931	78	58	73
1932	93	77	89
1933	115	98	115
1934	131	119	130
1935	141	130	142
1936	151	144	160
1937			119

TABLE A.2 *Prudential Insurance Company: investment in British ordinary*
shares, 1926–36

Year end	Growth in fund	Market value Original cost	Yield variations
1926	100.00	100.00	
1927	142.41	104.80	100.00
1928	193.69	128.68	113.16
1929	218.04	119.13	120.97
1930	251.79	97.92	117.22
1931	272.43	78.27	106.08
1932	280.03	92.86	89.14
1933	278.62	114.82	91.68
1934	291.74	131.33	102.55
1935	312.09	141.09	116.83
1936	368.85	150.72	117.64

Provincial and has been made available. This allows two of Keynes's series
to be reworked to clarify his method.

The Prudential data are shown in Table A.2. The precise definition of its
various components is important. The discussant stated that:

He had taken the market value at 31 December 1926 of the investments then held
as the starting point, and had added the actual cost of new investments less sales

TABLE A.3 *Provincial Insurance Company: investment in British ordinary shares, 1926–38 (£'000)*

Year end	Gross book value	Cumulative profits on realisations	Net book value	Market value
1926	4	3	43	44
1927	55	6	49	56
1928	66	15	50	59
1929	55	19	36	41
1930				
1931				
1932				
1933				
1934				
1935	211	37	174	262
1936	300	66	233	411
1937	399	81	318	393
1938	414	73	341	376

each year including the expenses of purchase and sale and without making any allowance for accrued interest; thus the realised profits from all complete sales were deducted from the total invested. The following table gave percentages representing (1) the growth of the fund, (2) market value to original cost price, and (3) yield of mean fund taking 1927 as a standard.[4]

While this is not entirely unambiguous, the correct interpretation appears to be that the growth in the fund is growth in the net book value – that is the book value less the accumulated profits obtained through realising assets at a higher price than they cost. The growth in the fund is therefore exclusively a measure of the growth in new money invested; all profit from trading in investments is excluded.

Similarly the 'original cost' denominator in the ratio provided in the second column is again the net book value, eliminating realisation profits. It is the 'market value' numerator that captures all appreciation, realised and paper only.

Unfortunately this approach does not appear to be consistent with that used by Keynes in dealing with the Provincial series. He appears to have based his calculations here on the industrial index block of securities which included most equities, but excluded those held in investment trusts and insurance companies. Unfortunately the index also seems to have included some American securities from 1929 to 1934. Keynes appears to have excluded these from his calculations, but information is only available

TABLE A.4 *Provincial Insurance Company: revised calculations of British equity investment performance, 1926–38.*
Proportion of market value to book value

Year end	JMK series (a)	JMK method (b)	Revised method (c)
1926	–	101	101
1927	–	113	114
1928	114	113	116
1929	110	109	114
1930	89	–	–
1931	73	–	–
1932	89	–	–
1933	115	–	–
1934	130	–	–
1935	142	139	145
1936	160	159	176
1937	119	119	124
1938	–	108	110

now to do so for 1929, so 1930 to 1934 (inclusive) have been omitted.. The remaining data is shown in Table A.3. Various methods were used to try to reproduce Keynes's results. A close fit was obtained by dividing the market value added to cumulative realisations by the gross book value.

$$(MV + CR)/ GBV \tag{1}$$

MV = market value of portfolio, CR = cumulated profits on the realisation of securities, GBV = gross book value of portfolio.

Column (b) in Table A.4 provides the series calculated in this way using the evidence in Table A.3. This can be compared with column (a) which repeats Keynes's own series from Table A.1. The correspondence is extremely close, except in 1935, when there are reasons for believing that the data available may have differed from that Keynes used. In any event, it seems sufficient to confirm that this was Keynes's method.

However, this method does not parallel the Prudential data or, more importantly, suit Keynes's objective of measuring the portfolio's appreciation. The gross book value denominator includes profits on realisation and is in no sense the 'original cost'. Furthermore, the numerator, by adding market value and cumulative realisations double counts realised profits. The correct ratio to capture all appreciation should be market value di-

TABLE A.5 *British equity investment: a comparison of the Prudential,*
National Mutual and Provincial, 1928–37

Year end	Prudential	National Mutual	Provincial	Investors' Chronicle index	Actuaries' index
1928	100	100	100	100	100
1929	96	85	90	76	83
1930	80	73	70	61	66
1931	63	52	57	49	50
1932	74	69	66	58	56
1933	92	86	83	72	69
1934	105	104	97	80	74
1935	116	114	111	87	80
1936	129	129	137	97	90
1937			110	79	74

vided by gross book value less cumulated profits on the realisation of securities: net book value.

$$MV/(GBV - CR) \tag{2}$$

Column (c) in Table A.4 provides a recalculation of the Provincial data using this method. The results of this revision are modestly in Keynes's favour. In the later 1930s the appreciation is rather greater, rising to a premium of seventy-six per cent in 1936, and not falling quite so far in 1937.

III

The ratio discussed above included the costs or benefits of investing varying amounts of new money at particular points in time and of trading in securities already in the portfolio. These were important elements in the capital appreciation performance of the portfolio. However their inclusion made comparisons with market indices impossible. Variations in the availability of new investment became an important element in success. The large sums invested in the mid 1930s when prices were high were reflected in a high net book value when market values subsequently fell in 1937. In order to provide a standardised basis of comparison, Keynes considered 'the results of investing a level £100 book value throughout the period, which eliminates the effect of purchases or sales of ordinary shares made at the wrong stage of the credit cycle'.[5] His results are shown in Table A.5.

TABLE A.6 *Prudential Insurance Company: a standardised index of British equity investment performance, 1928–36*

Year end	$\dfrac{\text{MV}}{\text{Book value}}$	JMK index (a)	Formula (b)	Index 1928=100 (c)	Index 1928=112 (d)
1928	129	100	139	100	112
1929	119	96	122	87	98
1930	98	80	98	70	79
1931	78	63	77	55	62
1932	93	74	93	67	75
1933	115	92	115	83	93
1934	131	105	133	96	107
1935	141	116	144	104	116
1936	151	129	160	115	129

TABLE A.7 *Provincial Insurance Company: standardised index of British equity investment performance, 1927–36*

Year end	JMK index (x)	JMK index recalculated (y)	Revised index (z)
1927			99
1928	100	100	100
1929	90	94	94
1930	70		
1931	57		
1932	66		
1933	83		
1934	97		
1935	111		
1936	137	139	154
1937	110	110	113
1938			95

He does not explain how he carried out this exercise, but it is possible to suggest a simple method which reproduces his results, though with one problem which will be investigated later. The method can be expressed as:
$$I_2 = (MV_2 - P_2)/BV_1 \tag{3}$$
I_2 = Index at year end, MV_2 = Market Value at year end, P_2 = Purchases over the year, BV_1 = Book Value at beginning of year.

This provides a measure of annual appreciation. Investment purchases during a year are deducted from the portfolio's year end market value to exclude growth funded by new money. The resulting net appreciation is then expressed as a proportion of the year's initial book value and can be seen as representing the increasing value of assets resulting exclusively from variations in market value.

These annual changes can then be standardised on a base year and compared with other companies or with market indices.

Using the information supplied in Table A.2, the above method was checked for the Prudential. An index of market value was calculated as the product of the indices of growth and the market value / book value ratio. Additional purchases (or sales) were calculated as the difference between each year's net book value. Substituting these data into the formula above produces series (b) in Table A.6, which is standardised on 1928 as 100 in (c) to match Keynes's index in (a). The discrepancy that remains is explained as a result of Homer nodding. Keynes's series appears to be based on a value of 112.1 for 1928, though it is represented as 100 in his memorandum. If this error is corrected, as in (d) in Table A.6, the tiny deviations from his series in (a) can reasonably be explained as the results of rounding or the 'errors of arithmetic' which he warned against in presenting the data. It seems reasonable to suggest that he based his index on 1926 and forgot to make the necessary adjustment. In any event it seems reasonable to suggest the proposed method as confirmed and (c) as the necessary correction.

With a confirmed method it becomes possible to check the Provincial series using the partial data in Table A.3. The results are indicated in Table A.7. Column (x) indicates the index Keynes provides in the memorandum.[6] Column (y) provides the results of a recalculation of the data in Table A.3 using formula (3) above, but using Keynes's original calculation of the market to book value ratio in Table A.4. Unfortunately the results are not exactly the same as Keynes's, but there is sufficient correspondence to suggest a high probability that the method is correct, if rounding in calculation and variations in the data are allowed. Column (z) shows the results when the data is recalculated from the original data, ignoring Keynes's incorrect ratio. The revision is again modestly in Keynes's

favour, suggesting a rather larger rise to 152 in 1936, instead of his calculation of 137. However the opportunity to extend the series to 1938 emphasises the dramatic nature of the subsequent fall with the index collapsing to only ninety-five, below its 1928 level.

Appendix B
Provincial valuations 1903–38

Various methods have been used to estimate the value of the Provincial at the end of each phase of development. For obvious reasons no precision is possible, so the estimates offered should not be taken too seriously, but they suggest orders of magnitude that allow worthwhile discussion.

The first approach is based on a method that tries to estimate the value of the Provincial's shares ignoring any value that could be attributed to control of the company. It capitalises shareholders' income on the basis of the yield offered by comparable companies, with an allowance made for the lack of marketability of the Provincial's privately held equities. Two estimates are made. The first is based on the actual dividends paid. However, because the Scotts paid out dividends on an exceedingly conservative basis, an alternative is provided, based on the Provincial's total investment income which might reasonably have all been paid in dividends. The results are outlined in Tables B.1 and B.2, together with notes explaining the method of calculation.

On the basis of these valuations estimates have been made as to the internal rate of return on the investment in the Provincial for various periods. In order to take into account the dividend income received by the Provincial's proprietors over these periods, these dividends have been capitalised on the conservative basis of assuming that they were invested in consols immediately on receipt. Table B.3 indicates the capital sums these calculations produce and the rates of return these sums imply.

Table B.4 provides a comparison with investment in a portfolio of industrial equities over the period 1903 to 1938. It adjusts the value of the sums invested in the Provincial at various dates by an index of industrial equity prices to suggest a portfolio value of £310,532 in 1938. This is compared with two alternative valuations of the Provincial in 1938. To discount the possible effect of a superior retention of profits by the Provincial, the table indicates the effect of deducting the reserves accumulated by the company, valued as though they had been invested at average consol rates of return which produces a value of £642,422.

TABLE B.1 *Provincial Insurance Company: valuation without control*
Capitalisation of dividends disbursed and investment income

	1913	1919	1929	1938
Dividends paid (gross £)	4500	9000	23,500	55,000
Investment income (gross £)	5216	10,177	30,530	69,939
Average percentage yield of three comparable companies plus 20 per cent (a) (%)	6.8	5.0	5.0	4.7
Capitalisation (£)				
Dividend basis	66,176	180,000	470,000	1,170,213
Investment income basis	76,706	203,540	610,600	1,488,064
Share value (£)				
Dividend basis	3.68	10.00	26.11	65.01 (b)
Investment income basis	4.26	11.31	33.92	82.67

Notes

(a) The three companies included are the Eagle Star and the General Accident as quoted non-tariff insurers and the Scottish Union which was specified by the Provincial's stockbroker as the most similar quoted concern in the 1940s. Eagle Star and General Accident were never as conservatively managed as the Provincial, but to the extent that this increased their yield, it will tend to underestimate the Provincial's value. A twenty per cent premium is added to yield to allow for the absence of marketability of Provincial equities. This was a suggestion made in a professional valuation exercise carried out in the 1940s.

(b) These are estimates of the equivalent value if the capital had remained the same with the original (1909) 18,000 £5 shares to avoid the complications otherwise imposed by changes in capital organisation.

TABLE B.2 *Provincial Insurance Company: valuation with control (£)*
Investments at market value plus capitalised underwriting profits (a)

	1913	1919	1929	1938
Market value of investments	110,000 (b)	170,000 (c)	609,000	1,759,935
Underwriting surplus capitalised at 10% (d)	28,310	69,830	394,050	710,560
Total	138,310	239,830	1,003,050	2,470,495
Share value	7.68	13.32	55.72	137.25 (e)

Notes

(a) Marine underwriting profits/losses have been entirely excluded. In effect it is assumed that this account broke even. However, the investment income from marine reserves is included. No assets other than investments are included. It is assumed that the value of all premises, subsidiary companies etc., is entirely captured in the underwriting surplus.

(b) In 1913 the book value was written down by £2,000 to allow for a fall in the value of securities; the auditors then stated that the resulting book value of £109,006 was less than the market value, so a round figure of £110,000 has been assumed.

(c) In 1919 £5,000 was written off investments; auditors then stated that the market value of investments showed a further depreciation of approximately £6,000 on the book value of £176,262 stated in the balance sheet. A round figure of 170,000 has therefore been used.

(d) In calculating this figure an average of the three years ending in the year specified has been taken. Deductions have been made from the underwriting surplus, including directors' fees, pension and profit sharing allocations and bad debt provisions. Capitalisation has been on a straightforward basis of an indefinite yield of ten per cent. This has been taken from a valuation report prepared by Peat Marwick for the Provincial in 1933. Using DCF methods would undermine the ten per cent basis thought appropriate by contemporaries.

(e) This would have been the value of the original £5 shares, had the capital structure not been changed after 1920. The value of the 1938 4s ordinary shares can be estimated by capitalising the interest due on the preference shares at 4.5 per cent (the approximate investment yield) and deducting this from the value of the company suggested in the above table. This indicates a value of £7.

TABLE B.3 *Provincial Insurance Company: internal rate of return, 1903–38*

	Capital value of Provincial (1) £	Provincial dividends capitalised(a) (2) £	Total (1+2) £
1903	75,000	0	75,000
1913	138,310	30,777	169,087
1919	239,830	69,385	309,215
1929	1,003,050	247,364	1,250,414
1938	2,470,495	658,062	3,128,557

Internal rate of return (b) (%)

1903–1913	6.73
1913–1919	10.58
1919–1929	13.47
1919–1938	11.98
1929–1938	10.38
1903–1938	10.35

Notes

(a) The company's dividends were capitalised by assuming that they had been invested from the date of payment until the end of each period in securities yielding the average rate on consols (1903–13: 3.1 per cent; 1913–38: 4.1 per cent).

(b) The internal rate of return was the rate of growth in the value of the company, including capitalised dividends, in the periods specified. The yield was calculated to allow for the addition of capital at various dates (1905: £15,000; 1920: £50,000; 1933: £40,000; 1937: £20,000).

TABLE B.4 *Provincial Insurance Company: comparison of investment in company with investment in industrial equities*

	Investment in Provincial	Industrial equity index in year invested(a)	Value of investment adjusted to 1938 index value
	£'000	1963 = 100	£'000
1903	75,000	11	156,818
1905	15,000	11	31,364
1920	50,000	20	57,500
1933	40,000	19	48,421
1937	20,000	28	16,429
Total			310,532

Value of Provincial 1938:

		£
Minimum basis	(Capitalisation of dividends paid(b)):	1,170,213
Maximum basis	(Potential sale price with control(c)):	2,470,495
Less reserves valued as if invested at consol rate of return:		
Minimum basis	less £642,422	527,791
Maximum basis	less £642,422	1,828,073
In comparison with industrial index investment		310,532

Notes

(a) London and Cambridge Economic Service, *The British Economy Key Statistics, 1900–70*, London, 1970, Table M Finance, p. 16.

(b) See Table B.1.

(c) See Table B.2.

Glossary

Gross premium income The Gross premium received before reinsurance and without the deduction of commission or management expenses.

Net premium income The gross premium less reinsurance premiums due or paid to reinsurers.

Corrected claims ratio The ratio to premium income of claims actually paid and estimates of amounts likely to be made under claims received plus an estimate of unexpired risk. This latter arises from the fact that when most policies are annual, in any accounting period some premiums have been received for policies that have not expired. If, for example, premium income is growing, this will artificially depress the claims ratio unless some allowance is made for unexpired risk. Conventionally insurance companies withhold forty per cent of premium income as a reserve to cover this liability. This can be shown to be a reasonable assumption in principle and has proved a good conservative convention in practice. The corrected claims ratio uses this convention by adding or deducting forty per cent of the change in premium income to the claims figure, to produce a better estimate of the true quality of underwriting. In practice, because it is based on a conservative convention, the corrected claims ratio tends to slightly exaggerate claims when premium income is growing, and discount them when premium income is rising.

Notes

Introduction

1 The best general survey of the industry since the late nineteenth century is B. Supple, *Royal Exchange Assurance A History of British Insurance 1720–1970*, Cambridge, 1970. This can be supplemented by H. E. Raynes, *A History of British Insurance*, London, 1964, and G. Clayton, *British Insurance*, London, 1971. R. L. Carter, *Competition in the British fire and accident insurance market*, Sussex D. Phil. , 1968, provides a survey of particular value for the main themes of this present study.

2 The best description of the later operation of the tariff is found in Monopolies Commission, *Report on the Supply of Fire Insurance*, HC. 396, 1972. See also H. A. L. Cockerell, 'Combination in British fire insurance' in F. Reichert-Facilides, F. Rittner and J. Sasse, eds. , *Festschrift fur Reiner Schmidt*, Karlsruhe, 1976. On the end of the tariff system see O. M. Westall, 'The assumptions of regulation in British general insurance' in G. Jones and M. W. Kirby, *Competitiveness and the State*, Manchester, 1991.

3 P. W. S. Andrews, 'The theory of the growth of the firm', *The Oxford Magazine*, 30 November 1961.

4 R. A. Church, *Kenricks in Hardware A Family Business 1791–1966*, Newton Abbot,1969 is an important exception to this generalisation. W. Lazonick 'The cotton industry' in B. Elbaum and W. Lazonick, eds. , *The Decline of the British Economy*, Oxford, 1986, pp. 44–5 touches on family firms in the cotton trade and the work stimulated by these two provocative writers is beginning to refocus attention on smaller industrial firms in the early twentieth century.

5 Important exceptions are T. C. Barker, *The Glassmakers. Pilkington: The Rise of an International Company, 1826–1976*, London, 1977 and T. A. B. Corley, *Quaker Enterprise in Biscuits: Huntley and Palmers of Reading, 1822–1972*, London, 1972.

6 A. D. Chandler, *Scale and Scope The Dynamics of Industrial Capitalism*, Cambridge, Mass. , 1990 and L. Hannah, *The Rise of the Corporate Economy*, London, 1983.

7 A. D. Chandler, *The Visible Hand The Managerial Revolution in American Business*, Cambridge, Mass. , 1977, pp. 6–12 for a succinct summary of his theoretical framework. See also B. Supple, 'Scale and scope: Alfred Chandler and the dynamics of industrial capitalism', *EcHR*, XLIV, 3, 1991.

8 E. Penrose, *The Theory of the Growth of the Firm*, Oxford, 1959.

9 D. A. Hay and D. J. Morris, *Industrial Economics and Organisation*, Oxford, 1991, Ch. 9 surveys theories of corporate growth.

10 *Ibid.* , Ch. 3 and M. Waterson, *Economic Theory of the Industry*, Cambridge, 1984, provide a flavour of this new approach.

11 Chandler, *Scale and Scope*, pp. 291–4; Elbaum and Lazonick, *The Decline of the British Economy*, pp. 3–9; D. F. Channon, *The Strategy and Structure of British Enterprise*, London, 1973, pp. 15–6 and 75–7.

12 Supple, *REA*, Chs. 10 and 18.

13 O. M. Westall, 'David and Goliath: the Fire Offices' Committee and non-tariff competition, 1898–1907' in O. M. Westall, ed. , *The Historian and the Business of Insurance*, Manchester, 1984 and O. M. Westall, ' The invisible hand strikes back: motor insurance and the erosion of organised competition in general insurance, 1920–38', *BH*, XXX, 4, 1988.

Chapter one: The origins of the Provincial

1 S. H. Scott, *Sir James William Scott A Short Memoir by his Son*, Oxford, 1914, pp. 7–16.

2 *Ibid.* , p. 20.

3 *Ibid.* , p. 34.

4 O. M. Westall, 'The retreat to Arcadia: Windermere as a select residential resort in the late nineteenth century' in O. M. Westall, ed., *Windermere in the Nineteenth Century*, Lancaster, 1991.

5 B. Bowker, *Lancashire under the Hammer*, London, 1928, pp. 12–16; R. E. Tyson, 'The cotton industry' in D. H. Aldcroft, ed. , *The Development of British Industry and Foreign Competition, 1875–1914*, London, 1968, p. 118.

6 *PH*, October 1903.

7 S. H. Scott and F. C. Scott, *Personal Account: Some Recollections of Fifty Years of the Provincial Insurance Company*, Kendal, 1953, p. 10.

8 *Ibid.* , pp. 10–11.

Chapter two: General insurance before 1914

1 *PMA*, 1901.

2 D. Deuchar, 'The necessity for a tariff organisation in connection with fire insurance business', *CII*, VI, 1903, p. lv and Supple, *REA*, p. 214.

3 *PMA*, 1901.

4 *Ibid.*

5 Supple, *REA*, p. 294.

6 The reasons why policyholders had good cause to be careful can be seen in D. Morier Evans, *Facts, Failures and Frauds*, London, 1859, Chapter III.

7 O. M. Westall, 'The evolution of marketing strategy in the British general insurance market, 1700–1939' in T. Nevett, K. R. Whitney, and S. C. Hollander, eds., *Marketing History: the Emerging Discipline: Proceedings of the Fourth Conference on Historical Research in Marketing and Marketing Thought*, East Lansing MI, 1989, p 380.

8 *Ibid.* p. 381.

9 R. Ryan, 'The Norwich Union and the British fire insurance market in the early nineteenth century' in O. M. Westall, ed., *Business of Insurance*, p. 43 and R. Ryan, *A History of the Norwich Union Fire and Life Insurance Societies from 1797 to 1914*,

University of East Anglia Ph. D. , 1983, p. 948.

10 Supple, *REA*, pp. 88–95; P. G. M. Dickson, *The Sun Insurance Office, 1710–1960*, London, 1960, pp. 87–97; C. Trebilcock, *Phoenix Assurance and the Development of British Insurance Volume I 1782–1870*, Cambridge, 1985, pp. 445–450.

11 Supple, *REA*, pp. 211–2.

12 Ryan, 'Norwich Union in the early nineteenth century', pp. 47–50; Supple, *REA*, pp. 123–4.

13 Ryan, *Norwich Union from 1797 to 1914* , p. 948.

14 Supple, *REA*, pp. 217 and 282; Dickson, *Sun*, pp. 149–60.

15 Deuchar, 'The necessity for a tariff organisation' p. lviii; Westall, 'David and Goliath'.

16 Trebilcock, *Phoenix*, pp. 267–84; Westall, 'David and Goliath', p. 134.

17 Supple, *REA*, pp. 211–12.

18 Supple, *REA*, pp. 289–94; Westall, 'Marketing strategy', pp. 383–5.

19 Trebilcock, *Phoenix*, Ch. 5; Raynes, *History of British Insurance*, pp. 267–82.

20 Supple, *REA*, p. 214 and 242–3.

21 Westall, 'The assumptions of regulation' pp. 144–5; Raynes, *History of British Insurance*, pp. 270–2.

22 *PM*, 2 January 1904, p. 16.

23 Supple, *REA*, pp. 293–303; Raynes, *History of British Insurance*, Ch. XXI; Clayton, *British Insurance*, pp. 132–7.

24 *PH passim.*

25 *Economist*, 25 January 1902, p. 111. This estimate is based on a comparison of the combined premium incomes of the companies before and after the amalgamation.

26 Supple, *REA*, pp. 224–37; Westall,'Entrepreneurship and product innovation in British general insurance, 1840–1914' in J. Brown and M. B. Rose, eds., *Entrepreneurship, Networks and Modern Business*, Manchester, forthcoming 1992.

27 Supple, *REA*, pp. 232–7; W. A. Dinsdale, *History of Accident Insurance in Great Britain*, London, 1954, pp. 199–207; Westall, 'The invisible hand' p. 434.

28 *PMA.*

29 Dinsdale, *Accident Insurance*, pp. 282–6.

30 *Ibid.* , p. 152.

Chapter three: The development of strategy

1 O. M. Westall, 'Sir Edward Mortimer Mountain' in D. Jeremy, ed., *Dictionary of Business Biography*, IV, London, 1985, pp 361–7; O. M. Westall, 'Sir Francis Norie-Miller' in A. Slaven and S. G. Checkland, eds., *Dictionary of Scottish Business Biography*, II, Aberdeen, 1990, pp. 416–20.

2 O. M. Westall, 'A. W. Bain', in Jeremy, ed., *DBB*, I, pp. 100–1.

3 O. M. Westall, 'A. R. Stenhouse' in Slaven and Checkland, eds., *DSBB*, II, pp. 418–20.

4 Westall, 'David and Goliath', pp. 133–5.

5 *Ibid.* , pp. 135–8.

6 O. M. Westall, 'C. E .Heath' in Jeremy, ed., *DBB*, III, pp. 136–41.

7 Westall, 'David and Goliath', p. 137–8.

8 Guildhall Library, London, MS. 14,026, Commercial Union , Fire Committee Minute Books, XXVIII, 17 April 1905; XXIX, 22 April 1907 and 13 April, 1908; *PM*, 7 January 1911, p. 12.

9 Westall, 'David and Goliath', pp. 138–40.

10 *Sprinkler Bulletin*, June 1899; F. J. Kingsley, 'Tariff legislation and risk improvement', *Journal of Federation of Insurance Institutes*, III, 1900, p. 353.

11 See, for example, Westall, 'Bain', pp 100–1.

Chapter four: A foothold in the market

1 Westall, 'Retreat to Arcadia'.

2 Guildhall Library, London, MS. 15,048, 12 November 1903.

3 Westall, 'Bain'.

4 Westall, 'Stenhouse'.

5 R. Northwood, *Fire Extinguishment and Fire Alarm Systems*, London, 1928, pp. 24–7.

6 Westall, 'David and Goliath', pp. 140–4.

7 Dinsdale, *Accident Insurance*, pp. 282–6.

8 *PM*, 9 January 1915, p. 32.

9 W. T. Easterbrook and H. G. J. Aitken, *Canadian Economic History*, Toronto, 1958, pp. 400–5 and 482–6.

Chapter five: The profitability of business

1 W. S. Coles and H. S. Bell, *Fire Insurance Handbook*, London, 1909, p. 269.

2 W. G. Fordyce, 'Accident claims', *CII*, XIII, 1910, pp. 377–8.

3 Supple, *REA*, p. 380.

4 H. A. L. Cockerell, *Sixty Years of the Chartered Insurance Institute 1897–1957*, London, 1957, pp. 29–30.

5 G. Clayton and W. T. Osborn, *Insurance Company Investment Principles and Policy*, London, 1965, Ch. III; F. W. Paish and G. L. Schwartz, *Insurance Funds and their Investment*, London , 1934, Ch. I.

6 J. B. Welson and H. K. MacIver, *Insurance Accounts and Finance*, London, 1952, p. 116; J. B. Welson ,ed., *Pitman's Dictionary of Accident Insurance*, London, 1938, p. 872.

7 The basis of these calculations is explained in Appendix B.

Chapter six: Uncertainty, war, and an interruption to development

1 *The Times*, 5 August 1913.

2 *The Times*, 9 July 1913; Lever, William Hulme, Viscount Leverhulme, *Viscount Leverhulme*, London, 1927, pp. 176–7.

3 This general account is derived from Sir Norman Hill *et al., War and Insurance,* London, 1927, the annual reports on the insurance markets in the *PM.* The investment values data are from *Insurance Shareholder's Guide 1920–21,* Manchester, undated, p. 19.

4 *PMA .*

5 Guildhall Library, London, MS. 14,026, Commercial Union Fire Committee Minute Book and MS. 16,248, Royal Exchange Assurance, Fire Manager, Special Report Book.

6 C. H. Feinstein, *Statistical Tables of National Income, Expenditure and Output of the U. K. 1855–1965,* Cambridge, 1976, p. T132.

7 W. Crichton Slagg, 'The part played by insurance companies during the war', *CII,* XXVI, 1923, p. 13–14.

8 Hill, *War and Insurance,* pp. 67–73.

9 *Ibid.* p. 79.

10 *Ibid.*

11 Guildhall Library, London, MSS. 14,026 and 16,248.

12 Hill, *War and Insurance,* p. 96.

13 Clayton, *British Insurance,* p. 179.

14 B. R. Mitchell, *Abstract of British Historical Statistics,* Cambridge, 1962, p. 230.

15 *PM,* 6 January 1916 and 18 January 1919.

16 Sir Norman Hill, 'State insurance against war risks at sea' in Hill, *War and Insurance;* Supple, *REA,* pp. 418–20.

17 *Insurance Shareholder's Guide, 1920–21, passim;* D. E. W. Gibb, *Lloyd's of London,* London, 1957, p. 226.

18 Supple, *REA,* p. 422–3.

19 Company expense ratios fell from 1916: *Insurance Shareholder's Guide, 1920–21,* pp. 12–13.

20 *PM,* 2 January 1915.

21 *PMA .*

22 Westall, 'Norie-Miller' and 'Mountain'.

23 *PM,* 5 January 1918.

24 Profitability has been calculated from *Insurance Shareholder's Guide, 1920–21,* pp. 12–13; security prices are found in the same source p. 17.

25 A. J. P. Taylor, *English History 1914–1945,* London, 1965, pp. 53–4.

26 Slagg, 'Companies during the war', p. 2.

27 *Parliamentary Debates,* HCD, 5 s. , 96, Col. 1106.

28 An index of the prices of consumers' goods and services rose from 100 in 1913 to 112 in 1915, 133 in 1916, 166 in 1917, 203 in 1918 and 223 in 1919: Feinstein, *Statistical Tables.*

29 Mitchell, *Abstract,* p. 429.

Chapter seven: Business in wartime

1 Guildhall Library, London, MS. 14,026, Commercial Union, Fire Committee Minutes, XXII–V; MS. 16,247, Royal Exchange Assurance, Fire Manager's Special Reports, VII.

2 A. Redford, *Manchester Merchants and Foreign Trade Vol. II 1850–1939*, Manchester, 1956, pp. 192–9.

3 *Ibid.*, pp. 197–9.

4 *Ibid.*, p. 199; *PM*, 6 January 1917.

5 See Chapters 10. 1 and 11. 1.

6 The best brief account is W. A. Lewis, *Economic Survey 1919–1939*, London, 1949, pp. 18–19.

7 *PM*, 15 January 1916, p. 46.

8 *PM*, 9 January 1915, p. 32.

9 *Insurance Shareholder's Guide 1920–21*, pp. 12–13.

10 Lewis, *Economic Survey*, p. 18.

Chapter eight: Profitability in wartime

1 *Guildhall Library*, MS. 14,026, Commercial Union Fire Minute Books, XXXII–V; MS. 16,247, Royal Exchange Assurance, Special Report Books, VII.

2 *Insurance Shareholder's Guide 1920–21*, pp. 60–1.

3 *PM*, 8 January 1916, p. 27.

4 *PM*, 5 January 1918, p. 7.

5 See Chapter 6. 2.

6 See Appendix B.

Chapter nine: Family concerns and wider horizons

1 E. Howard, *Tomorrow*, London, 1898; W. Ashworth, *The Genesis of Modern British Town Planning*, London, 1954, Ch. 5.

2 Westall, 'Retreat to Arcadia'.

3 S. H. Scott, *A Westmorland Village*, London, 1904.

4 A detailed description of the house can be found in T. , ' "Yews," near Windermere, A converted Westmorland homestead' the lesser country houses of today, *Country Life*, XXXI, 802, 18 May 1912, pp. 7–11.

5 Presumably W. Crichton Slagg, 'The future of insurance in all its branches', *CII*, XVIII, 1915, p. 9.

6 *Westmorland Gazette*,Kendal, 3 May 1919.

7 B. Mallet and C. O. George, *British Budgets Third Series 1921-2–1932-3*, London, 1933, *passim*.

8 B. H. Binder, the Provincial director, was also a director of the British Shareholders' Trust. The Trust was effectively an issuing house established by provincial interests to

counter the centrifugal strength of the London capital market. See W. A. Thomas, *The Provincial Stock Exchanges*, London, 1973, p. 251–2.

9 His principal literary works include *The Silver Ship*, London, 1926 and *The Exemplary Mr Day 1748–1789*, London, 1935.

10 Obituary of Sir S. H. Scott, *Westmorland Gazette*, 1 July 1960.

11 B. L. Thompson, *The Lake District and the National Trust*, Kendal, 1946, pp. 35–6.

12 Francis Scott eventually died on 1 January 1979 at the age of 97.

Chapter ten: The general insurance market between the wars

1 Supple, *REA*, p. 426–7.

2 A. C. Pigou, *Aspects of British Economic History 1918–1925*, London, 1948, *passim*.

3 County of London Fire Insurance, *PMA, passim*.

4 Guildhall Library, London, MS. 14,026.

5 E. H. Minnion, 'Modern developments in fire insurance', *CII*, XXXII, 1929, pp. 106–7; *PM*, 14 January 1922, p. 49; 13 January 1923, p. 61; 12 January 1924, p. 61.

6 G. W. Richmond and F. H. Sherriff, eds., *Pitman's Dictionary of Life Assurance*, London, 1930, p. 443; County of London Fire Insurance, *PMA*, 1937.

7 Westall, 'Norie-Miller'.

8 Westall, 'Mountain'.

9 County of London Fire Insurance, *PMA*, 1937.

10 R. G. Garnett, *A Century of Co-operative Insurance*, London, 1968, Part Four.

11 On the Cornhill I am grateful to D. Brindle-Wood-Williams for allowing me to read his unpublished history of Willis Faber, the brokers who founded the company.

12 See Chs. 6. 2 and 7. 1 above.

13 Hannah, *The Rise of the Corporate Economy*, Ch. 7; *PM*, 19 January 1935, p. 102.

14 County of London Fire Insurance, *PMA*, 1938.

15 *PM*, 12 January 1924, pp. 61–2, 10 January 1925, p. 68, 9 January 1926, p. 63.

16 Minnion, 'Modern developments', p. 107.

17 *Ibid.*, p. 108; the rate reductions can be traced in the annual surveys of the fire market in *PM*.

18 Minnion, 'Modern developments', p. 107.

19 *PM*, 21 January 1928, p. 106; 26 January 1929, p. 155; 18 January 1930, p. 102.

20 Guildhall Library, London, MS. 14,026.

21 Minnion, 'Modern developments', p. 114; *PM*, 10 January 1925, p. 67.

22 County of London Fire Insurance, *PMA, passim*.

23 Hinted at by Minnion, 'Modern developments', p. 107.

24 The Monopolies Commission, *Report on the Supply of Fire Insurance*, HC.396, 1972, paras. 132–6 and Appendix 8.

25 Guildhall Library, London, MS. 14,026.

26 *The Times* data from *PM, passim.*

27 D. W. Wood, 'Fire hazards of newer industrial processes', *CII*, XLI, 1938, 133–168.

28 H. Calvey, 'Trends and tendencies in fire insurance', *CII*, XLI, 1938, p. 456.

29 H. W. Richardson and D. H. Aldcroft, *Building in the British Economy between the Wars*, London, 1968, pp. 56 and 297.

30 Dinsdale, *Accident Insurance*, pp. 197 and 275.

31 Minnion, 'Modern developments', p. 131; H. Calvey, 'Trends and tendencies', p. 449; *PM*, 12 January 1924, p. 63; *PM*, 3 February 1923, p. 173.

32 A. Brown, *Cuthbert Heath*, London, 1980, pp. 69–72.

33 Calvey, 'Trends and tendencies', p. 452.

34 *PMA, passim.*

35 Dinsdale, *Accident Insurance*, p. 155.

36 *PMA, passim.*

37 Dinsdale, *Accident Insurance*, pp. 156–9; T. W. O. Coleman, 'Post-war influences on home accident insurance', *CII*, XXXVIII, 1935, p. 14.

38 *PMA, passim*; Coleman, 'Post-war influences', p. 14.

39 *PMA, passim*; Coleman, 'Post-war influences', p. 22.

40 *PMA, passim.*

41 *Ibid.*

42 *PM*, 1 February 1936, p. 186.

43 Dinsdale, *Accident Insurance*, pp. 158 and 171; H. M. Gates, 'Survey of modern development in accident insurance at home and abroad', *CII*, XXXIII, 1930, p. 255.

44 Dinsdale, *Accident Insurance*, pp. 171 and 213; Coleman, 'Post-war influences', pp. 37–8.

45 The estimates for 1920 and 1929 are obtained by deducting the estimate of motor insurance business in Table 10.1 from the total reported for miscellaneous accident insurance.

46 *PMA, passim.*

47 Dinsdale, *Accident Insurance*, p. 285.

48 *PMA, passim.*

49 The remainder of this chapter is largely drawn from Westall, 'The invisible hand'. On the early history of motor insurance see Supple, *REA*, pp. 232–7, Dinsdale, *Accident Insurance*, pp. 199–209 and 285–6 and F. V. Shaw, 'Some aspects of motor vehicle insurance', *CII*, XXXII, 1929, pp. 245–7.

50 On the expansion of motor vehicle use between the wars see H. J. Dyos and D. H. Aldcroft, *British Transport: An Economic Survey from the Seventeenth Century to the Twentieth*, Harmondsworth, 1974, Ch. 12 and P. S. Bagwell, *The Transport Revolution from 1770*, London, 1974, pp. 209–35.

51 Supple, *REA*, pp. 429–32 surveys the growth of motor insurance between the wars; see also Coleman, 'Post-war influences ', *passim.*

52 Mitchell, *Abstract*, p. 230.

53 On the problems created by the expansion of motor car ownership see W. Plowden,

The Motor Car and Politics in Britain, London, 1971, Chs. 6 and 13, Supple, REA, p. 432, Coleman, 'Post-war influences', pp. 13–4, 18–21, 37–8, and 42. The important 'Rose v. Ford' legal decision is discussed in F. V. Shaw, 'Some aspects of motor insurance', CII, XXXVIII, 1935, pp. 199–203 (NB. This article has a different date to that by the same author cited in note 49). The implications of compulsory cover are described in Dinsdale, Accident Insurance, pp. 210–2. The annual surveys of the motor insurance business in PMA make frequent reference to the problem of the 'first year motorist' in the 1920s. The detailed reasons for the increases can be followed in the annual surveys of motor insurance business in the PM usually published in January or February.

54 PM, 15 October 1938, p. 1975.

55 Ibid. and Dinsdale, Accident Insurance, p. 214, PM, 11 February 1928, p. 230 and 16 February 1929, p. 298. Between 1926 and 1928 the proportion of cars with a capacity of eight horsepower or less rose from 6.9 per cent to 28.6 per cent of all vehicles. Between 1924 and 1938 a representative index of private car prices, unweighted by changes in the size of vehicles, fell by 51. 4 per cent (Society of Motor Manufacturers and Traders, Motor Industry of Great Britain, 1939, London, 1939).

56 Plowden, Motor Car and Politics, pp. 244–51 discusses the controversial introduction of compulsory insurance. He reports that the estimate that about ninety per cent of private motorists were insured was made from 1924 onwards. Although he treats it sceptically, the representatives of the AOA and Lloyd's claimed that it was supported by their members' experience when giving official evidence to the Royal Commission on Transport (Minutes of Evidence, Ministry of Transport, 1928–30, II, pp. 496–500 and pp. 504 and 509). When Wardlaw-Milne, in opposition to the companies, proposed legislation to impose compulsory insurance in 1928, he accepted that the level for private cars was eighty-five per cent and for motor bicycles thirty-three per cent (Parliamentary Debates, 215, HCD 5 s. , 27 March 1928, Col. 995). In broad terms it is consistent with the very modest increase in motor premium income in the first year in which compulsory business was written in 1931, though the depression must have affected business. Coleman, 'Post-war influences', pp. 18–20 provides an insurance view of these events. It seems impossible to provide an accurate estimate of the proportion of cars purchased through hire purchase agreements. Wardlaw-Milne asserted a level of sixty per cent; F. R. Oliver, The Control of Hire Purchase, London, 1961, p. 91 implies twenty per cent; G. Maxcy and A. Silberston, The Motor Industry, London, 1959, pp. 4–5, suggests that as late as 1953 the level was 13. 5 per cent for private vehicles, thirteen per cent for commercial vehicles, and twenty-five per cent for used cars.

57 Dinsdale, Accident Insurance, pp. 199–209 and 285–6; Shaw, 'Some aspects' (1929), pp. 245–7. A tariff for motor cycles was not established until 1921 (PM, 28 January 1922, p. 115).

58 PMA, 1922, p. 124.

59 PMA, 1935–36, pp. 517–23 and 559.

60 On the growth of larger brokers see Westall, 'Bain' and 'Stenhouse'.

61 Dinsdale, Accident Insurance, pp. 209–10; Coleman, 'Post-war influences', p. 13.

62 Dinsdale, Accident Insurance, pp. 210–2; Coleman, 'Post-war influences', p 13 and 18–21. ; on claims settlement see A. G. M. Batten and W. A. Dinsdale, Motor Insurance, London, 1965, pp. 250–1.

63 *PM*, 16 February 1929, p. 298; Dinsdale, *Accident Insurance*, pp. 209–10.

64 *PMA*, 1922, pp. 55–6 and 91–2 and *PMA*, 1935–36, pp. 169–72 and 277–80.

65 Westall, 'David and Goliath', pp. 133–5.

66 Coleman, 'Post-war influences', p. 13; *PM*, 7 February 1925, p. 230.

67 The spread of the cumulative no claims bonus can be followed in the annual *Private Car Insurance Tables*, Stone and Cox, London. I am grateful to the publishers for allowing me to consult their annual series of this publication. It is now held in the Lancaster University Library. See also *PM*, 11 February 1928, p. 230 and 16 February 1929, p. 298.

68 *Private Car Insurance Tables* specifies the companies offering a country discount. On the introduction and operation of the tariff district rating system, see *PM*, 19 October 1935, p. 1931.

69 Dyos and Aldcroft, *British Transport*, pp. 381–93.

70 Supple, *REA*, pp. 457–8.

71 These ratios have been calculated from the annual statistical reports in the *PM*.

72 *PM*, 16 September 1939. Subsidiary companies have not been counted separately; mutual offices are included with the independents.

73 See Gibb, *Lloyd's*, p. 333.

74 Westall, 'Norie-Miller' and 'The invisible hand' p. 443.

75 Westall, 'Mountain'.

76 D. Brindle-Wood-Williams, Cornhill MS. ; Garnett, *Co-operative Insurance*, pp. 188–91 and 219–20.

77 Gibb, *Lloyd's*, pp. 329–34; Lloyd's motor business from 1925–34 is reported in *PM*, 11 July 1936, p. 1425, derived from *Departmental Committee on Compulsory Insurance (Cassel Committee)*, Minutes of Evidence, HMSO 1936, Cols. 1536–8.

78 *Private Car Insurance Tables*, 1938.

79 Revenue figures are taken from the annual *PM* surveys. The story of the companies is provided in *PM*, 20 April 1935, 19 October 1935, 26 September 1936, and 23 January 1939. See also *Economist*, 7 December 1935 and *Parliamentary Debates*, 315, HCD 5 s., 29 July 1936, Cols. 1536–8.

80 *PM*, 19 October 1935, p. 1931; 15 October 1938, p. 1975.

81 *PM*, *passim*; see also *Economist*, 7 December 1935, p. 1151.

82 *PMA*, 1938, p. 335. These calculations are naturally dependent on the companies' own allocation of costs between the various accounts. This was undoubtedly not particularly scientific, but none the less presumably formed the basis of their decision making.

Chapter eleven: The Provincial's home business between the wars

1 J. Singleton, *Lancashire on the Scrapheap The Cotton Industry 1945–1970*, Oxford, 1991, pp. 10–20.

2 Mitchell, *Abstract*, pp. 300 and 186.

3 Singleton, *Lancashire on the Scrapheap*, pp. 14–16.

4 *PM*, 14 January 1922, p. 51 and 9 January 1926, p. 62.

5 On the declaration policy see Ch. 10. 1.

6 *PM*, 21 January 1928, p. 106 and 26 January 1929, pp. 154–5.

7 *PM*, 21 January 1928, p. 106.

8 See Ch. 8.

9 See Ch. 10. 2.

10 Dinsdale, *Accident Insurance*, p. 272; Welson, *Dictionary of Accident Insurance*, pp. 276–7.

11 See Ch. 10. 3.

12 *PM*, 16 September 1939, pp. 1704–5; the estimate of the proportion of British motor insurance obtained abroad is based on the evidence in Table 10. 1.

13 Virgil M. Kime, 'Automobile insurance', *CII*, XXI, 1918, p. 42.

14 See Ch. 10. 3.

15 The underwriting data comes from *PMA, passim*.

16 P. W. S. Andrews and E. Brunner, *The Life of Lord Nuffield A Study in Enterprise and Benevolence*, Oxford, 1955, pp. 112 and 185.

Chapter twelve: The development of the Provincial's organisation

1 See Ch. 11. 3.

2 See Ch. 4. 4.

3 *Insurance Shareholder's Guide, 1920–21*, p. 438.

4 *CII*, XXXIV, 1931, xiv.

5 Feinstein, *Statistical Tables*, T140.

6 *Ibid.*

7 See Ch. 12. 3.

8 *Memorandum on Profit-sharing Applicable to the Staffs of the Provincial Insurance Company Limited and Drapers' and General Insurance Company Limited* Keynes Papers PCI.I (unpublished writings of J. M. Keynes copyright The Provost and Scholars of King's College Cambridge 1992), Modern Archives Centre, The Library, King's College, Cambridge (Keynes Papers).

9 J. M. Keynes to F. C. Scott, 27 January 1927, Keynes Papers PCI.I; *Britain's Industrial Future being the Report of the Liberal Industrial Inquiry*, London, 1928, p. 199.

10 F. Ashton, *A History of the Guild of Insurance Officials*, Association of Scientific, Technical & Managerial Staffs, undated, pp. 3–16. I am grateful to Dr R. Ryan for this reference.

11 The membership of the Guild of Insurance Officials rose from 14,700 early in 1936 to 19,967 at the end of 1937 (*PM*, 11 April 1936 and 11 June 1938).

12 *Insurance Shareholder's Guide, 1920–21*, pp. 135–6 provides the financial history of the Drapers' and General from its foundation.

13 J. B. Jefferys, *Retail Trading in Britain 1850–1950*, Cambridge, 1954, p. 78. Ch. II discusses the reasons.

Chapter thirteen: The Provincial overseas

1 A. S. Rogers, 'Some aspects of foreign insurance business. ', *CII*, XXVIII, 1925, p. 50.

2 S. H. Scott to J. M. Keynes, 2 May 1924, Keynes Papers, PCI.I.

3 G. F. Johnson, 'Foreign legislation as affecting insurance companies', *CII*, XXXIII, 1930, pp. 25–43.

4 Rogers, 'Foreign insurance business', p. 50.

5 Johnson, 'Foreign legislation', *passim*; on the general economic difficulties of the period see J. Foreman-Peck, *A History of the World Economy International Economic Relations since 1850*, Brighton, 1983, Chs. 7 and 8.

6 On the Rhondda business see M. J. Daunton, 'Thomas, David Alfred, 1st Viscount Rhondda', in Jeremy, ed., *DBB*, V, and 'D. A. Thomas', *Dictionary of National Biography, 1912–21*, London, 1927, pp. 526–7.

7 L. Katzen, *Gold and the South African Economy The influence of the gold mining industry on business cycles and economic growth in South Africa 1886–1961*, Cape Town – Amsterdam, 1964, pp. 83–6.

8 See Ch. 7. 3.

9 South Africa Act No. 37, 1923.

10 The Provincial's insurance business can be traced through *Union of South Africa, U. G. Series, Annexes to Votes and Proceedings of the South African Parliament, Report of the Registrar of Insurance Companies, passim.* Market information is found in Union of South Africa, Office of Census and Statistics, *Official Year Book of the Union of South Africa*, Pretoria, 1934, p. 872.

11 Katzen, *Gold and the South African Economy*, pp. 83–6.

12 *South Africa Year Book*, 1934, p. 872 and 1939, p. 652.

13 South African employers' liability premium income rose from £419,000 in 1933 to £1,085,000 in 1938 (*South Africa Year Book*, 1934, p. 872 and 1939, p. 652).

14 Calculated from Canada, Dominion Bureau of Statistics, *The Canada Year Book*, Second Series, Insurance, seriatim.

15 *Ibid.*,1939, p. 974.

16 *Ibid.*,, seriatim.

17 *Ibid.*, 1931 and 1939.

Chapter fourteen: The Provincial at sea

1 See Ch. 7. 5.

2 *PMA*, 1923, *passim*.

3 *PMA*, 1937.

4 *PMA*, 1930.

5 *PM*, 13 January 1923, p. 63.

6 *PMA*, 1922, p. 7; Westall, 'Mountain'.

7 *PMA*, 1924–25, p. 11; 1926–27, p. 11; 1927–28, p. 11; 1929–30, p. 11;1930–31, p. 11; 1935–36, p. 12.

8 *PMA*, 1934–35, p. 12; 1938–39, p. 12.

9 *PMA, passim.*

10 This was the backwash of the City Equitable collapse. See 5 above.

11 Supple, *REA*, pp. 448–9.

12 *PMA*, 1934–35, p. 12.

Chapter fifteen: Investment: riding the tiger

1 See Ch. 5. 3.

2 See Ch. 6. 3.

3 S. Howson, *Domestic Monetary Management in Britain*, Cambridge, 1975, A. T. K. Grant, *A Study of the Capital Market in Britain from 1919 –1936*, London, 1967, and Paish and Schwartz, *Insurance Funds*, are the best general references.

4 Thomas, *Provincial Stock Exchanges*, Chs. 8 and 12; F. Lavington, *The English Capital Market*, London, 1921, Ch. XXXIV.

5 R. F. Harrod, *The Life of John Maynard Keynes*, Harmondsworth, 1972, pp. 345 and 371.

6 The following paragraph is drawn from Harrod, *JMK* and R. Skidelsky, *John Maynard Keynes: A Biography*, I, *Hopes Betrayed, 1883–1920*, London, 1983.

7 J. M. Keynes, *The Economic Consequences of the Peace*, London, 1919.

8 Keynes's business activities are surveyed in D. Moggridge, 'John Maynard Keynes' in Jeremy, ed., *DBB*, III, pp. 588–91.

9 D. Moggridge, *The Collected Writings of John Maynard Keynes*, XII, *Economic Articles and Correspondence: Investment and Editorial* (abbreviated as *CW XII*), London, 1983, p. 30 and pp. 36–7. See also N. Davenport, *Memoirs of a City Radical*, London, 1974, Ch. 3 and N. Davenport, 'Keynes in the City' in M.Keynes, ed., *Essays on John Maynard Keynes*, Cambridge, 1975. Note that, contrary to Davenport in the last reference cited, Keynes was never Chairman of the Provincial.

10 B. Russell, 'Portraits from memory – II – Bertrand Russell OM on Maynard Keynes and Lytton Strachey', *The Listener*, 17 July 1952, p. 97.

11 John Brown, BA, DD; born Bolton 1830; ecclesiastical historian and Chairman of the Congregational Union of England and Wales, 1891. See Skidelsky, *Hopes Betrayed*, pp. 4, 16–17, 422.

12 Harrod, *JMK*, pp. 257–8, 337–8, 351 and 354; Davenport, *Memoirs*, pp. 44–6, 53–4; Moggridge, *CW XII*, p. 30.

13 Davenport, *Memoirs*, p. 44.

14 Samuel Scott's first wife's sister was married to Walter Bonham-Carter.

15 *Dictionary of National Biography, 1941–1950*, London, 1959, pp. 303–4.

16 *Who Was Who 1961–70*, London, 1972, p. 96.

17 Moggridge, *DBB* and *CW XII*, Ch. 1.

18 A. H. Bailey, 'On the principles on which the funds of life assurance societies should be invested', *Assurance Magazine*, X, 1861.

19 Clayton and Osborn, *Insurance Company Investment*, pp. 62–3.

20 Supple, *REA*, pp. 330–48.

21 E. V. Morgan, *Studies in British Financial Policy, 1914–25*, London, 1952, pp. 138–40.

22 Moggridge, *CW* XII, p. 33.

23 *Ibid.*, p. 243.

24 *Ibid.*, pp. 247–52.

25 H. E. Raynes, 'The place of ordinary stocks and shares (as distinct from fixed interest bearing securities) in the investment of life assurance funds', *JIA*, LIX, 1928, pp.21–50.

26 H. E. Raynes 'Equities and fixed interest stocks during twenty-five years', *JIA*, LXVIII, 1937, pp. 323–507.

27 Moggridge, *CW* XII, pp. 156–8.

28 *Ibid.*, p. 159.

29 *Ibid.*, p. 155.

30 *PM*, 1939, p. 475.

31 I am grateful to Prof. J. Butt for providing me with unpublished information based on his researches into the history of the Standard Life.

32 *PM*, 1939, *passim*.

33 Howson, *Domestic Monetary Management*, p. 49–50.

34 Moggridge, *CW* XII, p. 149.

35 Howson, *Domestic Monetary Management*, pp. 33–4.

36 E. V. Morgan, *Studies in British Financial Policy 1914–25*, London, 1952, pp. 141–56.

37 Moggridge, *CW* XII, p. 145.

38 *Ibid.*, p. 149.

39 *Ibid.*, p. 30 and Harrod, *JMK*, p. 354.

40 Howson, *Domestic Monetary Management*, pp. 38, 48 and 50.

41 Moggridge, *CW* XII, p. 34.

42 *Ibid.* , p. 34.

43 Grant, *Capital Market in Britain*, p. 145.

44 Moggridge, *CW* XII, p. 34.

45 Davenport, *Memoirs*, p. 46.

46 Moggridge, *CW* XII, p. 106.

47 Howson, *Domestic Monetary Management*, p. 153.

48 The most public statement of these views was 'The future of the rate of interest: prospects of the bond market' published in *The Index*, September 1930, published by Svenska Handelsbanken and reprinted in Moggridge, *CW* XX, pp. 390–9; D. E. Moggridge and S. Howson, 'Keynes on monetary policy, 1910–1946', *Oxford Economic Papers*, (New Series) XXVI, 2, 1974, pp. 234–8 discusses the theoretical background to this approach.

49 Howson, *Domestic Monetary Management*, p. 75.

50 R. G. Hawtrey, *A Century of Bank Rate*, London, 1938, p. 164.

51 Hawtrey, *Bank Rate*, p. 296.

52 Howson, *Domestic Monetary Management*, pp. 86–9.

53 Hawtrey, *Bank Rate*, p. 166.

54 Howson, *Domestic Monetary Management*, p. 153; U. S. Bureau of the Census, *Historical Statistics of the United States, Colonial Times to 1957*, Washington D C , 1960, Series X. 348–354, p. 657.

55 Howson, *Domestic Monetary Management*, p. 153.

56 C. Kindleberger, *The World in Depression*, Harmondsworth, 1987, pp. 192–201 and 231–6.

57 *Historical Statistics of the United States*, Series X. 350 and 352, p. 657.

58 Moggridge, *CW* XII, pp. 51–8.

59 Howson, *Domestic Monetary Management*, p. 153.

60 *Ibid.*, pp. 135–6.

61 *Ibid.*, p. 136; Kindleberger, *Depression*, pp. 265–9.

62 Howson, *Domestic Monetary Management*, p. 121.

63 *Ibid.*, p. 153.

64 Harrod, *JMK*, pp. 565–7; Moggridge, *CW* XII, pp. 19–20.

65 Moggridge, *CW* XII, pp. 37–8.

66 *Ibid.*, p. 11.

67 *Ibid.*, p. 105.

68 *Ibid.*, p. 100.

69 *Ibid.*, p. 106.

70 *Ibid.*, p. 70.

71 *Ibid.*, p. 71.

72 *Ibid.*, p. 39.

73 *Ibid.*, p. 100.

74 *Ibid.*, p. 78.

75 *Ibid.*, p. 101.

76 *Ibid.*, pp. 67–8.

77 *Ibid.*, pp. 12–4 provides detailed statistical evidence on Keynes's success in managing his own funds. Jess H. Chua and Richard S. Woodward, 'J. M. Keynes's investment performance: a note', *The Journal of Finance*, XXXVIII, 1, 1983, assess his management of the King's College portfolio.

78 Moggridge, *CW* XII, p. 70.

79 Howson, *Domestic Monetary Management*, pp. 150–1.

80 Bankers' Magazine, January 1947, pp. 39–44.

81 Moggridge, *CW* XII, pp. 92–9.

82 Raynes, 'Equities and fixed interest stocks during twenty-five years', (1937), pp. 323–507.

83 Beta risk measures the volatility of a security in relation to the market as a whole. See F. Amling, *Investments An Introduction to Analysis and Management*, New Jersey,

1978, pp. 16–8 or W. Sharpe, *Investments*, New Jersey, 1978, pp. 274–80. Chua and Woodward, 'Investment performance'.

84 Moggridge, *CW XII*, p. 79.

Chapter sixteen: Conclusion

1 F. C. Scott to J. M. Keynes, 4 November 1926 and F. C. Scott to J. M. Keynes, 24 September 1928, Keynes Papers, PCI.I

2 See Appendix B.

3 See Appendix B.

4 *PM, passim.*

5 Westall, 'Mountain' and 'Norie-Miller'.

6 P. W. S. Andrews, *On Competition in Economic Theory*, London, 1966, p. 77.

7 Westall, 'David and Goliath', p. 136.

8 Westall, 'The invisible hand'.

9 Westall, 'The assumptions of regulation', pp. 142–55.

10 *Ibid.*, pp. 144–6.

11 Monopolies Commission, *Fire Insurance*, paras. 343–6 and 350.

12 Trebilcock, *Phoenix*, Ch. 6.

13 Singleton, *Lancashire on the Scrapheap*, pp. 10–20.

14 Westall, 'The invisible hand', p. 435.

15 M. J. Weiner, *English Culture and the Decline of the Industrial Spirit, 1850–1980*, Cambridge, 1981; see also the discussion of these ideas in B. Collins and K. Robbins, eds., *British Culture and Economic Decline*, London, 1990.

16 H. W. Macrosty, *The Trust Movement in British Industry*, London, 1907, and A. F. Lucas, *Industrial Reconstruction and the Control of Competition The British Experiments*, London, 1937.

17 P. W. S. Andrews, *Competition in the Modern Economy*, Institute of Petroleum, London, 1958, pp. 35–7.

18 Macrosty, *Trust Movement* is full of examples of such episodes.

19 Chandler, *Scale and Scope*, pp. 366–89.

20 P. L. Payne, 'The emergence of the large scale company in Great Britain, 1870–1914', *EcHR*, XX, 3, 1967, pp. 524–5.

21 Chandler, *Scale and Scope*, p. 390.

22 *Ibid.*, pp. 235–42 and 389–92.

23 Supple, *REA, passim.*

24 Westall, 'Mountain' and 'Norie-Miller'.

25 O. M. Westall, 'Culture des entreprises et competitivite: le cas de l'assurance en Grande-Bretagne' in A. Beltran and M. Ruffat, *Culture d'entreprise et Histoire*, Paris, 1991, pp. 90–2.

26 Westall, 'The invisible hand' and 'The assumptions of regulation'.

27 Supple, 'Scale and scope', p. 511–2.

28 Elbaum and Lazonick, *The Decline of the British Economy*; I am grateful to my colleague Maurice Kirby for letting me read 'Institutional rigidities and economic decline: reflections on the British experience' prior to its forthcoming publication in the *EcHR*.

29 Singleton, *Lancashire on the Scrapheap*, pp. 11–20; M. W. Kirby, *The British Coalmining Industry 1870–1946: a Political and Economic History*, London, 1977; S. Tolliday, *Business, Banking and Politics: the Case of British Steel 1918–1939*, Cambridge, Mass., 1987.

30 M. W. Kirby, 'The Lancashire cotton industry in the inter-war years: a study in organisational change', *BH*, 16, 1974, pp. 149–55.

31 Tolliday, *Business, Banking and Politics*, Ch. 13.

Appendix A

1 Moggridge, *CW* XII, pp. 92–109.

2 *Ibid.*, p. 96.

3 Raynes, 'Equities and fixed interest stocks during twenty-five years' , (1937), p. 497.

4 *Ibid.*, p. 496–7.

5 Moggridge, *CW* XII, p. 96.

6 *Ibid.*, p. 96.

Sources and bibliography

Primary Sources

The archives of the Provincial Insurance Company and the Scott family are not open to the public, but it is possible to provide some idea of the main sources used to write this history. The most illuminating, on the history of the company down to the early 1920s, include two manuscript accounts written by the two chief protagonists. Francis Scott wrote a 122-page analysis of the company's development to 1916 in that year, outlining the company's problems, opportunities, and describing its operational arrangements. Sir Samuel Scott wrote a history of the company down to 1926 which emphasised personalities and described specific episodes in colourful detail. Other manuscript accounts of the company's history from employees' perspectives were provided by C. Dale Evans, *1911 and All That* and W. Nicholson (untitled). Briefer recollections were recorded by R. R. Baillie, S.W. F. Crofts and W. Gray. These could be supplemented by two privately published books of importance to the company's history. Sir Samuel Scott published *Sir James William Scott A Short Memoir by his Son* privately shortly after his father died. A typescript manuscript of this volume contains a little more information than that published. In 1953 Sir Samuel and Francis Scott collaborated to write *Personal Account: Some Recollections of Fifty Years of the Provincial Insurance Company*, to celebrate the company's fiftieth anniversary. The personal nature of this publication gives some of its contents a special value.

The most authoritative sources of material proved to be a series of annual reports to the board prepared by Francis Scott which were available from 1911. This could be supplemented by an annual series of minutes of Branch Managers' Conferences which was available from 1921. More direct material was obtained from Francis Scott's correspondence files which appear to have survived almost complete for the years from about 1910 to about 1925 and some series continue after that date. The main group consists of 169 correspondence series covering every aspect of the company's activities. Correspondence files covering some topics, especially investment affairs after 1930, were particularly detailed. Keynes and Francis Scott corresponded on an almost daily basis. For the inter-war years these could be supplemented by the minutes of the board committees that controlled foreign, marine and investment activities. These included records of the principal decisions taken and supporting statistical material. The main statistical framework of the study was provided by the company's annual report and accounts, ledgers, and, with the introduction of mechanised accounting in the 1920s, printouts, which provided detailed statistical information on every aspect of the company's British fire and accident insurance business, differentiated by class written (fire, accident, etc.), originating branch, and indicating premium income, claims, management expenses and underwriting surplus. At a late stage, a consolidation of this voluminous material was found covering the whole history of the company to 1945 bound up as *Provincial Insurance Company, Ltd. Records*. The author remains deeply indebted to the unknown individual (probably Mr W.

Nicholson) who collated this material so meticulously. These documentary sources were finally supplemented by extended interviews with some of those involved in affairs. Those kind enough to help in this way included Francis Scott, Mr D. W. Holloway, Mr W. Nicholson, Mr N. Proctor, Mr J. W. Tolfree and Mr A. Murdoch.

Secondary sources

ABBREVIATIONS USED IN FOOTNOTES AND BIBLIOGRAPHY

BH	Business History
CII	Journal of the Chartered Insurance Institute
CW	The Collected Writings of John Maynard Keynes
EcHR	Economic History Review
JIA	Journal of the Institute of Actuaries
Keynes Papers	Keynes Papers, Modern Archive Centre, The Library, King's College, Cambridge
PH	Policy-holder
PM	Post Magazine
PMA	The Insurance Directory Reference and Year Book (formerly Post Magazine Almanack)

N.B. Whenever a footnote refers to PMA in supporting statistical evidence, it can be assumed that it is referring to the tables summarising the insurance business transacted by individual companies or the whole market provided in this publication, unless a more precise reference is indicated.

Bibliography

Amling, F., Investments An Introduction to Analysis and Management, New Jersey, 1978.

Andrews, P. W. S., 'The theory of the growth of the firm', The Oxford Magazine, 30 November 1961.

— Competition in the Modern Economy, Institute of Petroleum, London, 1958.

— On Competition in Economic Theory, London, 1966.

— and Brunner, E., The Life of Lord Nuffield A Study in Enterprise and Benevolence, Oxford, 1955.

Ashton, F., A History of the Guild of Insurance Officials, Association of Scientific, Technical & Managerial Staffs, undated.

Ashworth, W., The Genesis of Modern British Town Planning, London, 1954.

Bagwell, P. S., The Transport Revolution from 1770, London, 1974.

Bailey, A. H., 'On the principles on which the funds of life assurance societies should be invested', Assurance Magazine, X, 1861.

Bankers' Magazine.

Barker, T. C., The Glassmakers. Pilkington: The Rise of an International Company, 1826–1976, London, 1977.

Batten, A. G. M., and Dinsdale, W. A., Motor Insurance, London, 1965.

Bowker, B., *Lancashire under the Hammer*, London, 1928.

Britain's Industrial Future being the Report of the Liberal Industrial Inquiry, London, 1928.

Brown, A., *Cuthbert Heath*, London, 1980.

Calvey, H., 'Trends and tendencies in fire insurance', *CII*, XLI, 1938.

Canada, Dominion Bureau of Statistics, *The Canada Year Book*, annual.

Carter, R. L., *Competition in the British fire and accident insurance market*, University of Sussex D.Phil., 1968.

Cassel Committee, *Departmental Committee on Compulsory Insurance*, Minutes of Evidence, HMSO, 1936.

Chandler, A. D., *Scale and Scope The Dynamics of Industrial Capitalism*, Cambridge, Mass., 1990.

— *The Visible Hand The Managerial Revolution in American Business*, Cambridge, Mass., 1977.

Channon, D. F., *The Strategy and Structure of British Enterprise*, London, 1973.

Chua J. H., and Woodward, R. S., 'J. M. Keynes's investment performance: a note', *The Journal of Finance*, XXXVIII, 1, 1983.

Church, R. A., *Kenricks in Hardware A Family Business 1791–1966*, Newton Abbot, 1969.

Clayton, G., *British Insurance*, London, 1971.

— and Osborn, W. T., *Insurance Company Investment Principles and Policy*, London, 1965.

Cockerell, H. A. L., *Sixty Years of the Chartered Insurance Institute 1897–1957*, London, 1957.

— 'Combination in British fire insurance' in Reichert-Facilides,F., Rittner, F. and Sasse, J., eds., *Festschrift fur Reiner Schmidt*, Karlsruhe, 1976.

Coleman, T. W. O., 'Post-war influences on home accident insurance', *CII*, XXXVIII, 1935.

Coles, W. S., and Bell, H. S., *Fire Insurance Handbook*, London, 1909.

Collins, B. and Robbins, K., eds., *British Culture and Economic Decline*, London, 1990.

Corley, T. A. B., *Quaker Enterprise in Biscuits: Huntley and Palmers of Reading, 1822–1972*, London, 1972.

Daunton, M. J., 'Thomas, David Alfred, 1st Viscount Rhondda', in Jeremy, D., *The Dictionary of Business Biography*, V, London, 1986.

Davenport, N., *Memoirs of a City Radical*, London, 1974.

— 'Keynes in the City', in Keynes, M., ed., *Essays on John Maynard Keynes*, Cambridge, 1975.

Departmental Committee on Compulsory Insurance (Cassel Committee), Minutes of Evidence, HMSO, 1936.

Deuchar, D.,'The necessity for a tariff organisation in connection with fire insurance business', *CII*, VI, 1903.

Dickson, P. G. M., *The Sun Insurance Office, 1710–1960*, London, 1960.

Dictionary of National Biography, 1912–21, London, 1927, 'D. A.Thomas'.

Dictionary of National Biography, 1941–50, London, 1959, 'Sir William Goode'.

Dinsdale, W. A., *History of Accident Insurance in Great Britain*, London,1954.

Dyos, H. J., and Aldcroft, D. H., *British Transport: An Economic Survey from the Seventeenth Century to the Twentieth*, Harmondsworth, 1974.

Easterbrook, W. T., and Aitken, H. G. J., *Canadian Economic History*, Toronto, 1958.

Elbaum, B., and Lazonick, W., eds., *The Decline of the British Economy*, Oxford, 1986.

Evans, D. Morier, *Facts, Failures and Frauds*, London, 1859.

Feinstein, C. H., *Statistical Tables of National Income, Expenditure and Output of the U.K. 1855–1965*, Cambridge, 1976.

Fordyce, W. G., 'Accident claims', *CII*, XIII, 1910.

Foreman-Peck, J., *A History of the World Economy International Economic Relations since 1850*, Brighton, 1983.

Garnett, R. G., *A Century of Co-operative Insurance*, London, 1968.

Gates, H. M., 'Survey of modern development in accident insurance at home and abroad', *CII*, XXXIII, 1930.

Gibb, D. E. W., *Lloyd's of London*, London, 1957.

'Goode, Sir William', *Dictionary of National Biography, 1941–50*, London, 1959.

Grant, A. T. K., *A Study of the Capital Market in Britain from 1919–1936*, London, 1967.

Hannah, L., *The Rise of the Corporate Economy*, London, 1983.

Harrod, R. F., *The Life of John Maynard Keynes*, Harmondsworth, 1972.

Hawtrey, R. G., *A Century of Bank Rate*, London, 1938.

Hay, D. A., and Morris, D. J., *Industrial Economics and Organisation*, Oxford, 1991.

Hill, Sir Norman, *et al.*, *War and Insurance*, London, 1927.

Howard, E., *Tomorrow*, London, 1898.

Howson, S., *Domestic Monetary Management in Britain*, Cambridge, 1975.

Insurance Shareholder's Guide 1920–21, Manchester, undated.

Jefferys, J. B., *Retail Trading in Britain 1850–1950*, Cambridge, 1954.

Johnson, G. F., 'Foreign legislation as affecting insurance companies', *CII*, XXXIII, 1930.

Katzen, L., *Gold and the South African Economy The influence of the goldmining industry on business cycles and economic growth in South Africa 1886–1961*, Cape Town–Amsterdam, 1964.

Keynes, J. M., *The Collected Writings of John Maynard Keynes*, see Moggridge, D., ed..

— 'The future of the rate of interest: prospects of the bond market', *The Index*, September 1930 (published by Svenska Handelsbanken and reprinted in *CW*, XX).

— *The Economic Consequences of the Peace*, London, 1919.

Kime, V. M., 'Automobile insurance', *CII*, XXI, 1918.

Kindleberger, C., *The World in Depression*, Harmondsworth, 1987.

Kingsley, F. J., 'Tariff legislation and risk improvement', *Journal of Federation of Insurance Institutes*, III, 1900.

Kirby, M. W., 'Institutional rigidities and economic decline: reflections on the British experience', *EcHR.*, forthcoming.

— 'The Lancashire cotton industry in the inter-war years: a study in organisational change', *BH*, 16, 1974.

— *The British Coalmining Industry 1870–1946: a Political and Economic History*, London, 1977.

Lavington, F., *The English Capital Market*, London, 1921.

Lever, William Hulme, Viscount Leverhulme, *Viscount Leverhulme*, London, 1927.

Lewis, W. A., *Economic Survey 1919–1939*, London, 1949.

London and Cambridge Economic Service, *The British Economy Key Statistics, 1900–70*, London, 1970.

Lucas, A. F., *Industrial Reconstruction and the Control of Competition The British Experiments*, London, 1937.

Macrosty, H. W., *The Trust Movement in British Industry*, London, 1907.

Mallet , B., and George, C. O., *British Budgets Third Series 1921-2–1932-3*, London, 1933.

Maxcy, G. and Silberston, A., *The Motor Industry*, London, 1959.

Minnion, E. H., 'Modern developments in fire insurance', *CII*, XXXII, 1929.

Mitchell, B. R., *Abstract of British Historical Statistics*, Cambridge, 1962.

Moggridge, D., 'John Maynard Keynes' in Jeremy, D., *The Dictionary of Business Biography*, III, London, 1985.

— ed., *The Collected Writings of John Maynard Keynes*, XII, *Economic Articles and Correspondence: Investment and Editorial* , London, 1983.

— ed., *The Collected Writings of John Maynard Keynes*, XX, *Activities 1929–31: Rethinking Employment and Unemployment Policies*, London, 1981.

— and Howson, S., 'Keynes on monetary policy, 1910 –1946', *Oxford Economic Papers*, (New Series) XXVI, 2, 1974.

Monopolies Commission, *Report on the Supply of Fire Insurance*, HC. 396, 1972.

Morgan, E. V., *Studies in British Financial Policy, 1914–25*, London, 1952.

Northwood, R., *Fire Extinguishment and Fire Alarm Systems*, London, 1928.

Oliver, F. R., *The Control of Hire Purchase*, London, 1961.

Paish, F. W., and Schwartz, G. L., *Insurance Funds and their Investment*, London, 1934.

Payne, P. L., 'The emergence of the large scale company in Great Britain, 1870–1914', *EcHR*, XX, 3, 1967.

Penrose, E., *The Theory of the Growth of the Firm*, Oxford, 1959.

Pigou, A. C., *Aspects of British Economic History 1918–1925*, London, 1948.

Plowden, W., *The Motor Car and Politics in Britain*, London, 1971.

Private Car Insurance Tables, Stone and Cox, London, seriatim.

Raynes H. E., 'Equities and fixed interest stocks during twenty-five years', *JIA*, LXVIII, 1937.

— 'The place of ordinary stocks and shares (as distinct from fixed interest bearing securities) in the investment of life assurance funds', *JIA*, LIX, 1928.

— *A History of British Insurance*, London, 1964.

Redford, A., *Manchester Merchants and Foreign Trade Vol. II 1850–1939*, Manchester, 1956.

Richardson, H. W., and Aldcroft, D. H., *Building in the British Economy between the Wars*, London, 1968.

Richmond, G. W., and Sherriff, F. H., eds., *Pitman's Dictionary of Life Assurance*, London, 1930.

Rogers, A. S., 'Some aspects of foreign insurance business', *CII*, XXVIII, 1925.

Royal Commission on Transport, Minutes of Evidence, 3 vols, Ministry of Transport, 1928–30.

Russell, B.,'Portraits from memory – II – Bertrand Russell OM on Maynard Keynes and Lytton Strachey', *The Listener*, 17 July 1952.

Ryan, R., 'The Norwich Union and the British fire insurance market in the early nineteenth century' in Westall, O. M., ed., *The Historian and the Business of Insurance*, Manchester, 1984.

— *A History of the Norwich Union Fire and Life Insurance Societies from 1797 to 1914*, University of East Anglia Ph.D., 1983.

Scott, S. H., *A Westmorland Village*, London, 1904.

— *The Exemplary Mr Day 1748–1789*, London, 1935.

— *The Silver Ship*, London, 1926.

— *Sir James William Scott A Short Memoir by his Son*, Oxford, 1914 (privately published).

— and Scott, F.C., *Personal Account: Some Recollections of Fifty Years of the Provincial Insurance Company*, Kendal, 1953.

Sharpe, W., *Investments*, New Jersey, 1978.

Shaw, F. V., 'Some aspects of motor insurance', *CII*, XXXVIII, 1935.

— 'Some aspects of motor vehicle insurance', *CII*, XXXII, 1929.

Sheppard, D. K., *The Growth and Role of U.K. Financial Institutions 1880–1962*, London, 1971.

Singleton, J., *Lancashire on the Scrapheap The Cotton Industry 1945–1970*, Oxford, 1991.

Skidelsky, R., *John Maynard Keynes: A Biography, I, Hopes Betrayed, 1883–1920*, London, 1983.

Slagg, W. C., 'The future of insurance in all its branches', *CII*, XVIII, 1915.

— 'The part played by insurance companies during the war', *CII*, XXVI, 1923.

Society of Motor Manufacturers and Traders, *Motor Industry of Great Britain, 1939*, London, 1939.

South Africa, Union of, Office of Census and Statistics, *Official Year Book of the Union of South Africa*, Pretoria, annual.

— *U.G. Series, Annexes to Votes and Proceedings of the South African Parliament, Report of the Registrar of Insurance Companies*, annual.

Sprinkler Bulletin, seriatim.

Supple, B., 'Scale and scope: Alfred Chandler and the dynamics of industrial capitalism', *EcHR*, XLIV, 3, 1991.

— *Royal Exchange Assurance A History of British Insurance 1720–1970*, Cambridge, 1970.

T., ' "Yews," near Windermere, A converted Westmorland homestead', the lesser country houses of today, *Country Life*, XXXI, 802, 18 May 1912, pp. 7–11.

Taylor, A. J. P., *English History 1914–1945*, London, 1965.

'Thomas, D. A.', *Dictionary of National Biography, 1912–21*, London, 1927.

Thomas, W. A., *The Provincial Stock Exchanges*, London, 1973.

Thompson, B. L., *The Lake District and the National Trust*, Kendal, 1946.

Tolliday, S., *Business, Banking and Politics: the Case of British Steel 1918–1939*, Cambridge, Mass., 1987.

Trebilcock, C., *Phoenix Assurance and the Development of British Insurance Volume I 1782–1870*, Cambridge, 1985.

Tyson, R. E., 'The cotton industry' in Aldcroft, D. H., ed., *The Development of British Industry and Foreign Competition, 1875–1914*, London, 1968.

U.S. Bureau of the Census, *Historical Statistics of the United States, Colonial Times to 1957*, Washington DC, 1960.

Waterson, M., *Economic Theory of the Industry*, Cambridge, 1984.

Weiner, M. J., *English Culture and the Decline of the Industrial Spirit, 1850–1980*, Cambridge, 1981.

Welson, J. B., ed., *Pitman's Dictionary of Accident Insurance*, London, 1938.

— and MacIver, H. K., *Insurance Accounts and Finance*, London 1952.

Westall, O. M., 'Entrepreneurship and product innovation in British general insurance, 1840–1914' in Brown, J., and Rose, M. B., eds., *Entrepreneurship, Networks and Modern Business*, Manchester, forthcoming 1992.

— 'A. W. Bain', in Jeremy, D., ed., *Dictionary of Business Biography*, I, London, 1984.

— 'C. E. Heath' in Jeremy, D., ed., *Dictionary of Business Biography*, III, London, 1985.

— 'Sir Edward Mortimer Mountain' in Jeremy, D., ed., *Dictionary of Business Biography*, IV, London, 1985.

— 'Sir Francis Norie-Miller' in Slaven, A., and Checkland, S. G., eds., *Dictionary of Scottish Business Biography*, II, Aberdeen, 1990.

— 'The evolution of marketing strategy in the British general insurance market, 1700–1939' in Nevett T., Whitney K. R., and Hollander S. C., eds., *Marketing History: the Emerging Discipline: Proceedings of the Fourth Conference on Historical Research in Marketing and Marketing Thought*, East Lansing, MI, 1989.

— 'A. R. Stenhouse' in Slaven, A., and Checkland, S. G., eds., *Dictionary of Scottish Business Biography*, II, Aberdeen, 1990.

— 'Culture des entreprises et competitivite: le cas de l'assurance en Grande-Bretagne', in Beltran, A., and Ruffat, M., *Culture d'entreprise et Histoire*, Paris, 1991.

— 'David and Goliath: the Fire Offices' Committee and non-tariff competition, 1898–1907' in Westall, O. M., ed., *The Historian and the Business of Insurance*, Manchester, 1984.

— 'The assumptions of regulation in British general insurance' in Jones, G., and Kirby, M. W., *Competitiveness and the State*, Manchester, 1991.

— 'The invisible hand strikes back: motor insurance and the erosion of organised competition in general insurance, 1920–1938', *BH*, XXX, 4, 1988.

— 'The retreat to Arcadia: Windermere as a select residential resort in the late nineteenth

century' in Westall, O. M., ed., *Windermere in the Nineteenth Century*, Lancaster, 1991.

— *The Historian and the Business of Insurance*, Manchester, 1984.

— *Family Policy A Brief History of the First 75 Years of the Provincial Insurance Company*, Kendal, 1978.

Westmorland Gazette, Kendal, seriatim.

Who Was Who 1961–70, London, 1972.

Wood, D. W., 'Fire hazards of newer industrial processes', *CII*, XLI, 1938.

Index